THE MAN WHO CREATED
SHERLOCK HOLMES

THE LIFE AND TIMES OF
Sir Arthur Conan Doyle

ANDREW LYCETT

FREE PRESS

New York London Toronto Sydney

Originally published in Great Britain in 2007 by Weidenfeld & Nicolson

First Free Press hardcover edition December 2007

FREE PRESS and colophon are registered trademarks of Simon & Schuster, Inc.

For information about special discounts for bulk purchases,
please contact Simon & Schuster Special Sales at 1-800-456-6798
or business@simonandschuster.com.

Manufactured in the United States of America

1 3 5 7 9 10 8 6 4 2

Library of Congress Cataloging-in-Publication Data
Lycett, Andrew.
[Conan Doyle]
The man who created Sherlock Holmes : the life and times of Sir Arthur Conan Doyle /
Andrew Lycett.
p. cm.
Originally published: Conan Doyle, the man who created Sherlock Holmes.
London : Weidenfeld & Nicolson, 2007.
Includes bibliographical references and index.
1. Doyle, Arthur Conan, Sir, 1859–1930. 2. Authors, Scottish—19th century—
Biography. 3. Authors, Scottish—20th century—Biography. I. Title.
PR4623.L93 2007
823'.8—dc22 2007034816
[B]
ISBN-13: 978-0-7432-7523-1
ISBN-10: 0-7432-7523-3

For Sue—"always *the* woman"

Contents

PART THREE

Giving Out

List of Illustrations

PERMISSIONS

[1]The Arthur Conan Doyle Collection Lancelyn Green Bequest, Portsmouth City Council, All rights reserved

[2]Georgina Doyle

[3]Toronto Public Library

[4]Stonyhurst

The ideal biographer should be a perfectly impartial man, with a sympathetic mind, but a stern determination to tell the absolute truth. One would like the frail, human side of a man as well as the other. I cannot believe that anyone in the world was ever quite so good as the subject of most of our biographies. Surely these worthy people swore a little sometimes, or had a keen eye for a pretty face, or opened the second bottle when they would have done better to stop at the first, or did something to make us feel that they were men and brothers. They need not go the length of the lady who began a biography of her deceased husband with the words "D—— was a dirty man," but the books certainly would be more readable, and the subjects more lovable too, if we had greater light and shade in the picture.

 — *Through the Magic Door*

Has anything escaped me? I trust that there is nothing of consequence which I have overlooked?

 — *The Hound of the Baskervilles*

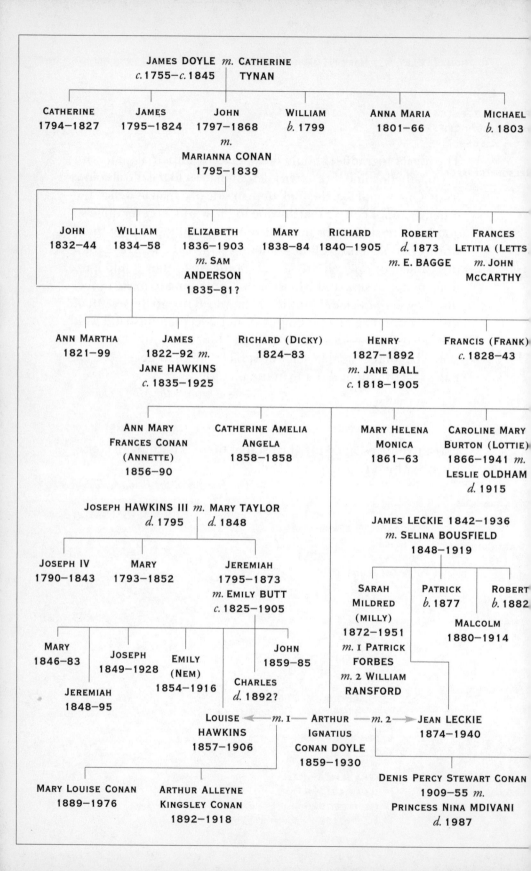

JAMES DOYLE *m.* CATHERINE
*c.*1755–*c.*1845 | TYNAN

CATHERINE 1794–1827
JAMES 1795–1824
JOHN 1797–1868
m.
MARIANNA CONAN
1795–1839
WILLIAM *b.* 1799
ANNA MARIA 1801–66
MICHAEL *b.* 1803

JOHN 1832–44
WILLIAM 1834–58
ELIZABETH 1836–1903 *m.* SAM ANDERSON 1835–81?
MARY 1838–84
RICHARD 1840–1905
ROBERT *d.* 1873 *m.* E. BAGGE
FRANCES LETITIA (LETTS *m.* JOHN McCARTHY

ANN MARTHA 1821–99
JAMES 1822–92 *m.* JANE HAWKINS *c.* 1835–1925
RICHARD (DICKY) 1824–83
HENRY 1827–1892 *m.* JANE BALL *c.* 1818–1905
FRANCIS (FRANK) *c.* 1828–43

ANN MARY FRANCES CONAN (ANNETTE) 1856–90
CATHERINE AMELIA ANGELA 1858–1858
MARY HELENA MONICA 1861–63
CAROLINE MARY BURTON (LOTTIE) 1866–1941 *m.* LESLIE OLDHAM *d.* 1915

JOSEPH HAWKINS III *m.* MARY TAYLOR
d. 1795 | *d.* 1848

JAMES LECKIE 1842–1936
m. SELINA BOUSFIELD
1848–1919

JOSEPH IV 1790–1843
MARY 1793–1852
JEREMIAH 1795–1873 *m.* EMILY BUTT *c.* 1825–1905

SARAH MILDRED (MILLY) 1872–1951 *m.* 1 PATRICK FORBES *m.* 2 WILLIAM RANSFORD
PATRICK *b.* 1877
ROBERT *b.* 1882
MALCOLM 1880–1914

MARY 1846–83
JEREMIAH 1848–95
JOSEPH 1849–1928
EMILY (NEM) 1854–1916
CHARLES *d.* 1892?
JOHN 1859–85

LOUISE HAWKINS 1857–1906 ← *m.* 1 — ARTHUR IGNATIUS CONAN DOYLE 1859–1930 — *m.* 2 → JEAN LECKIE 1874–1940

MARY LOUISE CONAN 1889–1976
ARTHUR ALLEYNE KINGSLEY CONAN 1892–1918

DENIS PERCY STEWART CONAN 1909–55 *m.* PRINCESS NINA MDIVANI *d.* 1987

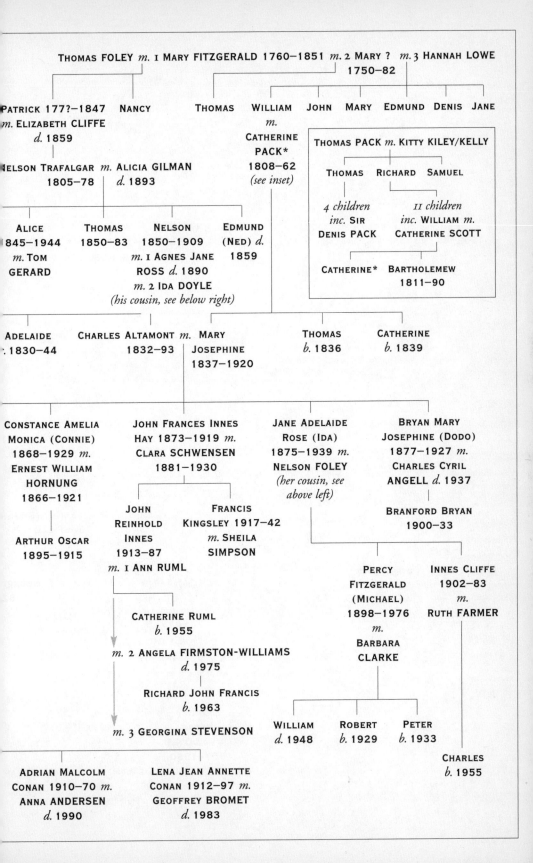

THOMAS FOLEY *m.* 1 MARY FITZGERALD 1760–1851 *m.* 2 MARY ? *m.* 3 HANNAH LOWE
1750–82

PATRICK 177?–1847 NANCY THOMAS WILLIAM JOHN MARY EDMUND DENIS JANE
m. ELIZABETH CLIFFE
d. 1859
 CATHERINE
 PACK*
 1808–62
 (see inset)

NELSON TRAFALGAR *m.* ALICIA GILMAN
1805–78 *d.* 1893

THOMAS PACK *m.* KITTY KILEY/KELLY

 THOMAS RICHARD SAMUEL

 4 children *11 children*
 inc. SIR *inc.* WILLIAM *m.*
 DENIS PACK CATHERINE SCOTT

ALICE THOMAS NELSON EDMUND
1845–1944 1850–83 1850–1909 (NED) *d.*
m. TOM *m.* 1 AGNES JANE 1859
GERARD ROSS *d.* 1890
 m. 2 IDA DOYLE
 (his cousin, see below right)

 CATHERINE* BARTHOLEMEW
 1811–90

ADELAIDE CHARLES ALTAMONT *m.* MARY THOMAS CATHERINE
c. 1830–44 1832–93 JOSEPHINE *b.* 1836 *b.* 1839
 1837–1920

CONSTANCE AMELIA JOHN FRANCES INNES JANE ADELAIDE BRYAN MARY
MONICA (CONNIE) HAY 1873–1919 *m.* ROSE (IDA) JOSEPHINE (DODO)
1868–1929 *m.* CLARA SCHWENSEN 1875–1939 *m.* 1877–1927 *m.*
ERNEST WILLIAM 1881–1930 NELSON FOLEY CHARLES CYRIL
HORNUNG *(her cousin, see* ANGELL *d.* 1937
1866–1921 *above left)*

 JOHN FRANCIS BRANFORD BRYAN
 REINHOLD KINGSLEY 1917–42 1900–33
ARTHUR OSCAR INNES *m.* SHEILA
1895–1915 1913–87 SIMPSON
 m. 1 ANN RUML

 PERCY INNES CLIFFE
 FITZGERALD 1902–83
 CATHERINE RUML (MICHAEL) *m.*
 b. 1955 1898–1976 RUTH FARMER
 m.
m. 2 ANGELA FIRMSTON-WILLIAMS BARBARA
 d. 1975 CLARKE

 RICHARD JOHN FRANCIS
 b. 1963
 WILLIAM ROBERT PETER
 d. 1948 *b.* 1929 *b.* 1933
m. 3 GEORGINA STEVENSON

 CHARLES
 b. 1955

ADRIAN MALCOLM LENA JEAN ANNETTE
CONAN 1910–70 *m.* CONAN 1912–97 *m.*
ANNA ANDERSEN GEOFFREY BROMET
d. 1990 *d.* 1983

PART ONE

TAKING IN

Two Irish Families

Molten lava and packed ice: even the natural forces that created Edinburgh's jagged landscape came in contrasting pairs. More than 300 million years ago one of the smouldering volcanoes that dotted the surrounding countryside erupted, making a series of crags, the tallest of which, serendipitously known as Arthur's Seat, now towers over the city. Later, vast glaciers ground their way through the lava-rich earth, shaping these contours and forming deep basins where today railways run instead of dinosaurs.

This was the ribbon of soaring pinnacles and perpendicular drops that Robert Louis Stevenson fondly recalled as his "precipitous city." For the full vertiginous effect, he probably also envisaged the steepling, overcrowded tenements or "lands" that spread upwards over what little space the cramped "crag and tail" topographical features permitted, so creating the high-rise skyline of Edinburgh's Old Town.

At ground level, a network of alleys or "wynds" led off the main Royal Mile. By the mid-eighteenth century, the stench, squalor and sheer numbers had become so insufferable that the professional classes leading the pragmatic intellectual movement known as the Scottish Enlightenment wanted somewhere more salubrious to live. After deciding on a solid sandstone ridge a mile away, they drained and bridged Nor'Loch, the inland lake that lay between, and hired a young architect, James Craig, to design a well ordered New Town, full of classical terraces and leafy squares.

As with the Old and New Town, so with Edinburgh in general. It is a city of dramatic contrasts, made tolerable by thoughtful accommodation. Here the ferocity of the outlying Highlands and Lowlands was blunted by the civilizing achievements of the Athens of the North. Here a Scottish fascination with witchcraft and the supernatural came

under the skeptical gaze of scholars such as David Hume who congregated at the university. With his home city in mind, Stevenson wrote his classic fictional portrayal of schizophrenia, *The Strange Case of Dr. Jekyll and Mr. Hyde*, drawing on Edinburgh's real-life Deacon Brodie—respectable shopkeeper by day, infamous body theif by night. The only thing that remained constant was the bitter cold.

Arthur Conan Doyle was born at a slight tangent to this polarized world in Picardy Place, a quiet enclave off the main road out of town to Leith. Taking its name from the colony of linen-weavers who came there from France in 1729 to start a local industry, it played host to newer arrivals such as Arthur's parents, whose families hailed from Ireland and who enjoyed the security of living across the way from their co-religionists in the Roman Catholic church of St. Mary's.

Arthur himself came into the world early on May 22, 1859. His horoscope later put the exact time as 4:55 A.M., confirming that, in astrological terms, he was a Gemini, born under the sign of the twins, which was doubly appropriate, given the contrary nature of the city and his own future as a figure whose lifelong struggle to find some middle ground between the opposing nineteenth-century forces of spirituality and reason would provide such a fascinating commentary on his times.

In "The Adventure of the Greek Interpreter," Sherlock Holmes and Dr. Watson discuss the hoary question of "nature versus nurture." When Watson attributes his colleague's remarkable powers of observation and deduction to his "early systematic training," the detective agrees, but only up to a point, arguing that the real reason lies in his veins. Although his family were mainly country squires, "who appear to have led much the same life as is natural to their class," Holmes believes his special skills come from the artistic genes he inherited from his grandmother, a sister of the real-life French painter Horace Vernet. And "art in the blood is liable to take the strangest forms."

So it was with Arthur himself. His family was a source of pride and inspiration, particularly to a *déclassé* Celt anxious to position himself securely in socially stratified Anglo-centric society. But there were skeletons in the cupboard that were worrying to a scientist schooled in murky Victorian concepts of heredity.

Both sides of his family came from Ireland. But lineages are often hazy there, since so many records were lost in the civil war. At one stage Arthur was so convinced the Doyles were descended from Dubgall, King of Ulster, that he had a stained-glass window built at Under-

shaw, his house in Hindhead, showing several putative crests, including the Red Hand of Ulster. In fact, his surname meant little more than "dark stranger" or "foreigner," a reference to the king's Viking origins. He later dropped this idea and settled for the Doyles being a cadet branch of the Staffordshire family of that name who went to Ireland with the English invasion and spawned a large clan in County Wexford.

So far as the record extends, Arthur's grandfather John Doyle was a tailor's son who started professional life as an equestrian artist in Georgian Dublin. He won commissions from aristocratic patrons, including Lord Talbot, Lord Lieutenant during a politically turbulent period from 1817 to 1821, and the Second Marquess of Sligo.

One thing is indisputable—the Doyles were devout Roman Catholics. Both John Doyle's sisters became nuns, and his brother James trained as a priest. As the Catholic journal *The Month* noted, John was the only child of the family who remained "in the world," and with this situation came a certain austerity—a character trait emphasized by his height, bearing and angular patrician features. But his daunting demeanor was offset by a good nature and gentle Irish sense of humor.

In 1820 he married Marianna Conan, whose father also worked as a tailor in the Dublin rag trade. Again her antecedents are blurred, purportedly stretching back to the ancient ducal house of Britanny. Within a short time she had borne him a daughter, Annette. The start of a family was a signal for John Doyle to think seriously about his career. Following the Union of Great Britain and Ireland, educated Irishmen of his type began to look to London as a cultural as well as political capital. At the same time Irish Catholics were making inroads into the discriminatory legislation that barred them from political office.

Ambitious and pragmatic, Doyle made the logical move to London where, with his wife and infant child, he rented a house in an artists' enclave in Berners Street, north of Oxford Street. As mementos and statements of intent, he took some heirlooms with him. According to family tradition, these included silverware, engraved with the Doyle crest and motto "Patientia Vincit" (he conquers through patience); a pestle and mortar; and a portrait, supposedly by van Dyck, of Thomas Wentworth, First Earl of Strafford. This was an odd choice since Strafford, in the early seventeenth century, had been a leading perpetrator of the despoliation of the Catholic landed gentry, which had cost the Doyles their estates. While suggesting that John bore few grudges, it

also pointed to the type of commission he hoped to obtain from high-born patrons.

Initially business was slow, and John was forced to move several times with his growing family, spending two years south of the river Thames in Lambeth. A change of artistic direction came after he visited the House of Commons. He found that his combination of wit and drafts-manship was well suited to producing caricatures of the participants in the mother of Parliaments. Making good use of modern tech-niques of lithography, he began in 1827 to publish a regular series of political sketches, which he signed with the initials HB, a composite representation of his initials. With obsessive secrecy, he managed for sixteen years to keep his identity secret. During that period his sarcas-tic, well observed and usually benevolent cartoons of Britain's politi-cal elite provided a graphic bridge between the angry Regency satires of Gillray and Cruikshank and the more respectful High Victorian out-put of Leech and Tenniel.

John was soon earning a comfortable living, enough to move in 1833 to a large, new house at 17 Cambridge Terrace (now Sussex Gar-dens), north of Hyde Park. By then Marianna had produced seven children, all of whom showed varying degrees of artistic talent. His daughter Annette was a gifted musician, and a pious one, who later became a nun. James, born in 1822, was a scholarly youth, whose adop-tion of his father's more severe traits earned him the nickname "the Priest." Fascinated by the past, he would make a name illustrating and writing about history. Richard, or Dicky, born in 1824, was the most naturally gifted, and would follow "HB" in a successful career, princi-pally as an illustrator. Henry, born in 1827, was also a promising car-toonist, before later finding his métier as an arts curator. Then there were Francis and Adelaide, who both died young without making a mark, and, finally, on March 25, 1832, came Arthur's father, Charles Altamont, his second name a nod to HB's early patron, the Marquess of Sligo, who held the subsidiary title Earl of Altamont.

The atmosphere at Cambridge Terrace was politically and culturally conservative, as might be expected from an Irish Roman Catholic fam-ily making its way in late Georgian society. The children were taught at home, since John was skeptical about English education. As was evi-dent from his choice of the French Chapel off Baker Street as his place of worship, he was Francophile in matters of mind and spirit—a throwback perhaps to his wife's French origins. His son Henry spent a short period at a Jesuit school in the Marylebone Road but, other-wise, the Doyle boys and girls grew up with their own private tutor, Mr.

Street, whose services were supplemented by both a fencing and a dancing master. As part of this privileged upbringing, they were expected to devise their own entertainments, centered around a play or a concert every Sunday. With an artist as father, they were also encouraged to go out and observe the world. After visiting the theatre, an exhibition or some public event, they were required to record their experiences for HB, illustrating them with amusing and meticulous line drawings in the family style.

Nevertheless there was an energy and sociability about the place. Ensconced in his comfortable four-story house, John Doyle was at last able to relax and enjoy the company of his wide circle of friends. Seated on prized Chippendale chairs, making merry around a large mahogany table in the high-ceilinged dining room, artists such as Wilkie and Landseer jostled with writers including Walter Scott, Thackeray and Dickens (the last of whom had originally been a parliamentary journalist colleague). Benjamin Disraeli was one of many politicians who visited, rooting for ideas as he tried to reinvent aristocratic romanticism for an industrial age.

This contented, productive ménage was cruelly broken just before Christmas 1839 when Marianna died of heart disease. Charles was only seven and, although he already showed the family aptitude for drawing, he was more withdrawn than his siblings. Lacking his wife's support, John Doyle reined in his professional, though not his social, commitments, and devoted more time and energy to his children.

The precocious Dicky responded well, as is clear from his journal for the year 1840. Significantly, he made no mention of his mother's recent death: emotional outpouring was not a Doyle family trait. Instead, with great facility, he wrote about and drew whatever he came across—his tutors, his visits to the Tower of London, his observations of military processions in the park and his involvement in a nursery version of the Eglinton Tournament. Within a short time Dicky was selling lithographed copies of his sketches of this mock-chivalric event, which his father had recently attended in Scotland. At first he did not find many takers: only his Aunt Anne (Conan) and Christopher Moore, an Irish sculptor who was a friend of the family, bought copies, and HB had to settle the 4 pounds 18 shillings bill for the printing. But Dicky persevered, sending one set to Count d'Orsay, Disraeli's friend and the leading dandy of his day, who commented that the boy, though still only fifteen, was "undoubtedly a genius of the first order."

Anticipating the medievalism that would inspire the Pre-Raphaelites,

Dicky also painted a large version of the eponymous archer hero of Walter Scott's novel *Quentin Durward*. History and its interpretation were endlessly discussed in the Doyle household. Dicky told his father he preferred reality to fiction (at that stage, at least), adding, as a sop to the old man's Francophilia, that, after examining the histories of England and France, he found them both full of romance, but favored the latter for its picturesque and poetical qualities.

Dicky particularly liked the historical feeling shown by the artist Paul Delaroche. It is not clear if he knew that Delaroche was Horace Vernet's son-in-law, and that together with Vernet's father and grandfather, also distinguished painters, they made up the sort of creative dynasty the Doyles would become. Dicky was more interested in the way these nineteenth-century French genre painters combined drama, realism and imagination. It was all about ways of observing and interpreting the world.

At exactly this time Delaroche was undertaking an official report on the new art of photography for the French government. Though he was apocryphally reported to have said, on examining a daguerreotype, "From today painting is dead," he was actually more enthusiastic, suggesting that this new technique would be a boon to artists.

Taking this all in, though with rather less enthusiasm, was Dicky's brother Charles who even, at the age of ten, gave the impression of finding childhood in an artistic hothouse overwhelming. In one letter to his father, he excused himself for not being able to recall any particularly striking painting at the Royal Academy and promised to return to have another look. In another, he signed himself off plaintively, "Your diminutive son Charles, who watcheth." He was as good as his word, for he passed on the gist of this lively family debate about history and its representation to his son Arthur who, nearly half a century later, would create the fictional detective who prided himself on his descent from Horace Vernet.

Another example of this trickle-down effect was the influence of Marianna Doyle's brother Michael Conan, who came to stay at Cambridge Terrace around the time of her death. He had been educated at Trinity College, Dublin—unusually for a young Catholic, as this was still an avowedly Protestant institution, proud of having been created by Queen Elizabeth I in the first flush of England's colonization of Ireland, and he would, on pain of excommunication, have had to obtain special permission from his bishop to attend it. But this was in the early 1820s, before the opening of government offices to Catholics, and he was ambitious and none too fussed about religion.

So he followed his married sister and brother-in-law to London where he qualified as a barrister and, as a deft painter in his own right, made useful contacts in the art world. (By then, two other Conan sisters, Anne and Elizabeth, had also moved to London, and joined the Doyle household.) But Michael decided to try his hand at journalism, initially working for the *Morning Herald,* which in December 1832 sent him as a foreign correspondent to report on the French siege of Antwerp, a curious sequel to Belgium's brief struggle for independence. On this occasion, the French troops were commanded by the veteran Maréchal Étienne Gérard—the surname adopted by Arthur Conan Doyle as the hero of his *Brigadier Gerard* stories in 1894. The fictional Brigadier was described as a cousin of the Maréchal, who in real life was accompanied at Antwerp by another veteran of the Napoleonic wars, Maréchal Baron de Marbot, whose sparkling memoirs, published in French in 1891, were later to provide useful source material to Arthur.

Back in London, Michael Conan found himself a more appropriate job, writing for the *Art Journal.* With his additional interests in heraldry and genealogy, he exerted a powerful presence in Cambridge Terrace. Young Charles was later able to pass on a sense of this to his own son Arthur, who recalled the powerful unseen presence of his journalist uncle during his childhood and how impressed he was when he finally met Michael Conan, a formidable man of letters in the tradition of the early Irish nationalists. As he entered his teenage years, Charles preferred to be out of doors rather than cooped up at home. His passion was fishing—casting distractedly for roach in the river Brent or sniggling for eels in the Paddington canal. He even went to the trouble of writing to Lord Canning for permission to angle in the Serpentine. As he would later say, he liked this particular pastime because it meant you could forget the cares of the world. His solitary whimsical view of the world comes across in his letters to his friend Frederick Ellis, whose father ran the Star and Garter Hotel in Richmond, Surrey—a haunt of the Doyle family friend, Charles Dickens. Once the young Charles Doyle admitted to liking Dickens's *Dombey and Son,* but mainly because Mr. Toots's dog was so similar to the Doyles' own Prinny. If pressed, he said he liked the historical and Gothic romances of the prolific, now forgotten novelist G.P.R. James. Perhaps the most revealing insight into his undemonstrative nature was his denunciation in 1845, at only thirteen, of the humorous magazine *Punch* for pillorying the Whig-turned-Conservative politician Lord Brougham. Charles may have been a skilled draftsman, but the family trade of car-

icature was clearly not for him. He was too sensitive, and that business too invasive.

Dicky had no such inhibitions. His illustrations now incorporated humor, history and fantasy, with a subsidiary line—since meeting the painter Richard Dadd—in sprites and fairies, that gave him licence to express his Celtic fancifulness and aversion to modernity without adopting the grave religiosity of the Pre-Raphaelites. But his forte was his incisive, quirky cartoons that he published under the name Dick Kitcat. His uncle Michael Conan brought these to the attention of his friend Mark Lemon, editor of *Punch*, who promptly offered Dicky a job in 1846. Three years later Dicky designed a cover that showed a cheerful Mr. Punch, sitting at his desk with his dog Toby, while what his biographer Rodney Engen describes as "an unmistakeable Doyle cloud of fairies, goblins, monsters, knights and maidens in distress pour from cornucopias on either side of the page." With minor alterations, this design was retained as the famous *Punch* cover, epitomizing the spirit of the periodical for the best part of a century.

By then the Doyle family had suffered further losses. Both Francis and Adelaide had died in the early 1840s and, with HB less active, everyone else needed to earn a living. Dicky was already successful, and Henry and James were commencing careers as artists. But Charles, without their self-will, was beginning to lag behind, and did not like it. So the decision was made to remove him from London's distractions and send him north to Edinburgh where he would be subject to the disciplines of a formal office environment, working as a deputy to Robert Matheson, the surveyor who molded the shape of Scotland's official buildings, as a clerk in the Office of Works. There he could put his skills to productive use as a designer and draftsman, and would be assured of earning a salary of 220 pounds a year.

The Foleys, the family of Arthur's mother Mary, were a more volatile Anglo-Irish hybrid. On her father's side, she looked back to a dynasty of hearty, mainly Protestant, yeomen with substantial holdings around Lismore in County Wexford. They owed their wealth and standing largely to their connections with the Dukes of Devonshire who have their Irish seat at Lismore Castle. Shortly after the Devonshires' arrival in 1748, Mary's grandfather Thomas Foley was appointed agent of their estate. He also operated a mill on the busy river Blackwater which, since the roads were so bad, was the main artery for travelers and commercial traffic to the sea at Youghal. But he became signifi-

cantly rich when he acquired the rights to fishing on eleven miles of the river—source of some of the best salmon in Ireland.

As a result the Foleys were linked to the Anglo-Irish ascendancy, and, as such, subject to nationalist opprobrium, although they survived relatively unscathed, since the Dukes were liberal landlords. Their sympathies were clear, nonetheless, from the pride the family took in the distorted legend of old "Black Tom" Foley and his son Patrick killing a member of the Whiteboys, a secret party of agrarian activists that flourished in the late eighteenth century.

Patrick Foley was the eldest of Thomas's nine children from three wives (a number that reflected the high mortality of the time rather than any special concupiscence). Because of his seniority, Patrick took over the mill and fishing rights. His half-brother, also called Thomas, was required, as the son of his father's second wife, to look further afield. So he became a lawyer, a calling that gave him the wherewithal to live comfortably at his nearby seat, Tourtane.

William, the first child of old Thomas Foley's third wife, Hannah Lowe from Cardiff, also sought advancement through the professions. In 1825 he gained a place to study medicine at Trinity College, Dublin, where, unexpectedly, he was recorded as being a Roman Catholic. This suggests that his father was originally a Catholic, adopting Protestantism as a convenience when he married his first wife, Margaret Fitzgerald, who was definitely a member of the Church of Ireland. As a result Patrick, the first of two children from this marriage, continued in his mother's religion, and this was confirmed when he married Elizabeth Cliffe, daughter of a powerful Protestant family with whom the Foleys were allied in business, land ownership and, for a while, fishing rights. From then on there was never any doubt that Patrick's side of the family was firmly Protestant. But by the time his father married for the third time, his commitment to his first wife's religion seems to have slipped and he reverted to Catholicism, the faith in which his son William (some thirty-five years younger than his half-brother Patrick) was brought up.

After graduating from Trinity, the easy-going William duly became a doctor, though not one fired with any great ambition. In 1835 he married Catherine Pack who, with her sister, ran a girls' boarding school that had been started by her mother in Kilkenny. Catherine came from a more cultured Irish family. While the Foleys were essentially upwardly mobile creatures of the Waterford soil (though they did make unsubstantiated claims of having arrived with English con-

querors in the seventeenth century), the Packs were more firmly entrenched in the Anglo-Irish establishment—a position that brought pedigree, responsibilities and pretensions. For the best part of a century they had centered on the ancient city of Kilkenny, where they turned out a succession of distinguished clergymen, doctors and soldiers. Earlier they had lived in King's County (now County Offaly) where they had married into an illegitimate branch of the Percy family, headed by the Duke of Northumberland.

Catherine's grandfather, Richard, had been headmaster of Kilkenny College, Ireland's leading Protestant secondary school, where he was succeeded by his son Anthony. Her great-uncle, Thomas Pack, had been a dean of the Church of Ireland Cathedral of St. Canice in Kilkenny. And this clergyman's son Denis (her first cousin once removed) was the dashing and spectacularly brave Major-General Sir Denis Pack who, after being wounded eight times in the Peninsular wars, commanded a brigade of Picton's division that played a crucial role at the battles of Quatre-Bras and Waterloo (where he was again wounded). As the youngest of Richard Pack's sons, Catherine's father William had been forced into trade as a grocer and wine merchant in Kilkenny. But he had married well enough to the daughter of Matthew Scott, who ran one of the woolen mills that powered the town's economy.

When she opted to marry a Catholic, Catherine Pack took the brave and romantic decision to turn her back on her family's Protestant heritage and adopt her husband's religion. However, six years later, in August 1841, William Foley died suddenly in Clonmel while still in his early thirties. Accompanied by her children, his widow was forced to return to the Pack stronghold of Kilkenny, where, following family tradition, she again started her own girls' school.

However, her circumstances had changed. She was now a Roman Catholic, a faith she held with the conviction of a convert. It was perhaps significant that she chose to situate her school in James's Street, opposite the convent and to use French as her medium of instruction. It was a very difficult time to set up on her own: by the middle of the decade the potato famine was hurting genteel town-dwellers such as herself just as much as impoverished agricultural laborers in the countryside. Its deathly consequences forced the closing of her school and may have deepened her religious feelings. In April 1847, aged only thirty-eight, she was forced to put her Kilkenny property up for sale and, shortly afterward, she moved with her two young daughters, Mary and Catherine, to Edinburgh.

Quite why she opted for the capital of the Scottish Enlightenment is a mystery. Because of the famine, vast numbers of Irish were emigrating, many to Scotland, where work could be found in the linen and construction trades, though Glasgow was a more popular destination than Edinburgh. Later, her daughter Mary used to talk of a Scottish family link between her grandfather Matthew and the great novelist, Sir Walter Scott. But she was given to romantic flights of fancy and may have got this wrong. More likely, her religious enthusiasm alienated her Pack relations, who remained jealous of their privileged links to the (Protestant) Cathedral, where Sir Denis Pack was remembered in a marble bust sculpted by Chantrey. The truth may be that, in difficult circumstances, the self-consciously upright Packs, with their long line of deans and headmasters, had made Catherine Foley's life in Kilkenny intolerable.

Edinburgh was a city in transition. Boosted by immigration from Scotland's internal regions as much as from across the Irish Sea, its population had grown further with the recent arrival of the railways. As a result it had been forced to expand beyond its strict demarcation into Old Town, now little more than a slum, and New Town, the preserve of the affluent middle classes. Catherine and her daughters found accommodation on the fringes of the latter at 27 Clyde Street, not far from the Catholic parish church of St. Mary's. There Catherine returned to the teaching profession, but in a slightly different way: she set up the Governesses' Institution supplying British and foreign governesses to families and schools.

With two daughters to support, Catherine Foley also needed a lodger to make ends meet. She probably asked the church to recommend someone, for the person who appeared on her doorstep was Charles Doyle, looking for a place to live shortly after arriving in Edinburgh in 1849 as a raw seventeen-year-old. "Very pleasant people and very Irish," he reported back to his friend Ellis, once he had settled in.

Though Charles did not stay long with the Foleys, it was time enough to note the attractions of his landlady's daughter, Mary—a bright twelve-year-old, with soulful grey eyes. Before he got to know her, however, she was spirited away to a school in France where, like her mother, she was imbued with a lifelong passion for French culture.

Charles had other matters on his mind, as he worked to emulate his brothers' success. Before the end of the year, he had entered a competition to design new stained-glass windows for Glasgow Cathedral. If

this was a positive move, he betrayed his lack of confidence by sending his drawings back to Cambridge Terrace for approval. The following August he played a prominent role when Queen Victoria and Prince Albert visited Edinburgh to lay the foundation stone for the National Gallery of Scotland. Young Charles raised the flag on Holyrood Palace as the royal couple arrived and reportedly also helped prepare the Queen's apartment.

But it was soon clear from his letters home that he was not happy. Edinburgh, with its quaint tumbling houses on the Canongate, was attractive enough, even if the overall stink was disgusting. But the Castle's looming presence reminded him of a prison and made him uneasy. As for the local people, they were uncouth. Finding himself on the streets one New Year's Eve, he was astonished by the displays of drunkenness and revelry. When, ever courteous, he offered to accompany two women home, he was further taken aback when a friend gave him a weighted truncheon, or "life-preserver," so he could crack the heads of anyone who molested them. This might not have mattered if he had found someone who shared his quirky view of the world. But Scots humor was rather more boisterous.

Sensing his natural introspection giving way to depression, Charles, who was not yet twenty, sought solace in the faith that had been an important part of his upbringing. The intensity of Scottish Presbyterianism probably contributed to his unease. It was less than a decade since the upheavals of the 1843 Disruption, when the more dogmatic members of the established Church of Scotland had staged a revolt against the alien practice of patrons appointing the minister and had gone off to form their own fundamentalist Free Church. At the same time the austere Anglican Church in Scotland was under threat from the Romanized rituals and practices of the Oxford Movement.

Britain as a whole was undergoing a period of spiritual reassessment as it sought to come to terms with the materialism of the industrialized age and related advances in science. Having played its part in meeting this challenge, Charles's own Roman Catholic Church was now seeking to capitalize on the situation, not only by ministering to Anglicans, such as those in the Oxford Movement, who were dissatisfied with their religion, but also by regaining political and civil liberties lost since the Reformation. In this latter context, it had won a notable victory in 1829 when the Catholic Emancipation Act allowed, *inter alia*, the Irish nationalist leader Daniel O'Connell to take his seat in the House of Commons. (One of John Doyle's most famous cartoons showed a bucolic O'Connell celebrating this legislation.)

Twenty years later, Roman Catholics were hoping to make further advance by reasserting their right to appoint their own bishops. But when Rome announced the resumption of the Catholic hierarchy in September 1850, the Protestant establishment in Britain viewed this as another example of "papal aggression" and Lord John Russell's government banned it. However this prohibition was never enforced—the result, in no small part, of the political skills of Cardinal Nicholas Wiseman, the man chosen by Pope Pius IX to be the first Catholic Cardinal-Archbishop of Westminster. Coming from an Irish merchant family, Wiseman was also a friend of the Doyles. Both Dicky and Henry drew him: the latter's 1858 portrait now hangs in the National Gallery of Ireland.

So Charles rallied to the Catholic cause in Edinburgh. In March 1851 he attended a meeting in the Waterloo Rooms to protest against the new Ecclesiastical Titles Assumption Bill and other anti-Catholic measures. When a seconder was required for a motion calling for the resolutions to be sent to Parliament, Charles obliged. He was not the only member of his family who took this religious discrimination seriously. Dicky had been going from strength to strength with his caricatures of English manners and customs in *Punch*. But four months earlier he had taken the drastic move of resigning from the magazine in protest at what he regarded as the anti-Catholic tone of its coverage of this same Bill. In taking his public stand, Charles may have been showing solidarity with his well known brother.

At the time Dicky was still living in Cambridge Gardens and enjoying a discreet affair with Blanche Stanley, daughter of Lord Stanley of Alderley. But in September 1851 she dealt him a cruel blow by marrying the young Earl of Airlie, who was more her social equal. Dicky poured his heart out to his younger brother in Scotland. Two years later he got his own back when, illustrating his friend Thackeray's novel *The Newcomes*, he gave Lord Airlie's features to the worthless Scottish Lord Farintosh (a surname later appropriated for a client of Sherlock Holmes in "The Speckled Band").

Meanwhile there had been changes at Cambridge Gardens. The Irish journalist Michael Conan had moved out, with his wife Susan and sister Anne, to a house on Campden Hill, though his other sister, Elizabeth, continued living with the Doyles until her death from cancer in March 1851. John Doyle himself was winding down as an artist, producing his last political sketch that year. Since, for medical reasons, he was unable to paint in oils, he thought that he might follow Charles and find employment with the Office of Works. When this initiative

failed, he became amiably eccentric, lobbying the government with his "inventions," such as ventilated tents and waterproof boots that he thought would improve the lot of troops in the Crimea—another inspiration for Arthur, who would later pepper the War Office with ideas for innovations such as body armor.

In June 1852 John's musical daughter Annette succumbed to the general religious fervor and joined the Society of the Daughters of the Heart of Mary in Kensington as a nun. Predictably the order had strong links with France where its founder had been a Jesuit. However, since it was not strictly community-based, Annette was able to continue to live at home and look after her father. Her experience encouraged her aunt, Anne Conan, to follow suit and join the same order in 1854, when Michael Conan and his wife took the logical step, given the family's admiration for France, of moving to Paris as correspondent for the *Art Journal*.

These comings and goings did little to boost Charles's morale, which was further dented by his lack of advancement at work. Dicky, who was closest to him, encouraged him to seek outlets for his illustrations. He also tried to buoy his brother's spirits with tidbits of London literary gossip. But the family's anxiety was evident from a letter from John Doyle asking Charles plaintively if he had increased his circle of friends as a result of Thackeray's visit to Edinburgh in late 1851.

When Charles obtained a commission to illustrate a scroll celebrating Cardinal Wiseman's links with Scotland, he again lacked confidence in his own ability and asked his family's advice. His brother James bluntly told him that this seemed "very like carrying a certain combustible material to Newcastle," and added, "Allow me to say that your remark about your not being equal to the job is nothing less than 'bosh'."

Charles's life took a turn for the better when Mary Foley returned from France in 1854. She had blossomed into an attractive young girl, whose vitality and intelligence poured from her petite five-foot-one-inch frame. Her mother was delighted when this sincere and obviously well connected young Catholic began to show a romantic interest in her daughter. Equally happy, Charles sent Mary's photograph to Dicky who, though still smarting from being jilted, conceded that the girl had "Irish charm" and told his sister Annette, "She looks nice— decidedly so for a "sun pictur [a photograph] that don't flatter." Dicky sketched her from this likeness, giving her round face an openness and intelligence, tempered with a touch of reserve, evident in her prim mouth and light brown hair swept back behind her ears.

Charles took his brother's favorable reaction as a signal to propose to Mary, who was still only eighteen when they walked up the aisle together at St. Mary's Church on July 31, 1855, the feast day of St. Ignatius. The couple took a short honeymoon at an inn on the outskirts of Edinburgh before settling down to married life in a series of rented apartments.

Before long the young Doyles had their first child, a daughter, Annette, who was born on July 22, 1856. When the infant was baptized in St. Mary's the following day, she was given the additional name Conan, ostensibly in honor of one of her godparents, the nun Anne Conan, but more probably out of respect for her grandmother's family, which had played an important role in Charles's upbringing.

The responsibilities of fatherhood did not sit easily with Charles, however. Dicky, who had visited Edinburgh the previous summer, redoubled his efforts to help his brother by finding him alternative sources of income. He put him in touch with London magazines and advised him on strategies to make sure he was paid. He even suggested Charles should become his Edinburgh agent or, failing that, earn some money touching up his own early watercolors.

More practically John Doyle tried to get his son a transfer to London. Charles scoffed at this suggestion, telling his sister Annette, "I have the greatest horror of being herded with a set of snobs in the London Office, who would certainly not understand and probably laugh at the whole theory of construction, as also the technical terms in use among the builders here, to whom brick is an unknown quantity." When an opening in the Accountant-General's office was proposed, he said this was something he "simply could not stand." After that job failed to materialize, Charles entertained the idea of emigrating to Australia and earning a living as a gold prospector. Arthur probably heard embellished accounts of his father's youthful ambition, encouraging him to add flashes of Australian color to several Sherlock Holmes stories such as "The Boscombe Valley Mystery."

Marriage did at least spur Charles to increase his output of illustrations. He developed a reputation as a comic artist in periodicals such as the short-lived *Illustrated Times.* After an exasperating decade in the shadows at the Dickensian Office of Works, he was at last allowed to take credit for his own designs, notably when he helped his boss Robert Matheson on the octagonal fountain in the courtyard at Holyrood Palace in 1858–59. Charles was responsible for the small statues of historical figures surrounding the spire, that Matheson obligingly described as "more in the class of a work of Art than ordinary building

work." But the trade magazine *The Builder* saw only a "confused and miserable mixture, ugly in outline and puerile in detail."

Such professional brickbats did little to boost the mild-mannered man's confidence, which had been further undermined when his second daughter Catherine died from water on the brain in October 1858 when she was six months old. As Dicky discovered when he passed through Edinburgh shortly afterward, Charles was in poor spirits and living in distressingly reduced circumstances at 11 Picardy Place when his first son arrived on the morning of May 22, 1859 and was given the names Arthur Ignatius Conan at his baptism at St. Mary's two days later.

As usual among the Doyles, these names were carefully considered. Arthur signified history and place, albeit a romanticized version, looking back to King Arthur, the mythic architect of Britain; Ignatius faith, evoking the saint's day on which Charles and Mary were married; and Conan kin, referring to the mixed Irish and European heritage of his mother's forebears. These three strands were to battle for supremacy in Arthur's personality.

Early Years in Edinburgh

1859–1868

One of Charles Doyle's last commissions before his son's birth was a set of illustrations for a volume called *Men Who Have Risen*. Subtitled *A Book for Boys*, this was a series of biographical sketches of figures, such as Robert Peel, designed to educate youngsters about the benefits of hard work and self-improvement. It marked the London debut of James Hogg, an opportunist Edinburgh publisher who was keen to establish a presence in the British capital. Hogg showed he lacked none of the commercial wiles of his metropolitan rivals, for *Men Who Have Risen* reached the market shortly before Samuel Smiles's bestselling *Self Help*, a similar collection that defined the Victorian ethic of pulling oneself up by one's bootstraps. The ameliorative and taxonomic demands of the age were also neatly represented in two other, rather different publications of 1859—Charles Darwin's *On the Origin of Species by means of Natural Selection* and the first magazine serializations of Mrs. Beeton's *Book of Household Management*.

Since Arthur would later epitomize a certain type of self-made professional man, his father's involvement with this book was ironic. Despite his wife's sterling support, Charles Doyle had fallen a long way from the solid comforts of Cambridge Terrace. His main problem was that he had started to drink heavily and behave erratically, often giving away his drawings for the price of a bottle of spirits. Pinpointing exactly when this became a liability is not easy. By 1861 Mary's mother and sister were cohabiting with the young Doyles at Picardy Place, where Catherine continued to run her Governesses' Institution. They were on hand when Mary gave birth to a daughter, another Mary, that May. The pressure on space cannot have added to domestic har-

mony and the entire family decamped to Portobello, a seaside suburb of Edinburgh, in 1862. There was another reason for this move: Catherine Foley was not well and in May that year she died of cancer at 3 Tower Bank, Portobello, age fifty-two.

As a lover of the open air, Charles welcomed the wide expanse of the sea and found he was able to paint. But his darker, romantic mood was reflected in the watercolor "A Gypsy Camp in the Gloaming," which he submitted from Portobello, as his first contribution to the 1862 Royal Scottish Academy's summer exhibition.

That winter the skies darkened, the days crowded in and the city and its surroundings became bitterly cold. A depressed Charles took more aggressively to the bottle and, by December, his condition had become so bad that, according to Mary, writing thirty years later to a doctor who was treating him in a mental home, he would drag himself around the floor, behaving like a nincompoop, unable to remember his own name. For the best part of a year he was unable to attend work and was put on half pay. In order to finance his regular binges, he would steal from his wife and children (breaking open the latters' money boxes) and he would run up large bills with shopkeepers for goods he later sold. One Edinburgh pub was full of drawings that Charles had given or sold cheaply for alcohol. When nothing else was available he drank furniture varnish. Already many family friends were urging that he should be institutionalized.

In his autobiography Arthur glossed over these disturbing memories and concentrated on the story of his family's poverty. He recalled his father's meager income and the resulting hardships. He said nothing about the real sources of tension in the Doyle household, which had repercussions for his own relationship with his parents. In an uncertain, often threatening, atmosphere he looked to his petite mother for more than usual emotional support. And, correspondingly, without a husband to fall back on, she enveloped her young son in maternal love and introduced him from an early age to the influences that had provided constancy in her hitherto short, often harsh life.

The religion she had learned from her mother remained important, but her faith had been undermined by her husband's behavior, and she began to look to history as an alternative source of inspiration and moral guidance. This was not a narrow, dogmatic reverence for the past, but a romantic enthusiasm that drew in particular on the Middle Ages for stirring examples of chivalrous behavior. It was underpinned by a passion for her own family's antecedents. All memories of a rift with her

immediate family in Ireland were forgotten. Rolling out the genealogical tree, she quickened her son's heart with stories of the Packs' bravery and the nobility of their proud kinsmen, the Percys. Mary's pedigree became an essential part of her identity, as she sought to escape the chilly, grim reality of mid-Victorian Edinburgh. For Arthur, it provided a wonderful window on the world, where the characters seemed more substantial than at home. It also bound him to his mother, whose hardships he recognized and whom he would poignantly tell, "When you are old, Mammie, you shall have a velvet dress and gold glasses and sit in comfort by the fire."

Living in a dysfunctional family was not easy for the boy. It is hard to be precise about his frame of mind as his childhood reminiscences were written much later, when the long-term consequences of his father's behavior were clearer. There is no reason to question the respect he retained for his father's wit, courtesy and "delicacy of mind." He enjoyed the occasions when the two of them embarked on outdoor pursuits, such as skating. But even he was forced to admit that Charles was "of little help" to his wife, "for his thoughts were always in the clouds and he had no appreciation of the realities of life." And there was a hint of his own unhappiness and insecurity in his conclusion, "The world, not the family, gets the fruits of genius."

With her husband only hanging on to his job through the goodwill of Robert Matheson, Mary Doyle was forced to make more of her own mark in society. Devastated by the death of her two-year-old daughter Mary in June 1863, she joined the Philosophical Institution, a high-minded literary and debating society where, to the consternation of Edinburgh's more conservative citizens, Professor Thomas Huxley had recently talked on the controversial topic of natural selection. Charles nominally joined at the same time, but it is doubtful if he was a regular attendee.

Mary made full use of the Institution's extensive library. At home her passion for reading became a joke: she always had a book in front of her whether she was knitting or feeding the children. Arthur later provided a fictional portrait of her as the "quaintest mixture of the housewife and the woman of letters. . . . Always a lady, whether she was bargaining with the butcher, or breaking in a skittish charwoman, or stirring the porridge, which I can see her doing with the porridge-stick on one hand, and the other holding her *Revue des deux mondes* within two inches of her dear nose."

By being both domestic goddess and intellectual, Mary combined

the responsibilities of both parents, which was just what Arthur needed. And her love of the biweekly *Revue* was significant, since it regularly, almost obsessively, featured the Middle Ages, which it portrayed as the antidote to all that was wrong with modern France. When he grew older and attended school, Arthur would expand his view of the world by reading to her from this magazine, which also played an important role in familiarizing him with the literary periodical, an important cultural phenomenon of the age.

Through the Institution, Mary developed her own bookish contacts, the foremost being Dr. John Brown, a God-fearing physician who had once worked for the celebrated surgeon James Syme, and who had since prospered as the author of witty essays and stories, such as the popular *Rab and his Friends*, a heart-rending story of a dog's devotion to the mistress he accompanies to her deathbed in Edinburgh's Minto Hospital. Brown had a bond with Mary since he too was coping with family trauma—the mental illness of his wife, who was to die in 1864. He found contentment in a wide circle of bookish companions, including Thackeray and Oliver Wendell Holmes, an American who, like himself, straddled the worlds of medicine and literature.

Wendell Holmes had a name that would feature prominently in young Arthur's life, and it is easy to understand why. He was an establishment figure with the wit and curiosity to hold up cherished nostrums to the scrutiny of contemporary knowledge. As a doctor in the 1840s, he had helped advance the germ theory of disease by showing that puerperal (or childbed) fever was carried by the attending physician from one delivery to the next. As a belletrist, he later made a name with his epigrammatic *The Autocrat of the Breakfast Table*, which exposed his own often superstitious, Gothic beliefs to the rigors of Victorian rationalism. The personification of the "Boston Brahmin," a term of his own coining, he retained an idiosyncratic conviction in the immortality of the soul, while being able to turn a cool scientific gaze onto subjects such as the workings of the unconscious mind. His fascination with the caste-like East Coast intellectual aristocracy from which he came encouraged him to wade into the controversial field of heredity in his "medicated novel," *Elsie Venner—A Romance of Destiny*, published in 1861.

From John Brown Mary gained a strong sense of Wendell Holmes's mystique, which she passed on to her son, who later appropriated this surname for his fictional consulting detective, Sherlock Holmes. In a doubtless unconscious reference that pinned his own recollection of

this book to these times, Arthur gave the name Venner and Matheson to the firm to which Victor Hatherly was apprenticed in his story "The Adventure of the Engineer's Thumb."

Brown probably also introduced Mary to some more immediately useful friends, the scholarly Burton family who liked her vivacious personality and welcomed her into their home. Her particular friend was Mary Burton, a formidable campaigner for women's rights, once described as "a unique example of the Victorian woman on the warpath." Mary Burton's field was education, which would have appealed to the daughter of a former schoolmistress.

The earliest incontrovertible evidence of their closeness came with a new addition to the Doyle family—a sister for Annette and Arthur, who was born on February 22, 1866 at Mary Burton's house, Liberton Bank, in the low-lying Pentland hills two miles southeast of Edinburgh. Lottie, as the baby girl was known, was baptized Caroline Mary Burton after her doughty hostess. This suggests an intimacy of some standing, though the date when the Doyles moved to Liberton Bank is unclear. Mary Burton made a habit of helping the needy and may have provided refuge as early as 1862 when Mary Doyle temporarily parted from her alcoholic husband.

What is certain is that Arthur spent part of his childhood in this female-dominated household, where he came within the orbit of Mary Burton's influential brother, John Hill Burton, an Aberdonian lawyer turned political economist and historian, who lived at Craig House in nearby Craiglockhart. Burton was one of the local literati who wrote regularly for *Blackwood's Edinburgh Magazine*, usually known as *Blackwood's*, or, more colloquially, *Maga*. Launched in 1817 by the successful publisher William Blackwood as a Tory version of the Whiggish *Edinburgh Review, Maga* had quickly attracted fine writers, such as Sir Walter Scott's son-in-law, John Gibson Lockhart, who gave it a reputation for brash iconoclasm, underpinned by solid literary and social criticism.

More recently, spurred by circulation wars with the *Edinburgh Review, Maga* had made a speciality of romantic fiction, in the traditional sense of transporting readers to other imaginative worlds, particularly through tales of high adventure and the supernatural. Parallel to this the magazine also featured true-life stories of daring and discovery—the kind of fare which appealed to a public excited by the opening-up of the globe through exploration and conquest and which was to make it the periodical of choice in expatriate clubs throughout the empire.

One instance bore on Arthur even at his tender age. *Maga* had printed the explorer John Hanning Speke's account of his discovery of the source of the Nile following his contentious expedition with Richard Burton (no relation) in 1856–9. But Speke had left so many questions unanswered that he was forced to return to East Africa in 1860 to substantiate his claims. Back in Britain three years later, he had an exciting yarn to tell—one that Blackwood was determined to publish, despite intense competition from John Murray. But when the first draft of Speke's manuscript proved unreadable and too sexually explicit, Blackwood turned to his friend Hill Burton to improve it.

Hill Burton spent August 1863 locked in Craig House, revising the copy with Speke, and the book was published in December. But the results were not successful: the bowdlerization was obvious and the text strewn with errors. As a result Speke failed to prove his claim to have been the first person to discover the source of the Nile. He was scheduled to debate the matter publicly with a still aggrieved Richard Burton in September 1864. But the day before the meeting he shot himself, and the jury remains out as to whether it was suicide or an accident.

Although too young to take in the details, Arthur gained a sense of a wider world brimming with adventure and excitement. His tastes were further whetted and his horizons expanded in the capacious library at Craig House, where Hill Burton's son William became his closest friend.

However his most important influence was his enthusiastic mother, who inculcated the fundamentals of storytelling from her own mouth. She thrilled him with the vividness of her tales, which served not only to educate him but also to dispel her personal anxieties. He later recalled her "art of sinking her voice to a horror-stricken whisper when she came to a crisis in her narrative. . . . I am sure, looking back, that it was in attempting to emulate those stories of my childhood that I first began weaving dreams myself."

Soon he started to commit his own fantasies to paper, though, being where he was, he used words rather than pictures, the preferred medium in his father's childhood house. When about six, he wrote his first story about an adventurer's untimely demise at the hands of a Bengal tiger. A fragment that was locked away in a family writing-desk and later given by Mary Doyle to her son's second wife shows the basics of Arthur's lively style as he described in the first person (with minimal punctuation) the adventures of a group of armed men coming across this magnificent beast. He recalled that the tiger had its way, which left

him "a realist in the age of the Romanticists." (The balance between these two poles—the factual and the imaginative—was to absorb him throughout his life.) He was also conscious of a failing since, following the deaths of his protagonist (or possibly protagonists), his story had nowhere else to go. "It is very easy to get people into scrapes, and very hard to get them out again," he subsequently noted, as he resolved to make early changes to his fictional technique.

The following summer, when Arthur was just seven, his mother took him across the Irish Sea to stay with some "well-to-do" relations in King's County. This seems to have been a journey of reconciliation with the family from which her own mother Catherine had fled. Since the proud woman had died three years earlier, there was no reason to continue any feud with the Packs or the Percys. (There was probably also some more pressing family business to sort out.) With the flowering of her mind, Mary harbored no prejudices against the Protestantism of such relations. Besides, she had lived in Calvinist Edinburgh for most of her life. And she may simply have wanted to give her bright son a taste of the stately lifestyle she often talked about and was seldom able to enjoy.

He remembered his introduction to the lush countryside of his mother's homeland for different reasons, however. While helping with the horses, he was urgently summoned by a groom to a loft from where, after barring the doors, they watched twenty or so men slouching along the road below. After an abusive exchange with them, the groom explained to Arthur that this was a party of Fenians, the Irish nationalists who were to cause mayhem the following year with their bombing campaign on the English mainland.

The incident was instructive for Arthur in several ways. Harking back to his Foley relation Patrick, who was surprised by an intruder (wrongly supposed to be a Whiteboy, a member of the secret Irish agrarian organization), it confirmed in him the idea that he was part of a privileged elite, threatened by a lumpen rural rabble. The fact that, in the Irish context, the former tended to be Protestant and the latter Catholic was mildly confusing because, until then, his religious upbringing had been Roman. But it helped wean him away from strong sectarian views and towards the ecumenism he later espoused. This flash confrontation in the Leinster countryside also led him to think that the Irish were untrustworthy agitators—the sort who later turned up in his fiction as members of the conspiratorial Molly Maguires or as Professor James Moriarty, the "Napoleon of Crime."

All in all, from an early age Arthur was developing a complex atti-

tude to the Irishness on both sides of his family. He appreciated his mother's Celtic vivaciousness, but was not so sure about being Irish, a word usually accompanied in his autobiography with qualifying adjectives such as volcanic, noisy or simply disaffected.

There was another reason for the holiday. Arthur's father Charles had recovered from the worst of his afflictions, and the Doyle family was about to make another move—this time, a couple of miles into the city from Liberton Bank where they rented part of a large Georgian house in a cul-de-sac at 3 Sciennes Hill Place in the growing suburb of Newington. It is true the building was overcrowded, with at least four families living there. But it was hardly the dirty, rough place Arthur liked to portray. It simply suited his subtle rewriting of history to hint at the apparent awfulness of his childhood without betraying the dark secrets at the heart of his family. At least Edinburgh was on the way to cleaning up its filthiest slums. The deaths of thirty-five people when an eight-story tenement block collapsed in the heart of the Old Town in 1861 had acted as a wake-up call. The city had appointed its first Medical Officer of Health, Dr. Henry Littlejohn, and would shortly institute a program of infrastructural and public health improvements.

Following this adjustment in his domestic arrangements, Arthur was ready to start his formal education. In the autumn of 1866 he was dispatched to a school in Salisbury Place, a couple of streets away. As he complained in his autobiography, conditions at Newington Academy were even more spartan than at home and the headmaster, Patrick Wilson, was a Dickensian character, with pockmarked skin and one eye, who brandished a "tawse"—a leather strap with vicious split ends.

Since education in Edinburgh was a very competitive business, Wilson made a point of employing the pick of the city's immigrant population, many of them political refugees from the 1848 liberal revolutions on the Continent. The Europhile Mary Doyle would have welcomed this. But she would have been less happy if she had known more about her son's French teacher, Eugene Marie Chantrelle, a footloose womanizer who later became one of Scotland's most notorious murderers.

Chantrelle was born in Nantes in 1834, the son of a ship-owner. He studied to become a doctor in Nantes, Strasbourg and Paris. But his radical political opinions took him abroad—to the United States, England and finally to Scotland, where he made a desultory living teaching French and dispensing medical advice. In February 1865 he was offering classes in conversational French, German and Italian at

his rooms in Rankeillor Street. By October that year he was teaching at Wilson's Newington Academy. There, in early 1867, when Arthur was a callow seven-year-old new boy undergoing "a thorough education in the elementary parts of the Classics," Chantrelle seduced one of his female pupils, Elizabeth Dyer, a fifteen-year-old merchant's daughter whom he met at a fashionable phrenology lecture. By the time the couple married in August 1868, Arthur had left Newington Academy and was about to start at Stonyhurst, a Roman Catholic boarding school, run by the Jesuit order.

If the Doyles' decision to move their child was in any way affected by Arthur's teacher's affair, they would have had confirmation within a decade that they had made the right choice. For in January 1878, Chantrelle was arrested for murdering his young wife. He was alleged to have killed her with a dose of raw opium, hoping to benefit from a 1,000-pound insurance policy he had recently taken out on her life. By then Arthur was a medical student at Edinburgh University and several of his teachers provided pharmacological and forensic evidence at Chantrelle's trial. But, curiously, he never made any mention of this sensational case, which ended in the Frenchman's execution. It was blotted from his memory, along with other details of his early life.

In reality there were more mundane reasons for Arthur's education being entrusted to the Jesuits. In January 1868 his grandfather John Doyle had died at the age of seventy at 54 Clifton Gardens in London's Maida Vale. Shortly before his death, John had visited his son Charles and his family in Edinburgh. Now Charles somehow blamed himself for his father's demise and went into a renewed depression. The situation at Sciennes Hill Place was not helped when in March Mary had another child, her sixth, Constance Amelia Monica, known as Connie.

The combination of a drunken husband and yet another mouth to feed concentrated Mary's mind on her promising son. Fearing for Arthur's future if he stayed at Sciennes Hill Place, she raised the matter with the Doyle brothers who, apart from Charles, were still all living together with their sister Annette in Clifton Gardens, and they assured her that the family would pay if the boy went to a boarding school. At some stage the name of Stonyhurst came up, almost certainly because Arthur's uncle Henry had recently married an Irishwoman in her late forties called Jane Ball, whose father, Nicholas, a prominent Catholic judge and politician, had been educated there. He had died in 1865, and, since his other two daughters were nuns, the remaining one, Jane, had probably nursed him in his final years and retained a sentimental attachment to his old school.

Within Arthur's nuclear family, his wayward, though still devout, father would have approved of a Catholic education, and so would his uncles and aunts in London, while his mother, with her intellectual horizons expanded through her local friendships, was probably less enthusiastic. Her reluctance was overcome by another family member, Michael Conan, not known for his dogmatism, who told her that the Jesuits impressed him not so much for their religiosity as for their emphasis on education. He thought the sensitive Arthur would benefit from their regime and become "an accomplished artist." However even he counseled against allowing the boy to stay in their care for any length of time. "They know well how to imbue an ingenuous mind with the overruling conviction of a vocation. Beware of that contingency."

So it was that, in September 1868, Arthur found himself taking a train to Preston in Lancashire, Roman Catholicism's strongest outpost in England, where it had survived the Reformation in underground form in recusant houses and chapels. Arthur spent the night in the care of the Jesuit priest who ran St. Wilfrid's church there. The following day, with three fellow pupils, he made his way up the Ribble Valley by carriage to the proud Jesuit establishment of Stonyhurst College— or, more specifically, to its junior school, known as Hodder.

Stonyhurst and Feldkirch

1868–1876

Arthur cried a lot on his journey from Edinburgh to Preston. His large grey eyes, normally so wary and alert, brimmed with tears, reflecting not just the anxiety of a cosseted child leaving home for the first time, but also the apprehension of an intelligent boy dimly recognizing a long life of responsibilities opening up before him. For the subscript of his foray into England was that, with his wider family's support, he would receive the education that would equip him to assume leadership of his branch of the Doyles and, in the absence of input from his father, keep his mother in the velvet he had promised.

Standing like a mini-Versailles at the end of a long drive, Stonyhurst, with its tastefully cupola'd Elizabethan gatehouse, commanded the foothills of the Pennines as much as Edinburgh Castle did the rocky outreaches of the Pentland range. But there the comparisons ended. Arthur's new school was set in rolling countryside, in marked contrast to the cramped, grimy suburbs of his home town. The general ethos was different too. While Edinburgh was practical, mercantile and slightly introverted, Stonyhurst was dedicated to a life of the spirit which looked across the English Channel to the great monastic traditions of Europe and to the ultimate authority of the Pope.

The school had been founded in 1593 in St. Omer in northern France to provide instruction to English Catholics unable to practice their religion at home. It followed the Jesuit precepts of the Spaniard St. Ignatius Loyola. After several moves, known as the migrations, its coming to England in the late eighteenth century was precipitated by the French Revolution.

Within a short time Stonyhurst was flourishing as an English board-

ing school. But its routines owed less to Thomas Arnold than to medieval scholasticism. Pupils progressed through seven "playrooms" or classes called Elements, Figures, Rudiments, Grammar, Syntax, Poetry and, finally, Rhetoric. Although their curriculum covered what Arthur dismissively called the "usual public school routine of Euclid, algebra and the classics," it was based on an old-fashioned "Ratio Studiorum"—a strict program of tests, examinations and public displays of their skills. At meals, if they were not listening to a reading, they would participate in "concertatios," or debates. At allotted times in the academic calendar, each "playroom" put on entertainments (known as Academies) designed to show off its accomplishments.

On his arrival on Tuesday September 15, 1868 Arthur bypassed the main building and made for Hodder, a mile away on a bend in the River Hodder known as Paradise. This had once been the site of a cotton mill which, after going bankrupt in 1802, was bought by Stonyhurst's original benefactor, Thomas Weld, as a novitiate for the returning Jesuits. Gradually the education of boys took precedence over the training of ordinands.

Diffident and small for his age, Arthur was fortunate in coming under the care of a kindly young priest, Father Francis Cassidy, who helped soften the pain of being away from home by telling him stories. Much later Arthur would recall how he used to soak up these tales "as a sponge absorbs water, until I was so saturated with them that I could still repeat them."

In keeping with the school's ethos, his fellow pupils were markedly cosmospolitan. Another new arrival was Patrick Sherlock, one of a sizeable contingent from Ireland. This was a familiar surname: Arthur's new Aunt Jane (Uncle Henry's wife) had been born a Sherlock at Butlerstown Castle in County Waterford. It was natural that, as Catholics, these Irish boys should seek a school that catered to their religion, even if, with the rise of Fenianism, they were often suspected of introducing a streak of anarchism that was harshly stomped on by the authorities. This was compensated for by the steady stream of suave aristocrats with names like de Castro, Corboda and de Ciechanowiecki from countries of Catholic Europe. They came to Stonyhurst to improve their command of English language and culture, and were prevalent in another section of the school—St Mary's Hall, where a small number of older students, known as "gentlemen philosophers," followed a two-year-long quasi-university course.

As was his nature, Arthur quickly adjusted to his new life and, by November, was participating in his first concertatio, which brought the

welcome bonus of a slap-up dinner. But as Christmas approached, he had a rude shock when he learned that he would not be going home. He and a handful of other boys were to remain at Hodder where their parents could send them festive boxes of turkey and plum pudding. He was told that this was because he lived too far away. But the real reason was that his father was still considered too unstable.

Arthur had to draw what comfort he could from his faith. In the new year he made his first Confession before a priest who was a friend of his uncle Dicky. When confronted with a second confessor who knew his grandfather, he might have been forgiven for thinking that his Doyle relations were monitoring his spiritual progress. The burden of this expectation explains why, when he took his first Communion in May, he described it in such extravagantly emotional terms: "Oh mama, I cannot express the joy that I felt on the happy day to receive my creator into my breast. I shall never though I live a hundred years, I shall never forget that day."

His other great solace was reading. So he was delighted when, in the autumn of his second year, he found fifty new books on the shelves of the small Hodder library. If, as he implied, these were really up-to-date they might have included *Over the Rocky Mountains* and *The Fatal Cord: A Tale of Backwoods Retribution*, the latest adventure stories by his favorite novelists, R.M. Ballantyne and Captain Mayne Reid, who were both making fictional capital from time spent in remote areas of North America.

As Arthur had begun to understand, such tales gave him an escape from events around him. He later enthused about the vividness of his experiences on such occasions: "Your very heart and soul are out on the prairies and the oceans with your hero. It is you who act and suffer and enjoy. You carry the long small-bore Kentucky rifle with which such egregious things are done, and you lie out upon the topsail yard, and get jerked by the flap of the sail into the Pacific, where you cling on to the leg of an albatross, and so keep afloat until the comic boatswain turns up with his crew of volunteers to handspike you into safety. What a magic it is, this stirring of the boyish heart and mind! Long ere I came to my teens I had traversed every sea and knew the Rockies like my own back garden. . . . It was all more real than the reality."

After two years under Father Cassidy's benevolent regime at Hodder, Arthur was ready in the autumn of 1870 to move to the upper school. Although he retained his old number, 31, the system was otherwise

very different—much tougher and more orthodox. In terms of the *Kulturkampf* of the day, Stonyhurst was conservative and ultra-montane. This meant that its Rector or Head, Father Edward Ignatius Purbrick, followed a firm Papal line in seeking to stem the tide of materialism in post-Darwinian Britain. On a day-to-day basis the Prefect of (Lower) Studies, Father George Kingdon, presided over an academic program that was essentially antisecular. Both these priests brought the fervor of converts to their jobs. Known as "the Padre," Father Kingdon had rejected orthodox medicine after studying at St. Bartholomew's Hospital where he won the Wix Prize for his antimaterialist essay, "On the Connexion between Revealed Religion and Medical Science." As a schoolmaster he was a meticulous Latin scholar, with several published textbooks to his name. As a Christian he was indisposed to any manifestation of the Enlightenment, to the point where he encouraged boys to devote their studies to the Virgin Mary and write verses in her honour during her month of May.

Father Thomas Kay, the First Prefect responsible for discipline, reinforced these reactionary influences. His frequent recourse to the tolley, a thick slab of rubber that was the Stonyhurst version of Newington Academy's tawse, brought out the worst side of Arthur, who later recalled, "I had a nature which responded eagerly to affectionate kindness (which I never received) but which rebelled against threats and took a perverted pride in showing that it would not be cowed by violence. An appeal to my better nature and not to my fears would have found an answer at once." Arthur usually took his medicine uncomplainingly, so this was a notable *cri de coeur*. In the context, Arthur's emphasis on his fears suggests that, by way of punishment, he was also threatened with all sorts of religious torments that undermined his youthful confidence. He may even have begun to wonder about the causes of his father's pitiable state—an issue that was to trouble him later in life.

What Arthur needed was someone to stand up for him, but his playroom master, the member of the staff responsible for his entire upper school career, was not that person. Father Cyprian Splaine was amiable, with enough of an aesthetic sensibility to be sent a copy of "The Wreck of the *Deutschland*" by its author Gerard Manley Hopkins. But he was frail in body, pedantic in manner, and lacked the character either to protect Arthur from bullying or to spur him to any great intellectual heights.

Despite the general fundamentalism, Arthur picked up enough of a sense of scientific method to enable him later to study medicine. Sci-

ence was certainly not ignored at Stonyhurst. The school had recently invested in a chemistry laboratory and although this was Arthur's least successful subject, he enjoyed it sufficiently to threaten his sisters with experiments during the holidays.

More to his liking would have been the school's new observatory, run by Father Stephen Perry, Francis Thompson's "starry amorist," originally a mathematician who made his name with studies in terrestrial magnetism. Although strictly Catholic, he was well versed in modern science, using photography to assist his research into solar physics, developing Stonyhurst as a licensed meteorological station, and participating in several scientific expeditions that looked into eclipses and other astronomical phenomena in the far reaches of the globe.

Arthur left no record of involvement with Father Perry. But his later fascination with the heavens (a feature of stories such as *The Hound of the Baskervilles*) must have started somewhere. It is hard to imagine his failing to note either Father Perry's election as a Fellow of the Royal Society in June 1874, one of the few Catholic priests so honored, or his journey later in the year to Kerguelen or Desolation Island to observe the Transit of Venus.

Arthur would also have heard of the exploits of the pioneer naturalist Charles Waterton, an old boy of the school who, despite his death in 1865, remained strong in its collective memory. Anticipating Arthur's fictional Professor Challenger, Waterton had mounted several scientific expeditions in the Americas in the early years of the century, variously searching for El Dorado, seeking out plants with medicinal uses, and amassing a collection of exotic animals and birds.

Back home, during his school holidays, Arthur came across a different scientific influence. He befriended another unusual character, a self-styled "medical galvanist" called Dr. William Harthill, who lived in Rutland Square, near Haymarket Station. When the doctor died in early 1872, Arthur felt the loss keenly, describing to his mother his love for the old man.

Harthill advocated one of the many pseudoscientific therapies that flourished at the time, as doctors tried to adapt advances in science to physical and mental healing. In an age of hydrotherapy, mesmerism and phrenology, he practiced medical galvanism, which sought to turn the powers of electricity to medical use. Claiming to have been trained in London by William Halse, a pioneer in the field, he ran a series of advertisements that advocated galvanism as a cure for complaints ranging from asthma to rheumatic gout. With the use of an electrical

contraption known as Halse's apparatus, he assured clients, "the great curative power of Galvanism consists in its supplying fresh Nervous Energy to all the Nerves and Muscles of the body." Perhaps at some stage he was called on to help the unfortunate Charles. His unorthodox views clearly appealed to Arthur who, though still firm in his Catholic faith, was beginning to understand that there were other ways of looking at the world.

Once in the upper school, Arthur had the run of the great building that had been ambitiously extended over the previous two decades. He made his way down corridors hung with paintings by Old Masters, took lessons under gaslight in the long drafty "study place," visited the library with its first folio of Shakespeare, and worshipped in a chapel surrounded by treasures such as King Henry's VII's cope and a reliquary of Queen Eleanor of Aquitaine. In the museum his fantasies of the Wild West would have come to life as he pored over a prized collection of Native American costumes and artifacts.

At mealtimes he repaired to the great marble-floored refectory, with its minstrels' gallery for readings. Not that the fare was anything but a poor reflection of the elaborate surroundings. For breakfast pupils normally made do with a basin of milk and two portions of dried bread. At lunch they were given meat and, twice a week, a pudding. In the afternoons they had more bread and a strange, brownish liquid they called "beer." For supper the regular hot milk and bread was supplemented by potatoes and, as a luxury, a slither of butter.

For the time being, Arthur's scholarly progress was equally uninspiring. He went dutifully through his paces, but his reports show that, despite a reasonable academic record, he was a problem child: "slovenly—caricature" read the damning indictment at the end of his first term in Rudiments in the autumn of 1870. The following year in Grammar was worse: "uncouth—noisy—scatterbrain" after the first term; slightly better in the second—"sulky temper, improved in marks all round—more careful"; then back to "slovenly—snappish" in the third. Repeated black marks referred to his temper, his messiness and, surprisingly, his laziness. There could not have been clearer evidence of a boy out of sorts and lacking in motivation.

Preying on Arthur's mind was the situation at home in Edinburgh. It was a decade since Charles Doyle had had his first alcoholic breakdown, but there is no evidence that his condition had improved much. For the time being he held down his Civil Service

job. But when he tried to make extra income from illustrations and paintings, even the Stonyhurst priests thought these were fair game. On one occasion they saw "Sir Kenilworth on St. Michael's Mount," a Walter Scott–inspired fantasy that Charles had drawn in his son's exercise book, and were so delighted with it that they decided to keep it.

Although not yet in his teens, Arthur had to perform the delicate balancing act of encouraging his childlike father, while giving the impression that he himself was happy at Stonyhurst. This was touching and understandable when, for example, he was making pleasing noises about Charles's beloved cats, but ridiculous when he was claiming to have enjoyed Christmas away from his family. So Arthur tended to steer clear of discussing domestic issues, though occasionally a flicker of his concern for his mother shone through the opaqueness of his letters home, as when he told her he was glad Mrs. Burton, his friend Willie's mother, had returned to Edinburgh and might give her a respite by having her to stay for a couple of days. The psychological consequence was that, though naturally direct and honest, Arthur found himself, from the best of motives, adopting a habit of glossing over his feelings.

His true, depressed state of mind was better reflected in his first recorded poem, "The Student's Dream," written in October 1870 when he was eleven.

> The student he lay on his narrow bed
> He dreamt not of the morrow
> Confused thoughts they filled his head
> And he dreamt of his home with sorrow
>
> He thought of the birche's stinging stroke
> And he thought with fear on the morrow
> He wriggled and tumbled and nearly awoke
> And again he sighed with sorrow.

The following month he spent a short time in the infirmary, after collapsing and vomiting in chapel. His convalescence was eased by the kindness of the matron, Ann Standish, who brought him a copy of Walter Scott's historical romance *Ivanhoe*. Despite an epidemic of mumps, Arthur reported home that he was beginning to enjoy Stonyhurst rather more than he had imagined.

The Franco-Prussian War had started a few months earlier and, by

December 1870, Arthur was rooting for France, which was facing defeat. He had a personal interest since, in the autumn, his sister Annette had followed their mother and gone to complete her education with an order of nuns at the Institution St. Clotilde in Les Andelys, the painter Poussin's birthplace on the River Seine, twenty-five miles southeast of Rouen. Although her great-uncle and -aunt Michael and Susan Conan, whom she visited en route, had decamped to Dieppe to avoid the war, her parents either felt they had good reason to get her out of the house or they imagined she would be in no danger to the west of Paris. They were taken aback when Les Andelys was overrun by the Prussian army and Annette found herself the only "English" (as she described it) girl still at the Institution. But this was nothing compared to Annette's surprise when she learned that her parents had sent extracts from her letters home to *The Scotsman*, where they were published pseudonymously. Her reports gave a graphic picture of incipient anarchy with the Prussians strutting around, blowing up bridges, and requisitioning horses and men. At one stage Annette heard one of the invaders say, "We know twenty roads to get into France, but we do not know one to return to our own country." Arthur was to recreate this locality and its ambience, rather generally in his *Brigadier Gerard* stories about the Napoleonic wars, and more specifically in his story "The Lord of Chateau Noir."

Life at Stonyhurst began to improve as he made friends, such as Arthur Ball, who he was delighted to discover came from Edinburgh and knew Willie Burton. Perhaps because he was one of the youngest in his own playroom, his closest companion was a boy in the year below him, James Ryan, the brisk and imaginative son of a Scots coffee planter in Ceylon. And there were other names, such as the Moriarty brothers from Ireland, one of whom, James, was a brilliant mathematician.

Familiarity was hardly encouraged, however. As Arthur later recalled, the Jesuits put so little trust in human nature that boys were not permitted to spend any time in each other's company. Priests accompanied them on walks and on the games field, and even prowled around their sleeping quarters. He may have been correct that "the immorality which is rife in public schools was at a minimum in consequence." But his subsequent relationships suffered from his lack of close friendships. The specter of a moral censor always hovered over him.

In such circumstances physical exercise, particularly team sports, becomes an accepted way of channeling youthful energy. Arthur

developed a passion for the very English summer game of cricket which he regarded in medieval terms, as a tournament where an individual could shine in a world of rules, rituals and spectacle. Initially there was an advantage in being small: fast bowlers considered it bad form to bowl quickly at someone half their size. But although he made decent scores in lower school matches, the reality was that he was not particularly good. His batting was slow and his bowling at this stage lacked penetration. In 1873 he suffered the ignominy of being voted down to the third XXII. The following year he was officially part of the second XXII, though he played for the second XI against the first XI, a match in which he opened and carried his bat, making a painstaking seven runs out of a total of 40. At the age of sixteen in 1875, when he desperately hoped to make the first XI, he was still only good enough for the next XI.

Drawn to the outdoors like his father, he made the most of Stonyhurst's position in a cradle of verdant valleys, where the streams from the Pennines gathered and flowed into the river Ribble. Like Charles, he enjoyed fishing for trout and salmon, sometimes taking a sketchbook to record his outings. In winter, when the wind whistled down from the mountain tops, the great Dutch ponds in front of the school froze and the boys were allowed to skate—a pastime Arthur enjoyed, reporting on his progress to his father, who was also an enthusiast.

For his inner resources, he still took comfort from religion, or at least this is what he told his mother, with an astute awareness that his progress continued to be closely watched by his wider family. As he made his way through the school, he liked to keep her informed about such uplifting occasions as his participation in a silent retreat.

He was preparing for his Confirmation in the summer of 1872, but this was postponed in strange circumstances after Bishop William Turner of Salford, who was due to perform the sacrament, died suddenly en route to Stonyhurst. (Arthur was told, somewhat implausibly, that the cause was sunstroke.) A replacement was found in Bishop Richard Roskell of Nottingham who had a relation at the school, and the following week, on Sunday July 21, Arthur was duly confirmed, using the name Charles which, as required, he rendered into Latin. Normally this would have been a simple mark of filial respect, but now Arthur had the added responsibility of wishing to boost his father's confidence, and thus his delight, tinged with relief, that the old man had expressed approval at his choice.

His spiritual progress continued when, four months later, he was admitted into the sodality, or religious fraternity, of the Blessed Virgin

Mary. This statement of commitment enjoyed special significance at Stonyhurst, which had its own Sodality Chapel, containing the relic of the martyr St. Gordianus, donated by the English College in Rome in recognition of Lancashire's role in preserving the faith in England.

Despite his own youthful religious enthusiasm, Arthur was receiving contradictory messages from his family. While his mother was falling back on her faith at a time of difficult family circumstances (there is evidence she was involved with a Catholic order in Dundee), his god-father and great-uncle Michael Conan had grown more anticlerical in Second Empire France. He was now wary of the Jesuits, despite still holding their system of education in high regard.

In this often charged situation, names had an added significance. On joining the sodality, Arthur had signed himself: "Arthurus Doyle, servus perpetuus BVM"—an indication of his ambivalence about being called "Conan." Michael Conan, however, clearly regarded this name not only as an affirmation of his family roots, but also as some-thing of a secular charm, for he once asked Mary Doyle, "When you write next to Master Arthur Conan (not Ignatius) Doyle, tell him to write to me" In reply Arthur sent his godfather a playbill on which he cheekily changed his name from A. Doyle (as he was usually known in the school) to A.C. Doyle. He knew this would please his rela-tion, who clearly expected it (and perhaps even had stipulated it as a condition of financial support for his nephew's education).

Trying to keep everyone happy was not easy. So Arthur must have been relieved to be able to fall back on another source of narrative and mystery that rivaled religion, and that was fiction. Once, after returning to school without finishing James Fenimore Cooper's sea novel *The Water Witch*, he wrote to his mother, desperately requesting details of the ending. Spurred by reading *Ivanhoe*, his taste was moving from adventure stories to historical novels, his favorite being *The Cloister and the Hearth*, Charles Reade's romance about the love affair between Erasmus' parents in Holland in the later Middle Ages. He was impressed by Reade's command of detail, which would inspire his own efforts. Indeed he would later fancifully claim that *The Cloister and the Hearth* transcended its historical genre and was the greatest English novel. By then he would be more familiar with Reade, a friend of Uncle Dicky, and would know how he had combined writing with social campaigning. Perhaps he recalled that Reade had once owned a violin business and, like Sherlock Holmes in *A Study in Scarlet*, could "prattle away about Cremona fiddles."

As Arthur grew older, he developed from mere reader into narrator

as well. "On a wet half-holiday I have been elevated on to a desk, and with an audience of little boys all squatting on the floor, with their chins upon their hands, I have talked myself husky over the misfortunes of my heroes." He held his youthful audience in such thrall that he discovered he could make demands, such as payment in the form of cakes and tarts. And there was a psychological payback that he found strangely satisfying. "When I had got as far as 'With his left hand in her glossy locks, he was waving the blood-stained knife above her head, when—' or 'Slowly, slowly, the door turned upon its hinges, and with eyes which were dilated with horror, the wicked Marquis saw—' I knew that I had my audience in my power."

During his final term in Syntax in July 1873 he tried his hand at another form of storytelling. With fellow form members he started a magazine called *Wasp*, which attracted unwelcome attention from the First Prefect because of its outspoken comments about other members of the school. No copy is known to exist, though a cartoon contributed by Arthur has survived, describing a man arrested after a fight. As the strip of spindly ink sketches shows, he contemplates an escape from an upper window. But having piled chair upon table, he gets stuck trying to crawl through this would-be exit. Arthur's final picture shows the offender hanging precariously, both inside and outside his jail. As evidence of his new-found authorial control, Arthur was inviting his colleagues to make up their preferred ending.

Writing and being seen to write, was important, for the following term he tried again, as publisher of the *Stonyhurst Figaro*, another short-lived magazine that was never published beyond his own foolscap notebook. Now he was fourteen his love of books had taken a new turn and he was devouring French novels, hoping to improve his command of the language so he could read his mother's favorite *Revue des deux Mondes* to her during the holidays. He was particularly keen on the works of Jules Verne, who kept him amused with *Vingt milles lieues sous les mers*, something Arthur transcribed as "A la lune et de retour [probably *From the Earth to the Moon*] and Trois Russes et trois Anglais"—the story of a peaceful bilateral scientific expedition in South Africa that—shades of *The Lost World*—turns into a struggle for survival when the two participating countries go to war.

He was also beginning to enjoy the theatre, a world of illusion introduced to him by his father and now, at Stonyhurst, bound up with arcane tradition. For some reason, the youthful actors were not allowed to reveal the name of the main school play and had to carry around their scripts in pockets specially sewn into their suits. Arthur

did not allow his embarrassment at being poor at elocution to stop him playing a blacksmith in a drama one holiday. When *Macbeth* was produced, his favorite scenes involved the witches and the ghost of Banquo. His taste for spine-tingling effect was beginning to develop.

Arthur's world changed for the better on March 31,1873 when, after nearly fourteen years as the only son in the increasingly matriarchal Doyle family, he was joined by a younger brother. John Francis Innes Hay Doyle was to be known by several names during his childhood— Francis, Frank, Geoffy, Duff and finally Innes, a tribute to his god-mother Katherine Hill Burton, the daughter of Cosmo Innes, Professor of History and Constitutional Law at Edinburgh University. Katherine had taken over from her unmarried sister-in-law Mary Burton as the Doyles' most constant support. As the mother of Willie Burton, she dutifully kept in touch with Arthur at Stonyhurst, sending him gifts such as stamps. She was also an officer of the Edinburgh Ladies' Educational Association, a pressure group for women's higher education, which was launched in January 1868 with a course of lectures on English literature given by the supportive Professor David Masson from the university. At the time the system was heavily weighted against women who could, if they attained the right qualifications, follow university courses, but not take degrees. Movement towards change had recently gained momentum following Sophia Jex-Blake's spirited but so far thwarted campaign to be allowed to study medicine at Edinburgh. In 1872 the university relented so far as to give a "certificate in Arts" to any woman who attended the Association's classes and passed in three subjects. The following year Annette Doyle, an alumna of Newington Academy, was awarded a scholarship of 30 pounds by the Association to study English literature, mathematics and chemistry in this manner. (She was known there as Annette Conan Doyle. Since she had not been baptized thus, it suggests that the childless Michael Conan had again sought recognition for his family name, possibly by making another financial contribution to the Doyle children's education.)

Arthur was able to celebrate three events—his brother's arrival, his sister's educational progress and, possibly, a respite in his father's alcoholism. Within a short time he was responding much better at school. The following month, he reported home that the Rector was delighted with his progress, particularly in triumphing over his former surliness. His school work took on a new confidence, indicated by his habit, when writing an essay and stumped for a quotation, of making

up a few lines of doggerel, which he would airily attribute to "the poet."

Like the rest of the nation, Arthur was diverted during the summer by the celebrated trial of the Tichborne claimant. Roger Tichborne had been the son of a baronet who, after schooling at Stonyhurst, had traveled the world and gone missing somewhere, presumed dead. After his father's passing, however, his mother went to great lengths and expense to discover if her son was still alive. Seeing an opportunity to make a fortune, an unemployed butcher from Australia claimed to be Roger. He was always a very unlikely figure, but Lady Tichborne had put so much energy into her quest that she was prepared to be convinced. The claimant, whose real name appears to have been Arthur Orton, first had to stake his claim in a court of law, where he failed. He was then charged with perjury in what, for over a century, was the longest trial in British legal history, running from April 1873 to February 1874.

These various legal proceedings were regarded with some hilarity at Stonyhurst. In his efforts to prove his claim, the would-be heir had to answer questions about different periods of his life, including his schooldays. But his knowledge of Stonyhurst was risible. He could not remember the meaning of the acronym AMDG, which is worked into the brickwork in every room, or LDS, which is printed on much of the paperwork at the College. (The former stands for Ad Majorem Dei Gloriam—To the Greater Glory of God—and the latter for Laus Deo Semper—Praise to the Lord Always. The claimant said in court, to general laughter, that he thought it meant "the laws of God for ever or permanently.") He had forgotten all details of the school routine, such as the hour of dinner. He said he had learned Latin, but could not remember it, so he was not sure if Virgil was Latin or Greek. As for the school's more arcane lore, such as the location of the Asses' Bridge or what "Bandy" was, he was completely stumped.

Arthur asked his parents to look out for accounts of the trial, which several members of the Stonyhurst staff had attended as potential witnesses. Among them was Ann Standish, the matron, who had been so kind to him that his mother took to sending her presents. Although she had been petrified before going, Arthur could not hide his indignation that the authorities were not only footing the bill for her travel and hotels but also giving her an allowance of ten shillings a day—as he put it, to do nothing. As he read the reports he may even have noted that Orton's solicitor was called John Holmes.

By the autumn, when he entered the "upper line" for his last two years at the school, Arthur was at last beginning to show something of

the application that was to characterize his later life. In October he was taken aback, however, when the school's Third Prefect, Chrea, went berserk. Relating the extraordinary story to his mother, Arthur explained how this master had always seemed ill-disposed towards him—to the extent that his fellow pupils teasingly dubbed him Mr. Chrea's friend. During Vespers Chrea was sitting not far from Arthur when he pulled out his handkerchief and started waving it above his head. As soon as the Laudate Dominum began, he was hustled out by two masters. In his mania, Chrea called out Arthur's name a number of times. It was said that the reason for his extraordinary behavior was that he had been in love with a woman who had ditched him for someone called Doyle. This had led Chrea to become a Jesuit and, ever since, the name Doyle had been a trigger for his fits. Oddly, the school retains no record of anyone called Chrea or any similar name. The Third Prefect in 1873 was Thomas Knowles, though it may be significant that he was only at the school for that one year. At least Arthur was honing his skills at telling a dark, mysterious tale.

Coming into his final year in the autumn of 1874 he had a new playroom master, Father Reginald Colley, who had taken over when Father Splaine decided to quit the uncertainties of the classroom and return to his studies. Befitting a distant kinsman of the Duke of Wellington, Colley was more forceful than his predecessor. In September 1874, for example, he suggested that Arthur obtain a copy of *The Civil Service Examination History of England* to help him with his forthcoming London University matriculation exams. This was found for him by Uncle Dicky in London.

Arthur was looking at history with heightened interest as a result of another gift—a copy of Macaulay's *Lays of Ancient Rome* that his great-uncle Michael had recently sent. He had yet to encounter Macaulay's vivid prose, but this small book conveyed the drama of history, showing that feats of heroism and patriotism could be captured in verse. It bore fruit, for Arthur took to writing ponderous historical verse, such as "The Passage of the Red Sea," which opened:

> Like to white daisies in a blooming wood,
> So round the sea the tents of Israel stood;
> To east and west, as far as eye could reach,
> The thronging crowds are seen along the beach.

Perhaps Michael Conan was again hoping to perpetuate his family name, for Mary Doyle was pregnant once more. It was clear that

another baby would lead to serious overcrowding in the Doyles' house in Sciennes Hill Place, which, following Annette's return from France, had to accommodate baby Innes, three girls (two of whom were under ten) and the occasional holidaying refugee from Stonyhurst. So Mary and (presumably) Charles girded themselves for another short trek, half a mile west, to a more substantial modern flat at 2 Argyle Park Terrace, which had fine panoramic views of the city though Arthur worried that its larger rooms would be perishingly cold in winter.

Because of related disruptions, it was decided that, during the Christmas holiday, Arthur should take the opportunity to visit his Doyle relations in London, where there had also been significant changes since the death of old John Doyle. In 1869 Uncle Henry and his new wife Jane had moved to Dublin after his appointment as Director of the National Gallery of Ireland. Then, only recently, another, more unexpected, marriage had taken place. Uncle James had appeared committed to a life of crusty bachelorhood, poring over ancient texts. But in February 1874 he surprised everyone by marrying Jane Henrietta Hawkins, a well connected judge's daughter from Monmouthshire. This was the cue for Uncle Dicky to join the exodus from the family home in Clifton Gardens and establish himself at 7 Finborough Road in Earls Court, where he lived with Aunt Annette, who managed to double as his housekeeper and a non-resident nun.

This trip to London was important for Arthur. Not only had he never been to the capital, but he would also meet some members of his family for the first time and, perhaps most significantly, he would expect his own future career to be discussed. At the last minute the whole journey was threatened because northern England had frozen under a blanket of snow and ice that made travel temporarily impossible. In such conditions, Stonyhurst became particularly bleak. With the thermometer dropping to fourteen degrees below freezing point, Arthur's hands were shaking as he wrote home plaintively about the drafty cracks in the wall and the lack of hot pipes or fires. But the thaw soon came and Arthur was able to travel by train to Euston, where he had briefed his Aunt Annette on how to recognize him. "I believe I am 5 foot 9 high, pretty stout, clad in dark garments, and above all, with a flaring red muffler round my neck." Together they took the underground to Earls Court and then a cab to Finborough Road where, after Uncle Dicky returned for tea, Arthur retired to bed exhausted at half past nine.

It was the start of a hectic three weeks. Twice he went to the theatre with Uncle James who borrowed a box from Tom Taylor, the new edi-

tor of *Punch* who had been caricatured as the hapless Brown in Uncle Dicky's hilarious "The Foreign Tour of Brown, Jones and Robinson." A popular playwright as well, Taylor's greatest success was *Our American Cousin*, the drama President Abraham Lincoln was attending on the night of his assassination in Washington in April 1865. Arthur was not particularly complimentary about a fêted production of *Hamlet* at the Lyceum Theatre, but he appreciated the young lead actor, Henry Irving.

He also enjoyed playing the tourist, visiting Westminster Abbey, the Zoo and Crystal Palace, as well as Hengler's Circus. The two places that most impressed him, however, appealed to the more ghoulish side of his imagination. In the Tower of London he noted approvingly the thumbscrews, racks and instruments of torture, while in Madame Tussaud's he was attracted by the grim relics of the French Revolution displayed in the Chamber of Horrors (a term coined by *Punch*). The waxworks were then situated above the Bazaar in Baker Street, which he would later make famous. While he was there, he took the opportunity to sketch Marat being killed in his bath and he later expressed himself delighted with "the images of the murderers."

Three months later Mary Doyle gave birth to another daughter, Jane Adelaide Rose, known as Ida, who was born at 2 Argyle Park Terrace on March 16, 1875. Arthur could do little more than ask lovingly after his new sister, before gearing up for the examinations that would determine his future. The tension was getting to him: before his mock exams he was plagued by a lengthy bout of neuralgia, which he thought came from a draft in the schoolroom. In advance of the real exams on 28 June he surprisingly asked his mother to say a Mass for him, while he himself sought a blessing at school. At the time his report predicted: "M just possible," M being his matriculation at the University of London.

He did not have to wait long for the results. The following month a throng of boys congregated in the refectory with their friends and hangers-on. The arrival of the Rector, clutching a sheaf of papers, was greeted with wild cheering and waving of handkerchiefs. He announced that thirteen of the fourteen candidates had passed, among them a thankful Arthur, who reported back to his mother, proudly signing himself "Arthur C Doyle U.G." (for undergraduate).

He had spent a Biblical seven years at Stonyhurst: having entered as a waif-like nine-year-old with a difficult home life, he had struggled to discover his individuality under the weight of a dogmatic Catholicism. He had escaped first into a dead end of unruly behavior and then, as

he began to readjust, into a more pleasing world of the imagination. As a result he was leaving school as a robust and intellectually curious teenager with a liking for books and a measure of emotional self-control, but otherwise uncertain prospects. He wrote home unconvincingly that he was sorry to be moving on but, after seven years, the regular procedure was becoming monotonous.

Even at this stage, little concerted thought had been given to Arthur's future. The unspoken factor was money: how to finance the next stage of his education? One idea was that he might be able to continue on the Stonyhurst campus as a "gentleman philosopher." But Father Purbrick had made clear that he was too young for this course and his math was not up to it. Still seeing a future for the sixteen-year-old boy within the Jesuit community, the Rector suggested that Arthur might instead benefit from a few months at Stella Matutina, a secondary school run by the order at Feldkirch in the Austrian Alps.

Arthur agreed happily enough, not least because he was keen to improve his command of German. In September 1875 he made his way southwards via Liverpool, where he stayed with a family called the Rockcliffe whose son was also going to Feldkirch, and Paris, where only the pressing need to catch a connecting train prevented him from meeting his great-uncle Michael for the first time.

Once Arthur had got over the shock of the Austrian cold, that was worse than anything he had experienced in Scotland or Lancashire (he had to use his toothbrush to knock a hole in the ice which covered his washing-water in the morning), he settled down to enjoy a leisurely few months. He liked the Alps and the opportunity for walking, the food was reasonable, and he was able to drink decent beer. One drawback was the lack of facilities for cricket. (His account of a three-day game between the college and the town, which appeared in yet another of his self-published magazines, was surely a fantasy, with its report of his own high-scoring innings.) But soccer provided an energetic alternative, even in its occasional local variation on stilts. He joined the school band, where he learned to play a tuba-like instrument, the bombardon, which made a noise like "a hippopotamus doing a step-dance." And he gained a taste for German history and culture. In particular he enthused about a biography of Frederick the Great written by Onno Klopp, a recent convert to Catholicism.

In the spring of 1876 a new name, Dr. Bryan Waller, began appearing in letters from home. Waller was an ambitious twenty-two-year-old doctor from a property owning family in Yorkshire who was complet-

ing the final year of his medical degree. In March he was on hand to treat Arthur's sister Lottie for measles. But he had emerged a few weeks earlier, when the Doyles decided to rent part of their large flat to a lodger. Waller had won over the sometimes unduly impressionable Mary Doyle with the quality of his literary small talk. He was descended from a long line of bookish figures, including the seventeenth-century Royalist poet Edmund Waller, while his uncle Bryan Waller Procter, better known by his pseudonym Barry Cornwall, was a distinguished Victorian salonist and friend of Dickens. He himself had just published a book of mournfully romantic poems, *The Twilight Land*, which he had dedicated to his uncle. Otherwise little was known about him except that he was a Freemason, a junior warden of the Celtic Lodge of Edinburgh and Leith, No. 291.

Waller was soon urging Arthur to follow in his own footsteps as a medical student at Edinburgh. He advised about possible scholarships and sent his own textbooks to Austria to help improve Arthur's understanding of his poorest academic subjects, chemistry and geometry. Waller's motives became questionable when in April Arthur heard that his father was again "unwell" and was retiring from his Civil Service post with the modest pension of 150 pounds a year. As he prepared to return home in June, he learned that his beloved "Mam" would not be in Edinburgh to greet him but would be staying at Masongill House, Waller's family estate on the edge of the Pennines near the Yorkshire village of Thornton in Lonsdale, less than thirty miles from Stonyhurst. Arthur was too innocent to suspect anything untoward: he even urged his mother not to change her plans on his account. But it is clear that within a few short months an outsider had charmed his way into Mary Doyle's feelings and was beginning to usurp her husband's role.

As Arthur completed his final weeks at Feldkirch, preparing himself for a new round of interviews and examinations to enter medical school, he suffered the ignominy of running out of money because his father had been unable to send him any. It is not clear who provided the cash, but it was probably Bryan Waller, who further curried favor by offering the boy his flute.

Having found an inexpensive route home, via Lake Constance, Basel, Strasbourg and Paris, Arthur was at last able to call on his great-uncle Michael. By the time he reached the French capital, he had only two coins in his pocket and had to walk from the Gare de l'Est to the Conans' apartment at 65 Avenue de Wagram, off the Champs Elysées. Towards his journey's end, he felt so tired and thirsty that he decided to splash out on a drink of what he thought was porter but

turned out to be liquorice and water. Although duly revived, he was reminded, if he did not already know, that things are not always what they seem.

It was much the same with his uncle. For public consumption Arthur portrayed Michael Conan as "a dear old volcanic Irishman who spent the summer day in his shirt sleeves, with a little dicky-bird of a wife waiting on him." But this was hardly the whole story. Why did Arthur make so little reference to what must have been an eye-opening month in the capital of the country that meant so much to his mother? Surely he visited the Emperor Napoleon's tomb at Les Invalides? A clue lies in his later story "The Leather Funnel," where the occultist Lionel Dacre lived in the Avenue de Wagram, in "that small [house], with the iron railings and grass plot in front of it, on the left-hand side as you pass down from the Arc de Triomphe." It seems that, as the fictional Dacre was a scholarly virtuoso to his English friends, but something darker to his French ones, so the real-life Michael Conan was a more complicated personality who, having once advocated the benefits of a Jesuit education, now encouraged his nephew's interest in a more shadowy world of mystery and imagination. By the time Arthur returned to Edinburgh, his reveries were lost in the richly wrought stories of Edgar Allan Poe, while his active mind was "conscious that real life," or his version of it, "was about to begin."

Edinburgh University

1876–1881

A strange Poe-like pallor hung over Argyle Park Terrace in the late summer months of 1876. Arthur told his mother that it was a reversal in their usual situations to find her in Yorkshire and him at home. Superficially, while Mary Doyle communed with her lodger, the rest of the family "jogg[ed] along very comfortably" in Edinburgh. Arthur beavered away preparing for exams for a university scholarship. Having heard that these were biased in favor of former pupils of the city's High School, he hired a tutor, Mr. Walker, at two guineas a month. At least, after renting the room to Dr. Waller, money was no longer such a problem. The household even boasted a nurse called Baa who looked after the younger children, Innes and Ida. Often, at night, Arthur would amuse her and ten-year-old Lottie by reading the swashbuckling nautical adventure *Mr. Midshipman Easy*. At other times he adopted a more somber mood and would startle them with ghost stories by Poe, his new favorite.

Their terror was all the more vivid because of the family ghoul at home. Tall, ungainly and heavily bearded, the newly pensioned Charles padded about the flat, with little to occupy him. His main social activities were the pub and gatherings of a literary-minded coterie, the Monks of St. Giles, whose members caroused, told whimsical stories and participated occasionally in undemanding sports such as fishing, golfing and curling. (One of his most successful watercolors, showing a curling match on Duddingston Loch, dates from this year.) He was particularly friendly with one "Monk," an Edinburgh GP called Dr. James Sidey, whose books of reminiscences he illustrated.

In an effort to suggest normality, Arthur told his mother that his

father seemed contented enough, but when he had received a letter from her, Charles had become uneasy on reaching the bit where she asked about some money from the *Graphic*. Mary must have been inquiring about a payment that her husband should have received. But these funds, required for the family budget, had already disappeared down his throat. There was no confrontation with Charles over the matter, however, no effort to analyze the problem. Arthur appears complicit with his mother in failing to deal with Charles's alcoholism.

This was a difficult situation for a seventeen-year-old. Despite a veneer of self-assurance, Arthur still had all the insecurities he noted in his semiautobiographical novel *The Stark Munro Letters* of that awkward stage "in the inner life of a young man from about the age of puberty until he begins to find his feet a little." He listed the symptoms—"the shrinking, horrible shyness, alternating with occasional absurd fits of audacity which represent the reaction against it, the longing for close friendship, the agonies over imaginary slights, the extraordinary sexual doubts, the deadly fears caused by non-existent diseases, the vague emotion produced by all women, and the half-frightened thrill by particular ones, the aggressiveness caused by fear of being afraid, the sudden blacknesses, the profound self-distrust. . . ."

His anxieties were not assuaged when, after applying for and winning one of the scholarships at the end of October, he found that medical students were not eligible. Not only did he have to forgo a stipend of 40 pounds for two years, but the next best award, which was available to him, had already been allotted and paid. He had to make do with a one-time honorarium of 7 pounds. It was a strange mistake for the Edinburgh-educated Dr. Waller to have made, and cannot have endeared him to Arthur.

Once enrolled, Arthur shuffled between three places approximately a mile from home—the medical school in the main quadrangle of New College (now confusingly called Old College) at the center of the campus, off South Bridge; a nearby warren of extramural teaching facilities based around Surgeons Square, off Chambers Street, and used by hospital doctors not formally employed by the university; and a variety of hospitals, particularly the Royal Infirmary on Infirmary Street, which moved to new premises on Lauriston Street in 1878.

Since the mid-eighteenth-century heyday of the Scottish Enlightenment, this interlocking complex had gained the university a global reputation for medical education. As pioneered by its first Anatomy Professor, Alexander Monro, Edinburgh's medical school had emphasized the practical side of its craft, priding itself on close links with the

Royal Infirmary, which had opened in 1741. It attracted students from far and wide, leading to a remarkable free market in medical education, with hospital doctors doubling as extramural teachers around Surgeons Square in competition with the official university professors. Occasionally it had been a victim of its own success. Because of this rivalry, the infamous body-snatchers William Burke and William Hare had, until their arrests in 1828, resorted to murder to keep Robert Knox's anatomy classes supplied with fresh cadavers.

However, the school had survived this setback and encouraged medical innovations such as Professor James Young Simpson's identification of chloroform as an anesthetic in 1847 and Professor Joseph Lister's pioneering work on antiseptics in surgery in the late 1860s. Subsequently, despite, or perhaps because of, substantial increases in undergraduate numbers, its star had waned, as it appeared to rest on its laurels, notably in the protracted campaign to keep out women. By the late 1870s the situation was again changing, as the old medical buildings around the university had been redeveloped, along with the rest of the Old Town. The Infirmary was about to open in its new location, while the medical faculty itself was moving from its cramped position in New College to new headquarters in Teviot Place.

Having been brought up in Edinburgh, Arthur was familiar with the institution and its workings. But he never much warmed to it, probably because its proximity to home evoked painful memories. In his clearest description, in his novel *The Firm of Girdlestone*, the university was portrayed as a spartan outpost of a laissez-faire type of English public school, where a student was left to his own devices "in a far from moral city." This Darwinian system allowed some to learn the benefits of self-reliance and become men of the world, and others to fall "at the very starting-point of [their lives'] race, never to rise again." As for his course, he was unconvinced by the official claims of its practicality, remembering it simply as "one weary grind at botany, chemistry, anatomy, physiology and a whole list of compulsory subjects, many of which have a very indirect bearing upon the art of curing." For all its drawbacks, however, this five-year-long slog was crucial to his development.

The official record shows that Arthur's student career was divided into various stages. For his first few months he polished up his French, German and moral philosophy for a preliminary examination in the arts in March 1877 (when his German was deemed below average, though worthy of a pass). Over the next year he studied for his first profes-

sional examination in April 1878, taking courses in botany, natural history, chemistry, anatomy and physiology.

Needing to earn money, he then took six months off to hone his bedside manner in general practices in Sheffield and Shropshire. (He later boasted of his ability, born out of necessity, to "compress the classes for a year into half a year.") Returning to Edinburgh in the autumn of 1878, he continued some of his earlier specialities, adding new ones in practical pharmacy and surgery. Subsequently he studied midwifery, clinical medicine, medical jurisprudence, materia medica and, briefly, vaccination. He also worked in the Infirmary as an outpatient clerk (sometimes described as ward assistant). Despite these commitments, he managed two more stints between 1879 and 1881 as a doctor on call in Birmingham, where his practical study of midwifery and dispensing was considered part of his course. In 1880 he also spent six months traveling to the Arctic as a ship's surgeon.

He sat for two further professional exams in April 1879 and June 1881 when, after written and oral procedures, he was awarded his MB or Bachelor of Medicine degree. Looking back, he correctly assessed that he had been an average student. (He put it more elegantly, referring to himself as "one of the ruck, neither lingering nor gaining—a 60 per cent man at examinations.") The only subject in which he excelled was botany, and the only one in which he fell below par in his finals was, oddly, one in which he had some experience—clinical surgery—a result which helped push him towards general practice.

If anyone epitomized the spirit of the medical faculty at the time it was Sir Robert Christison, the Professor of Materia Medica and Therapeutics, who was reaching the end of his career and would retire, age eighty, in 1877. With his successor, Professor Thomas Richard Fraser, he helped shift the department's focus from anatomy and surgery to plants and practical pharmacology, or, in a wider context, from the internal workings of the body to the external influences upon it. Although not mentioned in Arthur's memoirs, Christison's influence on the young student's ideas about drugs and poisons and on the gestation of the character Sherlock Holmes was significant.

In his earlier incarnation as Professor of Medical Jurisprudence and Medical Police, Christison had done pioneering work in forensic medicine and, to a lesser degree, public health. Through standard works such as *A Treatise on Poisons*, published in 1829, and the *Medico-Legal Examination of Dead Bodies*, a decade later, he had helped boost the scientific use of toxicology and post-mortems in court procedure.

One of his interventions was in the trial of Burke and Hare, who ini-

tially avoided detection because they believed they had found a way of suffocating their victims without damaging them physically. Christison's experiments into the bruising of corpses helped secure Burke's conviction after Hare turned King's evidence. Arthur alluded to this at the beginning of *A Study in Scarlet*, where, seeking to satisfy his "passion for definite and exact knowledge," the austere figure of Sherlock Holmes was found conducting similar investigations, which he combined with research into the effect of drugs derived from vegetable alkaloids.

Known also for his "cold and imperious manner," "Dignity Bob" made a point of testing these alkaloids on himself for possible therapeutic use—a practice followed not only by Professor Thomas Richard Fraser but also by both Arthur and Holmes. Once, having taken an almost fatal dose of the calabar bean, Christison counteracted the effects by making himself sick with a bowl of shaving water. However, he had ingested enough poison to paralyze his body for several hours—a process he later wrote up with due scientific objectivity. That did not stop him from using his students as guinea pigs, as in his research into the coca plant and its derivative cocaine in the 1870s. He seemed happy with the results for, when, at the age of eighty, he climbed Ben Vorlich, a mountain in the southern part of the Scottish Highlands, he eased his ascent by chewing coca leaf, which he claimed "not only removes extreme fatigue but prevents it." Playful interactivity was part of his teaching technique: when investigating the properties of the poison curare, for example, he liked to demonstrate how American Indians fired it from blowpipes.

By the time Arthur arrived at the university, Christison stories had become almost mythical. Their contribution to Holmes's penchant for cocaine and to his fascination with poisons, such as the curare in "The Adventure of the Sussex Vampire," is clear, particularly as Fraser, a former research assistant of Christison, followed so closely in his predecessor's footsteps. If anything Fraser, who definitely taught Arthur, was more fanatical about experimental method, the subject of his address to the International Medical Congress in 1881, when he pleaded for a relaxation in the law on vivisection in the interests of medical research—a campaign Arthur himself was to take up.

Christison's reputation hung over the university in other, more controversial ways. For he had led the diehard opposition to the education of women doctors, and thereby split an already factional academic community. In this respect he was a figure of hate for Mary Doyle's circle at the Edinburgh Ladies' Educational Association. With

his sinister network of patronage, he has been suggested as a template for Sherlock Holmes's opponent, the Napoleon of crime, Professor James Moriarty. It is a mark of his influence that he could serve as model for both the detective and his nemesis.

One of Christison's most determined opponents on this issue was Dr. Henry Littlejohn, who combined his main job as Edinburgh's first Medical Officer of Health with a thriving practice in forensic medicine—about which he was a popular lecturer in the university's extramural schools. In his public health role, and particularly as a result of his ground-breaking Report on the Sanitary Conditions of Edinburgh in 1865, Littlejohn helped transform the city from a stinking, overcrowded cradle of disease into a modern conurbation whose inhabitants could expect at least an average span of life. As a medico-legal expert, he followed Christison in introducing modern scientific advances, including evidence from photography and fingerprints, into the courts.

Littlejohn's legacy is evident throughout Arthur's life and works, but again he received no formal acknowledgment. This was odd since, as a reforming Medical Officer of Health, he would have been regarded as a white knight by the Burton clan, particularly by Mary, who had added housing and social services to her campaigning issues, and by her nephew Willie, Arthur's friend, who, after an engineering apprenticeship, was about to adopt public health as a full-time career. Arthur shared this enthusiasm for medicine as a means of social change, and was equally keen on forensics. Given that his former schoolteacher, Eugene Marie Chantrelle, had been convicted in 1878 with the help of Littlejohn's evidence, this omission is strange.

Instead Arthur emphasized his association with one of Littlejohn's students, the wiry Dr. Joseph Bell, scion of a family of distinguished Edinburgh surgeons. Perhaps because he himself was a curious physical specimen, with a jerky, disjointed walk and a high-pitched voice, Bell had become an inscrutable observer of his patients' traits and mannerisms, which allowed him to make instant diagnoses from minimal evidence. According to Arthur's autobiography, Bell claimed he could tell from a man's appearance that he had served, until recently, as a non-commissioned officer in a Highland regiment in Barbados. The surgeon explained his reasoning to his students thus: "You see, gentlemen, the man was a respectful man but did not remove his hat. They do not in the army, but he would have learned civilian ways had he been long discharged. He had an air of authority and is obviously Scottish. As to Barbados, his complaint is elephantiasis, which is West

Indian and not British, and the Scottish regiments are at present in that particular land." This last assertion indicates Bell's limitations: although elephantiasis had long been associated with the West Indies, to the extent that it was known as "Barbados leg," it was more prevalent elsewhere, particularly Africa, where a Scottish regiment was as likely to have been stationed as the Caribbean.

Like Christison, Bell liked to introduce an element of play into the process of deduction. Once, telling his students he wanted to test their "perception," he asked them to use their senses to describe the properties of a bitter, malodorous drug. Adding that he would not ask them to do anything he would not do himself, he showily sniffed and sampled the contents of a jar which he passed to them. After they had grimaced at the slightest taste of the liquid, he told them, "Gentlemen, I am deeply grieved to find that not one of you has developed this power of perception which I so often speak about; for, if you had watched me closely, you would have found that, while I placed my forefinger in the medicine, it was the middle finger which found its way into my mouth."

Bell made his mark on Arthur because, in 1878, he singled him out to become his outpatient clerk at the Royal Infirmary. As the surgeon's contact with the outside world, Arthur needed to brush up his Scottish idiom (he did not know that a patient with a "bealin" in his "oxter" had an abcess in his armpit). But he was able to observe the older man at close quarters and become familiar with his other interests, such as ophthalmology (which meant extra rounds at the Edinburgh Eye Infirmary), women in medicine (Bell corresponded with Florence Nightingale) and journalism (he edited the *Edinburgh Medical Journal*).

It is not clear why Bell plucked Arthur from his class, as there was little contact between doctors and students. It probably owed something to the powerful cliques in Edinburgh medicine. Bell had worked as house surgeon to the great Professor James Syme, another of whose former acolytes had been the Doyle family friend Dr. John Brown. In this way Arthur aligned himself to the "party" of Syme and his famous son-in-law Joseph Lister, who remained Professor of Clinical Surgery at the university until 1877. Another link was his chemistry teacher, Alexander Crum Brown, John Brown's half-brother. In his memoirs, Arthur remembered the mild-mannered Crum Brown as one of the notable characters on the Edinburgh medical scene, though he failed to mention that he too had given crucial evidence at Chantrelle's trial.

Arthur was later grateful to have a bank of memories of such color-

ful characters to draw on—not just Christison and Bell, but also Charles Wyville Thomson, who taught him natural history, fresh from three and a half years at sea researching the scientific properties of the world's oceans on HMS *Challenger*, and William Rutherford, his physiology professor and another vivisectionist, who, with his booming voice and Old Testament beard, was Arthur's professed model for the querulous explorer Professor Challenger in his novel *The Lost World*. But while Arthur recognized them all as "remarkable men," he would later criticize them for failing to stress the caring side of medicine.

On March 2, 1877, shortly before sitting for his preliminary exams, Arthur was presented with another sister who arrived in unusual circumstances. For a start, her birth was registered by her mother. This was the first time Mary Doyle had performed this official duty for any of her children; on eight previous occasions her husband Charles had done the chore. But this time he clearly was not up to it. In addition, the baby had some strange names not known to the Doyle family. At her baptism in St. Mary's church on April 6, she was christened Bryan Mary Julia Josephine, reflecting the intimate involvement of her sponsors, the mysterious lodger Dr. Bryan Waller and his mother, Julia. (As Georgina Doyle has noted, the infant was recorded in the church register as B. Mary Julia Josephine, indicating a reluctance to acknowledge her first name.)

It is easy to conclude that the child was Waller's, but this does not bear scrutiny. Neither the family nor the church would have allowed such a public statement of her bastardy. Rather the warm-hearted Mary Doyle had grown so fond of "the Doctor" that she wanted to acknowledge his emotional and financial support. Arthur had been called "Conan" for similar reasons, while Lottie and Innes also had names that recognized friends and benefactors.

That did not make the gesture any easier for Arthur. It is significant that when Waller wrote to him on March 30 from Masongill (where he appears to have gone to pick up his mother in advance of the christening), he made no reference to the baby, but limited himself to congratulating Arthur on his examination success. He suggested applying for another (Grierson) scholarship, offering to bring one of his own botany books (Professor Balfour's standard textbook, which he described as "a great lumbering uninteresting book"). Then, after signing himself "Your affectionate friend," he added, "I have written to the House Agent about the house in George Square."

This was the first mention of another impending move. Even with

the new baby (universally known as Dodo), Argyle Park Terrace was hardly crowded, as Annette had left, clutching her woman's version of an Edinburgh University degree, to work as a governess with a Portuguese family in Lisbon. Waller simply needed more substantial accommodation to reflect his growing professional status as a doctor now teaching in the extra-curricular schools and seeking an indentured university post. Perhaps he was able to call on Masonic contacts to find him a house at 23 George Square. For the privilege of living at this fashionable address, just south of the university, he was prepared to pay an annual rent of 85 pounds, and the Doyles had no alternative but to tag along. Arthur's *amour propre* was dented and remained so. He never referred to Waller by name in his memoirs, only commenting elliptically on how his mother's decision to take in a lodger may have brought temporary relief, but brought so many additional problems.

The actual move probably took place around late August or early September 1877 when Arthur accompanied his sisters Lottie and Connie on a walking holiday on the island of Arran on the Scottish west coast. His mother stayed with baby Dodo and the younger children in Edinburgh where Julia Waller was visiting, probably to help put the new house in order. The Doyle children were joined on Arran for a few days by their father, who came with J. Graham Fairley, a colleague from work who later made a name for himself as a church architect. Also in their party was Arthur's old school friend James Ryan, who had followed him from Stonyhurst to study medicine in Edinburgh. The Ryan family was now living in Greenhill Place in the southwest part of the city, where James's mother, Margaret, had become close to Mary Doyle. However, his coffee-planting father had died there only in April, so James was still getting over his grief.

Arthur was surprised to see Dr. Joseph Bell strolling in the small town of Brodrick on the island. From his description to his mother, he clearly knew the Edinburgh surgeon, but had yet to strike up a working relationship. He wondered rhetorically what Bell was doing there, apparently unaware of his habit of shooting grouse at that time of year. Not that Arthur was particularly concerned about furthering his academic career: he was there for recreation in its widest sense. Bounding over the craggy landscape that had inspired Walter Scott's epic poem *The Lord of the Isles*, his imagination was fired by the Gothic potential of the misty west coast which he would later summon up in stories such as "The Mystery of Cloomber." His taste for travel and adventure was also sparked by the sight of colossal ocean liners making their stately progress through the waves between Arran and the

Scottish mainland, en route to and from Glasgow. The young medical student was beginning to store up meaningful memories of his own.

Standing outside an Edinburgh theatre, waiting for the doors to open, Arthur heard a woman scream and saw a soldier pressing her roughly against a wall. When he tried to intervene, he was met with an elbow which was slammed into his solar plexus with all the force of a hardened military man. A full-scale fight broke out, with the assailant's friends urging him on, one of them striking Arthur's head with his cane. Serious injury was only averted when the doors opened and the belligerents were overwhelmed by a surge of ticket-holders. Arthur might have gone in too but decided against it, in case it was considered provocative.

He related this story in his memoirs to show that his university days were not all hard word. It also demonstrated something else: a young man beginning to find his strength, intellectually, emotionally and, in this case, physically, and being prepared to use it in a just cause.

Now his preliminary exams were over, he could relax and enjoy himself. "I read much," he wrote, still trying to prove his well-roundedness. "I played games all I could. I danced, and I sampled the drama whenever I had sixpence to carry me to the gallery." As far as his reading was concerned, he did not lack for material at home. But he also had access to a city renowned for its booksellers, and this was an opportunity impossible to ignore. Every morning, on his way to lectures, he passed what he called "the most fascinating bookshop in the world"— undoubtedly James Thin on South Bridge. This caused problems because, at lunchtimes, he usually had thruppence (three pennies) for a sandwich and a glass of beer. But once a week he would forgo his meal and spend his money on something more cerebral from Thin's second-hand bin. He found himself devouring eighteenth-century authors such as Addison and Swift. He also picked up a tattered copy of Macaulay's *Essays*, which became his favorite book, both for its subject matter (a series of vivid studies of historical figures) and for its style, which he would seek to emulate: "The short, vivid sentences, the broad sweep of allusion, the exact detail, they all throw a glamour round the subject and should make the least studious of readers desire to go further."

As for his sporting achievements, he recalled that he represented his university at cricket and rugby. This was an exaggeration, as the record shows that the summit of his cricketing career was in the second XI in 1879. Not in dispute was that he was an energetic young

man raring to shine at any sport, which enjoyed special status at the time as an officially sanctioned outlet for the competitive spirit required in a post-Darwinian world. At this stage he was, as he himself acknowledged, still "wild, full-blooded and a trifle reckless," so even off the field he liked to challenge friends to bouts of indoor fisticuffs, a curious ritual that involved stripping down and fighting bare-knuckled in an undergraduate's rooms.

Such outpourings of testosterone give the lie to any idea of nine-teenth-century universities as peaceful oases of learning. A boisterous-ness, bordering on anarchy, was never far beneath the surface in Arthur's student days. In his novel *The Firm of Girdlestone* he surely drew on personal experience when he described a rectorial election which ended in a near-riot in the university front quadrangle, threatening to upend the statue of Professor Sir David Brewster, the natural philoso-pher whose work on scientific instruments epitomized the institu-tion's practical approach to research. "What Goths! What barbarians!" remarked Thomas Dimsdale, the father of the novel's hero. "And this is my dream of refined quiet and studious repose." Assuming Arthur had witnessed such a scene, it is possible, since these elections for tit-ular headship of the university were triennial events, to say that he was referring to the contest at the start of his second year in November 1877, when the turf-loving Liberal Marquess of Hartington defeated the lackluster Conservative Home Secretary Richard Cross.

This unruly election was followed in real life as in the novel by an international rugby match—a clear example of unwanted aggression being channelled into a newly codified sport. This was the first game ever played with fifteen on a side instead of eighteen between Scot-land and England, resulting in a narrow win for the latter, though in Arthur's fictional account it was a more equitable draw.

Like medicine, organized sports reflected the Victorian gospel of improvement. On the field, Arthur strove for the boarding-school ideal of "mens sana in corpore sano" (a sound mind in a sound body). When he donned his white coat in the infirmary, he worked towards the same end by a different route. By joining science's battle against disease and superstition, he sought to make everyone's life healthier and more satisfying.

But, as the maturing Arthur was becoming painfully aware, a scien-tific view of the world came at the expense of the religious. A rational approach to history had already helped demolish the Bible's more extravagant claims. The intellectual struggle of the century was devel-oping into a search for the right balance between science and faith.

Following publication of the *Origin of Species* in 1859, the scales had shifted firmly towards the former. In an age when the onus was on people to explain and take control, Arthur found himself ranged both individually and professionally on the side of progress, so it was inevitable that his Roman Catholic beliefs would suffer.

It was partly a generational thing. He later recalled how, as he dipped into the works of rationalist thinkers such as Darwin, Herbert Spencer and John Stuart Mill, he sensed a disturbing gap opening up between men of his father's age and his own. He and his contemporaries could only laugh when they heard even such a venerable figure as Gladstone arguing for a literalist interpretation of the Bible.

Any jocularity quickly led him to the more sober thought that he was not happy with an existence based on mere materialism, to the exclusion of any sense of some greater being. Although committed to the spirit of scientific enquiry, he did not consider himself an atheist. As he put it, he remained "reverent" in his doubts, and the more he pondered them, the more confirmed he was in his appreciation of "the wonderful poise of the universe and the tremendous power of conception and sustenance which it implied."

So he began to develop his own synthesis between the new and the old, between the pressing demands of reason and his own awareness of a higher intelligence. He later described himself as "in a broad sense" Unitarian, but one more critical of the Bible than other members of a denomination that discarded many of the trappings of Christianity while maintaining an essential belief in a higher being.

In fact his attempt to bridge the gap between spiritual longing and contemporary rationalism was closer to transcendentalism, an offshoot of Unitarianism that had flourished in New England earlier in the century. Mixing German idealism, American practicality and a touch of British romanticism, it was built on the Kantian precept that there is intuitive truth beyond the senses. In putting the individual at the center of his or her universe it has often been presented as one of the intellectual cornerstones of United States democracy—a factor that may have contributed to Arthur's later enthusiasm for the New World.

Turning such rarefied thoughts to practical use in his medical studies was not easy. As a mark of respect to his ailing father, he continued to use poetry as a memory aid—a practice he had begun at school, on Charles Doyle's advice. So, in the margins of his copy of *The Essentials of Materia Medica and Therapeutics*, a basic pharmacological textbook

published in 1877, we find Arthur composing his own doggerel to remind him of the effects of drugs such as opium.

But now that he was involved at the sharp end of medicine, Arthur required more than mnemonics. The ingénu "with a face like plaster," described in "His First Operation," had become a blasé veteran who, in the same story, thought nothing of "eating his lunch in the dissecting rooms." He needed a sophisticated, personal approach to his chosen profession.

He found something of what he wanted in the tolerance of John Brown's American friend Oliver Wendell Holmes, whose "immortal series," *The Autocrat, The Poet* and *The Professor at the Breakfast Table,* he later praised for "that continual leaven of science, especially of medical science, which has from my early student days given those books so strong an attraction for me."

Behind this scholarly veneer, a personal agenda was clear. Arthur quoted an example that showed how dramatically his own decision-making was influenced by his father's condition. "Insanity is often the logic of an accurate mind overtasked," Wendell Holmes had written. "Good mental machinery ought to break its own wheels and levers, if anything is thrust upon them suddenly which tends to stop them or reverse their motion. A weak mind does not accumulate force enough to hurt itself; stupidity often saves a man from going mad. We frequently see persons in insane hospitals, sent there in consequence of what are called religious mental disturbances. I confess that I think better of them than of many who hold the same notions, and keep their wits and enjoy life very well, outside of the asylums. Any decent person ought to go mad if he really holds such and such opinions." What Holmes had said was that some minds buckle under irreconcilable pressures, such as the demands of religion. Reading this, Arthur would have thought of his poor father, who was having a torturous time squaring his orthodox Catholicism with more supernatural intimations, which were beginning to find expression in a more fantastical style of drawing, not dissimilar to his brother Dicky's fairies.

More pragmatically, Arthur began to take an informed attitude towards medical politics. Coming from a family dominated by his mother, he was always likely to be sympathetic to women in his profession, as was shown in later stories such as "The Doctors of Hoyland."

At the time the struggle for the education of female doctors was still being intensely fought. After being denied the opportunity to take her degree in Edinburgh in 1873 (the result of maneuvering by the reactionary Professor Christison), Sophia Jex-Blake had lobbied MPs for

changes in the British law while working for her own qualification through the Irish College of Physicians. Arthur would have taken note, particularly when her case was taken up by Charles Reade, who had been consolidating his reputation as a campaigning "documentary" novelist. In 1876, just as Jex-Blake's struggle for reform was coming to a head, this "English Zola" weighed in with a novel called *A Woman-Hater* which told her story through a fictional character, Rhoda Gale. To make his crusading point Reade arranged for the book to be serialized and then published in Edinburgh by the house of Blackwood.

Such evidence of the power of words to change the world may have encouraged Arthur to think about writing himself. Oliver Wendell Holmes had successfully combined the twin professions of doctor and author, and so, in a manner, had Reade's unorthodox nephew, William Winwood Reade, who was to have a significant influence on Arthur's thinking. After a modest career as a writer opposed to Catholicism and organized religion, this younger Reade had made his name as a traveler in West Africa, where he had taken a sympathetic, anthropological approach to local customs and religions. Hoping to bring the benefits of modern science to Africa, he had enrolled as a medical student and worked in a cholera hospital. He is remembered for his book *The Martyrdom of Man*, published in 1872, which started as a history of the world from an African perspective and grew into what he called "the plain unvarnished story of the human race," charting the effects of war, religion, liberty and intellect on the condition of man, and championing science as the scourge of superstition, particularly Christianity. For all its fierce iconoclasm, the book also paradoxically advocated a new deism, in which a supreme being was responsible for a world in which mind and matter were indivisible.

It is not known exactly when Arthur first read this work, but it was around this time when, in his search for a romantic synthesis between science and religion, he wanted some sort of practical antidote to transcendentalism. A measure of *The Martyrdom of Man*'s effect was that he would later have Sherlock Holmes recommend the book as "one of the most remarkable ever penned."

Back home the arrival of Dodo and therefore a new mouth to feed concentrated Arthur's mind on the need to earn his living. Seeking to make the most of the long recess at the end of the academic year, he advertised for a temporary opening as a doctor's assistant. In April 1878 he was taken on by Dr. Charles Richardson, an Irishman who

had done part of his training in Edinburgh and now worked as a general practitioner in an inner-city area of Sheffield. It was not a happy experience, and Arthur left after three weeks, perhaps glossing over a serious clash of personalities by telling his mother that he was considered too young by his Yorkshire patients. He did at least appear to have ventured out of the city into the Peak District, where his memory of the eerie limestone caves in the Pennine hills later provided material for one of his most spine-chilling stories—"The Terror of Blue John Gap."

After Sheffield, he went to stay with his relations in London, where he was happy to find his great-uncle Conan was also visiting and in better physical shape than he had been led to believe. Having traipsed round the tourist spots three years earlier, he devoted his time to more stimulating activities, such as visiting the Royal Academy, attending a Hallé symphony orchestra recital and again seeing Henry Irving on stage, this time in an exciting portrayal of Louis XI. He also managed to watch the visiting Australian cricket team at Lord's.

He continued to look for some form of medical assistantship, without much success. Indeed, mulling over his unhappy sojourn in Sheffield, he became depressed about the prospect of practicing in Britain and began thinking he might have a better future as a naval surgeon. He told his mother that, if he served at sea, he could provide for "Duff," as Innes was still known, and come out of the service after ten years with a sizeable lump sum, as well as a half-pension of 150 pounds a year for life.

Kicking his heels did not suit him. After he complained of feeling bored, his relations accused him of "Bohemianism"—a code word for the morally dubious aesthetic movement that had surfaced in London with the Grosvenor Gallery's opening a year earlier. To counter this suggestion he volunteered to go to the Balkans as a medical assistant in the event of a Russo-Turkish war (which never developed). Needing some spiritual sustenance too, he visited two former teachers, Fathers Cassidy and Splaine, who were on the staff at Beaumont School near Windsor. Otherwise he passed his time reading books such as Macaulay's *Life and Letters*, taking heart from its affirmation of novels as a way of smoothing out a character's rough edges—an insight that helped him understand his problems with Dr. Richardson, who had prided himself on not having read a book or seen a play in a decade.

At the back of his mind were worries about his father, who had been in poor health in July and was out of work. Partly because of this Arthur resigned himself to returning to Edinburgh and taking a lowly but

salaried job as a hospital dresser. At the last minute he was offered a temporary position that he had earlier thought had fallen through. He found himself working for Dr. Henry Elliot, another former Edinburgh graduate, with a general practice in the small, exotic-sounding village of Ruyton-XI-Towns, hard on the Welsh borders, eleven miles northwest of Shrewsbury. Once again he had problems with his employer, a man in his thirties who turned out to be coarse and bad-tempered. Elliot exploded when his young assistant dared argue against capital punishment, saying he would not have such things said in his house. Arthur calmly replied that he had a right to voice his opinions when and where he wanted. He told his mother he had a mind to write to *The Lancet* complaining about the hardships of life as a medical assistant.

Despite these drawbacks, Arthur blossomed during his four months in Shropshire. Discovering an ability to stand up for himself, his self-esteem grew appreciably. This was reflected in his physical appearance. He put on weight and gained a healthy-looking tan from lounging in the sun, often while on the cricket field. Somehow his general attitude had also changed and he had become "a stern and grave physician." He was forced to display these qualities once when Elliot was away and he was called to attend an emergency at a large house where a canon had exploded, leaving a lump of iron in the head of a bystander. After removing this intrusion, Arthur found himself peering at bare white bone. Luckily the victim's brain was not damaged and Arthur was able to bind the wound and leave with increased confidence in his professional abilities.

He spent any leisure time writing a lengthy essay that he described as a labor of love. Entitled "On the intemperance of our country; the cause of its prevalence and the means of suppressing it," this work reflected his concerns about his father. It was prefaced with a touching quotation—"Unless above himself he can/ Erect himself how poor a thing is man"—a truncated couplet from Samuel Daniel's early-seventeenth-century poem "To the Lady Margaret, Countess of Cumberland," which praised the advantages of a noble and untroubled mind. Arthur's treatise argued that any tyrant (other than alcohol) who forced his people to give up a third of their earnings and consume a commodity that humiliated them, ruined the peace of their homes and hastened them towards an early death would immediately be faced with protest and demonstrations. He listed a number of causes of drunkenness, from love of excitement and lack of self-respect to gregariousness and, always a worry to him, hereditary influences. He suggested various antidotes that centered largely on

education and temperance clubs, even a temperance party. And he looked forward to legislative measures including stricter selection and control of publicans. In Ruyton, a town of a mere one thousand inhabitants, he complained, there were four public houses, and even if a recovering alcoholic could avoid the attractions of the "Admiral Benbow" (which still exists), he was likely to fall prey to others down the street.

Arthur's idea was to submit the essay anonymously for a prize contest. Though he appears to have done this (with his mother's help), there is no evidence he was successful. As a result he was feeling the pinch when he prepared to return home in October. But when he asked his employer to contribute towards the 30 shillings cost of a third-class railway ticket, he was refused. Elliot said he would gladly have assisted if he had been paying a salary, but, as he was not, he regarded himself as under no obligation since his assistant was a gentleman traveling for his own improvement. Arthur had to rely on a 2-pound subsidy hastily sent by his father's friend, Dr. James Sidey. He went on his way with a final, perhaps unwitting, compliment from his employer ringing in his ears. When Arthur dismissed his essay's chances, Elliot disagreed, saying the fast-maturing nineteen-year-old "had the bump of self-esteem very largely developed" and he himself "didn't like men who hadn't."

The significance of Arthur's essay on insobriety became clear the following year when, bowing to the inevitable, his father was finally institutionalized at Blairerno, a home for alcoholics run by David Forbes, near Glenbervie, just north of Montrose in Kincardineshire (now Aberdeenshire). *The Scotsman* of March 10, 1879, pointed to a possible reason for this move in its report of a fire at 23 George Square. Though it provided no relevant details, it hinted at a drunken mishap, perhaps caused by an overturned candle.

Charles's absence gave added poignancy to thirteen-year-old Lottie's impassive summary of the year 1879 in her birthday book, a gift from her uncle Dicky. "Home all quiet," she wrote, which was no doubt true, but it glossed over the tensions silently reverberating around George Square now that Bryan Waller's ascendancy had been confirmed.

One of these was the unrelenting pressure Arthur felt to complete his course and assume responsibility for his family. After finishing his second year of clinical study in May 1879, he was ready for a further period of hands-on medicine as an assistant to Dr. Reginald Ratcliff

Hoare in the Midlands. This time he would at least be paid a salary of 2 pounds a month and his stay would count towards his degree since his employer was another Edinburgh graduate qualified to give training in midwifery and pharmacology. A generous touch—and an indication of the hopes riding on his progress—was the gift of 2 pounds from his sister Annette in Portugal. She had saved the money from her toils as a governess and thought he might need it to cover his fare from Edinburgh to Birmingham and generally tide him over until he was paid.

Arthur had hoped Dr. Hoare's medical practice, Clifton House in Aston Road North, would be located in a semi-rural suburb of Birmingham, but instead it was on a busy thoroughfare, with tramlines and shops on either side. He realized this had its advantages, for, as he gushed to his mother, Dr. Hoare had spondulicks, a recent Americanism meaning wealth, and so was able to run a five-horse practice, or one that operated from morning to night, earning 3,000 pounds a year. As Arthur later added, that "takes some doing when it is collected from 3s 6d [3 shillings sixpence] visits and 1s 6d bottles of medicine among the very poorest classes of Aston." Hoare, a stout, red-faced man with bushy whiskers, could no doubt afford the luxury of his honorary appointments at the Industrial School in Gem Street and as Medical Officer to the Aston Fire Brigade.

For Arthur this was an eye-opener: he saw for himself that an urban general practice could be a lucrative business. He soon settled into a busy routine—accompanying Dr. Hoare on his rounds in the mornings, spending the afternoon prescribing medication, and assisting in the clinic after tea when he was able to experiment with patients. Supper was not eaten until nine o'clock in the evening, after which there was a period of comparative peace until bedtime around midnight.

With his new confidence, he found himself enjoying a placement for the first time. He liked both Dr. Hoare and his attractive, well-read wife Amy, who shared his passion for tobacco. While Arthur and his employer usually smoked pipes, she preferred a post-prandial cigar. The only irritants were the Hoares' two spoiled children, Cecil and Josephine, and another assistant, an Irishman whose foppish manner raised Arthur's hackles. And at the back of his mind were always worries about George Square, where he feared conditions must be very crowded.

At least he had the satisfaction of living in a literary household. For Amy's birthday, he delighted in giving her a present of George MacDonald's *Alec Forbes of Howglen*—not an absolute favorite, but a novel with strong personal resonances, telling of a Scots boy (one of two

children at its center) who overcomes fearful beatings with the tawse to reach medical school where he is required to decide whether to make something of his life or dissipate it through alcohol.

Despite a punishing schedule, Arthur felt so at home—more like a son than an assistant, he declared—that he began to look to his own writing, primarily as a way of supplementing his income. There is still doubt about which story he wrote first. It was probably "The Haunted Grange at Goresthorpe" which he sent to *Blackwood's*, the obvious outlet, because of both his long familiarity with the magazine and the subject matter. This was an atmospheric mystery story about two college friends investigating the ghost of a murderer on the estate one of them owned in Norfolk. Its interest lies not so much in its detail but in its polarization of the views of the visiting Tom, who had a theoretical intelligence as a result of his schooling in Germany, and the host, who was much more practically minded following his medical training. This difference of opinion reflected Arthur's personal struggle as he began to move beyond his family's Catholicism and find some new way of interpreting his existence. Mention of German education referred not to his own short period at Feldkirch, but to more recent dabblings in German idealist philosophy that posited the ascendancy of mind over matter and provided an intellectual underpinning to the Gothic romanticism he had discovered in authors such as Poe. This approach was to have a profound influence on him, even if, for the time being, he still could not throw off the hold of the materialism at the heart of modern medical science.

The story failed to excite any interest at *Maga*, where it was put on one side and forgotten, only to be discovered in the magazine's archives more than half a century later. Arthur did not have to wait long for literary success, however, as he had sent "The Mystery of Sasassa Valley" to another Edinburgh periodical, *Chambers's Journal*. This was a similar mystery story, but set in a more exotic situation, reminiscent of the adventure tales of his youth. Two former student friends (again) were seeking their fortunes in South Africa, which was regularly in the news at the time because of the Zulu wars. They were down on their luck when some cattle strayed into a deep gorge where the native "Kaffirs" refused to go at night because of fears of "ghosts." When one of the men reports seeing a mysterious flickering light in this narrow passage, the other immediately suspects it might be a precious stone. One sortie to find this gem results only in the discovery of some worthless rock salt. But the next trip is more successful: the men become wealthy and, in general terms, the forces of progress tri-

umph over those of darkness and superstition. This time his story was accepted by Chambers's and published on 6 September, though the 3-pound fee for his first published work was hardly generous.

With both Arthur and Charles absent in the latter half of 1879, Bryan Waller was able to consolidate his position at George Square. Having achieved his ambition of becoming an official University Lecturer in Pathology, he was determined to continue influencing the mental and spiritual development of the undergraduate son of the house.

Waller's personal life is not easy to understand since, on his orders, all his papers were destroyed after his death in 1932. However, one of his letters to Arthur from this period survives, and it shows him trying to pass on some of his philosophical understanding. "Absolve you to yourself," Waller began, "and you shall have the suffrage of the whole world. If any one imagines that this law is lax, let him keep its commandment one day." He was quoting directly from the famous essay *Self-Reliance* in which the American poet-philosopher Ralph Waldo Emerson gave his gloss on the transcendentalist idea that, since man was indivisible from God, he could be his own confessor. Waller went on to counsel the young medical student: "Here we put our finger on the weakness of all blind vicarious and fiducial trust in a hypothetical Providence which forsooth is to help those who cannot or will not help themselves. Far nobler and truer is the teaching of the old proverb: Heaven helps those who help themselves . . . This manful and true inward life is what Theology would fain kill by making us hold ourselves sinful and degraded, which is a pestilent lie, and cuts at the root of all that is best in our nature: for take away a man's self-respect and you do much towards making him a sneak and a scoundrel."

Having got in this dig at Arthur's father, Waller continued, "Thus 'Do' is a far finer word than 'Believe': and 'Action' a far surer watchword than 'Faith' . . . Choose then who ye will serve: the principle of Slumber and helpless Dependence, draped in the rainbow mists of many a dead and dying age and bright with the phosphorescence of decay, or that other standing erect and mighty with its face towards the sunrise and its great wings dispread for measureless and viewless flight."

Behind Waller's not-so-subtle exhortations to action, his debt to the philosophy underlying Emerson's transcendentalism can be discerned. He subscribed to a practical Anglicized brand of German idealism, as had been mediated through the coruscating intelligence of Thomas Carlyle. It reflected Carlyle's crucial premise that the experience of

God (or indeed any other concept) could become atrophied if presented in the wrong manner. Although Carlyle was an ambivalent figure for Waller, having satirized the family circle around his friend (and Waller's uncle) Barry Cornwall, he was revered in Edinburgh, where he had been Rector of the university, his alma mater. So Waller thought the writer's ideas worth imparting to young Arthur, who had already shown his familiarity with German idealism in his story "The Haunted Grange at Goresthorpe."

The Doctor concluded his letter by urging Arthur to "show them the stuff you're made of yet." His comparison of the qualities expected of Arthur with what "our fellows at the relief of Ekowe did with those uncomfortable niggers in South Africa" helps with the dating as it refers to an incident in the Zulu war in early 1879.

Arthur took the hint, though he remained wary of Waller's desire to usurp his father's role. Emboldened by his story's acceptance by *Chambers's*, he decided to try his hand at another form of writing—medical journalism. In an age of rapid change, doctors were never slow to tell the world about their contributions to the advance of science. Their incursions into print were part of the modern process of self-promotion and career advancement. Edinburgh had its own *Medical Journal*, which Dr. Joseph Bell happened to edit, with Dr. Waller as an occasional correspondent. But Arthur chose to look further afield, to the *British Medical Journal* in London, to publish his first professional paper.

For years he had been plagued by headaches (or, as he called them, neuralgia), which he used to treat with a commercially available tincture of gelseminum, or yellow jasmine. This acted as a muscle relaxant but, as Arthur's university studies had shown, its active constituent was a poisonous alkaloid, and this brought out his inclination to experiment. Encouraged by the arrival of some fresh tincture at Dr. Hoare's clinic, he set out to discover how much of the drug he could take, and what would be the symptoms of an overdose. Every night for a week, after the supper plates had been cleared, he gave himself progressively larger doses of gelseminum. Over the period he increased his intake from 40 to 200 minims (in old-fashioned apothecary terms—a minim being one-twentieth of a scruple, or 0.0592 milliliters, and a scruple 1.3 grams, or 20 grains). In this reckless manner he found that his initial symptoms of giddiness gave way to severe diarrhea as he took more of the drug. His conclusion, published in the *BMJ* on September 20, 1879, was remarkably upbeat: although a dose of 75 minims had been described as fatal, he thought a body could learn to

tolerate it (like opium) and take even more. But for the diarrhea, he claimed he could have ingested up to half an ounce.

Amy Hoare was horrified at his drug experimentation and threatened to tell his mother. But Arthur persevered with the willfulness of someone determined to find out more about the narcotic oblivion his father had often known. In retrospect, his science was not very sound. He would have obtained different results from different parts of the same plant, which is now better known as a homoeopathic remedy. But at least, with his article, he had placed his foot on an accepted professional ladder and Waller must have been pleased.

Any plaudits would have been the warmer since, following his indentured appointment, the doctor had begun, in typically factional Edinburgh University fashion, to draw a circle of acolytes around him. Arthur could not avoid being one of them. His friend James Ryan was enlisted as Waller's medical assistant. And George Budd, another student who would play an important part in Arthur's life, became another member.

Budd was an extraordinary character, easily identifiable in *The Stark Munro Letters* as the irrepressible Dr. Cullingworth who was "well-grown, five foot nine perhaps, with square shoulders, an arching chest, and a quick jerky way of walking . . . His face was wonderfully ugly, but it was the ugliness of character, which is as attractive as beauty." He had a "demonaic cleverness . . . , a dash of the heroic" and a temper "nothing less than infernal." He was the twenty-four-year-old black sheep of a distinguished medical family so numerous in Devon that one visitor complained that all the county's doctors were "Buddists." As an epidemiologist in Bristol, George's father William Budd had been the first person to identify typhoid as a water-borne disease. During one of his wilder moments, young George had eloped with an underage girl who was a ward of the court. In order to escape detection during his honeymoon, he had "stained his yellow hair black, but the stain took in some places and not in others, so that he looked as if he had escaped from Barnum's show."

The simile was not inappropriate, since Budd was a show-off who loved challenging conventional opinion. For example, he abhorred his profession's emphasis on public health, arguing that improvements in sanitation were bad for doctors because they inevitably resulted in fewer patients. He too had recently begun to air his often bizarre ideas in the *BMJ*, and there may have been a competitive edge as Arthur vied with him for Dr. Waller's attention. This rivalry did not stop Arthur becoming a regular visitor to the Budds' sparsely fur-

nished Edinburgh flat. He was not put off by his host's habit of keep-
ing the windows open, in all seasons and at all times of the day and
night, ostensibly for health reasons. He grew accustomed to the
uncertainty of never being sure if he would be engaged in stimulating
conversation or challenged to a bout of fisticuffs.

For Budd brought out a suppressed anarchic side of Arthur. In *The
Stark Munro Letters* the two student doctors steal a specimen of liver
containing amyloid, a starch-like protein that they want to prove is
composed of glycogen. Arthur may have taken some artistic license in
his fictional account of this incident, not least in his detail of their fry-
ing the liver as part of their investigation. But there was clearly some
truth behind it. Budd had written a letter to *The Lancet* on the topic of
amyloid degeneration. And when a bit later Arthur asked his mother
not to tell Dr. Hoare about the preserved organ he had procured for
Waller, the impression emerges of the Doyles' lodger as a Robert
Knox–like figure—an ambitious pathologist surrounded by a group of
precocious disciples who, in age-old medical school fashion, occasion-
ally broke, or at least stretched, the rules.

Aside from Ryan and Budd, Arthur made no reference to any
other student friend, except the gifted Robert Henderson, who
became a major-general in the army medical service and was awarded
a knighthood. At Edinburgh he was one of the leading sportsmen of
Arthur's day, playing in the same university rugby XV as George Budd,
a rambunctious forward.

These few friends provided a nucleus for the boisterous student life
that Arthur hinted at in the margins of his "Notes on Medicine Ses-
sions 1879–80." Ostensibly Arthur used this fascinating compendium,
now held by the Royal College of Surgeons in Edinburgh, to record
details of clinical cases he was observing. He also listed topics such as
"The Constitutional Complications of Gout" and "Treatments of
Rheumatism" as well as the words of some ditties he and his friends
had composed. One was a raucous drinking song about Edinburgh's
Royal College of Surgeons and another an anti-Fenian ballad that
ends with three Irish "demagogues" being brought to justice:

> Three prisoners are waiting their trial in Gaol
> Waiting their trial neath padlock and key
> And Fenian Supporters are raising their bail
> And thousands bewailing the patriots three
>
> But the law is strong and the law is just

In his politics, Arthur clearly remained a Conservative, with a strong sense of identification with the property owners in Ireland.

But if Arthur would have liked to let off steam in typical student manner, circumstances conspired against him. He relished the comradeship that came from being part of Bryan Waller's faction, but he did not enjoy the betrayal of his father this implied. Then in December he learned of the death of his great-uncle Conan in Paris. A source of encouragement and often money had dried up. So Arthur did not need much persuading when, two months later, he opted to make another abrupt change, put his studies on hold, and set out again, this time as doctor on a steam-driven whaling ship, the SS *Hope*, which was embarking on a six-month-long voyage to the Arctic.

With whale oil still in great commercial demand, principally as an illuminant, a sizeable Scottish fleet would gather every spring to hunt for whales and seals in the frozen waters around Greenland. Arthur took the place of a fellow student, Claud Currie, who had worked on the *Hope* before, but was unable to go that year. He was doubtless attracted by wages of 2 pounds 10 shillings a week, plus a share of the "oil money." But he really needed little financial inducement to embark on what he called the "first real outstanding adventure" of his life.

The 575-ton *Hope*'s home port was at Peterhead, in Aberdeenshire, at the northeast tip of Scotland. Since Charles Doyle was based in the same area, his son may have visited him en route to Peterhead, where he arrived on February 27, 1880, ready for sailing the following day. At twenty, one of the youngest members of (initially) a thirty-three-man crew that ranged in age from seventy (the First Mate) to nineteen (a sail-maker), Arthur found a father substitute in the *Hope*'s skipper, Captain John Gray, a whaling veteran whose own father and grandfather had done the same job before him. He described the taciturn Gray, with his ruddy face, grizzled hair and beard, and light blue eyes, as "a really splendid man, a grand seaman and a serious-minded Scot."

After ten days they docked at Lerwick in the Shetland Islands to take on nineteen more sailors and join forces with ships from other ports, making an armada of around thirty whalers in all, though there was fierce turf-based rivalry. When Colin McLean, the burly cook's assistant on the *Hope*, heard six officers from Dundee running down his own ship, he challenged them to a fight, later telling Arthur, "It's lucky I was sober, Doctor, or there might have been a row."

Arthur would have been the first to admit his medical knowledge was rudimentary. But this encouraged him to throw himself into the

life of the ship where his unstuffy approach was appreciated. Having gained a taste for fisticuffs in Edinburgh, he took his on-board exercise in a makeshift ring where, after one fierce bout, the Steward Jack Lamb was heard enthusing about "the best sur-r-r-geon we've ever had . . . he's blacked my ee." Arthur in turn was impressed by the erudition of the largely self-taught crew. The harpooners engaged in conversation about "zoology, murders, executions and Ironclads" while the Chief Engineer liked nothing better than moonlit debates on the finer points of theology or Darwinism. Arthur happily contributed to the general fund of knowledge, lending favorite books such as Macaulay's *Essays*, which had the Second Engineer engrossed in the history of Frederick the Great. Since the mess was plentifully supplied with wine and champagne, it was a near-ideal existence. He told his mother he had never been happier in his life. "I've got a strong Bohemian element in me, I'm afraid, and the life just seems to suit me."

The fleet planned to make its way to the ice floes off Greenland where the seals congregated with their young pups. It then had to wait a few days until the end of the official close season that had been negotiated by the British and Norwegian governments as an early conservation measure. Later, after finishing its cull, it would move on to whaling waters further north. The *Hope* came across her first seals a week after leaving Lerwick on March 10. With two dozen other ships circling, she then had to wait, observing her innocent prey frolicking on the ice with their young, until, on April 3, their "brutal" work could begin, and the dazzling white expanses of ice became covered in pools of crimson blood. As Arthur jumped from one piece of ice to another, eager to gather in the shot and battered seals, he often missed his footing and fell into the sea five times in four days, much to the amusement of Captain Gray, who dubbed him "the great northern diver." When he returned from one of his sorties, with his shoulders chafed from ropes and his clothing covered in dirt, sweat and blood, Gray described him as the most frightful savage he had ever seen.

On May 22, towards the end of the seal-culling, Arthur turned twenty-one and officially came of age, though he found it an odd place for this. The *Hope* then moved northwards for her encounter with whales. She was not particularly successful, but Arthur was excited by the greater element of danger. By the time he left at the end of July he was writing expansively in his diary about the frozen wastes around him. Otherwise his written output on board ship was not significant: he struggled to complete poems, while two pieces of original writing—a short story, "A Journey to the Pole," and something described as "Mod-

ern Parable"—have not survived. However, his reading took in Carlyle, Morley, Boswell and Sterne, whose *Tristram Shandy* he described as "coarse" but "very clever." He also kept two volumes of journals, complete with over thirty meticulous pen and ink drawings attesting to his fascination with everything around him.

More important, he had been exposed to a series of dramatic situations. He had met unusual characters, visited new lands, and experienced sensations of danger, loneliness and, even, terror, all of which would provide material for his later fiction. One example: on the *Hope* there had been a swarthy dark-haired man of unknown origin, who was rumored to be on the run from the law. Even if Arthur looked back on his time cooped up on board as one of mental and spiritual stagnation, such characters would soon begin to bear fictional fruit in stories such as "The Captain of the *Polestar.*" Arthur was still drawing on his few months in the Arctic over twenty years later when he wrote the Sherlock Holmes story "Black Peter," in which Captain Peter Carey had once commanded the *Sea Unicorn,* the steam whaler where Patrick Cairns (based on the *Hope*'s Colin McLean) had been the leading harpooner.

By the time Arthur arrived back in Peterhead in mid-August, he knew nothing of the British army's defeat at Maiwand in Afghanistan which had resulted in a wound to Dr. John Watson's shoulder (or perhaps leg). His employment record was gratifyingly marked "General conduct: VG," "Ability of seamanship: VG," though the fact that all crew members received the same commendation removed some of the gloss. As Arthur noted in an appendix to his journals, the *Hope* had bagged two whales and 3,614 seals, of which his share had been fifty-five. Strangely in his autobiography he claimed four whales—an exaggeration along the lines of his assertion that he had been paid "more money than I had ever possessed before," which gave him the thrill of concealing 50 pounds' worth of gold coins in every pocket of every garment he owned, and imagining his mother hunting for them. The record suggests his final wage packet was a welcome but hardly Croesus-like 18 pounds 10 shillings.

So far as his schedule can be determined, Arthur stayed a few weeks in Edinburgh, before returning in October or early November to work with Dr. Hoare in Aston. He wanted to combine further practical medicine with earning some money, and revising for his final exams the following year. Amy Hoare was immediately aware that the boy who had left her house a year earlier had grown into a strapping young man. During his voyage he had often reflected on how fit

he felt as a result of his outdoors way of life. He had grown in stature and, with the maturing of his physique, had come his first overt feelings about the opposite sex. He had noticed the lack of women on the *Hope*, telling how when the ship returned to shore it dipped its flag to acknowledge a lighthouse and when a figure came out to answer, his colleagues burst out in excitement at seeing a woman. She was all of fifty years old, but she had breasts, and Arthur could not help agreeing when the crew used to say "Anything in a mutch," a reference to the woman's linen cap which defined the opposite sex for them. His new-found sense of his own masculinity was not lost on Amy, who made him promise not to make advances towards the attractive governess she had employed for her children.

Arthur duly put his head down and concentrated on his work and studies. To help him, he made a pact with Dr. Hoare that they should both forsake alcohol for the month of November. Although he did not sleep so well, he claimed he felt fresher in the mornings.

But already his sights were set on trying to find another ship to work on after he had graduated. His sister Annette had contacts in Portugal who might help him. If he did this for a year, he predicted, he would have enough cash to study for a while in Vienna, hone his skills in a temporary job on a hospital house staff, and then move to a "snug little practise" [*sic*].

Arthur's main diversion was some typical jousting with George Budd in the pages of the medical press. His old friend had left Edinburgh after graduating in 1880 and had set up a practice in Bristol, where he had grown up and could justifiably hope to benefit from his late father's good name. Towards the end of 1880 Arthur told his mother to look out for a letter he had written to the *British Medical Journal*, attacking Budd's opinions about gout. Budd's original article had appeared in the journal on December 18, and there was indeed a reply the following week, but it came from Hoare rather than Arthur—a development that has led Owen Dudley Edwards to posit a degree of animosity between Arthur's two very different types of friends.

At some stage Arthur had written another short but assured story, "The American's Tale." This showed him adapting recent experience to his own style as he mixed mystery, adventure and a touch of science fiction. It starts with the narrator, a hardy American with the Presidential name of Jefferson Adams, informing colleagues in "our social little semi-literary society" (based on Edinburgh's Philosophical Institution) that he could tell of "queerer things than that 'ere," for "you can't

learn everything out of books sirs, nohow." Adams insists, "If you want real interesting facts, something a bit juicy, go to your whalers and your frontiersmen and your miners and Hudson Bay men," before embarking on a graphic tale of revenge in the American Wild West where a man plotting murder gets his come-uppance when he is mysteriously killed by the thorns of a giant flytrap that "had been slowly driven through his heart as it shut upon him." The story neatly encapsulates Arthur's growing suspicion that the great truths of the world, not to mention its excitements, might lie beyond academia. It includes a cameo part for a scientist, who identifies the plant as *Dianaea muscipula*. And it ends on an ambiguous note, reflecting Arthur's internal debate about the advantages of imagination over hard fact (as found in the laboratory), with one of the clubmen complimenting the narrator on the truthfulness of his "deuced rum yarn" and another suggesting he might in fact be "the most original liar that ever lived." Arthur sent his story to *London Society*, the new magazine launched by his father's friend and sometime publisher James Hogg, who agreed to print it in his Christmas issue and pay him the princely sum of 1 pound 10 shillings.

By January 1881, he was complaining of being exhausted. Apart from a brief and uneventful meeting with Nelson Foley, one of his Irish cousins, at a Midlands railway station, his only recent amusement had been a couple of lectures in Birmingham, one of which, titled "Does Death End All?," he thought astute, if ultimately unconvincing. This was given by the Reverend Joseph Cook, a firebrand American preacher who had made his name in his native Boston with his popular weekly talks, which used modern knowledge to refute attacks on Christianity. Arthur's negative reaction indicated the direction of his thinking: he would have appreciated Cook's tussling with the latest scientific ideas, but rejected his traditionalist conclusions.

Shortly before he left the Hoares his mother came to stay, accompanied by her daughter Dodo who was almost four. In the past the Doyles had often traveled during house moves, and so it proved now. When next heard of back in Edinburgh in April, Mary and Dodo were living not in George Square but at 15 Lonsdale Terrace, an attractive bow-fronted house which was leased to Dr. Waller. With Arthur, Connie, Innes and Ida also at home, the only family absentees were Charles at Blairerno, Annette in Portugal and Lottie who, at the age of fourteen (she was now fifteen), had followed her older sister to the convent school at Les Andelys in France.

Arthur had moved back to Edinburgh to finish studying for his

finals. Although admitting he was worried about his exam, he did his best to reassure the absent Lottie that everything was normal at this new house. He and some friends had played charades at Innes' birthday. His father seemed better and had been sent to a health resort in Aberdeenshire. And there was genuine affection in Arthur's avowal to Lottie: "I have crammed my pet sister down the throats of every girl from fourteen to forty that I have come across. I wish I could come across another like you, but you are unique." He claimed he was looking forward to seeing her again even more than to earning his degree.

When his exams came round in June, he was annoyed when Professor Spence tried to trip him up in his surgery oral. But, unlike Tom Dimsdale in *The Firm of Girdlestone*, he did sufficiently well to pass with honors. Feeling the need for a well earned rest, he then set off at the end of the month to stay with his relations in Ireland, from where he wryly promised Dr. Hoare he would write "if I'm not shot as a process server."

On the Road—Ireland, West Africa and Plymouth

1881–1882

Arthur did not have to wait long before having his prejudices confirmed. Bounding off the boat at Waterford—six feet tall, thick-set, with a trace of a dark moustache, and altogether at the height of his physical powers—he was brought up short by the sight of a placard "imploring the citizens of the county to assemble in their millions and to hold their crops, whatever that might mean." This was the nationalist Land League signaling its intention to stage a boycott, and, once safely ashore, Arthur also noticed its constituency—"the traditional Irish peasant, whom I had always imagined to be a myth invented for music-hall purposes. There he was, however, as large as life, with corduroy knee-breeches, blue stockings, and high, soft hat with a pipe stuck in the side of it."

The atmosphere was rather different where he was staying with his Foley relations at their impressive new seat, Ballygally, on the river Blackwater, just west of Lismore. The journey required him to take the train along the coast and then inland to Lismore—a forty-mile-long section of the railway that had been opened only three years earlier. In the cathedral city he is likely to have been met by a high English dog cart, attended by a uniformed coachman and footman, all festooned with the Foley crest—a lion rampant and the motto "Ut possum," meaning "That I may do good." He would then have been driven five more miles, through some imposing gates, and up a long drive to a 300-year-old grey-stone house, with a fine marble entrance hall and a dome of Italian wrought iron.

Sitting at the center of 205 well-cultivated acres, with a croquet lawn and vistas stretching down to the river, Ballygally seemed like a "paradise," or so Arthur told Amy Hoare whose maternal role in his life was emphasized by the fact that he addressed her, like his own mother, as "Mam." But, as his earlier barbed comment to her husband suggested, he was wary of a place with the potential to blow up politically at any moment. He had had a taste of the underlying tensions when last in Ireland, age six. Then, as now, the basic issue remained land. Back in 1866, he had observed Fenians on the march, giving vent to the grievances of peasants who had suffered under the demands and neglect of often absentee landlords. In recent years the sporadic violence associated with that movement had become more insistent, following the emergence of the Irish National Land League which focused more directly on land tenure issues. The League had formed a loose alliance with advocates of Home Rule to provide support to nationalist MPs who, under Charles Stewart Parnell, had coalesced into a semi-independent offshoot in the House of Commons. According to a modern historian, Parnell was "riding a tiger" by linking his group with the Land League. But, as renewed agricultural depression had taken hold in the late 1870s, the combination of rural anarchy and parliamentary pressure had forced W.E. Gladstone, the incoming Liberal Prime Minister in 1880, to introduce a new Land Bill, while cracking down severely on attendant acts of terror.

With their genteel lifestyle (everyone had to dress for dinner) and their links to the Anglo-Irish ascendancy, the Foleys were obvious targets for the League. As recently as 1870 they had owned 1,300 acres around Lismore though, by Arthur's visit, their holdings were reduced, partly through family deaths, and partly by the League's demands.

For three decades the head of the clan had been Mary Doyle's cousin, Nelson Trafalgar Foley. With a name like that (commemorating his birth on the day news of Admiral Nelson's famous victory reached Lismore), there was never much doubt about his political affiliations. But he also had a social conscience. At the time of the Great Famine in 1845, he had advocated specialized agricultural schools to the Devon Commission. As a Justice of the Peace, he had been vice-chairman of the Lismore Board of Guardians, which dealt with applications for financial assistance from tenants suffering from economic hardship. But Nelson Trafalgar had died in 1878 and Foley affairs were in some disarray, as his large brood tried to manage his estates. Five years earlier his son Robert, a naval architect, had been tragically killed in an accident on board a ship. Another son Nelson (whom Arthur had

recently met) was following the same profession in England. Soon to emigrate to Italy, he had worked for Palmers, the Jarrow shipbuilders, and written the well-received *Mechanical Engineers Reference Book*. Since two older sons had already died, that left three others, Richard (Dick), Thomas and Edmund (Ned), to look after the patrimony with their four surviving sisters, Elizabeth, Mary, Letitia (Letz) and Alice—all of them Arthur's second cousins.

Arthur found two of the Foley brothers particularly good company. Dick was in his early forties, tall, thick-set and tanned, with a brownish beard, while Ned, the youngest of the brood, had been a merchantman's mate and was more compact. Arthur was astonished at their wealth, which came from land rents, and, in Dick's case, sole rights to fish salmon on a stretch of the Blackwater which netted him a thousand pounds a year, according to Arthur's estimate.

As de facto head of the family, Dick was not the kind of person to take the Land League's threats lying down. On one occasion he walked into a League meeting and told the president he wished his whole organization had one neck and he had his foot on it. When, using a tactic that had been introduced in County Mayo only the previous year, the League boycotted the Cork cattle show, Dick pledged to challenge this unwelcome restriction by making a mockery of it and exhibiting his mangiest cow. But he still needed to take basic precautions, as Arthur discovered when he arrived back late from visiting another cousin four miles away. (As Arthur noted, he seemed to have relations throughout the county.) Finding the front door closed, he shinned up a drainpipe, only to find Dick waiting with a double-barreled shotgun pointing at his head.

Watched over by its great castle and by its Protestant cathedral dedicated to St. Carthagh (or Carthage), the city of Lismore was less fraught than the surrounding countryside. Arthur was therefore able to enjoy its summer social season. When not out on the Blackwater fishing or shooting with his cousins (he bagged a wild duck, a water hen, and seven rabbits one day), he played cricket for Lismore, though without great distinction. He made 3 and nought and took two wickets against the 25th Regiment on Friday July 1, and scored a further 9 runs against Cahir the following week (both matches were lost).

Then there were more social diversions. On July 2, the *Munster Express* reported on a fancy fair and rose show that had taken place earlier in the week in Ballyin Gardens, Lismore. Among the attendees, it noted, was a "Miss Veldon of Belview." No matter that it got both names wrong; this was Elmo Weldon who was to be Arthur's first seri-

ous girlfriend. With her mother and sister, she was staying with rela-
tions at Bellevue, a grand house rented from the Devonshire estate in
Monoman, a village a couple of miles east of Lismore. Whether
Arthur met her at the fair in Ballyin Gardens is not clear. It is certainly
possible, since this latter house was owned by the Foley family. Elmo
was dark-haired, large (one account puts her at eleven stone) and not
in the best of health. But she was striking and before long (unfortu-
nately the letter is only dated July 1881) Arthur was enthusing to his
mother: "By Jove! Such a beauty! . . . Miss Elmore Weldon. We have
been flirting hard for a week so that things are about ripe." His sexual
stirrings did not stop there. He claimed to be hoping to marry two or
three other girls including "a Miss Jeffers from Kilkenny, a little dar-
ling with an eye like a gimlet who has stirred up my soul to its lowest
depths." By the end of a month in County Waterford, however, there
was only one young woman in his thoughts—Elmo Weldon (though,
at first, he seems not to have known how to spell her nickname). He
went away with her picture, which became such a treasured possession
that his mother's friend Charlotte Drummond, a Ceylon planter's
widow, gave him a frame for it.

Little is known about Elmo Weldon except that she was visiting an
elderly aunt, Mina Hewetson, at Bellevue. Her contacts show her to
have been part of the *haute bourgeoisie* who provided essential clerical
support to the Ascendancy with positions in the Church, law and
finance. She served partly as a model for Miss Clairmont, the much
desired (though largely for her fortune) girl in Arthur's Irish-based
story "The Heiress of Glenmahowley"—"a splendid, well developed
young woman with a firmly set lower jaw and delicately molded chin
which would have been almost masculine in their force had they not
been relieved by a pair of pensive blue eyes and a sweetly sensitive
mouth." But this tale would not be published for a couple of years. For
the moment Arthur occupied any free time with the latest in his
series of creepy-crawly colonial stories, "The Gully of Bluemansdyke"
which he dispatched to *London Society* while he was in Ireland, and
which would appear in the magazine's Christmas issue at the end of
the year.

On August 1, 1881 Arthur was back in Edinburgh for his degree cer-
emony. He celebrated by producing one of his spindly ink sketches,
showing himself with his MB certificate, and the rubric "Licensed to
Kill." His ideas for the future remained hazy: he had hopes of travel-
ing, perhaps on a boat to South America, and then working in a hos-

pital before setting himself up in a prosperous general practice. He was interrupted by the death and funeral of his family friend John Hill Burton. Despite the sad occasion, he was able to see Willie Burton, the dead man's son, who was now based in London where he and his uncle Cosmo Innes had set up a firm of consulting engineers that specialized in sanitation work. Willie was an enthusiastic photographer, taking after his grandfather, also called Cosmo Innes, a historian and lawyer who was a member of the exclusive Edinburgh-based Calotype Club, the oldest photographic society in the world, which had included Sir David Brewster and Henry Fox Talbot among its members. This older Cosmo Innes had subsequently joined the prestigious Edinburgh Photographic Society, which had elected Willie a member only the previous year.

Arthur was familiar with the Burton family's pioneering zeal for photography. Indeed his own enjoyment at fiddling with apertures and lenses had probably been nurtured at Craig House. Now Willie was more engrossed in his hobby than ever. He had begun contributing to journals such as the *British Journal of Photography*, which was soliciting articles for a new out-and-about section called "Where to go with a Camera." Knowing this, Arthur agreed shortly afterward to accompany a couple of friends on a four-day trip to the Isle of May at the mouth of the Firth of Forth. Their intention was to shoot birds, while he brought his camera and equipment to photograph the island's ancient cormorants. His subsequent article for the *BJP*—"After Cormorants with a Camera"—mixed breezy personal observations about the place with quirky technical information. For example, he had taken along several plates that he described as of his own manufacture, as well as enough chemicals to develop them at the end of each day. But when a policeman's light, which was part of his paraphernalia, proved inadequate as darkroom illumination, he improvised with a candle in an empty wine bottle.

Arthur's piece appeared in the *BJP* on October 14 and 21. But by then he had embarked on a new and unexpected adventure. He had forgotten that, as part of his post-degree planning, he had applied for a job as a ship's surgeon with the African Steamship Company. At short notice he received a telegram asking him to join a ship called the *Mayumba* that was departing for West Africa in a week's time. With the help of his friend Dr. Hoare, with whom he was again staying, he threw together his baggage, not forgetting his now important camera, and presented himself to Captain H. Gordon Wallace for sailing from Liverpool's Coburg Dock on October 22.

Arthur was to be paid 12 pounds a month to minister to the medical needs of some thirty passengers, who had secured berths among the mixed cargo and mail carried on this jobbing-iron screw-barque of 1,292 gross tons. No matter that the ship looked "a bit of a tub and very dirty"; she was "a good sea-going craft—which is sadly needed in these troublesome times." The few females on board proved diverting company: when they short-sheeted his bed, he got his own back by hiding a flying fish in one of their nightgowns. He had to put up with one woman who refused to allow him to examine her because she felt young doctors were liable to take such liberties. But a Mrs. Rowbotham flirted so outrageously that he fully expected to be met in Sierra Leone by her husband with a shotgun. With the men in the main saloon, he worked hard to improve his whist and cribbage. Generally, however, he found the *Mayumba*'s mock gentility inferior to the rough-and-ready atmosphere of the *Hope*. He particularly disliked the sleazy manners of one group of passengers—the rich African merchants who were returning home. One of them had shocked him by having half the *demi-monde* of Liverpool turn up to bid him goodbye.

The first few days of the voyage were so stormy and gut-wrenching that even the much traveled Stewardess claimed she was going to die. The weather improved after Madeira, but as the *Mayumba* made her way down Africa's Atlantic coast, calling at what appeared to be a succession of identical ports, Arthur found his surroundings unutterably depressing. After a month, he wrote to Charlotte Drummond from Bonny on the Niger Delta: "Never was there such a hole of a place, it is good for nothing but swearing at. I am just recovering from a smart attack of fever, and am so weak that the pen feels like an oar though I was only on my back for three days." He complained about the heat, the smell and the pervasiveness of death. "Here we are steaming from one dirty little port to another dirty little port, all as like as two peas, and only to be distinguished by comparing the smell of the inhabitants, though they all smell as if they had become prematurely putrid and should be buried without unnecessary delay."

His camera—a half-plate Meagher folding model, with a bellows body—provided a diversion. He had always intended to use it, as he noted, "to 'astonish the natives' by representations of their own hideous faces." In Bonny it helped establish communication with a warlike tribal chief called Wawirra who, having said that he had taken 500 men on his last campaign, proved less than amused by Arthur's claim that he could take as many in a single moment with his machine.

Arthur's jaundiced views were colored by concerns about his future. At one point during the voyage, he stood on the poop deck in the middle of a raging thunderstorm and decided he must rein in his desire to travel. He must have realized that he had taken to the seas in order to forget his domestic problems. But these had an unfortunate habit of recurring: his father's institutionalization weighed heavily on him, particularly as it had put even more pressure on him to fend for his family. So, being in a mood of abstinence, he decided to forswear alcohol for the rest of the trip. He later recalled how, at this stage, he enjoyed his drink and felt few consequences since he was blessed with a strong head and robust system. But the strength of the tipples he was offered on board ship and when he went ashore had alarmed him.

He was also in a quandary about his relationship with Elmo Weldon. From somewhere off Madeira, he wrote about her to Amy Hoare, feeling guilty because he felt he should have been addressing his Irish girlfriend directly. The problem was that Elmo had become besotted and was offering him an easy way forward: she had 1,300 pounds' worth of capital and was prepared to use it to fund the next stage of his career. With discussion of this topic in mind, Arthur urged Amy and her husband, who were now good family friends, to go and stay with his mother in Edinburgh over Christmas, when he was certain Waller would have left.

Since Arthur had time on his hands, he read a lot. As on his previous voyage, he had brought some Carlyle, which he greatly liked, and he also devoured Oliver Wendell Holmes's Professor books. He actually added to his library when, in lieu of a fee, he was given a magnificent scarlet and gold volume by a young French passenger suffering grievously from a tropical fever. This was *L'Atmosphère*, a meteorological treatise by the French astronomer, Camille Flammarion, known for his spiritualist views.

After reaching Fernando Po on November 27, the *Mayumba* turned for home, picking up cargoes of palm oil and other commodities in the same ports she had visited on the way south. A new passenger was Henry Highland Garnet, a dignified old black man who was traveling to Monrovia to take up his post as United States Consul in Liberia. Like many inhabitants of the country he was bound for, he was a former slave. He had become a campaigning abolitionist, with a breadth of learning that immediately endeared him to Arthur. The two men discussed the leading American historians Bancroft and Motley, the latter of whom had been the subject of a memoir by Garnet's friend Oliver Wendell Holmes a couple of years earlier. The diplomat

advised Arthur that the best way of exploring Africa was with a small unarmed party. The inhabitants did not take kindly to vast expeditions armed to the teeth. Arthur noted that this was the way of Livingstone rather than Stanley.

More detailed discussion about the developing scramble for Africa appears to have been off-limits. Both men would have been aware of the serious diplomatic squabble between Britain and U.S.-supported Liberia over the latter's incursions into Sierra Leone. But Garnet no longer had the physical constitution to deal with such matters. Monrovia proved detrimental to his failing health, and he died in harness the following year. But for Arthur the old slave-turned-diplomat provided welcome intellectual stimulation and remained long in his memory.

Otherwise the main feature of the homeward journey was a fire in the coal bunker that threatened to ignite the main cargo of oil. For a while it seemed that passengers and crew would have to abandon ship off the Portuguese coast. But such emergencies were a regular occurrence on the poorly maintained *Mayumba*, which survived this ordeal and limped back to Liverpool on January 14, 1882.

Looking back, Arthur put a remarkably positive spin on his three-month voyage. He claimed he had come back brimming with strength and self-confidence: "I was a strong full-blooded young man, full of the joy of life, with nothing of what Oliver Wendell Holmes calls "pathological piety and tuberculous virtues." I was a man among men. I walked ever among pitfalls and I thank all ministering angels that I came through, while I have a softened heart for those who did not."

But this was only part of the story. Other evidence points to a young man in mental turmoil. He himself admitted doing "a mad thing" at the old slaving port of Cape Coast Castle, now in Ghana. "In a spirit either of bravado or pure folly, I swam round the ship. . . . As I was drying myself on deck I saw the triangular black fin of a shark rise to the surface." More generally, his attitude to the African continent was confused. In two separate articles which appeared within eighteen months of his return he wrote, in one, that "you abhor [our black brothers] on first meeting them, and gradually learn to dislike them a very great deal more as you become better acquainted with them," while in the other he parroted the Garnet line, expressing his "firm belief . . . that an unarmed, unescorted Englishman could travel without let or hindrance through the length and breadth of Africa," and adding that Africans were "a quiet and inoffensive race of men, whose whole ambition is to be allowed to lead an agricultural life, unmolested and in peace."

Such disparity in Arthur's views did not suggest someone comfortable with himself. The truth is that he had disliked the oppressiveness and uncertainty of the tropics and was glad to be home. There was little uncertainty in his comment, "Better a week in the Welsh mountains with a light camera and a good companion than all the lights and shades of fever-haunted gorilla-land."

At the same time he had added immeasurably to his bank of worldly experience. For all his ambivalence about Africans, he had no doubt about the nobility of Henry Highland Garnet, who would act as a positive model for black people in stories such as "The Yellow Face." On both the *Mayumba* and the *Hope* he had picked up enough maritime know-how to buoy up several sea tales including "J. Habakuk Jephson's Statement" and "The Captain of the *Polestar*," while the business shenanigans of the African Steamship Company would be satirized between the lines in *The Firm of Girdlestone*. As he noted in a suitably nautical metaphor in his poem "Advice to a Young Author,"

> First begin
> Taking in.
> Cargo stored,
> All aboard,
> Think about
> Giving out.
> Empty ship,
> Useless trip!

Arthur was twenty-two years old and needed to get a grip on his life. But if he had imagined his problems fading on his return, he was mistaken. Hoping to clarify his professional future, he agreed to attend a family summit in London. However, this did not run according to plan—at least as far as his uncles Dicky and James were concerned. After promising him their support in any career he chose to follow, they were taken aback to learn that he had rejected the family's traditional Catholicism and was purporting to be an agnostic. To them this word was an ugly neologism coined thirteen years earlier by "Darwin's bulldog," Thomas Huxley, who was regarded as a scourge of the established moral order. Dicky took Arthur to his club, the Athenaeum, to try to talk him out of this late-Victorian heresy. But the young man stuck to his guns, arguing that it would be hypocritical of him to claim anything else.

His insistence on this point did not, as perhaps suggested, come

from a newfound closeness to Bryan Waller. Instead his pent-up anger about the doctor's position in the family ménage had erupted, and Arthur and the doctor were in the middle of a fearful row that appears to have led to blows. The reason is not clear. It may have been domestic: Waller was angling to move back to Yorkshire and take Mary Doyle and the rest of her family with him. Or it could have been related to Arthur's career. Whatever the cause, Arthur described the aftermath to his sister Lottie who had recently gone to join Annette as a governess in Portugal. (It is indicative of the pressures in Lonsdale Terrace that the unfortunate girl was still only fifteen at the time.) He told her with obvious relish how he had scared Waller so badly that the family's lodger had not set foot out of the house for over three weeks. At the end of it all, the doctor had quit Edinburgh and did not look like returning.

Arthur's bad mood was not helped by the tidings from Ireland, where Elmo had grown tired of waiting and had unceremoniously dumped him. He would not be falling in love again quickly, he assured Lottie. But at least there was better news in another area of his life. Almost at his wits' end, while in London, he had gone to visit James Hogg, who virtually single-handedly had kept Arthur's hopes of a literary career alive by publishing four of his stories in *London Society*. Hogg was "very polite and flattering," describing his young contributor as "one of the coming men of literature." Arthur offered the magazine a new piece titled "The Actor's Duel—a legend of the French stage," a farce about male rivalry set against a backdrop of the Parisian theatre, about which Arthur had fond memories. He himself thought it very amusing, particularly the scene where a Scotswoman in Paris has difficulty deciphering a letter from her wastrel son full of expressions such as "I have dropped a pony over the Cambridgeshire." But Hogg failed to find this funny, leading Arthur to declare that his "chief editorial fault [was] an utter want of sense of humour." At least Hogg had enough faith in his protégé to commission a timely tale about an April fool's prank for his forthcoming April issue. Arthur dashed off something that fitted the bill, mixing a cameo about an Australian mining community with what he described as his first real love story. Since he had thus proved himself capable of writing to order, he was asked for another topical contribution, loosely based on the Derby, which appeared in the magazine's next issue.

After what he described as "buzzing around England," he took refuge with his friends the Hoares. He could do some light work at the smaller practice Dr. Hoare ran in another part of Aston called Gravelly

Hill. But this would be little more than a sinecure, allowing Arthur to devote time to reading, writing and thinking about his future.

On the literary front he completed his stories for Hogg. He also sought to boost his medical credentials by sending a letter to *The Lancet* about the possible links between malaria and leukemia. Not for the last time, he showed his limitations as a logical thinker by suggesting, on the basis of a single case, that the one condition led to the other. But there was no doubting his interest in immunology and pathology and his commitment to conquering disease.

Always conscious of the importance of making the right career moves, he thought seriously about competing for a couple of medical prizes, which would not only help to enhance his reputation but also earn him some money. He intended writing an essay on "Listerism— a success or failure" for one of them, the Millar Prize, thinking, with a practical regard to the future, that if it was any good he could reuse it for the thesis he would have to write when he converted his current MB degree into a MD, or Doctor of Medicine.

At the same time he applied for whatever doctors' jobs were available, including a house staff position in Buenos Aires—all without success. At least, with his Birmingham friends' help, he was able to make some decisions. He would not return to sea (there was more money in writing). Nor would he work in a country practice. Instead his immediate future would be in a good hospital. As he put it, "my game is clear— observe cases minutely, improve in my profession, write to *The Lancet*, supplement my income by literature, make friends and conciliate everyone I meet, wait ten years if need be, and then, when my chance comes, be prompt and decisive in stepping into an honorary surgeonship." To this end, he applied for a job at the Queen's Hospital in Birmingham.

No sooner had he taken this step than his careful plans were thrown into turmoil when, in May, he received a telegram from his wayward former student colleague, George Budd, who was practicing in Plymouth. Arthur later recalled this as reading: "Started here last June. Colossal success. Come down by next train if possible. Plenty of room for you. Splendid opening." Arthur must have had a sense of déjà vu for, shortly before departing on the *Mayumba*, he had received a similarly breathless cable in which Budd had urged him to make haste to Bristol, the city where he was then working and where, it became clear, he had fallen into serious financial difficulties trying to maintain his father's standard of living. Asked his advice, Arthur could only suggest that his friend summon his creditors and beg their forbearance.

Budd's subsequent plea to the local tradesmen had its intended result and earned him a reprieve. Shortly afterward he had decamped to Plymouth, where his family had firmer roots. The evidence of *The Stark Munro Letters* was that he simply welched on his recently made promises in Bristol.

Given this history, Arthur was rash even to consider this latest telegram. It is further evidence of his vulnerability around this time. But he was at loose ends, his romance with Elmo was seemingly over, and Budd was offering him a chance of netting 300 pounds a year. Nothing he found on arriving in Plymouth seemed to contradict the notion that his friend had genuinely fallen on his feet. People were flocking from miles around to visit Budd's practice in Durnford Street in a working-class area close to the naval dockyard around which the economy revolved. The rogue, whom Arthur described as "half genius and half quack," had hit on the ruse of advertising free consultations. The only items his patients had to pay for were drugs, which his wife made up in a cubby hole at the end of a passage. Needless to say, Budd prescribed these in "a heroic and indiscriminate way." When his fellow medics took umbrage and spread the rumor that he was an American herbalist, he put a notice in the paper that his degree certificates were available for viewing at certain hours and thus only increased the flow of patients through his doors. As a result Budd was earning "several thousand pounds" a year and could afford a plush house at 6 Elliott Terrace, an elegant new development overlooking the Hoe where Sir Francis Drake supposedly continued lawn bowling as the Spanish armada approached.

Before long Arthur was offered a room in Durnford Street and allowed to attend to surgical cases and anything else Budd did not want. He put up a plate reading "Dr. A. Conan Doyle Surgeon," and began to see his own patients who, he reported enthusiastically to his mother, brought him in eight shillings in the first week, twenty in the second, and twenty-five in the third. He began to look forward to the future: he hoped to have his own house by September, and thereafter the possibilities were endless. He entertained the thought that if anything happened to Budd he would benefit, particularly as the professional competition in the town was useless. His only concern was the loneliness which he felt came from his lack of a permanent female partner. As he wrote elsewhere about himself at this stage, "I see more and more clearly that both men and women are incomplete, fragmentary, mutilated creatures, as long as they are single." But Ply-

mouth seemed to offer no way out; he complained to his mother that he would meet no one suitable while he was there.

He found working with the maverick Budd hilarious, leaving him exhausted with laughter. His attitude was later more circumspect, reflecting differences of opinion in his assessment of his colleague's medical methods: "I have no doubt he did a great deal of good, for there was reason and knowledge behind all that he did, but his manner of doing it was unorthodox in the extreme."

The clash of egos was not long coming. Budd claimed to have experienced a downturn in business as a result of the newcomer's arrival. In a fit of rage, he took a hammer to Arthur's plate and told him vociferously that they could no longer work together. Subsequently it emerged that Budd had another reason for his bad temper. "A man of strange suspicions and secret plottings," he had surreptitiously been reading Arthur's letters from his mother. Mary Doyle, who had known Budd as a student, had always been wary of him. She continued to regale her son in Plymouth with her misgivings, her negative tone probably affected by her distress at the recent deaths of two good friends, Mary Ryan (no relation to Arthur's school friend) and Dr. John Brown. Arthur found himself having to upbraid her, claiming that he had begun to dread the Edinburgh postmark and urging her to send him something more upbeat.

Budd soon calmed down enough to suggest that his partner should leave and set up on his own. When Arthur pleaded that he had no funds, Budd promised to give him 1 pound a week until he was established and could repay the debt. Arthur spent sleepless nights trying to decide what to do next. He toyed with the idea of taking a job as an on-call physician for vacationing doctors but decided he would not make enough money. He looked at openings in nearby Tavistock but again thought better of it.

At least his activity had provided a kiss of life to his romance with Elmo. No letters between the two of them survive, so the account of their relationship has to rely largely on Arthur's irregular updates to correspondents such as his mother. An important contributory factor was that Elmo had been seriously ill, with what appears to have been tuberculosis. Arthur had probably expressed his concern and, as a result, the affair was back on. Not only that but she, ever eager to help, had offered 100 pounds to tide him through his present difficulties, though at this stage he felt unable to take it.

Eventually concluding that, like Budd, he would prosper some-

where with a large floating population, he alighted at Portsmouth, another naval town on the south coast. By the time he boarded an Irish steamer for the short voyage there in late June, his ideas were much clearer. He would stay in lodgings for a week, find himself a centrally situated house, live cheaply without a servant and get credit from a drugs company in London used by Budd. This way he confidently expected he would be earning 1,000 pounds a year within three years. He felt he had been working for others for too long and it was not good for him. In the meantime it is true that he had to borrow 5 pounds from his mother but, as earnest of his intent, he told her categorically that he would marry Elmo if he succeeded in his new venture.

Bush Villas, Portsmouth

1882–1883

The Southsea clinic where Arthur put down roots for the next seven years was situated, appropriately, between a church and a pub. Having erected his doctor's polished brass plate, he continued his obeisance to the gods of science and modernity at No. 1 Bush Villas—a buffer, he said, between the opiates on offer on either side at the Elm Grove Pentecostal church and the Bush Hotel.

If he had expected to disembark at Portsmouth's historic naval dockyard, he was disappointed. Arriving on the morning of Saturday June 24, 1882, he set foot on Clarence Esplanade pier in Southsea, the city's salubrious suburb where sailors and soldiers parked their wives and children while abroad and where middle-class families went to take the sea air. The area around the pier was a hive of activity, as horse-drawn trams set down passengers who jostled to book tickets on the Isle of Wight ferry, which shared the same berth. In the distance a band played lustily as a regiment decked out in splendid white sun hats marched to join a ship bound for the Mediterranean and the unfolding campaign in Egypt. Elsewhere the town was *en fête* for a summer weekend: women in large floral hats and flowing crinoline dresses clutched parasols as they strolled along the pathways of Southsea Common, attended by gentlemen in boaters.

Arthur was overdressed in his heavy tweed suit, which looked all the more inappropriate because he had put on extra weight and was tipping the scales at 217 pounds. Leaving his baggage at the pier, he went in search of temporary accommodation, as envisaged in his carefully conceived plans. Having found what he wanted in the old town, he beat the rent down from thirteen shillings to ten shillings and sixpence

a week, before returning to pick up his leather trunk and other impedimenta. Then, with every penny counting, he paid a porter eight-pence to carry his belongings to his new lodgings, thus saving himself an additional fourpence on the price of a cab.

He recalled much of his life around this time in *The Stark Munro Letters*, published in 1895. The dangers of taking this source too literally are evident from his description of his first evening in "Birchespool." In the book he (as his alter ego Dr. J. Stark Munro) goes to a local park (almost certainly Victoria Park) to relax and listen to a band. On his journey back to his lodgings, his nocturnal reveries are disturbed by the sight of a drunken man assaulting a woman. Reluctantly, he engages the ruffian in a fight, before someone else in the crowd joins the fray and he is able to walk away unscathed. However in a letter to his mother he described a different incident on Coronation night (June 28, or four days after his arrival) when, to the delight of a raucous crowd, he had tackled a tinker who had been beating his wife. Arthur saw this encounter as a fine advertisement for his services.

Nevertheless *The Stark Munro Letters* give a workable account of his subsequent movements. He went to the post office and bought a large shilling map of the town. He then walked around, charting the locations of empty houses and doctors' clinics. By this process he alighted on No. 1 Bush Villas in Elm Grove, at a point where the comfortable residences of the local bourgeoisie met the brash shopping streets where they made their money. He bypassed having to provide a reference by giving the name of his Dublin-based uncle Henry, whose respectability was beyond question since he had been made a Companion of the Bath a couple of years earlier. He just managed to raise the rent money of 10 pounds a quarter (with an extra 2 pounds 10 shillings in taxes). After taking the keys, he "proceeded to go from room to room with a delicious sense of exploration. There were two upon the ground floor, sixteen feet square each, and I saw with satisfaction that the wall papers were in fair condition. The front room would make a consulting room, the other a waiting room. . . . Then down a winding wooden stair to the basement, where were kitchen and scullery, dimly lit, and asphalt-floored." When he entered the latter he experienced a great shock, for in every corner he saw piles of human jaws grinning at him. "The place was a Golgotha! In that half light the effect was sepulchral. But as I approached and picked up one of them the mystery vanished. They were of plaster-of-Paris, and were the leavings evidently of the dentist, who had been the last tenant . . . Then I ascended again and went up the first flight of stairs. There were two

other good sized apartments there. One should be my bedroom and the other a spare room. And then another flight with two more. One for the servant when I had one, and the other for a guest."

This tallies with the room plan he gave his mother. According to the 1881 census, a recent tenant had indeed been a dentist. And if those details are correct, his later account of what happened next should not be dismissed. *The Stark Munro Letters* paints a picture of something close to a mystical experience. On a gusty day, the narrator is peering out through a filthy window when "a sudden sense of my own individuality and of my own responsibility to some higher power came upon me, with a vividness which was overpowering. Here was a new chapter of my life about to be opened. What was to be the end of it? I had strength, I had gifts. What was I going to do with them? All the world, the street, the cabs, the houses, seemed to fall away, and the mite of a figure and the unspeakable Guide of the Universe were for an instant face to face." He falls to his knees, but can think of nothing to say: every prayer that comes to his head is based on the idea of a God who needs praising. His is a much more pragmatic attitude to religion: "Should the cog of the wheel creak praise to the Engineer? Let it rather cog harder and creak less."

This was Arthur's language a dozen years later when he wrote *The Stark Munro Letters*. But it gives an insight into his spiritual orientation when he arrived in Portsmouth—part deism, part self-help, couched in a clunking mechanistic idiom. Determined to brook no delay, his next move was to place an announcement in the *Portsmouth Evening News* which ran on Saturday July 1, exactly a week after his arrival, and again on the following Monday and Tuesday, stating: "Dr. Doyle begs to notify that he has removed to 1, Bush Villas, Elm Grove, next the Bush Hotel."

If he thought this was going to bring patients rushing through his door, he was mistaken. His first few weeks on his own were lonely and difficult. At first he had no takers at all and he could only look sadly out of his window and count the number of people who stopped in front of his door to read his plate—twenty-four in fifteen minutes one evening, twenty-eight in twenty-five the next. Supposing an average of one potential patient a minute during working hours, that meant 2,880 a week, he forlornly calculated. But this headcount was only notional: his youthful zeal or obsessive behavior (depending on one's point of view) was confirmed by his practice, late at night, when nobody was around, of slipping outside and polishing the beloved brass plate on which his future depended.

Initially this indicated he was offering free consultations from 10 A.M. to 1 p.m. on Mondays, Wednesdays and Fridays. But when this ploy, which he had copied from Budd, failed to attract large numbers, he accepted the advice of Dr. William Pike, another Edinburgh-trained GP practicing in Elm Grove, who told him he had got his psychology wrong: the gentrification of Southsea had created proud and independent citizens who did not want to be seen accepting charity.

His priority was to make ready one main consulting room. A sale in Portsea provided the basic furniture—a table, three chairs and a tacky piece of carpet. His mother added further accoutrements, as well as small gifts of money when she could afford them. Receipt of an overdue payment from *London Society* allowed Arthur to splash out 11 pounds 14 shillings on medicines from wholesale suppliers—a substantial outlay, he admitted, but, given the generous credit terms, more cost-effective than buying drugs piecemeal from local chemists. There was no spare cash, however, to install gas lighting, so for a while he made do with candles and, until his mother sent some blankets, he slept in his ulster overcoat. He later spent 1 pound 14 shillings on a new brass plate that made no off-putting references to free consultations. But it was a while before he was able to complete his ideal surgery by purchasing a doctor's red lamp to hang outside it.

Unsurprisingly Budd was no help, sending only one of his promised weekly payments of 1 pound before revealing something he had apparently not mentioned before—his anger at the derogatory references to him in Mary Doyle's letters to his former partner. Naively unaware of this until now, Arthur experienced a fit of paranoia in which he thought that his old friend had deliberately set him up to fail in Portsmouth, and thus besmirch his name and somehow get back at him and his mother.

Inactivity and a touch of depression accentuated Arthur's loneliness. Ideally he would have liked his sister Lottie to keep house for him. But she was in Portugal, so he inquired if fourteen-year-old Connie, who had just taken her first Communion at St. Margaret's Convent in Edinburgh, might be willing. When this was vetoed, he asked for his brother Innes, who was only nine. He promised to feed him well and teach him more than he would ever learn at school.

It was a measure of Mary Doyle's love for Arthur that she agreed. Not everyone would regard lodging with a penniless doctor as an ideal upbringing. But Arthur had been sent away when only seven. Mary probably decided it was better for Innes to enjoy his brother's bluff male company than experience the continuing pressures and

uncertainties at home in Edinburgh. Besides she herself was off to Ireland, hoping to resolve an unsettling family dispute over a legacy. By July 10, Innes was down in Portsmouth where he was soon entranced by never-ending military and naval displays, pronouncing it his favorite place ever.

With unwanted time on his hands, Arthur was able to consider the writing career he now saw as vital to his financial well-being. He must have known the local literary connections. Charles Dickens, Sir Walter Besant and George Meredith had all been born in Portsmouth. The previous decade a young child from India called Rudyard Kipling had spent a few miserable years with foster parents in nearby Campbell Road. And at that very moment H.G. Wells was working in Hyde's drapery store in King's Road, Southsea.

All these skilled writers showed (or were to show) the importance of knowing one's market. So Arthur immersed himself in reading different types of modern popular fiction, searching for tips on how to reach a wider audience. One novel he enjoyed was *Asphodel* by Mary Elizabeth Braddon, who had gained notoriety with her penny-dreadful stories a quarter of a century earlier. She had subsequently edited *Belgravia* magazine and now contributed to *All the Year Round*, the literary journal founded by Charles Dickens and known for serializing the kind of "sensation novels" she and Wilkie Collins wrote.

He then put this knowledge to good use. While waiting for patients to arrive, he penned a series of deftly observed stories in a flowing, girlishly rounded hand. His subject matter was colorful, his approach populist, and he was not deterred when his efforts were frequently returned by editors. He drew heart from the experience of one of his literary heroes, James Payn, who had once had twenty-two contributions rejected in one year, before becoming "facile princeps" (easily first) in his trade of writing short stories for the educated mass market.

One area where Arthur looked for sensational material was the supernatural. This was his birthright since Scotland had a fine tradition of Gothic storytelling from Walter Scott to Robert Louis Stevenson— a measure of its educated, mainly Protestant, elite's folk memories of alternative states of consciousness in the Highlands. This was now complemented by a more universal cultural trend—a craving for evidence of spiritual activity and life after death that had come with the decline of organized religion. Starting with the Fox sisters in America in the late 1840s, a flurry of mediums and spiritualists had appeared to meet this need. Evidence of the powers of mind over matter in displays of table-rapping and levitation had run parallel with experi-

ments in medicine and psychology where the possibilities of hypnotism and mesmerism had an enduring appeal. At the start of the year a group of mainly Cambridge-based scientists had set up the Society for Psychical Research to investigate "obscure phenomena . . . at present on the outskirts of our organized knowledge," including thought-reading, clairvoyance, haunted houses and apparitions at the moment of death. This was fascinating for an aspiring young writer with medical training and an interest in a synthesis between reason and faith. He did not understand much of the background of spiritualism and the SPR at this stage, but that would not prevent him, in his opportunistic way, from using the subject matter in his stories.

One example, "The Winning Shot," which he first referred to in July 1882, did the rounds of a couple of second-rate periodicals, *Temple Bar* and *London Society*, before being published a year later in *Bow Bells*. Drawing on his recent experiences of the West Country, this mysterious tale anticipated *The Hound of the Baskervilles* in its vivid descriptions of "the great wilderness of Dartmoor," where young Lottie Underwood and her fiancé Charley Pillar come across Dr. Octavius Gaster, a Swedish traveler to whom they offer a place to stay. Subsequently the foreigner turns unpleasant, working a sinister mesmeric effect on his hosts, which culminates in his presence at a rifle match where Pillar is unable to shoot because, eerily, he sees his own image directly in front of him. When he finally discharges his gun, he hits the bull and wins the contest. But immediately afterward he keels over and dies. The implication is that Gaster has used supernatural powers to transport the young man into the line of fire and to have him killed.

Arthur's interest in the paranormal was evident from Gaster's comment on a book he is reading. "It treats of the days when mind was stronger than what you call matter, when great spirits lived that were able to exist without these coarse bodies of ours, and could mould all things to their so-powerful wills." When challenged about such ideas, he says, "Who that has read Steinberg's book upon the spirits, or that by the eminent American, Madame Crowe, can doubt it? Did not Gustav von Spee meet his brother Leopold in the streets of Strasbourg, the same brother having been drowned three months before in the Pacific? Did not Home, the spiritualist, in open daylight, float above the housetops of Paris? Who has not heard the voices of the dead around him?"

In referring to such issues and dropping such names, Arthur was simply trying to grab his readers. He was intrigued by the supernatural, but his understanding remained limited. Daniel Dunglas Home, an

American originally from Currie, near Edinburgh, had been one of the first celebrity mediums to arouse an interest in spiritualism a quarter of a century earlier. If Arthur had known more, he might have mentioned Home's most famous demonstration which took place not in Paris but in London in 1868 when he levitated above Lord Adare's house. Home's apparent ability to contact the dead incurred both curiosity and hostility since it challenged blessed Victorian rationality. Typical of the scientific response was that of Sir David Brewster, the practical Edinburgh University Rector before Arthur's day, who first welcomed and then, after investigation, dismissed Home's abilities.

Arthur had been expecting to be paid 7 pounds by *London Society* for "The Winning Shot," so he must have been disappointed with the fee of three guineas he eventually received from *Bow Bells*. More down-to-earth, but equally gripping, was his story "That Veteran" which was quickly snapped up by *All the Year Round* after being rejected by *Belgravia*. Prefaced by an odd anti-Celtic diatribe, this told of a meeting in a Welsh inn with a ragged man who recounts plausible stories of his life as a soldier. However, having drifted off into sleep, the narrator wakes to find he has been relieved of his money and watch after his drink has been spiked with laudanum (tincture of opium). Once more Arthur had to make do with a lower fee than anticipated— 2 pounds 10 shillings rather than three guineas.

Returning to a supernatural theme, he also wrote "The Captain of the *Polestar*" which pitted a rational medical student against the unhinged captain and superstitious crew of a whaler in a powerful story about the clash of reason and the paranormal in the "white desert" of Arctic icebergs. Once more Arthur drew on his personal experience and once more he dealt with spiritualism, recalling his own skepticism at the time of the *Hope* voyage in his fictional student's joking comments to the ship's captain about "the impostures of Slade."

This time Arthur was referring to Henry Slade, another American medium whose exploits epitomized the rackety world of nineteenth-century spiritualism. For some time sensitives had claimed to receive messages from the dead through an elaborate process of tapping letters alphabetically. Slade speeded this up by making contact with spirits through automatic writing, which appeared on a slate he held. When he came to Britain in 1876 he convinced several eminent scientists, including Alfred Russel Wallace, a proponent of evolution who was sympathetic to spiritualism. But E. Ray Lankester, a young professor of zoology, was more skeptical. During a demonstration of this new technique, he snatched away Slade's slate before any communica-

tion had taken place and found that it was already filled with writing. Slade was arrested and prosecuted under the 1824 Vagrancy Act aimed at itinerant fortune-tellers. With the help of defense witnesses such as Wallace, he avoided his sentence of three months' hard labor on a technicality. Threatened with a private prosecution by Lankester, he left the country for Germany where he was much fêted. Lankester was supported in his suspicions by several other scientists, including Henry Sidgwick and Edmund Gurney, two of the founders of the Society for Psychical Research.

During these productive early months in Portsmouth, Arthur also contributed to the *British Journal of Photography* and wrote pieces that have not survived, such as "Our Confidential Column," which he sent to *Punch*, and "How my Carotid Artery was tied," that was returned by *Chambers's Journal*, the Edinburgh outlet which had published his "The Mystery of Sasassa Valley."

Amid professional anxieties and literary industry, his other main concern was more personal—his increasingly complicated affair with Elmo. His mother had been inadvertently dragged into the matter after receiving an anonymous letter from Ireland which took her to task over her son's behavior to the girl. She had never been particularly keen on Arthur marrying Elmo. But the relationship had an unhappy dynamic of its own. Arthur's latest position was that he could not marry Elmo so long as his income was so insecure. So he suggested that she should spend the winter with relations in Ventnor on the Isle of Wight where they could see more of each other. For a while, as a token of his love, he even adopted the name Bellevue for Bush Villas.

Events took a dramatic turn shortly afterward when her aged aunt died and Elmo was (or soon would be) in receipt of her fortune. Coincidentally Arthur heard through a family contact of an opening for a doctor on a tea estate in Sylhet in the Indian state of Assam. Since this would come with a decent salary, he saw an opportunity to cement his relationship with Elmo, declaring that, as a "tropical plant," she would benefit from a spell in a warm climate. As it was, she went to consult doctors in Switzerland where she was relieved to learn that she did not have tuberculosis (Arthur was not so sure). On her way back she seems to have met Arthur, who escorted her to Gilbert and Sullivan's operetta *Patience*. But he had not seen her for over a year and the magic that surrounded her in County Waterford was no longer there. By October he had bowed to the wishes of his mother and confidantes such as Amy Hoare, and had ended the affair. He admitted to Amy that this would be a blow to Elmo but, no doubt trying to reassure himself,

he added that there was no danger of his ever falling for any other woman.

His former fiancée had won the hearts of all who had met her, he said. A friend had even described her as having the most perfect face she had ever seen. But, commented Arthur, indicating the sort of Scottish melodrama he liked to read, "Her soul is prettier than her body though. She is as like Sheila in *A Princess of Thule*—the best heroine in modern fiction I think, as it is possible to be." Significantly, in William Black's novel the artist Lavender had described Sheila as "a beautiful wild seabird" while she was in Scotland. But back in the familiar environs of London, "he did not wish to gain the reputation of having married an oddity."

All these developments had taken place within three and a half months of his arriving in Portsmouth. After this excitement, it was a relief when patients started trickling through his door. Arthur used every ruse he could imagine to maximize their numbers. When someone was thrown from a horse outside his house he went out, scooped up the injured man, took him inside, treated him, and then rushed down to the offices of the *Evening News* to ensure that a report of his successful intervention was published, with his name prominently displayed. He inherited a health club from a drunken doctor who had disappeared. As he explained to Dr. Hoare, he was not sure of the rules, though so far as he could make out, all the members paid a halfpenny a week, which entitled them to as much medicine as they liked. Further income came from whatever cases a friendly dentist across the road could steer his way and from insurance cases he examined for the Gresham Life Assurance Company, earning him a guaranteed 6 pounds every month. As he methodically detailed to his mother, his monthly takings increased from next to nothing in the autumn of 1882 to five pounds 18 shillings and sixpence in December and 13 pounds 17 shillings and fourpence in March 1883. By July he could say that his first year's income had amounted to exactly 156 pounds 2 shillings and fourpence, which included about 30 pounds from his mother and 42 pounds from his literary efforts. A year later this total had risen to 260 pounds.

With money at last coming in, he could begin welcoming visitors. In the autumn Dr. Hoare had already been to stay, followed at Christmas by "the Mam" who pronounced Bush Villas a "jolly place." (As she had grown older, she was occasionally accorded the dignity of a definite article.) Buoyed by the sale of "The Captain of the *Polestar*" to *Temple Bar*, Arthur was able in the new year to send Innes to school as a day

boy at Hope House, a feeder for the Armed Forces, where Rudyard Kipling had preceded him a dozen years earlier.

He also had more time for recreations. In March 1883 Willie Burton and a friend called Davies traveled down to spend Easter with him. The three men went on a local photography expedition which Arthur wrote up in jaunty style for the *British Journal of Photography*. Having already expanded on Burton's new technique for emulsifying his photographic plates, he now turned the tables and looked into the medicinal properties of pyrogallic acid, which his friend used as a developer. As with his earlier study on gelseminum, Arthur tested it on himself before writing up his findings for *The Lancet* (or so he claimed to his mother, though there is no evidence that the piece was published).

By the spring Arthur was finally getting over his break-up from Elmo. He told Charlotte Drummond that it had all been traumatic at the time, but he now understood they would have been incompatible. As evidence of his new-found freedom, he attended a ball in April when, by his own admission, he got "as drunk as an owl." He told Lottie he had a dim recollection of proposing to half the women in the room, no matter if they were married or single. "I got one letter next day signed "Ruby" and saying the writer had said 'yes' when she meant 'no'—but who the deuce she was or what she had said 'yes' about I can't conceive."

By then some resolution had been reached in a family dispute over money. His mother had ended up 130 pounds the richer, with the expectation of a further 50 pounds to come. But he informed Lottie in Portugal that the argument had left bad feelings in London, where, uncharacteristically, he lambasted the intelligence of the male Doyles.

Despite his relief at such signs of improvement, the previous nine months had taken their toll. As he told his mother, he had recently been in a low state, with all sorts of ailments, including his neuralgia. He had been experiencing bad dreams that left him feeling strangely unrested.

In this respect, his well-being was not helped by his furious literary output. "J. Habakuk Jephson's Statement" was an idiosyncratic fiction based on the real-life mystery of the ocean-going brigantine the *Mary Celeste,* which in December 1872 had turned up off Gibraltar with no sign of its crew. Arthur showed his customary carelessness in getting both the date of the incident and the name of the vessel wrong. But there was no doubting the power of a story that introduced an element

of voodoo into a drama about a crazed, half-caste American, bent on revenge on the white race, taking control of the ship and steering it to a West African port where he wants to be king. Jephson's life is saved by his stone amulet, which is revered by the Africans. Arthur's villain, the half-black mutineer Septimus Goring, has none of the nobility of the abolitionist Henry Highland Garnet whom he had met only eighteen months earlier. But the story attracted the attention of James Payn, who had recently taken over as editor of London's most influential literary magazine, the *Cornhill*, alma mater to Thackeray, Trollope and George Eliot. To Arthur's delight, Payn was prepared to pay the magnificent sum of twenty-nine guineas for the piece.

With this foray into animalistic magic following soon after his references to Home and Slade, there was no doubting one area of Arthur's interests. But that did not mean he believed in spiritualism or was anything other than a skeptic applying his reason to matters he did not understand. As far as he was concerned "The Captain of the *Polestar*" was only a ghost story—a more sensational literary equivalent of the fairy paintings that had formed much of his uncle Dicky's recent output.

To the outside world, Arthur was happy to be seen as the scourge of organized religion, railing against "so-called Christianity" in a letter to the local paper. Otherwise he presented himself as a scrupulous advocate of modern science: for example, in a piece on advances in bacteriology. This took a populist approach, using the science fiction image of a man reduced to the size of less than a thousandth of an inch so he could travel through the bloodstream. It paid homage to pioneers in the field such as Louis Pasteur and Robert Koch, and strongly promoted the advantages of vaccination.

His interventionism did not stop in the laboratory or clinic. He was not afraid to court controversy in an article on the Contagious Diseases Act in the *Daily Telegraph*. Drawing on his experience of a garrison town and port, he argued that prostitution should be strictly controlled. In particular he supported the measures of the 1864 Act allowing for prostitutes to be picked up, inspected for sexual diseases and, if necessary, kept in locked hospitals until cured. In this respect he found himself ranged against a new generation of feminists who thought such regulations draconian and demeaning to women (and indeed they were repealed in 1886). But Arthur was delighted at the minor controversy he had caused and looked forward to follow-up articles in *The Lancet* and *British Medical Journal*.

His wariness about the way pseudo-science was used to support

paranormal fads was evident in his contribution to a heated exchange in the *British Journal of Photography*. As the weekly mouthpiece for aficionados of what was still a relatively new technique linking science and art, this magazine acted as a valuable litmus test for the intellectual vagaries of the time. On its pages one could turn from W.K. Burton on a variety of technical developments to another writer on spirit photography or "The Photographing of Reichenbach's Magnetic Flames." (As explained in the magazine, these were feeble flames that sensitives claimed to see emanating from magnets. Described by Baron Carl von Reichenbach in Vienna in the 1840s, they were seized on as proof by advocates of animal magnetism.)

W. Harding Warner had written to the *BJP* on July 13 advancing the extraordinary theory of an energy to which "scientific men . . . had given the name of 'Od.'" Apparently related to color, this force could be photographed, showing that "in certain conditions of body each one of us have radiating from us a halo of light in greater or lesser proportion, varying in intensity according to our health and to the purity and impurity of our bodies." The very next week Arthur replied to this mishmash of ideas in a state of some indignation. "Will Mr. Harding Warner consent to throw a 'photosphere or luminous halo' round this Delphic utterance of his? . . . From so-called facts he draws inferences which, even if they were facts indeed, would be illogical, and upon these illogical inferences draws deductions which, once more, no amount of concession would render tenable." Arthur challenged all Warner's claims, including that of a force known as "Od." "Can it be that the comprehensive syllable of the Hindoos, 'Om' (if I remember right) is running in the gentleman's mind?"

Warner returned to the fray in the following issue: "It is very plain to those few who understand about the new psychic force, 'Od,' that there are some men of science who know little or nothing of the laws of nature, and when something is stated that is beyond their power of comprehension, they turn it into ridicule and thus expose themselves as to their want of knowledge of occult science." Forty years later, Arthur would make very similar statements. For the time being, however, he steered clear of such mumbo-jumbo and was, no doubt, unconcerned about being ridiculed for failings as an occult scientist.

Instead he channeled his inquiries on this type of issue into his remarkable treatise "The Narrative of John Smith." He later claimed that this book, often described as a novel, had been lost in the mail. More likely, he discarded and tried to forget it because, under the figleaf of fiction, it was little more than a palimpsest for interesting

ideas. He mentioned it a couple of times in his letters, once towards the end of 1883 when he claimed to be rewriting it, and again in early 1884 when he said it was half-written. On the latter occasion he described it as a "political squib," but his adjective was misplaced: it was more philosophical and ideological.

The book was a dialogue between John Smith, a well-traveled fifty-year-old bachelor, and his doctor, with interventions from other characters who live around a house very similar to Bush Villas. Everyone involved seems to be a vehicle for Arthur's current obsessions. He starts with typical ruminations on the nature of medicine and literature, affirming that the test of a novel is not its morality but its ability to interest a reader. He waxes lyrical on the wonders of biology, with each cell having the potential to be a separate entity, and decries the evils of disease, which he is happy to report are being conquered by an obvious hero, Louis Pasteur. With the lot of the human race improving, a future is emerging when man "will navigate the air with the same ease and certainty with which he now does the water," war will be abolished, and "the forms of religion will be abandoned but the essence maintained so that one universal creed will embrace the whole earth which shall preach reverence to the great Creator and the pursuit of virtue, not from any hope of reward or fear of punishment, but from a high and noble love of the right and hatred of the wrong."

Through Smith, in particular, Arthur hurls his accustomed brickbats at organized religion, berates small-minded scientists, and heralds a new age of spiritual enlightenment, about which he quotes Emerson: "A correspondent revolution in things will attend the influx of the spirit. The kingdom of man over nature he shall enter without more wonder than the blind man feels who is gradually restored to perfect sight."

Arthur was typically wayward in his quotation from Emerson's 1836 essay *Nature*. But there was no mistaking his continuing debt to American transcendentalism and its central tenet that there is a discoverable world of the spirit beyond the intellect. The manner in which he regularly rejiggered "The Narrative of John Smith" shows he regarded these as ideas in progress. He may even have sent the manuscript to the publisher Routledge. But nothing appeared in print and Arthur was able to draw on this prototype in later years, notably in *The Stark Munro Letters*, but also in his Sherlock Holmes stories, which include several concepts first set forth in "John Smith."

Now that it was summer he was able to get away from his clinic and make the most of the seasonal good weather. Hoping to expand his

social contacts, he joined the local lawn bowling club where his friend, George Barnden, Superintendent of the Portsmouth branch of the Gresham Assurance Company, was a member. He also played five matches for the Portsmouth cricket club, scoring 62 runs at a modest average of 12.4 per innings.

Despite having engaged a reliable housekeeper called Mrs. Smith, Arthur was aware of moving in a very masculine environment, as he remarked to Jessie Drummond, the daughter of his mother's friend. When invited to a dance he found that, despite Jessie's tutelage, he had forgotten how to waltz. So he resolved to join the Masonic at-home parties in the winter. For the modest sum of 2 shillings sixpence he bought a ticket that entitled him to two balls, two further nights of revelry with a 3 A.M. curfew, and a party once a fortnight extending till midnight.

Such frivolous activities were fine but, as a serious-minded young man looking for answers to pressing questions about the nature of science, philosophy and religion, he could not ignore more cerebral pastimes. So in November 1883 he joined the Portsmouth Literary and Scientific Society, the local equivalent of the Edinburgh group that had played such an important role in his mother's intellectual development. It is likely that he had already been there as a guest and had impressed the members for, within a month, he was being asked to give a lecture.

He realized this was a great promotional opportunity. After some deliberation, he had recently invested in notepaper with the Doyle crest, "Patientia Vincit." Now he called on Charlotte Drummond, firmly established as another of his surrogate Mams, in Edinburgh to help him make a fashion statement by making him a new shirt (he thoughtfully sent her a length of silk with his waist measurement). With the help of an ebony and silver crutch stick that he had won in a competition, he declared himself a proper dandy.

On December 4 he attracted an audience of around 250 people to his talk on his Arctic travels. With an eye to presentation and effect, he complemented his words with some visual props—a selection of twenty birds from the frozen north that he and a friend called George Palmer had gathered from a local taxidermist's. Arthur described the evening to his mother as very successful, emphasizing the number of people who had stood up to congratulate him.

The president of the Society, Major-General Alfred Drayson, had recently retired to Southsea after a distinguished military career that had taken him to South Africa, India and Canada. A stout figure with

a receding hairline and long walrus mustache, he had served as a surveyor in the Royal Artillery and as a professor at the Royal Military Academy in Woolwich. He had also written extensively—a mixture of travel books, sporting manuals, adventure stories for boys and treatises relating to his professional activities, including the accepted textbook on military surveying and a number of works on astronomy, where he was known for his unorthodox views.

In many respects Drayson was a typical bluff ex-soldier—uncompromising in his opinions, whether advocating cold baths for young men or advancing his pet theory that the earth made two rotations each day. He was also a committed spiritualist who, as one of the first members of the SPR, had a deep interest in proper scientific research into the paranormal. The fact that Arthur met him at this stage, just as he was becoming aware of these areas, was a case of synchronicity almost worthy of the Society's investigation. Having been impressed by the general's practical experience, the young doctor was soon to imbibe the older man's wisdom on more esoteric matters.

Marriage and *A Study in Scarlet*

1884–1886

At the start of 1884, twenty-four-year-old Arthur had more mundane concerns. He was confined to bed in Bush Villas with a bladder infection and only wanted to pamper himself. He told his mother that he was suffering from a recurrence of an old African fever. Always ready to look on the positive side, he added that he was lying like a pasha, surrounded by books, pencils and papers. That way he found he could write much more fluently. Indeed he worried that if he pursued a literary career he would spend all his time in bed since his ideas seemed to come much easier there.

It was hardly surprising he was worn down. For eighteen months he had been toiling to launch the medical career on which his family's fortunes as well as his own depended. At the same time, he had been setting up a home, trying to make his mark in literary circles, disengaging from a romance and wrestling with pressing questions about the nature of knowledge and belief in modern society.

By March he had recovered and was back in harness, hoping to pick up some well-paid medical insurance cases to make up for any shortfall in his income. He could now admit to "the Mam" that, at one stage, his recent illness had turned very unpleasant and he had been comforted by the thought that his heirs might at least benefit from his demise, as his life was insured for 1,100 pounds.

His mother had been one of his main concerns. For, the previous summer, she had decided to leave Edinburgh and move with her remaining children to a cottage on Bryan Waller's Masongill estate in North Yorkshire. Her motives are difficult to assess since no documentary evidence of this important relocation has survived what appears to

have been a careful weeding of her papers. Still only forty-six, she was certainly capable of starting a new life, even if the remote countryside was very different from Edinburgh. At Masongill Cottage she would not have to pay any rent. She could be refreshingly anonymous, far removed from the distressing associations of her husband's alcoholism. Waller had a special place in her affections and, even if they were not lovers, they shared literary and historical interests. With his help she could reinvent herself as an English gentlewoman, even being prepared to change her religion. This meant casting off the Roman Catholicism that her mother had adopted through marriage, and rediscovering the Protestantism of her dashing Pack forebears. Before long she had become a devout Anglican, worshipping at the church of St. Oswald in Thornton in Lonsdale.

Arthur was coming to terms with this development when, on December 11, his favorite uncle Dicky died after "a fit" in the hall of the Athenaeum Club. When the *Daily News* failed to mention his name in its list of mourners at the funeral, someone, perhaps the young doctor himself, prevailed on the paper to make amends a couple of days later. Although Dicky died without leaving much money, Arthur would soon share in the proceeds of the publication of his uncle's boyhood journal and of an exhibition at the Grosvenor Gallery.

Bush Villas benefited from some furniture from the house Dicky had shared with Aunt Annette in Earls Court. Arthur's consulting room was beginning to look quite opulent, with sixteen paintings on its walls, including nine by his father. As a result, it could not accommodate a new bookcase which had to be put in the dining-room and which was filled with a selection of venerable volumes, strong on the eighteenth century with Boswell, Johnson and Pope.

With a degree of smugness he told his mother around this time that he had much to feel satisfied about. He had furnished his house in a decent manner and was not in debt for it. His name was more widely known and respected than that of many men who had been in Portsmouth much longer. And he could not help observing that his local friends seemed stuck in the same rut.

On the literary front it was much the same story. He felt he had achieved a significant breakthrough with the publication of "J. Habakuk Jephson's Statement" in the *Cornhill Magazine* in January 1884. He was not sure what was more satisfying—the prestige of this particular outlet, the reaction he got (the piece was widely regarded as a true account of the last voyage of the *Mary Celeste*), or the positive critical response from papers such as the *Illustrated London News* which

traced a line from Edgar Allan Poe's nautical adventure *The Narrative of Arthur Gordon Pym of Nantucket* and suggested the story might even have been written anonymously by Robert Louis Stevenson. This was a heady comparison for Arthur, since Stevenson, a stalwart of the *Cornhill*, was another of his literary heroes, and all the more so for his range which stretched from traditional romantic adventures, such as *Treasure Island*, published only a few months earlier, to edge-of-one's-seat horror stories, which he described as his "crawlers."

Arthur's sense of being on the cusp of recognition had been boosted by an invitation to the *Cornhill*'s end-of-year dinner in the "Ship Tavern," Greenwich. The magazine was experiencing a change of direction after its long-term editor Leslie Stephen had moved sideways to take the helm of the new *Dictionary of National Biography*, which was owned by the same enterprising publisher, Smith, Elder. His successor James Payn was determined to make the magazine more popular. This meant reducing both size and price (from a shilling to sixpence), beefing up the illustrations and hiring younger writers, such as Arthur.

Payn, a tall, thin Old Etonian with twinkling eyes and a high-pitched voice, complimented Arthur on his story which he said he had assigned to his best artist, William Small (the start of an important relationship between the writer and his illustrators). Arthur was thrilled to hobnob with twenty-five writers and artists including Grant Allen, who was making the difficult transition from academic science writer to popular novelist, George du Maurier, who would later cause a sensation with *Trilby*, his novel about hypnotism; and F. Anstey, author of the recent bestseller *Vice Versa*. Arthur traveled back into central London with Anstey whom he left, very drunk, on the steps of the Adelphi, before making his own way to stay with Willie Burton.

Though his writing career was still in its infancy, Arthur's self-confidence was such that he was already considering an edition of his collected works. An indication of his true attitude to the occult—still more of a literary construct than a lived experience—came in his proposed title, "Twilight Tales," which, he said, appealed to him because it implied something of the shadowy borderland between the real world and what lay beyond. It was clear he wanted to take an informed modern approach to that nebulous line between fantasy and reality that had been explored in so many different ways, from the Celtic romanticism of Walter Scott to the wispy fairy paintings produced much closer to home by his father and uncle.

Given Arthur's high hopes at the start of the year, the end result of his literary endeavors in 1884 was disappointing. His only success was "John Barrington Cowles" in *Cassell's Saturday Journal* in April. One of his few stories to draw on his Edinburgh University days, this capitalized on his interest in the paranormal, telling of a promising student who falls in love with a cold but beautiful woman with sinister mesmeric powers. His friend, the narrator, discovers that she comes from an exotic background, her father being a former Indian army officer with a reputation for the evil eye and, in particular, for having "theories of the human will and of the effect of mind upon matter." In a dramatic scene, she pits her innate abilities against Dr. Messinger, billed as "the well-known medium and mesmerist," but in fact no more than an entertainer giving a stage show in animal magnetism, as was fashionable at the time. Inevitably, after falling under her malignant spell the student follows the fate of two of her former lovers, loses his mind, and dies. In the context of Arthur's life, the story was intriguing for a couple of underlying assumptions: on the one hand it hinted at his own worries about inheriting his father's less noble traits (these were the concerns of a doctor schooled in Darwinism) and on the other it reflected a widespread prejudice—that India or, more generally, the wider world being opened up by the empire, was a source of occult powers that had been lost in the modern age of science and reason.

Otherwise Arthur managed to place a few slight pieces, but not in the outlets he wanted. In particular, hoping to capitalize on his promising entrée at the *Cornhill*, he had sent Payn a couple of well-constructed stories—"Alexis von Baumgarten's Experiment," which, with further nods towards mesmerism and spiritualism, was his most ambitious attempt yet to address questions of mind over matter, and "The Fate of the *Evangeline*," a thriller that made the most of its colorful maritime and Scottish locations. He stated defiantly that since the editor had complimented him on his talent, he would show that he was also prepared to apply himself. But both stories were rejected, causing Arthur unusually to moan towards the end of the year about his recent run of bad luck. He repackaged the former story as "The Great Kleinplatz Experiment," which eventually won favor with the *Belgravia* magazine, while the latter found a berth in *Boy's Own Paper*, which had often published General Drayson.

A man of his drive and ambition was not easily deterred by temporary setbacks, however. He threw himself into reading more widely and experimenting with different forms of fiction. "The Fate of the *Evangeline*" revealed a taste for detective stories when it mentioned Edgar

Allan Poe's fictional sleuth Auguste Dupin, quoting approvingly his dictum (which would later be identified with Sherlock Holmes), "Exclude the impossible, and what is left, however improbable, must be the truth." Arthur also tried his hand at a full-fledged medical story, "Crabbe's Practice," which drew on his time with George Budd and was published in the Christmas 1884 issue of *Boy's Own Paper*. His most ambitious literary project, however, was a novel. Having abandoned "The Narrative of John Smith," he turned his attention to *The Firm of Girdlestone*, a picaresque account of the life and loves of an Edinburgh medical graduate working for a venal London trading house. But though he started this in early 1884, it did not take off and he was never happy with it. As he explained to his sister Lottie, he had so many irons in the fire that he found it difficult to get any of them red-hot. So the novel received only sporadic attention, as it moved irregularly toward completion in November of the following year. Thereafter it failed to arouse any publisher's interest until 1890—after he had enjoyed literary success elsewhere.

His slow progress on this front can be partly attributed to a welcome visit from Lottie and Annette in the summer. After landing at Liverpool on May 28 they came straight to Southsea, but Arthur for some reason was not at home and did not turn up until the following afternoon. After a sociable couple of weeks, they were joined there by their old Edinburgh friend Jessie Drummond. Despite his commitments, Arthur enjoyed taking all three young women to the Isle of Wight, though he feigned shock at finding Annette and Jessie smoking. Before they left, Arthur moped to Jessie's mother, Mrs. Drummond: "I don't know what I shall do when the three of them go off and leave me in my primitive loneliness." Characteristically, he foresaw some respite in the prospect of hard work and losing himself in his novel.

This was not so easy, however, because toward the end of 1884 Arthur found a new outlet for his energies in the game of soccer. Although previously a rugby man, he now preferred to kick rather than run with the ball. After attending a meeting of fellow enthusiasts at the Blue Anchor pub in the Kingston Cross area of town on October 14, he became one of the founders of the new Portsmouth Football Association Club. In its early days, the team's goalkeeper (and, occasionally, one of its full-backs) was someone called A.C. Smith. For some reason (all the more curious because he was so adept at self-promotion) Arthur preferred to use this *nom de jeu*.

But such diversions did little to alleviate his loneliness. Although he

had recently counseled Lottie against rushing into marriage with a man she met on board ship traveling back to Portugal, his own need for someone to share his life had been gnawing at him since his time with Elmo. His writings were crammed with none-too-subtle references to the nobility of marriage. In "The Narrative of John Smith" he waxed lyrical about the girl living opposite, who was "going off also to fulfil the great female destiny—to become the supplement of a man."

Resolution of his problem came from an unlikely quarter. Some time early in March 1885 his friend Dr. Pike asked Arthur for a second opinion on a patient who was causing concern. Twenty-five-year-old Jack Hawkins had been living in Southsea with his mother and sister for the previous six months. The three of them had led a peripatetic existence since the death of Hawkins's father, a minor Gloucestershire landowner, in 1873. This was their latest out-of-season watering hole, where they could make the most of their fixed income in comfortable if reduced circumstances in a boarding-house. But Jack was suffering from convulsions that appeared to be getting worse. Both doctors were agreed that these were the symptoms of cerebral meningitis, at the time an incurable disease. Since this could not be adequately treated where Jack was staying, Arthur offered to take him in as a paying patient. He had a free room on his top floor where he and his house-keeper could keep an eye on the young man, while the other two members of the family could visit.

The prognostication was never good. But Jack Hawkins's end came quicker than expected, on March 25. In his memoirs, Arthur admitted feeling a heavy burden of responsibility. In *The Stark Munro Letters*, he hinted at an additional reason: he had been interviewed by a detective who had received an anonymous letter questioning the speed with which the young man's funeral was arranged. In this fictional version, Dr. Porter (Dr. Pike in real life) was able to confirm that he had examined Jack the previous evening and thus allay any suspicions. Munro (or Arthur) felt greatly relieved because there were "financial interests" riding on the death, not least a legacy of 100 pounds a year to Jack's sister, Louise.

If, in real life, any whispering campaign had taken hold, it would have become louder after what happened next. For, left to comfort the dead man's relations, Arthur found himself drawn to Louise, a quiet *jolie-laide* woman with wispy brown hair, an appealing rounded face and soft green eyes. Almost twenty-seven at the time of her brother's death, she was two years older than Arthur. Her helplessness and his

nagging guilt combined as aphrodisiacs. The couple's budding friend-
ship was helped along by their discovery that they harbored similar
family secrets. For seventeen years Louise's older brother Jeremiah had
been incarcerated in the mental hospital at Barnwood outside Glouces-
ter. He had trained as an art student in Gloucester where, in his lucid
moments, he produced passably good drawings.

Parallels with Arthur's father were immediately highlighted when,
on May 26, Charles Doyle was admitted to Montrose Royal Mental Hos-
pital (known as Sunnyside). Not for the first time he had become vio-
lent and abusive after obtaining alcohol, against the rules of his
treatment center at Blairerno. He had subsequently smashed a window
and tried to run away. When examined at Sunnyside, he said he had
"had a message from God that he must go" and "he was getting mes-
sages from the unseen world." He accused the medical staff of being
devils, refusing to speak to them or even move. He was also badly con-
fused about his immediate circumstances (he could not remember
how many children he had). So, although initially there for one day, he
was taken in as a long-term patient. Over the next few weeks his med-
ical notes describe a man in despair, who "complained at first of great
languor, then of an overpowering presentiment that he was going to
die." In moments of normality, he was happy to draw. In his doctor's
words, he also "took refuge in his prayer-book and had two long audi-
ences with a Priest, and prayed quietly."

This disturbing news hit Arthur just as he was wooing Louise—or
Touie, as she was known. One can imagine him telling her of his
father's plight, and their love growing stronger because she was able
to draw on personal experience to console and reassure him.

When the idea of marriage was first raised, she may have had mis-
givings, perhaps thinking it was still too soon after her brother's
death. Why else would Arthur have chosen now to pen "Saucy Kate,"
a ditty about the dangers of postponing matrimony?

> John was a farmer honest and brown
> Saucy Kate was the belle of the town
> And Oh she laughed as she tossed her head,
> "Shall I take the first who comes?" she said.
> "What, though John be a comely lad
> Such suitors as this may ever be had,
> I may very well wait,"
> Said Saucy Kate,
> "For suitors like John may ever be had."

Kate continues in this mood, rejecting two more suitors because she feels she can wait. But eventually she ends up unmarried and alone.

When in 1894 Arthur tried to reconstruct a timetable of his life, he noted that he had been in Eastbourne in May 1885, the month these verses were dated. Possibly the Hawkins family had moved on to another seaside town or perhaps he needed a period on his own to consider his future. The break seemed to work, for events moved quickly thereafter. In June Arthur accompanied Louise's mother, Emily Hawkins, to her family solicitor in Monmouth to draw up a marriage settlement. Despite humble Nonconformist origins, her people had built up sizeable land holdings in the area. As a result of this trip, Louise was confirmed in her receipt of a small annuity, as well as an income from the mortgages on several local farms. It was not much, but it was a useful addition to the household income of a young doctor conscious about monetary matters. On August 6 Arthur and Louise were married at St. Oswald's church in Thornton in Lonsdale, where Mary Doyle was a parishioner. Innes signed the register as a witness, but at the age of twelve he is unlikely to have been best man, so that role probably devolved on the unwelcome figure of the other male witness, Bryan Waller, though there is nothing to confirm this.

Indeed much about the wedding was sketchy, if not hasty, which may explain why Arthur dealt with it so cursorily in *Memories and Adventures*. His most personal reflection came in fictional form in *The Stark Munro Letters* where, when the doctor (based on Arthur) informs his mother of his engagement, she replies that he is a "true Packenham" (an obvious homage to the Packs), thus assuring him that his "mother's approval had reached the point of enthusiasm."

The marriage certificate recorded Louise's residence as Masongill which, since no special license was granted, suggests she was there from the middle of July. Arthur on the other hand remained in Portsmouth until at least July 29 when he played lawn bowling for his local club against Newport. He seems to have gone to Edinburgh to take his MD degree on August 1. (He was proud to append these two letters to his name in the church register.) It is likely that he also traveled farther north to tell his father what was happening and make sure all was well at Sunnyside mental hospital. He then took the train back to Lancashire where on August 3, three days before his wedding, he played cricket at Stonyhurst against his former school.

Immediately after the ceremony he was off again, joining the Stonyhurst Wanderers, the old boys' team he had turned out for a few days earlier, on a short tour of Ireland. This was hardly the most romantic

honeymoon for his new wife, who was still technically in mourning following the loss of her brother. Indeed if the execrable poem he composed about the tour for the *Stonyhurst Magazine* is any guide, she might not even have been on the trip at all. In rollicking terms, this celebrated various manly feats on the field, including his own "round duck" against the Leinster Club in Dublin. It also commented on the building works at "the old College," noting that whatever structural changes were made there, it would always retain an important place in his heart. There was no mention of his new marital status. More significant, certainly more prominent, was the professional swagger of his pseudonymous signature—MD.

So Louise may have spent the first week of married life involuntarily bonding with her new mother-in-law at Masongill Cottage. This would have been in keeping with Arthur's unthinking presumptions about the relative merits of his sporting and her emotional needs. He was relieved to have found himself the wife he desperately wanted as a domestic and professional prop. But she was unlikely to usurp the paramount position of his precious "Mam."

Arthur and Louise then returned to Bush Villas, where she fitted seamlessly into his now well-ordered existence. There is no evidence of her trying to alter Arthur's carefully assembled décor or impose her personality on the house. Doubtless there were problems as Arthur got used to a woman sharing his territory, for his regular correspondence with his mother inexplicably dried up for a couple of years after his marriage. During every other period of his life, his letters to "Mam" were meticulously kept. After his death they were collected as the centerpiece of an archive dedicated to Arthur's memory. But this initiative is tainted by evidence of weeding and self-promotion by his second wife and her sons. The records about Louise are minimal, pointing to a clear campaign to write her out of the family history.

One surviving communication presents an agreeable enough scene of domesticity. Arthur refers disarmingly to his need to consult Louise over some matter regarding his clothes. She is downstairs superintending the cooking in the kitchen, while her ever-present mother Emily is upstairs writing letters. The two women are preparing to go to Bath, where they often rented a house so they could take Jeremiah from his hospital bed in Barnwood. Arthur is perhaps looking forward to time on his own when, after the upheaval of his wedding, he might make some progress on his neglected writing. At the time twelve-year-old Innes was still living with him, expecting to join the navy at the end of 1886. But his presence had become superfluous, so he was packed off

to boarding school in Richmond, Yorkshire, which was about as far from Portsmouth as it was possible to go in England, though fairly close to his mother, and, significantly, the alma mater of Bryan Waller. Lottie also read the writing on the wall and, to Arthur's disappointment, decided not to return to England the following year. Clearly, though Bush Villas' outward trappings remained much the same, its internal dynamics were beginning to change.

There was no escaping the fact that at the time of his marriage, Arthur's nascent writing career was in the doldrums, and drastic measures were needed to revive it. All he had to show for 1885 was "Uncle Jeremy's Household," which drew on his recent short stay in Yorkshire. This was notable for its dramatic descriptions of the local landscape, with its "jagged scarps, where the grey granite peeped grimly out, as though nature had been sorely wounded until her gaunt bones protruded through their covering," and for its introduction of themes that would recur in Arthur's work, such as the exotic Oriental coming to Britain to carry out a bizarre ritual murder. The narrator even had an "old friend" with the familiar name of Dr. B.C. Haller, though Arthur's own feelings about Waller are probably more to be found in the "innumerable bad verses" of the eponymous Uncle Jeremy.

Shortly after his wedding, Arthur sent this story to *Blackwood's* with a fawning letter, pleading that it might be "found worthy of a place" in the magazine for, though he had "written for some years back for *Cornhill, Temple Bar* and other London magazines" he had "never yet had the good fortune to find a place in your pages." *Blackwood's* showed its usual dilatoriness, and the piece was not used until eighteen months later in *Boy's Own Paper*.

Toward the end of the year Arthur was still trying to get a selection of his stories printed in volume form. (An entry in one of his notebooks states that what he called "Light and Shade" was sent off to an unnamed publisher on November 27.) Again he was disappointed, only later managing to gain a place for seven tales in a three-volume anthology compiled by the second-tier firm of George Redway under the vivid title *Dreamland and Ghostland: an original collection of tales and warnings from the borderland of substance and shadow.*

An adjacent entry in this notebook showed how deflated he felt by his lack of success. He floated the idea of writing something called "The Autobiography of a Failure" in which, among other things, he reflected on the back-breaking travails of the man whose literary talents fall just short of being marketable. On a different tack, he mused

on man's progress from cradle to grave, until he pushes up daisies and becomes food for worms. With the relish of a metaphysical poet, he described the sole purpose of the human race as being to stop worms from breaking their teeth by having to chew gravel.

Arthur was wallowing in unaccustomed self-pity when Louise's subtle influence began to take effect. She was buoyed by an Anglican faith whose simplicity stood in sharp contrast to his own protracted struggle with his conscience. At her bedside she kept a copy of Thomas à Kempis' spiritual classic *The Imitation of Christ* in which she liked to mark comforting passages. In *The Stark Munro Letters* Arthur (in his persona as Dr. Munro) poignantly observes that he would no more think of interrupting his wife's innocent prayers than she would of carrying off the philosophy books from his study table.

Inspired by Louise's quiet devotion, both to him and to her Lord, and liberated by the order she brought to his domestic life, Arthur began rediscovering his enthusiasm for his work, or, as he put it, "After my marriage . . . my brain seems to have quickened and both my imagination and my range of expression were greatly improved." As a result, a year after his wedding, he experienced a sort of literary epiphany. He looked at his output of short stories, with their plots and devices, and concluded that he could carry on writing such stories for ever, without making any real mark. What he needed, he told himself, was his name "on the back of a volume."

This gives a false impression that he had not tried writing at length before. But his earlier attempts had been marred in one way or another. "The Narrative of John Smith" had been too didactic, and he had quietly secreted it, even pretending to have lost it. *The Firm of Girdlestone* was still doing the rounds of publishers without success.

He identified a possible way forward in the detective story, an increasingly popular genre, which he had acknowledged in "The Fate of the *Evangeline*," and one with a notable pedigree, some critics tracing its origins back to the Bible and to Daniel's searching examination of the Elders who attempted to rape Susanna. A better starting-point is Voltaire's short novel *Zadig* in which the eponymous hero shows off his eighteenth-century powers of reasoning, describing the king's horse and queen's dog from the physical marks they have left behind.

A loose tradition of solving cases by examining clues had developed over the previous century or so. Like many Enlightenment offshoots, it flowered in different ways, the two most distinctive being Realism, as pioneered from the 1770s in the *Newgate Calendars*, with their racy "true stories" of criminals incarcerated in London's Newgate prison, and

Gothic, in which more literary-minded authors strove to startle comfortable readers with a sense of the macabre. An important date in the latter's development was 1827 when Thomas De Quincey published "On Murder Considered as One of the Fine Arts," which invested the gory act of murder with elements of the terrible sublimity which the Romantics aspired to in their poetry and art. Significantly this essay appeared in *Blackwood's Magazine* which, to young Arthur's delight, had exploited Gothic horror as part of its local circulation wars. He himself also enjoyed (and later collected) the *Newgate Calendars*, though it is not clear when he first read them.

Such subject matter captured the public imagination because it seemed to reflect the prevalence of crime in the real world. With murder and mayhem apparently so widespread, the authorities were forced to take action. After London's formation of the Metropolitan Police in 1829, the Municipal Corporations Act of 1835 required each town to set up its own police force. By 1842 the Met had a detective branch, though it had to wait thirty-five years for a fully fledged Criminal Investigation Department. The point was that a pragmatic society was striving to apprehend its offenders, and this was reflected in popular writing (mainly fiction) by a greater appreciation, even glorification, of the foot soldiers in the war against villainy. In this context Edgar Allan Poe created the first identifiable detective in Dupin, whose expertise lay in deciphering clues. He described such output as "tales of ratiocination," though having an orangutan as the hit man in "The Murders in the Rue Morgue" (1841) suggests that the Gothic tradition was not dead.

The idea of a professional at the center of an enquiry had been highlighted a dozen years earlier in the influential memoirs of Eugène Vidocq, a former criminal who somehow emerged from the anarchy of the French Revolution as head of the Paris Sûreté. After Poe, it was embraced by leading English authors, from Charles Dickens, who introduced the unflappable Inspector Bucket into *Bleak House* (1853), to the more sensationalist Wilkie Collins, whose Sergeant Cuff triumphed amid the high emotion and Orientalist color of *The Moonstone* (1868)—"the first and greatest of English detective novels," according to T.S. Eliot. Alexandre Dumas and Honoré de Balzac spawned similar characters in France where the market for popular crime stories was greater because of the demands for copy from cheap mass-circulation *feuilletons*. In this fertile environment, a little-known journalist called Émile Gaboriau nudged the genre closer to the modern crime story by making his plots more sophisticated and inviting his

readers to share the problem-solving processes of Monsieur Lecoq, the policeman hero of his 1868 novel of that name. In his hands the *roman policier* became a more cerebral, interactive medium.

Such fictional output had been complemented by numerous memoirs by policemen and lawyers. Arthur was familiar with the work of Samuel Warren, a barrister with an Edinburgh medical training, who had turned his early experiences as a doctor into tales that first appeared in *Blackwood's* in the 1830s. Two decades later Warren expanded his repertoire by writing a series of quasi-autobiographical stories that drew on his legal work. Published in *Chambers's Journal*, these featured two attorneys (the equivalent of modern solicitors) called Ferret and Sharp whose case files often involved psychologically motivated crimes, such as fraud or arson, rather than outright murder.

Arthur saw an opportunity to put his doctor's training to good use. According to his old professor, Joseph Bell, the basis of "all successful medical diagnosis" was "the precise and intelligent recognition and appreciation of minor differences." Was this not precisely what was required of a detective? Arthur later wrote about his appreciation of Gaboriau's plotting and his early love of Poe's detective, Auguste Dupin. His problem was to find something new to add to the emerging genre. So he cast his mind back to Bell and his technique of picking up clues from the minutiae of a person's appearance. He convinced himself that, if his professor had been a detective, Bell would have gone about this different profession as if it were a science. So this would be his added ingredient.

Science was the operative word. Its techniques of observing, measuring and classifying underpinned the utilitarian age, helping drive progress not just in academic disciplines such as medicine and chemistry, but also in technology (including Arthur's hobby of photography).

In his own medical profession, the body was yielding up its secrets and the mind would soon follow, with the help of pioneers such as Dr. Sigmund Freud, who was just beginning his medical career in Vienna. One simple tool was the stethoscope, invented in 1819 but still enough of an innovation to be spurned by the old-fashioned Dr. James Winter in Arthur's story "Behind the Times." This instrument listened to a patient's breathing, but others performed more complicated tasks such as measuring the pulse—the function of the sphygmograph, introduced by the Frenchman Étienne Marey in the 1860s. Marey went on to develop the first electrocardiogram, as well as do pioneering work on moving photography. It was a short step to the lie-detector which, from the 1890s, would use changes in pulse to tell if someone was

telling the truth. In this respect, though, real life lagged behind fiction, for, half a century earlier, Poe had anticipated such a development in his story "The Tell-Tale Heart," where the pounding of a murderer's internal organs leads him to confess his guilt.

In this way science was helping to uncover crime. At university, Arthur had learned of its forensic potential on the autopsy table. As he made his way as a doctor, he found its more general principles being used in the courtroom. Sometimes this was purely a matter of observation. Over the previous decade, Sir William Herschel, a magistrate in Bengal, had noted how everyone's fingers had a unique configuration of ridges and furrows and this provided a means of identification that could be used to combat fraud among illiterate Indians. Simultaneously Henry Faulds, a Scottish medical missionary in Japan, suggested that such fingerprints could play a more direct role in apprehending criminals.

Then there was quantification. As recently as 1882, Alphonse Bertillon, a Paris police investigator and, significantly, a statistician's son, had introduced his technique of anthropometrics. The idea was that it was possible to describe criminals and even predict their behavior on the basis of precise body measurements, which Bertillon backed up with photographs, thus helping institutionalize the police "mugshot" which had been pioneered in the United States. The camera, of course, was a modern piece of technical equipment which could capture lasting images, not only of villains but the scenes of their crimes. In this context, it taught people to observe more closely and systematically. (An intriguing parallel was provided by the Italian art historian Giovanni Morelli, who suggested that the best way of ensuring an Old Master was genuine was to look at the painting of small details, such as earlobes and fingernails. These were the artist's signature, an assured means of his identification.)

To this mix were added the specific sciences of the nineteenth century. Another Italian, the criminologist Cesare Lombroso, took a Darwinian-cum-anthropological approach in his book *Criminal Man*, where he argued that it was possible to identify criminality from a person's features, such as large jaws or fleshy lips, which often betrayed an atavistic propensity to deviance. Despite providing another boost to the mugshot industry, Lombroso's presumptions of genetic determinism stimulated unhealthy developments in the field of eugenics and gave credence to racism.

Closer to home, these ideas were all overshadowed by the maverick British scientist Francis Galton. Having made his name as a traveler and

meteorologist, he later developed the more overtly eugenic aspects of his cousin Charles Darwin's theory of natural selection. Not surprisingly, given his distinguished family connections, he trumpeted the importance of breeding in his influential book *Hereditary Genius.* In the late 1870s he latched on to Lombroso's ideas about criminal types, focusing on one feature—the need for reliable photographic records. Intrigued by Eadweard Muybridge's attempts to photograph a moving horse, he carried out his own experiments into visualization, or how people see things. (His biographer talks of his "creating his own school of experimental psychology from scratch.")

In his prestigious Rede Lecture at Cambridge University in May 1884, Galton returned to an earlier theme, affirming that every aspect of human personality and temperament can be measured. Keen to develop this idea as part of his study of eugenics, he took a booth, which he described as his anthropometric laboratory, at that year's International Health Exhibition in South Kensington where he gathered basic physical data from anyone who cared to drop by. Among his mountain of information were records of people's fingerprints. After looking into Herschel's rather amateur work in this field, Galton did his own research, giving the practice a proper intellectual pedigree in his 1892 book *Finger Prints.*

As he cast around for a new subject, Arthur would have been delighted to see Joseph Bell's calls for close observation being so widely heeded. He may even have attended the International Health Exhibition, for he later corresponded with Galton about fingerprints. He was fascinated by Bertillon who, to jump the gun, was admired by Sherlock Holmes. (In "The Adventure of the Naval Treaty," Holmes talks to Watson about "the Bertillon system of measurements," expressing "his enthusiastic admiration of the French savant.")

Contemplating this field, Arthur would again have cast his mind back to Edinburgh and his youth. In his *Narratives from Criminal Trials in Scotland* John Hill Burton had noted how crime had historically failed to keep up with science. Willie's father recalled the unfounded fears that villains would use advances in science and technology, such as the steam engine, to outwit the forces of law and order, but they had usually been too dumb to take advantage. (He quoted another unlikely precursor of the detective story, Alexandre Dumas, whose Count of Monte Cristo decried the stupidity of the "vulgar criminal poisoner" for failing to see that arsenic leaves tell-tale signs open to scientific interpretation.) "One of the most observable things in the history of crime," wrote Hill Burton, "is the slowness with which it adopts, when

it adopts at all, the aids of advancing science . . . All our great discoveries, from printing down to the electric telegraph, have aided in the detection, rather than the accomplishment of crime, and every new surrender of physical difficulties to scientific skill, gives the supporters of order and morality new checks on licentiousness and vice."

Such realism was a long way from the fantastical tales in which Arthur had hitherto specialized. But his literary career needed a boost. If he could find a distinctive way of portraying science's battle against crime, he would surely find an audience. With its descriptive power and narrative flow, his style of writing was well suited to the task. His stories had always included a strong element of mystery. Now he only needed to discard their more Gothic trappings and introduce a contemporary, rational strand into detective fiction.

Having determined on his subject matter and general approach, Arthur could think seriously about his story and characters. In probably his earliest reference, he calls his work "A Tangled Skein." One of his notebooks shows him developing the concept. This title is soon crossed out and replaced with the more incarnadine *A Study in Scarlet.* In his finished text Arthur shows what he was driving at: "There's the scarlet thread of murder running through the colorless skein of life." He probably had not thought much about Sherlock Holmes at this stage. The little he says of his plot runs, "The terrified woman rushing up to the cabman. The two going in search of a policeman. John Reeves has been 7 years in the force. John Reeves went back with them." This suggests he envisaged a more mundane Sergeant Cluff–type of figure as his main investigator.

Before long this character developed into a more promising "consulting detective" called Sherrinford Holmes, whose story would be told by Ormond Sacker, with whom he shared rooms at 221B Upper Baker Street. On a draft page of early notes Arthur gave Holmes some unmistakable features. He was a philosopher, a collector of rare violins, and had, it seems, access to his own chemical laboratory. Sacker was a less defined personality: it is not clear if he was even a doctor. Instead the important thing about him was that, like many of Arthur's friends in Southsea, he had seen military service abroad—originally in Sudan, which was etched on British consciousness following the death of General Gordon at the hand of the Mahdists in Khartoum the previous year, 1885. To create some internal chronology in the subsequent stories, though, this was later changed to Afghanistan, which had equally redolent imperialist connotations.

These initial names were not yet right, however. Arthur was careful to avoid being too didactic: "One rebelled against the elementary art which gives some inkling of character in the name, and creates Mr. Sharps or Mr. Ferrets," he later wrote, seemingly unaware that the word "ferret," which, with connotations of "searching" and "hunting" his Edinburgh predecessor Samuel Warren thought apposite for a detective, actually derived from the Latin, *fur*, or "thief."

Arthur eventually opted to call his protagonists Sherlock Holmes and Dr. John H. Watson. Much energy has been expended second-guessing how he arrived at these particular monikers. Volumes of *Wisden Cricketers' Almanack* have been pored over, for example, in an effort to find similar-sounding fast bowlers whom he might have read about or even faced. Suffice to say that Sherlock Holmes derived his surname from Oliver Wendell Holmes, the doctor-philosopher whose quirky musings so profoundly influenced the young Arthur. Sherlock is of less certain origin: probably recalling Patrick Sherlock, his fellow pupil at Stonyhurst, a member of the prominent Irish family that included Arthur's own aunt Jane Doyle. Ireland was also responsible for the first part of "Ormond Sacker": the Earls of Ormond had their seat at Carrick-on-Suir, not far from Lismore. For the surname "Watson," Arthur looked no further than Southsea: Dr. James Watson was an Edinburgh-trained GP who had recently returned from prolonged service in China to practice in Grove Road, which intersected with Arthur's own Elm Grove. (This would account for the fictional Watson's wife calling him James in "The Man with the Twisted Lip.") In opting for "John Watson," however, Arthur rather ignored his own advice about not giving away clues to character in a fictional name. For the point about Dr. Watson was that, like his moniker, he was anonymous—a foil to the more exotic and enigmatic Sherlock Holmes.

At the start of *A Study in Scarlet*, Dr. Watson finds himself in London, after being invalided back from Afghanistan following an injury at the battle of Maiwand. Needing a place to live, he learns from Stamford, his old dresser at St. Bartholomew's Hospital, of a man looking for someone to share his rooms. Stamford warns that his friend, Sherlock Holmes, is taciturn and "a little queer in his ideas": though not a full-time medical student, he likes to dabble in the chemistry laboratory and "amass a lot of out-of-the-way knowledge." Stamford confesses that Holmes is rather too scientific for his tastes, with a "passion for definite and exact knowledge" that verges on cold-bloodedness. He can imagine him giving a friend a pinch of some latest vegetable alkaloid,

not out malevolence, but, in the manner of Arthur's self-ministrations, just to determine the effect.

True to this advance build-up, when Holmes is introduced to Watson, he is working feverishly among his pipettes and Bunsen burners in a corner of the hospital, trying to find a new way of detecting bloodstains that he says will supersede all existing methods and come to be known as the Sherlock Holmes test. (With a touch of the inconsistency found throughout these stories, nothing more is heard of this.) His first remark to Watson is straight out of the Joseph Bell textbook—"How are you? You have been in Afghanistan, I perceive."—and he later details the clues that have led him to this conclusion. This is the man who, in the words of a later story, is "the most perfect reasoning and observing machine that the world has seen."

There is another side to this curious figure, as Watson discovers when he agrees to share his rooms at 221B Baker Street. He finds he is living with someone not just eccentric but downright neurotic. Holmes is a workaholic who has difficulty unwinding. Occasionally, the "low melancholy wailings" of his violin can be heard into the night. At other times he falls into a stupor, gazing out on the world with such "a dreamy, vacant expression in his eyes" that Watson thinks he must be addicted to some narcotic, which is indeed true. On his next outing in *The Sign of Four*, Holmes is revealed as a user of both morphine and cocaine. He excuses his drug habit with a heartfelt cry that epitomizes the *fin de siècle* ennui that other writers and artists channeled into works of aestheticism, nihilism and even decadence. He cannot "live without brainwork," he moans: "What else is there to live for? Stand at the window here. Was ever such a dreary, dismal, unprofitable world? See how the yellow fog swirls down the street and drifts across the dun-colored houses. What could be more hopelessly prosaic and material? What is the use of having powers, Doctor, when one has no field upon which to exert them? Crime is commonplace, existence is commonplace, and no qualities save those which are commonplace have any function upon earth."

At this early stage in *A Study in Scarlet*, Watson is still getting to know his new companion. Arthur has some authorial fun showing Watson to be that slithery customer academics like to call an "unreliable narrator." Foreshadowing the many false deductions he will make in future cases, the good Doctor concludes prematurely that, although Holmes may be an expert in chemistry and "every detail of every horror perpetrated in the century," his knowledge of the finer points

of literature and philosophy is nil. During an otherwise silent break-fast, Watson alights on a magazine article entitled "The Book of Life" which purports to show how much a man can learn by simply observ-ing what is happening around him. "Like all other arts," it goes, "the Science of Deduction and Analysis is one which can only be acquired by long and patient study . . . By a man's finger-nails, by his coat-sleeve, by his boot, by his trouser-knees, by the callosities of his forefin-ger and his thumb, by his expression, by his shirt-cuffs—by each of these things a man's calling is plainly revealed." When Watson retorts that he has never read such rubbish, Holmes calmly informs him that he himself has written the piece, which sums up the tricks of his trade as a "consulting detective."

By now, just two chapters into *A Study in Scarlet*, a unique world has been suggested and two central characters deftly sketched: the reader can discern why Sherlock Holmes was set to become such an enduring figure. For he was already much more than a plodding detective. Behind his cerebral exterior lay a more fragile and intriguing creature who reflected not only his age, in which the certainties of reason were under threat, but also his creator, Arthur Conan Doyle, the meticulous doctor who was beginning to look beyond science for his understand-ing of the world. (This statement raises immediate caveats. For, as any self-respecting Sherlockian will tell you, the detective's memoirs were written by Dr. John Watson and not by Arthur Conan Doyle, who was only the literary agent behind the work.)

The relationship between Holmes and Watson contributes to the allure. The Doctor's dogged chronicling of the mercurial detective recalls James Boswell's biography of his friend Dr. Samuel Johnson (one of Arthur's favorite books). There is a similar blend of comedy, pathos and psychological insight. Arthur used the narrative ploy of playing off one character against another—something he had done since his earliest story, "The Haunted Grange at Goresthorpe," in which it had helped him examine the rival claims of rationalism and skepticism. Seven years later Holmes and Watson still represent oppos-ing poles of mind and heart, but their contrasts are more subtle and better assimilated into the plot.

This time the central pair are bachelors living alone in London with no discernible family ties. This gives the story a contemporary feel: according to the parlance of the time, the couple are Bohemians (in the same way that Arthur sometimes called his existence in Portsmouth "Bohemian"). To ensure the point is not lost, Watson reads Henri Murger's *Scènes de la vie de Bohème*, the novel which had

acted as a manual for aspiring Bohemians since its publication in 1848. This might seem irrelevant to a "consulting detective," but it implied a slightly affected, solipsistic world in which someone might well despair and take to drugs. Arthur was showing his usual skill at absorbing and reflecting trends, whether literary (Gothicism and sensationalism), cultural (science and its discontents) or social (how two men disport themselves). This was a knack that came from the chameleon side of his nature: it was something he often tried to hide, for it smacked of the sensitive, ambitious Celt, casting high and wide in his endless search for fulfillment. It was nevertheless a trait that was to serve him handsomely as an author.

Arthur's London was more run-of-the-mill: a "great cesspool into which all the loungers and idlers of the Empire are irresistibly drained." It was thus an ideal environment for crime—a bustling city, often shrouded in fog, both murky and macabre, befitting the mysteries Holmes sought to penetrate. But while the detective was at home there, showing great familiarity with the capital as he stepped resolutely in and out of hansom cabs, Arthur's own topographical knowledge was limited. Apart from occasional visits to relations, he had spent little time in London and would later admit he "worked it all out from a post-office map."

After revealing himself to Watson as a detective in *A Study in Scarlet*, Holmes elaborates on how he goes about his business. Though observation is "second nature" to him, he admits that intuition is also part of his repertoire. In this way his severe image is again subtly subverted: he is more than a calculating machine, as Watson unkindly characterizes him later in the canon. In his fictional article "The Book of Life," Holmes had tried to throw further light on his technique, which took as one of its basic premises the idea that a small part of a picture can provide enough clues to enable the whole to be seen. He called this "deduction," and, as if to emphasize the point, "The Science of Deduction" was used as a chapter title in both this story and *The Sign of Four*. Arthur was again drawing on his scientific background, and in particular on the work of the French naturalist and palaeontologist Georges Cuvier, whom Holmes would mention by name in "The Adventure of the Five Orange Pips" as the man who "could correctly describe a whole animal by the contemplation of a single bone." If he had not read Cuvier himself, he was probably directed to him by Thomas Huxley, who dubbed the Frenchman's approach "the method of Zadig" in a lecture subtitled "Retrospective Prophecy as a Function of Science."

Purists would argue Arthur was wrong to call this "deduction,"

since such logic involves looking at pieces of data and saying for certain that something happened. Instead, the detective's method is more correctly known as "abduction," which is about assessing various clues and concluding that on the best balance of probabilities something happened. The former is what the plodding detective does, the latter is Sherlock Holmes's more creative modus operandi. "Retrospective prophecy" is not a bad way of describing it. Intriguingly, at the moment of Sherlock Holmes's inception, the most innovative thinking about abduction since Aristotle was being done in the United States by the mathematician and philosopher Charles S. Peirce. Given Arthur's fondness for American thinkers such as Emerson and Wendell Holmes, he was likely to know of Peirce, whose work was widely disseminated in journals such as *Popular Science Monthly* and who personally had gained notoriety in 1884 when he was dismissed from Harvard University for having an extramarital affair with a French gypsy woman. For his work in this and related fields, Peirce is often described as the founder of semiotics, the study of signs in a social context. And, as the Italian critic Umberto Eco has pointed out, this was precisely Holmes's method.

By the spring of 1886 Arthur was ready to put pen to paper. He might have started earlier but his mother had paid a lengthy post-Christmas visit—looking in remarkably fine form, even if a trifle heavier of build than of old. So it was not until March 8 that he started work on *A Study in Scarlet.* Working at a furious pace, he is usually said to have finished at the end of April, but it appears to have been earlier, if the evidence of a cheery letter he and Louise sent Lottie is anything to go by. Although undated, this was clearly written on a Sunday in April: in her part Louise mentions that she and Arthur were on their own at home while everyone else had gone to church. (The household now comprised the housekeeper, Mrs. Smith, an old retainer called Collins and a new cook. During the mornings a maid, who was paid the princely sum of a shilling a week, used to come and help Mrs. Smith. With this growing army of servants, Louise was on her way to becoming the "commander of an army," as recommended by Mrs. Beeton in her *Book of Household Management.*)

Louise explains how Arthur has just completed the manuscript of a "little novel" called *A Study in Scarlet,* running to approximately 200 pages, or just over 43,000 words, and this had been packaged the previous day and sent to James Payn at the *Cornhill.* It is likely to have been a Sunday toward the beginning rather than the end of the month

since Easter fell late that year on April 25, and there was no mention of this festival (or indeed of Palm Sunday). Meanwhile Louise's comment that another local GP had gotten married "the other day" suggests the earlier date since this wedding had taken place in March. So a good bet is that Arthur dispatched the book on April 11, particularly since four days later he was out in the community, making a speech about the benefits of vivisection—a cause he approached with what today would be described as a degree of "spin" since the context of the meeting was that this practice was kind to animals.

Reflecting not just the speed of execution but the effort that had gone into characterization, atmosphere and scientific exactness, the story pulsated with excitement, interest and humor. The main drawback was a plot crudely divided into two halves—the murder investigation in London and an earlier historical saga set among the Mormon community in Utah (a backdrop that borrowed heavily from *The Dynamiter*, written by Robert Louis Stevenson and his wife Fanny only the previous year). There were also flaws in Sherlock Holmes's detective work. For example, he made great play of having contacted the police in Cleveland about Enoch Drebber's marriage. Having been told that Drebber had sought the protection of the law against an old rival in love called Jefferson Hope, Holmes had then presumed that this same Hope must have been the murderer. But if Hope had taken the elementary precaution of changing his name when he went to London, the sleuth's not very subtle theory would have collapsed.

Because of these inherent weaknesses, *A Study in Scarlet* did not prove easy to place. Arthur was, by his own admission, "hurt" at the "circular tour" his work took as it made the rounds of publishers. James Payn claimed to be enthusiastic, but found its "penny dreadful" style inappropriate for the *Cornhill.* Two more houses, Arrowsmith's and Frederick Warne, passed on the opportunity. It was not until September that it found a berth at Ward, Lock and Company, which specialized in cheap, sensational fiction. (Jeannie Gwynne Bettany, the wife of the editor-in-chief, is credited with plucking it from the slush pile.) They offered Arthur 25 pounds, which he found insulting, particularly as they were demanding the full copyright. But he was tired of hawking his wares and eager to make an impression.

On November 20 he wrote a humiliating letter to Ward, Lock, divesting himself of all proprietary interest in his work. As he pointedly noted in his autobiography, this 25 pounds was the only money he ever received for a work that became an instant success when it finally saw the light of day a year later in the publisher's popular *Bee-*

ton's Christmas Annual. Not only was his return from his endeavors disappointingly meager, he had compromised his high literary aspirations by agreeing to have his novel published by a downmarket firm.

A curious feature of *A Study in Scarlet* was Sherlock Holmes's professed ignorance of Thomas Carlyle, since Arthur had recently given a laudatory lecture on him to the Portsmouth Literary and Scientific Society. Arthur had been obsessed with the Scots-born sage since reading his works on the *Hope* in 1880, when he himself was beginning to explore transcendentalism and learn something of Carlyle's role (through his friend Ralph Waldo Emerson) in promoting German idealist philosophy in America. He felt an affinity with someone who treated great issues of history and religion with such facility. Carlyle was an iconoclast who, like Arthur, believed in a divine order but could not stomach its being presented in outdated trappings of Christianity. Since they shared this "post-Christian" position, Arthur was also sympathetic to Carlyle's idea about great men or heroes personifying the spirit of an age.

He was in no doubt about Carlyle's personal failings after reading Froude's controversial biography, published in 1882, the year after his death. Nonetheless he found him inspiring; as he told his mother, "Carlyle has started a fermentation in my soul and made me ambitious."

This was immediately clear in "The Narrative of John Smith," where Arthur comments favorably on several of Carlyle's traits, including his anger, humor and no-nonsense approach to writing, which was "not like a warrior going to the battlefield but like a slave lashed to his task." When the eponymous narrator of this unpublished work is attacked by a local curate for holding Unitarian views, he argues that he is not interested in denominational labels: religion did not peak nineteen hundred years earlier, but was "a vital living thing still growing and working," while God was as capable of speaking through "Carlyle the Scotchman as Jeremiah the Jew." Smith adds, his voice chiming in with Arthur's: "I carry my own church about under my own hat. . . . I believe with Christ that the human heart is the best temple."

Smith also reflects on Carlyle's definition (in his history of Frederick the Great) of genius as the infinite capacity for taking pains. Smith disagrees, preferring to think of it as "the power of arriving at results intuitively and instinctively." Four years later this idea was taken up in *A Study in Scarlet* where Sherlock Holmes describes Carlyle's epithet as "a very bad definition, but it does apply to detective work." Coming soon after he had denied knowledge of the author,

this was odd, particularly as it did not express his real attitude to his profession, which required intuition as much as hard graft. But this was Arthur's way of signalling his character's complex nature. When Holmes next appeared in *A Sign of Four*, he was at least prepared to admit he knew Carlyle, though he found him an inferior thinker to the German Johann Richter, who he slyly suggested was the Scotsman's intellectual mentor.

Arthur's talk to the Society about his intellectual hero was strangely bland. He failed to get the measure of an audience that wanted more than a eulogy of Carlyle's "horror of cant and conventionality." The *Hampshire Post* ran a disapproving editorial: "Dr. Doyle proved a stronger clansman than a medico, and rolled his eyes heavenwards throughout his discourse in a sort of holy frenzy. . . . Why did he not mention the darker side of Carlyle's character . . . ?" Taken aback, Arthur fired off a letter denouncing the desire for scandal: "As flies settle on the least sound portion of the meat, so critics love to dwell on the weaker side of a great mind." This comment about flies was ironic in light of the controversy caused by Froude's life of Carlyle, with its revelation of his marital difficulties. Some critics were shocked, but Carlyle would not have minded: he had given Froude his papers and indicated his attitude to biography in 1838 when he greeted Lockhart's life of Scott with the words: "How delicate, decent, is English biography, bless its mealy mouth."

Talking to the Literary and Scientific Society at least gave Arthur an opportunity to raise his local profile. Having courted the limelight earlier in the year with his speech on vivisection, he now prepared to enter the political arena. An opening came abruptly in June 1886 with the defeat of Gladstone's Liberal government over its proposal to grant Home Rule to Ireland. Although nominally a Liberal, Arthur was strongly opposed to this legislation. His jottings in his notebook at this time indicated the depth of his feeling: "Ireland is a huge suppuration which will go on suppurating until it bursts." On July 6 Arthur wrote to the local *Evening News* declaring his support for the new Liberal Unionists who had broken away from the official Liberal Party over this issue. Drawing a veil over his complex anti-Irish prejudice, he argued that the British empire, which he enthusiastically supported, was moving toward a federation, in which every country would have equal representation: "any exceptional Irish legislation of the nature proposed would hamper this just and symmetrical design."

After contriving to have himself elected vice-chairman of the local Liberal Unionists, he was required to give an off-the-cuff speech to a

crowd of 3,000 people who had turned up for a meeting, only to find that the new party's candidate, General Sir William Crossman, had been delayed. "It was one of the tight corners of my life," Arthur recalled. "I hardly knew myself what I said, but the Irish part of me came to my aid and supplied me with a torrent of more or less incoherent words and similes which roused the audience greatly, though it read to me afterward more like a comic stump speech than a serious effort."

Shortly afterward he was again wheeled into action when Arthur Balfour, a Conservative Unionist, came to Portsmouth to whip up opposition to Gladstone. When Arthur tried to stop a heckler hurling abuse at the visitor, he was roundly assaulted and knocked down. Crossman and the official Conservative, Sir Samuel Wilson, were duly returned to Parliament, allowing Lord Salisbury to form a new government with a solid Unionist majority. Although Arthur's Liberal credentials were genuine enough, he also had deeply Conservative sympathies. As a result he was not unhappy at Salisbury's ascendancy, which ensured the continuation of the empire that he had grown to love.

Still awaiting news about the fate of both *A Study in Scarlet* and *The Firm of Girdlestone*, Arthur took the occasion to write "Cyprian Overbeck Wells (A Literary Mosaic)," a breezy parody of several well known authors including Defoe, Smollett, Scott, Swift and Dickens. This was accepted by *Boy's Own Paper*, but when his other writing outlets dried up he was prepared to take on any piece of any hack work, even translating a piece on gas pipes, originally in German, for the *Gas and Water Review*. Such humdrum material was hardly to be expected from a putative novelist, though he was later able to paint the experience in a positive light: "There comes a day when, instead of sending a story, a story is ordered, and that day marks the turning point in an author's career. These orders may lead him into strange places."

The subject matter did at least have some bearing on his growing involvement in public affairs. From his Edinburgh days, he had regarded infrastructural development as essential to good health. His views were reinforced by his camera-toting friend Willie Burton, who was a trustee of his marriage settlement. For most of the decade Willie had continued to run a sanitation consultancy with his uncle Cosmo Innes in London. But this was never successful, and he often threatened to try his hand at something else—either writing a novel (in which Arthur looked forward to seeing himself portrayed) or setting up a factory to make his own patent photographic emulsion process. When these ventures also failed to take off, Willie moved to Japan in 1887 as Professor of Engineering at the Imperial University in Tokyo.

As he edged into public life, Arthur found someone else with whom to discuss civic improvements. One of his new friends was Percy Boulnois, Portsmouth's Borough Engineer, who had enjoyed the sort of peripatetic career Arthur loved hearing about and often drew on for his stories. After a year of building railway lines in the Vendée, Boulnois had been apprenticed to Sir Joseph Bazalgette, the celebrated architect of London's sewer system. Boulnois had worked as a district engineer in Jamaica (where one of his tasks had been to construct a gallows) and city surveyor in Exeter, and he had written the standard *Municipal and Sanitary Engineer's Handbook*. There was no doubting his commitment to social improvement: he was endlessly lecturing on subjects such as housing for the working classes—his topic when he addressed the 1884 International Health Exhibition. (His presence there will have increased the likelihood that Arthur also visited and so familiarized himself with Francis Galton's work.)

Yet for all his undoubtedly paternalistic activity, Boulnois was also the sort of man who could be relied upon to address the local Literary and Scientific Society, particularly if a speaker was needed at short notice. This was a relief to Arthur because he had added to his portfolio of public appointments after being elected joint secretary in October. Before the end of the year his friend General Drayson had addressed the Society a couple more times, and on December 8 Boulnois was tackling "A few facts about money," which turned out to be an informed discussion of the bimetallic monetary system—a speciality, it would emerge, of Holmes's brother Mycroft.

More significantly, Boulnois' father William had made a fortune by converting a former Life Guards barracks in north London into the famous Baker Street Bazaar, where young Arthur had once visited Madame Tussaud's waxworks. The Bazaar was now run by Percy's older brother Edmund, who was another paragon of Victorian civic virtues—a Justice of the Peacee and later Member of Parliament in Marylebone, a director of water, electricity and insurance companies, and a leader of the Municipal Reform Party, a front for the Conservatives in their turf battles with the Progressives (or Liberals) in the stormy early days of the London County Council. Arthur may have nodded to Boulnois by housing Sherlock Holmes in Baker Street.

As Arthur advanced in Portsmouth society, he made several similar friends—reliable bourgeois citizens, progressive in outlook, conservative by nature. Vernon Ford, for example, was a surgeon at the Portsmouth Eye and Ear Hospital, a voluntary concern that had been set up by his solicitor father in Clarence View at the back of the main

barracks in December 1884. Coming from a family of artists, the other Arthur (Conan Doyle) had always been intrigued by the mechanics of sight and had recently created a detective who made a living from the evidence of what he saw. Before long Dr. Conan Doyle was offering to help in this infirmary, correcting refractions and ordering glasses. He began to consider specializing in eye surgery, thinking he might earn more money than in general practice. As the Budd figure in *The Stark Munro Letters* puts it, "There's a fortune in the eye."

Another companion was Henry Ball, a local architect who had studied under Alfred Waterhouse, the prolific designer of Victorian municipal buildings. After traveling in northern Italy he had mastered the Romanesque style, which he was to use to good effect in his best-known local commission, St. Agatha's, a controversial church that offered incense and Anglo-Catholic sacraments in the roughest area of Portsmouth. Arthur looked upon Ball as a restless seeker after truth made in his own mold. At one stage he considered him a prospective match for his sister Connie, telling his mother that his friend was both handsome and spiritual, which was a quality Arthur would come to appreciate as he now turned his attention back to the prodigious metaphysical questions that continued to vex him.

Discovery of Spiritualism

1887–1888

On January 24, 1887 Arthur and Henry Ball found themselves in a group of five people sitting nervously around a dining-room table at Kingston Lodge in the north of Portsmouth. As candidates for spiritual enlightenment, they seemed eager but slightly out of their depth. Not knowing precisely how to conduct a table-rapping session, they had decided to follow a set of instructions published by *Light*, the journal of the recently formed London Spiritualist Alliance. To get themselves in the mood, they intoned the first chapter of the Book of Ezekiel where a spirit appears to the Prophet in dramatic forms: "And I looked, and, behold, a whirlwind came out of the north, a great cloud, and a fire infolding itself, and a brightness was about it, and out of the midst thereof as the color of amber, out of the midst of the fire. Also out of the midst thereof came the likeness of four living creatures. And this was their appearance; they had the likeness of a man."

Kingston Lodge was the substantial Georgian house of a patient of Arthur's called Thomas Harward, a Lieutenant-General. As a soldier he was not of the caliber of Arthur's other great military friend, General Drayson, but he had acquitted himself creditably as a gunnery officer in India, participating in General Havelock's relief of Lucknow during the Mutiny, and he had now retired to Portsmouth, where one of his tasks was compiling material for a book he would write about his claimed ancestor Hereward the Wake. (Fittingly for a place with such strong service links, Havelock had given his name to a park in Southsea where other heroes of the Mutiny such as Colin Campbell were also commemorated.)

Apart from Arthur and Ball, the others hoping to make contact

with the spirit world were General Harward himself, Annie, his twenty-two-year-old daughter, and Louise Conan Doyle. If they had been expecting dramatic visions, they were to be disappointed. The group sat around for a half an hour without anything happening. Then, in response to Ball's request for a message, the table began to move jerkily, spelling out the words, "You are going too slowly; how long are you going to take?" A bit later, with only Ball and Annie Harward at the table, it started again, "Elm is your best and kindest spiritual adviser." None the wiser, the intrepid psychic researchers soon gave up and went their separate ways.

The next session, nine days later, was only a little livelier. The same five people went through a similar period of expectancy. Then a message was tapped out: "I have not nor ever shall forget you, darling little Nancy. Please love mother for my sake. Henry Hastie." Henry Hastie turned out to be Annie Harward's cousin who had died three years earlier and Nancy was his pet name for her. With this revelation, the room temperature plummeted, Arthur noted in his meticulous record of these séances. "Miss Harward became icy cold and experienced a sensation as of soft hands patting her upon the palm with a strong feeling that someone was standing behind her. At the command of the spirits we discontinued the sitting."

For Arthur, these gatherings were the latest stage in his quest for some explanation about the paranormal. In all he went to around twenty such sessions, trying different approaches, without gaining much enlightenment. At one he tried to see if he could summon up some automatic writing—one of the tricks of the many mediums who were cashing in on the spiritualism boom of the time—but to no avail. At another he was excited to find that when he thought of his wife, the table began to rap out TO. Expecting this to carry on to spell Louise's nickname, TOUIE, he struggled not to touch the tabletop with anything but his fingertips. But the next few letters turned out to be MMY. Arthur became downhearted about his lack of progress. He recalled how his fellow researchers had "sat round a dining-room table which after a time, their hands being upon it, began to sway and finally got sufficient motion to tap with one leg. They then asked questions and received answers, more or less wise and more or less to the point. They were got by the tedious process of reciting the alphabet and writing down the letter which the tap indicated. It seemed to me that we were collectively pushing the table, and that our own wills were concerned in bringing down the leg at the right moment. I was interested but very skeptical."

He was probably correct in intimating that these sessions were heavily influenced by the preconceptions of the participants. Annie Harward seems to have been particularly keen to obtain a result. Not only had her cousin died, but also two younger brothers, Francis and James. In seeking to reach them, she was typical of her sex, Louise included. As modern historians have noted, women were tired of having spiritual experience mediated by men. They sought direct personal contact with a higher force as a means of bypassing, if not throwing off, masculine influence. In this way a feminist agenda was at work in spiritualism.

Arthur had his own reasons for wanting a similar revelation. For years he had been flailing around in this area, searching for common ground between his well honed Edinburgh rationalism and his innate sense of some greater power in the universe. This had been a torturous business for a young man whose background was both artistic and Irish Catholic. He had always been conscious of something beyond the realm of the senses—a feeling reinforced by his family's aesthetic leanings, his Jesuit education and his own readings in literature. He had struggled to distance himself from any suggestion of superstition, finding consolation in a mixture of transcendentalism and agnosticism. But however much he tried to compensate by investing his mental and physical world with the stiff scientism of his medical training, he could never shake off the attraction of the supernatural.

As he matured, he realized there might be room for a synthesis. For one of the paradoxes of his age was that, as fast as orthodox religion came under attack from reason, other forms of paranormal experience, such as mesmerism and spiritualism, tried to usurp its place, before being subjected to the same scientific scrutiny as everything else. This process had been going on since the Enlightenment. The German-born physician Franz Anton Mesmer had led the way in the eighteenth century with his concept of a universal force that, when blocked, can cause illness, but, when freed by someone with "animal magnetism" (a power that can be enhanced with the use of a magnet), speeds recovery. From his discoveries arose the practice of hypnotism which, in the medical context known to Arthur, allowed patients to be placed in a deep trance where doctors could perform operations without hurting them.

Such essentially practical developments were given an occult tweak with the arrival of the first spiritualists in the 1840s. The Fox sisters claimed to be able to get in touch with the spirits of the dead who communicated with them by the laborious means of table-rapping

(each knock on the table spelling out a letter). Before long such mediums devized other means of contacting spirits, including automatic writing (usually on slates). They also found ways of materializing these spirits in the form of ectoplasm and of further demonstrating their powers through feats such as levitation. Daniel Dunglas Home was a prime exponent of all these manifestations of mind over matter.

Although spiritualism first caught on in the United States, it soon became popular in Britain, attracting the enthusiastic attention of Dickens and Thackeray, as well as the disapprobation of Robert Browning, who was famously caustic about Dunglas Home in his poem "Mr. Sludge the Medium." Befitting the age, scientists sought to observe, quantify and assess the various claims of paranormal experience. Some, such as Alfred Wallace, remained sympathetic, while others, certainly the majority, were less welcoming, including E. Ray Lankester who took the slate-writer Henry Slade to court, and the physicist John Tyndall, a hardline materialist who described spiritualism as "intellectual whoredom." At least one branch of science—psychology—benefited from this debate as it became clear how difficult objective truth was to achieve: the unconscious mind introduced too many variables and therefore needed to be better understood.

But a core of reputable scientists still wanted to know more about the mind's hidden powers and pressed for further investigation. Who actually founded the Society for Psychical Research in February 1882 is still hotly debated. But there is no doubt that the intellectual core quickly coalesced around three Cambridge academics, Henry Sidgwick, Frederic Myers and Edmund Gurney, together with another researcher, Frank Podmore. This group took a rigorous scientific approach to paranormal experimentation, setting itself apart from the Society's more credulous members who felt that any psychic powers might be upset by its intrusive enquiries. This split between skeptics and believers was to be a feature of the Society's work for many years.

One of the SPR's first successes was its debunking of theosophy, a fashionable synthesis of Eastern ideas about reincarnation and spirit travel, originally developed in India by a colorful Russian woman called Madame Blavatsky. Around 1884 Arthur had become intrigued by its precepts, almost certainly at the suggestion of General Drayson, his mentor in this field. Drayson introduced him to A.P. Sinnett, a close associate of Madame Blavatsky who had returned from India the previous year after being sacked as editor of the Allahabad daily newspaper, the *Pioneer*. (One advantage of living in Portsmouth was access to the vast range of contacts and knowledge on esoteric subjects

that had been gathered by the ex-military men who had retired there.)

Arthur was already peppering his stories with references to the paranormal but, being a thoughtful person, preferred to place any other-worldly intimations within the context of a more comprehensive belief system. He was cruelly disillusioned when Richard Hodgson, reporting to the SPR in the summer of 1885, denounced Madame Blavatsky as a fraud.

This coincided with Arthur's marriage to Louise, whose quietly focused faith helped him take a more practical approach toward the paranormal. She weaned him away from the fantasies about Tibetan avatars found in the writings of Madame Blavatsky and encouraged him to make the most of his scientific training by conducting his own experiments in fields such as table-rapping and thought transference. This is a reasonable deduction from a story in the unofficial history of a local family that tells of "Doyle and his circle" participating in table-turning sessions at the Grand Parade house of a solicitor called Douglas Morey Ford (the eye surgeon's brother) in "about 1885." Ford's wife Honor was well known for her interest in spiritualism. This account loses some credibility, however, when it suggests that Ford flew into a fury when he arrived home one day to discover a séance in progress. The idea that Arthur would have participated in any session without the knowledge of the head of the house is not credible. It may simply have been that Louise dabbled in table-rapping on the ladies' tea circuit, perhaps in the hope of contacting her recently deceased brother.

There is no doubt that Arthur also benefited from continuing discussions with General Drayson. In one of his notebooks from this period, he noted how the General had been converted to spiritualism after getting a message from his dead brother. Underneath he carefully listed the names of several eminent scientists who had embraced spiritualism, as well as some weighty books he intended to read: Carl von Reichenbach's *Abstract of Researches on Magnetism*, William Gregory's *Letters on Animal Magnetism*, Robert Dale Owen's *Footfalls on the Boundary of Another World*, Robert Hare's *Experimental Investigation: the Spirit Manifestations* and even Daniel Dunglas Home's *Incidents in My Life*. This was a crash course in science and the paranormal, so far as it was then known.

One volume that made a particular impression on Arthur was rather more anecdotal. He later described it as "the Reminiscences" of Judge Edmonds, but he was obviously referring to one of the works

on spiritualism by the New York Judge John Worth Edmonds, who took up the practice in the early 1850s in the hope of communicating with his recently deceased wife. Those were the early days of paranormal exploration in the United States when the Fox sisters had not been exposed as frauds and were still creating waves with their pioneering table-rapping sessions in upstate New York. Edmonds made a point of meeting the "Rochester knockers," as the girls were known, and Arthur was impressed by the meticulous scientific approach the American judge brought to the task.

But he still could not slough off his deep skepticism. His main concern was the status of the spirit in such cases. He had long convinced himself intellectually that there was a world of the spirit, but he had not experienced it personally. Here worries about his father weighed upon him. He could not understand what happened to the spirit or "soul" of a man who cracked his skull or became addicted to alcohol or drugs. So far as he could make out from the unfortunate inmate of Sunnyside, "his whole character would change, and a high nature might become a low one." This was the rational doctor's point of view: at this stage the "soul" was simply a physical entity to him—the sum of the inherited and mechanical workings of the mind. But he was beginning to discern that there might be another reality and that higher forces were having difficulty manifesting themselves.

With his concern to ensure that any position he took was backed by adequate scientific evidence, he was encouraged by the work of the newly formed SPR. Although he does not mention it, he was almost certainly buoyed by the Society's massive study *Phantasms of the Living*, published in 1886, which catalogued the stories of people who claimed to have felt, seen or otherwise experienced the deaths of others who were far away from them. Myers stated that the book's aim was to move away from the "ghoulies and ghosties" image of extrasensory perception and establish it as simply another form of communication. For this he coined the term "telepathy."

This was the cue for Arthur to attempt his own experiments with Henry Ball. The two of them would sit in Ball's house in Portland Place and try to project their thoughts to each other. Although Arthur divulged little about this, he did say that he had repeatedly drawn little figures, which Ball had more or less replicated, and that these experiences had convinced him of his ability to communicate without having to speak. But still Arthur balked at the implications of his research, and subsequent table-rapping sessions at General Harward's did little to allay his suspicions that the participants were willing an answer.

By early 1887 Arthur's investigations into the paranormal were being conducted on at least three separate external fronts. There was this rather prosaic experimentation into thought-transference. There were his more unwieldy séances at General Harward's. And, leaving nothing to chance, he had also followed Bryan Waller into the Freemasons. Normally this move might be dismissed as an excuse to join another male club where he could indulge in mutual back-slapping and self-advancement. But the date of his initiation into Phoenix Lodge No. 257 in Southsea suggests there was rather more to his application. For it happened on January 26, only two days after his first table-rapping session at Kingston Lodge, and it suggests he was hoping to tap into the store of occult knowledge that traditionally stood at the heart of Freemasonry. Not that he lacked for support among his local professional friends. He could not have had a more distinguished proposer than the former mayor, W.D. King, later Sir William King and Lord Lieutenant of Hampshire, while his seconder was John Brickwood, one of the most influential brewers in the country, who was also knighted. And among those present when he first joined the craft was his friend and colleague Dr. James Watson.

Arthur did not neglect his medical duties during this period. An invoice shows that thirty-six times between 3 February and 7 April he visited Mrs. Chapman in Cottage Grove, a run-down area to the north of Elm Grove. But she did not survive and her husband was left to pay 7 pounds 11 shillings sixpence for her care—a total that included sixteen bottles of medicine.

Arthur's metaphysical doubts may have been heightened by his experience of death as a practising doctor. Certainly they persisted until the summer, when Ball arranged a series of meetings with a professional medium called Horstead. The scene was again his house where three men gathered—Ball, Arthur and their friend Percy Boulnois. So far as Arthur was concerned, the breakthrough came on June 16. He had been flattered to be told by the small, bald Horstead that he had a great brain, was full of magnetism and had a gift for healing. As they sat around, the medium began to talk in different voices. He then became clairvoyant and advised Arthur to read books on magnetism. When the party asked for examples of spirit writing, he jotted down, specifically for Arthur, "This gentleman is a healer. Tell him not to read Leigh Hunt's book." Arthur was staggered to hear this as he had been debating whether to read that author's *Comic Dramatists of the Restoration* but had, he rather primly recalled, been put off by the lewdness. Since he had never mentioned this to anyone, nor was he

thinking about it at the time, he found this conclusive proof of some power at work. In his contemporary notebooks he wrote, "This message marks in my spiritual career the change of 'I believe' into 'I know.' "

This about-face seems abrupt and unconvincing. As recently as the start of the year Arthur had been dismissive of the positive noises from friends who had been presented with similar evidence, albeit without a medium's involvement. A few weeks earlier he would have been hard-pressed to say honestly that he "believed," and now he was stating emphatically that he "knew." But as he wrestled with his concerns about his father's soul, he had been working toward this end.

A medium's presence was perhaps vital for someone brought up in a tradition of a powerful priesthood. In his autobiography Arthur suggested bizarrely that he had been too poor to employ his own professional medium, but it seems rather that he needed a hieratic intermediary to legitimize an experience otherwise devalued by lay people sitting round a dining-room table. Somehow the direct personal nature of Horstead's advice about Leigh Hunt had done the trick. It had precipitated a conversion in which the reality of paranormal communication had become clear. And if that could happen, other barriers could also fall.

Before long Arthur had dashed off a letter to the magazine *Light* about his experiences. He described how "after many months of enquiry" he had come to discover that "it was absolutely certain that intelligence could exist apart from the body." This, he had decided, was not explicable "on any hypothesis except that held by Spiritualists." He then waxed lyrical about what he understood this to mean. "Let a man realize that the human soul, as it emerges from its bodily cocoon, shapes its destiny in exact accordance with its condition; that that condition depends upon the sum result of his actions and thoughts in this life; that every evil deed stamps itself upon the spirit and entails its own punishment with the same certainty that a man stepping out of a second floor window falls to the ground; that there is no room for deathbed repentances or other nebulous conditions which might screen the evil doer from the consequences of his own deeds, but the law is self-exacting and inexorable."

Ignoring Arthur's obvious allusions to the laws of karma and reincarnation at the heart of Eastern religions, including theosophy, Frederic Myers at the SPR was delighted to read of this new scientifically literate recruit to psychic research. The very next day he wrote asking if Arthur

could now help him and the Society with further investigation into the phenomenon he had experienced. "Your profession has doubtless accustomed you to weighing evidence, and you will recognize that inquiries like the above are dictated by no idle curiosity." The following month Arthur was again writing to *Light*, this time taking it to task for asking its readers not to co-operate with the work of Richard Hodgson, the man who had exposed Madame Blavatsky, because it believed that he was predisposed to see all mediums as fraudulent.

For all his new convert's zeal, this pronouncement was a sin against Arthur's other calling as a scientist. Although describing himself significantly as "a spiritualist," he pleaded that every assistance should be given to Hodgson. "If Spiritualism be true and the phenomena genuine, why should the mediums be warned against Mr. Hodgson or any other inquirer? Far from throwing difficulties in Mr. Hodgson's way, a fund might well be set on foot by Spiritualists to assist him in cleaning out the Augean stables of professional mediumship."

Becoming a spiritualist so soon after creating the quintessentially rational Sherlock Holmes: that is the central paradox of Arthur's life. It seems strange for someone steeped in Edinburgh's empirical tradition to take what amounted to a leap of faith. For Arthur there was no discrepancy, however. He regarded spiritualism as a science or, at least, a natural extension of science. In *A Study in Scarlet* he had drawn on fields such as psychology and forensics at the boundaries of modern experimental research. In exploring the paranormal he had taken this further and incorporated findings about extrasensory communication that were more theoretical and more disputed, even if they had the support of reputable scientists such as Frederic Myers.

Having arrived at a satisfactory solution in this area, Arthur was ready to try his hand elsewhere. He was not happy about the compromises he had had to make in publishing in *Beeton's Christmas Annual.* As he put it in typically forthright fashion in his autobiography, "Feeling large thoughts rise within me, I now determined to test my powers to the full." Top of the agenda was the great British historical novel he had been contemplating for some time. This way he hoped at least to "combin[e] a certain amount of literary dignity with those scenes of action and adventure which were natural to [his] young and ardent mind." So in July, he launched into writing *Micah Clarke*, a fast-paced account of the adventures of a young man brought up in the Puritan tradition in rural Hampshire, who travels to the West Country to join

the Protestant rebellion of James Scott, Duke of Monmouth, against his unpopular Catholic uncle, King James II.

It was unusual for the product of a Jesuit education to take a sympathetic approach to a Protestant insurrection against what, in 1685, was the established Roman Catholic religion. But, for Arthur, as for Micah, it was a matter of principle. He saw his own efforts to slough off the oppressive dogma of Catholicism as the nineteenth-century equivalent of Micah's more physical struggle to achieve intellectual freedom. As he put it, "I had always felt great sympathy for the Puritans, who, after all, whatever their little peculiarities, did represent political liberty and earnestness in religion."

In the book Arthur canters as spiritedly over the history of the period as he does over the English countryside. He refers to contemporary writers including Dryden, Milton and Edmund Waller, vaunted ancestor of the laird of Masongill. Throughout he maintains a dramatic tension between the idealism of Micah's religious beliefs and the illegality of the act of treachery involved in taking up arms against the King. While the battle (at Sedgemoor) is disastrously lost, the campaign against tyranny continues and is eventually won. But even here Arthur remains ambiguous, contrasting the picaresque adventures of Micah and his friend Decimus Saxon with the havoc wrought by military action. "Oh, war, my children, what a terrible thing it is," Micah wails as he surveys the devastation on the battlefield at Sedgemoor. "How are men cozened and cheated by the rare trappings and prancing steeds, by empty terms of honour and glory, until they forget in the outward tinsel and show the real ghastly horror of the accursed thing!" Through Micah's words, Arthur was even prepared to launch an attack against the arms industry: "I have seen a Christian minister blessing a cannon which had just been founded, and another blessing a warship as it glided from the slips. They, the so-called representatives of Christ, blessed these engines of destruction which cruel man had devised to destroy and tear his fellow-worms. What would we say if we read in Holy Writ of our Lord having blessed the battering-rams and the catapults of the legions?"

Such pacifist editorializing was a long way from the respect for the martial arts that had been inculcated in him from a young age by his mother. He might have argued that he was highlighting the gap between her medieval chivalric code and the unpleasantness of modern war. He was also touching on a more personal conflict—the gap between his own father's gentle unworldliness and his mother's love of noble exploits. He had alluded to this in the book by contrasting the Puritan-inspired simplicity of Micah's father with the reverence for

the hierarchy of the Anglican Church shown by his mother. Thus far, Arthur's fiction had tended to balance his father's influence (broadly, the imaginative, even fantastical tenor of many of his stories) with his mother's (their down-to-earth, extrovert style). But this novel was more orientated to the Mam's view of the world: it was dedicated to her—a gesture reinforced by Micah's response when asked, prior to battle, if he had any message: "None, save my love to my mother." Arthur's caveats about the arms business were his nod to Charles Doyle's views on the matter.

As for the differences of attitude between Micah's father and mother, the crucial factor was the manner in which Arthur resolved them—by promoting a universal faith devoid of the trappings of religiosity. His hero was Micah's friend Zachariah Palmer—"one who is religious without being sectarian, philosophic without being a partisan, and loving without being weak"; a man who could write, "Nature is a silent preacher which holds forth upon week-days as on Sabbaths." Though this was a Christianized version of Arthur's beliefs, it suggested how much his own philosophical quest had been based on a need to find a balance between the opposing influences of his parents.

In November 1887, shortly before *Micah Clarke* was completed, *A Study in Scarlet* was finally published in the gaudy yellow and red livery of *Beeton's Christmas Annual*, which trumpeted its "skilful presentation of an extremely ingenious detective, whose performances, while based on the most rational principles, outshine any hitherto depicted." The local *Hampshire Telegraph* ignored the story, preferring to note two of Arthur's insubstantial contributions to *Boy's Own Paper*. However, after winning praise from *The Times*, the novella proved an instant success, and *Beeton's Christmas Annual* itself was sold out within two weeks.

That was satisfactory enough, but Arthur refused to be distracted from what he always regarded as a more important project. He wrote the last chapter of *Micah Clarke* around Christmas, and then had to spend another couple of months meticulously copying its 670 closely written pages. Early in the new year he traveled to Taunton to consult Mrs. Frances Prideaux, the aunt of Henry Ball. Her interest in the religious conflicts of the seventeenth century was evident from her epic ballad "The acquittal of the seven bishops, 1688," which had appeared in her recent book *Philip Molesworth and other Poems*. She seems to have provided useful color—both local and historical—because Arthur made a point of sending her the proofs of his work.

Around this time, with only one volume of *Micah Clarke* copied, he sent it to Blackwoods, determined still to be published by the stuffy Edinburgh firm that had meant so much to him as a child. He explained how the complete run of *A Study in Scarlet* had been sold before Christmas and how Ward Lock was "now bringing it out in a more permanent form with new type, illustrations and everything." Blackwoods were at first favorably inclined, telling Arthur they would like to see the other two volumes. But, having read these, they decided against proceeding. Arthur was very disappointed and tried to negotiate, offering to forgo any royalty and to take instead a share of the profits. Informed that he had been rejected because his characters were too rooted in the nineteenth century, he replied, naïvely for a genre novelist, that he had done this on purpose, hoping, like Alexandre Dumas in France, "to break away from the conventionalities of historical romance and make the dry bones live." There was a note of desperation in his plea: "As an Edinburgh man I should be very glad if my first solid book could appear through you."

He also sent *Micah Clarke* to James Payn, his patron at the *Cornhill Magazine* who was dismissive, clearly thinking that historical novels were anachronistic and not suitable for a writer of his talents, and then to two other publishing outlets, Richard Bentley and the Globe Newspaper Syndicate, which were equally unsympathetic. Undeterred by the negative response, Arthur remained confident of his novel's ultimate success, and this allowed him to think expansively about the future. He began telling Lottie about the possibility of selling the practice, putting his furniture in storage and embarking on the next stage of his life.

Never satisfied with progress in just one area, Arthur had set his store on becoming an eye surgeon—the speciality he had been practicing locally at his friend Vernon Ford's hospital. So his future scenario involved studying ophthalmology in London, Berlin, Vienna and Paris, before returning to London to work as an eye surgeon—all the while maintaining himself and his family through his writing. He admitted to Lottie that there was little to strive for as a GP in Portsmouth, while as an eye specialist he would have the time and leisure to write. But he was well aware that this was something of a dream, and it all rather depended on the success of *Micah Clarke*.

So for the time being he occupied himself with a number of other short-term projects. Having turned down *A Study in Scarlet*, the publisher Frederick Warne came back to him with a suggestion, though it was hardly complimentary in its inference as to where they thought his

talents lay. They wanted him to write a short 40,000-word boy's adventure story, for which they were prepared to pay 30 pounds. Arthur fobbed them off by saying he would do 50,000 words for 50 pounds, and does not appear to have been troubled further.

His correspondence shows him toying with an idea for a story called "The Sign of the Sixteen Oyster Shells," perhaps an embryonic version of *The Sign of Four* the following year. He also worked on repackaging *A Study in Scarlet* for publication in "shilling dreadful" book form by Ward Lock. For this he commissioned six pen-and-ink illustrations from his father, who was still incarcerated at Sunnyside where, along with his alcoholism, he was now troubled by depression and by fainting fits, ascribed to epilepsy. (He would frequently state that he was going to die, though his faith ensured that this was a happy prospect: as his doctors noted, "not that he fears it, on the contrary.") Still keen to make a mark as an artist, Charles had contributed three works to the Royal Scottish Academy's annual exhibition in 1887, but none had sold. He had asked for his sketchbooks to be sent to his wife, in the hope that they might be published, but became dejected when nothing happened.

Little wonder Arthur felt obliged to do something. But he took on more than he bargained for because, for some reason, perhaps Ward Lock's parsimony, he had to trace his father's drawings before they were made into blocks. For this he enlisted the help of Henry Ball who, as an architect, was used to such tasks, though Arthur made a point of telling his mother that he himself had been solely responsible for the sketch that showed Jefferson Hope administering the poison pill to Enoch J. Drebber.

Charles Doyle's artwork was wooden and appeared to depict himself, lank and bearded, as Sherlock Holmes, as if pleading from the asylum for recognition. Nevertheless Arthur persevered, calling on his father to provide one more (very similar) illustration for his next project—a short novel, initially called "The Problem," then "The Mystery of Cloomber," which explored the ever fascinating theme of reincarnation and karma. Written between April and July, this told the story of a former army General who, having been cursed after killing a Buddhist adept in India, is forced into a life of terrified seclusion on his estate on the west coast of Scotland, as he awaits the fated appearance of three of his victim's associates intent on retribution.

This time Arthur's authorial hand was as uncertain as his father's. Despite its moments of vivid drama set against a suitably eerie Scottish backdrop, his portrayal of the vengeful Indian holy men was slap-

dash, giving Sikh and Muslim names to Buddhists and topping one with a fez. The General is eventually led to his death in an archetypally hellish swamp known as the Hole of Cree, which both recalls the mad priest at Stonyhurst and presages the murky bogs of Dartmoor in *The Hound of the Baskervilles*. But Arthur's interest is clear: he wants an excuse to explore some of the more esoteric ideas he had recently encountered. So his so-called Buddhists go into flashy trances and talk of out-of-body experiences. When one of them expands on astral projection, he uses the language of experimental physics being carried out at that time by scientists such as the future Nobel Prize winners Lord Rayleigh and Joseph John Thomson (both of them supporters of spiritualism): "This is accomplished by our power of resolving an object into its chemical atoms, of conveying these atoms with a speed which exceeds that of lightning to any given spot, and of there re-precipitating them and compelling them to retake their original form."

Arthur put this into his own context at the end of this short book when his main narrator signs off: "Science will tell you that there are no such powers as those claimed by the Eastern mystics. I, John Fothergill West, can confidently answer that science is wrong. For what is science? Science is the consensus of opinion of scientific men, and history has shown that it is slow to accept a truth. Science sneered at Newton for twenty years. Science proved mathematically that an iron ship could not swim, and science declared that a steamship could not cross the Atlantic." Far from being a denial of science, this was Arthur's statement of his belief that Western science was not yet equipped to understand some of the complexities of Eastern religion.

A curious addendum found in some editions of the book enlarges on this theme, quoting from the theosophist A.P. Sinnett's *The Occult World* on the problems of describing occultism: "How could one describe a calculating machine to an audience unfamiliar with the simplest mechanical contrivances and knowing nothing of arithmetic?" Such references make *The Mystery of Cloomber* difficult to fathom, for they suggest that this book might have been written earlier—in around 1884, when Arthur was at the height of his interest in theosophy. Indeed Owen Dudley Edwards has argued persuasively that *Cloomber* predates Arthur's 1885 story "The Man from Archangel," which draws on its predecessor and, in his estimation, improves on it. There is no doubting the similarity between certain passages of these two works. But Arthur was not above plagiarizing himself. It seems likely that he was exhausted after *Micah Clarke* and refashioned some old material into a new story.

* * *

While Arthur continued to be intrigued by the occult, the scientist in him still longed for some sort of rational explanation, along the lines being investigated by the Society for Psychical Research and allied bodies. His Southsea notebooks show him looking carefully at the latest work on mesmerism and hypnotism, which was being done not in Britain but across the Channel. In Paris the neurologist Jean-Martin Charcot had used his patients at the Salpétrière asylum to show that a person under hypnosis behaved in a similar manner to someone with the neurotic symptoms of hystero-epilepsy. This seemed to divest hypnotism of any occult dimension and place it firmly in the realm of physiology. However, the opposing Nancy school of the emerging study of psychiatry saw hypnotism as more of a therapeutic tool. Followers of Charcot retaliated with a theory of what actually happened in hypnotism: a sensitive subject could pick up on signals put out by the hypnotist who, it was said, always made a minute muscular or verbal articulation of any thought. Such response to slight cues was not so different from the deductive skills of Sherlock Holmes (and before him Joseph Bell).

After his last recorded séance on August 5, 1887, Arthur committed his thoughts on the development of hypnotism (or, as he put it in an alternative title, "the youngest of the sciences") in a well argued paper that drew heavily on Alfred Binet and Charles Féré's recent *Animal Magnetism.* One of his concerns was whether free will was being undermined by hypnotism: "What appears to us to be our own choice may prove really to have been as unalterable and inexorable as fate—the unavoidable result of the sum total of suggestions which are acting upon us. As Spinoza remarks, 'the consciousness of free will is only ignorance of the causes of our acts.'"

On a more practical level, his own work at the Portsmouth eye hospital led him to take an interest in another Frenchman, Henri Parinaud, who was trying to make sense of people's perception of color under hypnosis. Arthur observed how "Parinaud the oculist at the Salpétrière" was examining the "colour phenomena apparent in the hypnotic state at the same time as Charcot was treating the subject from a more general point of view."

His comment emphasized the way in which various scientific disciplines were coming together. In 1885, shortly after embarking on his research into the analgesic effects of cocaine, the Austrian psychiatrist Sigmund Freud had visited Charcot in Paris to observe the effects of hypnosis at first hand, and the following year he published a German

translation of Charcot's *Lectures on Disorders of the Nervous System*. While Freud, from a mainstream scientific position, was putting the finishing touches to his theory of the unconscious, Myers, from an occult, was developing his concept of the "subliminal self" to account for paranormal experiences. The idea was that the personality was composed of several different selves, some of which, though not fully developed (for evolutionary reasons), were capable of paranormal communication.

For some later historians these parallel developments were part of a conspiracy by the professional classes to categorize and tame potentially antisocial behavior—whether it be madness, hysteria or talking in tongues. Thus the hidden depths of the mind and even the soul were beginning to be sorted and classified, in much the same way as the mysteries of the physical body earlier in the century. It was the latest phase of the great nineteenth-century scientizing project Arthur had embarked on when he became a doctor and which he subtly reflected in the character of Sherlock Holmes.

Arthur had personal reasons to feel pleased. As Myers' findings were rolled out over the next decade or so, they helped resolve something which had been troubling him, particularly in relation to his father. They seemed to confirm the existence of a subliminal self, or even soul, integrally linked with a person's identity and capable of surviving his death.

In the meantime Myers himself encouraged Arthur to maintain his interest in hypnotism, describing it as "a great field . . . for good work, and, before long, for fame, for a young physician taking to it." He suggested that Arthur should try to replicate some experiments made by his colleague Edmund Gurney, who only six weeks earlier had been found dead in mysterious circumstances, having asphyxiated himself with a dose of chloroform. Myers put Arthur in touch with a young hypnotist, George Albert Smith, who had worked closely with Gurney in Brighton. Smith's stage partner, Douglas Blackburn, later revealed that their "second sight act" had been a hoax. But that did not stop Smith from continuing to work closely with the Society, contributing a paper, "Experiments in Thought Transference," to its *Proceedings* in 1889. Ever the showman, he later turned his attention to moving pictures, overseeing such a range of technically innovative films that the twentieth-century producer Sir Michael Balcon would later describe him as "the father of British cinema." (Two of his early films, both produced in 1898, were *The Mesmerist* and *Photographing a Ghost*, which used the simple ruse of double exposure to produce the illusion of superimposed spirits.)

Throughout this period Arthur was working on the novel still called *The Problem of Cloomber.* When that was finally finished in July, he felt drained and may once again have tried to recycle some of his earlier work. This may also explain the confusion that has arisen around a dramatized version of *A Study in Scarlet* that was first announced in the *Portsmouth Crescent* on September 28, 1888. This play, titled *Angels of Darkness,* was curious because it made no mention of Sherlock Holmes, it concentrated on the Mormon sub-plot of the book, and it only introduced Dr. Watson at the end in a cameo role in San Francisco. Once again Arthur has been accused of dissimulating over the chronology of his work. In particular, it has been suggested that he wrote this drama before *A Study in Scarlet.* Although it is tempting to agree that this accounts for the bizarre division of the published story into two very different London and Utah sections, there is no evidence to support this thesis. Arthur made no mention of a play prior to *A Study in Scarlet.* Perhaps he saw a play as an opportunity to win back some respectability both for himself and for a story that had been tainted by its "penny dreadful" associations. So he picked at it over the next year or so, finally abandoning it in October 1890 when he wrote in his diary "Play 'Angels of Darkness' finished."

His general lethargy did not mean he was unproductive. He wrote "The Bravoes of Market Drayton," an unusual short story about peasant anarchy in Shropshire, not far from where he had once worked as a medical assistant. He also indulged his scientific leanings in an article for the conservative journal *The Nineteenth Century* on "The Geographical Distribution of British Intellect"—a rather pointless exercise in determining where the country's best minds came from. Claiming to base his findings on a survey of the birth places of 1,150 contemporaries, Arthur concluded that Scotland had the greatest concentration of "men of distinction," followed by England, Wales and Ireland. No doubt there was special pleading in his discovery that Edinburgh was three times more likely to produce superior intellects than London.

This was his modest sociological contribution to the Victorian debate about what constituted the "man of genius." Thomas Carlyle's theoretical speculations, to which Arthur had alluded in *A Study in Scarlet,* had been complemented by the research of scientists such as Francis Galton. In particular, the pioneering criminologist Cesare Lombroso had indicated a close link between genius and madness, positing, not unlike Wendell Holmes, that the man of genius was someone whose "madness" was a form of evolutionary compensation for excessive intellectual development. In this way Arthur was able to ventilate his con-

cerns about his father and suggest that, although Charles was in an asylum, his condition was not too far removed from genius.

A further reason for a hiatus in Arthur's affairs was that, some time in mid-summer, Louise learned she was pregnant. Since this came almost three years after her marriage—a long period in Victorian terms—it is possible that she had had difficulty conceiving and this had contributed to Arthur's listlessness after he had finished writing *Micah Clarke*. Luckily Lottie returned from Portugal in August and was able to go down to Southsea to help. This freed Arthur to travel to Southampton to attend the inaugural meeting of the Hampshire Psychical Society, of which he had agreed to become vice-president. He was also happy to recycle his lecture on Carlyle to Portsmouth's Jewish Literary and Debating Society.

In October his anxious wait over *Micah Clarke* came to an end when the novel was finally accepted by Longmans. This was good news because it was an established publishing house, the London equivalent of Blackwoods. Despite his reputation as a high-minded folklorist and man of letters, its reader, Andrew Lang, was also a great advocate of the manly romance or adventure story.

Having introduced the novels of Rider Haggard to the reading public, he now endorsed Arthur's book, though he was clear that, running at 170 pages more than Haggard's bestselling *She*, it needed radical pruning. Arthur reluctantly removed ten pages and asked Lang to suggest further cuts while he fulfilled a long-standing obligation to take Lottie and Louise's older sister Emily (known as Nem) on a trip to Paris. (Lest his mother should think he was squandering money, he informed her that Lottie's fare had been paid by Nem and her mother Mrs. Hawkins. Always attentive to the Mam's needs, he returned with a gift of a smart bracelet he had bought for her at the Palais Royal.)

As a tourist in the French capital Arthur also visited the Louvre, which soon emerged as a suitable backdrop for "The Ring of Thoth," a macabre story that mixed Egyptology and the occult, told with the verve of Rider Haggard, though he claimed to be disappointed in this author's *She* when he read it around the same time. In its evocation of a man's love for a mummy (or, more accurately, of a reincarnated Egyptian's attempt to free his former lover's soul from its mummified earthly form), Arthur's story was one of the first of a genre of "mummy tales" and is often credited as the source for Boris Karloff's film *The Mummy*. Arthur found an eager buyer in Payn at the *Cornhill*, who told him jocularly that the "Ring" would fit.

Having at last found a publisher for *Micah Clarke*—and made contact with such an influential critic as Lang into the bargain—Arthur found himself thinking more deeply about the craft of writing. His role model continued to be his Edinburgh near-contemporary Robert Louis Stevenson, whose story *The Dynamiter* had been in his mind when he wrote *A Study in Scarlet*. Similarly *Cloomber* had drawn on Stevenson's "The Pavilion on the Links" for its setting and ambience, though Arthur told his mother frankly that she should not think it was better than its model, which had stronger characters and did not rely on supernatural assistance. He had no such inhibitions about *Micah Clarke*, however, telling her that she would be correct in considering it superior to two of Stevenson's historical novels, *Kidnapped* and *The Black Arrow*.

He was shortly to turn such thoughts into an article on Stevenson's methods in fiction for the *National Review* that reiterated his admiration for his fellow writer's range and sheer ability to tell a story. Stevenson was the master of Arthur's ideal of the true romance, "a modern, masculine novel," which did not see love and marriage as the "be-all and end-all." This was his unaffected input into the ongoing debate on where the novel was going. Commentators, such as Lang, were anxious about the threat to fundamentals of old-fashioned story-telling from ideas of realism and decadence emerging from the European Continent. Arthur's response reflected in part a sexual prejudice that, since Dickens and Thackeray, the influence of George Eliot and her female successors had become too dominant in English letters, and in part an unconscious reaction to the state of the world, with new frontiers opening up and waiting to be conquered, along traditional male lines.

Influenced by Payn's repositioning of the *Cornhill* and by his own experiences over *A Study in Scarlet*, Arthur also argued that it was not a crime for an author to be popular. "The final court of appeal" as to any work's merit "must always, in the long run, be public opinion," he wrote. "And that slow-going and ponderous tribunal must be given at least a generation before being asked for its final decision. When it does say its last word, however, it is seldom or never wrong." This was an important statement of Arthur's approach to writing: despite regular protestations of his ambition to create great literature, notably in historical novels, he was a product of his democratic age, and the final arbiter of his work would be the public, rather than the critic.

More pressing was a lecture on the Portsmouth-born novelist George Meredith, which he was due to give to the Literary Society a

week after his return from Paris. With a voice that was soft and clear but forceful, he was always a popular speaker, though a friend later found his accent difficult to place. "It had an unfamiliar intonation; sounded outlandish, like the talk of shepherds in Cumberland, or the local exchanges one hears in the hill countries, Welsh for instance. Finally I fixed it as Northumbrian, all burrs and sing-song." This was not a bad attempt at identifying an Anglo-Scottish burr with perhaps a hint of Irish in it. On this occasion it transpired that Arthur thought Stevenson had been strongly influenced by Meredith, whom he declared to be much better than any modern writer. Arthur particularly admired Meredith's controversial, sexually explicit novel *The Ordeal of Richard Feverel*, perhaps warming to its description of a problematic father-and-son relationship. "To read Meredith is not a mere amusement," he later wrote; "it is an intellectual exercise, a kind of mental dumb-bell with which you develop your thinking powers. Your mind is in a state of tension the whole time that you are reading him." Finding his books suddenly popular in the local library, Meredith wrote to thank Arthur for his talk, and a valuable personal relationship ensued.

On November 21, the day after his lecture, Arthur traveled to London to discuss cuts to *Micah Clarke* with his publisher. Lang took him to the Savile Club where the young doctor was still unaffected enough to be excited about sitting at the same table as the novelist Walter Besant and the critic George Saintsbury. He was beginning to find his bearings in London's complex literary society. Meeting Besant was particularly significant since, like Lang, Stevenson and Payn, he was a keen advocate of traditional English storytelling. He had recently completed a novel, *For Faith and Freedom*, which, like *Micah Clarke*, was about Monmouth's rebellion. And he was the founder of the Society of Authors, which was beginning to lobby for writers as a profession. The two men had probably first met earlier in the year when Arthur had taken Louise to a civic banquet for the bearded, bespectacled Besant who, like Meredith, had been born in Portsmouth.

What would now be called networking was part of the secret of Arthur's success. It came naturally to his outgoing nature. On his return to Portsmouth he found in a periodical a photograph of Lang and Haggard that he sent to his Savile Club host. Lang reciprocated by puffing the book version of *A Study in Scarlet* in his influential "At the Sign of the Ship" column in *Longman's Magazine* in January 1889.

As the author of a recent story about a London-based detective, Arthur might have taken an interest in the spate of horrific murders of

young women, almost all prostitutes, that had recently occurred in the city's East End. However if he inquired about what became known as the Jack the Ripper affair, he kept quiet about it, and had to suffer the ignominy of a satirical article in a Portsmouth paper calling on him, as a known spiritualist, to use his psychic powers to solve the murders that were front-page news. Similarly he made no mention of the Bryant & May match girls' strike that summer in much the same area of London. This was a significant event in trade union history, and all the more notable for being led by Walter Besant's sister-in-law Annie, who would shortly swap political agitation for the spiritual comforts of theosophy.

Arthur was more concerned for the moment with personal ambitions. Buoyed by his reception in the capital, he returned to Southsea with renewed purpose. He told his mother he had embarked on reducing the length of *Micah Clarke,* but he still intended to spend time on a range of other activities, from studying the eye to astronomy. Not surprisingly, he had the usual author's niggles to contend with. True to form, Ward Lock tried to wheedle out of paying him for the pictures his father had provided for the book version of *A Study in Scarlet.* After denying they owed him anything, they eventually settled on a paltry 5 pounds. Then his father's friend, James Hogg, the Scottish bookseller who had run a shaky London operation, went bankrupt. Arthur claimed he had lost nearly 10 pounds in unpaid royalties on stories from Hogg's *London Society* that were included in the collection *Dreamland and Ghostland* published by George Redway the previous year. But these setbacks were trivial compared with the extraordinary advances he had recently been making in his overall writing career.

Birth of a Daughter

1889–1890

Arthur was fortunate that his medical practice ticked over without problems. So he was at home at Bush Villas at 6:15 on the morning of January 28, 1889, and able to deliver his first child, a plumpish girl with blue eyes and bandy legs. Over the previous few months he and Louise had become quite competitive about who would produce first. He seemed mildly put out that the infant Mary Louise (a combination of the names of his mother and wife) arrived before *Micah Clarke*, and he vowed that his fictional offspring would not be far behind.

Shortly after Mary's birth he was back at his desk, working through one whole day from 10 A.M. to 7:30 P.M. to complete his final revision of the proofs of *Micah Clarke*. At this late stage, he managed to cut another couple of pages and make further alterations—mainly, changing modern words into shorter "Saxon" ones. But such author's chores did not give him an excuse to neglect his more personal duties. He told his mother that he had to go out shopping as he was now in charge of the housekeeping.

With *Micah Clarke* finally out of his hands, he could again think of other projects. Once more he dusted down the manuscript of his long-gestated novel *The Firm of Girdlestone* and sent it to Longmans, hoping, wrongly, that although they had rejected it as long ago as 1884, they might now have second thoughts. Realizing he would have to skip nimbly between his literary and money-making ambitions, he seriously considered embarking on "The Inca's Eye," a boy's adventure book in the Rider Haggard style.

While this promising-sounding idea never reached the page, two others that he sent to Longmans were unceremoniously turned down.

One was "The Great Brown-Pericord Motor," which he described as his "flying machine story," about two inventors who coexist on strictly demarcated Holmes-Watson lines as they work on developing an airplane: "I invent, you build. It is a fair division of labour." But their relationship is always fragile, and when one is accidentally killed during a quarrel, the other pulls the plug on their project. After rejection by Longmans the piece made the rounds of *Temple Bar* and *Tit-Bits* before finding a berth with Joseph Tillotson, a printer that specialized in syndicating to the provincial press.

A similar fate awaited "A Physiologist's Wife," a better story which also deals with a clash of personalities. It tells of a cool, rational medical professor who might have been echoing Holmes in his remark, "Romance is the offspring of imagination and ignorance. Where science throws her calm, clear light there is happily no room for romance." After finding a prospective wife, he improbably discovers that she was once married in Australia to a colleague called O'Brien who belabors the point (clearly significant to Arthur) of his very different racial nature: "You would have me take out my Celtic soul and put in a Saxon one." When, shortly after this revelation, the professor dies of a wasting disease, ascribed to a cardiac complaint, his doctor says that, if the deceased had not been so unemotional, he would say he had died of a broken heart. Once again Arthur was making a point about the incompatibility of different temperaments—in this case, reason and passion. Once again he had to work to get it published. After Longmans, Arthur sent it to the *Cornhill* and to *Blackwood's* which, only after repeated inquiries, finally acceded, giving him the kudos he had long sought of being published in the *Maga* in September 1890.

Meanwhile he kept up his interest in the supernatural. When a Belgian stage hypnotist, "Professor" Milo de Meyer, came to Portsmouth to give a presentation at the Portland Hall, Arthur joined a small group of local professional men who were invited to witness a more intimate demonstration of the maestro's "animal magnetism." But while several of the city's great and good responded to de Meyer's hypnotic suggestions—falling asleep while he was out of the room, for example—Arthur proved a poor subject. As the *Evening News* reported, "An attempt to magnetize Dr. Doyle in a similar manner failed, the Professor remarking, after the attempt, that the process would take too long."

At the end of February *Micah Clarke* was finally published in a modest edition of 1,000 copies. Arthur immediately wrote to several friends

urging them to order the book for their libraries. (He did not include the Ryans or other Roman Catholics, because he feared they might take offense at its unorthodox religious views.) This proved a successful ruse because the first impression was sold out within a month, and a further 1,000 copies were printed, with 2,000 more later in the year. As usual he collected his reviews and was gratified that they were generally favorable.

Shortly afterward Louise and baby Mary came downstairs for the first time. His chubby daughter laughed a lot, particularly when looking at her father, whom for some reason she seemed to think irresistibly funny. Within two weeks, however, her screams had become unbearable and he decamped to sleep alone in an upstairs room.

Perhaps to get away even further, he was working three hours a day at the eye hospital. Informing Lottie of this development, he added that this did not mean he had abandoned his plans for the future—about giving up his general practice and training as an eye surgeon. Once he had changed rooms at home and could enjoy a little more quiet, he was at least able to indulge in some reading—a couple of minor novels by J.M. Barrie and David Christie Murray, a timely treatise on *Ophthalmic Science and Practice*, and Winwood Reade's *The Martyrdom of Man* (the last doubtless for a second time since he had mentioned its author in "The Narrative of John Smith").

Arthur's booklist also included several volumes on medieval history, including William Warburton's biography of Edward III and Henry Hallam's classic *Europe During the Middle Ages*, which left him pondering on the frightening authority of the Vatican. He was clearly developing some theme because on February 26, he attended a lecture on fourteenth-century trade and commerce at the Literary Society, while his notebooks filled up with colorful details of exotic pieces of military hardware such as aspen arrows with goose or peacock feathers.

His intentions became clearer when, toward the end of April, he abandoned his domestic duties and took a week's holiday with his friends Drayson, Boulnois and Dr. Vernon Ford. The four men rented a cottage in Emery Down, a peaceful village on the edge of the New Forest, just beyond Lyndhurst. Getting there was not easy: there would be no direct train service between Portsmouth and Southampton until the following year, so they had to travel inland via Bishopstoke Junction (now Eastleigh) where—Sherlock Holmes would later revel in such details—they caught the main London and South Western Railway to Southampton and thence to Lyndhurst Road station.

They could not have chosen a better time: it was the height of

spring, and the surrounding countryside—a medley of ancient heath, bog and woodland—was cloaked in brilliant green. Before long Arthur would use this setting for the opening chapters of a historical novel about three young Hampshire recruits to the White Company of bowmen who act as mercenaries on French soil during breaks in the Hundred Years' War. *Micah Clarke* had stuck firmly to English locations and could not escape its essential Protestant triumphalism. This new work would be more European in scope, it would place greater emphasis on historical exactitude, and it would champion manly virtues of courage and comradeship rather than more abstract notions of freedom of conscience. It would be a true Langian "romance": more than ever, a tribute to his mother and to the chivalric ideals she had inculcated in him from an early age.

The story starts in the ancient Cistercian abbey of Beaulieu, seven miles from where he was staying. Arthur doubtless accompanied his friends on long walks, visiting not only the Abbey but also surrounding places that were to feature in his book such as Denny Wood, Hatchet Pond and, slightly to the north, Minstead, where he would later be buried. This was a part of the country he loved, as was clear from his descriptions in *The White Company*, as his book would be called, of the "magnificent forest of the very heaviest timber, where the giant bowls of oak and of beech formed long aisles in every direction, shooting up their huge branches to build the majestic arches of Nature's own cathedral." Not once but twice in the Sherlock Holmes canon does Dr. Watson, when frustrated by the confines of London, "yearn for the glades of the New Forest or the shingle of Southsea."

The three protagonists in *The White Company* recalled Alexandre Dumas' *The Three Musketeers*, which Arthur had read appreciatively a few months earlier. They reflected differing aspects of Arthur's own character, particularly John of Hordle, who takes his name from another local village, and who, because of his worldliness, is expelled from the communal certainties of the abbey (read: the dogmatical confines of Catholicism) and is forced to find his way in the outside world.

Arthur would have known that Hordle had until recently been home to the Children of God, a utopian religious community, otherwise known as Shakers or Girlingites after their charismatic leader Mary Ann Girling. After being evicted from New Forest Lodge, they camped in the vicinity where, in the face of official opprobrium, their case was taken up by supporters of spiritualism. After Girling's death in 1886 the sect fell apart, but for a decade its activities and beliefs had

seldom been out of the newspapers, helping reinforce the idea of the New Forest as a place of supernatural potency, epitomized, *inter alia*, by the myth of William Rufus, King William II, who was killed near Minstead by an arrow fired inadvertently by a hunting companion.

Even after this short familiarization tour, Arthur was undecided about where his research was taking him. He contacted the publishers, Macmillan, offering to write a life of Edward III's heroic military commander Sir John Chandos for their *Men of Action* series. He explained that he was "well up" in Froissart and the Middle Ages, and so could "compile all that is known of him in a readable shape if we could come to terms." He added self-effacingly, "You may possibly have heard my name as the author of a book called 'Micah Clarke.'"

Back in Southsea he again took up the cudgels on behalf of his beliefs. Adopting the pseudonym "Spiritualist," he fired off a letter to the *Evening News*, defending the practice of spiritualism which had been pilloried at a public meeting in Southsea as "an old snake of Satan's in a new dress." Arthur used a now familiar argument: "When any new form of knowledge arises above the mental horizon of the human race there are always a certain number of well-meaning but narrow-minded men who are ready to denounce it as being opposed to Scriptural teaching." And he quoted Sir James Simpson as example of someone whose invention of chloroform had been denounced as contrary to Divine ordinance.

A couple of days later he was able to relax on the cricket pitch, scoring 111 not out for Portsmouth against the Royal Artillery. He also kept up his political interests, representing the Liberal Unionists in June in organizing an all-party meeting where the Chief Secretary for Ireland, A.J. Balfour, defended the anti–Home Rule policies of his uncle Lord Salisbury's Conservative government.

By then Arthur had celebrated his thirtieth birthday with the minimum of fuss, and it was Louise's turn to have a holiday. So, accompanied by baby Mary, she joined her mother, who had taken a place on the Isle of Wight. A couple of months later Arthur was able to go back to the New Forest to continue working on his historical novel—alone this time but for the company, he claimed, of 150 essential books.

Arthur began writing *The White Company* on August 19, 1889. But he put this project to one side later in the month, when he received an unexpected invitation to dinner from Joseph Marshall Stoddart, the influential managing editor of *Lippincott's Monthly Magazine*, based in Philadelphia. Stoddart was over in London trying to set up a British

version of his periodical which specialized in printing full-length novels. Transatlantic relations in the books trade were beginning to improve, following a troubled period when British authors had been mercilessly pirated in the United States—a practice which may have helped their reputations but which was bad for their bank balances. Now, in advance of anticipated changes in U.S. copyright law, some forward-looking American publishers were making an effort to preempt the market and sign British authors directly to their companies. Running a magazine was a useful way of attracting writers to their literary stables.

Stoddart had linked up with Ward Lock to publish the British edition of his magazine. Arthur was unlikely to have been recommended by that company, in view of their difficult relationship over *A Study in Scarlet*. But Stoddart had managed to secure the editorial services of Ward Lock's George Bettany, the man whose wife had promoted the merits of that work. So he is likely to have heard favorable comments from him, as well as from James Payn (or so the latter claimed).

Arthur was invited to meet his American host at the fashionable Langham Hotel in Portland Place where, on what proved to be a "golden evening," he was introduced to two additional guests. One was the Irish journalist and MP Thomas Patrick Gill, who, despite his unsavory Parnellite politics, proved "entertaining"; the second, another Irishman called Oscar Wilde who had a colorful reputation as a wit, raconteur and leading exponent of the contemporary cult of aestheticism.

Arthur and Wilde may well have known each other—through their families, if nothing else. The latter's father, Sir William Wilde, had been an eminent Dublin eye and ear surgeon (a profession that would not have escaped Arthur's notice), while his mother was once, before decamping to London, a noted literary figure in Irish nationalist circles. Oscar himself had contributed to some of the same English magazines as Arthur, such as *The Nineteenth Century*. He immediately endeared himself to his fellow guest by saying he had read *Micah Clarke* and enjoyed it. "His conversation left an indelible impression upon my mind," Arthur later recalled. "He towered above us all, and yet had the art of seeming to be interested in all we could say. He had delicacy of feeling and tact, for the monologue man, however clever, can never be a gentleman at heart. He took as well as he gave, but what he gave was unique."

Arthur's response reveals his openness and good nature. Coming from a provincial city, he had only just begun to make his way in liter-

ary society and had yet to encounter many such dilettantes. Ostensibly the values of the romances he aspired to write were different from theirs. But he was never easy to typecast, and, in challenging accepted interpretations of time and space, some of his shorter stories were striving for effects not so different from theirs. Finding this natural rapport with Wilde gave him a sense of belonging to a community of artists and added to his sense of his own worth.

The upshot of the evening was that Stoddart commissioned works from both authors. Wilde went away to ponder a story that later appeared as *The Picture of Dorian Gray*, while Arthur agreed to put his mind to a project still undefined. The fact that the details had yet to be finalized did not stop Stoddart from preparing a letter of contract— apparently, that very night. Arthur was offered a fee of 100 pounds for a contribution of not less than 40,000 words, and this was just for magazine use: with book publication and serial rights, he stood to earn significantly more. Since no one (apart from the editor of *Gas and Water Review*) had hitherto taken any of his stories, let alone given him money, before he had put pen to paper, he returned to Portsmouth very satisfied.

Within four days he was writing to firm up the subject matter. Not for the first time he may have drawn on earlier work, because he informed Stoddart his story would be called either "The Sign of the Six" or "The Problem of the Sholtos"—the first of these names being not so different from his discarded "The Sign of the Sixteen Oyster Shells." "You said you wanted a spicy title," he said, without great conviction. And then came his bombshell. "I shall give Sherlock Holmes of *A Study in Scarlet* something else to unravel. I notice that everyone who has read the book wants to know more of that young man. Of course the new story will be entirely independent of *A Study in Scarlet* but as Sherlock Holmes & Dr. Watson are introduced in each, I think that the sale of one might influence the other."

This was the moment Arthur decided to extend the life of his detective. For the next month he worked on the sequel, doing little else as he cantered through an account (influenced by Wilkie Collins and Robert Louis Stevenson) of the murderous efforts of Jonathan Small and his fellow conspirators to regain their shares of the purloined Agra treasure. Again Arthur moved between two very different locations— modern London and India around the time of the Mutiny, aided no doubt by local military friends. But he was now more adept at integrating the elements of his story. From the first page, where Holmes is introduced injecting himself with a seven percent solution of cocaine,

his character is more clearly realized. In *A Study in Scarlet* his wider intellectual interests were skated over, but in "The Sign of the Four" (as it was initially called—the second "the" was later dropped) Arthur, inspired by meeting Wilde and by the knowledge that he was no longer writing directly for the "penny dreadful" market, had no such inhibitions. Holmes is now emphatically the cultured modern "consulting detective," who is effortlessly superior to the plodding journeymen such as Detective Inspectors Tobias Gregson, G. Lestrade and Athelney Jones, produced by Scotland Yard and other police forces.

The story moves at a cracking pace as Holmes careers over London, with his band of urchins, the Baker Street Irregulars, helping him track down his suspect, leading to a dramatic boat chase on the river Thames. Although still casual about details (this time Sikhs have Muslim names), Arthur's enjoyment is clear: he gives Thaddeus Sholto some of Oscar Wilde's traits, he makes knowing references to the Langham Hotel, he describes Winwood Reade's *The Martyrdom of Man* as "one of the most remarkable [books] ever penned," and he refers to Jonathan Small coming from near Pershore in Worcestershire, the birthplace of Amy Hoare.

His biggest tease was an in-joke about his own craft. Holmes chides Watson for writing *A Study in Scarlet* as a romance, thereby failing to stick to the facts that are at the core of detective work. ("Honestly, I cannot congratulate you upon it. Detection is, or ought to be, an exact science and should be treated in the same cold and unemotional manner. You have attempted to tinge it with romanticism, which produces much the same effect as if you worked a love-story or an elopement into the fifth proposition of Euclid.") This reflects Arthur's new conviction about his aims as a novelist. He sees himself in the tradition of Stevenson and Lang, and would later describe his Holmes output as situated in the "fairy kingdom of romance," confirming it as a clever commercial update of the chivalric tales beloved by his mother.

In defiance of his own caveats about using marriage in a novel, he introduced a love interest when Dr. Watson falls for Mary Morstan, the girl at the center of the intricate plot. These impending nuptials threaten to leave Holmes on his own once again (perhaps signaling that Arthur had no intention of resurrecting the partnership). Not that Holmes gave any indication of hoping to follow his flatmate out of bachelorhood. When Miss Morstan first consults him at Baker Street, Dr. Watson remarks with enthusiasm on her attractiveness. Clutching his pipe, Holmes leans back and notes languidly, "Is she? I did not observe." This ridiculous statement cuts to the heart of the

detective's elusive appeal, for his whole existence is about observing. As a result Dr. Watson can only exclaim exasperatedly, "You really are an automaton—a calculating machine. There is something positively inhuman about you." Holmes relishes this suggestion, for he smiles gently and launches into a short diatribe on the importance of not letting one's judgment be clouded by emotion.

On September 30 Arthur could write in his diary that "The Sign of the Four" was finished and dispatched. The following day he addressed Stoddart about his work: "It has the advantage over *The Study in Scarlet* not only as being much more intricate, but also as forming a connected narrative without any harking back as in the second part of *The Study*. Holmes, I am glad to say, is in capital form all through."

Arthur's star was now in the ascendant, and both he and literary London knew it. While successive editions of *Micah Clarke* heralded a change of status, news of the impending publication of *The Sign of Four* confirmed it. Eager to capitalize on *Micah Clarke*'s success, Arthur had sold serialization rights in *The Firm of Girdlestone* to the Globe Syndicate in June for 240 pounds, by far the largest sum he had ever earned. He celebrated the following month by spending 215 pounds on a couple of mortgages, the start of a substantial portfolio of investments that would help make him a rich man.

Determined as ever to capitalize on his new-found reputation, Arthur wrote to Chatto & Windus in late October, shortly after *Girdlestone* first appeared as a serial in *People*. He enthused about his sales elsewhere and asked if the firm—owners of *Belgravia* magazine, where his story "The Great Kleinplatz Experiment" had been published—might be interested in putting out a hardcover edition of *Girdlestone*. He offered it for outright sale at 500 pounds, letting slip that he intended moving to London and therefore needed the money. As he had indicated to Lottie, he had been toying with such an upheaval for at least eighteen months, but this was the first time he had gone public.

While Chatto & Windus made up their minds about *Girdlestone*, Arthur pocketed a further 60 pounds, with the promise of twelve percent royalty to come, by selling American rights to the book to Wolcott Balestier, a highly strung young American who was beginning to develop a wide range of literary contacts in his capacity as resident London agent for the American publisher John W. Lovell.

Arthur also set about finding a publisher for an anthology of his earlier stories. To his annoyance, one of these, "The Secret of Goresthorpe Grange," had appeared without his authorization in a book, *Strange Secrets*, put out by the same Chatto & Windus in June.

The culprit there had been James Hogg, who had risen from the ashes and was trying to make money from rights he owned in stories he had published in *London Society* at the start of Arthur's writing career. Using his new-found clout, Arthur prevailed on Longmans to bring out his own selection in March 1890 as *The Captain of the Polestar and Other Stories*, complete with a dedication, "To my friend Major-General A.W. Drayson, as a slight token of my admiration for his great and as yet unrecognized services to Astronomy." He was livid to find that he was again outmaneuvered by Hogg, who arranged for seven of his old *London Society* stories to be collected in a shilling edition published by the firm of Walter Scott under the title *Mysteries and Adventures*, trumpeting that they were by A. Conan Doyle, "author of 'Micah Clarke.'" Arthur disowned this book, telling a newspaper editor that the less it was reviewed or even read the better.

The new year had started badly with the news that Arthur's valiant sister Annette was seriously ill with pneumonia in Lisbon. She had spent a year in Brazil in 1887–88, but had returned to Portugal to be close to her two sisters. Arthur wired offering to come to her bedside, but his mother talked him out of this, and went herself. She reached Lisbon three days before her first-born child died on January 13, 1890. Arthur was not certain that Annette even recognized her mother. In mourning her death in a letter to his alternative "Mam," Amy Hoare, he noted that, at just thirty-three, Annette had passed away shortly after their brother Innes had succeeded in his preliminary examination to enter the Royal Military Academy at Woolwich, and he felt this indicated the intervention of some higher power that recognized her work had been completed. She had also died intestate, so letters of administration were obtained, leaving her estate, worth 420 pounds, to be used for the benefit of her father, who was unambiguously described as a "lunatic" in the accompanying document.

This legal directness removed any sentimental doubt about Charles's state. After his lackluster attempts to illustrate his son's books, he was still firmly confined to Sunnyside. But he himself was determined to make one more attempt to gain the recognition that had so far eluded him. In early 1889 he had started an illustrated diary as a showcase for his childlike imagination. "Keep steadily in view," he noted on its first page, "that this Book is ascribed wholly to the produce of a MADMAN? Whereabouts would you say was the deficiency of intellect? Or depraved taste? If in the whole Book you can find a single Evidence of either, mark it and record it against me."

For a few months he filled this book with extraordinary images. With their whimsical, sometimes morbid, supernatural themes, his drawings veered vertiginously between charm and menace, providing searing insight into the devils that gnawed at his soul. They sat side by side with sketches of stark realism and occasional wry cartoons, confirming the impression of him as a gentle family man unable to cope with reality. One drawing shows him reading with a cat draped around his neck. "Where pussy used to sit at home," reads the caption. "Observe her observant critical look, friendly but sorrowful." Another provides a stark example of his mental turbulence. It depicts an angry sphinx devouring an artist trying to sketch the pyramids, under which Charles himself writes, "When I was drawing the Royal Institution, Edinburgh, I was a good deal worried by sphinxes." His brooding about these mythological beasts must have permeated the Doyle household, perhaps sparking his young son Arthur's curiosity about paranormal powers.

Despite his generally benevolent tone, Charles could not avoid giving vent to his frustrations. "I am certain if my many Vols. of, well, I'll not say of serious Work, were organized into some form submittable to the Public they would tickle the taste of innumerable men like myself—and be the Source of much Money which I should like to bestow on my daughters, but Imprisoned under most depressing conditions, what can I do?" He suggested that he had been "branded as Mad solely from the narrow Scotch Misconception of Jokes" and railed against "utterly false conceptions of sanity and Insanity [which work] to the detriment of the life and liberty of a harmless gentleman."

An unexpected feature of the text was the strength of Charles's Irish feeling. At one stage he describes the Act of Union between England and Ireland as "quite Illegal." He draws a bedraggled agricultural worker, describing him as "what an Irishman was, and is always believed to be under British rule," and compares him with a sleek elegant figure in a suit—"what the Irishman certainly is under American rule." His nationalism is moderated with family affection in a touching self-portrait of him with a young woman, and the rubric "Mary, my ideal Home Ruler No Repeal of the Union proposed in this case."

This suggests that Charles hung on to his Celtic identity. No doubt it contributed to his artistic temperament. But it would have made him (and his cause) suspect in Protestant Edinburgh, both in the workplace and, to an extent, in the home. By contrast, his wife never made much of her Irishness. She encouraged her son to be skeptical of Charles's whimsical brand of fantasy, which she could not help link-

ing with madness, and instead to channel his imagination into more realistic and manly historical ideas, such as the medieval novel he was writing.

Arthur did his best to accede, but could not help occasionally looking at the world through his father's more visionary eyes. This did not happen often, as he had little time for the tenets of Charles's Catholicism. But, try as he might, he could not avoid the emotional impact of this faith. Another of Charles's diary entries showed him shaking hands with a skeletal Death, over the words "Well met," and a penciled note: "I do believe that to a Catholic there is Nothing so sweet in life as leaving it. Glory be to God." And that sort of conviction was powerful. As a result, even in his more skeptical phases, Arthur could not let go of the idea that the soul has an afterlife: it was at the root of his spiritualism. And at the same time he wrestled with the concept that Charles's "madness" might not be far removed from genius.

For the time being Arthur's attention was focused on more earthly matters. In February 1890 *The Sign of Four* appeared to great acclaim, followed over the next couple of months by the story collection *The Captain of the Polestar* and the novel *The Firm of Girdlestone*. Catching himself boasting of *Micah Clarke*'s sales figures, which were fast approaching 10,000 copies, Arthur was aware enough to observe that the business of writing was not good for a man's character as it made him conceited.

With this in mind, he took time off from completing *The White Company* and arranged an event to commemorate his friend Percy Boulnois' service to the community. The Borough Engineer was leaving to take up a similar post in Liverpool and, in time-honored municipal style, was presented with a gold watch (and a white marble clock for his wife). Arthur was also able to attend a lecture at the Literary Society on "Witches and Witchcraft." True to form, when he proposed a vote of thanks to the speaker, he could not help pointing out, "Modern Science, far from having destroyed the original idea underlying this topic, has gone some way to confirm it."

Then in early July he finally finished his magnum opus, the novel. He was so delighted that he threw away his pen, spattering the blue wallpaper. "The first half is very good," he told Lottie triumphantly, "the next quarter very good again, and it ends with the true heroic note."

Completing the book gave him the confidence to take the important step of finding himself a literary agent. The choice was not difficult: Walter Besant had recently recommended A.P. (Alexander) Watt to

another aspiring author, Rudyard Kipling, and he is likely to have done the same to Arthur. Like Besant himself, the Scots-born Watt was involved in many aspects of publishing. Apart from being a forceful and canny agent whom Kipling credited with doubling his income, he had dealt in property, represented both *Blackwood's* and the *Art Journal*, and would soon take responsibility for printing *The Author*, the magazine of Besant's Society of Authors.

Over the summer Arthur allowed himself the luxury of playing a lot of cricket, his preferred form of exercise which he was convinced also helped improve his work. He told Lottie in early July that he had never felt better, though by the end of the month he had strained his back in a game and was in such pain that he was unable to take to the field again that season. His condition was not improved by his having to look after a vacationing colleague Dr. Claude Claremont's practice, nor by having to take his visiting sister Ida to her first ball at Goodwood.

During this period he must have mentioned *The White Company* to Watt for, in his first known letter to his new agent on September 23, 1890, he half apologized for having already received a direct offer for it. For he had sent the novel to *Blackwood's* in July, asking 300 pounds for serial rights. But they had shown their customary slowness, so before they replied, he had agreed on terms with his friend James Payn who, in a reversal of his previously negative views about historical novels, proved unusually enthusiastic, offering 200 pounds for serialization in the *Cornhill*, plus a further 250 pounds for publication in volume form by the magazine's sister company, Smith, Elder.

Almost in mitigation Arthur sent Watt a story called "A Straggler of '15," a poignant old man's recollection of his minor heroics at the battle of Waterloo, which he claimed to be particularly satisfied with. He added that he had been used to getting three guineas for his stories, and *Macmillan's Magazine*, not one of his usual outlets, had recently expressed an interest in taking something from him. But Watt turned to *Black and White*, an ambitious new weekly review covering literature and the arts, to make an immediate sale. By September 25, two days after his initial inquiry, Arthur was happily telling his agent that his suggested terms were excellent and he proposed leaving him to negotiate all further details, though, recalling his problems with Hogg, he made it clear that he wanted to retain book rights. Watt clearly asked for another story, for the next time Arthur wrote he was apologizing that he could not say when he could do this as he was busy, but he hoped he would have something within a month to six weeks.

This last letter was not written in his usual neat, well-rounded hand.

For, as evidence of his professionalism, he had just bought a second-hand Remington typewriter from Bessie Sala, whose flamboyant husband George had made his name as one of "Dickens's young men" in *Household Words*. Although she had originally wanted 20 pounds for her machine, Arthur seized on the fact that there was an unspecified click in its action to offer her half that sum, which was accepted. Before long he was devising schedules for his sisters to type his story drafts.

He dragged himself through the usual early autumn schedule of municipal gatherings and sporting events. But his mind was elsewhere and, in mid-November, he decided, apparently on the spur of the moment, to travel to Berlin to attend a demonstration of a cure for tuberculosis by Professor Robert Koch, the German bacteriologist about whom he had written favorably a few years earlier. Koch had subsequently made advances in the study of cholera and had recently returned to the University of Berlin to pursue his research into tuberculosis.

Looking back Arthur could never explain what led him to make this sudden move. Tuberculosis was not his speciality and, despite his positive response to medical innovations such as chloroform and vaccination, he was skeptical of Koch's claims of a breakthrough in this field. His interest seems to have been sparked by a report on the subject in the *British Medical Journal* of November 15. He packed his bags and was on his way within hours, pausing only (perhaps at the behest of his new literary agent) to call on W.T. Stead, the crusading editor of the Liberal-inclined *Pall Mall Gazette* and now the *Review of Reviews*, who promised to take an article on his return and who gave him, as requested, letters of introduction to the British ambassador and *The Times* correspondent in Berlin.

On the train to Germany, Arthur befriended a smart London doctor who was going to the same conference. His name was Malcolm Morris, a skin specialist from St. Mary's Hospital, with pronounced views on public health. But neither Stead's contacts nor Morris's company could save Arthur from being barred from attending the demonstration he had traveled to see. According to Arthur, Professor von Bergmann, who was presenting the tuberculosis findings on Koch's behalf, was motivated by anti-British prejudice. Luckily Arthur was helped by an American physician, Dr. Henry J. Hartz from Detroit, who enabled him to gain access to the German doctors' wards and, the following day, Arthur penned a letter to *The Daily Telegraph* recording his doubts about Koch's process, which involved specially treated lymph. By the time this was published on November 20 Arthur was himself

back in London, from where he gave a somewhat different impression to Dr. Hoare in Birmingham, boasting that he had been the first person to leave Berlin with knowledge of Koch's process and that in three months' time he would have the necessary lymph himself. Then, he suggested, "If you have a lupus case, we might do it. Eh?"

Three days later he returned to Portsmouth where, the following day, he gave an interview to the local *Evening News* announcing his intention to give up his practice and leave the town for good. Such a move had been on the cards for at least eighteen months. But now, all of a sudden, he decided that the appropriate moment had arrived.

Everything had moved so quickly that it is hard to work out exactly how events unfolded. Arthur claimed his decision was prompted by a long talk with Malcolm Morris, who told him that his talents were wasted in the provinces and encouraged him to come to London. When Morris learned that Arthur was interested in eye surgery, he suggested his new friend should undertake further studies in this field in Vienna before settling in London, where, with a respected specialty, he would be able to earn enough to consult and write at the same time.

Having publicized his departure, Arthur had a mass of chores to complete. On a professional level he needed to arrange for his patients to be transferred to his usual stand-in, Dr. Claremont. More personally, his brother Innes had been living at Bush Villas since October after failing the final stage of his army exams. He had come to Portsmouth to attend Grammar School for what amounted to four months' further cramming. So temporary accommodation had to be found for him, possibly with Alfred Wood, a cricketing colleague of Arthur's who was a mathematics master at the school. What to do with another member of the family—baby Mary—was easier, since her grandmother, Emily Hawkins, was living on the Isle of Wight and could look after her.

On Friday, December 12, thirty-four of Arthur's friends, presided over by Dr. James Watson, held a going-away party for him at the Grosvenor Hotel—the same venue as Boulnois' do earlier in the year, but, since everything had been so rushed, there was no carriage clock or its equivalent for Arthur. Then the key in the clinic door was turned for the last time. Arthur and Louise spent a couple of nights in a boarding-house in Southsea before going to Birmingham to stay with the Hoares. They continued on to Masongill for Christmas and then returned to London's Victoria station, the embarkation point for their railway journey to Vienna on January 4, 1891.

PART TWO

CARGO STORED

Vienna and London

1891–1892

It was snowing heavily when the Conan Doyles arrived in the Austrian capital two days later. Fortunately the Viennese knew how to make life comfortable in such weather, and the warmth of the Hotel Kummer was preferable to the bleakness of an out-of-season English seaside resort. Freed from having to run a busy medical practice, Arthur could relax and eat well, though he was aware that, with no regular income and his recent investments already underperforming, he needed to continue writing to provide for his family. His reasons for employing a literary agent to boost his returns from his secondary profession as an author now became clearer.

After a short stay in the hotel, Arthur and Louise moved into a cheaper boardinghouse run by a Madame Bonfort in the heart of the university district. Arthur thus had no trouble getting to the Kranken-haus for the first lecture of the morning at eight o'clock. But since this was only a couple of hundred yards away, he could return to the pension for breakfast with his wife and then write until lunch at 1:30. After a postprandial walk, he again wrote until five o'clock when he had another class. In the evening he often put in another couple of hours at his desk before retiring to bed around 10:30.

The result was that, in intervals between studying the eye, he did an extraordinary amount of writing. At first he concentrated on a short novel, *The Doings of Raffles Haw*, which the young magazine proprietor Alfred Harmsworth had commissioned for his new penny paper, *Answers*. Its significance was not so much the subject matter (roughly 30,000 brisk words, dedicated to Malcolm Morris, about a man who fails to find happiness despite having discovered the secret of manu-

facturing gold), but the fact that Arthur was again prepared to compromise his higher literary calling and, in his determination to make money, write for the mass-market readership that a new type of entrepreneurial magazine proprietor such as Harmsworth was trying to reach. Arthur polished off this commission between January 6 and 23, 1891, before turning to what he called his "Puritan"—or really Huguenot—story, an early draft of *The Refugees*, an ambitious novel set on both sides of the Atlantic Ocean in the time of Louis XIV, which he had originally been contracted to produce in serial form by the American magazine *Harper's*.

At the same time he worked on several shorter tales, including "The Voice of Science," in which he celebrated his freedom from provincial city life by poking fun at his old Literary Society friends in a tale of the Eclectic Society in Birchespool (his name for Southsea), where learned professors gave talks with nonsensical titles such as "On the Perigenesis of the Plastidule." His agent Watt again proved his worth by sending this to Herbert Greenhough Smith, editor of the new monthly *Strand Magazine*, another ambitious mass-circulation periodical owned by George Newnes. Published in the *Strand*'s third issue in March, this story marked the start of a long relationship between Arthur and a magazine whose sixpence cover price positioned it upmarket from *Answers* (itself modeled on Newnes's *Tit-Bits*) as a journal to be savored as a medium of instruction in the privacy of an aspiring middle-class home rather than perused as instant entertainment in a train en route to work.

Newnes had made his intentions clear when he had gone into business the previous year with W. T. Stead on the *Review of Reviews*. But they had soon fallen out over the publication of Leo Tolstoy's novel *The Kreutzer Sonata*, a radical, supposedly realistic attack on marriage that had been banned in the author's native Russia. As Newnes did not consider this proper fare for his new joint publication, he bought himself out of his partnership and founded the more obviously successful (rather than struggling) *Strand Magazine*.

Still in Vienna, Arthur claimed that, despite the high cost of incidentals such as laundry, he made enough from a day's writing to cover his cost of living in the city for a week. Able to relax a bit, he took Louise skating and splurged on tickets to the Anglo-American ball (having been introduced into local expatriate society by *The Times* correspondent, Brinsley Richards). At one stage he was thinking of spending a few days in Budapest. But then something happened to curtail his increasingly sociable sojourn. Arthur disingenuously claimed it had to

do with his German not being up to the technical standard required in his lectures. But this was unlikely, and not the sort of thing he would normally have let stand in his way. Family responsibilities provide a better explanation: he was worried about his mother's finances (particularly as Dr. Waller, however kindly meant, was offering to lend her money) and about his sister Connie's romance with a young man called Cross, who, he noted, had no profession and no sympathies or tastes in common with her. On February 16 Arthur wrote to Lottie, who was more his confidante, virtually commanding her to bring both Connie and herself back from Portugal to London where he intended to find some furnished rooms in a central square where they could all live. And she need not worry about the expense because *Harper's* was paying him an unprecedented 800 pounds for the serial rights to his story *The Refugees*. "Now! none of your larks, and just do what you are told," he ordered.

As a result Arthur and Louise left Vienna prematurely on March 9 and traveled to Paris via Venice and Milan. They stayed less than a week in the French capital—just long enough for him to be able to say he had studied under Professor Edmond Landolt, who was renowned for coining the word "optometry" and writing the standard textbook *The Refraction and Accommodation of the Eye and their Anomalies*.

By March 24 he was back in London, looking for somewhere to live with his wife and daughter. He found a suite of rooms at 23 Montague Place behind the British Museum in Bloomsbury, where he described himself as an Ophthalmic Surgeon in the 1891 census taken on April 5. He agreed to pay an annual rent of 120 pounds for professional premises at 2 Upper Wimpole Street, fifteen minutes' walk away, on the fringes of the city's medical heartland. His parallel literary career was also on track, for he had applied for a reading ticket at the British Museum, stating that he wanted "information on subject of 30 Years War and Puritan movement" as part of his research for *The Refugees*.

Looking to the future, he also renewed his relationship with A.P. Watt, though his first communication with him since his return, written on March 26, was humdrum—a request for his agent to check some unspecified detail of his business with Chambers. (Possibly he had not been paid for "The Surgeon of Gaster Fell," a dark, Gothic tale of mystery and madness on the desolate Yorkshire moors around Masongill, which had appeared in the Scottish firm's magazine in December.) Watt responded in an equally low-key manner, saying he would take the matter up when he paid a scheduled visit to the publisher's Edinburgh offices the following week.

There was no indication that, four days later, less than a week after returning to London, Arthur would send Watt a story that would change his life. This was "A Scandal in Bohemia," the first of a series of six tales he proposed featuring his brilliant, troubled, often annoyingly smug detective Sherlock Holmes. He had decided that old-fashioned serials were no longer suited to modern readers. They had worked in a more leisurely age when people could enjoy the unfolding of a narrative over several issues, but the market now required fiction that offered more instant gratification.

Arthur's solution was to write a number of stories, each entire within itself, but with the common features of their leading characters Holmes and his sidekick Dr. Watson. He later asserted, with no false modesty, that he had invented this genre: "I was a revolutionist, and I think I may fairly claim to the credit of being the inaugurator of a system which has since been worked by others with no little success."

Arthur recalled that he wrote "A Scandal in Bohemia" in his new Upper Wimpole Street consulting room, and was able to do so because, as an unknown quantity, he had no patients. Possibly this is true: his diary recorded that he did not get his new professional quarters in order until April 6. But so quickly did this story appear on Watt's desk that it is hard to imagine it was not written during Arthur's period of furious industry in Vienna. It shows distinct Central European influences, with its ingenious plot about the soon-to-be-married King of Bohemia who travels incognito from Prague to Baker Street to seek Holmes's help in recovering a potentially incriminating photograph of himself with the mysterious cross-dressing adventuress, Irene Adler— always "the woman" to Holmes, and the only female in whom he ever showed the slightest interest.

Arthur's well-honed arguments about the pros and cons of serials also suggest he had been pondering the matter while away. At that time *The White Company* was being featured on a monthly basis in the *Cornhill* and he was working on *The Refugees*, another serial, for *Harper's*. But he decided to put this assignment aside and concentrate on Sherlock Holmes. He received encouraging feedback from Watt who sent "A Scandal in Bohemia" to the *Strand Magazine*, one of the few outlets prepared to take stories at that length (over 8,500 words). The editor, Greenhough Smith, immediately accepted it and Watt was able to close a deal at a rate of 4 pounds per thousand words, a healthy premium on Arthur's usual three guineas.

Less than two weeks later, on April 11, Arthur had delivered his second Holmes story, "A Case of Identity," and Watt was returning him

page proofs of "A Scandal in Bohemia," saying that Greenhough Smith wanted some slight changes at the start "to make the character of Sherlock Holmes intelligible to those who have not had the pleasure of reading *The Sign of Four*." But Arthur paid little attention, only cutting a cursory reference to this earlier book.

He was too busy completing his next story, "The Red-Headed League," which reached Watt on April 20. By then his agent had also sold the proposed six Holmes stories to S.S. (Samuel) McClure, the ambitious owner of a newspaper syndicate in New York, for 50 pounds—not a huge sum, but a useful addition to Arthur's income. He was also able to advise his client about the vagaries of American copyright law. After years of lobbying by British and foreign authors, the United States was shortly to introduce legislation protecting their intellectual property rights. But the Chace Act would not come into effect until July. So, even if it meant restraining Greenhough Smith at the *Strand Magazine*, Watt had to ensure that the Holmes stories did not appear in Britain or America until after this date. He also suggested that Arthur inform *Answers* of a similar embargo on the appearance of *The Doings of Raffles Haw*, a work which he himself then proceeded to sell to McClure for 40 pounds.

Although the *Strand* complied in not publishing "A Scandal in Bohemia" before July, its eagerness to establish good relations with the author was clear from the way it so quickly paid Watt a generously rounded up fee of 36 pounds. After deducting his 15 percent commission (soon to be reduced to 10 percent) the agent sent 30 pounds 12 shillings to Arthur on April 29. By then Arthur had delivered his fourth Holmes story, "The Boscombe Valley Mystery." He may not have seen many eye patients during April, but his literary vocation had taken a spectacular leap forward.

Early the following month his dual career was put on hold for three weeks while he suffered a bad bout of influenza. For a period his condition was very serious, or so it seemed to family members who remembered his sister Annette's fate only sixteen months earlier. If he had died in May 1891, a few days short of his thirty-third birthday, his literary reputation is unlikely to have survived after just two novellas and three short stories featuring Sherlock Holmes.

Instead circumstances conspired very differently. Arthur's fever was punctuated by moments of great clarity, which enabled him to scrutinize what was going on in his life. He realized he was earning more than enough from his literary endeavors, while his room in Upper Wimpole Street was only proving a financial drain. So, as he

later noted, he decided in a moment of exhiliration to stop vacillating and to devote his energies to writing. Conscious of the telling detail in such situations, he recalled that, like the pen he had tossed at the wall after completing *The White Company*, he threw his handkerchief to the ceiling in delight. "I should at last be my own master. No longer would I have to conform to professional dress or try to please any one else. I would be free to live how I liked and where I liked. It was one of the great moments of exultation of my life."

Arthur's professional life had been full of abrupt moves—to Plymouth, to Portsmouth and even to Vienna. But this was different. After a few short weeks in London, he was abandoning the fruits of more than the dozen years of medical training and, with it, the professional status he had regarded as vital to his family's well-being.

In retrospect, this had a certain predictability. He had been willing himself to take that final step to full-time authorship: the typewriter, the agent, the transfer to the capital all pointed in the same direction. His latest decision had resulted partly from his obvious success, partly from his feverish state, and partly from something less tangible—the exhilarating but often confusing effect of being in London, the dirty, teeming center of the British empire and the hub of English letters. For too long he had mulled over literary matters from a distance. Now he could visit the offices, cafés and clubs where the futures of the novel and the theatre were being decided. It was a heady time to be in the metropolis, where cultural battle-lines were clearly drawn between intellecturals and jocks, particularly since the publication of Oscar Wilde's controversial novel *The Picture of Dorian Gray* (the fruit of the same meeting at the Langham Hotel that produced *The Sign of Four*). By taking a principled but commercially minded position somewhere between these two extremes, Arthur was convinced he could succeed.

Within a couple of weeks, Arthur had recovered from his flu and was again sending Watt stories, including his latest (fifth) Sherlock Holmes offering "The Adventure of the Five Orange Pips." Being in London did not mean he needed to live in the center. With a wife and child to consider, he preferred the more salubrious suburbs, a short train journey away. After scouring newspapers and visiting real estate agents, he found what he was looking for—a comfortable red-bricked house at 12 Tennison Road, South Norwood, some eight miles south of the River Thames, next door to Upper Norwood, home of the cultured Bartholomew Sholto in *The Sign of Four*.

After moving in on June 25, Arthur quickly established a clubby

domestic atmosphere, with bats, tennis rackets and cycling gear competing for space with military prints in the hall, and a solid mahogany desk and some plain, well stocked bookshelves dominating his upstairs study, which looked out over the Surrey hills. A visitor would remark that "no trace of luxury or aestheticism" was to be found in this room. This was true of such knick-knacks as the bear's skull and seal's paw from Arthur's Arctic trip over a decade earlier. But it ignored several paintings by Charles Doyle with which his son proudly covered his walls. And there were family mementos and works of art strewn throughout the other rooms—here Christopher Moore's marble bust of his friend, Arthur's grandfather, HB; there an engraving of the Great Exhibition signed to Richard Doyle from Joseph Paxton (whose magnificent glass and iron Crystal Palace had been removed to a site only a mile away and could be seen from the garden); even some oils by Louise's brother Jeremiah. In the drawing-room Arthur displayed a prized possession—a large blue and white plate that was a going-away present from an old woman patient in Southsea. It had been looted by her son during the siege of Alexandria in 1882 and she had wanted her doctor to have it as a token of her regard.

Arthur settled into an agreeable routine that allowed him, when not working, to step out of his front door for a game of tennis, to frolic in the garden with his three-year-old daughter, and to take long tricycle rides, often in tandem with his wife. He joined the Norwood cricket club and again took up photography, investing in new equipment after realizing 6 pounds 10 shillings from the prompt sale of his optical instruments.

His presence did not fail to cause a stir among his more straitlaced neighbors, to judge from his 40,000-word novella *Beyond the City*, which he rushed off for the Christmas issue of an overtly religious periodical, *Good Words*. (He had originally wanted to write more, but the editor could not afford to pay a higher fee, so Arthur had to throttle back, having been given a taste of the realities of the marketplace, which was more interested in the exploits of his consulting detective.) Set in a modern suburban development, such as his, near Norwood, *Beyond the City* starts with two women peering anxiously through their curtains as a cab pulls up and disgorges the new occupant of the villa across the street, together with what to them is an alarming range of sporting paraphernalia including dumb-bells, golf clubs and a tennis racket. One can imagine Arthur's arrival in Tennison Road creating a similar flurry of curiosity and even apprehension. But these items belong not to a sportsman such as himself but to a masculine-looking

"new" woman, who is easily satirized as she prances around in short skirts, sounding off about the slavery of modern marriage, and remarking on the good sense of the sexual equality practiced by the inhabitants of the Marquesas Islands, which she has just visited. After a widowed doctor in another modern villa on the same street grows fond of her, his daughters hilariously adopt this liberated woman's seemingly outrageous ways to put him off marrying her. Arthur also weaves in some financial intrigue, which not only demonstrates his familiarity with the arcane ways of the City of London but also focuses on the untold mysteries hidden behind the closed doors of suburbia.

Arthur's attempt to write a version of the new social novel was curious, given the encouraging response to his detective stories. It shows signs of haste (it was dispatched on July 8, shortly after—and perhaps designed to cash in on—the publication of his first Sherlock Holmes story, "A Scandal in Bohemia"). And, with its layers of satire, slapstick and realism, it could be said to be hedging its bets. But *Beyond the City* is a testament to Arthur's range, dynamism and determination to succeed in a competitive business.

It was soon clear he had made the right career decision. With *The White Company* continuing to attract attention in the *Cornhill*, he was being courted by editors, publishers and agents on both sides of the Atlantic. When "A Scandal in Bohemia" appeared in George Newnes's *Strand Magazine* in July, it was accompanied by a series of simple line drawings by the established artist Sidney Paget. As a businessman, Newnes had been keen to take advantage of new printing techniques and have an illustration at every opening. The *Strand*'s art editor, W.H.J. Boot, reportedly wanted to hire Paget's brother, Walter. But Sidney, who had drawn for several publications including the *Illustrated London News*, got the job, producing an enduring image of a trim figure with sharp, thoughtful features, wearing smart modern clothes which, later in the year, ran to a cape and deerstalker hat. Although Paget quickly picked up on Holmes's frequent disguises, he made no suggestion of the more troubled side of his subject's personality—the drug-taking and the anxieties: this was a clean-cut sleuth for Newnes's middle-class readers.

Arthur was even disappointed that Paget's depiction was too handsome: he had imagined his creation as "a more beaky-nosed, hawk-faced man, approaching more to the Red Indian type." But, as over 300,000 copies of the magazine flew out of the shops, he could see that the illustrations were an essential part of the magazine process (making him something like Dickens to Paget's "Phiz") and he wrote

to Greenhough Smith asking him to congratulate the artist and to keep the blocks so they could be used by any future book publisher. He also showed his satisfaction in another way, paying 250 pounds at the end of the month for his first stock issue of what would later be 1,000 shares in George Newnes's embryonic holding company.

This suggests that he saw a long-term future for his Sherlock Holmes stories, even if he soon began to deny it. On August 10 he sent off the sixth in the series, "The Adventure of the Man with the Twisted Lip." Then, five days later, he closed his study door and embarked on a cricket tour of Holland with his local Norwood team.

He did not pick up his pen in earnest for another two months. Even then, as autumn winds began to envelop the house, he was not particularly responsive to editors' requests. A proposal for a humorous book, received through Watt, was turned down and when Ward Lock wanted him to write a preface for *A Study in Scarlet*, his answer was predictable, given the company's behavior over earlier editions of that book. He took a similarly negative line when Ward Lock requested permission to use a subtitle with the name Sherlock Holmes, gleefully boasting to his mother about his awkward behavior.

At the same time he claimed the *Strand* was begging him to continue his Sherlock Holmes stories. But he was holding out for a fee of 50 pounds (rather than an average of 35 pounds up till now). Far from being put off, Greenhough Smith was convinced of the importance of Arthur's work to his magazine's success, and promptly ordered six more tales.

Having obtained this commission, Arthur wasted no time. Before the end of the month he had polished off two of his quota—"The Adventure of the Blue Carbuncle" and "The Adventure of the Speckled Band" (which he carefully differentiated from the others as a thriller) and, being well on top of a third—"The Adventure of the Noble Bachelor"—he was sure he would have little difficulty with the remainder. By November 11, he had finished two more—"The Adventure of the Engineer's Thumb" and "The Adventure of the Beryl Coronet." But already he was bored with the formulaic nature of the job and was looking forward to killing off Holmes in the final story because he said the detective was taking his mind off "better things."

He was not concerned about being saddled with a typecast character. Rather he was convinced his true literary calling lay elsewhere, particularly in historical novels. He had recently returned to the "Puritan story" he had abandoned earlier in the year. For the time being it featured Micah Clarke, the eponymous hero of his earlier novel, now a

refugee at Louis XIV's court, where he witnesses various significant events, including the Revocation of the Edict of Nantes, before meeting a Huguenot family, falling in love with their daughter, and following them when they in turn are forced to flee to Canada and to a life played out against the bloody backdrop of the French and Indian Wars.

More significant, he was anxiously awaiting reaction to *The White Company*, which had been published by Smith, Elder on October 26. After the first clutch of reviews he was disappointed: none was hostile, but he was annoyed that "they treat it too much as a mere book of adventure—as if it were an ordinary boys book—whereas I have striven to draw the exact types of character of the folk then living & have spent much work and pains over it, which seems so far to be quite unappreciated by the critics."

This was where Arthur discovered the benefits of the professional contacts he had been cultivating. For, two days after the book came out, he and Louise were invited to dinner with James Payn of the *Cornhill* and Smith, Elder. Also present were Payn's son-in-law George Buckle, the former Fellow of All Souls who was editor of *The Times*, as well as Baron von Tauchnitz under whose imprint most English novels were published in Europe. A few days earlier Payn had sent a copy of the novel to *The Times* saying that it was the best of its kind since *Ivanhoe*, which even Arthur had to admit was over the top. Arthur would have been cheered by the anonymous notice in the paper a couple of weeks later that went to some length to point out that *The White Company* was "a good deal more than a glorification of archery" and to categorize it as "not a mere item in the catalogue of exciting romances. It is real literature."

Another early recipient of the book (along with Meredith, Lang and W.T. Stead) was Lord Tennyson. This suggests that Arthur knew the now ailing Poet Laureate, who was also President of the Society of Authors, and raises the intriguing possibility that the visit he recorded as paying to the Surrey town of Haslemere in April 1890, just as he was finishing the book, was to Aldworth, Tennyson's Camelot-like home nearby. If so, he would have discussed the novel and, with Tennyson's Arthurian *Idylls of the King* as a model, been encouraged in his idea of a chivalric romance, stressing the need for order and morality in an age of empire, even if *The White Company*'s actual quest was hardly the most noble—fighting for Pedro the Cruel.

As a couple the Conan Doyles were sociable, with dinner parties, and occasional dancing, a feature of life at Tennison Road too. Arthur's sister Connie had recently succumbed to his entreaties and

had come home from Portugal, while Lottie was due to follow in the spring. So Connie was on hand to help in October when the Conan Doyles entertained Frederic Myers of the SPR (Arthur's interest in the occult was still strong) and another literary figure, the enterprising American Wolcott Balestier, whom Connie described as "a small ugly but very interesting and nice little man," adding, "Arthur says that he will come to the very front in the literary line. At present he is writing a book with Rudyard Kipling, and he explained to us how they do it. Imagine, they write sentences about; I told him that when we read the story I should try and spot which were his sentences and which were Kipling's."

The following day Balestier courteously sent Louise some books from the New English Library series he had just started with William Heinemann to compete with Tauchnitz on mainland Europe. However his promise was unfulfilled, since, within weeks, he had died of typhoid in Dresden, prompting Arthur to write a fulsome obituary in the *Pall Mall Gazette.* Balestier's joint novel—an inferior adventure story called *The Naulahka*—had been completed, but, distraught at his death, his collaborator Kipling rushed home from India and married his friend's sister, Carrie, only a couple of months later. Arthur told Stoddart that Balestier's passing opened an opportunity for an American publisher prepared to treat his authors decently. "A mere man of business can't fill Balestier's boots. . . . What does anyone care about Lovell! But Balestier was a power."

Also present at this same Norwood dinner party had been some new friends, Kingsley and Amy Milbourne. Milbourne was a merchant with West Indies connections and a nephew of Charles Kingsley, a muscular Christian best known as the author of patriotic historical novels. Arthur and Louise enjoyed this couple's company since, that same month, they pedaled their tricycle all the way to the Milbournes' house in Woking. Not satisfied, they continued to Louise's mother in Reading, returning via Chertsey, home of some other City-related friends, Stratten and Clara Boulnois. (Perhaps it was the effect of the suburbs, but Arthur was spending a lot of time with businessmen: Stratten, Percy's brother, was a former army officer turned tea broker, and Clara was his second wife.)

Making this round trip of over one hundred miles was a long journey by any standards, and the delicate Louise was not necessarily as keen as her husband about such excessive exertion. Although an interviewer noted that Arthur was never happier than when taking his wife on a thirty-mile spin, it is significant that she bailed out of a sub-

sequent twenty-six-mile ride into the Surrey countryside and opted to travel home by train. One is left with the impression of a man with boundless energy, encouraging, sometimes even bullying, his often reluctant wife to keep up.

Arthur could afford to take some time off, for his end-of-year accounts show that in 1891 he earned 1,616 pounds, mainly by his pen. This was roughly five times his return from his Southsea clinic, which still contributed to his bank balance through an annual 40-pound subsidy from Dr. Claremont, who had taken over his practice.

But if he had ideas that this would enable him to do as he had threatened and kill off Sherlock Holmes, his mother quickly put a stop to such nonsense. She came up with a plot involving a girl who, after being kidnapped and having her golden hair chopped off, is required to impersonate someone else. Over the Christmas holidays, Arthur felt duty-bound to incorporate this into "The Adventure of the Copper Beeches," an atmospheric, slightly kinky story about a governess who is hired to work at an inflated salary in Hampshire, provided she agrees to cut her luxurious tresses and occasionally wear a blue dress. The reason, it transpires, is that her employer wants to pass her off as his daughter by a previous marriage, whom he has locked away, hoping she will sign over her inheritance to him. By featuring a governess, Arthur paid homage to the genteel trade favored by women in his mother's family. He kept up his habit (begun in *A Study in Scarlet*) of introducing dogs into his stories—in this case, a burly mastiff that Dr. Watson has to shoot. (It was called Carlo, a name which Arthur would later adopt for his own dog, and one perhaps derived from his own father.)

On January 6, 1892 Arthur was able to tell his mother he had finished the story: "So now a long farewell to Sherlock. He still lives, however, thanks to your entreaties." All he had to do was finish his Puritan story which now had a title—*The Refugees*—though it no longer featured Micah Clarke. Instead it was divided methodically into French and North American halves and, perhaps chastened by the lukewarm response to *The White Company*, Arthur said it would be "conscientious, respectable and dull." He had also struck an excellent deal with J.W. Arrowsmith to write *The Great Shadow*, a book about the Napoleonic wars, for its forthcoming Christmas annual. He forecast that these two commissions, plus others in hand, might occupy him until the summer when he hoped to go to Norway. Then in the autumn he intended taking his family to the Riviera where, with help from his sisters, he could

maintain his literary output. But he was determined not to work too hard, having recently noted the fate of the unfortunate Guy de Maupassant who had gone mad after writing thirty books since 1880 and who clearly proved it was misguided to push oneself too hard.

Such caveats did not stop him from wanting to extend his range. So he agreed to pen part of a serial novel, *The Fate of Fenella*, which was being published on a communal basis in a new magazine, *Gentlewoman*. The salable idea was that a different author would continue the story each month. Arthur's contribution, "Between Two Fires," was an uninhibited portrayal of jealousy in marriage. It came with an epithet: "Happier is he who standeth twixt the fire and the flood than he who hath a jealous woman on either side of him."

The piece's raw emotion suggests that it drew on personal experience. For as Arthur rearranged his affairs in South Norwood and began to frequent gentlemen's clubs in the capital, his wife, never a forceful personality, faded even more into the background and he himself began to show his liking for other women. Around this time, he was notably forward in his communications with Jeannie Bettany, the woman who had saved *A Study in Scarlet* from the slush pile. Her husband had just died, and Arthur showed scant regard for conventional etiquette when he asked if he could bicycle over to see her, adding the hope that she was not sacrificing "upon household and maternal duties what was meant for the world."

This last comment suggests that, like many men at the time, he could not make up his mind whether women were for recreation, education or breeding. He poured out his feelings in a hitherto unpublished poem called "A Lover's Duet" which highlights a man's dilemma as he tries to choose between someone familiar who has lost her lover's spark (almost certainly his wife) and an exciting rival with bewitching blue eyes. On the one hand he recalls:

> Dark eyes, dark eyes
> Calm serene and critical
> Weighing me, surveying me
> And reading me aright
> Dark eyes, dark eyes
> Coldly analytical
> Can you lighten, can you brighten
> With the lover's light?

But this stern figure has little chance against the bewitching attraction of the other woman more usually absent from his side.

> Blue eyes, blue eyes
> Masterful, importunate
> Rudely staring, overbearing
> Insolently gay
> Blue eyes, blue eyes
> Am I not unfortunate
> I who fear you when I'm near you
> Love you when away.

Arthur returned to the topic of jealousy in "The Cardboard Box," one of his next batch of Holmes stories. (His resolve to take a break from that particular treadmill did not last long either.) This was a gory story of multiple revenge about a ship's steward who murders his wife and her lover after she has been turned against him by her sister, who becomes furiously green-eyed after her own romantic advances toward him are rejected. The story is notable for its Sherlockian touches, such as when the detective discerns what Dr. Watson is thinking from observing his eye movements, and when he shows off his understanding of Bertillon and anthropometrics to conclude, from their ears, that the two sisters are related. But the extraordinary feature is the web of smoldering emotions—the woman who pines after being rebuffed by her sister's husband, the wife who casually takes a lover, and the husband whose jealous fury drives him to murder.

The suspicion that this reflected some secret passion within the Conan Doyle household is hardly quelled by the fact that, once the story had been published in the *Strand Magazine*, Arthur decided it was not suitable for inclusion within book covers and refused to allow it in his second collection, *The Memoirs of Sherlock Holmes*. Since he gave no reason, commentators have been left to speculate whether it was because the subject matter was too salacious or too violent. Arthur kept them guessing with the tale's unusually somber ending: "What object is served by this circle of misery and violence and fear? It must tend to some end, or else our universe is ruled by chance, which is unthinkable. But what end? There is the great standing perennial problem to which human reason is as far from an answer as ever." Arthur was reminding the world that, for all his immediate concerns about Sherlock Holmes, he was still exercised, probably even disturbed, by more profound issues of life and death.

* * *

Ever eager to refine his art, Arthur began taking a greater interest in the stage. He had participated in productions at school and appeared in amateur revues in Portsmouth. Now that he lived close to central London, he relished the opportunity to frequent its theatres. Since he had always tried to convey a sense of excitement and action in his writing, he appreciated the immediacy of drama, an art form going through similar changes to the novel, with old-fashioned melodramas and light comedies under threat in particular from the gritty realism of European playwrights such as Emile Zola and Henrik Ibsen, who were scathing about bourgeois hypocrisies.

Aware of these developments, Arthur had been up to London the previous autumn to see the Independent Theatre Society's controversial production of Zola's *Thérèse Raquin* at the Royalty Theatre. The Society had been set up by a Dutchman, J.T. Grein, with backing from influential authors such as the Irishman George Moore, who was incensed that British audiences should be denied the chance to see pieces by gritty new dramatists such as his friend Zola. Because of the risqué subject matter of some of its plays (notably Ibsen's *Ghosts*, which dealt with syphilis), the Society circumvented the Lord Chamberlain's censorship by not charging for entry. Arthur left Louise at home and went on his own because he felt Zola's unflinching account of an extramarital affair, murder and guilt was not suitable for women.

Mindful of his mentor Stevenson's adage, "Drama is the poetry of conduct, romance the poetry of circumstance," Arthur was forced to consider whether it was really his kind of piece either. By nature and family background he was a fantasist. But this trait had been tempered by the hunger for objective truth, which came with his medical training. He was therefore sympathetic to Zola's comparison of the work of a novelist with that of a scientist and a surgeon: "we must operate with characters, passions, human and social data as the chemist and physicist work on inert bodies, as the physiologist works on living bodies." In his particular way Arthur had tried to reflect this scientific approach in his Sherlock Holmes stories. But his own narrative technique tended to something different—a variety of the traditional romance—that he soon concluded was at odds with the realism of contemporary theatre.

That did not mean he would not write for the stage. An extrovert novelist such as himself would always enjoy getting away from his desk and experiencing the glamour and financial rewards of the theatre. When an audience later rose to its feet in appreciation of one of

his plays he recalled, "Such moments to a dramatist give a thrill of personal satisfaction such as the most successful novelist can never feel. There is no more subtle pleasure if you are really satisfied with your work than to sit in the shadow of a box and watch not the play but the audience." Like Henry James, Arthur would spend more time trying to achieve this elusive author's ideal than he should have. But he would do it his own way, as he wove his way between the competing dramatic styles of the age.

Arthur found a similar unorthodox spirit in James (J.M.) Barrie, a fellow Scotsman whose quirky style of storytelling was gaining favor, almost as an antidote to prevailing tendencies. Although the two men had been contemporaries at Edinburgh University, there is no evidence of their paths having crossed there. They had gotten to know each other on the cricket field the previous summer, when Arthur had played for Barrie's team the Allahakbarries. They became firm, if physically ill-proportioned friends, the increasingly portly Arthur noting that there was nothing small about Barrie except his body (all five feet of it). Barrie had written a gentle pastiche of Sherlock Holmes in *The Speaker*, a new Gladstonian magazine published by Cassell's. But his general satire could be much tougher, as in his recent short parody *Ibsen's Ghost*.

Arthur shared Barrie's wariness about the radicalism of modern European theatre. In particular, he balked at Ibsen's critique of patriarchal society. He would have argued that he sympathized with women's aspirations. But Ibsen and his ilk had become too proscriptive in their feminism, threatening the bonds of comradeship that Arthur cherished and sought in another phenomenon of the age, the all-male social club.

Only in October he had applied to join the Reform Club. Ostensibly this was an active Liberal organization, designed to further the ideals of the 1832 Reform Act. In practice, it was a cozy fraternity where men could plot and carouse, away from the encumbrances of women. This central paradox was encapsulated in the figure of Wemyss Reid, the veteran journalist and friend of James Payn who had proposed Arthur for membership. (The surgeon Malcolm Morris seconded him.) Reid was a committed Liberal, close ally of Gladstone and stalwart of the Club's committee. Now manager of Cassell's publishing house and editor of *The Speaker*, Reid had previously edited the magazine *Woman's World*, where he was succeeded by the unlikely figure of Oscar Wilde. But none of these politically correct credentials could make him other

than a creature of his age—a typical Victorian gentleman who believed that the female's place was in the home.

Until his membership in the Reform Club was confirmed in June 1892, Arthur enjoyed the company of the Idlers, a more Bohemian group that gathered to eat, drink and make merry in Arundel Street, off the Strand. They took their cue from the innocent flaneurism of *Idle Thoughts of an Idle Fellow*, a book of arch essays written in 1886 by one of their members, Jerome K. Jerome, a shy actor-turned-humorist who had subsequently reached a much wider public with *Three Men in a Boat*. In late 1891 Jerome joined forces with Robert Barr, a volatile Scottish writer who had returned from North America, to edit *The Idler*, a magazine that gave a purpose to their otherwise indulgent gatherings.

Arthur's choice of these two groups for his social activity in London was significant. Although his general views about literary matters were never in doubt, he was steering clear of obvious factions. Specifically he was not identifying with either the "Henley Regatta" of hearty young men associated with W.E. Henley at the *National Observer*, nor the flowery aesthetes in the circle of Henry Harland in the Cromwell Road. Instead he eschewed controversy and opted for the calm certainties of a traditional gentleman's club that reinforced one side of his personality—his old-fashioned Liberalism—while, for more frivolous occasions, he looked to the company of an unpretentious coterie of fellow writers with no obvious agenda.

The informal ties between the Reform and Idlers Club were underlined in an article Arthur penned for Wemyss Reid's *The Speaker* in January 1892. The subject was British humor, and the piece lavished praise on *Three Men in a Boat*. That same month Arthur attended his first Idlers' soirée, probably at the invitation of Barrie. Jerome and Barr were also present, as well as a couple of other authors, Israel Zangwill and Barry Pain. Although not involved in producing the magazine, Arthur soon began contributing to its pages, comparing it to an agreeable mistress when he later denied having been "unfaithful to 'The Strand,' but there were some contributions they did not need, and with these I established my connection with The Idler." In dealing with the apparition of a dying man to his wife, "De Profundis," Arthur's first story for Jerome's magazine in March showed he had lost none of his interest in the supernatural.

Since Barrie was in London for only a few weeks, Arthur invited him to stay for a weekend at the end of January. At Tennison Road, the conversation quickly turned to theatre. Barrie was looking for a

piece that would act as the curtain-raiser to *Walker, London*, a short play about two innocent girls on a houseboat (decidedly more Jerome than Ibsen) which he himself had written and which the actor-manager J.L. Toole intended to stage in March. It is not clear if he mentioned his infatuation with the actress Mary Ansell, whom he wanted to act in his play. But he did inquire if Arthur might be interested in adapting "A Straggler of '15,'" his story about a veteran of the battle of Waterloo, for this purpose. This was the sort of realism Arthur could cope with on stage—precise in its depiction of the old soldier's deprived living conditions, but basically sentimental and unthreatening to the social order. He was delighted at the prospect, telling his mother that he had decided anyway to focus on writing for the theatre and this would make a good start.

But Toole was a comic actor, while "A Straggler" needed a more formidable stage presence. So Arthur sent his new play to Henry Irving, whom he had revered since his school days. Irving handed the manuscript to his Dublin-born business manager, Bram Stoker, to read during a rehearsal. Stoker, who was to write the classic vampire tale, *Dracula*, was immediately enthusiastic, with the result that Irving accepted the script within three days of receiving it on March 5 and agreed to pay 100 pounds for exclusive rights before another week was out.

Barrie bore no grudges for, at exactly this time, with *Walker, London* now running successfully in London, he paid a return visit to South Norwood. Arthur was reaching the end of *The Refugees*, so was happy to accompany his guest on an outing to Box Hill, near Dorking, to see George Meredith, whom he had long revered but never met. The two men were joined on this journey by another friend of Barrie's, the Cornish writer Arthur Quiller-Couch, known as Q. (To add to the sense of a cliquish literary "third way," this athletic-looking young man with red hair was also assistant editor of *The Speaker*.)

After greeting his visitors on the doorstep with a song, Meredith introduced them to Leslie Stephen, whom Arthur found retiring and unprepossessing. Meredith seemed fascinated with military history, regaling his young guest with his recollections of the Austro-Prussian War, before engaging him in discussion about Napoleon's General Marbot, whose recent memoirs had controversially suggested that the Emperor's projected invasion of England had had every chance of success and was only stymied by the stupidity of his naval commander, Villeneuve. Since Arthur was working in one way or another on both a play and a story ("The Great Shadow") about the battle of Waterloo, he was fascinated, and immediately bought the original three-volume

French edition of the memoirs, with its enticing red-and-gold cover. It was the beginning of an important affair.

Family matters intervened at this stage. In January Charles Doyle had been moved from the Montrose asylum, Sunnyside, to its Edinburgh equivalent, with the equally rosy name of Morningside. Doctors were concerned that his condition, particularly his short-term memory, was deteriorating. This put Arthur in a quandary. In his dutiful way he had tried to keep an eye on his father, even if he found his situation disturbing. But now, because of his own celebrity, he had become embarrassed about this commitment. Back in the autumn he had refrained from updating an old Edinburgh friend, David Thomson, now Medical Superintendent of the Norfolk County Asylum at Thorpe, because he did not want the news getting out of Scotland, and now he suggested that his mother, rather than he himself, should deal with the hospital since his name would encourage it to raise its prices.

Once he had finished *The Refugees* on March 13, a week or so after *The Doings of Raffles Haw* came out, Arthur could no longer ignore his father's plight. When he traveled to Scotland for Easter, his primary objective was a spot of fishing with Barrie at Kirriemuir. But it is inconceivable that he did not also visit his father at Morningside. Even then, he was remarkably reticent about his family secret of a father in a lunatic asylum, for all he told Barrie was that he was passing through Edinburgh in order to see W.E. Henley. Similarly, when he wrote to his mother from Barrie's on Easter Monday, the only family member he mentioned was his sister Ida who had studied with great distinction at Heriot-Watt College in the city of his birth. Rather than address any detail of his father's condition, he preferred to joke about Barrie's fame round Kirriemuir, where the locals would peer at him from behind bushes, many having no idea what being an author meant, imagining perhaps that it had something to do with the excellence of his handwriting.

A month later, however, Arthur's efforts bore fruit for, on May 23, he signed a form agreeing to Charles's transfer to another asylum, the Crichton Institution in Dumfries, albeit to a private room and theoretically within easier reach of Masongill, where Mary was living.

If Arthur still thought he might be spared having to write further Sherlock Holmes stories, he was mistaken. At the start of 1892 he was already being pestered on this score by Greenhough Smith. He offered to do twelve more for 1,000 pounds, thinking such a steep price would deter the *Strand Magazine*. He was not to be so lucky: his

request was accepted and Arthur was reluctantly forced to add extra work to his exacting schedule.

One factor that kept him at the job was that he was now a celebrity on the receiving end of sackfuls of fan mail. Some correspondents simply wanted to compliment him, but others regarded Sherlock Holmes as a real character and sought his advice. One unexpected letter came from Joseph Bell, who wondered if Arthur had had him in mind when he let slip in an interview in *The Bookman* that Sherlock Holmes was the "literary embodiment" of one of his old Professors of Medicine in Edinburgh. Arthur was happy to acknowledge that this was indeed the case, though he was cagier when Bell went on to outline one of his cases involving a "bacteriological criminal" and suggested it might provide the basis for a good story. Arthur said he was wary of introducing the laboratory too obviously into his stories, because he needed to ensure that he did not go "beyond the average man, whose interest must be held from the first, and who won't be interested unless he thoroughly understands." Nevertheless he asked for further details of this case and indeed "for any 'spotting of trade' tips, or anything else of a Sherlock Holmesy nature."

Since Bell replied with some further useful storylines, Arthur felt free to mention his old teacher's name to Harry How, the next interviewer who made his way to Tennison Road. As an eager journalist, working for the *Strand Magazine,* How contacted Bell for confirmation and, when this was forthcoming, he had a scoop. (Indeed he even went so far as to print in full Bell's letter outlining his Sherlockian methodology.) When, after publication of the piece, Arthur next communicated with Bell, he commiserated that, as a result of being "outed," his old professor would have to endure receiving letters from idiots. He quoted examples from his own mailbag including the mystic youth from Glasgow who always recorded the time, down to the nearest second, as well as an American lady with a curved spine, a Liverpool merchant keen to know the identity of Jack the Ripper, and many other folk who suspected their neighbors of all sorts of abuse.

Arthur knocked off the first stories in the new series—the Adventures of "Silver Blaze," "the Cardboard Box" and "the Yellow Face"—during the early summer. Then in June he broke off to take a long-planned holiday in Norway in a party that included Jerome K. Jerome, his sister Connie, his sister-in-law Nem, and Josephine Hoare, the daughter of his medical friends from Aston. It is not clear if Louise accompanied them, but it is possible that she stayed at home (or with her mother) because she was expecting another baby in the

autumn. Arthur made his mark by learning some Norwegian (though this had its drawbacks when, in an effort to display his mastery of the tongue, he inadvertently offered one of his carriage ponies to a native traveler). He also insisted on taking everyone to the St. George's leprosy hospital in Bergen, where Armauer Hansen had discovered the leprosy bacillus twenty years earlier.

He returned to England in time to take part in a cricket match between the Idlers and his local Norwood club. He captained the Idlers, whose team included Jerome K. Jerome, Robert Barr and E.W. (known as Willie) Hornung, as well as a couple of "ringers" in Innes Doyle, now at Woolwich, and Alfred Wood, the schoolmaster from Southsea, whom Arthur would later employ as his secretary. The game ended in a creditable draw, after the Idlers, boosted by Innes's hard-hit 25, scored over 100, causing Jerome to counsel his colleagues not to applaud so enthusiastically as it might lead their opponents to think that they had never reached that figure before.

Off the field Willie Hornung, an *Idler* contributor who would make his name as the creator of Raffles, the Albany-based gentleman thief, was able to pursue his romantic interest in Connie Doyle. Willie had first met her in Lisbon, where his brother Pitt had established the family sugar business, following the bankruptcy and death of their father, an Anglicized Transylvanian-born ironmaster. Uppingham-educated Willie had tried his hand in the City, after spending three years in Australia, whose free-wheeling, bush-ranging spirit pervades several of his stories. But he was not suited to the business world and was soon contributing to the same magazines as Arthur and participating on the same cricket teams.

The following month *The Adventures of Sherlock Holmes* was published by George Newnes in a handsome edition of 10,000 copies, carrying the dedication (now that the secret was out) "To my old teacher Joseph Bell MD." Little more than a year after Holmes had been resurrected for readers of the *Strand Magazine*, he had found his way back into hard covers. From this perspective, he was still basically the same character who had surfaced in *A Study in Scarlet*—the gaunt Bohemian who could rouse himself from drugged oblivion to extraordinary bursts of lucid energy as soon as there was the possibility of an absorbing case to engage his brilliant mind. As he made his way purposively around London and the countryside, he adhered to his familiar procedural guidelines, stressing the need to observe, rather than just see. ("You know my method," he told Dr. Watson in "The Boscombe Valley Mystery," " It is founded upon the observance of trifles.")

Intellectually he was more bookish, ready to quote Hafiz and carry Petrarch in his pocket. But professionally, though familiar with the latest techniques of categorizing and measuring criminal behavior, he tended not to flaunt his knowledge. Rather than introduce fingerprints or photography into his investigations, he kept matters on a more homely basis, noting in "A Case of Identity" the individuality of a person's typewriting style, a reflection of Arthur's recent acquisition of his quirky Remington machine.

One thing now clear was Arthur's sense of the detective's chivalric crusading role in modern society. Holmes did not rush after gory murders and robberies; he was happy using his talents to recover a photograph (in "A Scandal in Bohemia") or to unravel a complex family relationship (in "A Case of Identity"). As he noted in "The Blue Carbuncle," three of his six cases till then had not involved any legal crime. His adventures fit the bill because they managed to be both exciting and safe for the family readers of the *Strand*.

The implausibility of some of the plots in which he was involved, such as "The Red-Headed League," and the error of the detail (for example, there is no such snake as the swamp adder that appears in "The Speckled Band") somehow heightened Holmes's allure and confirmed the fantastical antirealist nature of the enterprise. Adopting his disguises (an important feature of his chameleon-like persona), the detective took on an almost superhuman role as he made his way among familiar late-nineteenth-century sights, sounds and places. This position was enhanced by his uncanny ability to pre-empt the established judicial system and mete out his own brand of natural justice—declining to prosecute in "A Case of Identity" or "The Blue Carbuncle," and allowing the thieving lovers off the hook in "The Beryl Coronet" (declaring enigmatically that they would receive "a more than sufficient punishment"). As he stated forcefully in "The Five Orange Pips," "I am the last court of appeal."

This confident pronouncement reflected Arthur's own command of his subject matter. His surviving notebooks show how professional he was and how hard he worked to achieve this effect. After jotting down ideas and phrases in a black pad, he would tick them off as he used them, or else transfer the details to another more detailed record. This way he might try out a form of words in at least three places (including the final story).

One small notebook contains his ideas for pieces that appeared in 1893 and 1894: historical notes on the background to his poem "The Home-coming of the *Eurydice*," for example, and an experiment with

titles for "The Case of Lady Sannox" and "Story of the Yellow Mask" which, when followed by the letters SH, can only mean the Sherlockian "The Adventure of the Yellow Face." One of his notions was for a tale about a "masonic-like ritual in a private family" (surely the genesis of "The Musgrave Ritual"). "The Irishman who hated England" doubtless led to "The Green Flag." But what happened to the man who was given a gold bangle by a lady—"her husband discovers it and then allows himself to be prosecuted as a thief rather than betray the giver"—or the "older man making love to an adventuress"?

His notebooks confirm that he had lost none of his old fascination with metaphysics and religion. He was also thinking deeply about the future of Britain's empire, concluding that it needed to incorporate the United States and develop into a federation, based on kinship rather than coercion. Women remained much on his mind, as he toyed with an idea for a novel or play about a minx who came out with sub-Wildean lines such as, "I hate boys. I like a man of thirty. And he likes me." or "A coquette! How horrid! Well, I never thought of it. Perhaps I am." Then Arthur would draw back from such titillation and, as if reminding himself of his need to remain virtuous, would note some uplifting motto such as the reformed hedonist Count Tolstoy's aperçu, "He who knows only his wife, and loves her, understands all women better than a man who has had a thousand."

Arthur had good reason to be thinking along these uxorious lines. For on November 15, 1892, a month after the publication of *The Adventures of Sherlock Holmes*, Louise gave birth to their second child, a boy. The infant was not called Sherlock or anything remotely connected with his successful literary character; rather, Arthur Alleyne Kingsley—Arthur for his father, Alleyne after the hero of *The White Company*, and Kingsley as a tribute to the family friend Kingsley Milbourne and his relation Charles Kingsley, a strange Protean figure who, like Arthur, managed to straddle the cultural divide between hardy philistinism and consummate artistry.

Tennison Road, South Norwood

1892

By late 1892 Arthur had been away from Portsmouth for nearly two years. He had tasted London life, with all its splendor and seediness, and he had seen what the capital's literary lions had to offer. But he remained restless: he did not want to become identified with Sherlock Holmes and, although he had his preferences, he could not commit himself exclusively to any style of writing. Perhaps there was a future in the theatre. But he was still only thirty-three and he felt there was much about the universe that he wanted to understand.

Just now, though, it was business as usual. Arthur might have been impulsive by nature, but it was not the time to make radical changes to his routine so soon after the birth of his son and heir. What is more his uncle James, the long-time head of his family, had recently died. Only the hospitalized Charles Doyle now remained from that older male generation. So, as had been foreseen before he started at Stonyhurst, responsibility for the clan had finally devolved to Arthur, underlining his need to continue a little longer on the Sherlock Holmes treadmill.

First he had to do some research. One of the running jokes in the Holmes stories is the gap in attitude between the lightning-sharp consulting detective and his dogged Scotland Yard counterparts, who like to steal the credit when he solves their cases for them. But for all his theoretical understanding, Arthur himself had only limited knowledge of day-to-day police procedure. Needing some local color now, he had, ironically, to turn to the Yard.

As so often occurs, medical contacts provided the entrée. On December 2 Dr. Philip Gilbert, physician at London's two biggest prisons, Newgate and Holloway (for women), arranged for him to visit

Scotland Yard's crime museum, hidden away in the basement of its new granite headquarters on Victoria Embankment. Officially closed to the public, this was designed to inspire and assist police officers in the performance of their duties. But already it was known as the Black Museum because of its macabre collection of exhibits, such as murderers' death masks.

Arthur took two Idler colleagues, Jerome K. Jerome and Willie Hornung, who was now officially engaged to Connie. He did not say much about his visit, except that he was shown a letter supposedly written by Jack the Ripper and wondered why Scotland Yard, true to fictional form, had not taken more trouble to investigate its handwriting. Sherlock Holmes, he confidently said, would have made a facsimile of the signature and published it in the leading newspapers of the world to see if anyone could come up with a match.

At the time Arthur visited the Black Museum he had published one Sherlock Holmes book and had made a start on the next. He had written three stories from this second series by the middle of the previous summer, the first of which, "The Adventure of Silver Blaze," had just appeared in the December issue of the *Strand Magazine*. This had taken his detective out of his normal London habitat and sent him to Dartmoor to unravel the mystery of the disappearance of a prize horse and the apparent murder of its trainer. While Arthur retained his knowledge of the area from his time as a young doctor in Torquay, his grasp of the racing world was poor. As he later admitted, if events had occurred as he told them, half the characters would have been in prison and the rest banned from the sport for life. But he claimed to be unperturbed since the story was a fantasy and, unlike his historical fiction, did not have to be entirely accurate. It certainly had some fine imaginative turns, as when the sleuth deduces that the horse, Silver Blaze, could only have been removed from its stable by someone familiar. "Is there any other point to which you would wish to draw my attention?" asks the raddled Inspector Gregory. "To the curious incident of the dog in the night-time," replies Holmes in a famous exchange. "The dog did nothing in the night-time." "That was the curious incident," remarks the detective in a neat demonstration of the creative touch that set him apart from plods such as Lestrade.

After this initial burst of writing three stories, Arthur had cut back on his Holmes output, while he went on holiday to Norway and awaited the arrival of his son. Although the documentary evidence for the ensuing period is thin, it makes sense that he should have returned to the task after Kingsley's birth and be writing "The Musgrave Ritual,"

the fourth (or fifth) tale in the published series, in the pre-Christmas period following his visit to the Black Museum. (The counting of the stories is complicated by the fact that Arthur declined to publish the second one, "The Cardboard Box," in *The Memoirs of Sherlock Holmes*.) This interpretation is reinforced by the fact that the next story in the sequence, "The Reigate Squire," is linked to his exchange over the festive season with an Edinburgh handwriting expert, Alexander Cargill, who had sent him some samples showing how to diagnose health conditions from a person's script. Arthur's reaction to specimens which included "decided evidences of an alcoholic's insanity" might have been revealing. Instead he wrote back amicably, expressing mock concern that he might be demonstrating signs of imbecility in the dots of his "i"s. "I would like now to give Holmes a torn slip of a document," he added, "and see how far he could reconstruct both it and the writers of it." This was exactly what he did in "The Reigate Squire."

Over the next three months, Arthur took the opportunity to polish off his Sherlock Holmes quota. He also felt able to launch himself on a new initiative—a series of medical tales he had undertaken the previous summer for *The Idler*. Jerome had asked him to write some "very strong" stories that he intended using as a sequel to the magazine's popular "Novel Notes" which were ending in the new year. The editor hoped for something to emulate the success of Sherlock Holmes in his bitter rival, the *Strand Magazine*.

Prepared to commit to paper what he would not want on the stage, Arthur came up with a series of realistic medical stories. One showed a young doctor passing out at his first operation, another dealt with the emotional drama of childbirth, a third tackled the thorny subject of hereditary syphilis which had caused such controversy in Ibsen's *Ghosts*. Two underlying themes were the need to incorporate women into the mainstream of medicine and, a source of continuing concern, what happened to the soul in cases of disease and madness.

On April 6 he could state triumphantly to his mother, "All is very well down here. I am in the middle of the last Holmes story, after which the gentleman vanishes, never never to reappear. I am weary of his name." He added, "The medical stories also are nearly finished, so I shall have a clear sheet soon. Then for playwrighting and lecturing for a couple of years."

Arthur's house in South Norwood was in temporary disarray as it was being redecorated. On the day he wrote to his mother, the disturbing presence of painters had forced Lottie, who had finally returned

from Portugal, to move out and to visit the Hornungs (the impending nuptials had drawn the two families close), while Louise had gone up to town to buy a new carpet. Since Arthur had a cold, he remained comfortably by the fire at Tennison Road enjoying the unassuming style of *Pride and Prejudice*, the first Jane Austen novel he had ever read.

Arthur told his mother that he was spending 15 pounds on the painting. Refurbishment had been going on for a couple of months—probably a gesture toward Louise following the birth of Kingsley. This can be charted from the records of Arthur's withdrawals from the Capital and Counties Bank, covering a brief period from March 1891, when he moved his account from the Landport branch in Portsmouth to Oxford Street in London's West End, up to the spring of 1893. These show that *inter alia* Arthur had recently spent 21 pounds 14 shillings eightpence on new furniture from James Shoolbred, an emporium in Tottenham Court Road.

Taken with his meticulous notes (now in the British Library) of the payments he received for each item of his work, a picture emerges of a man careful with his money, growing increasingly rich, and gradually learning to enjoy the fruits of his labors. In 1892, we learn, he wrote a total of 214,000 words, which contributed to the large part of his over-all income of 2,729 pounds, while his expenditures were only 1,433 pounds. (Among those words, he included seven Sherlock Holmes stories of 7,000 words each, as well as "The Naval Treaty," which had been conceived as a double feature at 14,000.)

His expenditures show a taste for financial investments. The name of a stockbroker, Pim, Vaughan, begins to appear, as he acquires holdings in basic utilities including the Portsmouth Tram Company and the Glasgow and South Western Railway, in business-related ventures like George Newnes, and in Australian mines. Little wonder that shares and company promoters crept into his Sherlock Holmes stories in "The Stockbroker's Clerk."

In 1893 he at last began to splurge at shops such as Inter Fur Stores (perhaps buying a coat for Louise). He joined the Beckenham Golf Club and paid his ten guineas subscription to the Reform Club. His other dues included two guineas for the National Society for the Prevention of Cruelty to Children, and one guinea each for the Society of Authors and for the Manchester-based United Kingdom Alliance for the Suppression of the Traffic in Intoxicating Liquors—further evidence of the ambivalent attitude to alcohol he had developed as result of his father's addiction.

Balancing his thespian interests with an astute sense of commercial

opportunity, he had ploughed 200 pounds of his growing fortune into the speculative Palace Theatre Company in London. Along with others, he had been encouraged that Sir Augustus Harris, the successful owner of both the Drury Lane and Covent Garden theatres, had formed this company hoping to acquire Richard D'Oyly Carte's troubled Royal English National Opera in Shaftesbury Avenue and turn it into a music hall. But, as was to be the case with many of Arthur's investments, the business did not take off and was in receivership within two years.

Arthur developed a personal business relationship with D'Oyly Carte through another avenue. Eager, as always, to maintain links with the London stage, J.M. Barrie had agreed to write a libretto for a short comic opera commissioned by D'Oyly Carte, who had made his fortune as the impresario behind Gilbert and Sullivan's successes in the same field. However when Barrie found his health suffering as a result of difficulties in both his professional and his personal life, he realized he could not complete the work in time and asked Arthur's help.

This seemed as good an opportunity as any for Arthur to return to writing for the theatre. The result was a whimsical joint piece called *Jane Annie, or, The Good Conduct Prize,* with music by Ernest Ford, which was premiered at the Savoy Theatre in May 1893. Its subject matter, dealing with the consequences of male students infiltrating an all-girls' academy, could have been genuinely subversive. But Barrie and Arthur muddied the storyline with Clubland obsessions such as golf, and the result was a disaster. Recognizing the antithesis of the Ibsenite realism he valued, the Irish-born critic George Bernard Shaw lambasted it in the *World* as "the most unblushing piece of tomfoolery that two respectable citizens could conceivably indulge in public."

Although Arthur desperately wanted to make his mark in the theatre, he was not happy with the results of this collaboration. He sought to distance himself from it, telling his mother that he had about as much to do with the plot and dialogue, the aspects of the libretto that had been most criticized, as she had. He later added that "the only literary gift which Barrie had not got is the sense of poetic rhythm, and the instinct for what is permissible in verse." Barrie could at least see the amusing side of things. He recalled a friend coming into his box on the first night and replying, when Conan Doyle asked why he had not cheered, "I didn't like to, when no one else was doing it."

Despite this unpromising debut, the opera ran for six weeks, allow-

ing Arthur to develop his theatre contacts, among them the formidable Charles Charrington and his wife who managed Terry's Theatre in the Strand and were soliciting work for a program of five one-act plays in June. When the idea of staging Sherlock Holmes arose, Arthur demurred, and there is an undated letter from him to Mrs. Charrington (the accomplished actress Janet Achurch, who had appeared as Nora in the first English production of *A Doll's House*) regretting that, after much thought, he had decided that Holmes was "not fitted for dramatic representation. His reasonings and deductions (which are the whole point of the character) would become an intolerable bore upon the stage." In the light of the detective's later success, both in the theatre and in the cinema, this was another example of Arthur's poor commercial sense. The inference was that the theatre was a medium for action, humor and unfolding of plot rather than for ideas. But, still excited by the prospect of having his name in lights, he spent an evening revising his story "A Question of Diplomacy" for her theatre. Renamed *Foreign Policy*, this short play, about the wife of the Foreign Secretary who gets her own way in domestic matters through her own style of diplomacy, appeared on June 3 on a bill with works by Thomas Hardy, Lady Colin Campbell, Mrs. W.K. Clifford and J.M. Barrie.

Having made this indifferent start to his theatrical career, Arthur now set his mind to lecturing. It is curious that he had been so specific in April about wanting to explore these two activities. In a sense they were professional rites of passage undertaken by any author wishing to extend his professional range, while gaining assured financial returns. But in Arthur's case they also reflected a certain amount of confusion, as if he could not decide where to concentrate his talents.

Arthur made contact with Gerald Christy, a young man who ran a successful lecture agency. He told Christy that, following a change in his plans, he expected to be in England until at least the following January and was ready to undertake some lectures. Within a couple of days his initiative had paid off, for his mother's window on the world, the Edinburgh Philosophical Institution, had agreed to pay him the not inconsiderable figure of eighteen guineas for a talk on George Meredith in November.

Arthur was also hoping at some stage to flee the pressures of London and thus fulfill another ambition to see more of the world. He had planned to spend part of the previous winter on the French Riviera and had lined up his sisters Lottie and Connie to help him, essentially with typing. But the birth of Kingsley and other family obligations had put a stop to that.

Having struck up a correspondence with Robert Louis Stevenson, Arthur now suggested that he might visit him in Samoa. In April Stevenson had mentioned how much he had enjoyed the Sherlock Holmes stories, though there was a backhanded compliment in his description of them as "the class of literature that I like when I have the toothache." Arthur was doubtless unfazed, as he took much the same view. He told Stevenson he hoped never to have to write another word about the detective and sent him a copy of *The White Company*, which he said he would much rather be remembered by. But it was another Sherlock Holmes tale—"The Adventure of the Engineer's Thumb"—that Stevenson insisted on commending when he wrote later in the summer, saying he had read it to one of his servants who was riveted. But, he added, it would be no use introducing Arthur as the author of the piece in Samoa as the local people had no concept of fiction and regarded all stories as true. In such circumstances, concerns about the merits of romance over realism seemed superfluous.

In one of his letters Stevenson had referred to Arthur as a "fellow Spookist." He had noticed from the Proceedings of the Society for Psychical Research that Arthur had finally joined the organization in January 1893. Arthur said little publicly about this, but he had been intimating that his interest in the more esoteric workings of the universe was unabated. His need to find answers to pressing questions on this score had probably contributed to the sense of confusion in his life at the time.

The date was significant because it coincided with the Society, largely at the instigation of Arthur's friend Frederic Myers, setting up an important research project to look into stories of "second sight" in the Scottish Highlands. This related to the supposed gift, which Arthur had often drawn on in his stories, of being able to see events, both in the future and in the past, to which normal people were blind.

The inquiry would be conducted by Ada Goodrich Freer, the assistant editor of *Borderland*, a new quarterly magazine about the paranormal, which W.T. Stead had set up. Arthur did not write for this publication, but he must have known about it as the two men had met that January when Stead, with his passion for both spiritualism and imperialism, had tried to involve Arthur in another of his many ventures—a new reader-supported "Daily Paper" that he hoped would follow in the campaigning spirit of his *Pall Mall Gazette* and *Review of Reviews*. In particular, Stead wanted Arthur to contribute to a typical headline-grabbing ploy—a novel written on a daily basis by a rota of

famous authors reacting to the news of the previous twenty-four hours.

After his experience of communal writing the previous year, Arthur was not enthusiastic, though he dressed up his refusal in a manner that showed how seriously he took his craft. "Your plan would spoil the Novelist, and the Novelist would spoil your plan," he declared, adding that a leading foreign correspondent could have reported a recent skirmish in Egypt as well as a novelist such as Kipling, the only difference being that the latter's fee would be ten times greater.

Arthur's main point was that all signs of a person's character would be lost if several writers worked on a story. "There remains only incident, which a good craftsman only uses as a means for elucidating character. Incident for any other purpose is the lowest form of art." Drawing here from a remark of Barrie's which he had written in one of his notebooks, he was reaffirming the need for romance in fiction. But Arthur's ultimate criterion remained utilitarian: as he put it to Stead, art was about "tact in one's work, and knowledge of what is effective and what is not."

Arthur's instincts were sound, for Stead could not get the necessary support to start his new newspaper. However the campaigning editor did manage to publish the first issue of *Borderland* in July 1893. This was a popular digest of all the topics the SPR was investigating with rather more scientific diligence. In the first issue there were pieces on the SPR's ongoing census of ghosts, on cases of premonition of disaster, on psychic healing, on popular science ("Can Matter Pass through Matter?") and on the Spectre Dog of Peel Castle. But Arthur was loath to go public about such matters. His membership in the SPR confirmed his general interest, but his contemporary notebooks suggest that he was more exercised at this stage about finding answers to basic theological questions about man's role in the universe than proving the validity of paranormal phenomena such as telepathy.

This helps explain why he made his own arrangements to speak at a convention sponsored by the magazine *The Young Man* in the Swiss lakeside resort of Lucerne in August. With his increasingly high profile, he was well suited to address a youthful audience. Nevertheless, this was an unusual publication for someone of his views, since, with its companion *The Young Woman*, it peddled an overtly Christian message along with its diet of otherwise unassuming adventure stories, character sketches and sports features. The mixture reflected the Methodist faith of its main editor, the Reverend W.J. Dawson, who was a great fan of Arthur's historical novels and who had already prevailed

on him to write a piece for the magazine revealing his choice as the best book of the previous year. With typical exuberance Arthur had exceeded his quota and named not one but two volumes, both unexpectedly works of manly poetry, Henley's *The Song of the Sword* and Kipling's *Barrack Room Ballads*. He was particularly appreciative of the latter's achievement in documenting the world of the British soldier. "What would we not give to have some authentic record which did for Cromwell's Ironsides what this does for the nineteenth century Tommy," he declared with feeling.

The Young Man had promoted its Lucerne meeting in its editorial pages, offering readers nine days in central Switzerland for the bargain price of eight guineas, including railway travel. After making his way there with Louise, Arthur gave his now familiar talk on George Meredith at the Hôtel de l'Europe on August 9. He was delighted to find himself in the company of an unusually distinguished group of Nonconformist clergymen. As well as Dawson, participants at the meeting included Henry Lunn, a former missionary who had pioneered inter-faith conferences in the Alps and who was soon to set up an eponymous travel firm, Benjamin Waugh, who had founded the National Society for the Prevention of Cruelty to Children in 1884, and Silas Hocking, also a novelist, whose story about street children in Liverpool, *Her Benny*, had sold over one million copies since its publication in 1879.

Between lectures, Arthur accompanied these reverend men on long walks in the hills, where he took the opportunity to discuss the metaphysical questions that were exercising him. He seems to have found the experience therapeutic for he celebrated it in a poem for *The Young Man* in tones reminiscent of Lewis Carroll's "The Walrus and the Carpenter":

> And we talked of many things
> As we tramped through that oasis;
> Of republics and of kings,
> Of religion and its basis,
> Of the patience of the poor,
> Of the evil in high places,
> So we walked from Engelberg
> With the breeze upon our faces.

There were clearly other issues on the agenda, however. For Dawson, Lunn and Hocking all later claimed to have played a part in solv-

ing another matter still troubling Arthur—how finally to rid himself of his troublesome detective? Despite his firm avowal to his mother in April that he had done the deed, he had still not managed to destroy Holmes—at least, not to his satisfaction.

Strangely, the three ministers' stories were all slightly different. Looking back two years later Henry Lunn recalled Arthur's saying in Lucerne, "I have made up my mind to kill Sherlock Holmes; he is becoming such a burden to me that it makes my life unbearable." Lunn added, "It was the Rev. W.J. Dawson who suggested the spot, the Reichenbach Falls, near Meiringen, where Conan Doyle finished the great detective, so I was an accessory before the fact."

Dawson's involvement is borne out by the fact that he accompanied Arthur and Louise for part of the way when the Conan Doyles continued south from Lucerne to another resort, Zermatt. Their itinerary took them via Meiringen to the Reichenbach Falls, where Dawson admitted in his own magazine that he had been "an unintentional accomplice" to Holmes's murder. "The decree had gone forth that Sherlock Holmes must die, and it is a tribute to Dr. Doyle's sense of artistic fitness that he finally selected this spot for the tragedy. The water pours over a curving precipice into a huge cauldron, from whose black depth rises a cloud of vapour, through which the morning sun flashes innumerable rainbows. The eye vainly searches the abyss for any bottom; the depth seems infinite, and the thunder that rises from the boiling cauldron is terrific. A narrow path winds along the edge of the abyss, from which the scene may be viewed in all its grandeur."

Dawson continued with Arthur and Louise through the Gemmi Pass to Visp in the Swiss Rhône valley, where the Conan Doyles met up again with Silas Hocking and his wife who, like them, were taking the train up to the fashionable resort town of Zermatt. From there they had to rely on donkeys to carry them higher until, at 7,306 feet, surrounded by snow-capped peaks dominated by the jutting Matterhorn, they reached the family-owned Riffelalp Hotel, a favorite haunt of English travelers, including, at that time, the Archbishop of Canterbury and his family.

One day Arthur and Hocking joined E.F. (Fred) Benson, the Archbishop's son, on a hike up to the nearby Findelen Glacier. Benson had just written *Dodo*, a comic novel of manners and society, whose success would soon allow him to give up his job as an archaeologist and become a full-time writer. As this trio made their way across the ice, Arthur again talked about his desire to get rid of Sherlock Holmes. "If you are determined on making an end of Holmes," Hocking claimed

to have suggested, "why not bring him out to Switzerland and drop him down a crevasse? It would save on funeral expenses."

Passing through Paris on his way home and finding himself with nothing to read, Arthur bought a volume of Maupassant's stories. The first he dipped into was called "L'Auberge," from which the two words "Gemmi Pass" stared out. He was immediately struck because not only had he recently been there (he and his party had spent the night in a small hostel in the pass) but he had conceived it as the setting for a story of his own about a group of travelers, holed up over winter, and slowly getting on each other's nerves, with dire and inevitable consequences. Reading on, he found Maupassant had written something very similar—about a party of people cut off by the snow. "Everything that I imagined was there," Arthur later wrote, with a touch of license, "save that Maupassant had brought in a savage hound." He was fascinated that not only had he visited the same inn, but also he had bought the one book which would stop him copying his predecessor and so making a fool of himself. (Copying someone else's work was anathema, making him all the more angry whenever he was occasionally accused of it.)

He was convinced that this experience was not mere coincidence but the result of some "spiritual interposition" by a "beneficent force outside ourselves, which tries to help us where it can." He later speculated if this might be the working of his guardian angel, as he had been taught in his Catholic upbringing, or perhaps, to use the terminology of psychic research (he was writing in 1907 but conveying his thoughts of 1893), his subliminal or astral ego which can "learn and convey to the mind that which our own known senses are unable to apprehend."

More immediately, Arthur's visit to Switzerland had determined him on the Reichenbach Falls as the place to finish off Holmes. He would no longer pay any attention to his mother's pleas for the detective's retention. Soon after returning to Tennison Road, he penned the dramatic scene in "The Final Problem" that had Holmes and his arch rival Professor James Moriarty grappling with each other on a narrow ledge by the Falls, before tumbling to their deaths below.

Having made his decision, Arthur wrote to his publisher, George Newnes, on August 28, requesting that his story "The Cardboard Box," which had been published in the *Strand Magazine* in January, should be left out of his forthcoming collection *The Memoirs of Sherlock Holmes*. Instead he wanted "the one about Holmes's death to come in at the end so as to complete the dozen. The story omitted is rather

more sensational than I care for." This confirms that Arthur had written a new (or much revised) account of Holmes's death to conclude the series. And in the book version "The Final Problem" was replacing "The Cardboard Box," which, perhaps in deference to recently encountered Methodist sensibilities, he had decided was unsuitable, since it involved an illicit love affair.

In the meantime there were pressing family matters. First was Connie's marriage to Willie Hornung. With her sultry Pre-Raphaelite looks, she had always been the most sought-after of the Doyle daughters. But after rejecting the attentions of several suitors, including Arthur's architect friend Henry Ball, she had opted for Hornung, with his gift of sparkling repartee.

Having spent so long in a Roman Catholic country, Connie had not weakened in her faith and turned to Protestantism like the rest of her family. She opted for a traditional wedding in St. Peter and St. Edward's, a Catholic chapel in Palace Street, Westminster, on September 27, 1893. In the absence of his father, Arthur is likely to have given her away, though there is no record of it. He certainly approved of the association because he often tried to boost Willie's career and, as his bank statements show, he helped him out financially.

Shortly afterward came two much less welcome pieces of news. On October 10 Charles Doyle finally succumbed to his various ailments. With his strong belief, he would have insisted that he went happily to his Maker. His condition had steadily deteriorated during his slightly more than a year at Crichton Royal Institution. With a hernia to add to his problems, he was described in October 1892 as being "in a very feeble condition: his hands and feet are always cold, and his pulse is rapid and weak." By then his family was resigned to him ending his days there. A couple of months later his wife Mary used a mix-up over Charles's clothes to air her pent-up anger over her husband's condition in a letter to the medical superintendent, Dr. James Rutherford. She ran through tales of his drunkenness stretching back thirty years and was brutally direct in her admission of his continual mendacity. As a result she was loath to recommend his discharge, because she feared it would quickly lead to Charles killing himself. She added that her son, whose clothes were usually passed on to his father, as they were much the same build, agreed with her.

So, while Arthur continued to enjoy success, his father became weaker and "more discontented" throughout 1893. A month before he died, Charles rallied slightly: he got up for the first time in months and

was said to be "rather more sensible." It was as if he knew his end was near. On October 3 he was "pleasant and easily pleased," presenting Dr. Rutherford with a blank piece of paper which he said contained gold dust he had collected in the sunlight on his bed and which was a reward for the doctor's professional services. A week later he passed away following a fit during the night. An obituary in *The Scotsman* provided a wistful sense of what might have been, describing him as "a most likeable man, genial, entertaining, and amusing in conversation. Possessed of a fertile imagination, it was always enjoyable to listen to his anecdotes. He was a great reader, and was in consequence well informed. His abilities and gentlemanly manner secured to him a cordial welcome wherever he went."

Under normal circumstances, Arthur, as a dutiful son, might have been expected to travel to Dumfries to supervise his father's funeral. Instead he chose to stay south and attend Frederic Myers' talk for the Norwood Literary and Scientific Society on October 11. The subject was "Recent Evidences as to Man's Survival of Death." If Arthur needed further indication of coincidence, this was one. As it was, his interest in the paranormal clearly remained undiminished.

The reason for his continued presence at Tennison Road was the second, apparently unforeseen, piece of distressing news—that Louise was dangerously ill. Since their return from Switzerland, she had been suffering from a cough and had complained of a pain in her side. Arthur had mentioned this to Amy Hoare the previous month. He had subsequently told his Birmingham "Mam" that his wife was better but, since she would not be well enough to travel that winter, he proposed taking her to Rome in the spring.

When Louise's condition deteriorated again, Arthur called in his local GP. He was mortified to learn that her lungs were infected with tuberculosis, and her prognosis was very poor, particularly given her family history. (The cerebral meningitis that had killed her brother had almost certainly been consumptive.)

One of Arthur's worst nightmares had come to pass. Had he not visited Berlin to find how to beat this killer disease? Despite hopes of a cure, tuberculosis had not been tamed and its malignant influence had pervaded his own literary output. Dr. Watson's need to attend an Englishwoman in "the last stage of consumption" had caused his absence from Holmes's side during the Alpine climax of "The Final Problem."

Given Arthur's interest in non-verbal communication, it was as if he had had premonitions of Louise's condition. This would explain his

reluctance to travel earlier in the year and his decision to take her to the salubrious Alps during the summer. But perhaps the reason was simpler. As a doctor with knowledge of tuberculosis, he must have suspected something, if not before going to Switzerland, at least afterward, when his wife was complaining of a cough. Yet on a conscious level he managed to ignore these symptoms. No wonder he would later look back on Louise's illness as "the great misfortune which darkened and deflected our lives."

At the start of the final week of October 1893, he escaped to London where he was in obvious denial when he wrote to A.P. Watt from the Reform Club. On a formal level he apologized as he would not be using his agent's service so much in the future. This was not a reflection on Watt's abilities, he said, but the result of his own father's death, which had added enormously to his family responsibilities and compelled him to exercise economy. Almost as an afterthought, Arthur added that his wife had recently developed serious chest symptoms and he was afraid that they would have to spend the winter in the Engadine.

While at the Club, he made a payment of 40 pounds to someone who appeared in his bank statements as "Labusseere." This was without doubt his fellow Club member, the maverick Liberal MP Henry Labouchere, who waged a tireless campaign against corruption in his gossipy magazine *Truth*. Always prepared to take up cases of fraud brought to his notice by the Charity Organisation Society, Labouchere was being sued for libel by a husband and wife couple called the Zierenbergs whom he had accused of passing off the sweatshop they ran in Kennington as the fine-sounding St. James's Home for Female Inebriates. Although rich, Labouchere must have mentioned the prohibitive costs of this action in the Club, and a distraught Arthur, looking for an appropriate way of honoring his father in the middle of a pressing crisis, agreed to help. In court Labouchere was able to show that the Zierenbergs ran a dingy music hall next to their so-called home. But although he won the case, he was never able to recover costs running to 8,000 pounds. Arthur had to write off his money, albeit in a worthy cause.

From his Club Arthur updated his mother on Louise's situation, following a confirmatory visit by the Queen's physician Sir Douglas Powell to South Norwood the previous weekend. His wife's cough continued to be troublesome, and she was bringing up lots of phlegm. For the moment she showed no signs of hemorrhaging, though Arthur feared she soon would. His plans now were to take Louise to

Switzerland for the winter and then perhaps travel to Egypt in the spring, before returning to England when the weather was warmer. The succession of events had all been rather taxing, he said, with some understatement. Nevertheless he was determined not to neglect his work, which took his mind off his troubles. So he stressed to his mother that he intended to continue writing while away. And, before that, he was going to complete the nationwide schedule of lectures which Christy had arranged for him, ending around December 10.

He proposed that Louise should stay with her own mother in Reigate until then. Only when he had finished his tour would they both go to St. Moritz, which had been recommended by her doctors because it was slightly higher, and therefore healthier, than Davos, the usual destination for British consumptives. Lottie would come as a companion for Louise (presumably to help out when Arthur was working). While they were away, Louise's sister Nem Hawkins would stay at Tennison Road with the two small children, their nurse Ada and one servant (the others would have to be dismissed).

Since Lottie was away in Bournemouth, Arthur needed to talk matters over with her on her return. But Louise's condition seems to have deteriorated and Lottie prevailed on him that his wife's health needed to be addressed without delay. For the plan changed and Louise left for Switzerland almost immediately, on November 1, accompanied by her sister Nem. By the following day the two of them were ensconced in the Kurhaus Hotel in Davos, which had been preferred to St. Moritz, perhaps because Arthur's new friend Robert Louis Stevenson had been there a dozen years earlier, seeking a cure for his own tuberculosis. Arthur explained to his mother that he had been advised that it was essential for Louise to travel now rather than in December when the weather would be too cold.

He then set out on his lecture tour, which took him, in two stages, through middle and northern England, and up to Scotland. He kept Lottie, who was holding down the fort at Tennison Road, informed of his progress in a series of self-consciously upbeat letters. While in Scotland, he might have been expected to see to their father's estate. But he made no mention of him, and only cursory reference to Louise. Instead he asked Lottie to write to some business contacts, telling them he would be away for six months and could be contacted in Davos.

This was important to him since his relationship with Watt was in abeyance, largely as a result of misunderstandings following his abrupt letter from the Reform Club. The main bone of contention was the commission on his medical stories for Jerome. In a letter to Watt from

Glasgow, Arthur admitted he could not expect his agent to work at unremunerative rates. However he saw no reason for paying him a cut on transactions he did himself. Since Watt had indicated he would only operate on an all-or-nothing basis, Arthur reluctantly declared he must resume selling his own work.

In another letter, Arthur accused Lottie of playing at Sherlock Holmes after she had tracked him down to a hotel in Newcastle. He now planned to take her with him to Davos, where she would change guard with Nem, as originally intended. He advised her to buy some thick undergarments because it would be very cold. (Somewhat mystifyingly, he said she should regard this as part of her American trousseau, suggesting that not only was he contemplating a forthcoming trip to the United States but he was also intending to take his sister with him.) Otherwise his dogged progress was summed up in a rhyme he sent Lottie:

> The butterfly has wings of gold
> And some have wings of flame
> The little bug has only legs
> But he gets there all the same.

While he was away, "The Final Problem" appeared in the *Strand Magazine*, providing an unambiguous conclusion to his second batch of twelve detective stories which were soon collected by Newnes in book form as *The Memoirs of Sherlock Holmes*. According to popular but unconfirmed myth, City of London clerks donned black armbands in mourning at the detective's demise. Arthur's own reaction was rather different. The bald entry for December in one of his diaries showed a mixture of relief, anger and satisfaction. It read simply "Killed Holmes."

Swiss Interlude

1893–1894

Arriving in Davos Platz on December 10, 1893, eager to see his family, Arthur found his entry to the Kurhaus Hotel blocked by a stout woman. As he tried to negotiate a way past this Rubensesque figure, he realized to his astonishment that she was his wife. By his estimate she had put on fourteen pounds in little more than a month, which was excellent progress.

He dashed off an appropriately upbeat message to his new clubland friend, Sir John Robinson, editor of the liberal *Daily News*, enthusing that, in the absence of their "cracks" (in the Irish sense of convivial encounters) at the Reform Club, Davos was "a most glorious place— such a blue sky and bright sun, although 5,000 feet up. The air too so exhilarating! It's a rare place for work. I should like to pick up your editorial sanctum, and plump it down on the top of the snow crowned peak opposite my window."

Despite his knack of sounding carefree, Arthur's underlying mood was more somber. The last few weeks had been very difficult, with his father's death and his wife's illness. Although he had enjoyed his lecture tour, he told Christy he did not want to repeat the experience, except in America. Writing usually offered a palliative in stressful situations, but he now found himself without an agent. Only recently his head had been teeming with ideas, including a book about the Regency. But he had had to abandon these because every volume he read suggested two more. It was not even clear if he was in a fit state to undertake such work.

Almost in desperation he had committed himself to writing a semi-autobiographical epistolary novel called "The Threshold" about a

young doctor's growing awareness of divine purpose in the universe, as he plots a course between the conflicting demands of science and religion. It was a subject close to Arthur's heart, but also something of a penance since his medical stories for *The Idler* had proved so explicit that only three of his eight could be used. Luckily, Jerome had recently started a book-publishing arm and was seeking submissions. Arthur's time with the Methodists in Lucerne had left him pondering spiritual and moral issues, and his contemplative mood had been reinforced by his father's death. When Jerome offered him 1,000 pounds for serial rights, Arthur saw an opportunity to rework some earlier ideas relating to these topics.

By the time he arrived in Davos he claimed he had already completed a quarter of this new work. That may have been true, but he did not reveal the extent to which he was recycling a book he had written a decade earlier in Portsmouth. This volume, "The Narrative of John Smith," had never been published because, Arthur insisted, it had been lost in the mail. It had been a scrappy compendium of his general views in the early 1880s. "The Threshold" was more structured and more obviously based on himself and his quasi-theistic beliefs. He described it to Payn as "a queer little book, a sort of dissection of a young man's life, his view of things, religious and otherwise, his difficulties in starting a career etc." It was "more analytical and certainly far more contentious than anything I have done."

Soon retitled *The Stark Munro Letters*, this book provided colorful portraits à clef of Arthur's relations and friends. The main character, Dr. Munro, has a mother much like his own. Munro's foil (and partner) is a larger-than-life character called Cullingworth, obviously modeled on George Budd. (Later in 1894 Arthur would suggest that one problem with "John Smith" was that it had been libelous—obviously of Budd. In fact this was more true of *Stark Munro*, but the threat of a writ had been removed with Budd's death in February 1889.)

Intriguingly, Munro marries Winifred La Force, a "quiet, gentle-looking" woman "with a somewhat enigmatical smile," who, like Louise, is the sister of a patient who died. She also brings a dowry that eases Munro's financial problems, though whether the detail that the doctor was suspected of foul play and questioned by the police after her brother Fred's death reflected what happened in Bush Villas, Portsmouth, in 1885 is not made clear.

Charles Doyle is a more spectral presence, discernible in the account of Munro's visit to an estate in Perthshire to watch over the Hon. James Derwent, the deranged son of Lord Saltire. Careful to state

this episode is based on a friend's experience, rather than his own, Arthur uses Derwent's insanity to examine an idea that obsessed him about his own father's illness—that a man's essence or soul cannot be crushed by alcoholism, madness or even death, because it does not lie in his material form, but in something more intangible. However, he could not fully discard his post-Darwinian scientist's hat. So his alter ego Munro was forced to speculate that drunkenness and debauchery were part of the Creator's overall plan. Since alcoholics and syphilitics were less likely to reproduce, this was nature's way of removing its weak links. "When there are no more drunkards or reprobates, it means that the race is so advanced that it no longer needs such rough treatment. Then the all-wise Engineer will speed us along in some other fashion." Such was Arthur's latest position statement in his search for a synthesis between science and religion.

His claim to have lost "The Narrative of John Smith" has to be treated with skepticism, following the discovery of a manuscript copy in the Conan Doyle family archive and sold in May 2004. Comparison with *The Stark Munro Letters* confirms not only a similarity in their themes, but also the identical nature of certain passages. For example, the earlier work forecasts that "the forms of religion will be abandoned but the essence maintained so that one universal creed will embrace the whole earth which shall preach reverence to the great Creator and the pursuit of virtue, not from any hope of reward or fear of punishment, but from a high and noble love of the right and hatred of the wrong. . . . And then? Why by that time perhaps the Solar System will be ripe for picking." In *The Stark Munro Letters* this became, "The forms of religion will be abandoned, but the essence will be maintained; so that one universal creed will embrace the whole civilized earth, which will preach trust in that central power, which will be as unknown then as now. That's my horoscope, and after that the solar system may be ripe for picking." Arthur's dissimulation can perhaps be explained by his depressed frame of mind at a time when his father's death, his wife's illness and his rift with his agent all seemed to militate against him.

Being in an Alpine resort did little to dampen his industry, however. On January 23, 1894, he told his mother that, despite having been confined to bed for a week with the flu, he was nearing the end of his book, which he expected to "make a religious sensation if not a literary—possibly both." He added, "I am going to lead the life of a savage when it is finalized—out of doors on snow shoes all day."

His savagery was postponed, initially because the Conan Doyles

were not happy with the Kurhaus, where they were the only English guests in a sea of Europeans. So in mid-February they moved to the larger Grand Hotel and Pension Belvedere which catered exclusively to Britons, many of whom were in Davos for their health.

A further reason for Arthur's delay in getting on the slopes was that he started another novel, *The Parasite*. This time his subject matter was more sensational—the enslavement of a young physiologist, Professor Gilroy, by a female mesmerist, Miss Penclosa. Having written a broad-ranging metaphysical book, he had decided to look more closely at the fundamentals of scientific investigation—one of the issues resulting from by his membership in the Society for Psychical Research.

While in Switzerland Arthur had been in touch with Professor Oliver Lodge, a leading physicist who kept up the tradition of prominent scientists investigating the paranormal. He thanked Lodge for sending a copy of the Transactions—perhaps a mistake for the Proceedings of the SPR, but more likely a reference to a paper in which Lodge, a close collaborator of Frederic Myers, had reported on his inquiry into the American medium Leonora Piper, who was the phenomenon of the moment in paranormal circles. She had managed to convert the fiercely skeptical SPR researcher Richard Hodgson to a belief in life after death, and now Lodge was convinced of her powers. In his letter to Lodge Arthur mentioned Phinuit, Piper's spirit guide, the disincarnate being who supposedly spoke through her in her trance-state and who was very similar to the guardian angel Arthur had recently encountered in Paris.

Lodge was no fanciful paranormal researcher, but a hard-headed scientist making significant discoveries about the capacity of electromagnetic waves to send messages without wires. He saw correspondences between this and the extra-sensory communication at the center of modern psychical research. Arthur was fascinated by such findings because they seemed to prove his hypothesis about the close links between science and religion. However, he apologized to Lodge for being only a novice in this field, adding that his curiosity was greater than his understanding.

So his new novel suffered from being a fictional vehicle for the ideas that were teeming in his head—in this case, how the new science of psychology was developing in parallel with the study of the paranormal. Arthur made much of the contrast between Gilroy's dogged materialism ("Show me what I can see with my miscoscope, cut with my scalpel, weigh in my balance [scale], and I will devote a lifetime to its investigation") and the excitement of the research conducted by

his psychologist colleague, which "strikes at the very roots of life and the nature of the soul!"

Arthur remained obsessed by what happened to the soul, in mesmerism, madness and death. When Gilroy's girlfriend is mesmerized, he notes, "Her organs were acting—her heart, her lungs. But her soul! It had slipped from beyond our ken. Whither had it gone? What power had dispossessed it?" Miss Penclosa explains her powers by saying "practically, you send your soul into another person's body." When Gilroy's mind is taken over by her, he has a breakdown and acts in a manner that must have recalled Charles Doyle on a bad day, spouting "silly jokes" during a lecture, "sentiments as though I were proposing a toast, snatches of ballads, personal abuse even against some member of my class."

The suddenness of this project suggests an opportunistic attempt to cash in on the phenomenal success of *Trilby*, George du Maurier's recent novel about mesmerism. Arthur was clearly intrigued by the paranormal aspect of mesmerism, but this new book had an additional, personal, connotation. In calling it *The Parasite*, he was referring, if only subconsciously, to the bacteria which had invaded his wife's body. In the past he had frequently used the metaphor of disease as an enemy to be conquered. When reporting Louise's current condition to his City friend Stratten Boulnois, he reiterated, "What an infernal microbe it is. Surely science will find some way of destroying it. How absurd that we who can kill the tiger should be defied by this venomous little atom. Could we not impregnate every tissue of the body so that they could not live. One can keep parasites out of wood and out of cloth. I believe the Engineers would solve the problem quick enough. Doctors are, I really think, a very conservative hidebound and above all timid set of people. They are so afraid of hurting their patients with strong drugs that they allow these little beasts to turn them into incubators." Though, for the benefit of his friend, this was a forthright endorsement of scientific medicine, Arthur, through the title of his book, was pointing to close links between physical and paranormal phenomena that were beginning to be explored by Lodge and other contemporary scientists. Intriguingly, his mother gave those two words another unintended layer of meaning for which he had to tell her firmly that his book was called *The Parasite* and had nothing to do with parricide.

On March 7 he was writing positively to a correspondent about this 20,000-word story. He was disappointed when J.M. Barrie did not pay him a promised visit later in the month, as he had been looking

forward to traveling with him to Rome and Naples. Having toned down some of the more melodramatic content, he had managed to sell his "realistic" medical stories to Methuen (and to D. Appleton in the United States) for autumn publication under the inappropriate working title "Dream and Drama," later changed to *Round the Red Lamp*. He apologized shamefacedly to James Payn, the apostle of romance in fiction, for their realistic nature, but at least, he said, they had been written with serious rather than flippant intent.

Once he had completed a total of 100,000 words (or so he claimed) during his short stay in Switzerland, he felt he could finally devote himself to some energetic Alpine activities, rather than the tame pastimes of skating and tobogganing around the hotel. His main ambition was to master the infant sport of skiing, or ski-running, as it was then called. The Swiss, who traversed mountains on cumbersome snowshoes, were learning from the Norwegians who were much quicker on their wooden skis with flexible bindings. Arthur had been impressed by the Norwegian explorer Fridtjof Nansen's account of his perilous crossing of Greenland on skis in 1890, and had asked about the latest developments when he visited Norway a couple of years later. Around the same time Tobias and Johannes Branger, who owned a sports shop in Davos, had ordered several pairs of Norwegian skis and began experimenting on local slopes. The previous March they and a colleague had crossed the fourteen-mile long Mayerfelder-Furka Pass (normally closed in winter) linking Davos with Arosa.

This was the same journey that Arthur made with the two brothers on Good Friday, March 23, 1894. It meant leaving Davos at 4:30 in the morning, climbing the 1.5-mile pass on snowshoes, and then making their descent on skis. At one steep point on the way down the Brangers tied their skis together with a leather thong and set off over the precipice as if on a sled. But when Arthur tried to copy them, his skis slid from underneath him, hurtling away into the abyss below. The only way out was for him to launch himself down the mountain on his backside. He landed not far from the brothers and his skis were also found nearby. He later commented that his tailor had assured him that Harris Tweed suits were indestructible, but he had proved him wrong, leaving several samples of expensive cloth strewn between the top of the pass and Arosa. The party reached the small Italian town shortly after 11 A.M., had lunch at the Hotel Seehof, and then, as the *Davoser Blätter* reported, "an extra post [reservation] was secured for Chur, and the travelers arrived at Davos by tram at 9:30 P.M.," having thoroughly enjoyed their exciting excursion. The following day Arthur informed

his mother about this feat, claiming to be the first Englishman to tra-
verse an Alpine pass in winter in this way. In that claim he was correct
and, though he was not exactly the pioneer of Alpine skiing he is
sometimes portrayed, he certainly helped popularize the sport, partic-
ularly among the British.

He had now decided on his future course of action. In April he
would take Louise back to England, traveling via Paris where they
would stay at the Hotel Byron. In the autumn he would embark on a
major lecture tour of the United States which he had been negotiating
with Major James B. Pond, a New York agent recommended by George
Kennan, an American explorer with a vast knowledge of Russia. Innes,
now an adjutant in the Royal Artillery, would accompany him, rather
than Lottie. While they were on the other side of the Atlantic, Louise
would return to Switzerland (he expected she would need two more
seasons there before she was cured). Arthur would join her before
Christmas and they might travel further afield the following year.

Back at Tennison Road, life with a sick woman was not easy. Louise's
illness now hung over the house. So when she went to stay with her
mother in Reigate, her room was promptly repapered by Lottie in an
effort to banish germs and lingering medicinal odors. Arthur started
to spend more time in London, where he had decided to resume his
business relationship with A.P. Watt. In a letter to her mother, Lottie
made this sound as though Arthur was frightfully busy, attending
dinners night after night. But the truth was that he was beginning to
chafe at aspects of his domestic life.

Not that he neglected his new responsibilities as head of the
extended family. Ida, the latest of his sisters to emerge from the family
nest, came to stay in May. She had won a scholarship to study for a
Bachelor of Scinece degree at the Royal Holloway College, London. A
photograph shows her, age nineteen, in the garden at Tennison Road,
looking intense and rather fragile, flanked by her brother, dapper in
blazer and boater, a remarkably resilient-looking Louise, and a couple
of visitors, Robert Barr and Robert McClure, who ran McClure's syndi-
cation service in London for his brother Sam. The photograph would
accompany an interview Barr did both for *The Idler* and—with a nice
promotional touch, to coincide with Arthur's forthcoming tour—for
McClure's Magazine, Sam's latest venture in the United States. Arthur
took the opportunity to commend some of his favorite British and
American authors. Barr noticed his host's methodical nature—how he
stuck lists of things to do over his mantelpiece and annotated vast vol-
umes of reading in a series of notebooks. Arthur's most recent jottings

were about Napoleon, whom he described as "a wonderful man, perhaps the most wonderful man who ever lived. What strikes me is the lack of finality in his character. When you make up your mind that he is a complete villain, you come on some noble trait, and then your admiration of this is lost in some act of incredible meanness."

With an eye to Ida's future, Arthur was keen to introduce her into his social life. So she was almost certainly the Miss Doyle reported in *The Times* to have accompanied Arthur on one of his London jaunts to the Society of Authors annual meeting, chaired by Leslie Stephen, at the end of May.

He also had a more protective role to play. Now that Connie was married and living in Chelsea, her older sister Lottie was conspicuously unattached. Although she was only twenty-eight, that was considered ancient in the Victorian matrimonial stakes. Mary Doyle was aware that her cousin Nelson Foley had lost his wife at the start of the decade. He was living in some style on the island of Gaiola in the Bay of Naples, where he was employed as a naval architect by the King. Mary seems to have suggested that Lottie might like to go there. But her daughter reacted strongly against this, causing Arthur to take the unusual step of rebuking his mother for raising the possibility. Once the Mam had an idea in her head, however, she did not let it go. Later in the summer she visited Nelson, taking Ida instead of Lottie. This time her matchmaking was more successful, for, before the year was out, Ida was engaged to marry her cousin.

Having written *The Parasite*, Arthur needed to boost his credentials in professional paranormal circles. As a traveler in this field for almost a decade, he had contributed little personal research. And for all his related reading (attested to in his notebooks) and his trotting-out of names such as Nancy and Salpétrière in his new novel, his understanding remained superficial. He seemed to regard psychology and physiology as opposing disciplines, when they were increasingly allied. Professor Jean-Martin Charcot, who was making significant advances in the study of mesmerism at the Salpétrière hospital in Paris, was a physiologist whose insights into the workings of the mind were interesting Sigmund Freud.

So in June Arthur agreed to accompany Frank Podmore and Dr. Sydney Scott from the Society for Psychical Research on a field trip to Dorset. He liked to recall how the Society had been summoned by a Colonel Elmore, a veteran of the Second Afghan War, who was concerned about mysterious noises in his house in the seaside village of Charmouth. Although something of a skeptic, Podmore was keen to follow the matter up as he was conducting a study of poltergeists.

Arthur later offered different versions of what happened, not all of them featuring an ex-army officer. Luckily he provided James Payn with a contemporaneous account of events which must be as close to the truth as possible. According to this, he stayed in the Coach and Horses Hotel in Charmouth. From there, he and his colleagues had access to the supposedly haunted house, a thatched former smugglers' retreat, which was inhabited not by a Colonel but by a cheerful, though somewhat apprehensive, Irish family, comprising mother, son and daughter. Also living there was a forbidding middle-aged maid, also Irish, whom the investigators suspected of instigating the supposedly ghostly disturbances.

On the first night they sat up with a camera and magnesium wire, hoping to take a spirit photograph, but nothing happened. On the second, Dr. Scott left early, and the mother and daughter went to bed, leaving Arthur and Podmore talking to the son, who was in his early twenties. After they declined his offer of a drink, he left the room for ten minutes. When, on his return, they began to leave, he begged them to stay. About five minutes later there was a loud crash in the kitchen, and a noise, so Arthur told Payn, like a table or door being hit with a stick. After half an hour this commotion happened again, but when the investigators went to look they found nothing. Arthur stayed up till two in the morning, hoping to catch someone or something, but to no avail. He eventually decided that the young man of the house was responsible, with an accomplice, since the maid was too stupid to devise such a ruse.

The odd thing was that when Arthur described this incident thirty years later in his autobiography, he dismissed this simple explanation, which tallied with Podmore's conclusion in his official report. Perhaps he felt he had been unduly swayed at the time by Podmore's skepticism. Instead he suggested that the whole experience had had something to do with the skeleton of a child that was later dug up in the garden in Charmouth. Later, in 1924, when he was more deeply committed to spiritualism and he had come to abhor Podmore's impartial approach to such phenomena, he alluded to the theory that the spirit of a young person, whose life is cut short, may stay around the place of its' supposed death, manifesting itself in odd ways and so helping to remind everyone of dimensions beyond the material.

After his exertions in Davos, Arthur was less demanding of himself when it came to literary output. Between games of cricket, he wrote some articles for *Great Thoughts* about his favorite authors, which would provide material both for his talks in the United States and for

a later book, *Through the Magic Door*. He liaised with Sir Henry Irving over his play "A Straggler of '15'," but basically left the actor-manager to get on with the slow process of bringing the work to the stage. Arthur was more interested in developing for Irving a new, much longer drama on a Regency boxing theme. He attempted to involve his brother-in-law Willie Hornung in the project and gave him 50 pounds as a down payment. But the two of them had only written one act when Arthur put the piece aside. Despite the attractions of seeing Irving as a dandy he felt, for the time being at least, he could use the material better in a novel.

Eventually on September 21 (A Story of) *Waterloo*, as "A Straggler of '15" was now called, received its premiere at the Princes Theatre, Bristol. After Irving had taken eight curtain calls, his manager Bram Stoker could legitimately describe the play as an "enormous success." The following day Ellen Terry, Irving's regular leading lady whom Arthur had earmarked as the co-star of his Regency play, wrote to Tennison Road to congratulate the author. Indicative of the versatile reputation Arthur had gained as a writer, she asked for a copy of "The Storming Party," a poignant poem Arthur had written a couple of years earlier about two soldiers at a battle-front. Shortly before a dangerous action, one of them is startled to see the other kissing a locket that he recognizes as having gone missing from his own wife's chain. When challenged, this man admits he had been in love with his friend's wife, but swears she did not know this or that he had stolen the trinket from her during a dance. After he dies, his friend recovers the locket and returns it to his wife, telling her the extraordinary story. There was unusual sexual sophistication in Arthur's final verse, in which the wife recalls her dead paramour:

> For she loved him—yes, she loved him—
> For his youth and for his truth,
> And for those dying words, so false.

Ellen Terry told Arthur she wanted the copy for her son Gordon Craig, who was training to be an actor. She did not let on that the poem may have touched a more personal nerve, since she had to put up with being mistress to the married Henry Irving.

By this point Louise, her mother, the two children, Mary and Kingsley, and the maid, Ada, had already set out for their second season in Davos. In early September Arthur accompanied them across the English Channel, leaving them in Calais, where, as is clear from his book

Uncle Bernac, he refreshed his knowledge of the French shoreline, before returning home. He was not in Bristol for the first night of his play. Nor, it must be assumed, did he receive Ellen Terry's letter at the time. For on September 23, 1894 he and twenty-one-year-old Innes were at the Southampton docks, boarding the North German Lloyd liner the *Elbe* before it departed on its voyage to New York.

America, Egypt and Undershaw

1894–1897

Arthur was relieved to put the tribulations of the last few months behind him and sail for the land of his dreams. He loved what he knew about the United States and remained unwavering in his enthusiasm for closer Anglo-American relations. One of the many events he had attended in London during the summer of 1894 had been an official banquet for the American naval historian Captain Alfred Mahan and his fellow officers on the USS *Chicago*. As the largest of the three original protected cruisers authorized by the U.S. Congress for its "New Navy," the *Chicago* was a floating testament to America's growing military and industrial strength. Mahan, its commander, had made his name with his study of the historical importance of sea power, particularly for Britain. His conclusions about the benefits of strategic outreach were to be studied in foreign ministries across the world as international tensions rose over the next couple of decades. They also provided none too subtle evidence that America was coming out of its isolationism.

Not everyone was so happy that America was beginning to flex its military muscle. Some observers regarded it as a threat to British interests. But Arthur, with his irrepressible optimism, looked on this as an opportunity. His writings bore witness to his desire for close relations between Britain and her North American cousins. This passion had begun with his youthful enthusiasm for tales of the Wild West and had matured with his discovery of the philosophies of Ralph Waldo Emerson and Oliver Wendell Holmes. The American state of Utah had featured prominently in his first Sherlock Holmes story, *A Study in Scarlet. The White Company*, published in 1891, carried the trenchant

dedication: "To the hope of the future/The reunion of the English-speaking races/This little chronicle/Of our common ancestry is inscribed." The following spring his views were underlined in Sherlock Holmes's declaration in "The Noble Bachelor": "It is always a joy to meet an American, Mr. Moulton, for I am one of those who believe that the folly of a monarch and the blundering of a Minister in far-gone years will not prevent our children from being some day citizens of the same world-wide country under a flag which shall be a quartering of the Union Jack with the Stars and Stripes."

Arriving at one of New York's busy Hudson River piers on October 2, 1894, Arthur and Innes were met not only by Major Pond, a gangling U.S. Civil War veteran with a goatee beard and nasal twang, but also by a posse of press-men clamoring to hear what the author of the Sherlock Holmes stories had to say, particularly about their country. British concerns about rising United States power were mirrored in America by marked disdain for its one-time colonial master. Arthur put everyone at ease with his down-to-earth manner. "He is tall, straight, athletic, and his head that his blue eyes make radiant with affability must have been modeled by Energy herself," wrote the *New York Times*. "His look is merry, quick, curious, inventive, and resolutely fixed on the things that happen, and not on an invisible star."

Pond, who had a reputation as a hard taskmaster, had lined up forty appearances requiring much travel up and down the East Coast and across to the Midwest. Arthur had prepared three talks—one on Meredith, another on modern writers, and a third, at Pond's request, on Sherlock Holmes. He seemed genuinely surprised when his audiences usually wanted the last, and he would compromise by delivering a mixture of all three.

Arthur allowed himself a week to adjust to the novelty of the New World. From his first outing to the top of New York's tallest building, he was captivated by the vitality and wealth around him. After a day out hunting in the Adirondacks, he was ready to give his first talk on October 10 in the huge 1,506-seat auditorium of the Calvary Baptist Church on West 57th Street. Shortly before walking on stage, he discovered he had misplaced his collar stud and tie. An embarrassing incident was averted when Pond offered him his own.

The next day, he and his brother boarded the New York Limited Railway for the twenty-four-hour journey to Chicago. From the luxury of his Pullman car, he was astounded at the beauty of the Hudson River and, as the train made its way westward, he accorded the country his highest praise as he marveled at the "romance of America, the

romance of change, of contrast, of danger met and difficulty over-come."

Once settled into the Grand Pacific Hotel in the center of Chicago, Arthur quickly adapted to the robust manners and good humor of the Midwest. On his first evening he addressed a meeting under the aus-pices of the Twentieth Century Club, whose president (knowingly or otherwise, it is not clear) introduced him as Canon Doyle. When alerted to his mistake, he blamed the Club secretary for describing the author as a "big gun from England." The story was taken up and given an ecclesiastical twist by Eugene Field, a gossip columnist for the *Chicago Record*. By the time he was finished Arthur was being addressed as the Right Reverend Dr. Doyle and invited to say grace at breakfast meetings. Fascinated by the visitor, or perhaps in need of copy, Field went on to complain in print about how badly produced the Sherlock Holmes books were in the United States. At a subsequent luncheon he cheekily handed Arthur one such volume to autograph—a pirated copy of *The Sign of Four*. Arthur signed it, giving vent to his feelings in the offbeat rhyme:

> This bloody pirate stole my sloop
> And holds her in his wicked ward
> Lord send that walking on my poop
> I see him kick at my main-yard

From Chicago he peeled off to give talks in Indianapolis, Cincin-nati, Toledo, Detroit and Milwaukee. Finding a small anti-British audience in Detroit, he rose to the occasion, telling them that, as a nation, they were beginning to find a role on the world stage. "Then your friendships and enmities will be guided, not by prejudice not by hereditary dislikes, but by actual practical issues." With feeling and some foresight, he predicted a coming world crisis when "you will find that you have no natural friend among the nations save your own kin; and to the last they will always be at your side."

Back in Chicago, he attended a notably drunken harvest dinner of the farmers' Fellowship Club, where he was harangued from the plat-form, "We are all farmers and we want to buy where we can buy the cheapest and sell where we can sell the dearest!" He won respect for his good-natured responses when members asked how they could "twist the tail of the British lion until wheat would bring them a dollar a bushel." The evening ended with everyone singing "For He's A Jolly Good Fellow."

Returning to the East Coast, he used his visit to the university town of Cambridge, Massachusetts, to make a pilgrimage to the leafy Mount Auburn Cemetery, final resting place of many Boston Brahmins he revered. Among them was Oliver Wendell Holmes, who had died only the previous month. Arthur laid a wreath on his grave on behalf of himself and the Society of Authors.

Temporarily in New York again, he stayed at the Aldine Club on Fifth Avenue, where he was visited by Sam McClure. Perhaps because it suffered in comparison with the established *Century, Harper's* and *Atlantic* magazines, McClure's eponymous magazine was not prospering. Embarrassingly, its main creditors were its English contributors. When Arthur heard of these problems, he made a snap decision to invest $5,000 (the exact sum owed to English authors) in *McClure's Magazine.* He wrote out a check that same day, and it promised to be a good investment. Over the next year the monthly's circulation rocketed from 40,000 to around a quarter of a million, as home-grown talent was given free rein.

Still not finished with traveling, Arthur went back north for more lectures. Because of a cancellation he was able to spend Thanksgiving with Rudyard Kipling, who lived with his American wife, Carrie, in a self-built house called Naulakha, outside Brattleboro, Vermont. The visit had been fraught with minor difficulties. Arthur had bridled at not receiving a reply to a couple of letters and Carrie had identified him as "stuffy" in her diary. The holiday, which celebrates the Puritans' arrival in North America and thus their deliverance from England, could have proved contentious, since the two men held differing attitudes about the United States: Kipling feared the anarchic potential of the American masses, while Arthur embraced their democratic promise. But on meeting they found plenty of mutual interests, including Southsea, photography and the paranormal. They were united in their affection for Carrie's brother, the publisher Wolcott Balestier, who had died so young in Dresden. They also had a healthy regard for each other's literary output: Arthur took every opportunity to praise his host's originality, while Kipling had recently been riveted by the realism of *Round the Red Lamp*, which he complained brought out his hypochondria and made him think he had all number of fatal diseases. When Kipling recited his new poem "McAndrew's Hymn" in a broad Glaswegian accent, Arthur was enthralled. The two men cemented their friendship in a round of golf, a sport little known in America. Locals were astonished to see a small white ball being hit over the fields outside Naulakha. A dog-eared card records a nine-hole game of foursomes in

which Arthur and Kipling's brother-in-law Beatty Balestier lost to Innes and their host by one hole.

A few days later Arthur summed up his thoughts on America to his Reform Club crony, Sir John Robinson. He allowed himself some reminiscences about literary figures he had met—not just Field and Hamlin Garland in Chicago, but also the better-known James Whitcomb Riley and William Dean Howells. He also made some general remarks about the affability and good humor of Americans, who he felt had been maligned in travelers' reports. "Every globetrotter has paragraphs about the number of spittoons in a hotel bar (as if it matters!) but they pass over such trifles as that there are no hereditary chambers and no landlords. There is an absence of affectation and a kindly frankness too on all hands which is not to be computed in spittoons." This was a dig at Kipling, whom he had had to tell, "For God's sake, let's stop talking about spittoons." But the main point of the letter was to bring around an important opinion former to Arthur's views about the importance of a transatlantic alliance. "By Jove," he thundered in full propagandist mode, "when I see all these folk with their British names & British tongues, and when I consider how far they have been allowed to drift from us, I feel as if we ought to have a Statesman hung from every lamp-post in Pall Mall. We've got to go into partnership with them, or else to be overshadowed by them. The center of gravity of the race is over here, and we have got to readjust ourselves."

To friends and family he was more personal, claiming he had had a good trip but was glad to be home. His only regret was that, after his expenses, he stood to make so little money (a total of around 500 pounds, he told his mother). His griping on this point led to a rift with Pond, for which he had to apologize. But for the time being he had decided he did not want to do any more lecturing.

After sailing home on the Cunard Line's SS *Etruria* he did not delay in England, preferring to hurry to Davos, where his wife and children were waiting in the same Grand Hotel Belvedere as before. At first he could not get America out of his head, as he dashed off effusive letters to new friends there and juggled plans to take Louise to Colorado for her health. He even sent a pair of skis to Kipling in Vermont.

He soon knuckled down to his latest round of hard work. At the age of thirty-five, he had arrived at an important turning point. Three years after opting for a literary career, he had killed off his main cash cow, Sherlock Holmes, but had failed to excite much interest in subsequent novels such as *The Refugees*. He was hoping for a boost from *The*

Stark Munro Letters, which were still being serialized in *The Idler*, prior to publication in book form the following September.

But he needed a big new idea, perhaps for a series, so he had been mulling over various storylines. "A Foreign Office Romance," which had just appeared in *McClure's Magazine*, had introduced a new character, a sophisticated French diplomat called Alphonse Lacour, who recalls how he saved an important treaty by using skulduggery to keep the British from learning that they had taken Egypt. Another recent tale, "The Recollections of Captain Wilkie," related with relish how a very Holmesian doctor, who likes to boast of his skill at spotting people's backgrounds after studying at Edinburgh under a Professor "who was a master of the art," is relieved of his leather purse in a railway carriage by a reformed cracksman who has been regaling him with his exploits.

Although this story hinted that Arthur might be toying with reviving his detective, he found the person he wanted in his favorite Napoleonic wars—not the suave Lacour, but the brave, quixotic Brigadier Etienne Gerard, a fictional version of Maréchal Baron de Marbot, whose memoirs he had read. He was encouraged by Sam McClure, a fellow Napoleon fanatic whose *Magazine* had been prospering ever since he ran a life of the emperor by Ida M. Tarbell. While in America, Arthur had amused himself by penning "The Medal of the Brigadier," a brisk story of deception in which Bonaparte gives Gerard and a colleague a letter to take through Prussian lines to his brother in Paris. Inevitably the vain, swashbuckling Gerard is arrested, but he has such chutzpah that he manages to evade his captors, swap uniforms with a Cossack soldier, walk through the Prussian lines, and fulfill his mission. When he returns unharmed to Rheims, Napoleon is furious because he had wanted Gerard to be imprisoned, thus allowing the enemy to read his letter, which contained false information about his position.

Arthur had received encouraging feedback when he read this story on his tour. Through the American writer-cum-agent Irving Bacheller he arranged for its publication in the *San Francisco Examiner* at a rate, it was proudly advertised, of twelve and a half cents a word. At just over 10,000 words, this meant a fee of $1,250, or 256 pounds—much the same as the 250 pounds per story he requested when, on December 18, the day before departing for Switzerland, he floated the idea of a series of six similar tales to Arthur Waugh, an old colleague of Wolcott Balestier, who now worked for Bacheller in London.

By January 24, 1895, he had written two of these and was already

arguing about the book's title with his publisher George Newnes, who wanted to call it "The Adventures of Brigadier Gerard," but Arthur felt there had been too many "Adventures" (including those of Sherlock Holmes) and preferred the omnium gatherum "Exploits." These and three further stories confirmed his general approach. A cavalier with more bravery than good sense, Gerard galloped recklessly across a historical canvas that was thin on Napoleonic set-pieces but strong on period detail, from the look of the French military uniforms to the occasional unflattering glimpses of the Emperor—short, with a body too long for his legs, looking "more like a Professor at the Sorbonne than the first soldier in France."

For all their historical awareness, the *Brigadier Gerard* stories work best as examples of the simple art of storytelling. Refusing to buckle under the burden of his reading, Arthur maintains a light touch, seducing the reader with his vision of Gerard as a Watsonian everyman at the court of the Holmesian Bonaparte. This was not simply a James Bond–like fantasy of the hussar who "fought the men and kissed the women in fourteen separate kingdoms." Rather, in contrast with the didacticism of *The Stark Munro Letters*, Arthur was liberated by the romance of a bygone era. He was back in territory where his mother had first given him license to roam imaginatively. As tales of chivalry and the frontier life had once helped take his mind off his father's alcoholism, he found diversion in Napoleonic times now that his wife was ill.

While completing these stories in Davos, Arthur also began work on a more English novel, *Rodney Stone*, set in the same era but dealing specifically with the Regency and its vogue for prizefighting. This drew on the play that Arthur had started a year earlier with his brother-in-law Willie Hornung. He argued to skeptical friends such as James Payn and Sir John Robinson that boxing in the ring was in the same noble Anglo-Saxon tradition as dueling in the lists. He thought he was blazing a new trail, romanticizing an important historical period in a way that, as Walter Scott had showed, could only be done after a passage of time had elapsed. Historical figures, including the Prince of Wales, Admiral Nelson, Lady Hamilton and Beau Brummell, spiced up the narrative, but the main character, Sir Charles Tregellis, was never more than a cartoon London dandy. The best parts of the book were the boxing scenes, whose immediacy reflected the author's own love of the sport.

Was Arthur being untypically subversive when he placed the Regency Marquess in a scene with Sir George Bunbury, the Jockey

Club Steward at the time? For he cannot have failed to recall Wilde's reference in *The Importance of Being Earnest* (which was premiered in London in February) to Bunbury as the fictional invalid friend whom every married man should have as an alibi to remove himself from his domestic chores. As such Bunbury was a symbol of modern hypocrisy, and, by extension, of the double life of homosexuals.

When not at work, Arthur could usually be found participating in some form of sport. A single issue of the weekly English-language *Davos Courier* reported his progress in a billiards tournament, his appearance for the resort in a game of bandy (a form of ice hockey), and his competing in a toboggan race. He helped lay out a new golf course in the town and explored new ski routes across the mountains with the Branger brothers. On one occasion, using a combination of skis, sleigh and toboggan, the three of them made their way across the Engadine to St. Moritz, where Arthur stayed for a few days. With his last *Brigadier Gerard* story completed, he took Louise to Feldkirch and Innsbruck (he felt this was her due since she had not seen a green field in six months). The two of them then returned briefly to England at the end of April.

Arthur complained that he did not want to make this journey, but he had accepted an invitation for May 4 to the same grand Royal Academy dinner as the previous year. Staying temporarily at the Reform Club, he joined his fellow member Sir John Robinson at Burlington House in Piccadilly, where he could hobnob with dignitaries such as the Prince of Wales and lobby them about the transatlantic alliance and other political matters. He listened to speeches that, following the recent successful relief of Chitral on the northwest frontier of British India, were markedly more passionate about the military than the arts.

Because of this prior engagement he was unable to attend the London opening of *Waterloo* at the Lyceum Theatre on the same night. He asked Henry Irving for seats for one afternoon and one evening performance the following week, so Louise could at least see it before they returned to Switzerland. The critics proved generally favorable toward the play. But their opinions were overshadowed by a notice in the *Saturday Review* by George Bernard Shaw who, in his acerbic way, laid into Irving for his old-fashioned approach to acting. Shaw was reviving an old argument with Irving, whom he had accused of consistently failing to support the new theatre of realism associated with Ibsen and Zola. Although he did not say anything offensive about *Waterloo*'s author, he attacked him by implication, saying that he had betrayed his profession

by failing to write a "literary play" that required actors to dig into their own resources, and by producing instead an " 'acting play,' which acts them." The underlying theme was that Arthur's work had no place in the modern theatre: it was sentimental and belonged to the music hall.

Arthur had told James Payn that one reason for visiting London was that he wanted to see his nephew, Willie and Connie Hornung's son, who had been born on March 24. The infant owed his first name, Arthur, to him, and his second, Oscar (by which he came to be known), to his father's friend Oscar Wilde. As such, it was a brave act of solidarity on Willie's part. For over the previous few weeks, Wilde had fallen from the heights of acclaim surrounding the enthusiastic reception of *The Importance of Being Earnest*, to the depths of personal degradation, after he had been arrested and put on trial for gross indecency on April 5, following his ill-judged decision to sue the Marquess of Queensberry, the father of his lover Lord Alfred Douglas, for libel the previous month.

Arthur's own attitude toward Wilde was complex. After warming to the Irishman when they first met at dinner in 1889, he had created the Wildean Thaddeus Sholto in his subsequent story *The Sign of Four*. But while Holmes had maintained much of the lifestyle of the aesthete, his philosophy and mode of action were different, as became clear in "A Case of Identity" when the detective declared, almost as a slogan for "new realism" and in flat contradiction to Wilde's position in "The Decay of Lying" that "life is infinitely stranger than anything which the mind of man could invent." In the meantime Arthur had belittled Wilde's ability as a storyteller in a letter to their dinner host, the American publisher J.M. Stoddart, and he described Wilde as mad after encountering him shortly after the opening of his play *A Woman of No Importance* in 1893.

Arthur's brother-in-law Willie Hornung remained a great admirer of Wilde, sharing a mutual friend in George Ives, a Cambridge-educated criminologist and talented cricketer who played on J.M. Barrie's team. Living at Albany in Piccadilly, Ives was a discreet gay who set up a secret society, the Order of Chaeronea, to promote his sexual preferences. When the writer Grant Allen had penned an article in the *Fortnightly Review* advocating sexual freedom, Ives, in what Richard Ellmann, Wilde's biographer, uncharitably called "the one daring action of his life," picked up his pen and asked if this liberality extended to homosexuals.

Hornung may not have understood this sexual side of Ives's charac-

ter, but was intrigued enough to use his friend as a model when he created his fictional gentleman thief Raffles, who enjoys a remarkably intimate relationship with his sidekick Bunny Manders.

Although Allen's article was provocatively titled "The New Hedonism," a quotation from Wilde's novel *The Picture of Dorian Gray*, the answer to Ives's question was implicitly no: despite his feminism and libertarianism, Allen had a robustly Darwinian view of sexual relations which, though not needing to be bound by marriage, were designed for the propagation of the species. Outside of this heterosexual norm, only "hateful and unnatural vices" were to be found.

Was it purely coincidence that, at some stage on his short trip to London, Arthur should come across Grant Allen, this unlikely scourge of homosexuality, whom, like Wilde, he had also first met over dinner? Since their first encounter at the *Cornhill* over a decade earlier, the two men's paths must have often crossed, for they shared the same agent and were published by the *Strand Magazine* and George Newnes, a company in which they both had financial stakes.

A gaunt, brooding man with a silvery beard, Allen was the epitome of the late-nineteenth-century professional writer identified by George Gissing in his 1891 novel *New Grub Street*. Radical and unconventional by nature, he had made his mark as a popularizer of modern science, before taking up a wider range of fictional and nonfictional subjects. He was known for his advocacy of Darwinian ideas of evolution, particularly as applied to society in the works of Herbert Spencer. Arthur would have warmed to Allen's uncompromisingly scientific attempts to explain religion (they shared a mutual friend in this field in Andrew Lang), though he would have balked at his materialist conclusion that there was nothing beyond this life. As a fiction writer, Allen had been attracted by the *Strand Magazine*'s rates to try his hand at the increasingly popular genre of detective stories. He had achieved notoriety earlier that year with his novel *The Woman Who Did* which, true to his own sentiments, confronted the institution of matrimony in its earthy account of a Cambridge-educated woman who, after refusing to marry, was left to bring up an illegitimate baby.

Arthur would have been sympathetic because, only a year earlier, he had leaped into print to defend George Moore's Zolaesque novel *Esther Waters* about a servant girl abandoned after being made pregnant by her footman lover. When this was banned from W.H. Smith's railway book stalls for its supposed immorality, Arthur was incensed at the censorship of a book that was "good both in literature and in ethics."

Given this background, the two writers are sure to have discussed the ongoing Wilde saga when they met in the spring of 1895, though their deliberations are lost to posterity. Instead, Allen offered Arthur more immediate and practical advice. Having suffered from tuberculosis himself, he mentioned that he had found a cure for his illness in the healthy air of Hindhead, the upland Surrey village where he lived between Guildford and Portsmouth. (As a naturalist he had been writing regular essays about the area round his home in *English Illustrated Magazine*.)

Acting quickly, Arthur looked at some properties in this "English Switzerland." Before returning to the Alpine original, he had paid a deposit on a plot of land just shy of the top of Hindhead ridge, slightly south and east of the junction between the main London-to-Portsmouth highway and the road to Haslemere. With Louise's health in mind, he had convinced himself not only that this site was protected from the biting northeast wind but also that the damp mist from the valley below fell short. Having discussed building a house there with Henry Ball, he was looking forward to living there the following year, after wintering in Egypt where the climate would provide the next crucial phase of Louise's rehabilitation.

If, by some chance, this idea did not work out, he could at least realize some capital appreciation on the land, which he had paid for out of gains from some of his other investments, notably mines, where he was sitting on a profit of 2,000 pounds (This was what he told his mother: there was something odd about the way he continued to harp on about his finances to her. It was as if they were a smokescreen that allowed him to avoid dealing with more personal matters.) Eager as ever to find productive outlets for his earnings, he also acted on a tip from Stratten Boulnois and bought into Bessons, a company well known for making musical instruments but in need of recapitalization following the troubled divorce case that its French boss, Horace Besson, was experiencing after his wife had run off with a Spaniard and taken most of his money.

On his return to Switzerland, Arthur moved Louise and the family to the plush Hotel Kursaal in the Upper Engadine lakes at Maloja, some twelve miles from St. Moritz. Swiss resorts were quiet in the summer, so, in an effort to keep guests amused, the hotel management staged a series of *tableaux vivants*, a popular Victorian form of entertainment in which live actors replicated versions of famous paintings. Arthur agreed to be responsible for a triptych based on the theme of the Death of General Gordon. Such subject matter was highly topical

since, following the fall of Lord Rosebery's Liberal government in June, Joseph Chamberlain had been made Colonial Secretary, an appointment confirmed when Lord Salisbury's Conservatives won the general election the following month. As an ardent imperialist, Chamberlain could be expected to avenge General Gordon's assassination at the hands of Mahdist forces in Sudan a decade earlier. And, as an increasingly forthright advocate of the British empire, Arthur would be certain to support him, not least because both men were Liberal Unionists, the Conservatives' coalition partners.

According to the emerging imperialist consensus, Gladstone's pusillanimity toward the Irish was mirrored in his weakness in prosecuting British interests elsewhere. He had been blamed for not sending British troops to Gordon's aid in 1884, a failing about which Arthur had made his views clear in *Waterloo*, where Sergeant Brewster rails against Gladstone's inability to deal with the Boers in a recent confrontation. "I see by this morning's paper that the Government has knuckled under to these here Boers. They are hot about it in the non-com. mess, I can tell you, sir."

So Arthur's *tableaux vivants* had a distinct propagandist motive, adding a dimension to his forthcoming trip to Egypt. For all his concern about his wife, he could not help being excited about visiting Cairo, which would be the center for any revanchist operations into the Sudan.

The main chore Arthur allowed himself was the task of polishing off the remaining chapters of *Rodney Stone*. That completed, after a brief detour to Davos in mid-September to pick up their luggage, the Conan Doyles settled for six more weeks into the Grand Hotel Victoria at Glion in the hills overlooking Lake Geneva above Montreux.

Arthur used this latest interlude to make a start on another Napoleonic story, *Uncle Bernac*, which he had contracted to write for the magazine *Queen*. This told of the machinations experienced by Louis de Laval when he enters Napoleon's service after returning from exile in England in 1805. Its commissioning followed unprecedented interest in *Rodney Stone*, for which he was offered 1,500 pounds for serial rights by the *Strand Magazine* and then, after hard and satisfactory bargaining, a 4,000-pound advance from the publisher Smith, Elder.

Arthur returned briefly to England in mid-October, primarily to deal with a problem that had arisen with his land in Hindhead. His immediate neighbor, Louisa Tyndall, widow of John Tyndall, the physicist who had taken an uncompromising materialist scientist's approach to

the claims of the paranormal, had objected to the possibility that, as part of his building work, Arthur might have to cut down trees adjacent to her own property, Hindhead House. Hoping to deter him, she informed him that a right-of-way ran through his land and that, contrary to what he had been led to believe, this was often covered by damp mists from the valley. Before she had accidentally killed her husband by giving him the wrong medicine, the Tyndalls had sought to protect their house from the outside world, surrounding it with forty-foot-high screens made of larch poles covered with heather.

Arthur showed his steeliness in telling Mrs. Tyndall that, in that case, he might have to sell his land in small parcels, since the right-of-way would clearly prevent him from finding an outright purchaser. He reserved his right to do what was needed about the trees, but he did admit concern about the fogs. He was clearly in no mood for compromise, though the need to find an amicable solution did prevent an immediate start to building.

He was probably joined on his return to Switzerland by his sister Lottie and sister-in-law Nem Hawkins. For the latter came along to pick up the two children and their nursemaid Ada, and bring them back to be looked after by their grandmother in Reigate, while Lottie stayed on to accompany Arthur and Louise on their journey to Egypt. The three of them made their way from Lucerne, down the Italian peninsula, through Milan, Florence, Rome and Naples, to Brindisi. In Naples they were able to see Nelson Foley who, in their absence from Britain, would marry Ida Doyle at Masongill in December. (Despite the couple's difference in age, Arthur approved, describing Nelson as "an exceptionally fine fellow in every way.") But Louise's condition remained a worry. As the weather grew warmer, for example, she was unable to go into museums with the other two because she had been told that the contrast between the outdoor heat and the cool interiors might be dangerous.

By the end of November 1895 the Conan Doyle party was ensconced at the Mena House Hotel, within walking distance of the Pyramids at Giza, seven miles southwest of Cairo. Once a hunting lodge for the Khedive, it had been turned into a comfortable hotel to cater to the growing influx of tourists. Despite the pharaonic ruins outside his window and the usual range of leisure facilities, such as tennis courts and a billiards table, to amuse him, Arthur was listless. Letters to his mother were unusually full of business details though, among the lists of mining shares, he was able to report his financial coup with *Rodney*

Stone, which was set to bring in roughly 7,000 pounds—all the more satisfying, he told his mother, as he had written *Brigadier Gerard* in the same year.

He found the weather enervating and could make little headway with his writing. (The only thing he managed was a play based on *Halves*, a novel by James Payn whose chronic rheumatism was forcing him to give up his editorship of the *Cornhill* in March. This was an act of homage on Arthur's part, since the story was lackluster, telling of two brothers who agree that, after going their separate ways, they will meet after twenty-one years and share their fortunes with each other.) Climbing the Great Pyramid proved uncomfortable and, he felt, pointless. When he tried his hand at riding—a new experience for him—the Arabian horses tended to be lethargic, except on the one occasion when a frisky black stallion sent him flying and then kicked him in the head. Arthur had to have five stitches and was lucky not to lose an eye. A fellow guest, the gentleman scholar William Stone, witnessed this and commented, with ill-disguised contempt, "He was like a good, open-air Scotsman, but he told me he had never been on a horse before." As photographs showed, Arthur was left with a permanently drooping right eyelid.

He became much more animated when he made the short journey into the center of Cairo. From a seat at the Turf Club in Maghraby (now Adly) Street, he could watch Britain's "Camel Corps" of administrators going about their imperial duties, while her soldiers headed by General Sir Herbert Kitchener, "Sirdar" or Commander-in-Chief of the Egyptian army, itched for the opportunity to strike militarily against the Mahdi's successor, the Khalifa Abdullahi, in Sudan. Sometimes Arthur might see the strapping figure of the Consul-General, Lord Cromer, in his carriage. More often he would look around him and, like Rudyard Kipling in a similar watering hole in Lahore a few years earlier, take pride in the achievements of his countrymen who he was convinced brought good to the country. "There are Garstin and Wilcocks," he wrote in a note at the time, "the great water captains who have coaxed the Nile to right and to left, until the time seems to be coming when none of its waters will ever reach the Mediterranean at all. There is Kitchener, tall and straight, a grim silent soldier, with a weal of a Dervish bullet upon his face. There you may see Rogers, who stamped out the cholera, Scott, who reformed the law, Palmer, who relieved the over-taxed fellaheen, Hooker, who exterminated the locusts, Wingate, who knows more than any European of the currents of feeling in the Soudan—the same Wingate who reached his arm out a thousand

miles and plucked Slatin out of Khartoum." As he struggled with *Uncle Bernac*, Arthur thought seriously about taking on another challenge—writing a popular history of Britain's involvement in Egypt since 1882. He told his mother that he was finding modern Egypt more interesting than ancient, and for the time being it put fiction in the shade.

But to his close friend Amy Hoare he expressed reservations. The English, he said, had done more for the country in thirteen years than the pharaohs ever did. But, from a wider perspective, their presence was muddle-headed. They always seemed to be trying to improve the Egyptians' general conduct, like some pernickety old relation. His caveats put into relief another remark to Amy about his delight in the peace and natural order of the East, which was unlike anything he had previously encountered. The incompatibility between nature with its inherent harmony and man with his desire to intervene struck to the core of not only his own existence but also Western civilization itself. It was reflected in his battle to square his idealism with the proven tools of materialistic rationalism. In politics he usually resolved this dilemma by pushing for action (particularly if the British were involved); in metaphysics the issues were not so clear-cut, and he increasingly came down on the side of nature.

Louise's health was responding well to the climate: her cough had almost disappeared and her rheumatism was much better. So, after a month around the capital, the Conan Doyles joined passengers seeking even warmer winter sun and a greater range of antiquities on the Thomas Cook company's paddle-steamer *Nicrotis* on an 800-mile cruise up the Nile to Wadi Halfa. Even Arthur in his jaundiced mood could not fail to be fascinated by the temples of Upper Egypt. But while he marvelled at the longevity of the country's history, his journal of the trip was strangely flat for a writer of his ability. He observed how nearly all the tombs and pyramids had been robbed; maintaining his interest in mummies, he noted that Cleopatra's embalmed body had not been discovered, indeed there was no mummy older than the Fourth Dynasty; and he enjoyed several local entertainments, including an Arab circus and a camel race. But he only got excited when, as his party edged southward toward Sudan, he sensed the vulnerability of his small group of travelers in the face of the vast inhospitable desert that was home to deadly Mahdist militias on their camels.

Stopping for the night at Dendour on January 13, 1896, Arthur witnessed the southern sky "all slashed with red streaks . . . [which] seemed symbolical of that smouldering barbaric force which lies there." The following evening he reached Korosko where he met two

young English officers from the Royal Engineers who were taking levels for a railway and who told him, with a touch of bravado, they had been placed there as "ground bait for the Dervishes." He was intrigued to note the secrecy that surrounded the men's activities. Two days later, visiting a village beyond Korosko that had been raided by the Khalifa's forces a month earlier, he pondered: "If I were a Dervish general, I would undertake to carry off a Cook's excursion party with the greatest ease."

Back in England he used this experience as the basis for a novel, *The Tragedy of the Korosko*. Much more vivid than his diary, this told of the horrors and compromises experienced by a multinational group of tourists taken captive by a hostile Mahdist raiding party in just such a situation. A pioneer in the xenophobic literary genre that pitched Westerners against Islamic "terrorists," this book was interesting for its exploration of Arthur's ideas about imperialism, contrasting the attitudes of an observant American and a devious Frenchman with two Britons (one skeptical about the role of "policeman of the world"; the other more experienced, arguing that Anglo-Saxons had a mission to civilize the world on a par with Germany's in abstract thought and France's in literature and art). The novel is modern in its evocation of the uncompromising nature of Islam. Not that the religion of the Prophet Muhammad had much chance in the face of Arthur's implacable anticlericalism. When the author comments on the Moolah (or Mullah) breaking "into one of those dogmatic texts which pass in every creed as an argument," the baleful legacy of his schooling is clear.

War fever was greater than ever when the Conan Doyles returned to the Mena House Hotel at the end of January. Imperialist rhetoric had been ratcheted up by the botched Jameson Raid in South Africa at the start of the month. Arthur immediately recognized that his mining shares would suffer but, certain they would bounce back, he offered to compensate his mother for any temporary fall in income.

Bored with the tourist routine and recognizing that military action was imminent, he left his wife and sister at the hotel and set off on a tour of what he called the Libyan desert with an acquaintance, Colonel David Lewis of the Egyptian army. There was a surrealistic touch about their mode of transport—an ornate gilded coach left over from the opening of the Suez Canal. Their journey is unlikely to have taken them far into the desert because their destination, the fourth-century Coptic monasteries beside the salt lake at Wadi al Natrun, was on the edge of the Nile Delta. Arthur was taken aback by the "debauched"

look of some of the monks, but happily reverted to his medical persona to attend an ailing abbot, to whom he later sent medicine from Cairo.

During his short absence, the situation in the capital had changed radically. After years of fobbing off the demands of soldiers such as Kitchener who wanted to avenge General Gordon, Lord Cromer's Anglo-Egyptian government had finally agreed to an expedition against the Mahdist forces in Dongola in the Sudan. Two regional developments provided an excuse for this change of mind. One was the appearance of French troops in Britain's traditional stamping ground of southern Sudan. The other was the Ethiopian defeat of the Italian army at the battle of Adowa on March 2. It was argued that the proposed Egyptian army advance would take pressure off the Italians.

Thrilled at the prospect of taking part in an expedition of the type he had only read and written about, Arthur obtained Louise's agreement to go, but only for a month or so, because after that the heat would become too oppressive for her health. He still had to find an appropriate role: a journalistic assignment would suffice, but correspondents from the big dailies such as *The Times* were already arriving. So, calling on his contacts at the *Strand*, he cabled the *Westminster Gazette*, a newish liberal evening newspaper owned by George Newnes, which agreed to take him on as a stringer. As soon as he heard back, he showed his mettle by requesting the assistance of Major Reginald Wingate, the army intelligence chief, who had been a skillful propagandist about the evils of the Mahdist regime. Only the previous month Wingate had published his translation of *By Fire and Sword in the Sudan*, the memoir of Slatin Pasha, a well known Austrian administrator who had recently escaped from lengthy captivity in the Mahdist capital at Omdurman. When Wingate co-opted the small, ruddy-faced Slatin as his deputy, Arthur sycophantically wrote that the Austrian's one wish now was to turn the tables and have the Khalifa at his sword-point.

Despite kitting himself out with an Italian revolver and learning the rudiments of camel lore from his fellow correspondents, Arthur's month with the troops was disappointing. By special permission of the Sirdar he did go to the southernmost British outpost at Sarras, which he found "a war-like little place, with its fort, its wire entanglements, its sandbag battery and its long lines on picketed horses." But otherwise he was holed up in the stifling heat of Wadi Halfa, waiting for the troops' camels to arrive. He made some useful friends among the soldiers and journalists. But eventually Kitchener persuaded him and his companion, the future naval historian Julian Corbett who was working

for the *Pall Mall Gazette*, that there was no use hanging around. Disconsolately Arthur bought up some tins of apricots, the only food he could find in the local Greek merchants, and boarded a boat back to Aswan, with only Rousseau's *Confessions* as reading matter. (Afterward he could never stand either the fruit or the book.)

Arthur had to excuse himself to his mother for having failed to see action. As she had been hoping he would cover himself in glory, like one of her chivalric heroes, he explained to her in another language he knew she would understand that if he had stayed in Egypt he would not have been paid, leaving him 2,000 pounds the poorer, and in addition he would not have been able to fulfill his existing literary obligations. He was at least able to turn his experiences into a wry short story, "The Three Correspondents," which neatly captured the foreign reporter's mixture of camaraderie and competitiveness and which, along with *The Tragedy of the Korosko*, provided a worthy literary legacy of his time in Nubia.

This time Arthur did not tarry in Cairo, but brought his wife and sister back to England, stopping only in Naples to inquire about the Foleys' wedding. However he did not stay with the newly married couple because he felt the island of Gaiola might be damp at night (and thus prejudicial to Louise's health). Strangely for a doctor, but indicative of his deep anxieties about tuberculosis, Arthur also told his mother that, since Nelson Foley had lost his first wife through consumption, it would not be right to bring an infected person into his house.

In his autobiography he claimed he was back in London to attend the Royal Academy banquet in early May. He recalled how he had looked at his wrist and seen a number of ugly red ulcers, the legacy of some jiggers that had burrowed under his skin in Egypt and were now hatching. Unfortunately his memory was again playing tricks. Out of respect for its president Lord Leighton, who had died in January, the Academy held no such banquet that year.

There was, however, a meeting of the Authors' Club in June. Arthur discussed his career and, quoting (in fact, typically, misquoting) Kipling's adage that "there are nine and sixty ways of constructing tribal lays, And every one of them is right," he glorified the concept of diversity in literature. No longer was he going to be held back by an arid debate that pitched realism versus romance. He had worked out his accommodation between them, and there was no doubt now where he stood. As he emphasized to the members of the Society, "To interest is the ultimate object of all fiction."

* * *

Since there had been little progress on the new building in Surrey, the Conan Doyles moved temporarily into rooms at 44 Norfolk Square, off Hyde Park. For in the interim, Grant Allen offered to rent the family his own house, which was also in Hindhead. Arthur was initially enthusiastic about this prospect, but decided instead to rent a furnished villa called Grayswood Beeches closer to the main Southern Railway in nearby Haslemere. This gave him a foretaste of the literary community he was joining, for its most recent occupants had been the writer Mrs. Humphrey Ward and her family.

From there he could keep an eye on the ongoing construction, while nipping up to London for dinners and clubland assignations. In the short term it also proved convenient for the holiday home the Conan Doyles rented in their old stamping ground of Southsea for six weeks during May and June. Staying on the promenade at 4 Southsea Terrace allowed Louise further time in the sun for recuperation and Arthur the opportunity to resurrect old cricketing contacts, which he put to good advantage, scoring 84 not out and taking two wickets for the Hampshire Rovers in a two-day game with the United Services.

Arthur was able to meet two old friends. One was Henry Ball, whom he had hired to build his house in Hindhead, but who was at the time overseeing the construction of St. Agatha's, a controversial Anglo-Catholic church in a slum near the dockyard. The other was Dr. Vernon Ford, who ran the voluntarily funded Eye and Ear Hospital. As honorary phyiscian to the Gordon Boys School, an orphanage founded in the memory of the hero of Khartoum, Ford would have been interested in hearing about Egypt. But in his personal capacity he was also in desperate need of financial assistance and Arthur, showing one of his frequent flashes of generosity, was happy to oblige, paying 1,800 pounds to buy South View Lodge, the bow-fronted house where Dr. Ford lived with his family. Arthur proved an easygoing landlord, forgoing rent on the property (at 53 Kent Road, between Elm Grove and the seafront) for at least four years, until Ford had resolved a dispute with his brothers over his father's estate.

A couple of weeks later Arthur moved into Grayswood Beeches and was feeling settled, with a "splendid lot of servants" and a menagerie of animals that made the place a delight for his two children, now ages seven and three. There was even a horse for him to indulge his new enthusiasm for riding. The main problem, apart from his sick wife, was his book *Uncle Bernac.* "I am labouring heavily over that wretched little Napoleonic book," he told his mother. "It has cost me more than

any big book. I never seem to be quite in the key and I don't know that waiting will help me. I must slog through it somehow."

While he continued to take seriously his responsibilities for the financial needs of his immediate family, making regular payments to his mother, Innes, Connie and Lottie, he managed to ignore (at least in his surviving letters and journals) the emotional significance of an important development in Yorkshire. At the age of forty-three, Bryan Waller had finally given up his bachelor status on August 11 and married Ada Roberts, the sixth daughter of the Professor of Humanity at St. Andrew's University. As prickly as her husband, the new Mrs. Waller protested at his habit of disappearing through the far end of the garden for literary tête-à-têtes with Mary Doyle at Masongill Cottage. But the only reference Arthur made to his mother about this change of circumstances was the kindly thought that if she felt like moving south to be nearer to him, he would be happy to provide the finance. Given the significance of Waller's marriage and the absence of further material, this sole epistolary relic suggests it had been the result of another careful weeding process, designed to show Arthur in the best possible light.

As he waited for the completion of his new house, Arthur kept on with his psychic interests, participating in old-fashioned séances with his friends. But he remained unconvinced about their significance since their intimations of life beyond the grave were proving so bizarre. One such pre-supper séance on October 25, 1896, raised a spirit called Dorothy Postlethwaite who claimed to have been at the same school as Amy Milbourne, one of the women present. Amy could not remember her, but when she ran a little test to see if Dorothy knew her old headmistress, the table tilted violently at the correct name.

Arthur himself was picked out when he asked Dorothy if she or her fellow spirits knew anyone at the table. He showed his gullibility as a psychic researcher when he then tried to identify the person involved. When given the letters TR, he rather too helpfully suggested this might be the former Somerset cricketer Surgeon-Captain John Trask (Dodd in *The New Revelation*), who had died of cholera in Sudan three months earlier, and this of course was confirmed. Trask then proceeded to recall meeting Arthur at the Mena House Hotel in Cairo. He referred to the Sudan war, but said he had not met General Gordon or anyone famous in the afterlife. According to Arthur's note of the séance, he was told that spirits live in families and communities. Married couples do not necessarily meet again, but those who loved one

another do. And on that note Trask gave a series of tilts to indicate "goodnight," and Dorothy followed suit.

By the start of 1897, the stock market was picking up after its reversal following the Jameson Raid, and, with the construction of his house now proceeding apace, Arthur wanted to be regularly on site to supervise important features, such as the introduction of electric light and the positioning of the full-length stained-glass window bearing his family's coats of arms. Having fussed about the need to keep Louise warm and comfortable at Grayswood Beeches, he chose the frosty month of January to move her and his family to Moorlands, a boarding-house on the crossroads adjacent to his new property.

The excitement at being close to his dream house put him in a better mood. On his first day in Hindhead he wrote a jaunty marching song. His writer's block eased and, demonstrating his extraordinary range, he made progress on a series of swashbuckling stories about Captain Sharkey, a villainous eighteenth century pirate. He also put the finishing touches to *The Tragedy of the Korosko*, his oblique study of imperialism, wrapped in an Egyptian adventure tale. His task was made easier by the fact that he was being paid tenpence halfpenny a word, which led his brother Innes to suggest he should write a memoir with the title "From A Penny a Line to a Shilling a Word."

Having mastered the art of horsemanship to his satisfaction, he also treated himself to a six-year-old horse, which he called "Brigadier" after his prancing fictional character. At 15.3 hands (a little over five feet tall) the new steed was short, but strong, good-mannered, well proportioned and cheap at 65 guineas. Arthur forecast that, with some filling out in the stable, Briggy, as he came to be known, would be worth 100 guineas within a year.

Family responsibilities continued to occupy him. He wrote to Lady Jeune, a judge's wife and society hostess who knew Nelson Foley, with a view to getting Ida presented at Court. He also contacted the Egyptian army Sirdar General Kitchener in the hope of obtaining for Innes a post on his staff. His brother was stationed with the Royal Artillery at Topsham Barracks in Exeter, where he had fallen in love with a twenty-year-old local girl, Dora Hamilton. When her family invited Arthur to a dance in March, he felt duty-bound to accept.

In mid-February Innes visited his Foley relations for some fishing around Lismore. This coincided with, or perhaps even inspired, a reassessment by Arthur of his attitude to Ireland. Both his parents had been born in that country and, as was clear from his positive portrayal

of an Irish couple, the Belmonts, in *The Tragedy of the Korosko*, he believed the Irish had an important role to play in his idealistic vision of the British empire.

His Unionism was obvious when he took the chair at a dinner of the Irish Literary Society at the Café Monico in Regent Street on June 13. His presence in that role was significant, because it showed that not only he himself, but others too, considered him enough of an Irishman to participate in a group that was in the vanguard of the Irish literary renaissance of the 1890s. But, despite the presence of the Society's founder, W.B. Yeats, Arthur was not prepared to compromise on certain principles: as it was a formal occasion, he insisted that the loyal toast should be drunk, while Barry O'Brien, Parnell's biographer, was adamant that this would only be done over his dead body. An understanding was reached whereby the official nature of the dinner was forgotten, no toasts at all were made, and Arthur simply gave his speech on the contribution of the Irish (including the Brontës) to English letters. "I imagine Conan Doyle was the only loyalist present who would have thought of putting up a fight on the question at issue," wrote Frederic White, who worked for the publisher Cassell's, "and I imagine Barry O'Brien was the only rebel who would have willingly forgone the feast."

Arthur clearly felt Anglo-Irish opinion needed more convincing for he returned to the Society two weeks later to talk on the "Wild Geese," the Irish Brigades who had fought with the French during the eighteenth century. He was sympathetic to the soldiers, conceding that British policy in Ireland had been divisive and evil, and emphasizing that the exiles had believed they were fighting for the rightful Jacobite (and Catholic) king. But Catholic Emancipation had subsequently turned the struggle from the battlefield to the political arena, where "successful attacks upon bigotry and prejudice have at last opened some prospects of an enduring and natural bond between them." He could not prevent himself, in conclusion, from quoting the Duke of Wellington on the bravery of the Irish soldier. There was a propagandist note to this, for, having read his Kipling, he understood, and wanted to encourage, the vital contribution the Irish were making to the British army, particularly in India.

As for Arthur's own output, *Rodney Stone* had recently appeared in book form and *Uncle Bernac* was being serialized. But while he was generally happy at the former's reception, he remained disappointed with the latter. Although he felt he had improved the text by adding a couple of chapters on Napoleon for its book publication in March, he was

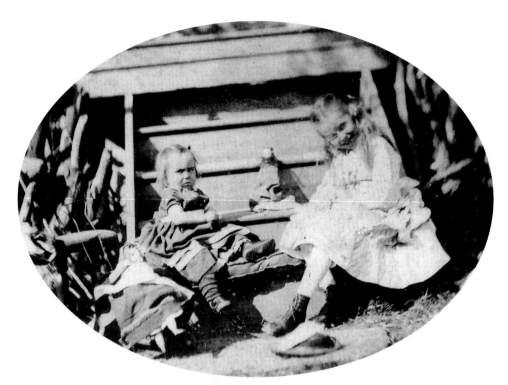

Arthur age two, with sister Annette

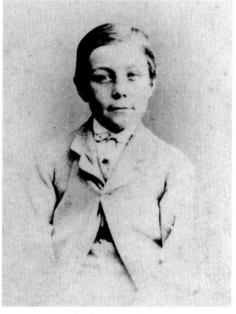

Arthur age four

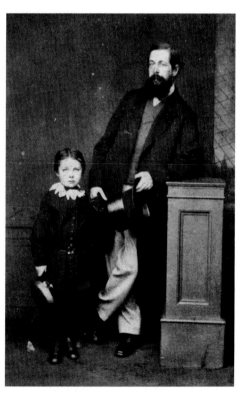

Arthur with his father

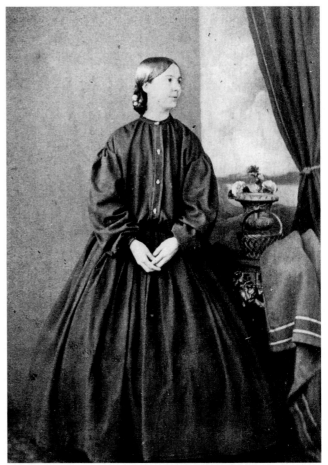

Mary Doyle,
Arthur's mother, *c.* 1867

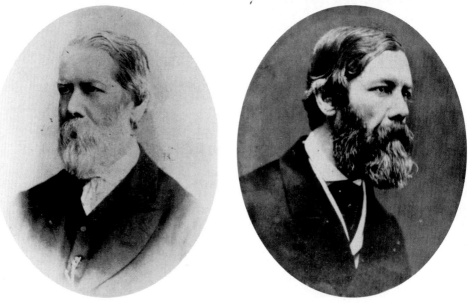

James Doyle

Henry Doyle

Dicky Doyle

Arthur's sisters: Connie, Lottie
and Annette in Lisbon

Michael and Susan Conan

Ida Foley (née Doyle)

Dodo Angell (née Bryan
Mary Josephine Doyle)

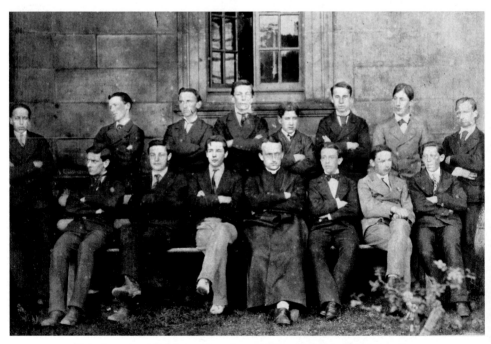

Stonyhurst: with his poetry class master, Cyprian Splaine, 1873
(Arthur is at the back, fourth from left)

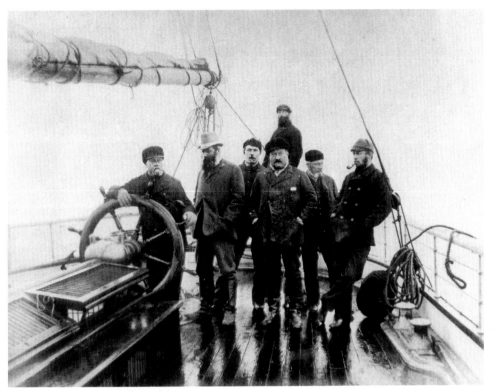

Whaling on the *SS Hope* (Arthur is third from left)

Professor Joseph Bell

Arthur's university friend and partner
in general practice, George Budd

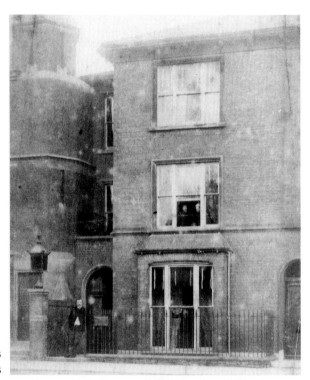

Arthur outside Bush Villas
in Portsmouth in the 1880s

Arthur and Innes
in Portsmouth 1890

On a return visit in 1911
when the re-named Doyle House
had become a corsetry shop

Louise before marriage

Louise, her mother and her two children, Mary and Kingsley, at Tennison Road

Family Group 1894: Standing (from left): Innes Doyle (with young Oscar Hornung in front of him), Connie and Willie Hornung, Mary and Arthur Conan Doyle (with Kingsley in front of Mary), Lottie and Leslie Oldham, Dodo and Cyril Angell. Seated (from left): Nelson Foley, Louise Conan Doyle, Mary Doyle, Ida Foley (with Innes Foley). In front: Percy (Michael) Foley, Branford Angell.

His mother, Mary, in 1891

Arthur in the snow 1894

Jean Leckie 1907

Lily Loder-Symonds

Wedding of Jean and Arthur September 1907, with Lily Loder-Symonds (left), Lesley Rose (seated right), Innes Doyle (best man, standing right), and Branford Angell (page, seated on floor)

Arthur and Jean on holiday: at the Acropolis, on honeymoon 1907

At the Pyramids

At the seaside with baby Denis
c. September 1910

Undershaw

Windlesham

Arthur at the French
front June 1916

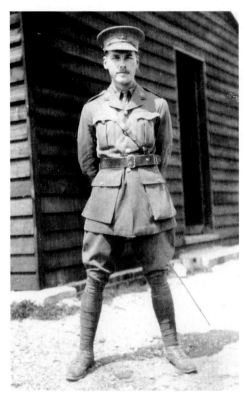

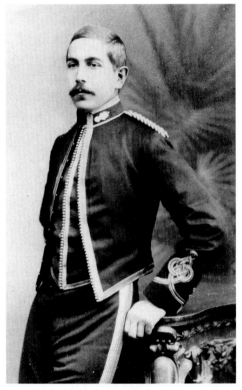

Kingsley 1916

Innes in uniform

Conan Doyle sportsman: deck cricket on the *Durham Castle* (September 1909)

Playing tennis with Malcolm Leckie

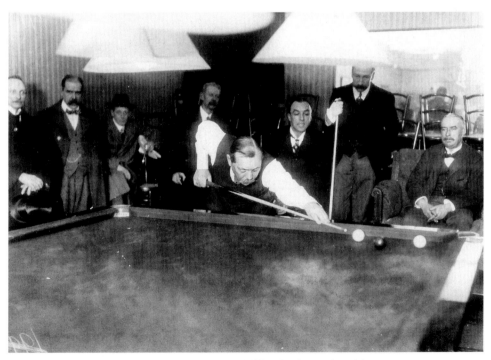

Competing in the Amateur Billiards championship 1913

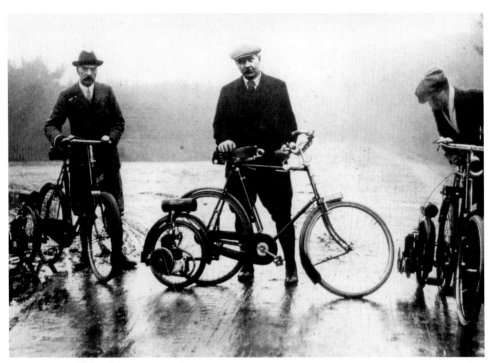

With his Autowheel (his friend F.G. Guggisberg is on his left)

With Douglas Fairbanks
Hollywood 1923

Arthur the Spiritualist:
with spirit manifestation

Arthur with daughter Mary
and two employees inside
the Psychic Bookshop

The family
at Bignell Wood

Mary Doyle and
her daughter Connie

With his wife and children at Waterloo Station
departing for the United States March 1923

Picnic at Jasper Park in Alberta, Canada

aware he had still not dealt with the greater problem of his failure to decide whether the Emperor was a hero or a villain.

Over the summer Arthur tended to relax, and this year, as he was technically homeless, he had little incentive to push himself, preferring to dabble with further stories in his Captain Sharkey series, think about a stage version of Sherlock Holmes, play cricket, and take his family on a series of holidays to Southsea, Eastbourne and Cromer in Norfolk. Toward the end of June he attended Queen Victoria's Jubilee in London, which he enthused about, stressing its importance for the good of the empire, in an affectionate letter to Kingsley Milbourne who, after business reverses in London, had moved to Canada to work in the mining business. In September Arthur had hoped to be able to move into his new house, which he had decided to call Undershaw, from the Anglo-Saxon word "shaw," meaning a small copse or wood. But the handover was delayed and it was October 17 before the Conan Doyles finally took up residence.

Standing on a four-acre site, just below the 895-foot summit at Hindhead, the house looked southward over woods and rolling heathland toward the point where the Surrey, Sussex and Hampshire borders converge. It had not always been such a desirable place to live. When William Cobbett passed nearby on his Rural Ride of November 1822 he gave the place a wide berth, describing it as "the most villainous spot that God ever made." The summit was then known as Gibbet Hill, after the gallows that once stood there to dispose of the highwaymen who preyed on passing coaches before the arrival of the main railway through Haslemere. The myths associated with the Devil's Punchbowl, the spectacular natural amphitheatre skirted by travelers coming from London, added to its romance. But the powerful Victorian combination of public order and technology had tamed its wilderness, and many writers and intellectuals now liked to live there.

Henry Ball had had the unenviable task of marrying the requirements of Arthur, who wanted a comfortable modern house where he could show off and entertain in a manner befitting his status as a moneyed literary gentleman, and Louise, who needed somewhere quiet to marshal her waning strength. From the outside, the uneasy compromise showed in an ugly, sprawling version of Victorian stockbroker baronial, dominated by chimneys, gables and red brick.

Internally it could not have been more comfortable, with eleven bedrooms and dressing-rooms designed to cater to every type of guest. When her physical condition permitted (her rheumatism had

now given way to arthritis), Louise could play at her small Broadwood upright piano in the wood-panelled drawing room, which, since it faced south, also allowed her to enjoy a view of the garden, which disappeared across the tops of the woods beyond. The views on this south side were also shared by the dining-room and Arthur's study.

The entrance hall made a bold statement of Arthur's aspirations, with its display of swords and its stained-glass window. Embarrassingly, despite having taken advice from a distant relation, Sir Arthur Vicars, the Ulster King-at-Arms, he made the mistake of forgetting to include any pictorial reference to the Foleys of Lismore. He quickly rectified this by inserting a Foley crest into the window above the main staircase. But he compounded his error by getting his own family motto wrong, rendering it as "Patientia Vincit" (he conquers through bravery) instead of "Fortitudine Vincit" (he conquers through patience).

No expense had been spared to furnish a complex that included substantial servants' quarters, a four-room lodge, a stable, a coach house, a garage and a tennis court. Not many houses of the period could boast a power plant that ensured a continual supply of electricity. This cost 550 pounds, out of a total 8,000 pounds, which Arthur calculated in his meticulous manner he had paid for the place. This sum included 4,249 pounds for construction, 1,072 pounds for furniture and 1,000 pounds for the original land, as well as smaller amounts for fancies such as 100 pounds for a wine cellar and 80 pounds for the table in his own personal billiard-room.

Arthur congratulated himself that, within a few years, his investment would be worth between 9,000 and 10,000 pounds—and, as he told his mother, all without his getting into debt or having to sell any shares, which was remarkable in the depressed economic climate of the times. He made this sound as though it had happened in a fit of absence of mind, as Sir John Seeley had described the acquisition of the British empire. In fact it was the culmination of years of hard work and canny budgeting, as the once impoverished GP had clawed his way to comfortable respectability. But insofar as Arthur epitomized some of the basic qualities of his age, this could not have been more appropriate.

Jean Leckie

1897

With that ambition achieved, it was time to realize another. According to the carefully maintained record, Arthur first met Jean Leckie on March 15, 1897. He would later celebrate the anniversary each year by giving her a single white snowdrop, with its obvious symbolism as the flower of regeneration and hope after the chilly blasts of winter. Although, inconveniently, he still had an invalid wife, he had found a striking younger woman with whom he fell passionately in love.

Jean had a trim figure, searching green eyes and cascading golden hair, her only possible blemish being a small, downturned mouth that brought out a pinched quality in her features. Blessed with a fine mezzo-soprano voice, she was studying to be a singer, which meant that, for the time being, she lived with her parents in Blackheath, south London, within easy commuting distance of her father's office in the City.

The previous day (a Sunday) she had celebrated her twenty-third birthday, a coincidence that suggests some planning had gone into this encounter with Arthur. Given her musical interests, perhaps he had invited her, as a belated treat, to the hot ticket of that day—the climax of the season of Monday Popular Concerts at St. James's Hall given by the Hungarian violinist Joseph Joachim and his quartet.

This interpretation would support an alternative version of Arthur and Jean's first meeting, which came from their daughter, also called Jean, who later claimed that her father became smitten after watching her mother playing rounders, apparently while visiting one of her uncles. It certainly suggests a summer encounter and lends credence to another possibility—that Arthur had met Jean the previous May when, as Geoffrey Stavert discovered, a Mrs. and Miss Leckie were

guests at Southsea's Grosvenor Hotel at the same time he Conan Doyles were in town. If this couple was indeed Jean and her mother Selina, and a *tendresse* developed, it would explain Arthur's frequent trips to London over the following months for occasions such as ladies' night at his latest literary coterie, the New Vagabonds Club. It would also throw light on his unusual problems in completing his work in 1896. *Uncle Bernac* had proved his most difficult commission ever, which was odd, since the subject matter, which took him closer to the historical Napoleon than ever, was much to his liking.

Predictably Arthur does not disclose much in his memoirs about his emotions during this period. The first occasion he mentions Jean Leckie—and the only time by name—is when he marries her in 1907, a year after Louise's death. But what he does say about his frame of mind in the mid-1890s is revealing. "I had everything in those few years to make a man contented," he wrote, "save only the constant illness of my partner." And he continued, "And yet my soul was often troubled within me. I felt that I was born for something else, and yet I was not clear what that something might be."

There was nothing new in his spiritual yearnings. But they were now linked in his mind with Louise's illness, which had taken over from his father's alcoholism as the psychic irritant, forcing him continually to question the nature of man's relationship to the universe. As he was not specific, it is difficult to know his exact thought processes. Perhaps in the way he used to wonder what became of the soul when a mind was damaged, he had similar thoughts as he witnessed his wife's physical decay. And all the while the specter of death intensified his sense that there must be other dimensions to existence. Such an ordeal would challenge anyone's attitudes, whether a rationalist or a believer. It came at a time when Arthur was looking for answers elsewhere in his life—for example, in politics, where the idealistic side of imperialism, in its sense of shouldering the white man's burden, appealed to his innocent enthusiasm for heroic causes.

As he wrestled with these cerebral matters, he felt a more pressing personal need for a help-meet—a role he had reluctantly decided that Louise, after more than three years of suffering from a life-threatening illness, could no longer perform. As a doctor he had come to realize that, as much as he admired his wife and would do all he could to improve the quality of her existence, her health was not going to get better, and she was likely to die within the next decade.

Added to this was a physical dimension. At the age of thirty-seven, Arthur was in his prime. However, so far as can be said without being

privy to the secrets of his bedroom, his sex life had ground to a halt. In her condition and in keeping with then medical practice, Louise would have been warned off conjugal relations. All the evidence suggests that she maintained this abstemious regime. At Norwood she had her own room, which had developed an off-putting air of disease.

When a beautiful young creature stepped into Arthur's world, Louise had no chance. Despite himself, the impulsive author was drawn to Jean, and to her promise for the future. Here was someone who struck an attractive compromise between the competing female role models of the age. Her fledgling career gave her an air of independence. Yet she was neither a suffragette nor a non-reproducing blue stocking of the type abhorred by Grant Allen. While Louise's family background was rural and self-contained, Jean's was bourgeois and entrepreneurial, with links to the wider imperial world. And while, more personally, Louise now looked in on herself, her calm Anglican piety reinforced by readings from St. Thomas à Kempis, Jean reached outward to music and entertainment with all the natural exuberance of youth.

Arthur must have sensed that Jean would provide the support he needed as he geared up for the next period of his life when, secure at home, he would play a more public role in the nation's affairs. He did not intend to desert his wife: that would be alien to his nature. But while she remained alive and he had no physical outlet for his sex drive, Jean Leckie would offer him an idealized romance. This was an understandable option for a man such as Arthur who, for all his blunt physicality, had an unusual capacity for living in his mind. It would also let him off the moral hook, for he would convince himself that, so long as he was chaste, this type of dalliance was acceptable.

Remarkably he also convinced his mistress. He offered her no certainties, apart from his informed opinion that Louise was unlikely to live long. There was no obvious reason for Jean to spend the best years of her life in expectation. But she decided that the prospect of becoming the wife of a celebrated author was worth waiting for, and the March date probably marked the moment when she and Arthur understood the realities of the situation—that they were in love and would have to make the best of it. Perhaps there was significance in the fact that the fifteenth was also the Ides of March, the day in the Roman calendar associated with impending danger. The symbolism of the snowdrop came later, when Arthur could look back on his life till then and cast it as bleak and wintery before the coming of a joyful spring.

* * *

Despite some similarities, hers was a more materialistic background than his own. Jean came from Scottish stock that had made its way in the world. Her branch of the Leckies originated from Peebles where her great-grandfather, Thomas Leckie, had been a noted secessionist minister, once close to the Reverend John Brown, father of Mary Doyle's friend, the physician and author of the same name.

Thereafter Thomas Leckie's ten sons fanned out across the globe, one becoming a doctor with the East India Company, another teaching in the United States, a third taking care of finance as an influential cashier at the Commercial Bank in Edinburgh, while Jean's grandfather Patrick went to London where he prospered as a stockbroker and, later, director of one of Britain's leading insurance firms, the Equitable Assurance Company. Now in his eighties, he lived comfortably in Kensington and had seen one of his daughters marry into a leading City family, the Kemp-Welches, and another to a top Oxford surgeon, Horatio Symonds.

Jean's father, James Blyth Leckie, was originally destined for a career in the army. But after failing to gain admission to the Royal Military Academy at Woolwich in 1861, he had turned to trading in China and India, which allowed him to return to London and establish himself as a silk and tea merchant. After marrying Selina Bousfield in 1870, he fathered five children—Mildred, the oldest, who had consolidated the family's fortunes by marrying their long-time lodger Patrick Forbes, the amiable artist son of James Leckie's partner in Assam tea estates; Jean; Patrick (known as Stewart, perhaps to avoid confusion with his brother-in-law); Malcolm; and Robert.

Jean's own upbringing was typical of a young woman from the prosperous middle classes. After completing her education in Dresden, which was highly regarded for its culture, particularly opera, she had attended the Guildhall School of Music, where she was commended for her "admirable progress" in 1894. She subsequently studied under the vocal maestro Vincenzo Vannini in Florence. But by early 1897 she too had reached a dividing line. Was she prepared to commit herself to becoming a professional singer? Or would she seek an easier way out, using her looks to find a mate who would indulge her as his nightingale?

Arthur's solution was to incorporate her into his life, particularly after his move to Undershaw. Remarkably, Jean was accepted by his family, who warmed to a personality that was chatty, a trifle garrulous, but never reflective. She particularly endeared herself to Lottie and to

the Mam, who must have noted the similarities between this young woman's relationship with her son and her own with Bryan Waller. Although the details of that liaison have been kept tightly secret, there is little doubt that Mary Doyle flirted with Waller, who gave her a new outlook on life at a time when her spouse was in poor health and needed her full support. And Arthur doubtless excused his own behavior by keeping this parental model in mind.

Jean's style did not please everyone. According to Georgina Doyle, who would marry Innes's son, John, "I have heard again and again from members of the Doyle family that Jean was gushing and affected, and a woman who craved the limelight. Another comment made to me was that she was artificial and theatrical, forever waving her arms about."

Was it coincidence that her presence among the Conan Doyles was first noted (by Innes in his diary) at a grand Jubilee Ball in Portsmouth in July 1897? By the end of the year she had become a regular fixture at Undershaw. Although she never stayed the night (at least her name does not appear in the green guest book), she was often there during the day, accompanying Arthur on country walks and rides. (One of her attractions was that she was a good horsewoman who liked to hunt.) On one occasion in November she was present when Arthur read from the play version of Sherlock Holmes he was developing.

His emotional and spiritual turmoil was evident in a story called "The Confession" which he wrote that autumn. In May he had announced he was embarking on a course of reading the French skeptic, Ernest Renan, "to steady myself down." But this therapy had had the opposite effect. Within weeks he was contemplating a new book about the Jesuits. Oddly, given his schooling, he asked his mother if she knew a young member of the order who could enlighten him about its present-day practices.

"The Confession" revealed less about the Jesuits than his own problems trying to square his passion for Jean with his responsibility toward Louise. First laid out in a notebook three years earlier, it told of a Dominican abbess in Portugal who confesses to a charismatic Jesuit priest her continuing guilt at her pleasurable memories of a one-time love affair. He absolves her in the practical way Arthur might have hoped for: "My sister, our thoughts are not always ours to command. When they are such as our conscience disapproves, we can but regret them and endeavour to put them away."

It only emerges subsequently that this same Jesuit had once been the

abbess's lover. He had become a priest after being tricked into thinking she had rejected him. When she tries to console him with thoughts about the good they have both done in the world, he is inconsolable. "What about our lives!" he pleads. "What about our wasted lives!" This earthy but sacrilegious cry only hinted at the anguish Arthur knew he would have felt if he had not pledged his love to Jean.

The generator was not functioning properly when the Conan Doyles moved into Undershaw in October 1897. Otherwise, the new house was in good working order and, as intended, guests soon began to arrive. The Hornungs were there from the very first day, and Innes followed on the weekend, noting approvingly in his diary that the place was "very comfortable."

The visitors put an extra burden on the ailing Louise but, with help from her sister-in-law Lottie, who had supervised much of the move, she gamely played her part, marshalling her corps of servants and supervising a Mrs. Beeton–inspired menu each day. On October 19, two nights after taking up residence, the house party ate a supper of "white soup," a typical concoction from the matron of "household management," involving chicken, almonds, stock and lashings of cream, "sole" (with extra cream, if the exact recipe was followed), "boiled fowl" and "rice soufflé," another dairy-heavy pudding from Mrs. Beeton's mammoth tome.

During the first few weeks, Innes was at Undershaw more than usual, initially because he was feeling sorry for himself after being jilted by his inamorata Dora Hamilton, and then because he broke his collarbone while hunting on December 7. The fracture was set by Arthur and a local doctor, but it necessitated four "dressing gown and garden days." Shortly after Christmas William, the engineer, joined the casualties after he fainted in the power plant and burned himself badly about the foot.

Even at this stage a few extras were required. Arthur bought a second horse, a bovine chestnut called Korosko, nominally for Lottie to ride, but probably more with Jean in mind. He also splurged on an elegant Landau carriage, mainly for Louise, as well as a four-wheeled dog cart. For his own pleasure, he commissioned a portrait by his friend Sidney Paget. The artist came down shortly before Christmas and remained for a leisurely working week, during which time he managed to go hunting twice with Arthur (on the second occasion accompanied by Jean Leckie who, eager to make her mark, asked for his autograph—a request to which he courteously acceded). The

result of his professional endeavors shows the new owner of Undershaw looking confident, if grimmer than usual, with his hair swept back and noticeably thinning. He adopts a seigneurial attitude, with his English-style mustache magnificently waxed into thin strips that jut out beyond his cheeks. Appropriately, he looks up from writing something in a notebook. Prominently positioned in the top right-hand corner of the canvas is an early version of his coat of arms.

Such extravagances put pressure on even Arthur's ample financial resources. Earlier in the year builders' bills had forced him to ask Greenhough Smith at the *Strand Magazine* for prompt payment of the 900 pounds that were due him on delivery of *The Tragedy of the Korosko.* At the same time he was not only supporting most adult members of his family (the invaluable Lottie, for example, received an allowance of 6 pounds 13 shillings fourpence each month) but he was also helping out with loans to several friends in financial trouble—750 pounds to Willie Hornung's brother Charles, 400 pounds to Kingsley Milbourne, and 500 pounds (recorded in his diary as a long-standing debt) to Jerome, who tried to make amends by giving the Undershaw household a large prize bulldog named "Derby the Devil." In addition his sister Dodo had just become engaged to Cyril Angell, a well-intentioned but impoverished Westmorland parson, and would soon require financial assistance.

Another drain on Arthur's bank balance was his interest in the supernatural. His diaries show that from the autumn of 1896 (around the time of his séance with "Dorothy Postlethwaite" and "Surgeon-Captain Trask") he began making substantial regular payments to *Light,* the magazine of the London Spiritual Alliance. Hitherto his financial outgoings in this field had been limited to his regular two-guinea subscription to the Society for Psychical Research. But now he began disbursing sums of a different order—300 pounds here, 500 pounds there, adding up to 4,250 pounds over a seventeen-month period—to ensure the survival of this minority-interest magazine.

His choice of *Light* was significant. Although a supporter of the SPR, and in particular of the meticulous research conducted by his friend, Frederic Myers, he was wary of the Society's uncompromising skepticism, which had recently led it to dismiss the Italian medium, Eusapia Palladino, as a fraud. He was also suspicious of the other main tendency in this field which, in the wake of the fashion for theosophy and Eastern religions a decade or so earlier, emphasized the occult. In his opportunistic way, he had been happy to adopt some of this group's more fanciful ideas in his stories. But he remained too much

of a rationalist to accept unsubstantiated accounts of astral travel. The London Spiritualist Alliance trod a comfortable middle path between scientific enquiry and mystical arcana. At the start of the year *Light* had been relaunched as part of an internal restructuring that left Arthur's Portsmouth friend General Drayson still on its council. Arthur saw its magazine as a worthy recipient of his money.

As a proponent of psychical research, however, he could not ignore his various fellow-travelers. Several writers, including his acquaintance W.B. Yeats, had gravitated toward the Order of the Golden Dawn, which claimed to stand in the ancient hermetic tradition of magic and esoteric knowledge. Sidney Paget's eldest brother Henry Marriott Paget, also an artist, was a member, together with his wife Henrietta and sister-in-law Florence Farr, an actress and muse of both Yeats and Shaw. The Order also boasted a strong contingent of doctors who practiced alternative medicine such as homoeopathy. But despite his general openness to unexplained phenomena, Arthur, as a medical man, was too much of a therapeutic interventionist to follow them.

He did make contact with one such practitioner who lived not far from him in Liphook, Hampshire. Arthur's curiosity had been sparked by learning that Dr. Henry Pullen-Burry kept a den in his house that no one else was allowed to enter since it was reserved for occult practices. When Pullen-Burry suggested that he join the Golden Dawn, Arthur did not demur. He was told he would be examined by the group's initiates, but need not attend in person. A week or so later, he woke in the night with a tingling sensation that he likened to a mild electric shock. When he next met the doctor, he was told that he had been examined and had passed. But Arthur made no further moves to join, claiming he was too busy to study to become an initiate.

A couple of months later Pullen-Burry returned with a colleague, Dr. R.W. Felkin, whom Arthur recognized as a veteran of Sudanese exploration. When the two doctors started talking about astral travel, and having met over a town in Central Africa, Arthur was glad he had not joined their Order, which he described as neither spiritualism nor theosophy, but an often unscrupulous mixture of assumed occult powers. He was adamant that progress in paranormal knowledge had to be matched by similar advances in ethics and morals.

One reason Arthur could not contemplate joining the Golden Dawn was that he needed to make money and so, from the beginning of 1898, he knuckled down to an intensive bout of writing. After a flurry of verses celebrating country life, he put his mind to what

became known as the *Round the Fire Stories*. With professional attention to detail he told Greenhough Smith, who published most of them in *Strand Magazine*, that the title "Detective Stories" did not fairly characterize his output, which he later considered among his best: "I want to give myself a very free hand so that in case any tap runs dry I can turn on another." He advised the editor not to mention "Detectives" or "Holmes" in any announcement. "To say however that they deal in mystery and adventure would be true, also that they are concerned with the weird and the terrible."

In more than a dozen stories, he drew promiscuously from various familiar genres, as he made references to his new surroundings (Haslemere's museum suggesting the backdrop to "The Jew's Breastplate"), his interest in new technology (with the gramophone in "The Japanned Box") and his love of trains (central to "The Man with the Watches"). He injected a stiff dose of the macabre into "The Sealed Room," where a millionaire's dusty remains are found in a barred chamber of his son's house in Hampstead. He had lain there undiscovered for several years, as he had always been thought to have left the country to avoid his creditors. Significantly this was written in March 1898, at exactly the time Arthur became curious about Dr. Pullen-Burry's inner sanctum. Secret rooms were often featured in his output, a metaphor for his own obsessive desire to keep his innermost thoughts somewhere safe. In this tale, the discovery of the old man's decomposed body reflected his feelings as he contemplated his own father's minimal legacy.

But the dominant theme of these stories was the paranormal. Like "The Ring of Thoth" nearly a decade earlier, "The Brown Hand" is about a man from the East who plagued a distinguished Indian surgeon as he searched for the hand that had been amputated from his arm in an operation many years earlier. In this way he sought, in mystical terms, to make his body whole and thus a perfect dwelling place for his spirit. (As a member of the Society for Psychical Research, the narrator of this story drew on Arthur's ghost-hunting experiences in Dorset to tell of the night he and two colleagues had spent in a haunted house.)

The extraordinary "Playing with Fire" focuses on a group of occult-minded friends who come together for a séance at 17 Badderly Gardens, a London address suggestive of Bedford Park in Chiswick, where Florence Farr and her fellow members of the Order of the Golden Dawn congregated. One is an artist, reminiscent of Henry Marriott Paget, who has just painted a unicorn, his latest work in the genre for

which he is well known (and obviously familiar to Arthur from his father and uncle)—"all very clever and imaginative, fairies and animals and allegorical figures of all sorts." Also invited is a visiting Frenchman, M. Paul Le Duc, who is described as "a famous student of occultism, a seer, a medium, and a mystic." After a vivid sitting with a medium, full of dire warnings about forces that cannot be controlled, Le Duc jokes that English people are too serious about such matters and need to have more fun. So, in his desire to prove that thoughts can be materialized, he summons up what is first a "patch of radiance" and then becomes an animal like a horse (clearly a unicorn) that careers through the room, terrifying the participants. The narrator, who lives in Albany, Piccadilly, a favorite address of Arthur's, is left wondering if he had been present at a hoax, a terrible event, or some unfathomable mystical experience.

Such goings-on gave a new twist to the Sherlockian remark of the railway detective Inspector Collins in another of these stories, "The Lost Special." Called to provide a cold dose of professional skepticism in an equally bizarre situation, he comments, "It is one of the elementary principles of practical reasoning that when the impossible had been eliminated the residuum, however improbable, must contain the truth."

Typically Arthur's industry was reflected elsewhere in his life, as he filled his house with guests such as the J.M. Barries, he kept up his Napoleonic interests by plowing through six volumes of Napier's *Peninsular War* before January was over, and he learned the banjo. He joked to his mother that strumming this instrument and hunting were the two things he might have been thought least likely to do. He did not mention Jean's influence: she played not only the piano, but also the viola and guitar, and he must have been hoping to accompany her. In a further effort to please his young love, he adopted a strict exercise program, designed to reduce his weight to 219 pounds. But it was not successful: for much of the start of the year he tipped the scales at a bulky 222 pounds, at one stage topping 224 pounds.

His furious activity was checked in late March by the death of James Payn, the writer who had helped him most in his literary career. He had managed to dedicate his recently published *The Tragedy of the Korosko* to Payn. But their joint play had yet to be produced, as it shuffled among various theatre managements. Arthur poured his grief into a letter to the literary journalist Clement Shorter: "London will never be the same to me without that cheery sickroom in Maida Vale where I have spent so many happy hours. It was an object lesson in

pluck to visit him. Twisted and crippled with a strong cigar held among his distorted fingers he would sit, twinkling behind his glasses, the merriest comrade in the world . . . One went with the thought of cheering him up and one came out cheered oneself."

On April Fools' Day 1898 Arthur finished his third *Round the Fire* story, "The Sealed Room," and felt he deserved a break in the gap, as he put it, between the hunting and the cricket seasons. Leaving behind his sick wife and his children, he took himself off to see various family members in Italy. In Rome he visited the Hornungs who were staying in rooms on the Via Gregoriana where the once popular English poet Mary Howitt had died. Willie Hornung was working on his stories about "Raffles: The Amateur Cracksman." When, after appearing in *Cassell's Magazine*, they were collected in book form in March 1899, Willie declared his debt by dedicating them "To A.C.D. This form of flattery."

One hot April evening Arthur dined with the Hornungs and a couple of visiting authors, George Gissing and H.G. Wells, who, somewhat like he, were both escaping tangled romances at home. Arthur recognized a kindred spirit in Wells, whom he had almost certainly met as a young assistant in a Southsea dry goods store. Wells had recently begun to make his mark as a writer of science fiction, one feature of which was its use of the future to make political points about the present. In *The War of the Worlds*, published only two months earlier, he had written about an invasion from outer space, in which the Royal Navy's fictional ironclad torpedo ram HMS *Thunder Child* is blown away by superior alien firepower. Since this was clearly a contribution to the growing debate about British naval strength in the face of threats from other powers, particularly Germany, Arthur suggested that, when in Naples, Wells might like to discuss the matter further with his brother-in-law, the naval architect Nelson Foley.

Arthur must have done the same when he visited Nelson on Gaiola later in the month. For he was thinking of entering politics and directly influencing such discussions himself. But when, on his return to Britain, he was invited to be the Liberal Unionist parliamentary candidate in Portsmouth, he declined, fearing that the work required in a busy dockland constituency would be too much for him.

While he had been away the United States had joined the ranks of Western imperialists, going to war with Spain over Cuba. Arthur told his friend, the American writer John Kendrick Bangs, that he was delighted because this would not only mean an end to Spanish provocation but would also benefit the Anglo-American alliance, the union

of English-speakers (in his estimation the true United States), which could only draw strength from being arrayed against foreigners.

In the British sphere of interest, the long-drawn-out campaign in the Sudan was drawing to a close, but the situation in South Africa was growing more tense, while long-term strategists worried about rivalries closer to home. After making his presence felt in Egypt, Arthur was taken increasingly seriously by the War Office. In early September he found himself in the unusual situation of attending a dinner on Salisbury Plain and sitting next to the Commander-in-Chief, Lord Wolseley, when news of the battle of Omdurman came through. He was impressed at "the whole-hearted boyish warmth" with which that experienced soldier "sprang to his feet" and drank to the health of Sir Herbert Kitchener, who had achieved the success that had eluded Wolseley himself in the Sudan. The dinner took place during a massive mock invasion being rehearsed across vast expanses of Wessex. Arthur owed his presence to his friend Arthur Griffiths, who was reporting the military maneuvres for *The Times*. Griffiths was one of those busy people whose company Arthur enjoyed—a man who juggled several careers, including military correspondent, inspector of prisons and author of many books that displayed his professionally garnered knowledge of crime. Arthur's diaries attest to Griffiths' influence in suggesting books on the Peninsular War. He is also likely to have drawn on his friend's experience of police procedure and criminality.

Over the summer Arthur had been content playing cricket for a wide range of teams (including his own). He also completed his *Round the Fire* stories, which attracted the interest of Grant Richards, Grant Allen's ambitious nephew, who had just started his own publishing house and had already drawn A.E. Housman and George Bernard Shaw to his list. Arthur was reluctant to allow Richards to package his stories as they would compete with his recent volume of poems, *Songs of Action*, which included two hymns to the fighting Irish in Cremona and "An Irish Colonel" as well as recent verses on hunting, such as "With the Chiddingfolds."

Instead, in an effort to help a newcomer in the book business, Arthur offered to try his hand at the fashionable genre of novels exploring the position of "new women" in society—a subject linked to the general interest in realism in art and literature, and one much discussed among the chattering classes in Hindhead. Grant Allen himself had had his say, but, whereas he had attacked the institution of marriage, Arthur wanted to support it—even to the point of being polem-

ical, as was clear from his working title, "The Threshold," his original name for *The Stark Munro Letters.*

What came to be known as *A Duet* was an extraordinary undertaking, given his own matrimonial complications. It is the good-natured story of the romance of a young suburban couple, Frank and Maude Crosse, as they move from the innocent joys of courting to the early promise and inevitable compromises of wedlock. It offers advice about how to make a marriage work: a man and a woman should not be angry with each other at the same time, for example. It looks at the lives and marriages of historical figures such as Samuel Pepys and the ever fascinating Thomas Carlyle. ("I want you to promise me that you will never be a Carlyle," pleads Maude.) In one light-hearted chapter Arthur shows his dislike for the domestic tyranny perpetrated by Mrs. Beeton and her pervasive *Book of Household Management.* The Crosses' cozy home life is disturbed from time to time by various threats, including a jealous former girlfriend, Violet Wright, quite possibly a prostitute, certainly a seasoned seductress, who inveigles Frank into meeting her in Mariani's, a racy restaurant in Covent Garden. The woman adopts a blackmailing tone and threatens to tell his wife about their tête-à-tête. But when she makes her way to the Crosse house in Woking, she is disarmed by Maude's sincere and unaffected love for her husband.

Despite this tame conclusion, Arthur was disturbed by his foray into the unfamiliar world of "the woman question." Only a couple of years earlier his Hindhead neighbor, the respected if aged novelist Mrs. Oliphant, had railed in *Blackwood's Magazine* against English novelists' newfound tendency to copy the depraved French in dealing with "subjects hitherto considered immoral." It was proper to write about love, she argued, but "what is now freely discussed as the physical part of the question . . . has hitherto been banished from the lips of decent people, and as much as possible from their thoughts."

On reflection Arthur thought he had gone too far in hinting at sexual infidelity in Mariani's. ("She put out two hands and took hold of his. That well-remembered sweet, subtle scent of hers rose to his nostrils. There is nothing more insidious than a scent which carries suggestions and associations. 'Frankie, you have not kissed me yet.'") He decided to withhold the book from serialization, fearing it relied too much for its effect "upon feeling and atmosphere rather than upon incident" and ran the risk of producing "a false impression."

In reality, *A Duet*, begun in October, was little more than a gentle primer about mutual sensitivity in marriage. Arthur's reaction reflected his fraught situation with Louise. However if the book had in

any way been aimed at reassuring her at a time of stress, Arthur undid the good work by giving the manuscript to his true love Jean. She, rather than his wife, was the woman he believed needed enlightening about the finer points of intimate relationships.

Arthur did at least receive an encouraging letter about the book from H.G. Wells who, he surely knew, had started a similar novel about young romance (*Love and Mr. Lewisham*) while in Rome. The two authors had been exchanging further ideas: when, after joining the Society for Psychical Research, Wells started writing stories about the paranormal for the *Strand Magazine*, he took the trouble to inform Arthur, as the more experienced author, of his intention to "keep clear of the danger of comparisons." Arthur seemed happy to acknowledge his friend's input into *A Duet* since the Crosses lived at The Lindens, Maybury Road, Woking, which, until recently, had been Wells's address, bar the fact that his house was called Lynton. When soon afterward Wells thanked Arthur for similarly positive comments about one of his science fiction books, *The Sleeper Awakes*, he promised, apropos *Love and Mr. Lewisham*, to "send you *my* young couple book next year."

Not that Undershaw was the book's neat little house in Woking. It was the seat of an aspiring country gentleman, a role underlined two days before Christmas, when Arthur held a grand fancy dress ball at the nearby Beacon Hotel. The self-congratulatory tone of the event was evident from the fact that Arthur had to disabuse Clement Shorter of the idea that the guests had been invited to come as characters from his own works. Inevitably some people did—one appeared as Rodney Stone, another simply as a "study in scarlet," while Mrs. Vernon Ford, wife of the Southsea doctor (and tenant), cut an extraordinary figure as the horse Silver Blaze from the Sherlock Holmes story of that name. Arthur showed his manly self-image as a towering russet-colored Viking, while Louise played it safe in an eighteenth-century costume described as "poudré." Among Italian peasants, French noblemen, and Arab chieftains, Jean Leckie stuck to her Scottish roots in the garb of one of the "four Maries" associated with Mary, Queen of Scots. Captain Philip Trevor, a writer and cricketing friend of the host, may unwittingly have hit the right reverential note when he adopted the guise of Arthur Conan Doyle himself. The only discordant strain, according to an enthusiastic Innes in his diary, was that the band had the rank bad manners to steal all the cigars.

Boer War and Aftermath

1899–1901

While Undershaw ran smoothly, it was hard to fathom the emotions swirling beneath the surface. But there was no mistaking the desperately personal nature of Arthur's plea to his mother at the start of 1899, begging her to advise one of her friends against marrying a man with tuberculosis. He said that consumptives should be banned by law from matrimony. And if the Mam's friend thought she would be helping her prospective husband, she was wrong. In fact she would be adding to his worries and making his position much harder.

Arthur's insistence on this point showed how much Louise's condition had preyed on his mind. In the six years since her diagnosis, his distress about her illness had developed into a phobia. Somehow he managed to convey this to his mother as concern for the victim and his (or her) suffering. But this was verbiage, as he had never given much thought to the hurt he caused his wife through his dalliance with Jean, or, more to the point, he had never felt reason to act upon it.

Underlying his attitude were some surprisingly anachronistic views about genetics and heredity. Arthur seemed to regard tuberculosis as both an inheritable and communicable disease, which helps explain his treatment of Louise. As she was still of childbearing age, he was apprehensive that sex with her might produce a consumptive child. This rationalization may have helped assuage his conscience over his affair with Jean, but it also pointed to something deep-rooted in his make-up—a very Victorian fear that aspects of Charles Doyle's illness, even madness, had been passed on to him.

At the time Arthur was in the middle of writing *A Duet* which, in the circumstances, seemed more than ever a description of an idealized

marriage to Jean. He threw himself into the book, finishing it before the end of January, barely three months after starting. Grant Richards played his part by rushing the book out in March. But despite the positive response from H.G. Wells, the general reaction was unenthusiastic and sales were modest. Though satisfied that he had tried something new, Arthur blamed himself for jeopardizing the success of his young friend's fledgling publishing house. To make matters worse, four years later he encouraged Richards to publish a mystery novel, *The Episodes of Marge: Memoirs of a Humble Adventuress,* written under the pseudonym H. Ripley Crowmarsh by his sister Dodo. This was a flop and Arthur later had to buy up half the copies.

In the case of *A Duet,* Arthur was particularly annoyed that Robertson Nicoll, editor of the journal *The Bookman,* had exerted what he felt was undue influence by reviewing the book negatively in several different outlets, using a variety of pseudonyms. His public attack on Nicoll showed his tetchiness, particularly at this juncture, but it also reflected his genuine concern at declining standards in the book trade. (By the same token he had crossed swords a couple of years earlier with the novelist Hall Caine, whom he had accused of the heinous sin of being a self-publicist after his rival author had had the cheek to talk up his bestselling novel *The Christian* in interviews and other media.)

Mary Doyle tried to lift her son's spirits by suggesting that now that he had demonstrated his range, he should concentrate on what he did best, which was historical novels. He cannot have been too happy to hear her old refrain: "Take us out of the little tick tack of our daily drone to the clear bracing atmosphere of our forebears when there were no problems, less complexity and more room in the world. To so few is it given to be able to call it up—the sun that shone, the life that stirred, the love and beauty and charm that were in those 'spacious' days when we were not—it is such a gift, a true inspiration. Man today I find such an introspective, carping, fussy, perplexing atom, and if man—then woman ever so much more so—let us go back to the old days."

In deference to her, Arthur began contemplating a new medieval novel along the lines of *The White Company.* But he had no major project to fire his imagination, apart from the second-hand pleasure of watching the development of his dramatic version of Sherlock Holmes by the charismatic American actor William Gillette. This was something that had been brewing for the best part of a year. He had bypassed A.P. Watt and entrusted the job of agenting the play to Addison Bright, a theatre specialist who worked for Barrie. As a result the

leading actor-manager Herbert Beerbohm Tree had been to Hindhead the previous spring to hear Arthur's adaptation. But Tree made such extravagant thespian demands that Arthur was doubtful about its ever being staged.

The scenario changed a few months later when Gillette, who was in London starring at the Garrick Theatre, decided with his compatriot, the producer Charles Frohman, to approach Arthur about his now well publicized Sherlock Holmes play. Gillette too had his requirements, but by then the author was happy to get the work off his hands. Encouraged by the idea of the money American audiences would generate, he agreed to give Gillette a free hand in choosing how to bring his great detective character to the stage. Initially Arthur's only restriction was that he did not want Holmes involved in any romantic interest. But by the autumn of 1898 he had relented again and told Gillette, in the words of the *Strand Magazine*, that he "might marry the detective, or murder him, or do anything he pleased with him, preferring to leave a stage detective in the hands of a master actor." In November, however, disaster struck when a fire destroyed the San Francisco theatre where Gillette was working, taking with it his ongoing dramatization of Sherlock Holmes. Since there was no copy, the actor had to start again. But the undertaking did not prove too onerous, since by the following spring he was able to take his manuscript to England for Arthur's approval. Holmes's original creator did not balk at Gillette's giving his detective a catchphrase "Oh, this is elementary, my dear Watson," which was taken up and shortened by the film industry. He made some cursory alterations and the play was given a copyright performance at the Duke of York's Theatre in London on June 12, 1899. However, its official opening was always scheduled for the United States, probably in the autumn, and Arthur was awaiting this event with some excitement.

As his paperwork grew, Arthur hired a secretary, Charles Terry, to assist him two mornings a week. But his creative output hardly warranted the expense of 10 pounds a quarter—limited, as it was, to some prefaces for a putative collected edition of his works and a few more stories for the *Strand Magazine*, including "The Croxley Master," a gritty, modern version of *Rodney Stone*, and "The Crime of the Brigadier," a new Gerard tale, which showed his sure comic touch in its dashing description of his hero inadvertently getting involved in a British hunt during the Peninsular War.

At least Arthur could point to positive developments in his family affairs. Two of his responsibilities had been reduced as, shortly after

Dodo's marriage in April 1899, Innes stopped dithering over the direction of his army career and joined the Royal Horse Artillery in India. However, there was still the problem of Lottie. The Mam wanted her to spend some time with her sister Ida in Italy. But Lottie had taken a dislike to Nelson Foley, and prevailed on Arthur to allow her to follow Innes to India, even if this did mean she would join the vast fishing fleet of women looking for eligible husbands. She did not have to wait long, for on the voyage to Bombay in September she befriended a family called Oldham. Innes's chaperone duties were minimal, for Lottie had met Leslie Oldham, a young captain in the Royal Engineers, whom, after a lightning romance, she married in Nagpur the following August.

Once on the subcontinent Innes had the temerity to raise the delicate subject of Jean Leckie. Shortly before leaving, he had accompanied Arthur to lunch with her in Blackheath. His inquiries now were met defensively: Arthur assured him there was no need to worry as he would never cause Louise any pain. "She is as dear to me as ever, but, as I said, there is a large side of my life which was unoccupied which is no longer so." This was as near as Arthur came to admitting that he needed a romantic interest in his life and could no longer find this with Louise in her invalid state. It also appears to be an admission that he enjoyed sexual relations with Jean, but as he denied this elsewhere, it is impossible to confirm. Arthur promised his brother that nobody would get hurt. Louise, looking out over the Surrey hills with her sad contemplative eyes, no doubt felt differently, but her thoughts on this compromise—and she must have had some—have, almost certainly wilfully, not been recorded.

Cricket provided its usual outlet for Arthur's energies, as he embarked on a heavy schedule of forty games (some over two days) between May and September. His diary records how he prepared with his usual thoroughness: "Must cultivate the faster leg ball with swerve. Move along the crease. Bowl two balls with leg swerve over the wicket and then one with off break from the extreme edge of the crease." Having reached the age of forty, he now boasted of his prowess as a hitter (he had blasted 67 in an hour in a game against East Gloucestershire). If his batting average for the season was a modest 21, his 106 wickets made him a valuable addition to any team.

He invited cricketing friends and relations to Undershaw for his August "cricket week," when he staged daily games against Haslemere, Grayshott and other local clubs. That year this ritual was observed by a reporter from America, who noted how the players were driven every-

where in a (horse-drawn) brake, "a vehicle very essential to English country life, which will carry the entire eleven with room to spare. On the return to evening tea the table is illuminated by a banquet lamp shaded by a design in salmon silk. This is called the Victory shade, as it is considered a sign of good luck and is always brought out by Mrs. Doyle during 'Cricket Week.' Through its influence several trophies are supposed to have been won. The hostess is as enthusiastic as her husband over the sport, and if necessary to afford room, will 'bundle' the children off to some relative's to remain until the guests have departed." The journalist was as correct on this point as in his comment, "As the cricket season occupies nearly two months, it may be surmised that very little literary work is done about Undershaw until its close between spring and autumn."

But sporting commitments could not mask the question of what the Conan Doyles would do in the winter. Louise looked forward to returning to Egypt, but Arthur was against this. He told Innes callously that he found it impossible to write in Egypt and anyway, Surrey was far healthier, particularly as the indications of his wife's illness were now related more to her digestion than to her lungs.

In fact Arthur was toying with another destination, where Louise was unlikely to accompany him. For throughout the year the threat of war in South Africa had been getting closer and he was determined to play a part. After General Gordon had finally been avenged at the battle of Omdurman in September 1898, the whipping of the Boers in the Transvaal became the dominant imperialist cause. Not that everyone was agreed on its military sense or even its morality, which meant that London was full of lobby groups, keen to garner Arthur's support.

For all his enthusiastic backing for the British empire, he was no out-and-out jingoist. With his chivalric spirit of fair play, he was to be found in January 1899 chairing a well attended meeting in Hindhead that called for a positive government response to a Russian initiative aimed at halting the global arms race.

In April his views appeared to harden as he and Griffiths were again guests at a private dinner for Lord Wolseley and War Office aides. A few days later Arthur was at another gathering attended by the colonial administrator Colonel Lugard, who was surprisingly dismissive of Cecil Rhodes, the mining entrepreneur who was stoking up tension in Southern Africa. Arthur's attitude toward what was happening there was not unrelated to the heavy weighting of mines in his stock portfolio. For at the root of the dispute lay control of valuable mineral resources, notably gold and diamonds, in the Rand which was

part of the Transvaal republic controlled by dogged Dutch-speaking Boers. Since this was outside British territory, imperialists such as Rhodes and Alfred Milner, the High Commissioner in the Cape, had been goading the Boers for some time, looking for a pretext to invade. (The Jameson Raid had just been one incident out of many.)

During 1899 a new issue arose—the question of voting rights for over 50,000 Uitlanders, or non-Boer Europeans, who serviced the mining industry in the Transvaal. The Boers resisted this idea, as it would lead to their becoming a minority in their own country. But forward strategists seized on it as a way of forcing the issue.

After a series of failed diplomatic initiatives during the summer, the likelihood of war increased, and, to their mother's consternation, both Arthur and Innes began thinking of wintering in South Africa. But Arthur still held back from committing himself because he wanted to gauge the reaction to Gillette's *Sherlock Holmes*, on which, he told his brother, all his immediate plans depended. The crunch came in the autumn when the Transvaal's President Kruger issued to the British an ultimatum to remove their forces from his frontier. When this did not follow he launched an attack on October 11 into the British colony of Natal, and the Boer War had started.

Arthur was staying at the Reform Club in London that day. His own response remained ambivalent: he told his mother that if Gillette's production of *Sherlock Holmes* allowed it, he might stop off in South Africa en route to visiting Lottie in India. At least he was happier now about the morality of the imperial cause, having satisfied himself that President Kruger's posturings over the previous two months had helped legitimize Britain's position.

By then he was coping not only with the enormous gap Lottie's departure for India had left at Undershaw, but also with a rash of deaths of people he loved—Willie Burton in Japan, his aged aunt Annette in her London convent, and Grant Allen nearby in Hindhead. Burton had died suddenly, just as he was about to return home to show off his new Japanese wife and daughter. At Tokyo's Imperial University he had contributed significantly to his adopted country, partly as a photographer, but particularly as the engineer who laid the foundations of many of Japan's water and sewage systems and who built its first skyscraper, the Ryounkaku in Akakusa, Tokyo. Having left most of her money to her mother superior, Aunt Annette mystified Arthur by giving him a violin bow. He said he would now have to buy himself a violin. As for Allen, Arthur later commented about how difficult it must have been for his neighbor, as a virtual atheist, to con-

template his painful end from cancer. But he helped as best he could, completing the final two installments of *Hilda Wade*, Allen's Sherlockian-inspired serial about a female detective, for the *Strand Magazine*. When Greenhough Smith commended him for his generosity, Arthur told him he was making too much of a trifle. "Poor chap, anyone who knew him would have done anything to ease his mind."

Under the circumstances, it was not surprising that Arthur described his state of mind as "jaded" when he filled out a questionnaire (possibly for a newspaper or magazine) four days after Allen's death. In his obvious struggle not to give too much away in his answers, he was actually rather revealing. There was no mistaking his commitment to toil and responsibility: his favorite occupation was work, his idea of happiness "time well filled," his idea of misery having nothing to do and his favorite heroes in real life "men who do their duty without fuss." While he had "no strong opinions" on his favorite painters or composers or indeed colors or flowers, his favorite virtue was "unaffectedness" (and his pet aversion "conceit"). And while he hedged in describing his favorite qualities in a man as "manliness" and in a woman "womanliness," he was more specific in his favorite poet (Kipling) and in his favorite motto: "Hope for the best—prepare for the worst."

Arthur overcame his jadedness by throwing himself into a short but lucrative lecture tour on which, he liked to recall, his main problem was keeping a straight face while reading his new story "The Crime of the Brigadier." Then, on 6 November, after a few out-of-town performances, Gillette's *Sherlock Holmes* finally reached New York's Garrick Theatre. That same evening Arthur was at the Authors' Club, where he had recently been elected chairman. He was presiding at a talk given by Lord Wolseley, who showed breathtaking complacency in suggesting that the troubles in South Africa would be ended with the dispatch of two divisions. For by then the British Army was already wavering under the Boer assault, and the towns of Ladysmith, Mafikeng and Kimberley were under siege.

Once Arthur could relax after learning of his play's enthusiastic reception on Broadway, he no longer had any excuse not to volunteer to fight. But he still had to deal with the wrath of his mother who remonstrated in a letter dated November 22 that, with his size, he would be a sitting target in South Africa and, anyway, he was much more valuable to his country at home where his writings gave pleasure to many people. As often before, she did not stint in her belief that the war had been engineered by a clique of diamond millionaires and that the Boers were plucky nationalists, not unlike the Irish, with justice on their side.

Arthur's mind was finally made up by the so-called Black Week of December 10–15, which marked the nadir of British fortunes in South Africa. "This war!" he remarked to Greenhough Smith. "Our commanders seem to have all gone demented. It's no use wishing anyone a Merry Xmas in the circumstances." Now openly describing himself as a member of the patriotic party, he wrote a combative letter to *The Times* on December 18, declaring that he did not see why Britain should expect civilians from the colonies to serve in this war, when it was "full of men who can ride and shoot" because of their country pursuits. He then set about pulling strings to get himself selected for action. He told his mother that, having suggested the idea of volunteering in his letter, he was honor-bound to go. He also noted that, aside from Kipling, he had the most influence over young men, particularly the sporting types.

His best hope of achieving his aim was the Middlesex Yeomanry, where Archie Langman, a family friend whom he had met on the ski slopes at Davos, was serving. Applying to this particular regiment was significant since it was part of the Imperial Yeomanry being financed for overseas service by Wernher-Beit, the largest pro-British gold-mining firm in the Transvaal. When asked at his interview if he had military experience, he replied that he had some knowledge of army operations in Sudan. He later commented how a gentleman was allowed to tell two white lies—to protect a woman and to participate in a battle when the cause is just. He was dismayed to be placed on the reserve list. However he found a way around this because, in the upsurge of patriotism, Archie's father John Langman was equipping a field hospital for South Africa and invited Arthur to join it as a doctor. It was a pity that this was such an afterthought. Medicine after all was the job Arthur had been trained for and the one in which he was most likely to be useful. In comparison, a middle-aged volunteer was just a romantic poseur.

Here again the mining industry was making its presence felt. For Langman *père* was an archetypal Victorian meritocrat. Originally of Cornish farming stock, he had been apprenticed to a London diamond merchant and risen to become one of the two owners of the Goldsmiths and Silversmiths Company, the leading commercial jeweler in the West End with premises at 112 Regent Street. Having made a fortune when the business was floated on the Stock Exchange in 1898, he increased it by astute property investments around Oxford Street and in Canada.

As military reverses accumulated in South Africa, the Royal Army

Medical Corps, which was little more than a year old, could not cope. When the idea of filling the gap through charitable initiatives was proposed in *The Times*, the Duke of Portland stepped in and set up the first private field hospital, with John Langman as its treasurer. But no sooner was this on its way in early December than the need for additional facilities arose. At this stage Langman decided to fund his own tented hospital of 100 beds. The subtext, never publicly mentioned, was that his jewelery business had profited hugely from the mines of the Rand, and this was his way of repaying his dues.

Arthur was now able to tell his mother that the hospital would enable him to reconcile their differing concerns. He promised not to volunteer again for active service, unless there was an emergency. This way his physical safety would be ensured and he would also be doing his duty to his country. In addition it would allow him to take a total break, which he stressed he very much needed.

He reiterated this point in a further letter in which he begged the Mam not to interfere by writing to the Langmans. Coming closer than ever to admitting that his grounds were not entirely altruistic, he said his motives were clear. "Nothing could fit into my life better. I have lived for six years in a sick room and O how weary of it I am! Dear Touie! It has tried me more than her—and she never dreams of it and I am very glad she does not." He added that this was the restlessness Connie had noticed in him. Or, to put it plainly, he wanted some respite from the pressure of juggling a sick wife and a mistress.

So he arranged for Louise and the children to spend the next few months with the Nelson Foleys in Naples. (His concerns about foisting his consumptive wife on his brother-in-law had suddenly disappeared.) Having given power of attorney to his solicitor, A.C.R. Williams, he made a will, leaving the bulk of his estate to his immediate family, but also 4,000 pounds to his mother, as well as generous sums for Lottie, Innes and Dodo. (His other sisters, Connie and Ida, were thought to be taken care of because they were married. Dodo was an exception because her husband was an unworldly parson.)

Before departing for South Africa, he had one more task to perform. He had long been fascinated by the idea of the inventor, the practical man who contributes to the world, such as the Major in "The Narrative of John Smith," who lobbies the War Office with his new invention—a metallic gunstock. In that unpublished book Arthur had contrasted the different contributions of the doctor with his cures, and the Major with his weapon. "Perhaps however they all fit in this wonderful conundrum of life and have each their subordinate but indis-

pensable part in the grand scheme of Creation. Slaying and saving, breaking down and building up, dissolving and reuniting, synthesis and analysis, who shall say which is ultimately the true philanthropy and which the violation of nature's profound and mysterious laws." Now, having committed himself to donning his doctor's white coat again, it was appropriate that he should also conduct his own amateur ballistics experiment. He was hoping to solve a battlefield problem that he imagined would be significant in South Africa. What is the use of direct rifle fire, he argued, when your opponent, the Boers, can always hide behind cover or in trenches. His solution was a small apparatus that a soldier could attach to his gun and which would allow him to raise the trajectory of his fire and rain down bullets on the enemy. He experimented with a prototype around Frensham Pond, four miles from Undershaw. But when he sent the War Office details of his research into how, as he put it, to turn a rifle into a howitzer, he was shocked to be rebuffed by them—so shocked, in fact, that he wrote to *The Times* to complain about "the curt treatment which inventors receive at the hands of the authorities."

At least Arthur was not falling into the trap of becoming too closely identified with the military establishment. His sense of grievance contributed to his maverick comments when, less than a week later, he and his butler Cleeve, whom he was paying to accompany him, joined other members of the Langman Hospital on board the converted P&O freight ship the *Oriental* at London's Royal Albert docks at the start of their voyage to South Africa. Arthur eschewed making any easy propagandist points. Instead he announced that he saw no imminent end to the war, preferring to express his admiration for the fighting qualities of both the Boers and the Irish (on the British side) and to forecast that the final settlement would mean "complete home rule for both republics under the protection of the British flag." Adding another strand to his web of motives, he declared that he did not intend to contribute to any newspapers while in South Africa, but hoped to write a short history of the conflict. (He had already written the introduction and had been been so pleased with his clear exposition of the issues that he had to be dissuaded from publishing it then and there.) His mother had come down from Masongill to see him off. But, as the *Oriental* pulled away from her berth, he did not realize that another woman, Jean Leckie, was standing in the waving crowd. She had told him she could not bear to witness his departure, but then had come, unannounced and alone, to wish her lover god speed.

* * *

The war situation was much improved by the time Arthur and the Langman Hospital reached Cape Town on March 21, 1900. Lord Roberts, hero of the Afghan War, had replaced the hapless Sir Redvers Buller as Commander-in-Chief and the Boers were on the retreat. Kimberley and Ladysmith had been relieved and Bloemfontein, capital of the Orange Free State, had been taken. So there was a mixture of muted gaiety and continuing uncertainty at Cape Town's Mount Nelson Hotel, where Arthur stayed among the odd mixture of camp followers and strays from the front.

Before leaving the city, he had an errand to perform. He and Archie Langman had been given funds by a charity to distribute among Boer prisoners of war. He was impressed by the quiet pride of the men he met, particularly one, perhaps a Huguenot, with brooding eagle eyes who bowed with grave courtesy when given a small sum for cigarettes.

Before the week was up he and the hospital personnel were on their way by ship to east London where, lying offshore on March 28 he remarked on South Africa's remarkable potential. He regaled his mother with visions of great fortunes to be made by anyone with an ounce of vim. Indeed, if he did not have other things to occupy him, he said he would definitely stay there. At the same time, more personally, he apologized: "If I have ever seemed petulant or argumentative—it is all nerves, of which I possess more than most people know." Now that he was rested and had something interesting to do, he promised to come back looking and feeling five years younger.

Once disembarked, he and his colleagues made their way by train across the rolling veldt to the newly liberated Bloemfontein. Well before arriving early on the morning of April 2, they had grown used to the sounds and smells of battle. After a short, unseemly wait amid teeming mules and baggage trains on an expanse of wasteland outside the town ("you would have smiled if you could have seen me in my pink undershirt, breeches and helmet, burned red and covered with dirt," he wrote to his wife), the Langman Hospital was allowed to pitch its tents on the Ramblers cricket club ground (later used for test matches) and to use the pavilion as its main ward.

As Arthur made his way around the town, with its neat bungalows festooned with Union Jacks and white chrysanthemums, he might have thought he had come too late. He had just missed a triumphal visit by Sir Alfred Milner. Bloemfontein was already on the tourist circuit, having played host to Lady Violet Cecil, one of the large contingent of army officers' wives whose noisy presence had angered Queen Victoria.

In the carnival atmosphere Arthur was pleased to find he knew several of the war correspondents holed up in the town. One of his first initiatives was to borrow a horse and ride out in search of signs of the Boers with H.A. Gwynne, a Reuters representative whom he had met in Egypt, and Sir Claude de Crespigny, a sporting baronet with a dashing Norman surname. While waiting for the troops to move on, Gwynne and three other reporters had been asked by Lord Roberts to take on the temporary duty of running *The Friend*, a bilingual newspaper that the Field Marshal hoped would win the hearts and minds of the 4,000 or so townspeople. This editorial team had already co-opted the visiting Rudyard Kipling, and hoped to recruit this latest writer to their strength. Arthur composed a piece on his first impressions of the town, making much of the sterling character of the troops. But he felt that his primary duty was to the hospital and that he should not on this occasion mix his callings.

On April 5, he is reported to have attended a meeting of an emergency Masonic lodge, Rising Star Lodge No. 1022, English Constitution. He does not seem to have devoted much time to the craft since Portsmouth. But the comradeship of war may have rekindled his enthusiasm for the universal principles of Freemasonry.

His relaxed introduction to Bloemfontein did not last long because the town was soon laid low by a typhoid epidemic. His first intimation of this came when he tried to turn on a bath and found there was no water. The Boers some twenty miles away had cut off the supplies, driving the British army and local townspeople to use the contaminated River Modder and some old wells, with disastrous consequences. Figures are difficult to pin down, but by the end of the month some 10,000 to 12,000 men had contracted the disease. At its height the death toll reached forty a day. Arthur had some protection since he had been inoculated on the way out, and the Langman Hospital was not affected as much as its government and military counterparts, because it could choose its patients. Even so, its tents were filled well beyond its limits, taking in fifty patients more than its capacity of a hundred.

The effects were devastating. Arthur wrote in his autobiography about the hellish experience of living in the center of not just carnage but filth. A stage, incongruosly set for a performance of *HMS Pinafore* at one end of the building, had been called into service as makeshift latrines for those who could reach it. Those who could not were expected to cope in any way they could, and the same was true for anyone else who happened to be there.

Despite his instinct for fair play, Arthur might have played down the awfulness of the situation if the Conservative MP William Burdett-Coutts had not whipped up a sense of outrage in Britain with his reports to *The Times* about the ravages of the disease and the incompetence of the newly formed Royal Army Medical Corps.

In the midst of this, the Langman Hospital had its own, largely self-inflicted problems. In his memoirs Arthur recalled how he had spent a week at its benefactor's Stanhope Terrace house helping to choose the personnel. But he did not have much input into the calamitous appointment of the unit's chief civil surgeon, an obese friend of Langman's called Robert O'Callaghan, whom Arthur could only witheringly describe as an excellent gynecologist, while observing that this was not a specialty much in demand in Bloemfontein. When the typhoid cases began to mount, O'Callaghan found the pull of his lucrative private practice in London too hard to ignore. And Arthur could not influence the selection of the War Office's official link to the hospital, Major Maurice Drury, from the Royal Army Medical Corps, whom he found entertaining but brusque, which led to regular squabbles with his staff.

As a result Arthur was rather busier than expected. His style of medical care came into its own when he had to treat a young private soldier who was perilously ill from typhoid. He asked Charles Gibbs, a young surgeon who carried the brunt of the work, what would happen if he gave the lad a decent meal, and was told it would surely kill him. Arthur stuck to his instincts and fed the patient, who not only recovered but later wrote to Arthur to thank him. But it was demanding business, as the artist Mortimer Menpes, who was reporting the war for the *Illustrated London News*, discovered. When Menpes asked him what was his favorite Sherlock Holmes story, Arthur was so preoccupied that he could only reply that he thought it was "perhaps the one about the serpent," but he could not for the life of him remember the name ("The Speckled Band"). And then he moved on.

Arthur found time to drag himself away from his work to watch Bloemfontein's waterworks being recaptured, with scarcely a shot fired, on April 24. Just over a week later Roberts began his advance northwards toward Pretoria, the capital of the Transvaal. Riding a horse called Fathead, Arthur, with Archie Langman at his side, took another five days off to accompany the invasion force across the veldt as far as Brandfort and the Vet river. He was impressed by the sight of 10,000 troops "rolling slowly like an irresistible lava stream over the plain." (Other sources put the figures much higher.) This time he did

come under fire, but, as at the hospital, he was too busy to be concerned. "My mind kept turning on other things," he wrote. "I was so annoyed at losing my haversack that for a time I forgot the shells while I bustled about looking for that haversack." Later he found a suitable replacement, beside the body of a dead Australian. It was full of chessmen, which he imagined were looted. With considerable effort, he and Langman slung the corpse over his horse and carried it for a couple of miles until they came across a convoy that would perform a decent burial. Arthur hung onto the haversack as a memento of war— an act of looting, however trivial, on his own part.

On his return to Bloemfontein he found letters from his wife and children in Italy. Mary had been attending a school in Naples and had visited historical sights such as Pompeii. She later recalled an incident that showed the strong feelings beneath her mother's normally implacable, accepting exterior. When there was a fireworks display in Naples, everyone at Gaiola went to watch, except Kingsley who had been sent to bed early as a punishment for some misdemeanor. As the rockets burst in the Mediterranean night, Mary noticed her mother crying. As she interpreted it, Louise was shedding tears because she realized how much the absent Kingsley would have enjoyed this display. Shortly afterward, as if to make up, Louise took her two children to the local aquarium where Kingsley's wide-eyed appreciation of the colorful fish made up for both his and her earlier disappointments.

Also awaiting Arthur were copies of his new book, *The Green Flag and Other Stories*, which had been published by Smith, Elder at the end of March. This gathered some of his more recent work, such as the Captain Sharkey tales and his favorite, "The Crime of the Brigadier." It was significant for its title story, a seven-year-old piece about the bravery of Irish soldiers in Sudan. Originally this was sheer anti–Land League propaganda (the Irishman at its center had joined the British army to get away from a family feud). Now Arthur was making a different point, saluting the bravery of the Irish troops fighting incongruously in South Africa for the British empire.

Without the army's presence, Bloemfontein reverted to being a sleepy provincial capital and, though typhoid was not yet eliminated, the Langman Hospital's workload considerably eased. At some stage Arthur organized a series of interhospital football games, though his own involvement proved short-lived after someone stuck a knee into his ribs. At last he was able to make significant progress in writing his history of the war, taking in the morale-boosting news of the relief of

Mafikeng on May 17, and Lord Roberts' entry into Johannesburg two weeks later. Before long the British were in Pretoria and the result of the war was no longer in doubt.

Shortly after this military success, Arthur took the time on June 5 to write to the *British Medical Journal* dampening down some of the heated claims that were being made about the performance of the medical services. His line was that there had been a very serious outbreak of typhoid, but everyone from the hospital staff to the patient soldiers had coped as best they could. His only proposal (apart from defending the private hospitals) was that the troops should be inoculated, as he had been, against this disease.

Largely because of his views on this subject, he found himself two weeks later making his way to newly liberated Pretoria. The last part of the journey (made with Major John Hanbury Williams, Milner's military secretary and intelligence chief, and Leo Amery, the chief correspondent of *The Times*), was tense, as he traveled on the first train after the railway had been ambushed by the Boers, who had now reverted to the guerrilla tactics that would prolong hostilities for nearly two years. In his memoirs he suggested that he had come to see for himself what was happening at the center of the campaign so as to gain material for his history of the war. But his main objective was to see Lord Roberts, who had been concerned about the furor that had been created in Britain by Burdett-Coutts's reports about the failures of the army medical services. In Pretoria Arthur had a brief, memorable interview with the Commander in Chief on this topic. He also discussed the conflict with local Boers, whom he liked but found poorly informed. Otherwise there were diversions such as a visit to a prison camp which had been freed only a few days earlier. Having explored a tunnel dug by some enterprising Hussar inmates, he was photographed emerging from it by *The Daily Telegraph*'s Bennett Burleigh. Later he inscribed copies with the words: "Getting out of a hole, like the British Empire." During a day in Johannesburg he took the opportunity to descend into another hole in the ground, this time a deep though temporarily inactive Robinson gold mine. Although he was given numerous tips about which mines would prosper after the war, he later noted that they were all wrong.

By July 4 he had returned to Bloemfontein and was preparing to leave. He convinced himself that he had done his duty. Indeed he told his mother that, what with his medical responsibilities and his history, there were few people in South Africa who had worked harder. A week

later he was on board the Union Castle liner *Briton*, traveling home from Cape Town with several aristocratic sightseers including the Dukes of Norfolk and Marlborough.

During the voyage Arthur made friends with a couple of journalists, Henry Nevinson, a radical Boer sympathizer from the *Daily Chronicle*, and Bertram Fletcher Robinson, a more conventional correspondent of the *Daily Express*. The latter, twelve years Arthur's junior, was a chip off the Conan Doyle block. A nephew of Sir John Robinson of the *Daily News* and Reform Club, he had worked at *Cassell's Family Magazine* with Max Pemberton, another staunch clubman, who described him as "an immense figure of a man, a magnificent Rugby forward and a fine rider to hounds." In 1897 he had taken over editing the Isthmian Library of sports from Pemberton and had since produced volumes on cycling, rowing, boxing, golf and skating, before coming to the attention of Cyril Pearson, another entrepreneurial magazine proprietor in the Newnes and Harmsworth mold who, not content with running his own eponymous *Magazine* and *Weekly*, had recently started his own newspaper, the *Daily Express*.

The voyage was enlivened by a contretemps with Roger Raoul-Duval, a French officer who had accompanied his ambassador on a mission to the Boers, and who raised Arthur's hackles by insisting that British forces had been using lethal dumdum bullets that expanded and did terrible damage on entering a body. Arthur told him he was talking rubbish, and refused to accept the Frenchman's apology because, he claimed, it was not he personally who had been traduced, but the entire British Army. Only Fletcher Robinson's intervention averted a more serious incident.

By late July Arthur was back in London. Stumbling through blood and feces in a makeshift ward on a Bloemfontein cricket pitch must have seemed like a distant nightmare. But Arthur had done something he wanted: he had tasted life on the front line and this gave him, at the mature age of forty-one, an important sense of masculine achievement. With a general election likely, and the issue of the army's performance in South Africa at the top of the political agenda, he now felt he had not only the experience but also the duty to become a Member of Parliament.

First he had to tidy up loose ends from the war. He had hardly stepped off the *Briton* before he was appearing as a witness in front of the independent South African Hospital Commission which had been requested by Lord Roberts. He took an emollient tone, subsequently denying that he had said, as *The Times* reported, "We had not beds or

utensils, and could not treat the patients properly." Then he had to finish the history he had started six months earlier on the ship to Cape Town. Here his approach was more uncompromising. In the main body of the book he attacked the authorities for underrating Boer determination and fighting qualities. Realizing that, despite the definitive-sounding title of his penultimate chapter, "The End of the War," the conflict was by no means over, he devoted his final few pages to a fiercely argued treatise on "Some Military Lessons of the War." His main conclusion was that the professional army should be smaller, and backed by a well drilled volunteer militia. For one of the points he drew from the Boers was that a determined citizenry was hard to beat. This observation led him to deduce that recent fears of an invasion of Britain had been overplayed. "A country of hedgerows would be the most terrible entanglement into which an army could wander." He was full of praise for the common soldier, but thought his training had been poor and outdated. It was not important to know how to march in step: "there is only one thing which wins a modern battle, and that is straight shooting." He had similar strictures about the cavalry: "lances, swords, and revolvers have only one place—the museum." He also had harsh words about the British artillery's reluctance to use cover and raised the delicate point of its far too frequent tendency to fire at its own troops, as at Talana Hill, Stormberg and Colenso. "Surely officers could be provided with a glass which would make it impossible to mistake Briton for Boer at so close a range," he sneered.

While putting the finishing touches to his book, he moved his family back into Undershaw. Mary was now eleven years old and beginning to notice what was going on around her. She later recalled Nelson's extraordinary Isola di Gaiola, which was situated off a promontory overlooking the Bay of Naples to the north side of the city, as "a huge rock split down one side and the sea came surging up and plunged through it," leaving spray running down the drawing-room windows. It was linked to the mainland by "the cage," a Heath Robinson–type contraption rigged up by Nelson's engineering genius—a stirrup-shaped seat that was hauled across a short stretch of water on a system of pulleys. The promontory was once the seat of the Augustan imperial villa, known from Pliny as Pausilypon (now Posillipo). Its antique Roman connections attracted many English residents, from the writer Norman Douglas (who became a good friend of Willie Hornung on his visits) to the Liberal politician Lord Rosebery, who owned the largest house on the coast. This fact did not

escape the attention of the wily Mary Doyle, who wrote to the Peer asking if Louise and her children could be allowed to visit his villa. He graciously agreed, adding forcefully that he owed "so much gratitude to Sherlock Holmes. . . . I only wish you could persuade Dr. Doyle to resuscitate his fascinating detective. After all his demise is only a matter of strong inference."

Although the history took precedence, Arthur did manage to steal away from home for a few cricket matches. One in which he played was a triumph. From August 23 and 25 he appeared in his first ever first-class game for the MCC against Dr. W.G. Grace's short-lived London County team at Crystal Palace. His opponents had risen out of a curious piece of late-Victorian private enterprise: two years earlier, the Crystal Palace Company had asked the aging Dr. Grace to set up a side that would bring first-class cricket to their extensive fields. As one doctor bowling to another, Arthur made the most of his opportunity by taking the wicket of fifty-two-year-old Grace, albeit off a skyer to the wicketkeeper after the batsman had made 112. As this was his only bowling success in ten first-class games between 1900 and 1907, he later celebrated it in a poem, "A Reminiscence of Cricket," beginning:

> Once in my heyday of cricket,
> Oh, day I shall ever recall!
> I captured that glorious wicket,
> The greatest, the grandest of all.

However, another game at which he was a mere spectator turned into a disaster. For he had fallen into the habit of using cricket as a cover to meet and, now that he was brimming with the testosterone of war, display the attractive young Jean Leckie. One day in August he took her to a match at Lord's where he had the misfortune to run into his cricket-loving brother-in-law Willie Hornung, who had been enjoying success with *Raffles: The Amateur Cracksman*, published the previous year. Feeling he ought to explain why he had been promenading with an unmarried woman, albeit one known to the family, he went round that evening to the Hornungs' house in Pitt Street, Kensington. Willie and Connie seemed to understand, and agreed to join him and Jean at Lord's the next day. But they did not turn up, either for lunch, as agreed, or for dinner. Connie pleaded a toothache, but Arthur was unconvinced and again traveled to Pitt Street, where he found Willie adopting a very different tone—carping and critical, as if he were a criminal barrister. When Willie was skeptical of his

brother-in-law's argument that his relationship with Jean was platonic, Arthur protested that this made all the difference between guilt and innocence.

Now it was Arthur's turn to feel offended. He waited a couple of days, expecting some letter of explanation, and when there was none, he poured out his heart to his mother, thanking her for her support, justifying his actions and painting Jean as the injured party. When Mary Doyle now wrote to console her son, he replied, "It is sweet to me to think of J. with your sweet motherly arms around her. The dear soul gets these fits of depression (it is her artistic nature) and then her remorse is terrible and she writes, poor soul, as if she had done some awful thing. I never love her more than at such moments. Dearest, I don't know how to thank you for all your goodness to us." But Connie, the only one of her generation of Doyles to retain her Roman Catholic religion, remained more uncompromising in her attitudes.

By then the Conservative Prime Minister, Lord Salisbury, had called a general election (the so-called "khaki election" because so many of his MPs were away fighting in South Africa). He was taking advantage of successes in the war that had left the Liberal Party in disarray. He also wanted to show the Boers that Britain was resolute and that they could not look forward to sympathy from the less confrontational Liberals for at least seven years (at the time, the length of a parliament). Arthur had already been offered the chance to fight Dundee for the confusingly named Liberal Unionist Party (in fact, staunch allies of the government). But he had balked at that, describing the city in pejorative terms. Even now he was wary of the committee work and the curtailment of freedom that would come from being an MP. Nevertheless, he calculated that he was the right age to take on that role (and might be too old by the next election) and, with assets of up to 30,000 pounds and income, even when not working, of 2,000 to 3,000 pounds, he could afford the expense. So he was happy when, on September 24, he was adopted for the Edinburgh Central constituency, in the heart of the city where he had been born.

He had timed "Some Military Lessons of the War" to a Tee. It came out at the end of September in the *Cornhill Magazine* (owned by Smith, Elder who published his history, *The Great Boer War*, a few days later). It created a certain amount of controversy (both for and against his views) and added kudos to his candidacy. However, the conflict in South Africa did not appeal to the electors of Edinburgh Central, who were more concerned about local issues. Despite the support of several eminent citizens, including his old teacher Professor Joseph

Bell, Arthur could not dislodge his Liberal rival, George Mackenzie Brown, who ironically was the managing trustee of the Thomas Nelson publishing company. This was odd, since the Conservatives and Liberal Unionists recorded a thumping majority of 134 across the nation. Arthur believed that the reason for his relatively poor showing was that the night before the polls three hundred posters had been put up, denouncing him as a Papist conspirator intent on destroying the Scottish Kirk and Covenant. Back at the Reform Club on October 13 Arthur fired off a letter to *The Scotsman* denying these charges. He said he had not been a Roman Catholic since his schooldays. "For more than twenty years my strongest convictions have been in favor of complete liberty of conscience, and I regard hard-and-fast dogma of every kind as an unjustifiable and essentially irreligious thing putting assertion in the place of reason, and giving rise to more contention, bitterness, and want of charity than any other influence in human affairs." He claimed that the only place of worship he attended was the Theistic church, led by the Reverend Charles Voysey, in Swallow Street, off London's Piccadilly.

Arthur's views did at least bring him to the attention of Winston Churchill, who had made a name for himself with his own accounts of the war, particularly of his own feat in escaping from the Boers, and who had recently been reelected as the Unionist MP for Oldham. The two men found themselves talking at the same event at the Pall Mall Club at the end of October, after which Churchill sought Arthur out to chair his talk on "The War as I saw it" at the St. James's Hall on November 5.

By then Arthur was well ensconced back at Undershaw, where he still smarted from his contretemps with Connie and Willie Hornung earlier in the summer. Though he swallowed his pride and wrote his sister a conciliatory letter, he insisted to his mother that "I do and must feel hurt. And I don't feel better by contemplating the fact that William is half Mongol half Slav, or whatever the mixture is." Always willing to do his family duty, he put up money for his brother-in-law Cyril Angell to become a partner in Hindhead School, a local preparatory school run by Edward Turle and attended by, *inter alia*, his friend Philip Trevor's son. But despite Arthur's efforts—for example, he put Turle together with the educational agent Gabbitas Thring, who drew up a prospectus—the arrangement did not work out and a couple of years later Cyril returned to being a parish priest in Victoria Park, northeast London.

As the winter of 1900 approached, Arthur busied himself with his

new project—the formation of an armed militia. After negotiating with a newly emollient Louisa Tyndall for access to a piece of her land, he set up the Undershaw Rifle Club with three ranges of fifty, seventy-five and a hundred yards and invited local men to come there two days a week to improve their shooting skills. He boasted that in a couple of years there would "not be a carter, cabman, peasant, or shop-boy in the place who will not be a marksman." The *bien-pensants* of the Surrey Alps were less supportive than usual, but Arthur did win the backing of one neighbor, Bernard Hamilton, a self-obsessed former boulevardier-turned-writer who liked to waylay people with his views on politics and religion.

Hamilton was devoted to Arthur, dedicating his 1899 novel *A Kiss for a Kingdom*, a bizarre anti-Catholic fantasy about an American millionaire who tries to become king of San Marino, "To a Great Nature and a Great Writer, ARTHUR CONAN DOYLE, In token of sincere regard." Hamilton shared his friend's interest in occult philosophy, particularly theosophy, which occupied him rather more than it did Arthur at this stage. He described visiting Undershaw on one occasion when Arthur was finishing off his Boer War history—all beautifully written, Hamilton noted, in the clear hand that would later win him plaudits from George Newnes as "the printer's friend." It was raining and the two men played billiards. In Arthur's study, Hamilton picked up an edition of Blake's drawings and claimed he had had similar visions. Arthur was doubtless concentrating on his cue, for he demurred with the words, "Well, after all, 'one world at a time.' " Hamilton claimed this as a quotation from a play by Arthur's friend Israel Zangwill. But Arthur's source was almost certainly the American writer Henry David Thoreau, who answered thus when asked if he was ready for the next world. Hamilton later adopted the phrase as the title of a book he wrote attacking Arthur's spiritualist beliefs after, perhaps inevitably, the two men fell out.

For the time being, however, Hamilton could not have been more supportive of his friend. As journalists such as John St. Loe Strachey, editor of *The Spectator*, thronged to Hindhead in the new year of 1901 to view the rifle club, Hamilton arranged for the distinguished lawyer and local resident Sir Frederick Pollock to present the war chronicler of Undershaw with a silver rose bowl inscribed "Arthur Conan Doyle, who at a great crisis—in word and in deed—served his country." Plaudits were coming from all sides: on the previous day (March 8) he was elected to the Athenaeum Club, having been proposed by George Buckle, James Payn's son-in-law and editor of *The Times*. This was a

statement of intent: the Athenaeum was much more of an establish-
ment club than the Reform, with its breezy radical tradition. Indeed,
only a few months earlier Arthur had had to respond to a whispering
campaign that he should have resigned from the Reform when he
became a Unionist parliamentary candidate. Now he was making his
way in distinctly Tory circles. Within a short time he had been invited
to the Athenaeum by his new friend Winston Churchill, who also
asked him to join him at the House of Commons for a gathering of the
Hughligans, a select group which took its name from Lord Hugh
Cecil, the scholarly, firmly Anglican youngest son of the Prime Minis-
ter, Lord Salisbury.

 In the middle of this, over the weekend of March 16 and 17, Arthur
took a short early spring break at the Ashdown Forest Hotel, on the
edge of the Weald in Forest Row, Sussex. From there he wrote in
ebullient mood to Bernard Hamilton on a sheet of paper bearing the
hotel's telegraphic address "Romantic Forest Row," telling his friend he
was "en retraite" with his mother. The reason for his high spirits only
became clear a century later, with the publication of the 1901 census.
This showed that he was lodging at the hotel with not just his mother
but also Jean Leckie, whose parents had a country house not far away
in Crowborough. This jolly threesome was no doubt fully aware of the
significance of the date, which was as near as Arthur could get to the
fourth anniversary of his first meaningful liaison with his mistress.
Meanwhile Louise was far away, staying with her mother at a boarding-
house in Torquay, while the two children were being looked after by
her sister Nem at Undershaw.

The Hound of the Baskervilles
to Louise's Death

1901–1906

Arthur was increasingly determined to escape the demands of domesticity in Hindhead. Six weeks after his return from his anniversary retreat with Jean and his mother in the Ashdown Forest, he embarked on another short holiday. This time his companion was Bertram Fletcher Robinson, the genial younger journalist he had met on the voyage home from South Africa. They stayed at the Royal Links Hotel on a windswept promontory overlooking the North Sea at Cromer in Norfolk.

When not playing golf, Robinson grabbed Arthur's attention with an account of the legend of a gigantic hound that had terrorized the inhabitants of Dartmoor, southern England's largest open space, which was close to his family seat at Ipplepen in Devon. After his recent experiences of the veldt, Arthur was familiar with the eerie effect of vast, inhospitable tracts. Before even leaving Cromer, he had informed his mother of his intention to write a creeper called *The Hound of the Baskervilles*, with his new friend. He fired off a letter at the same time to Greenhough Smith, inquiring if the *Strand Magazine* would be interested in this story of not less than 40,000 words. However he stipulated that, though it would be in his style, it would have to be run under the joint names of himself and Robinson, who had given him the idea and local color.

The *Strand* was publishing some of his output at the time. Showing his enduring fascination with delinquent behavior, he had retold three real-life crime tales from the early 1860s that appeared as part of a series

"Strange Studies from Life" (again illustrated by Sidney Paget) in the magazine's March, April and May issues. (The last had just been published when he arrived in Cromer for the weekend of April 27–28, 1901.) The first, extravagantly titled "The Holocaust of Manor Place," told of a multiple murder in Walworth by a man who hoped to defraud an insurance company. The second, "The Love Affair of George Vincent Parker," was about a young man in the Midlands who murdered his girlfriend after she had turned her affections elsewhere. Although sentenced to hang, Parker (actually George Victor Townley) was found insane and sent to an asylum. The third, "The Debatable Case of Mrs. Emsley," looked back on the murder of a wealthy widow in the East End of London. But Arthur became dissatisfied with these stories and called a halt to their publication after receiving letters of complaint from the families of those involved. Robinson now gave him a way out by suggesting an idea for a return to fiction, in comparison with which real-life crime seemed banal. As Arthur had written, the crime in "The Love Affair of George Vincent Parker" was "characterized by all that inconsequence and grim artlessness which distinguish fact from fiction."

So Arthur was happy to let the idea of his new joint book develop over the month of May. Since a strong central character was required, Arthur began wondering if he should not use Sherlock Holmes. Greenhough Smith cannot have been too unreceptive, as he had a canny sense of the publicity that would be generated by the detective's return, and Arthur saw the sense too, as publication of his story would coincide with the arrival of Gillette's Sherlock Holmes play in London. Greenhough Smith was not happy about the idea of joint authorship with the relatively unknown Robinson, however, and although the *Express* man had a track record as a journalist and would later write his own detective stories, he found himself being sidelined as a collaborator, though in the end he was not treated too shabbily: because the *Strand* was taking all rights, Arthur was able to negotiate a fee of an unprecedented 100 pounds per thousand words, out of which Robinson reportedly took a third. Arthur's bank account book does indeed show him paying Robinson over 500 pounds in the latter half of 1901, but subsequent payments were more sporadic.

As recently as December Arthur had declared in the hundredth issue of the *Strand*'s downmarket sister paper *Tit-Bits* that, although he had never regretted killing Holmes, he had not closed the door on his revival and, luckily, there was "no limit to the number of papers he left behind or the reminiscences in the brain of his biographer." He was probably beginning to chafe at the number of Holmes's imitators: not

just Willie Hornung's Raffles, but a range of fictional detectives seeking to usurp his own creation, including Arthur Morrison's Martin Hewitt in the *Strand*, Guy Boothby's sinister Dr. Nikola in the *Windsor Magazine*, and Cutcliffe Hyne's Captain Kettle in *Pearson's Magazine*. So it was no surprise when, on May 25, 1901, *Tit-Bits* ran an exclusive story reporting the imminent return of Sherlock Holmes.

Arthur was already well advanced with his project. On June 1 he claimed to be almost halfway through his story. By then he and Robinson were in Devon, staying the weekend at Rowe's Duchy Hotel in Princetown in the center of Dartmoor, from where he sent his mother an upbeat report: "Robinson and I are exploring the Moor over our Sherlock Holmes book. . . . Holmes is at his very best, and it is a highly dramatic idea—which I owe to Robinson. We did 14 miles over the Moor today and we are now pleasantly weary. It is a great place, very sad & wild, dotted with the dwellings of prehistoric man, strange monoliths and huts and graves. In those old days there was evidently a population of very many thousands here & now you may walk all day and never see one human being."

Arthur knew the area from working with George Budd in Plymouth two decades earlier. So he only needed to refresh his memory and add a few pieces of local color to his hazy generic concept of a treacherous moor. A visit by the governor and three staff members from nearby Dartmoor prison no doubt contributed some detail to the story of the escaped prisoner. (Touchingly, the four of them had come, their pencil note explained, to "call on Mr. Sherlock Holmes.") Robinson took Arthur to see the "mighty bog," Fox Tor Mire, or Grimpen Mire in the story. But so keen was Arthur to convey a sense of desolation that he ignored the presence of disused tin mines along the way. The two men also went to the Robinson family house, Park Hall, where they met the coachman, Harry (or Henry) Baskerville, who later liked to produce a copy of *The Hound of the Baskervilles*, with a personal inscription from Robinson and the words "with apologies for using the name."

This was the title of Arthur's tale, which mixes a conventional Sherlock Holmes investigation into the death of the hereditary owner of Baskerville Hall on Dartmoor with a more sinister fantasy about a terrifying spectral hound. The contrast between the modern rational detective and deeper archetypal forces is spelled out more clearly than usual. If, by telling Bernard Hamilton he was taking on "one world at a time," Arthur meant he was focusing on temporal rather than spiritual matters, he could not quell the emotions that churned below his

waking mind, giving rise to such dark imaginings as a monstrous dog.

The workings of the subconscious were a closed book to him, however. He could accept the idea of the subliminal mind, a psychologically sophisticated version of the soul, as developed by his late lamented friend Frederic Myers, who had died in Rome earlier in the year from Bright's disease. But Arthur could not make the leap to more radical concepts emanating from Vienna, where Sigmund Freud, another member of the Society for Psychical Research, had just published his first papers on the interpretation of dreams. This was the direction science was going; the mind was the latest territory for nineteenth-century rationalism to conquer. But Arthur had taken his scientific dabblings far enough with forensics and other investigative techniques. He did not want either himself or his supposedly logical detective Sherlock Holmes delving too deep into the irrational mind.

So *The Hound of the Baskervilles* remains an anachronism, full of Victorian novelistic devices, such as a hereditary curse and a rash of mistaken identities, as well as stock Victorian figures, including a doctor interested in craniology and a naturalist with his butterfly collection. (The original dates of the real-life crime stories had probably been an influence.) Holmes still represents the spirit of scientific reason, declaring, "An investigator needs facts, and not legends or rumours." But he is nothing if not ingenious, calling on an unholy trinity of anthropometrics, genetics and spiritual science to uncover the villainous Stapleton as the scion of a cadet branch of the Baskervilles. "A study of family portraits is enough to convert a fellow to the doctrine of reincarnation," the detective observes wryly.

As in other Holmes stories, a dog featured prominently, with "the footprints of a gigantic hound" being treated as evidence of the canine killers of the Baskerville family. This idea drew on a ubiquitous myth of satanic hounds that had its Devon version in the legend reported by Sabine Baring-Gould in *A Book of the West* a couple of years earlier: "There existed formerly a belief on Dartmoor that it was hunted over at night in storm by a black sportsman, with black fire-eating hounds, called the 'Wish Hounds.' " Similar stories were found elsewhere in Britain, so it is no surprise that other sources of inspiration have been suggested—for example, around Hereford, where, on one of the properties, Louise Conan Doyle's family, the Hawkinses, had a neighbor called Baskerville.

As usual Arthur peppered his tale with personal snippets. The Yew Alley at Baskerville Hall corresponded with a similar feature at Stony-

hurst. James Desmond, Sir Henry Baskerville's heir, was a clergyman in Westmorland, close to where Arthur's brother-in-law, Cyril Angell, had been a curate. According to Dr. Mortimer, Sir Charles Baskerville had brought back scientific information from South Africa (where Arthur had recently been) and liked to discuss the comparative anatomies of the Bushman and the Hottentot.

Arthur's haphazard method of choosing names was evident in the Stapletons' original surname, Vandeleur, which drew on the respected African explorer and Irish Guardsman Lieutenant-Colonel Cecil Vandeleur who, after injuries in South Africa, would return to the field and meet his death, as noted in a later edition of *The Great Boer War*, in a train ambush on August 31, 1901. The London pet shop Ross and Mangles also betrayed Arthur's military interests, looking back to Ross Lewis Mangles, who won a Victoria Cross in the Indian Mutiny, one of only five civilians ever to receive that award.

Jean's presence was hinted at in the detail of Devonian matrimonial problems, with Stapleton claiming to be a bachelor and offering to wed Mrs. Lyons, who wanted a way out of her unhappy marriage, while himself pushing forward his wife (who was passing as his sister) as sexual bait for Sir Charles Baskerville. Like the wild black feline in Arthur's 1898 story "The Brazilian Cat," the hound was a symbol of the unruly passions disturbing the outward equanimity of Arthur's life.

Arthur did not stay long on Dartmoor, for on June 3 he was due in Sherborne, Dorset, for the start of a tour of the West Country with the Incogniti cricket club. A steady stream of games followed over the summer, including a return match with the London County XI at Lord's where the opposing captain, W.G. Grace, obtained revenge by capturing his wicket. While in London Arthur seldom now stayed at either the Reform or the Athenaeum Club, preferring a hotel around Trafalgar Square (the Golden Cross, the Grand and Morley's were his favorites, any of which could have been the model for the Northumberland Hotel in his book). One obvious reason was that this allowed him to see more of Jean Leckie, who was sharing rooms in town with two friends. In July her singing career had taken a step forward when she won a bronze medal as a vocalist in the London Academy of Music's public examination (her friend Lily Loder-Symonds was awarded a silver medal for her harp-playing). In between cricket games Arthur managed to take time off at the Esplanade Hotel in Southsea (probably with his family), but when he went to Norwich to play for the MCC against Norfolk in August, Jean Leckie was staying not far away at the Marlborough Hotel in Southwold.

Despite this full schedule, which explains some of the story's inconsistencies, Arthur found time to complete *The Hound of the Baskervilles* which, with Sidney Paget's illustrations, began serialization in the *Strand Magazine* in August. This proved a great success, running through to the following April, after a book edition of 25,000 copies had been published by Newnes.

As envisaged, Gillette's version of Sherlock Holmes arrived at the Lyceum Theatre in London on September 9. The critics were sniffy, but audiences loved it and, before the end of November the play's run had been extended. For Christmas Gillette sent Arthur an illustrated card that read, "Mr. Sherlock Holmes at the Lyceum Theatre, London, presents his Compliments and the Best Wishes of the Season." He added a personal message, "Did you ever imagine that Sherlock Holmes would be sending his compliments to his maker! Good wishes, dear Doyle." Arthur had his own way of marking an eventful year with his festive card featuring a picture of "Derby the Devil," the bulldog he had been given by Jerome.

Shortly after Gillette's play opened in London, Arthur enjoyed his own moment on stage at the Royal Albert Hall. On 14 September he was a judge of a much publicized competition to find the man with the world's best physique. This event had been arranged by thirty-four-year-old German-born Eugen Sandow, a self-publicist who had skilfully engineered his rise from circus muscle man in the late 1880s to respected advocate of "physical culture," a patented regime of bodybuilding and healthy living that chimed with turn-of-the-century needs. Not content with merely setting up his own school, he also published *Sandow's Magazine* as part of a mission to improve Britain's manliness and strength.

Arthur had declined to submit a story to *Sandow's Magazine* three years earlier, but he was an enthusiastic supporter of the strong man's regime, which he had adopted on November 16, 1898, when, as faithfully recorded in his diary, his weight in trousers and undershirt was 219 pounds.

Although fighting was still going on in South Africa at the time of the Albert Hall competition, Britain's lackluster military performance had already been widely attributed to the poor physical shape of her troops, and there had been a clamor for some sort of improvement. Ever the showman, Sandow seized on the opportunity to stage a colorful spectacle with prizes worth 1,000 pounds. At the start, twenty spotlights picked out a troupe of boys from the London Orphan Asylum

going through a series of precision routines. After further displays of fencing, gymnastics and both Greco-Roman and Cumberland wrestling, the band of the Irish Guards played "The March of the Athletes," said to have been composed by Sandow, but widely believed to be the work of his close companion, the Dutch musician Martinus Sieveking. Then the contestants marched into the hall, dressed in black tights, black jockey belts and leopard skins. Arthur, Sandow and another judge whittled their number down to ten, before picking the winner, William Murray of Nottingham, who was given what was said to be a solid gold statue of Sandow, later discovered to be bronze with a thin gold plating. At least the Lord Mayor's Transvaal War Fund benefited to the tune of 435 pounds 1 shilling sixpence from this camp extravaganza.

As the lessons of the Boer War were assimilated, the event's militaristic tone would become a more regular feature of British life. The year 1902 would see the founding of the National Service League, which lobbied for conscription. While Arthur, with his Liberal instincts, did not believe in any form of compulsion, he had already committed himself to the idea of a reformed citizen army with his enthusiastic backing for rifle clubs, and he would later be identified with organizations such as the Legion of Frontiersmen and the Boy Scouts. The Legion promoted, albeit in greater earnest, the frontier spirit that had sparked young Arthur's imagination through the books of authors such as Captain Mayne Reid. The Scouts, interestingly, were to look to Arthur as much for inspiration as support. Their founder Robert Baden-Powell's original Boer War manual *Aids to Scouting for NCOs and Men*, published in 1901, had noted approvingly the observation skills of both Sherlock Holmes and Dr. Joseph Bell. His subsequent *Scouting for Boys* (1908) recommended the *Adventures* and *Memoirs* of Sherlock Holmes as aids to tracking and woodcraft, as well as *The White Company* for its insights into chivalry. Sherlock Holmes became something of a literary mentor to the Scouts, encouraging them to use their deductive powers by looking for clues and exercising their visual imagination. It was similar to police work, as Baden-Powell acknowledged when he included *Criminal Investigation*, the first English translation of the Austrian jurist Dr. Hans Gross's *Handbuch für Untersuchungsrichter als System der Kriminalistik* (handbook for examining magistrates in the system of criminology) on the reading list in *Scouting for Boys*.

Meanwhile Arthur busied himself with another salvo about the Boer War. He had already written his prescription for a new army. But

he felt that Britain had been failing in her efforts to justify her ongoing campaign in South Africa to the wider world. Traveling to London by train one day, he snapped as he read yet another report denigrating the British war effort. (He was particularly incensed by the political capital made by the Liberal Party and others out of Emily Hobhouse's reports on the treatment of Boer women and children in refugee— later termed "concentration"—camps.) So he decided to pen a riposte—something, as he put it, that a German editor could absorb in an hour. He recalled how at dinner that very evening he happened to sit next to Eric Barrington, Private Secretary to the new Foreign Secretary, Lord Lansdowne, who offered to help him not only with money but also with access to official sources. According to Arthur's memoirs, this encounter took place at one of the surgeon Sir Henry Thompson's famous "octave dinners," a superior form of networking where eight well-connected guests (often including royalty) consumed eight courses during the course of a meal that started at eight o'clock.

Arthur gave the date of this dinner as January 7, 1902, which may well have been correct. But by then he had already finished his 60,000-word pamphlet called *The War in South Africa: Its Cause and Conduct*—an idea he had first proposed on November 20 to the supportive Reginald Smith at Smith, Elder who had agreed to underwrite the production costs. Arthur had written furiously and completed his text four weeks later. At this stage he probably began to seek some official backing. For shortly after Christmas he complained to Smith that the War Office was dragging its feet and he went to London to lobby Lieutenant-Colonel Edward Altham, head of Section B of the War Office's Intelligence Department, who had served in South Africa. In a letter received by Smith on January 4 Arthur referred to the final proofs, and twelve days later 250,000 copies of his sixpenny pamphlet were published. Since the date coincided with the State Opening of Parliament, Arthur feared that the public's attentions would be diverted. But this was not the case: he reported delightedly how the vendors at London Bridge and Charing Cross had sold out and were clamoring for more. As for the leading bookseller W.H. Smith, he always thought its order was too low.

Official involvement allowed Arthur to be more ambitious than expected in his plans for the pamphlet. He told *The Times* that, although he and his publisher had given their services for free, he now wanted to translate his work into several different languages and distribute it to every parliamentarian and every newspaper in Europe and the United States. Funds immediately began flowing in, mainly small

sums from the man in the street (on one day he received 129 pounds in 120 letters), but also 50 pounds from Lord Rosebery, and a hefty 500 pounds, which both Arthur and Smith were led to believe came from the new King Edward VII and which they thus agreed would be identified on any list of donors only as a gift from "a loyal citizen." In fact this sum came directly from the secret vote which funded the British intelligence services. Not that this connection harmed the publication: by the end of March *The War in South Africa: Its Cause and Conduct* had gone through sixteen editions, including one in Welsh.

Arthur had sat next to the King at a dinner the previous March, shortly after the death of Queen Victoria. He described him as "an able, clearheaded, positive man, rather inclined to be noisy, very alert and energetic. He won't be a dummy king. He will live to be 70, I should say." (His estimate was not far off. Edward VII was in fact sixty-eight when he died in May 1910.)

In the spring of 1902 the combination of his Boer War history, his propaganda work and a mysterious air of royal patronage led to speculation that Arthur was about to be offered a formal title, probably a knighthood. In many respects, such recognition would be the fulfillment of all he had striven for. (Revealingly, when he had recently told his mother how his pamphlet had led to invitations to dinner with political luminaries like Joseph Chamberlain and Lord Rosebery, he had quoted Burns, "So far I've clambered up the Brae.") But he knew that other authors such as Rudyard Kipling had turned down honors as unbefitting to members of their profession. From Masongill Mary Doyle counseled him to do the decent thing and accept. But he remained uncertain, arguing that the only title he valued was that of "Doctor."

His uncharacteristic indecision was a symptom of continuing emotional turmoil in his personal life. When his own physician told him he was run-down and suggested he take a holiday, he jumped at the opportunity to spend some time on his own with the Nelson Foleys in Italy. Before departing he pressed Greenhough Smith to decide about publishing "The Leather Funnel," a creepy tale that showed his continuing taste for the paranormal. It centered on Lionel Dacre, a Paris-based collector of occult literature and artifacts, and dealt with psychometry—the idea that sensitive individuals can recall an object's history by touching it. The narrator's contact with Dacre's leather funnel gives him disturbing dreams of a woman being badly treated. It emerges that she was the Marquise de Brinvilliers, a notorious seventeenth-century French murderess, and he was reliving her experience

of being subjected to the "extraordinary question," a form of torture that involved having sixteen pints of water forced down her throat.

This story touches on several areas of Arthur's life. In its exploration of the supernatural it advances a thesis that had long intrigued Arthur: "The charlatan is always the pioneer. From the astrologer came the astronomer, from the alchemist the chemist, from the mesmerist the experimental psychologist. The quack of yesterday is the professor of tomorrow." In its detail, Dacre had a large house on the Avenue de Wagram where Arthur's uncle Michael Conan once lived. He has been compared with the real-life magician Aleister Crowley, a member of the Hermetic Order of the Golden Dawn, but there is no evidence that Arthur knew him. More likely, Dacre was an imaginative literary composite drawn from the central characters in J.K. Huysmans' novels *A Rebours* and *Là-Bas*, the first of whom was reclusive and decadent, the latter an avowed satanist. Three years earlier Arthur had described himself as feeling unclean after reading *Là-Bas*. He told Edmund Gosse that, as a result, he was fed up with French literature and could not accept his commission to write on Alexandre Dumas. That did not mean he did not read Dumas, who had published a study of the Marquise de Brinvilliers, while, coincidentally, Aleister Crowley described Durtal, the protagonist in *Là-Bas*, as a remarkably prophetic portrait of himself. This all suggests that "The Leather Funnel" had been kept on one side from the *Round the Fire* tales Arthur was writing in 1899. Now, keen to be rid of this story before leaving for Italy, he urged Greenhough Smith to pay 200 pounds for it.

When Arthur sailed from Tilbury on April 10, Jean Leckie did not have to hide in the background as when he had embarked for South Africa. She came brazenly on board the RMS *Austral* to plump up his pillows and kiss him goodbye. Once he reached the Isola di Gaiola, he and the English writer Norman Douglas, who lived nearby, visited Lord Rosebery for tea at Posillipo. Douglas had been at school at Uppingham with Willie Hornung, and although nominally married, he was a hedonistic pedophile who had helped gain the area a reputation for sexual (particularly homosexual) licence. This had attracted a visit from Oscar Wilde four years earlier and had added to the whispering campaign that Rosebery was gay. But this idea, which had ramifications for the court case that led to Wilde's downfall, has been rejected by the Liberal peer's latest biographer, Leo McKinstry. Arthur simply got on well with Rosebery, telling his mother about another occasion when he went to Posillipo. Rosebery was out but, Arthur

reported with schoolboyish enthusiasm, the peer had returned his call, despite being about to set sail for Sardinia on his yacht.

Only a month earlier he had exchanged letters with Rosebery, who had been reading *The Hound of the Baskervilles*. Arthur reassured him that he had been all over Dartmoor: "It is only a morass in fine weather but it all quivers like jelly and you feel that if you stamped hard the outer skin would burst and you would go through into some horrible abyss. In evil weather it is, I fancy, quite impassable." He concluded, "I am glad the hound amused you. It is its best justification." One reason for Rosebery's interest was the tradition of a baying hound at Barnbougle Castle on his Dalmeny estate on the Firth of Forth—a myth Arthur might have vaguely recalled from his Edinburgh days.

After a short sortie to Sicily with his sister Ida, Arthur took a leisurely route home, via Venice, the Italian Lakes and Switzerland. His return coincided with the end of the Boer War at the Peace of Vereeniging on May 31, 1902. Now that he was refreshed, he was ready to accept the knighthood that was officially offered to him as part of Edward VII's Coronation honors list for services rendered in the South African war. He had less problem with another part of the package—his appointment to the largely ceremonial post of Deputy Lieutenant of Surrey, which gave him the thrill of being able to dress up in a uniform largely of his own choosing.

The King's enthronement was in fact postponed because he had an attack of appendicitis. During his convalescence, he read "a great many novels and thought them all very poor, especially Conan Doyle's Hound of the Baskervilles." But his opinion of Arthur's novelistic talents did not hold him back from investing the author at Buckingham Palace on October 24. And he was appreciative of Arthur as a playwright, for the following month he invited Sir Henry Irving to perform his version of *Waterloo* for the visiting German Kaiser Wilhelm at Sandringham. Admittedly Irving had made this piece his own. Indeed, having bought the rights off Arthur for 100 pounds in 1892, he felt embarrassed and sent Arthur a guinea every time he played the part. Arthur thanked him but told him not to worry: "I made my bargain all right, and if things have turned out better than I for one expected it is your work which has made them so."

After a summer on the cricket pitch, Arthur's main writing project was his new series of *Brigadier Gerard* stories. As he conjured up the Frenchman's exploits on foreign fields, he may have been thinking of

Innes who, although initially posted to India, had seen service in China in the aftermath of the Boxer Rebellion, and, more recently, in South Africa. On November 22 Innes returned home after more than three years away, and Arthur was on hand at Waterloo station, with his mother and Connie, to welcome his brother off the boat train from Southampton.

After Innes had insisted on spending a few contemplative minutes in Westminster Abbey, the Doyles took a late-afternoon train back to Haslemere, where they found a band playing "Home Sweet Home." They traveled by carriage up the hill to Hindhead, where they were greeted by an enthusiastic crowd of about fifty people who removed the horses and pulled them manually the last few yards to Undershaw, which had been decorated with fairy lamps and Chinese lanterns. There was no mistaking the instigator of this festivity. It was Arthur's tribute to a brother who had been at the sharp end of fighting. He had insisted on his mother being present, even though she had not been well.

Arthur's ability to turn out the locals reflected his new status as Knight of the Realm, Deputy Lieutenant of the county and founder of the rifle club (which now boasted 300 members). And there was another factor, noted by Flora Thompson, later author of the bucolic memoir *Lark Rise to Candleford*, but then a young sub-postmistress in nearby Grayshott: Arthur was actually liked. "Scarcely a day passed without his bursting like a breeze into the post office, almost filling it with his fine presence and the deep tones of his jovial voice. As he went about the village he had a kindly greeting for all. . . . He was probably the most popular man in the neighbourhood."

A similar if more critical impression emerges from his daughter Mary's description of him inside the house at Undershaw. Now nearly fourteen and very observant, she later recalled him as "a huge, kindly presence, only occasionally seen and rather awe-inspiring." But that was not the whole story, for she added, "At that time he was driven and harassed for my mother was very ill, so we two children . . . lived a quiet nursery routine rendered happy by that magic alchemy of make-believe by which children live in a world of their own." In this sheltered environment Mary's imagination had been given rein. When, four years earlier, she had written a lively account of being lifted to a Sunday School version of the Elysian Fields after putting up her umbrella in a storm at Undershaw, Arthur was so impressed that he had it published as "A Visit to Heven" in a limited edition by Constable in Edinburgh, complete with spelling mistakes.

At that time Mary attended a primary school in Hindhead run by a Miss Gruner, a little thick-spectacled old German woman who was described by Frances Partridge, a later pupil, as "guttural of speech and fiery-tempered," though when in a good mood she would tell spectacular stories about being chased by wolves through the snow in east Germany. Arthur seems to have been equivocal about her influence for he adopted her name for the villainous Baron Adelbert Gruner in his later story "The Illustrious Client."

By 1902 Mary had moved (as a boarder) to Priors Field, a small, new girls' school housed in a Charles Voysey–designed building and set in leafy countryside west of Godalming. The founding headmistress was Julia Huxley, granddaughter of Thomas Arnold, daughter-in-law of Thomas Huxley, and mother of Aldous Huxley, whose high academic standards had attracted pupils such as Rosalind Murray, daughter of Professor Gilbert Murray, and Enid Bagnold, the future playwright. Meanwhile Mary's brother Kingsley attended a nearby prep school, Sandroyd (not Turle's), before going to Eton in the autumn of 1906.

As she grew older Mary began to enjoy living in the countryside. She loved it when her father allowed her to caddy for him at Hankley, as this involved a five-mile ride in the dog cart. Mindful of his Stonyhurst days, he was keen to cultivate a sense of freedom and thus self-reliance in his children, who were encouraged to discard their shoes and get mud on their feet. Mary would wander over the top of the hill to her friend Winifred, daughter of the auctioneer and ardent positivist Rayner Storr, at whose house overlooking the Devil's Punchbowl she played cricket (and at one stage hoped to start a women's team). The only rule was that she and Kingsley had to be at home, clean and tidy, in time for meals.

Her father seemed to prefer them out of the house, because when they sat down to eat, he liked to hide himself behind his newspaper and then scurry off as soon as he had finished. Mary recalled how on one painful occasion she was rash enough to mention her rabbits at lunch. Arthur's face "emerge[d] from behind the 'Times,' black as a thunder cloud. The words withered away on my lips with an appalled silence. It was evidently not the thing to talk about new born rabbits at meal time." He took an austere attitude toward his food, which was certainly not something to be fussed over or enjoyed, as Mary learned when she and her brother put aside some Yorkshire pudding, intending to eat it on its own at the end because they particularly liked it. Arthur ordered the maid to "take the children's plates away," leaving Mary to comment, "He never could abide long meals, and was himself a very quick eater."

Arthur had a hot temper, though it soon subsided, as Mary captured in her account of the evening she was asked to walk up to the Lodge to tell Holden what time to prepare the carriage. Later, she could not sleep, as she was afraid she had not conveyed the correct information. Sure enough, she heard her father bounding up the stairs. He "had a most unusually light step for so powerful a man. The light switched on and a furious giant filled the doorway. I had given the wrong time with dire results—and I got what was coming to me. The next minute the door had closed and he was gone. The effect on me was of Wotan arriving in black clouds of wrath. Next day all was sunny and normal. His anger was over in an instant, and he never bore a grudge against any one."

Arthur's moods reflected the specter that Louise's chronic illness cast over the household. Although he acted the perfect squire to the outside world, he could not avoid seeing Undershaw, like Tennison Road, as her sickly domain. Moved by the concerns of Willie Hornung and others, he did his best to include her in family outings, such as a visit to London for the Coronation, when he made a point of getting a front room at Morley's Hotel so she could have a good view of the King's procession through Trafalgar Square. But as his absences from home became longer, Louise increasingly surrounded herself with her close Hawkins relations. Her mother Emily moved into The Cottage, on the main road, near the Grayshott junction, while her sister Nem became a frequent visitor and, despite her growing addiction to chlorodyne, proved particularly good at looking after the children.

Mary's reminiscences were written after Louise had died and her father had remarried. So there is a sense in which she needed to protect her mother's memory against a usurper. Consequently the invalid comes across as an ethereal figure imbued with a quiet pride and almost superhuman courage. Once, for example, her father invited the authoress Helen Mathers to supper, but forgot about it. The Conan Doyles were halfway through their evening meal when their guest arrived in pink evening dress and pearls. Mary noted how a little feather of hair on the crown of her father's head stuck straight up "as it always did when he was tired or agitated." But Louise took charge of the situation "with a calm sweetness and a charming little dignity all her own." She "put everyone on their ease by her own refusal to be embarrassed or appear to be taken aback. We all took our cue from her, started talking naturally and soon the position was restored."

One of Arthur's gripes was that Undershaw curtailed his social life. At least the seclusion allowed him to work and exercise. But

when the avid Austrian sportsman Count Carl von Seilern und Aspang, who lived at nearby Frensham Place, came to dine with some friends, Arthur could not help observing, "I really don't know anyone that I would care much to pal with in the neighbourhood. I want a rather rare combination of qualities in a friend."

His general unease was evident from his persnickety concern for his health. He apologized for not being himself on the night before Innes returned to South Africa: he had just learned that he had raised levels of sugar in his urine and he feared he might be diabetic. Subsequent tests found nothing to worry about and he was able to reassure Innes, "What with my diet, my teeth, and general care I expect a fresh lease."

Nevertheless he admitted to feeling peculiarly nervous at a gala evening for the Union Jack Club in February 1903. This was not the first time he had mentioned his nerves, but it was odd as this was the sort of event where he would normally have been at ease—a meeting to raise money for a residential club in London for all servicemen (regardless of rank). Recognizing a good cause, he made a speech and donated 100 pounds for a Lady Conan Doyle memorial bedroom. Whether this came from his own pocket is not clear, because the Union Jack Club was one of several causes to which he contributed money remaining from the 5,000 pounds raised for *The War in South Africa*.

For all his overt success, Arthur seemed to be flailing around in the dog days following the Boer War, looking for some new cause, and this intensified his sense of unease about Louise. The global economy had yet to pick up, nations were increasingly competitive, and overall prospects looked bleak. No one could fault his patriotism as he organized his rifle club, gave evidence to the Royal Commission on the War, or scurried to a meeting of the Boys' Empire League where, as president, he offered a prize for the best patriotic song. But these preoccupations were taking him into some odd places. For example, he had become a financial supporter of the British Brothers League, which campaigned against alien, by which it meant Jewish, immigration into London's East End. But while the League was anti-Semitic and is now described as proto-Fascist, Arthur was not anti-Jewish. He supported the burgeoning Zionist movement and, largely through the offices of his friend Israel Zangwill, sat on the London Committee of the General Jewish Colonising Organisation.

He found a way out of this impasse in May after Joseph Chamberlain announced he was turning his back on free trade and advocating a program of tariff reform or protectionism as a way of cementing

imperial ties in the face of greater rivalry from other powers. For Arthur this was a godsend, since it provided a credible political program to add to his dogged nationalism. Having identified Chamberlain as the coming man in the Unionist Party, Arthur began describing himself as a protectionist and voicing his views, notably in the pages of his friend Strachey's magazine, *The Spectator*, where, in presenting a detailed case against free trade, he argued that the British economy was better served by his spending 1,000 pounds on a motor car manufactured in Birmingham rather than in Paris.

Before long, Arthur was once more thinking of fighting a parliamentary seat on this platform. Initially he was uncertain whether to run again in the city of his birth, albeit in Edinburgh South, or to seek new pastures in the Border Burghs, as the southern Scottish towns of Selkirk, Hawick and Galashiels were known. He admitted to E. Bruce Low, an old university friend who was the Unionist agent in Edinburgh, that one reason for running among his own folk was that they might look kindly on him for having recently given 1,000 pounds to the university. But events were moving fast at Westminster. Since the Prime Minister, Arthur Balfour, would not commit himself to protectionism, Chamberlain resigned his Cabinet post in September to give himself more freedom to promote "imperial preference." Under the circumstances Arthur felt the Border Burghs, with its woolen industry suffering from German competition, might be better disposed to protectionism. On November 14 he accepted the nomination for this seat and, although there was no immediate election pending, went north before Christmas to rally his supporters. "I have made a lot of converts," he reported to Low from Selkirk on December 13, "and all my people are red hot."

Arthur's protectionist instincts were clear earlier in the year when he had been contemplating purchasing a car. He could not decide the type, though he did suggest something with a detachable convertible top so he could take Louise for drives. Count Carl von Seilern und Aspang had a handsome 35-horsepower French car to sell, probably because, after recently being charged with speeding, he had claimed in court that he was being persecuted rather than prosecuted. Since the Count had bought his car for 2,000 pounds and proposed to sell it for less than half that price, it seemed a bargain. But Arthur told Innes he thought that he might have problems with a foreign motor car. So he opted to pay just over 400 pounds for a medium-sized 10-horsepower blue Wolseley with red wheels but no convertible top. Having sent his coachman Holden to the Birmingham factory to get used to its

mechanics, Arthur himself subsequently went to collect and drive it the 150 miles home. He could see the joke when a woman at Birmingham station asked him the way to Walsall, taking him to be a guard because of his peaked yachting cap, which he considered the height of motoring fashion. Having joined the Royal Automobile Club as a country member in June, he was an eager proselytizer for this new pastime, talking up the motor car's role as an educative and modernizing invention. However, he found that adapting to four wheels had its problems, and over the next few years he was to take up the count's refrain that the authorities were over-zealous toward motorists.

His main writing commitment in early 1903 had been a stage version of *Brigadier Gerard*, which he had finished by the beginning of March and was hoping to sell to Beerbohm Tree. He expected it would prove very lucrative, particularly if he could get it into production to coincide with the publication of his next collection, *The Adventures of Gerard*, in September. Ironically, while working on these stories he was offered a retainer by the *Strand Magazine*, but declined, telling Greenhough Smith not to fret: the magazine would always be his first port of call. However, he was keen to establish his rate for British rights for this material at 50 pounds per 1,000 words, plus a further 25 pounds for American, adding, "Sherlock is another question. But he won't come up so far as I can see."

This letter is undated, but before long Arthur was following up a proposal from the other side of the Atlantic to revive his detective. The suggestion came from *Collier's Weekly*, which had published the Raffles stories in the United States and was now the most successful of the general interest periodicals there. His decision was made easier by the extraordinary fee he was offered. Various figures have been bandied about: according to John Dickson Carr, $25,000 for six stories, $30,000 for eight or $45,000 for thirteen, to which he replied laconically on a postcard, "Very well, A.C.D." The reality was more complicated, with Arthur demonstrating his best haggling skills. He told Innes in early March how much he had enjoyed his negotiations with the Americans, who had put up 6,000 pounds for his next six Holmes stories. But he was only prepared to give them American rights at this figure, knowing he would get at least 3,000 pounds from the *Strand* in Britain. (In reality, 6,000 pounds was not very different from $25,000 at the prevailing exchange rate of $4.86 to the pound.)

Needing to explain what Sherlock Holmes had been doing since his apparent demise at the Reichenbach Falls (*The Hound of the Baskervilles* was specifically from before his disappearance), Arthur

concocted a fanciful account of how the detective had managed to evade the clutches of Professor Moriarty by using a form of Japanese wrestling described as "baritsu." Holmes had subsequently made for Florence from where, with help from his brother Mycroft, who had connections with the intelligence services, he had spent two years traveling in Tibet (masquerading as the Norwegian explorer Sigerson), before returning via the Hejaz, Persia and Sudan and spending time studying coal tar derivatives in Montpellier in the south of France. (This period in Holmes's career gives great scope to the imaginations of his Sherlockian devotees, who term it the "great hiatus.")

Arthur claimed that the plot of his first new "Sherlock revivus" story, "The Empty House," which involved the detective's commissioning a wax replica of himself to attract the murderous fire of Colonel Moran, a former associate of Moriarty's, had been suggested to him by his beloved Jean Leckie. But there was no variety of wrestling known as baritsu, which was Arthur's typically cavalier appropriation from the world of popular physical culture, where Edward Barton-Wright, a mining engineer who had worked in Japan (and perhaps knew Willie Burton), was trying to promote his patented form of Eastern martial arts known (after his name) as bartitsu.

Having completed this story (the first confirmed date, in a letter to Collier, is April 3), Arthur was in buoyant mood, telling his mother he was looking forward to summer in the fresh air and claiming, on the flimsy evidence of his *Brigadier Gerard* output and his return to Sherlock Holmes, that this had been his best year ever so far as his writing was concerned.

One reason for his upbeat attitude was undoubtedly Jean, whose presence was again evident in his second Holmes story "The Norwood Builder," with its south London locations and his detective's urgent need to "be in direction of Blackheath," where her family lived. Holmes's cumbersome use of the builder's thumbprint to determine his guilt demonstrated ingenuity rather than any sophisticated grasp of modern forensic techniques—a point taken up by Francis Galton, who told him he could not understand how a wax mold of a seal could have left a legible fingerprint on a wall. As a pioneer in the field Galton said he had been trying the method, but "wax and blood do not take kindly to one another, neither is it possible to get good impressions from a hard engraved material upon a hard uneven surface." However, he felt sure that the great author had experimented himself and he asked for details. There is no evidence that Arthur had done his homework, nor that he replied to Galton's letter.

The third story, "The Solitary Cyclist," took Arthur back to familiar Surrey heathland. Motor cars had yet to intrude into the Holmes canon. But Arthur had always evoked a sense of the mobility and expansiveness of his age, if only in references to cycling and South African mining. His sporting interests surfaced in this tale when Holmes, cut and bruised after an altercation with a criminal, ascribed his escape to his "proficiency in the good old British sport of boxing," which had allowed him to use his "straight left against a slogging ruffian."

Perhaps miffed at being pre-empted by *Collier's*, Greenhough Smith was lukewarm toward these two latest stories, thinking they lacked not only originality but also tangible crime. Forced to defend himself on May 14, Arthur argued that "The Norwood Builder" was well up to his standards "for subtlety and depth" and, although he admitted problems with "The Solitary Cyclist," he reminded his editor that his reluctance to return to Sherlock Holmes had been caused by the near-impossibility of "prevent[ing] a certain amount of sameness & want of freshness."

By then he was on the Norfolk coast staying at the Hill House Hotel in Happisburgh. He had delayed going until May 9 so as to be on hand to take Kingsley back to school the previous day. While away, he was able to see his mother, who had been visiting Connie and Willie Hornung, who had taken a house just inland at East Ruston for the summer.

The North Sea location provided the necessary stimulation, for a few days later he was able to tell Greenhough Smith that he had "a strong bloody story," "The Dancing Men," for the fourth in the series. He had been given the basic idea by Gilbert Cubitt, the seven-year-old son of his hotel landlady. The boy had written his name in a cousin's autograph album in the form of a cryptogram, using images of dancing men to denote the letters. Arthur latched on to this idea and, with help from Edgar Allan Poe's *The Gold Bug*, devised his own cipher to be used by the dangerous American Abe Slaney in his efforts to woo his former wife, Mrs. Hilton Cubitt, away from her new husband, now living at Ridling Thorpe Manor in Norfolk. (The similarity of her name with Arthur's landlady was obvious.)

Back in London on May 16, preparing to play cricket for the MCC and Ground against Kent, he told his mother that he regarded his three finished stories as "two bulls and an outer," which was as good a hit rate as he had ever had in the past. But he was determined to have another bull for his fourth. So "The Dancing Men," on which he

had made a start, remained in abeyance. It was not the writing he found difficult, he assured her, only the advance plotting, where he was now getting assistance from Jean.

Although they would not be published until the autumn these new Sherlock Holmes stories were already generating advance publicity, fanned no doubt by the resourceful Greenhough Smith. *Punch* ran an amusing lyric about the detective, called "Back to His Native Strand," and designed to be sung to a tune from the musical comedy *The Toreador*. This recalled how

> . . . we thought a wicked party
> Of the name of Moriarty
> Had dispatched him (in a manner fit to freeze one).
> They grappled on a cliff-top, on a ledge six inches wide:
> We deemed his chances flimsy when he vanished o'er the side.
> But the very latest news is
> That he merely got some bruises.
> If there is a man who's hard to kill, why he's one.
> Oh Sherlock, Sherlock, he's in town again,
> That prince of perspicacity, that monument of brain
> It seems he wasn't hurt at all
> By tumbling down the waterfall.
> That sort of thing is *fun* to Sherlock.

This ditty was penned by twenty-one-year-old P.G. Wodehouse, who had just left his job in a bank and was making his first tentative steps as a writer. A devoted fan of all Arthur's work, he would proudly claim toward the end of his life, "Conan Doyle was my hero. Others might revere Hardy and Meredith. I was a Doyle man, and I still am." He is reported to have referred to Sherlock Holmes over five hundred times during his writing career. One of his first articles, "The Pugilist in Fiction," had looked at *Rodney Stone* (among other works) and appeared in *Sandow's Magazine*, one of the many recent periodicals "for boys and old boys," as the subtitle of *Captain* had it. *Captain* was published by the ever resourceful George Newnes, who was also responsible in April 1903 for C.B. Fry's *Magazine of Sports and Out of Door Life*. Such periodicals, with their diet of sport and adventure, provided light literary fare for Edwardian boys in the increasingly militaristic period between the Boer and First World wars.

The Sherlock Holmes publicity machine was also working on the

other side of the Atlantic, where it was reported that Arthur was preparing to visit the United States in search of local color. According to the *Evening News*, he had leased a hotel in Montauk on Long Island as his center of operations. As a result President Roosevelt, who had a home on Long Island (through his secretary), wrote to *Collier's* inquiring when Arthur would be there, since he clearly hoped to meet him.

No trip materialized, and Arthur spent the rest of the summer completing "The Dancing Men" and four more stories, thus ensuring that his clients, the *Strand Magazine* and *Collier's*, had their agreed complement of eight when they began publication with a fanfare in October. One of these, "Black Peter," was notable for being based around Forest Row in Sussex where he and Jean had been for weekends. Another of the stories, "The Priory School," provided further evidence of his often fragile command of the finer points of police procedure. He made the basic mistake (which he admitted in his autobiography) of imagining that it was possible to tell which way a bicycle was traveling from the mistaken notion that its back tire made more of a mark on the ground than the front. At least Holmes had the pleasure of upbraiding a Duke and pocketing the peer's cheque for 6,000 pounds for locating his son.

Having completed his eight stories with "The Six Napoleons," Arthur was free to finish there, with an appropriate valedictory from Lestrade: "We're not jealous of you at Scotland Yard. No, sir, we are damned proud of you, and if you come down tomorrow there's not a man, from the oldest inspector to the youngest constable, who wouldn't be glad to shake you by the hand." But already *The Bookman* was reporting that, as Arthur was preparing for a holiday in Devon, "it is not unlikely that the series will extend to twelve stories."

Once more Arthur refused to be rushed. Toward the end of September he wrote to A.S. Watt, the son of his agent, who was playing an increasing role in the business, saying that he did not want to hurry his decision over further stories. "If I give them an answer by Christmas it leaves them ample time. If I did them I should not promise four, but do one at a time and so lessen the feeling of strain." Watt took this as a positive sign that Arthur would indeed write four more stories and would provide details by the end of the year, thus allowing both the *Strand* and *Collier's* to maintain their popular sequence.

With the publication of *The Adventures of Brigadier Gerard* on September 22, 1903, Arthur took some time off, first for his holiday in Devon and then to pursue his political interests. Jean appears to have played a significant supportive role, for there is no other way to interpret the

effusive letter Mary Doyle wrote her, enclosing a Christmas present. She said her friends, the Rubies, had been delighted to meet her and Arthur, adding, "I do not forget you ever" and concluding, "So see you soon and with a very loving hug—Ever as ever your Mammie."

Coming back to his detective stories in the new year, Arthur polished off a further four and was able to tell Greenhough Smith on April 26, 1904, that, with "The Abbey Grange," he had completed his "solid dozen." As a result, Holmes "ends on his top note, I think. Requiescat in pace." And that, Arthur clearly felt, was Holmes's swansong. He even had his detective talking gamely about the textbook on the art of detection that he would write in retirement. It was a good story, too, returning once more to the Leckie heartlands of southeast London, bordering on Kent, and thus providing a personal dimension to the fulminations of his leading character, the Australian-born Lady Brackenstall, about Britain's "monstrous" marriage laws. Holmes was again at his most sophisticated in showing that the accumulation of bee's wing in only one of three wine glasses rather discounted the idea that three people (the supposed murderers) had partaken in a bottle. And it finished with Holmes emphasizing his superhuman (certainly extra-legal) role as he assumed the authority of a judge, calling on Dr. Watson as the mock jury to acquit Captain Crocker, the sailor who murdered the drunken Sir Eustace Brackenstall, because of the extenuating circumstances of the case.

Arthur had forgotten that Holmes had one more commitment. His friend Sam McClure had been in London before Christmas and, seeing the success his rival *Collier's* was enjoying with Sherlock Holmes, offered Arthur an extraordinary $75,000 for a further twelve stories featuring the detective, or $25,000 for a novelette—either to run in his *McClure's Magazine*. Arthur had rejected the first idea because he felt he had run out of plots, but he was prepared to consider the latter once he had finished his quota for *Collier's*. On May 20 A.P. Watt wrote to tell McClure that Arthur was ready to write the single Holmes story "for a special occasion," but it could not be used until January 1905 because, annoyingly, *Collier's*, who was in the driving seat, had decided to defer its last four stories and run them in September, October, November and December 1904, thus making sure that Holmes went out in a blaze of glory in their Christmas issue. (This was exasperating for two reasons: the *Strand* did not want to interrupt its sequence of the stories and therefore declined to follow suit, completing its complement as contracted in September; it also meant the collected stories could

not be published in book form on either side of the Atlantic by George Newnes and McClure, Phillips until after *Collier's* had finished.)

Arthur was hoping to write the unpublished saga of "The Second Stain"—an investigation he had mentioned in an earlier story, "The Naval Treaty," as so secret that it could not be revealed. Arthur Bartlett Maurice, junior editor of the American version of *The Bookman*, had been intrigued by this dangling strand and, on a visit to England the previous summer, had suggested it as a possible future tale. Arthur saw how he could tackle it—by having Holmes recall the case from retirement. This would serve two purposes—he would have one extra Holmes story that would commemorate his close relationship with McClure, and he would not have to write any more because he could justifiably say his detective was no longer working. Watt asked McClure for 1,000 pounds for this valedictory piece. But the magazine decided this was too much for a stand-alone piece, particularly as the idea of Holmes retiring was tame, compared with his death. So *Collier's* was delighted to acquire an extra story, the thirteenth in the current series, which they duly trumpeted as "the last Sherlock Holmes story ever to be written."

In "The Second Stain" Holmes had taken up bee-keeping in his retirement on the Sussex Downs. Now the story could be told of the wife of the minister with the anachronistic portfolio of European Affairs. In her effort to extricate an old love letter from a blackmailing French spy, she had, at his request, purloined the text of an important missive from her husband's dispatch box and sought to do a swap. She did not know that this document was considered to be particularly inflammatory in a volatile international situation and that its publication might lead Britain into war. After the spy was murdered, she later returned to his house to recover the letter, knowing where it had been hidden. But Holmes detected her hand in moving the rug beneath the murdered man because its bloodstain did not correspond with that on the wooden floor. Again he declines to inculpate and lay her open to the criminal charges, instead encouraging her to return the letter to her husband's dispatch box, where the minister is asked to look again and amazingly finds it. As the minister (who is based on a young Joseph Chamberlain) describes him as a "wizard" and a "sorcerer," them prime minister (Lord Salisbury) wonders how the letter has been returned to the box and Holmes is left saying, "We also have our diplomatic secrets."

* * *

This reference to clandestine affairs was apt. For at the beginning of January 1904 Arthur's name appeared on a committee soliciting funds for a testimonial for Superintendent William Melville, who was retiring as head of Scotland Yard's Special Branch. After making his name as the scourge of Fenians and anarchists, Melville had won plaudits as the "King's detective," protecting the British and foreign royal families, and at one stage uncovering a plot to kill the German Kaiser at the time of Queen Victoria's funeral.

Arthur's links to Melville are worth exploring. A dozen years earlier, he had been spirited into Scotland Yard's basement museum. But in general he had not sought contact with the police, nor had they initiated it. Scotland Yard's Commissioner throughout the 1890s had been Sir Edward Bradford, a prickly former Indian administrator with an amputated left arm, whose assistant in charge of the Criminal Investigation Department was Sir Robert Anderson. Following his retirement in 1901, Anderson had voiced his disquiet about the exaggeration in the Sherlock Holmes tales.

Arthur did, however, lobby Scotland Yard in a low-key manner in September 1901 after he had been approached by Cuthbert Whitaker, editor of the eponymous *Almanack*, who was concerned about a mysterious letter that had been sent to one of his former employees from western Canada. This was only one of the many instances in which people had turned to Arthur as an authority on obtaining justice. Sometimes they simply cut him out of the process and, either seriously or otherwise, wrote directly to Sherlock Holmes.

As his casual attitude to his *Strange Studies from Life* suggested, Arthur's interest in real crime waxed and waned. He may have done his homework for *A Study in Scarlet*, but that had been nearly two decades ago, and his latest stories had shown a lack of familiarity with police practice. But with Bradford's retirement, changes were taking place at Scotland Yard. Like his predecessor, the new commissioner, Sir Edward Henry, had spent his earlier career in India where he had developed the growing research on fingerprints into a comprehensive system suitable for police work. After the publication of his book *Classification and Uses of Fingerprints* in 1900, he was appointed head of the CID. Following the first conviction by fingerprint evidence in 1902 (the felon was a burglar called Henry Jackson), Henry became commissioner the following year, his technical and managerial skills doing much to boost a demoralized force.

Henry's appointment coincided with a more rigorous approach to the use of forensic medicine in the courts. With the London County

Council now requiring general hospitals to employ two qualified pathologists for post-mortem examinations, there had been a growth in related expertise. A team of pathologists and toxicologists from St. Mary's Hospital in London worked closely with the Home Office. One who would become famous for his courtroom interventions was Bernard Spilsbury, who would get to know Arthur at Our Society (otherwise known as the Crimes or Murder Club), a group of writers and lawyers who came together for convivial discussion of controversial trials. Arthur accompanied members two months later on a tour of Jack the Ripper sites in Whitechapel. John Churton Collins, an English lecturer at Birmingham University, recalled that "Conan Doyle seemed very much interested, particularly in the Petticoat Lane part of the expedition, and laughed when I said 'Caliban would have turned up his nose at this.' "

Always conscious of being a Celtic outsider, Arthur was attracted to such clubs for their sense of belonging. The more secretive, such as the Freemasons, the more they appealed to his ingrained Jesuit sensibilities. This explains his involvement with William Melville, the epitome of the early tight-lipped secret policeman. In the run-up to the Boer War Arthur had been welcomed into the inner circles of military intelligence. Now, having written both his history and his apologia—*The War in South Africa*—he was privy to some of the post-conflict army reforms. So he almost certainly knew that, though Melville was retiring from Special Branch, the former policeman was moving to another important job as head of Mo3 (subsequently Mo5), the counter-intelligence branch of military intelligence, as part of changes at the War Office instituted by Lord Esher. Five years later Mo5 would become the Secret Service Bureau, later known as MI5 or the Security Service, with Melville still at its head, familiar in James Bond terms as M. As the threat to Britain's security increased in the run-up to the First World War, Arthur was at least partially "in the loop," and would have known not to boast of his contacts in this secret world.

Despite the dullness of the post-war economy, Arthur was earning huge sums from his writing. So he had plenty of money not only to sponsor patriotic prizes but also to invest in schemes that interested him. One such project was a machine for copying sculptures that Arthur had seen demonstrated by its Italian inventor when visiting his engineer cousin Nelson Foley at Gaiola. Convinced that this would have a market in Britain, Arthur combined with Jean's father, James, and others including a company promoter called W.G. Jones to form

the Automatic Sculpture Company. He sent out prospectuses to friends such as E. Bruce Low, urging them to invest. After some promotional features in the Newnes magazines, the company managed (with some difficulty) to raise the necessary capital to manufacture its product in London. As the largest shareholder, Arthur became chairman, showing his usual family solidarity by ensuring that Innes had a small stake in a venture that he forecast would be either a disaster or a great success. After starting in a small shed under the Albert Bridge in London in late 1903, the company planned to move to premises in Southwark. But, despite the presence of a dedicated Italian mechanic, the device's teething troubles (basically, a tendency to split the marble it was working on) persisted. After orders dried up, the company folded and Arthur was left inveighing about the awfulness of Jones.

Another of Arthur's investments—more amicable, but equally unproductive—was a rust-proofing process called sherardizing, after its inventor, the electro-metallurgist Sherard Cowper-Coles. This should have been a certainty in an advanced industrialized country, since it was more precise than galvanizing. But like many of Cowper-Coles's 900 patents, it was not taken up commercially.

Undeterred, Arthur poured money into the Grosvenor Recovery Syndicate, which aimed, in the spirit of his Captain Sharkey stories, to find supposed treasure on an East Indiaman that had sunk off Durban in 1782. He helped finance a similarly abortive effort to recover a Spanish galleon off Tobermory on the Isle of Mull. Typically he also supported businesses run by friends and family such as Sena Sugar, which exploited the Hornungs' Mozambican estates, and Doloo Tea, one of the Leckies' interests in Assam. When Nelson needed money to develop property around Gaiola, Arthur obliged.

More conventional was his stake in Raphael Tuck, the holder of the royal warrant for making cards, calendars and gift books, which floated on the Stock Exchange in October 1901. As with the instrument maker Bessons, Arthur became a director and made a point of regularly attending board meetings, where he loyally supported the controlling Tuck family with speeches defending its excellent dividend record and, on one occasion, expressing the quirky view that no firm had done more to raise Britain's artistic standards.

Intriguingly, his diaries note regular payments from "Kate Reilly Ltd," the royal dressmaker with premises on 12 Dover Street in London's West End. She specialized in copies of French haute couture for British customers and is famed for training the celebrated French couturier Madeleine Vionnet, who instigated the bias cut. However,

after being involved in a court case in 1902, she faded from the fashion scene. It is not clear how Arthur became involved, but a possible scenario is that she was the court dressmaker who in October that year advertised in *The Times* to sell her business for 3,000 pounds and Arthur took a stake, thus providing a ready supply of gowns for his young mistress.

In the meantime Arthur's letters to various officers, requesting a Royal Staff College position for his brother, finally paid off and Innes returned from South Africa on March 19, 1904. Arriving at Southampton at daybreak, he found Arthur and Kingsley waiting to drive him back to Hindhead in the Wolseley. Eight days later the two brothers were lucky to escape when, after a round of golf on a Sunday afternoon at Hankley, Arthur struck the gate turning into the drive at Undershaw. The car spun over, pinning him and Innes to the ground. But they managed to extricate themselves and suffered nothing worse than a few bruises.

The following day, a Monday, they were both fit enough to travel to Sheringham in Norfolk for three more days of golf before "the Leckies arrived" on Maundy Thursday for the Easter weekend. It is not clear when Arthur left, but probably, like Innes, it was Tuesday, April 5. Jean's presence on this jaunt was as marked as Louise's absence. Because of the accident, Arthur had gone by train to Norfolk. But his wife seldom traveled by car anyway, preferring to take the carriage, usually no further than her mother's cottage.

Her reluctance was a shame as Arthur was a more enthusiastic motorist than ever. In October 1904 he ordered a new 20-horsepower car from the Dennis company in Guildford. After constructing a garage, he put it to good use as a boxing ring where he liked to square up to his more athletic visitors. The following April Arthur won a local time trial in his Wolseley and in May he was reported to be entering a 9-horsepower Roc machine for an international motorcycle race on the Isle of Man at the end of the month.

His passion for motoring was temporarily checked on May 20 when he was stopped and fined for speeding in Shalford, not far from his house. When told he was doing 30 mph in a 20 mph zone, he claimed he did not know his car could travel that fast. But, true to his nature, he found it difficult to slow down. Two months later he was again apprehended for speeding, this time in Folkestone. Taking a leaf out of Count von Seilern's book, he wrote a blistering letter to the *Daily Mail*, advising motorists to beware when driving in this Kentish town. "I was approaching it for the first time along a wide and deserted

road," he thundered, "when I was stopped by the usual vidette [measuring device]. On turning back I discovered three other constables lying with their instruments in a graveyard that skirted the road. It was a Sunday, and these skulkers upon consecrated ground, seemed utterly blind to the fact that, if I had indeed exceeded by a few seconds, the legal time, they had themselves, if words have any meaning been guilty of the rather more serious offense of sacrilege. The magistrate, in taking my money, remarked with heavy jocularity, that unless I were mulct [fined] I would no doubt kill several people—I, who have never hurt nor frightened a soul in three years constant driving."

In retaliation for his previous motoring offense, he castigated Shalford as a den of vice ruled by a crooked lord in *Sir Nigel*, the medieval novel he worked on during the latter half of 1905. A prequel to *The White Company*, this told of the earlier exploits of Sir Nigel Loring as he romped over Arthur's familiar Surrey countryside, before going to France to earn his spurs under Edward III in the Crécy campaign of 1346. Despite several excellent descriptive passages, it lacks a credible plot, one reason being the personal wish fulfillment invested in the central character, which is clear from the title of one of the chapters— "How Nigel Fought the Twisted Man of Shalford." By the end of July Arthur had completed a third of it and was typically crowing about "the best thing I have done yet"; four months later it was over—"Dei gratia finished, 132,000 words, my absolute top."

Overshadowing everything, however, was Louise's fluctuating state of health. In May, she had been well enough to accompany her daughter Mary on a trip to Paris. She then went to Southsea where Arthur made a point (so his insistent diary entry suggests) of ensuring that he was with her for a couple of days, after he had given a speech before the Prince of Wales at the centenary meeting of the Royal Medical and Chirurgical Society. Probably it was Louise's condition that spurred far-flung members of the Doyle family to congregate at Undershaw during the summer, including Lottie and her husband Leslie Oldham, who came from India in May, and Ida and Nelson Foley from Gaiola a couple of months later. There is a remarkable photograph of them—all four Doyle sisters, with their husbands and children, Arthur standing at the back like a ship's captain, and Louise frail but still pretty, clutching a white handkerchief that symbolized her illness, the antithesis of her mother-in-law, Mary, who sat beside her looking stout and matronly.

In mid-August Arthur's high standing in the land received a ringing endorsement. As a mark of the Entente Cordiale between the two

countries the previous year, the French fleet's Northern Squadron was paying an official visit to Britain. Leaving his ships at anchor in the Channel, Vice-Admiral Caillard and his fellow officers spent the weekend in London. On their way back they visited two contrasting houses, Undershaw and Arundel Castle, the seat of the Duke of Norfolk. The Conan Doyles' visitors' book filled up with signatures such as "H. Gaultier de Kermoal lieutenant de vaisseau" who offered "his grateful thanks for the nice afternoon he enjoyed."

Louise's health was hardly helped by the death of her mother on Christmas Day 1905. Emily Hawkins was four days short of her eightieth birthday and had been the rock on whom her daughter depended. Louise took the news with great equanimity, Mary noted, "for I knew how much the loss meant to her. She always accepted God's will so completely that it gave her a certain soft radiance, and the ability to smile where others might have cried."

Arthur's attentions quickly reverted to the Scottish borders since in December Arthur Balfour had resigned as Prime Minister, no longer able to lead a party fatally divided between free-traders and Chamberlainite protectionists. A general election had been called for mid-January 1906, so, after three years' nursing his constituency, Arthur was finally being called on to fight. During that period he had lobbied hard, taken up local issues and argued tirelessly for tariff reform. He had claimed Border ancestry (on his mother's side, through the Walter Scotts) and had even talked of financing a new newspaper to counter the Liberal bias in the local press. "I'll supply (or have supplied) the politics," he told his agent.

But although Innes came and lent valuable support, Arthur failed to convince the voters, and the Liberal candidate was reelected with an increased majority of 681. After digesting the results, Arthur decided he had had enough of party politics. He told his mother that he had done what he had to do, but now he needed to look after himself. It had been a hard contest, but he was not sorry to be cleaning off the dirt from a place he could not help comparing to hell. Try as he might to keep it bottled up, his underlying anger erupted in an incident on his departure at Hawick railway station. A young supporter bounded up and gave him a handshake that squeezed his signet ring so that it nearly cut his finger. Arthur, who by his own admission was tense, launched into a torrent of abuse that left his back-up staff wondering if the electorate had not made the right decision. On the way home, he stopped for a night at the Grand Hotel in London, where he learned that the actor-manager Lewis Waller had finally accepted his

play *Brigadier Gerard*—the first piece of good fortune he had had for some time, he peevishly told his mother. He returned to Hindhead complaining of the flu and slept for forty-eight hours.

He joked, in the words of his friend the American writer John Kendrick Bangs, that the electors had returned him—to the bosom of his family. But that was hardly the case. He immediately made his way back to London, leaving Louise almost certainly in the care of her sister Nem. But it was young Mary who took a leave of absence from school to accompany her mother (and a French governess) to the Italian Mediterranean resort of Sanremo at the end of January. Arthur remained conspicuously in England where, apart from his usual club-land interests, he was occupied with his play. There seems little doubt that, after failing to find a producer, it had been pulled from the slush pile at short notice to fill a slot at the Imperial Theatre. But at the dress rehearsal, prior to the opening on March 8, Arthur was unhappy at the soldiers' inappropriate uniforms. "This is not a comic opera!" he remonstrated, and insisted that the expensive costumes be roughed up. Closer to home, he was involved in setting up a new golf club at Hindhead. Up till then he had had to travel five miles to Hankley, but now a new course was being laid out off the Churt Road, much nearer to his front door. Despite the fact that Edward Turle had taken on the role of honorary secretary (his Hindhead School having just closed), Arthur agreed to be president and looked forward to the opening in the summer.

When Louise returned from abroad at the end of April her illness was seriously affecting her throat and she could only speak in a whisper, though, as Mary noted, she still had the same "brave, gay, little smile, and never a word of complaint." Louise had even reconciled herself to the fact that her place would soon be usurped. For she summoned her daughter and told her that, while some wives required their husbands to remain faithful to their memory, she was not one of them. "To this end she wanted me not to be shocked or surprised if my father married again, but to know that it was with her understanding and blessing."

On May 29 Louise accompanied Innes and Mary to see *Brigadier Gerard* at its new venue, the Lyric Theatre, and she at least had the pleasure of meeting the Spanish-born Lewis Waller who, in his regular melodramatic roles, was one of the first English actors to gain a following as a result of his looks and manliness.

Arthur was not with his family on this occasion, but there was a rea-

son for his absence. Three days earlier Addison Bright, the agent he employed for his plays, had shot himself in Lucerne after it had emerged that he had been systematically embezzling his clients' box office returns. J.M. Barrie, who had recommended Addison Bright, went to Switzerland to see what he could do for the dead man's family. On June 1 his poignant obituary appeared in *The Times*, describing his agent as "for many years . . . my most loved friend." At this stage Arthur did not know how much he had lost, if anything. But he must have been hugely concerned, and may well have been discussing the matter with Barrie that night. It was later confirmed that Addison Bright had milked his clients of 26,000 pounds, just over half of it from Barrie, but a sizeable 9,000 pounds from Arthur (largely on account of his American productions) and a small amount from Hornung, who had been beginning to enjoy success with Raffles in the United States.

Coming on top of Louise's illness this was an added blow for Arthur. As he dragged himself through various commitments—a High Sheriff's dinner, a ladies' night at the Authors' Club and a visit to Bath to unveil a memorial tablet to Henry Fielding, all in one week in June—he kept Innes informed of his wife's condition in regular bulletins. On June 20 he admitted that whether it was a matter of days or weeks, her death seemed certain. Louise's left side was paralized and there was evidence of some growth in her brain. Despite this she remained her usual sweet self and showed interest when read a letter about the imminent marriage of Nelson Foley's daughter, Claire.

After a series of hopeful entries in his diary, Innes jotted down on June 30, "Serious news from Arthur." This probably coincided with his brother's undated letter saying that Louise had become delirious. By bad chance, that day had been earmarked for an exhibition match to celebrate the golf club's opening. Arthur had to attend, but it was a subdued event. The rifle club stopped firing and a newly constructed electric monorail no longer ran round the Undershaw garden.

At 6:45 P.M. on Tuesday, July 3, Arthur telegraphed his brother that Louise was drifting away and then at eight o'clock the following day came the inevitable news. His wife of twenty years had died at three o'clock that morning. Arthur sat by her bedside with his children, "tears coursing down his rugged face, and her small white hand enfolded in his huge grasp." Minutes before her death Louise was aware enough of her situation to whisper to Mary, when she bent down to kiss her, "Take care of Kingsley."

The two children were then packed off back to school. Neither

Mary nor Kingsley was present at their mother's funeral and burial two days later at Grayshott parish church. Arthur revealed something of his personal torment when he disingenuously told his mother that he had tried to avoid giving Louise a moment's unhappiness. He had wanted "to give her every attention, every comfort she could want. Did I succeed? I think so. God knows I hope so."

PART THREE

GIVING OUT

Edalji, Second Marriage and Windlesham

1907–1908

For more than a dozen years Arthur had wrestled with the consequences of his wife's illness. He had indeed tried to make her existence as easy as possible. But for all his kindnesses it was plain she was not the most important woman in his busy world (nor, probably, the second most—a position reserved for his mother). Louise was the wife he had acquired for reasons of professional propriety and domestic convenience. She had helped him through difficult years as he made the transition from doctor to writer. But she was not the love of his life.

Her final years would have been more satisfying if she had not known that her husband's affections lay elsewhere. But she had survived much longer than expected. According to her daughter Mary, she had only been given three months to live in late 1893. And Mary, perhaps naively, had painted her mother as generally content, certainly uncomplaining, and accepting of her fate.

In ideal circumstances, perhaps in one of Arthur's medieval romances, the characters might have played different roles and the outcome have been happier. But this was more a turn-of-the-century morality tale as written by George Bernard Shaw. There was irony and a touch of tragedy in the way that Arthur, without ever being a prig, would have regarded himself as an upholder of traditional bourgeois values. Yet he had essentially betrayed Louise by carrying on with his mistress while his wife was terminally ill. On the other hand he lived in the real world, and the compromises he was prepared to make as he

followed the dictates of his heart and libido were indicative of his character and the determination he needed to succeed as an author.

After Louise's death, Arthur made much of his solitariness, but this was not the full story. On August 3, 1906, within a month of her funeral, he was able to rouse himself and make his way to his favorite trysting-place, the Ashdown Forest Hotel, on the Kent-Sussex border. Kingsley had finished his last term at Sandroyd three days earlier. There is no evidence that either he or Mary accompanied their father, so Arthur must have made alternative summer holiday arrangements for them before traveling to meet Jean at the hotel. Although not every day in between is accounted for, he was joined by Innes on August 10 when the two brothers went over to dinner with the Leckies in Crowborough.

From the Ashdown Forest Hotel he felt robust enough to enter a controversy in the *Daily Express* about whether Britain was becoming a less religious society, taking a line that showed a typical combination of emotion and utilitarianism. At the top of his list of tests of progress in religion, he stipulated "a kinder and broader view of such subjects, enabling all men of all creeds to live in amity and charity." He also laid down several other idiosyncratic criteria, including an improvement in criminal statistics, savings bank returns and trade statistics ("showing greater industry and efficiency").

He did not totally ignore his children. By September 14 he was with Kingsley in Scotland for on that date Innes noted in his diary that he joined the two of them at the Roxburghe Hotel in Dunbar. Two days later, a Sunday, this small family group entertained Lewis Waller who, in a break from *Brigadier Gerard*, was traveling to Edinburgh by car. Then on Monday Innes took Kingsley south, leaving Arthur on his own in the Borders and thus, rather callously, absent when, later in the month, his son started his first term at Eton.

Perhaps the next few days, which Arthur apparently spent on his own, were enough to justify his recollection of "long solitude" before being invited to stay the following weekend with Arthur Balfour at his nearby house, Whittingehame. He had not seen his party leader since a gathering at Hall Barn, the lavishly appointed Buckinghamshire seat of Lord Burnham, proprietor of *The Daily Telegraph*, over a year earlier. At the time Balfour was still Prime Minister, but was wilting under pressure from Chamberlain and the tariff reform lobby. Arthur had been interested in Hall Barn because Edmund Waller, the royalist poet and ancestor of "the Doctor," had once lived there. One of Burnham's prize fixtures was his Turkish bath, where Arthur was sitting

when Balfour came in. A comical scene ensued: Arthur was wearing only a towel on his head, but he nevertheless tried to doff it as a mark of respect.

In the meantime Balfour had lost not only his parliamentary seat but the nation's mandate at the general election in January 1906. He had since been elected to another constituency and hung on as party leader. Arthur was delighted to find him in good spirits after winning at least something—a medal in a golf tournament at North Berwick. He enjoyed meeting members of the politician's cultured family, as well as renewing his acquaintance with Lord Roberts who visited Whittingehame on a Sunday, when, showing a typically inconsistent religious sentimentality, Arthur warmed to the sight of his host praying with his household. Politics was no doubt on the agenda: Arthur held similar views to his leader on defense, though they diverged on trade. But he only noted some of Balfour's less controversial views—his belated outrage at the Russian fleet's unprovoked attack on Hull trawlers on the Dogger Bank (which had occurred in October 1904) and his opinion that the royal family was very stupid, the King not even knowing who Meredith was.

All in all the weekend was a delightful interlude during a difficult period. Arthur noted that he talked more than usual because of the time he had been on his own. However he was later to reproach himself for not engaging on the subject of supernatural powers with someone known for his interest in the subject (Balfour had been president of the Society for Psychical Research from 1892 to 1894). Arthur excused himself that he was not then as convinced of psychic phenomena as he was later.

His enthusiasm had been jolted toward the end of Louise's life when he had attended some séances given by the mediums Cecil Husk and Frederick Fisher Craddock in north London. These were commercial affairs organized by the eccentric photographer, psychologist and animal-lover Gambier Bolton, who charged 10 shillings sixpence for entry. Perhaps Arthur hoped to gain some insight into his wife's condition. But, as he recalled in his autobiography, he was left feeling confused and often suspicious. The séances almost certainly included the occasion he noted in his spiritualist memoir *The New Revelation* when a medium he frequented was afterward exposed as a fraud. In May 1906 Craddock was convicted of fraudulent mediumship and, although Arthur would have later dismissed such a prosecution as a travesty of justice, he found the circumstances troubling at this juncture in his life.

In the aftermath of Louise's death he was still too raw to follow this up and not even sure he wanted to. Indeed, for all his romantic ideas about the afterlife as a place where one maintained the close relationships of one's earthly existence, he had little incentive, with Jean at his side, to communicate with Louise at all. Not surprisingly, his mistress had no desire to share him with his dead wife and discouraged him from a practice she considered "uncanny and dangerous." And though he later returned to what he called his "psychic studies," he was never in touch with Louise.

In October he was back in Hindhead, playing golf with Fletcher Robinson and others. As a token of thanks for her hospitality he had sent Alice Balfour, who kept house for her brother at Whittinge-hame, a copy of his collected works for the library, adding in typical if ingratiating fashion, "If I could feel that I had diverted Mr. Balfour's thoughts for one day I should feel my existence justified. I should like to think that he had read 'The White Company' and knew me by something better than 'Sherlock Holmes.'"

With not much else going on at Undershaw during this period of mourning, Arthur found some comfort in his books. So he recycled some previous material into a series of articles on his favorite authors, which began appearing in *Cassell's Magazine* in December and were published in book form as *Through the Magic Door* the following November. With a pleasing lightness of touch, these took the form of a rummage through his own library so as to provide, he said, a chatty guide to literature that might assist a young man in forming a small collection of his own. They are full of his enthusiasms and, for this reason, unusually self-revealing.

His grounding in eighteenth-century classics was obvious. The book that had given him the most pleasure over the years was still his stained and tattered copy of Macaulay's *Essays*, which had introduced him to so many other writers. He appreciated this author as a stylist, for his "marvellous mixture of precise fact and romantic phrasing." But if he had to take a book to a desert island he would opt for the sheer scope of Gibbon's *Decline and Fall of the Roman Empire*.

Looking along his shelves he chose Boswell's *Life of Johnson* as the best biography, largely because it told him the "little things" he wanted to know. "How often you read the life of a man and are left without the remotest idea of his personality. It is not so here. The man lives again." His most cherished personal memoir, Pepys's *Diary*, was even older, leading him to note (in an aperçu he later ignored himself): "Those affairs of the heart, for example, which are such an index to a man's

character, and so profoundly modify his life—what space do they fill in any man's autobiography?"

Turning to fiction, he regarded Richardson as the father of the English novel—a subtler and deeper craftsman than Fielding, he argued. For intellectual stimulus, however, he looked to the nineteenth century and to George Meredith, while Charles Reade's *The Cloister and the Hearth* remained the greatest ever historical novel. As for the short story, Poe was the master, Stevenson in a class of his own and Kipling a brilliant modern exponent, both exuberant and concise. More generally, he continued to see the "modern masculine novel" as a reaction against the "abuse of love" in fiction: too many books had promoted matrimony as the be-all and end-all of existence. But, said Arthur, drawing on personal experience, "In the career of an average man his marriage is an incident, and a momentous incident; but it is one of several."

He defended his love of French memoirs about the Napoleonic era because "man is never so interesting as when he is thoroughly in earnest, and no one is so earnest as he whose life is at stake upon the event." At the same time he suggested that his putative collector should devote one evening a week to studying some work of science—not a textbook, but something more popular, though his prime example, Samuel Laing, author of *Human Origins*, is no longer read.

He could not resist including something about the paranormal, though he limited himself to *Human Personality and Its Survival of Bodily Death*, the fruit of Frederic Myers' lifetime of research into consciousness, published in 1903. It posited a personality that was something like the electromagnetic spectrum, capable of survival after death, with some "subliminal" parts only communicable to people with special powers. Arthur gamely forecast that this would "be recognized a century hence as a great root book, one from which a whole new branch of science will have sprung."

He was adamant that science did not have to be dry. Used cleverly, it could brighten any work, as in Poe and Jules Verne, who, he suggested, hinting at a direction he was contemplating, "produces a charmingly credible effect for the most incredible things by an adept use of a considerable amount of real knowledge of nature." And in this context he had to mention his old favorite Oliver Wendell Holmes, whose "subtle, dainty, delicate thought is continually reinforced by the allusion or the analogy which shows the wide, accurate knowledge behind it."

In November Mary came home from school, at the same time as Julia

(or "Juey") Pocock, a painter who had trained at the Female School of Art in London and was a friend of the local Storr family. A much older woman, she was to become Mary's constant companion and what amounted to her (and Kingsley's) guardian. As a sign of the times, Jean Leckie was, after a suitable break, again among the regular visitors to Undershaw, together with members of her family including her brother Malcolm, who was completing his medical training at Guy's Hospital.

Far from being subdued, Arthur now had the energy to take on *The Times* over one of his favorite subjects, authors' rights. His hackles were already raised by continuing fallout from Addison Bright's suicide. Within a week of Louise's death he had written to Charles Frohman in New York on black-bordered paper, expressing his shock at the agent's fraud. Still uncertain how much he had been affected, he proposed making a test case of a single account and, if that was incorrect, he suggested they were all probably so.

The dispute with *The Times* was closer to home, involving the Net Book Agreement, which writers held sacred. Signed between publishers and booksellers in 1900, this accord had established fixed retail prices for books and provided for sanctions if these were discounted. *The Times* undermined the deal when, five years later, it set up a book club as a free circulating library for its subscribers. Publishers initially played the game and supplied their latest volumes on trade terms, but when they found these were being quickly sold off at below-market prices, they refused to do further business. Arthur became apoplectic when he received a letter from the book club, dated November 16, noting that it had been unable to obtain copies of his recently published *Sir Nigel* from Smith, Elder, and asking if he would use the clause in his contract that allowed him to purchase his own work at a discount. If so, *The Times* offered to buy 1,800 copies of the book off him at this reduced price, plus a small premium. Like most authors Arthur was incensed at the paper's tactics. He wrote to John Henniker Heaton, the Conservative MP for Canterbury, who had campaigned for a cheaper, more efficient postal system, begging him to use his influence "to preserve the Times as a great imperial asset and to prevent its lowering its prestige and lessening its influence by this huckstering. I know so many men—and a good class of man—who have sworn never to read it and never to write to it again. It is deplorable for it was the center ganglion of the Empire." He added that, apart from "Hall Caine (who plays for himself) and Mrs. Humphry Ward (who has a family connection with the Times) and Mr. Frederic Harrison who is a crank, I have heard no second opinion among authors."

Shortly afterward Arthur became embroiled in another dispute which was to gain him a reputation as a champion of the underdog. After a cheerful and energetic Christmas (much golf, tobogganing and even skiing on the golf course) when Lewis Waller and his brother Victor Lewis (also an actor) came to stay, Arthur was visited at Undershaw on December 28 by his Crimes Club friend John Churton Collins, on his way back from a fact-finding trip to Parkhurst prison on the Isle of Wight. Churton Collins was disconcerted by the speed at which he was driven along the narrow snow-covered road from the station. (It is not clear if Arthur was driving.) But he recorded that he "had a delightful time with Conan Doyle who is on fire with the Edalji case; going to deal exclusively with it in the Daily Telegraph."

In the new year of 1907 Innes noted this same name in his diary: "Much talk of Edalji." The references were to George Edalji, a thirty-year-old lawyer who had recently been released from prison after serving three years of a seven-year sentence for the horrific crime of maiming animals around the Staffordshire village of Great Wyrley, where his father Shapurji was vicar. Originally a Parsee, Edalji senior had converted to Anglicanism in his native India where he had published an English-Gujarati dictionary. After moving to Britain and training as a clergyman, he had been appointed to his parish. But he found middle England woefully unprepared to have an Indian ministering to its spiritual needs, and he had been subjected to a torrent of abusive letters which he had met with considerable equanimity.

In 1903, after the outbreak of mutilations of sheep, cattle and horses, his son George was arrested and accused of the crimes. By then George, whose mother was English, had written a topical manual on railway law for the individual traveler and was working for a firm of solicitors in Birmingham. He had a virtually watertight alibi, various pieces of evidence used against him were either false or fabricated, and it was clear that, with his poor eyesight, he would have been unable to walk over fields and railway lines to commit such offenses in the dead of night. However Captain George Anson, the Staffordshire Chief Constable, had decided that this dark-colored man was the culprit and he made sure that George Edalji was arraigned before the local Quarter Sessions rather than the less pliable Assizes.

George repeatedly protested his innocence, but to no avail. While he was in jail, a campaign was started to secure his release and obtain a pardon. This achieved its first goal but the second was still some way off when, toward the end of November 1906, the newly freed Edalji sent Arthur some cuttings on his case culled from the magazine

Umpire, and asked for his help. The moment could not have been better chosen. Arthur was at a loose end and looking for something to occupy him. He may have been spurred by an element of competition because another Crimes Club member, George Sims, had won plaudits a couple of years earlier for his dogged investigation in the *Daily Mail* of the case of Adolph Beck, a Norwegian engineer who had been wrongly imprisoned for robbery.

Overcoming his own latent prejudices (he was later to write that "the appearance of a colored clergyman with a half-caste son in a rude, unrefined parish was bound to cause some regrettable situation"), Arthur agreed to meet Edalji at the Grand Hotel, Charing Cross, where he was immediately struck by the myopic manner in which the Parsee was reading his newspaper. He concluded that the evidence of the man's astigmatism (which had been confirmed by independent oculists) was correct: Edalji could not have carried out complicated maneuvres in the middle of the night. He did not realize that the young man's bulging eyes and dark appearance had marked him out as guilty according to Captain Anson's understanding of the "scientific" categorizations of the Italian criminologist Cesare Lombroso.

Arthur immediately wrote to Anson requesting a meeting. He also contacted the Home Office, suggesting that the police had perpetrated "an incredibly stupid injustice." Anson, the second son of the Earl of Lichfield, cavalierly thought he recognized a potential ally and tried to win Arthur over by offering him "any amount of information for your own satisfaction if it would go no further than yourself." He even repeated the defamatory accusation that had been bandied around in the racist atmosphere of the original trial that the Edaljis (father and son) had shared a room because they indulged in unnatural practices. (Sodomy was mentioned.)

Early in the new year Arthur traveled to Great Wyrley, where he quietly made his own inquiries, before proceeding to Stafford to talk with Anson. When it became clear that his requests for an official investigation were falling on deaf ears, he decided to write two articles about the case for *The Daily Telegraph*, which agreed to publish them without copyright so that the issues could be taken up by other papers, particularly in the Midlands.

As soon as Anson realized that Arthur was not on his side, he started castigating him to the Home Office in what were clearly standard police terms as a Sherlock Holmes who viewed himself as "l'état, c'est moi" and "so vastly superior to us." Published on January 11 and 12, 1907, Arthur's impassioned articles railed against the stupidity and

prejudice of the Staffordshire police and demolished its evidence. Raising the stakes, he likened the conviction of Edalji to the framing of the Jewish soldier Dreyfus in France.

Arthur's Holmesian entry into the case sparked a revival in the nation's interest. Friends such as Barrie rushed to compliment him on his courage, though the ever enduring George Meredith, in striving for the right note, was slightly off-key in his observation, "I shall not mention the name which must have become wearisome to your ears, but the creator of the marvellous Amateur Detective has shown what he can do in the life of breath."

A Support Committee was set up, headed by Roger Yelverton, a barrister who had once been Chief Justice of the Bahamas and who had been lobbying on Edalji's behalf, largely as a part of his efforts to bring about a Court of Criminal Appeal. Alongside this body, under *The Daily Telegraph*'s auspices, was a separate Campaign Fund Committee, on which Arthur agreed to serve with Horace Voules, the editor of Henry Labouchere's *Truth*, which had also been campaigning on the issue, Sir George Lewis, the nimble-footed lawyer, and Jerome K. Jerome and Churton Collins, his friends.

On January 15 Arthur visited the Home Secretary, Herbert Gladstone, to discuss the evidence. As a result of his own investigations, he also suggested who had actually been responsible for the atrocities— a gang headed by Royston Sharp, a simple-minded butcher's boy who had been at school with George Edalji. At this stage Arthur made a bad strategic mistake: encouraged by weasely Home Office promises to set up an inquiry and looking no further than to gain Edalji a pardon and perhaps compensation, he cut his links with the Support Committee, which had additional reforms of the legal system in mind. Arthur arrogantly convinced Edalji that his personal contacts with the Home Office were more likely to be fruitful. But having set up an internal committee to look into the matter, the Home Office recruited as a member Sir Albert de Rutzen, the Chief Magistrate of London, who was Anson's cousin.

Although this body did indeed exonerate Edalji in May (three days after Arthur gave what was no doubt a self-congratulatory talk on the whole saga to the Crimes Club), it refused to retract the allegation that he had been responsible for a series of anonymous letters surrounding the case. It also placed no blame on the Home Office or Staffordshire police, and it granted Edalji no financial reparation. As a new round of anonymous letters started and further maimings were reported in Staffordshire, Arthur continued through the year to unearth new evi-

dence. In August he even met with one of the alleged gang hoping (to no avail) to encourage him to turn King's evidence. Although Edalji was readmitted as a solicitor, he was not granted compensation, causing a disappointed Arthur to look to the new Home Secretary, his friend Winston Churchill, to take up this matter in October 1910. He was still locked in acrimonious correspondence with Anson the following year. As for the Court of Criminal Appeal, the Edalji case is often quoted as the catalyst that led to this body finally becoming part of the judicial system in August 1907, but much of the legislative donkey work had been done the previous year as part of the Beck case.

Arthur might have done more to help a victim of injustice closer to home. In July 1907 a collection of valuable gems, known as the Irish "Crown Jewels," was stolen from a safe inside Dublin Castle that was the responsiblity of his distant cousin, the Ulster King-at-Arms, Sir Arthur Vicars. The police believed the robbery was an inside job by Vicars' deputy, Francis Shackleton, the feckless brother of the explorer. But because of his involvement in a homosexual ring, which included members of the royal family, Shackleton escaped prosecution. Instead, a viceregal commission was set up to investigate if the Ulster King-at-Arms had been derelict in his duties. When this body refused to exonerate him, Vicars pressed unsuccessfully for a public inquiry. He was forced to retire to Kerry, where he would be brutally murdered by the IRA in 1921.

Arthur could be forgiven for failing to act fourteen years earlier, partly because he did not want to be regarded as a general busybody, and partly because he was occupied with more personal matters. In March he had formally announced his intention to marry Jean Leckie. Inevitably this heralded major family changes, which had been anticipated in Juey Pocock's presence at Christmas. Finding her role in the Conan Doyle children's affairs superseded, Louise's sister Nem settled into a peripatetic existence, at times rumored to have been seen in a pub in Guildford, at others in France. When her father became engaged, Mary was in her last term at Priors Field, preparing to pursue her musical studies in London in the summer. She was looking forward to the move if her comments on the school's "chronic mental indigestion" can be credited. She noted prissily that everything her fellow pupils learned went "straight through them, and out the other side, like water through a hollow tube. That all-important thing, how to make use of knowledge is completely neglected." But she was worried about Nem's unhappiness: "I would so gladly do anything I could for her—but the one thing she would like, that is for me to live with her, I

feel more and more would be impossible, and perhaps in the end desasterous [*sic*]."

Around this time Arthur succumbed to the various pressures and disappointments (the latest being the death of Fletcher Robinson from typhoid in January) and his own health broke down. Most of his substantive work on the Edalji case having been completed, he was cared for by his future in-laws at Monkstown where his daughter wrote saying she was not anxious because "the dear Leckies" were looking after him and she remembered the wonders they had done for him the previous summer. On that occasion his "illness" was probably little more than exhaustion, providing an excuse to get away from his children and be with Jean. This time he was unwell enough for his condition to be noticed by *The Times* on March 8, though the paper's assertion that he had only risen from his bed four days earlier and gone from Hindhead to Crowborough on the sixth was odd as he had written from Monkstown to *The Daily Telegraph* about the Edalji business on March 4. (A reference in Innes's diary to "Arthur's Ptomaine" suggests the illness was basically food poisoning.)

Now officially part of the family and no longer required to dissimulate, Jean was able to join her fiancé, along with Mary, Innes, the Hornungs and the Angells, for a party to celebrate the Mam's seventieth birthday on July 8. After dinner at the Gaiety restaurant, they moved along the Strand to Terry's Theatre to see *Mrs. Wiggs of the Cabbage Patch*, a piece of American whimsy billed as the "funniest comedy in town." At the age of thirty-three, Jean could at last see an end to her lengthy period of waiting for the man she loved. There had been something both coldly resolute and deeply romantic in the way she had waited for the death of Louise. In her eagerness to tie the knot and escape her nebulous role as a long-term mistress, she now drew up a calendar that charted the period from mid-August until her marriage and she ticked off each day as it passed.

In the meantime Mary and Kingsley spent their summer holidays with Juey on the Isle of Wight, before the whole clan congregated again in London for the wedding on September 18. The night before Arthur entertained thirteen of his male friends and family to dinner at the Gaiety, which was more of a mid-market caterer than a gourmet's paradise. The actual ceremony at St. Margaret's Church, Westminster, was, however, magnificent. Jean, attended by her friends Lily Loder-Symonds and Leslie Rose, wore a semi-Empire robe of silk-embroidered Spanish lace outlined in pearls. Innes, who had dragged himself away from autumn maneuvers in Buckinghamshire, was best

man, and the ceremony was conducted by Arthur's brother-in-law the Reverend Cyril Angell. As a nice touch, the guests included not only George Edalji but the eighty-three-year-old Miss Victoire Tenniel, a throwback to the middle years of the previous century when the Doyles were the toast of London's artistic community, since she was the sister of Sir John Tenniel, the illustrator who succeeded Arthur's uncle Dicky on *Punch* in 1850. (Sir John was still alive but unable to make it.) After the service the Leckies gave a reception at the Hotel Metropole, and then Arthur and his new bride boarded the boat train at Victoria for Paris at the start of a honeymoon that would take them, via Dresden, across Europe to Turkey.

Dresden, the cultural capital of Saxony, was Jean's territory. She had studied there as a girl and a besotted Arthur was so impressed with the refined results that he was determined his children should follow. Much against her wishes, Mary was the first to be sent there to study music, which explains the detour made by the newlywed couple. Although she reported that Arthur and Jean looked "very flourishing and happy," she herself was already feeling homesick (particularly for Kingsley) and she had a shrewd idea she had been parked there because she was an inconvenience. Two months before the event she was pining to come home for Christmas, but the prospects did not look good. "There is no reason why I shouldn't," she told her brother, "unless they want to clear us both out of Windlesham, and have it to themselves for Xmas. We're a bit of a mistake now. But never mind old chap, *we'll* stand together whatever happens."

Little Windlesham was the house Arthur had bought in Crowborough, a short distance down Lordswell Lane from Monkstown, the country retreat of his in-laws. Their hospitality in times of sickness and health had given him ample opportunity to negotiate with its vendor, Mrs. Charles Scott-Malden, widow of the headmaster of Windlesham House prep school outside Brighton (and hence the name). With his grandiose ambitions, Arthur immediately dropped the diminutive and would later grumpily refer to it as Swindlesham, because, after paying a hefty 2,600 pounds, he was forced to spend almost the same again on extensions and improvements. But its situation, on the south side of the town, looking out over the Weald and the South Downs, was delightful. It was within forty minutes of London by train, it had a golf club and a common on its doorstep, and Crowborough's elevation— some 800 feet at its highest point—had gained it a reputation, like Hindhead, as a health resort.

There had been no question of Jean slotting into Louise's place at Undershaw. So Windlesham was the house where she and her new husband returned in mid-November. During their honeymoon the Conan Doyles had visited Pompeii, Venice and Athens, cruised through the Greek islands, where Arthur claimed to have seen a young ichthyosaurus swimming in the sea, and spent time in Istanbul, which provided a stark reminder of the fervor of Islam. (It was a measure of the sophistication of European travel that he was able to pay their hotel bills by check in most places they stayed, but in the Ottoman capital he needed to arrange a special 200-pound letter of credit.) While staying at the Pera Palas Hotel there he was summoned to see the Sultan who, he was told, was an enthusiastic reader of his work and wanted a complete edition. As it turned out the ruler of the Sublime Porte was unable to receive him because it was Ramadan, but he did order his chief secretary to invest Arthur with the Order of the Mejidie. There was even a lesser award for the new Lady Doyle—the Shefkat Nisham, given to women for charitable work, which was appropriate, Arthur thought, because she had spent much of her period in Istanbul trying to feed the hordes of starving dogs.

As the besotted couple settled down to married life in Sussex, Mary regarded her stepmother as anything but charitable. She was not forgotten, her uncle Innes having visited her in Bremen while he was in Germany in November on a training course linked to his new position at the Royal Staff College in Camberley. But as her father's reluctance to allow her to intrude on his matrimonial bliss became clear, she felt increasingly annoyed. "I can't think why my father is so hard," she told her brother. "I have not had one gentle word, or sign of love from him during the whole two years since Mother died. One would have thought it would be otherwise. But no—life had gone to make him a very hard man." She resolved that the best course was for her to keep quiet and be patient.

Events did not turn out as she wanted. Sometime over Christmas she had what she described as "words" with her stepmother. Mary had tried to be understanding because she knew Jean's youngest brother Bob had died in early December. But she could not keep quiet when Kingsley was dispatched to the Hornungs for Christmas. He subsequently went to Windlesham, but did not enjoy it, so Mary saw fit to admonish Arthur and Jean (in a letter to her brother) for failing to make him feel at home and "happy in the New Life . . . In neglecting you like that, I consider they have let slip a very important duty. I'm disappointed in both of them." As she came up to her nineteenth birthday on January

28, 1908, she was tired of having to lie to people in Dresden to explain her family's neglect of her. And her worst nightmares were confirmed when it became apparent that she would have to stay in Germany until August, well after the other British girls in her circle had returned home, fleeing the summer heat.

At Windlesham, Arthur set about rearranging the house to his and Jean's needs. The main elevation, with its distinctive gables, was a slightly smaller, more elegant version of Undershaw. Initially his study was on the ground floor, but he later commandeered a couple of bedrooms with better views upstairs to provide office space for himself and his secretary, Alfred "Woodie" Wood. As designed by local architect Langton Dennis, the main addition on the ground floor was a spacious thirty-by-thirty-nine-foot music room that stretched eastwest from front to back of the house, allowing it to be converted occasionally into a ballroom. Normally a third was occupied by Jean's musical instruments (a harp and a grand piano, thus cunningly trumping Louise who had only been allowed a smaller upright by her husband), a third by Arthur's billiard table, and a third by a living space (sometimes screened off) where the family could relax in Arthur's favored baronial style, surrounded by paintings (including one of Napoleon gazing out from St. Helena), incongruous hunting mementos and an open log fire. Next to it was the dining-room where Arthur seized on the opportunity of Jean's short absence in early 1908 to change the mantelpiece. In time Jean established a new garden at the back and a garage was also built.

Amid the confusion created by workmen, Arthur followed the time-honored practice of authors wanting to maintain their sanity: he retired to the peace and quiet of his study. His first story to emerge was "A Pot of Caviare," which he described as "very gloomy but of my best." Published in the *Strand Magazine* in March, it was a dark, tense and crisply written tale about a siege during the Boxer Rebellion in China. Reflecting Arthur's own fears about threats to British society, and doubtless drawing on Innes's experiences in the Far East, it was similar to *The Tragedy of the Korosko* in its exploration of the behavior of a small band of Europeans under threat from a large, unknown external force. Despite initial hopes that their garrison will be relieved, the German colonel in charge comes to believe that their rescuers have been repulsed. Told of the atrocities committed by the Chinese in such situations, particularly against women and children, he decides to poison all under his charge by mixing cyanide in a jar of caviar. However, the Colonel's information about the state of the siege proves

wrong, and the relieving commander arrives to find all the Westerners dead. In the context of Britain's position in the world, it was indeed a depressing warning against defeatism.

At the same time Arthur had been working on some plays. Clearly believing he had hit on a topical theme, he had written a stage version of *The Tragedy of the Korosko* called *The Fires of Fate*, which he told his mother was to be produced almost immediately by Vedrenne, the impresario behind George Bernard Shaw's success. He had also been revising the Regency boxing play he had started with Willie Hornung fourteen years earlier. This was now called *The House of Temperley* and again Arthur was convinced it was scheduled for a theatre.

But finding a stage for this output did not prove easy, particularly after Addison Bright's suicide. And he was not faring much better with his fiction. So, when an unknown story did not work out, he resorted to Sherlock Holmes, telling Greenhough Smith that, though he did not envisage attempting a whole series, he saw no reason why he should not write the odd story from time to time under a title such as "Reminiscences of Mr. Sherlock Holmes." He offered to do one such piece for the *Strand Magazine*'s midsummer issue and another for the Christmas issue.

He told his mother this return to Baker Street would not be so awful as to damage his name, and the financial rewards would be worthwhile. The latter point was significant since the Sculpture Company had finally folded after giving him, he admitted, more worries than anything else in his business life. Now he had hopes for a new venture, the Roc cycle company, which had manufactured one of his early motorcycles. He granted that this business, which originally made bicycles, had appeared to be a disaster, but it was now changing and, since he owned it outright, he predicted not only success but riches.

On April 17, six weeks after raising the matter with Greenhough Smith, Arthur finished the first of his new Holmes tales, "The Adventure of Wisteria Lodge," which pitched the detective incongruously into a Conradian world of immigrants and their politics. To make it more bizarre, the drama was played out in the deepest Surrey countryside. Once again he touched on the topic of foreigners in Britain's midst, though this was simply a new version of a Conan Doyle plot line that can be traced back to *A Study in Scarlet*, telling of acts of revenge being carried out for crimes and injustices in distant lands.

Before tackling "Wisteria Lodge," Arthur had no doubt identified with Sherlock Holmes's predicament—his mind "like a racing engine,

tearing itself to pieces because it is not connected up with the work for which it was built." As usual he laced his writing with details from his personal life: Scott Eccles, Holmes's original informant, for example, came from Lee, the area of Blackheath where the Leckie family lived. The surname of one of the exiles, Durando, was a contemporary reference to the Italian runner Dorando Pietri, a popular hero of the Olympic games held in London in July 1908. In the marathon race, Pietri had entered the stadium in the leading position, but stumbled from exhaustion on his final lap and was helped over the finish line. As a result he was disqualified and the gold medal awarded to the second-place runner, the American Johnny Hayes.

The public was incensed at this injustice. At the awards ceremony Queen Alexandra insisted on presenting a special medal to the Italian, who was invited onto the music hall stage. Irving Berlin celebrated him in the first song he ever sold, and Arthur, who reported the event for the *Daily Mail,* led the call for a fund to honor the athlete: "No Roman of prime had ever borne himself better; the great breed is not extinct." A few days later on July 31 a small group gathered in the newspaper's offices where Jean presented Dorando with a gold cigarette case and a cheque for 308 pounds 10 shillings, while Arthur, presuming to speak for "all the English nation," again praised his sportsmanship.

Since he had started "Wisteria Lodge" in April and it was not published in the *Strand Magazine*'s summer issue, but rather kept back as a two-parter for September and October, it seems likely that he altered this name to Durando at proof stage. It was entirely in keeping with his casualness that he should not only have given an Italian's name to a Spaniard but also misspelled. It was also true to form that Jean should have been with him in the *Daily Mail* offices. Unlike Louise, his new wife was never far from his side when he visited London, where the couple now moved in exalted circles. In May they had both attended the King and Queen's court at Buckingham Palace. Arthur had subsequently described Jean as the most attractive and elegant woman there.

But being married to a younger woman had its drawbacks. He did not have the energy of old, and twice in as many months he complained to his mother about the demands of his social life which he claimed were beginning to tire even Jean, somehow cleverly turning the subject around. In one letter at the end of June he reeled off a long list of family, friends and cricketers who had been or were about to visit them, and said it was time to call a halt, as he and his wife had

not had four days to themselves since returning from their honey-moon.

He consoled his mother with a résumé of his output, which he claimed had been substantial. Apart from "Wisteria Lodge" and "The Pot of Caviare," he had added two chapters to *A Duet With An Occasional Chorus*, the marriage primer he had originally written for Jean. One of these extra chapters was printed by the Union Jack Club in May, and the revised book, having fallen out of print at Grant Richards, would be republished a couple of years later by the obliging Smith, Elder, which in September put out *Round the Fire Stories*, a collection of tales "concerned with the grotesque and with the terrible," most of which had been published in the *Strand* around the turn of the century.

Always prepared to mix his styles, Arthur had also been working (at Windlesham) on "The Silver Mirror," a macabre tale of a beveled mirror whose owner, an accountant on the edge of a nervous breakdown, witnesses a man being torn from his lover's arms and brutally killed. Recalling the psychometry of "The Leather Funnel," it transpires that he is reliving the murder of David Rizzio, the favorite of Mary Queen of Scots, at Holyrood Castle in Edinburgh, from where the fictional mirror had come (along with several real items of furniture belonging to Arthur's father). He told Robertson Nicoll that this was an experiment, as he tried to make a series of vivid sketches of the past in a manner similar to Kipling's *Puck of Pook's Hill* stories. "The idea is to stick very closely to the truth of history and only to introduce that absolute minimum of fiction which enables you to get color and human comment into your picture."

At the same time he had been working at and promoting his plays. He claimed that *The Fires of Fate* was now contracted to the actor-manager Aubrey Smith and would be staged before Christmas. Arthur had decided to take this opportunity to sack Arthur Hardy, Addison Bright's former partner, who had continued with their joint theatrical agency. In October 1908 he informed Hardy that, because he had done all the negotiating with both Vedrenne and Aubrey Smith, and he anticipated much the same happening over his boxing play, he saw no reason to continue paying the intermediary's 5 percent commission. But the results of his initiative were not encouraging: his only dramatic presentation that year was a version of *A Pot of Caviare* that was staged in November by a Mrs. Arthur Mortimer in the unlikely surroundings of the Jersey Opera House.

By then Arthur had written a second new Sherlock Holmes story,

"The Adventure of the Bruce-Partington Plans," which did indeed go, as he suggested, into the *Strand*'s Christmas issue. This reflected the prevailing xenophobia of the time in its detail of foreign spies, English traitors and the theft of top-secret submarine plans from the Royal Arsenal at Woolwich. Arthur hinted at his knowledge of the workings of the secret state in his reference to funds being smuggled through the parliamentary defense estimates in order to purchase a monopoly on the invention. But he did not write a spy story in the manner pioneered by his fellow Crimes Club member William Le Queux. Despite occasional echoes of the ridiculousness of Hornung's Raffles stories, this was a conventional detective investigation, which meant that crucial deductions were made from clues such as broken tree branches and random messages in *The Daily Telegraph*.

These two latest Sherlock Holmes stories were published in America by *Collier's Weekly* which inquired in October about the possibility of a series. Watt replied cautiously, saying Arthur might be prepared to do this, and would offer *Collier's* first refusal on his next three, four or six Holmes stories at the same rate as before (now a healthy 750 pounds each), but if he had not completed them within a year he had the right to give three months' notice of withdrawal from the agreement.

The reason for Arthur's reluctance was that his schedule had just been interrupted by the news (long anticipated, according to Mary) that Jean was pregnant with a baby expected in March. Arthur took time off to attend to family matters, writing to one brother-in-law, Malcolm Leckie, now a Lieutenant in the Royal Army Medical Corps, about another, Nelson Foley, who had developed what he called tubercule in his neck. With an eye no doubt to picking up the cost of treatment, he wanted to get an idea of both the prognosis and the possible expense. But his inquiries proved too late and Nelson died, age fifty-eight, in Kensington on January 3, 1909.

The following month Arthur was not above lobbying General Sir Reginald Wingate, the Governor-General of Sudan and Sirdar of the Egyptian army, about finding Malcolm Leckie a post in the Egyptian Medical Service. He described his relation as a fine young man, an England hockey player, and above all a gentleman. As for himself, he said he was happily married, but anxious about the impending addition to his family.

In the background his relations with his two children from his previous marriage remained as fraught as ever. Kingsley was allowed home for Christmas but Mary fumed that she had been condemned to another festive period on her own in Dresden. In early January 1909

Arthur's own sporadic health problems led him to have an operation at Windlesham on January 10 for what *The Times* saw fit to report as "a painful but not serious intestinal affection." It added that "the patient, though still very weak, is progressing favorably," delicately skating over the fact that Arthur had been suffering from hemorrhoids, as he himself told George Meredith the following week, giving thanks for the benefits of morphia, which had done so much to relieve his excruciating pain.

His acceptance of this matter did not stop him from berating his daughter for failing to send her condolences, although she swore that she had written to him on each of the three days after she had heard of his illness. "Faithful Patience to us both," she joked conspiratorially to her brother, referring to the family motto that her father had mistakenly adopted.

On January 31 he had a further small operation, which left him feeling in top form. He congratulated himself on having used his indisposition to good effect—revising his will to take care of future offspring, entering negotiations to represent Edinburgh University in Parliament, and writing two long poems. With family matters high on the agenda, one of these was probably "1902–1909," a romantic ballad about a stout Devon man who, after being wounded in South Africa, was taken in by a Boer whose daughter he befriended. Now he had four children by her, each of whom claimed to be neither Boer nor English, but South African. Arthur could not help editorializing that this was an example of "the welding of the race."

He had recently paid a neighbor 1,400 pounds for some land next to his property where he proposed building a garage, stables and a chauffeur's house. These additions would supplement ongoing work on an extension to the kitchen wing, designed to provide a store-room and a boot-room, with two additional bedrooms above. Arthur felt he needed the space, not just to accommodate his growing establishment (that now ran to nine servants) but also, recalling problems that had arisen with the pregnancies of both Lottie and Dodo, to guard against all eventualities which might befall his wife. (He had arranged for Jean's highly strung friend Lily to be nearby, staying with the Leckies at Monkstown.)

The baby, a boy, duly arrived without great fuss on March 17. As this was St. Patrick's Day, his mother suggested the name Patrick, as well as Percy, for family reasons. Arthur pointed out that the recently widowed Ida already had a son called Percy and it would be odd to have two cousins with the same moniker. When she insisted, Arthur backed

down, admitting that he and Jean could refuse her nothing, and the names Denis Percy Stewart Conan Doyle were agreed. (It was perhaps significant that Ida's son later came to be known as Michael.)

With a baby in the house, Arthur and Jean were reluctant to have Kingsley at Windlesham over Easter. So arrangements were made for him to visit his sister in Dresden. But even then there were problems. When Mary sought some extra money to visit Berlin to see an opera she was studying, her father sent a 10 pound check, but placed her in a fearful quandary when he told her she would have to choose between this and having Kingsley to stay, since he claimed he could not afford the combined expense. For one of Britain's richest authors to say this was nonsense and palpable blackmail. As it was, he must have relented, for she went to Berlin and Kingsley to Dresden.

Arthur's attitude to his two older children had become unnecessarily hard, as can be ascertained from a groveling letter Kingsley was forced to write to his father from Germany, apologizing profusely for annoying him and asking pathetically, for a list of his faults, so he could improve on them. A sense of his offense can be gained from his admission that he had been remiss about some flowers that Jean had either given him or put in his room. He said he had intended to thank her but then in the rush of coming home and going to Germany he had forgotten. A classic stepfamily split was developing, with the two children and Jean clearly resenting each other's presence.

When Mary herself finally returned home in June, she was thrilled to see her baby brother. After she had had an opportunity to talk to her stepmother, she, a child of the emerging suffragist age, was incensed by Jean's argument that a clever man should never marry a woman of equal intelligence. Inclined to be charitable, however, Mary decided that Jean was fine as she was—not a wonderful artist, but a great housekeeper who looked after the needs of her father who, thankfully, had lost his recent truculence and seemed "softer, more genial, less nervous and unreliable than he used to be." As she confided to her diary, "He seems to have grown more human." And one obvious reason was his overwhelming love for his new son.

Her truce with Arthur did not last long. After spending the summer visiting friends in Britain, she returned to Germany with the intention of taking a course in voice composition with Professor Albert Fuchs of the Dresden Royal Conservatory. She was horrified to receive a devastating letter from her father, informing her that she was not up to it: her singing was flat and she did not have a good ear. She had no doubt who was behind this: Jean now considered herself the musician in the family,

and did not want any rivalry. Although Mary was in fact allowed to continue her course with Fuchs, who was appreciative of her talents, she lived in terror that she would hear from Windlesham that her father was calling a halt to her other singing lessons. With a certain inevitability, she realized that "in all future dealings it is Jean and not Daddy with whom I shall have to reckon with."

Arthur's attentions were indeed focused elsewhere, as a more contemplative Mary acknowledged to her confidant Kingsley in October 1909. "Daddy seems to be making a fine stir over this Congo business. I do wonder what the results will be. My dear, I am sure Daddy was born to be a Public Man and a husband, but not to be a father."

The Congo was Arthur's latest cause. He had been looking for something to occupy him since the Edalji affair. The previous summer he had lent his weight to a campaign to introduce Daylight Saving Time to Britain. This had led him to argue before a Parliamentary Committee that an extra hour of light in the mornings would promote the health and happiness of a majority of the population, particularly children. But this was small-scale compared with his enthusiastic support for the journalist E.D. Morel's campaign against atrocities in the Congo, which was run as a personal fiefdom by King Leopold of the Belgians. In 1904 Morel had set up the Congo Reform Association (with Arthur's friend St. Loe Strachey on the executive committee), after Roger Casement, the local British Consul, had confirmed allegations of slavery.

Arthur began taking an interest in 1906, following the publication of Morel's book *Red Rubber*, which exposed King Leopold's exploitation of slaves in his Congolese rubber plantations. His first letter to Morel is dated July 10, 1907, a couple of months before his marriage. He smoldered about the issue for the next couple of years, adding his signature to a protest letter to *The Times* in December 1908. But he did not become actively involved until the summer of 1909, a few months after King Leopold had formally ceded control of the Congo to Belgium, hoping that this would appease international opinion. When it became clear that nothing much had changed, Arthur arranged to meet Morel in a London hotel, where he offered to write a short book, partly to keep up the propaganda effort and partly to raise funds for the cause. Morel sent Arthur everything he had written on the subject. "For a couple of weeks, hardly a day passed without a letter from him," he recalled. (The evidence of Morel's archive suggests this was in August.) "Then, when he had probed the whole thing to the

bottom, he shut himself up in his study and worked like a demon, hardly giving himself time to shave, as he put it." Within eight days (one of which was spent in London) Arthur had written 45,000 words and the job was done. In October *The Crime of the Congo* was published by Hutchinson, which sold 60,000 copies in Britain. Doubleday, Page brought the book out in the United States and there were also French, German and Portuguese editions (the last aimed particularly at Brazil).

Arthur would later claim that his anger about the Congo was fired by a novel. This was not the obvious contender, Joseph Conrad's seminal *Heart of Darkness*, but Henry de Vere Stacpoole's lesser-known *The Pools of Silence*, published in 1909. This would confirm that he met Morel in July or August, for he wrote very formally to Stacpoole in June, praising his earlier novel *Blue Lagoon* and adding that he had not enjoyed any new writer's work so much since Frank Norris's "Shanghaied." Since Stacpoole was a fellow Anglo-Irish doctor-turned-author who had been producing novels for several years, this was faint praise. But the inference is that, shortly afterward, Arthur was spurred to read *The Pools of Silence*, with its Congolese theme, and this led him to Morel.

Not content with writing a book, Arthur threw himself into exposing what he described to readers of *The Times* as "the greatest crime which has ever been committed in the history of the world." He took up Morel's cry that Britain and France should act to prevent further atrocities—if necessary, by blockading the Congolese port of Borma and preventing rubber exports. He crossed swords with the Catholic Archbishop Bourne of Westminster, admonishing him in a correspondence reproduced in both *The Tablet* and *The Times* for not harrying the Belgians enough: "It is a sad thing to see the venerable Catholic Church falling out of line with the rest of Christian Europe over this scandal." He lobbied his American contacts and argued with his friend H.A. Gwynne, editor of the conservative *Morning Post*, who feared that, if Britain took a unilateral role, Germany might come to Belgium's aid and Europe's hard-won peace might be endangered. Arthur was incensed: "As to keeping Belgium for a friend, if it means throwing our honour overboard in order to conciliate this little ape-tiger, it is not worth it. This is bad opportunism and unworthy of noble England. Let us keep our word and our principals [sic] and trust to God for the rest." His preferred solution was a show of force: "A second-class cruiser could take Borma, which is the sole outlet of the country. There never was so vulnerable a place either from the sea or from Katanga." But he agreed that, at least for form's sake, it was necessary to have a multinational conference first.

Even Morel thought Arthur sometimes went too far in stating his case. But he did nothing to rein in his enthusiastic supporter because "it is perhaps just as well that I should appear more moderate than he is." The two men joined forces on a barnstorming tour of Britain in October and November. Arthur then took the lead when, the following year, Lord Cromer, who had retired as Britain's Agent and Consul-General in Egypt and was proving an unlikely advocate of the Congo Reform Association, suggested a testimonial for Morel. Although the response was initially poor, Arthur was not deterred: he weighed in with a personal contribution of 100 pounds and kept up his offensive against exploitation wherever he saw it.

A year later, in October 1910, Arthur tackled the thorny issue of race in a speech at a dinner given by the Anti-Slavery and Aborigines' Protection Society in London for the conservative black civil rights campaigner Booker T. Washington. That same month, after visiting the Old Bailey to watch the trial of Dr. Crippen, the infamous poisoner, he delivered a lecture on Morel at the City Temple, the free-thinking "Cathedral of Nonconformity" on London's Holborn Viaduct. At the time Arthur was still not satisfied by the paltry 2,000 pounds that had been raised for Morel, but he persevered and was able to hand over more than double that sum at a presentation ceremony the following May.

Stacpoole could only sit back and admire, later writing of Arthur, "His motto was that of Theodore Roosevelt: 'Aggressive fighting for the right is the noblest sport the world affords,' and he lived up to it . . . Doyle was the finest man I have ever met, taking him by and large."

Stacpoole's juxtaposition of military and sporting metaphors was apt. Arthur loved men of action, particularly those capable of sublimating their aggression in civilized pursuits such as cricket or justice.

One of his closest friends fitted the bill. With his wavy dark hair and matinée idol looks, Major Gordon Guggisberg was a former officer in the Royal Engineers who had recently returned from a spell as Director of Surveys on the Gold Coast. Born into a Swiss family in Canada, he, like Arthur, was something of an outsider in England and therefore all the keener to play the game, excelling at polo, racquetball, golf, football and cricket. The two men probably met at a cricket game between the Authors and the Royal Engineers at Chatham in June 1902, when the admiring P.G. Wodehouse observed Arthur coming on to bowl as fourth change after the opposition had scored

220 for four on a perfect pitch. Within seventy minutes the Engineers were all out for 290 and Arthur had taken five wickets for 44. "He was captain that day. A captain who is capable of bowling like that, and yet does not try his hand till fourth change, is no ordinary man." Arthur clearly inspired admiration wherever he went.

Guggisberg provided a link to another of Arthur's favorite activities, the theatre. Before going to Africa in 1905, he had married the petite actress Decima Moore. Arthur, a witness at the wedding, may have introduced them, since she had played the bad schoolgirl Bab in the original production of *Jane Annie*, the unfortunate comedy Arthur had written with J.M. Barrie. After three years in the tropics, the Guggisbergs came back to England and wrote about their joint adventures in a vivid travelogue called *We Two in West Africa* (1909). Decima made a quick return to the stage, where she joined her two sisters (one the mother of Jill Esmond, who was to marry Laurence Olivier).

Such connections ensured that Arthur's theatrical aspirations survived the setback of Addison Bright's death. However, his efforts to sack Bright's partner Arthur Hardy had not proved successful because, as dutifully attested in the schedule of payments in his diaries, he was still employing the same agent when *The Fires of Fate* was finally staged at the Lyric Theatre in London from June to October 1909. The play was mauled by the critics, whose "cynicism and obtuseness" baffled Arthur. They were not alone: when Mary saw it on her return from Dresden for the summer, she found the "clergymen rather ponderous, and the women mere sketches."

Constitutionally unable to be anything but bullish about its prospects, Arthur told Innes, who had attended the first night, that it was breaking all records, sermons were being preached about its message, and the Queen had been to see it (on July 10) and the King was expected the following week. (There is no evidence that Edward VII did attend.) Not only that, but the play's prospects looked good in the United States, where Frohman had unusually offered 500 pounds on account, though Arthur did suggest one or two cosmetic changes for American audiences, such as dropping the subtitle "A Morality Play."

But *The Fires of Fate* only ran in London for four months, after which, like much of Arthur's work, it became fair game for parody. No sooner had the curtain come down than the actor-manager H.G. Pelissier staged a music hall version in his Potted Plays series at the Apollo Theatre. In this short burlesque the stout-hearted Colonel Egerton was portrayed as an alcoholic and the dervishes a figment of his drink-addled brain.

In the wake of *The Fires of Fate*, Arthur's position in the theatre was complicated by a legal dispute between Hardy and Bright's estate, which claimed it should be still receiving a share of the earnings of the dead man's clients. When the case came to court in early 1910 the judge found against Hardy, requiring him to pay up 1,670 pounds, including costs. One result was that Hardy gave up working as an agent and became a manager, whom Arthur used on various later productions.

Another consequence was that Arthur was spurred to dust off his long-discussed Regency boxing play, *The House of Temperley*, and, since no theatre had been prepared to commit itself to the project, he decided to hire the Adelphi Theatre and mount the production himself. It was an expensive undertaking: the initial outlay was 2,000 pounds and the salaries of leading actors such as Ben Webster added a further 600 pounds a week. The play opened on Monday December 27, 1909 (nominally Boxing Day), when it was given an equivocal reception by *The Times*, which compared it with Thomas Hardy's *The Dynasts*: "it throws down the whole period, artlessly and baldly, it's true, but with an interesting completeness and no puling reticence."

With his added financial interest, Arthur promoted the play with more than usual gusto. He told his mother he was amused to observe the change in attitude of people who had formerly rejected it. But by mid-January 1910 it was already clear that *The House of Temperley* was only just surviving—a fate Arthur attributed to the alternative pull of a general election. He had hopes when Lord Esher, the army reformer, paid 300 pounds to hire the theatre on February 11 for an exclusive performance for forty officers and 1,400 men of the London Territorial Force. A hard-hitting Liberal member of the Royal Commission of South Africa a few years earlier, Esher was now adviser to R.B. Haldane, the minister of war, who also attended. He was a strong proponent of the Territorial Army, though differed from Arthur in that he also believed in compulsory national service, but thought it could not be implemented for political reasons and so promoted the Territorials as a necessary stopgap.

Arthur was delighted by this support for his production. "We think we will soar up after this week," he told Innes with his usual bravado. "What an advertisement!" But the expected upturn did not happen. In his eagerness to save his investment, Arthur added a couple of curtain-raisers (one being *A Pot of Caviare*), but these failed to do the trick either. Eventually the play's fate was determined by the death of King Edward VII on May 6, or so the official apologia went. The West End

was plunged into darkness and some plays, such as Arthur's, were never revived. He himself later admitted that it had been doomed by its lack of appeal to women.

With part of his six-month lease on the Adelphi Theatre still to run, he had toyed with the idea of putting on a piece about the Congo. But realizing that his audiences were tired of being lectured at, he decided on the easier option of a stage version of his popular Sherlock Holmes story "The Speckled Band," something he had been working on since as far back as February. He originally called it "The Stonor Case," changing the surnames of the two main female characters from Stoner to Stonor, while the evil Dr. Grimesby Roylott became Dr. Grimesby Rylott. But under the circumstances he decided to play it safe and he kept the easily identifiable title *The Speckled Band.*

After his recent setbacks, this proved a great success, though Lyn Harding, in the role of Rylott, almost stole the show from the more experienced H.A. Saintsbury as the iconic Sherlock Holmes. Arthur had originally conceived Harding as a melodramatic stage villain, but the actor himself argued for a more subtle interpretation, a stand that was endorsed by J.M. Barrie, who was called in to adjudicate.

Although the new play was soon making money, Arthur's ambitions as an impresario had lost him over 5,000 pounds in 1910, or so he told his friend Frank Bullen at the end of the year, adding, true to form, "Hope to make it up by hard work, but it will take time." Although he now liked to suggest he was finished with the stage, he continued to benefit from revivals, usually in the provinces or the music halls, where he mentioned at least two plays being performed in 1912—one, *The Lift,* later the basis for a chilling story of that name, and the other, a Sherlock Holmes piece in one act, probably *The Crown Diamond,* which had to wait several more years for a full production. He also adapted *Mrs. Thompson,* a book by Mary Elizabeth Braddon's son W.B. Maxwell, for the stage. But this was not performed, even though he believed the now unremembered Maxwell was "the greatest British novelist."

Soon afterward Arthur's association with Arthur Hardy finally ended, following a dispute over money. His former agent was subsequently declared bankrupt, blaming his losses on the stage. By then the reason for Arthur's fading interest in the theatre was clear: he had found a new, more promising medium. Film studios had been sniffing around his work since the start of the century when the American Mutoscope and Bioscope company produced an appropriately named mishmash, "Sherlock Holmes Baffled." Over the next decade the

detective's services were appropriated for several non-canonical films, including a series in Denmark. But no original Conan Doyle material was used until 1912 when, with Arthur's cooperation, the Anglo-French firm Eclair shot several of the Holmes stories. Only one, "The Copper Beeches," is known to have survived and the print is now too fragile to be shown.

The transfer of Sherlock Holmes to the screen was dogged by the fact that no one was sure who owned the copyrights. Had Arthur inadvertently given away the cinematic rights to *A Study in Scarlet* as part of the package for which Ward Lock paid a miserly 25 pounds in 1887? Did William Gillette retain some lien on the character after his pioneering efforts on the stage? Arthur felt he was on safer ground with his non-Sherlockian material. When, in late 1913, the London Film Company put out the first movie version of *The House of Temperley*, he enthusiastically endorsed it, declaring that it was "infinitely better than my own play," or at least those were his words as they appeared in an advertisement.

He was aware that something significant was happening in the business of storytelling. When Mrs. Humphry Ward asked for advice about "some of these new schemes for the cinematographic reproductions of novels," he urged her not to rush, "for our rights are an asset which is rising in value, no one knows quite how much. English cinema films are in their infancy, but promise well, and it is there that our hopes lie. Unhappily the higher literature of thought and pathos is handicapped as compared to mere plot and action." In other words, he thought the cinema could be useful for a character such as Sherlock Holmes, but less so for the great imaginative work he still yearned to write.

Pre-war:
From Cornwall to Canada

1909–1914

Back in the spring of 1897, Sherlock Holmes became so exhausted that he was ordered by his Harley Street physician to take a complete rest, or else he would suffer a nervous breakdown. According to the story "The Adventure of the Devil's Foot," he then removed himself to the remote village of Poldhu, a "singular spot" on the bleak western side of the Lizard peninsula in Cornwall, where, accompanied by Dr. Watson, he was on hand to investigate the strangest case he had ever handled.

Thirteen years later, Arthur found himself in a similar situation. His mental health was not at risk, but he desperately needed to get away from various pressures. His marriage to Jean was happy enough, but he had not been prepared for his difficulties with his older children. The legal proceedings over Addison Bright's estate had added a discordant note to the problems surrounding his plays. Because of the drain on his financial resources he was actively looking to sell Undershaw.

Partly for this reason he turned down Mary's request for a yearly income. What she described as an "unfortunate scene" had occurred when she broached the subject the day before her twenty-first birthday in January 1910. She had returned to Dresden until the summer, while her brother completed his schooling at Eton. The plan was for them then to change places, Kingsley taking a year off to brush up on his languages at a Feldkirchian establishment in Lausanne, before going to St. Mary's Hospital to study medicine, while she pursued her musical stud-

ies in London. Arthur had his son's career mapped out: the boy was going to be a cancer specialist; he would qualify by a particular date, spend a year in a foreign laboratory by another, and be ready for a junior post in a research laboratory at Christmas 1918. Smoothing the way, Arthur needed to gather his thoughts for a talk to students at St. Mary's on "The romance of medicine."

He also had some serious political thinking to do. For Britain was in the middle of a constitutional crisis. Pressed by the emerging Labour Party to its left, the Liberal government had embarked on a number of social reforms, starting with old age pensions. To pay for these, it had tried to raise taxes, but this had antagonized the House of Lords, which had rejected Lloyd George's People's Budget in November 1909. A subsequent general election had backed the reforms, giving Prime Minister Asquith a mandate to overhaul the Upper House if required, but left the balance of power in the hands of the Irish nationalists.

This was a fraught situation for a man of Arthur's complex views and sensibilities. Although he remained essentially a Liberal Unionist, his politics had drifted to the right, even if he retained solid radical instincts on subjects such as individual rights. But the de facto Irish veto in the House of Commons complicated matters and, as he prepared to go on holiday in March 1910, he had plenty of options to weigh in this area.

He kept his opinions on the immediate constitutional issue close to his chest. But his old school friend James Ryan, who was back in Scotland from his Ceylon estates, must have felt he was addressing a sympathizer when, before the election in January that year, with the Liberals threatening to create as many peers as were needed to pass their legislation, he told Arthur he was looking forward to Asquith's new creations all changing sides, thus making the new Upper House not only stronger than before, but "twice as active & twice as Conservative."

Jean needed a rest too. It was almost a year since Denis's birth, and she had just learned she was expecting another baby. The timing could not have been better: this was "officially" the thirteenth anniversary of her first meeting with Arthur. So they were both able to celebrate in the Poldhu Hotel, which had been built in 1901 for the workers who set up the nearby communications station from which Guglielmo Marconi sent the first wireless signal across the Atlantic Ocean. The snowdrops were no doubt flowering in Cornwall's temperate climate.

Arthur relaxed by playing golf on the links at Mullion. Like Sherlock Holmes he was excited by evidence around him of Cornwall's ancient language and culture, with its stone monuments and burial mounds providing "traces of some vanished race." He had waxed lyrical along these lines in *Through the Magic Door*. "That long peninsula extending out into the ocean has caught all sorts of strange floating things, and has held them there in isolation until they have woven themselves into the texture of the Cornish race." There he had praised the strong, beautiful, un-Saxon qualities of the part-Cornish Henry Irving. Although he characterized these as pre-Celtic, perhaps sensing links with his purported Breton antecedents.

Never able to tear himself away from his work for long, he continued to tinker with *The House of Temperley*, even while he was in Poldhu and the play floundering in London's West End. Either while still on holiday, or shortly after his return home, he wrote "The Adventure of the Devil's Foot." This is one of the best stories in the canon—taut, exciting and true to form, with Holmes as rational as ever: even when the local vicar rushes around declaring that, following a spate of murders, his parish is "devil-ridden," the detective remained coolly scientific, scoffing at any "diabolical intrusion into the affairs of men," and happy to demonstrate his (and Arthur's) old bravado by being prepared to experiment with a potential poison on himself and Watson.

"The Devil's Foot" was evocative not just of Cornwall but also of Arthur's wider interests. Holmes's engagement with history and philology was mirrored in Arthur's exploration of the fossils and artifacts hidden in the chalk soils around his house in Sussex, and in his poring over books such as Isaac Taylor's *The Origin of the Aryans* (very good, according to the note in his diary, where he added a typical comment that, because all Aryan languages had similar words for beech, snow and ice, the original Aryans must have come from a cold climate).

Appropriately the murderer in this latest story was an African explorer, Dr. Leon Sterndale, who excused his villainy by arguing that he had been avenging the woman whom he loved but could not wed since he was already married and unable to obtain a divorce. Holmes was so moved by this defense that he again decided against delivering the guilty man into the arms of the law, declaring that, though he had never loved a woman, he imagined that, if he had, he would have acted in a similar manner. This reflected Arthur's own sympathy to people locked in unhappy marriages—an attitude that had led him to adopt another public cause and take an active role in the Divorce Law Reform Association.

Over the next few months, as his theatrical fortunes revived with *The Speckled Band*, Arthur wrote two further, if less interesting, Sherlock Holmes stories, "The Adventure of the Red Circle" and "The Disappearance of Lady Frances Carfax," which took their usual place in the *Strand Magazine*. (In the latter the eponymous lady had been staying in Lausanne, Kingsley's destination in October.) Greenhough Smith seemed happy enough at what he was getting, for on December 7, 1910, he published the first and apparently only issue of the *Daily Strand*, a tabloid that carried the headline "Mysterious Horror in Cornwall" and "striking photographs from the scene of the crime," and which directed readers to the full story in the current issue of the *Strand Magazine*.

While he was at it, Arthur could not refrain from updating the adventures of some of his earlier characters, including Brigadier Gerard in "The Marriage of the Brigadier" and Captain Sharkey in "The Blighting of Sharkey." He also produced an underground horror story, "The Terror of Blue John Gap," which looked back to his student on-call days for its setting in the Derbyshire Peak District and forward to *The Lost World* for a science fictional glimpse of a mysterious creature being nurtured over millennia in an alien natural environment.

Arthur himself seemed stuck between the past and the future as he embarked on a series of stories about the Roman empire, a much earlier period than usual. Appearing sporadically from late 1909 to early 1911 in lesser-known outlets, such as the Harmsworth-owned *London Magazine*, these were often fables about modern Britain's position in the world. He himself noted that "The Last Galley" was about the British naval question and "The Last of the Legions" about the abandonment of India.

His unexpected adviser was James Ryan, who had just finished editing Robert Knox's seventeenth-century account of being held captive on Ceylon. Ryan inundated Arthur with ideas, such as a story about a Christian slave who smashed a senator's treasured Greek statue of Venus. Arthur adopted this as "An Iconoclast," but balked at his friend's suggestion of a scene in the arena with African pygmies, gorillas and okapis.

These stories showed that Arthur had lost none of his interest in the paranormal. Thus, the concept behind "The Silver Mirror" in 1908—that sensitive people can unlock historical memories through their contact with objects and places—surfaced again in "Through the Veil," one of these historical tales, in which a Scots couple's visit to a fort at Newstead results in a vivid dream of a Roman battle. "For an

instance," Arthur wrote, "the curtain of the past had swung aside, and some strange glimpse of a forgotten life had come to them."

Arthur's ongoing quest for unusual subject matter was evident from his good-natured remarks at a luncheon at the Royal Societies Club in May 1910 for the American explorer Commander Robert Peary. He had been attracted to the lure of new frontiers since learning of Speke's exploits and reading about the American Wild West as a child. He knew only too well how exploration had led directly to the expansion of the British empire. He had recently developed an interest in the detail of mounting expeditions to distant corners of the earth following his research into the Congo (and thus the appearance of Dr. Leon Sterndale in "The Devil's Foot"). He had addressed a similar luncheon for Ernest Shackleton the previous year, and had subsequently appeared with Captain Robert Scott at a fund-raising meeting for the British Antarctic Expedition.

His agenda became clearer as he skittishly admonished Peary for following a profession which had taken the romance out of story-telling. In his own younger days, Arthur recalled, he could write about somewhere such as Tibet without fear of contradiction. Now every far-flung part of the planet was known and mapped, "and the question is where the romance-writer is to turn when he wants to draw any vague and not too clearly-defined region."

Again the Congo provided a roundabout answer. As a result of his lobbying on that issue he had agreed to write a preface to *The Fair Land of Central America* by the Belgian Maurice de Waleffe. The thrust of his low-key contribution was to question the author's thesis that the United States posed a threat to its Latin American neighbors. Although this book was not published until October 1911, Arthur's few paragraphs were written two years earlier, just one month after *Truth*, the muckraking weekly until recently owned by Henry Labouchere, printed startling allegations that a British trading concern, the Peruvian Amazon Company, was mistreating workers on its rubber plantations in the Putumayo basin of Peru as badly as the Belgians had done in the Congo. Arthur made no mention of this piece of journalism but his antennae were so well tuned that he must have known it, and thereafter his attention was more focused toward South America.

One reason was his growing friendship with Roger Casement, who in the summer of 1910 had returned to London on leave from his posting as British Consul in Brazil. Arthur enlisted the Irish-born diplomat's support for the testimonial for E.D. Morel. But their rela-

tionship was not all business-related as he entertained Casement on at least three occasions (including a visit to the play *The Speckled Band*). At the time the scandal about the Peruvian Amazon Company was brewing, and the Liberal government was forced to commit itself to sending Casement to investigate on his return to South America.

Hearing of this, Arthur told Casement how much he envied his impending journey up the Amazon, adding that he hoped to write "a sort of wild boy's book" about the region. "The idea roughly is that news reaches a group in England of a peculiar place up in the unexplored parts at the head of one of the tributaries of the Amazon. At this a considerable plateau has been elevated long years ago, and left with cliffs all round which forbid access. On the 40 square miles of the top the extinct flora and fauna still live, dinosaurs, maslodaurs & a weird prehistoric race up trees. My group go there, take photos & have wondrous adventures." He charged Casement with letting him know if he discovered "anything weird & strange out there . . . and I'll sew it into my patchwork quilt."

James Ryan confirmed this project's existence when, at much the same time, he expressed his delight that his friend had "a boy's book in embryo." He thought it would be "good stuff—rocketing pterodactyls and expanding bullets poured into armoured plated armadilloes."

But Arthur was in no hurry to put pen to paper: he needed more background detail. One of his contacts was Percy Fawcett who, after a military career specializing in undercover missions, had been heading the Bolivian Boundary Commission, mapping the Amazon basin between Brazil and Bolivia. When Fawcett gave a talk to the Royal Geographical Society on February 13, 1911, he found Arthur particularly interested in his description of the flat-topped Ricardo Franco hills in the Matto Grosso. "He mentioned an idea for a novel on Central South America and asked for information which I told him I should be glad to supply."

One reason for the book's slow progress was that Arthur had discovered dinosaurs in his backyard, or at least he thought he had. He had been fascinated by these creatures ever since coming across a fossil dig while out on a walk at Stonyhurst. Moving to Crowborough had revived this enthusiasm, because the soils of the Weald were stuffed with bones and other relics from prehistory. His imagination was further stimulated by the young ichthyosaurus or fish dinosaur he believed he had observed on honeymoon in the Greek islands. A year or so later he was presenting his compliments to the Marquess of Abergavenny, a major

landowner in Sussex and Kent, and asking his permission to make a
small excavation in search of traces of primitive man in the High Rocks
area south of Tunbridge Wells. Although the rocks were already well
known, Arthur stressed that any discovery he made would add to their
fame. That initiative does not seem to have succeeded, as there is a sub-
sequent undated letter, presumably to the Marquess's agent, stating that
he had made two trenches at the High Rocks but drawn a blank.

In the spring of 1909, he had more success. Having found giant
lizard tracks and associated fossils in a quarry near Windlesham, he
wrote to the Natural History section of the British Museum, asking for
an expert to come and view them. Arthur Smith Woodward, Keeper of
Geology, traveled by train to Groombridge where Arthur picked him
up in his car. Although little seems to have arisen from his visit, Smith
Woodward obviously mentioned it to his friend, Charles Dawson, a dis-
tinguished amateur paleontologist who lived in Lewes and was involved
in many local excavations. Dawson informed him he would like to
meet Arthur.

Arthur made another prehistoric sighting in February 1911, when
he told Smith Woodward, "We are keeping it carefully—it is 9 foot
long—in the hope that you may be able to come down." The British
Museum man seems to have traveled down again, because three
months later Dawson wrote to him, referring to a consequence of his
visit, which was that a "wild story" was circulating "about the discovery
of a whole iguanodon at Crowborough." Dawson was amused that this
had brought W. Ruskin Butterfield, the curator of Hastings Museum,
bicycling nearly forty miles to investigate, and "on his arrival he was
shown a rock supposed to have a resemblance to a curled up Kanga-
roo, understood to be a type of Iguanodon!"

But still Arthur held back from his boy's novel about the Amazon.
His Roman stories made up the bulk of his collection *The Last Galley*,
published in April 1911, which he claimed with typical if unwarranted
braggadocio was his best ever. He had also recently completed a long-
discussed book of verses, *Songs of the Road*, whose date of publication,
March 16, the day after his anniversary with Jean, pointed to a special
significance. Four months earlier she had given birth to her second
son, Adrian Malcolm. Now Arthur made a public statement of his
love for her in a poem pointedly titled "To my Lady," about a man who,
when asked to choose from among four women with different attrib-
utes—kindness, mellifluousness, grace and beauty—cannot make up
his mind, until an angel puts him out of his misery by presenting a lady
who precludes all debate "by being all in one."

Elsewhere, Arthur seemed curiously uncertain of Jean's affections, penning two poems about a wife whose romantic affections had strayed. Although there was no evidence that he was writing from his own experience, he hinted at the source of his anxiety in a poem about a man's love for a woman approximately twenty years his junior. Age has not dimmed his ardor, though "I am a year/ Short of sixty, my dear,/ And you are—well, say thirty nine."

Indeed, beneath the surface of his Kiplingesque ditties and neatly scanned philosophical disquisitions, he gave the impression of a man struggling to come to terms with not only his own age (now fifty) but also the passing of the whole golden Edwardian era.

Arthur's poem "A Post-Impressionist" suggested that he and Jean had visited the controversial Manet and the Post-Impressionists exhibition at the Grafton Gallery in late 1910. In it he vented his indignation at its unaccustomed aesthetics in this poem about an artist who, after a lifetime's toil as an academician, absent-mindedly left a landscape painting out in the rain, only to find "All the outlines blurred and wavy,/ All the colors turned to gravy." But this new style was fêted by critics, who told him he had "out-Monet-ed Monet." When asked his secret, the painter replied casually, "English climate's best for Art."

Arthur had not lost his sense of humor, but was having difficulty coming to terms with the cultural relativism of the modern world. He vented his spleen in his commonplace book: "One of the singular characteristics of the present age is a wave of artistic and intellectual insanity breaking out in various forms in various places. If it stops where it is, it will only be a curious phenomenon. If it is a spreading movement, it will be the beginning of vast human changes." He recalled how this development had been noted by Max Nordau in his 1895 book *Degeneration*, but had made considerable advances since then. "It is the difference between queerness and madness, between the Pre-Raphaelites and the Post impressionists, between Wagner's operas and Electra, or between the French symbolists and the Italian futurists. Nietzsche's philosophy in a purely mental way is symptomatic of what I mean. It is openly founded in lunacy for the poor fellow died raving. One should put one's shoulder to the door and keep out insanity all one can." He compared what was happening to the grotesque Byzantine art which supplanted classical. He conceded that sometimes, in art as in politics, it was necessary to have a revolution which, although appalling in itself, opened the way to new things. But he could see no need for this now, particularly if it meant flirting with unreason. That is why, he said, he was so keen on Tennyson. "He

was strong, original and always sane. If his head was among the stars his feet were on the ground."

This was a significant outburst. On one level, it was a neat summary of Arthur's cultural conservativism. On another, it showed his visceral reaction to any hint of his father's pitiful state of mind. Coming at this stage, it was also a position statement. He had never regarded himself as part of the avant-garde, but he had tried to remain open to new literary trends. Now, after a period of uneasy poise between the past and the future, he was firmly closing his mind to modern ideas.

This was odd because many recent intellectual developments were in keeping with the fluid model of the universe that came with his paranormal interests. Linear notions of time had been challenged by philosophers such as John McTaggart and Henri Bergson, while the concept of the solidity of matter had been dented by the discovery of the electron by J.J. Thomson in Cambridge and by the theory of special relativity being articulated by Albert Einstein.

Arthur might have lost faith in the culture of his day but, as he settled into quirky middle age, he had not turned his back on the modern world. Still fascinated by technical developments, he went up in a biplane at Hendon in May 1911. This proved a mixed blessing, as his aircraft had difficulty making headway into the wind. Since there had been a fatal accident there the same day, Arthur was relieved to return to base.

At the same time he supported innovative companies with hard-earned cash. One such business manufactured the Autowheel, a basic two-stroke engine that could be attached to the back wheel of a bicycle. This had taken the place of the Sculpture Company as the business he tactfully pushed to his friends. It had developed out of the Guildford-based Roc cycle company in which he had held a stake for some years. When the inventor, A.W. Wall, moved to Birmingham and set up his eponymous firm to produce the Autowheel, Arthur continued as his chief financial backer. After this machine was shown at the leading trade fair, the Stanley Show, in 1909, Arthur was delighted with its reception and told his mother that since he controlled two-thirds of the company, he and his family stood to make a lot of money. For a while the forecasts looked good, with James Ryan, for example, suggesting that the Autowheel had a future powering the all-pervasive rickshaws in Ceylon. But again the results failed to match the hopes: Arthur fell out with Wall and lost heavily as he chucked good money after bad.

His holding in the East Kent Coal Company did not fare much better. Since the first tentative borings of a Channel tunnel in the 1880s, the southeast corner of England was believed to enjoy the same rich carboniferous seams as in northern France. But early attempts to mine around Dover were plagued by the involvement of a notorious fraud, Arthur Burr, and East Kent followed in this tradition. Arthur recorded wryly how he descended 1,000 feet to inspect this precious commodity, which seemed to have every quality of coal except combustibility. When the shareholders held a publicity-seeking dinner which was supposed to be cooked by local coal, they were forced to send out to buy something which would burn.

At least he recognized the funny side of this obsession. In his study he kept a chunk of coal and would regale visitors:

> Here in my room I keep a lump for show
> This I would gladly drop upon your toe
> As round the room in frenzied hops you went
> You would acknowledge there was coal in Kent.

To finance such holdings Arthur had been trying to sell his interest in the American publishing company McClure's. After continuing success at the start of the century, when it set the standards for investigative (President Theodore Roosevelt called it "muck-raking") journalism, *McClure's Magazine* had suffered a setback when its entire editorial staff walked out, declaring its proprietor impossible to work for. McClure had steadied the ship by hiring the respected Willa Cather as his managing editor in 1906. But two years later, when he discussed several other wildly ambitious projects after selling his book-publishing arm to Doubleday Duran, Arthur began to ask seriously about cashing in his shares, and when he found himself rebuffed he called in not only his American lawyer Augustus Gurlitz but also his *Idler* friend Robert Barr, who had some residual influence with McClure.

Arthur offered Barr a commission on any settlement he could broker. He thought it outrageous that McClure should be claiming a profit of only 6,000 pounds, when his magazine still had a circulation of 400,000. But the creditors were indeed gathering, and despite the magazine's continuing healthy circulation, its failure to make money forced McClure to sell it off the following year. Arthur did not receive his payback for another ten years.

Despite his lack of obvious business success, his name was still sought to lend gravitas to company boards. In June 1908 he had been

invited to become a director of Cranstons Hotels, a family firm run by the former Lord Provost of Edinburgh, Sir Robert Cranston, a robust Conservative and patriot, who had attended Arthur's wedding and was a strong Scottish advocate of the Territorial Army. (His group owned the Waverley Hotels in Edinburgh and Glasgow, as well as the Waverley, Kenilworth and Ivanhoe Hotels in London.) Although Arthur had signaled to Cranston that he would not be able to do much work outside London, he had accepted because of the attractive salary. But within three years he was being asked to resign, ostensibly for missing vital board meetings and failing to visit the group's hotels (a charge he denied). He claimed he had only been asked to become a director because Cranston's affairs had been in a mess and in need of a respectable public face to raise money for his company. Having put his case to the shareholders, Arthur agreed to travel to Edinburgh for a board meeting on June 27, 1911, a date which he felt had been deliberately chosen to inconvenience him as it clashed with his plans for participating in an international motor rally, the Prince Henry Tour. This interpretation gained credence when the meeting was delayed, so preventing his return to London, as booked, on the afternoon train.

With its natty green livery and garish cockatoo mascot, Arthur and Jean's French-built 16-horsepower Lorraine-Dietrich looked out of place in a major event run in Germany and Britain under the auspices of the kaiser's brother and admiral of the German fleet, Prince Henry of Prussia. Although it had the sporting aim of testing the cars of both nations against one another, the tour's underlying diplomatic tensions were obvious, not least from the way each vehicle carried an observer who was a serving officer from the other nation. But Arthur, usually so sensitive to Britain's interests, had always been a Germanophile and, testament to the diplomacy of his "minder," Count Carmer, Rittmeister of the Breslau Cuirassiers, he wrote to *The Times* after the first stage of the trial in Germany remarking on the "extreme kindness and sympathy" which he and his fellow competitors had received there.

Oddly there was no suggestion of the growing military threat that many commentators felt Germany posed to Britain, particularly after the Kaiser had dispatched the gunboat *Panther* to Agadir at the start of the year. In his memoirs Arthur tried to backtrack from this position, referring to strained relations between the two countries from the start. But this was not the impression he gave James Ryan, whom he informed at the time that, after a week in Berlin, he found much to

admire and little to fear, and he had returned feeling easier. Although he did also admit that the British officers on the trip saw matters differently and were very pessimistic, his German sympathies undoubtedly got the better of his equally long-standing concern about British defenses. The tour became a massive publicity coup for Prince Henry, an outcome Arthur no doubt discussed when he was soon back on the Continental mainland for Innes' wedding to Clara Schwensen in Copenhagen on August 2, 1911.

It was not until October that he finally sat down and started writing *The Lost World,* his long-planned book about the Amazon basin. This was an enjoyable confection, bringing together his obsessions with exploration, prehistory and science, in a fast-paced romp that stuck closely to the outline he had given Casement over a year earlier. Its science was sound, even if the detail of the prehistoric animals was taken from Professor E. Ray Lankester's 1905 book *Extinct Animals.* (The exact location was imprecise from the expedition's itinerary: it could have been either Fawcett's Ricardo Franco hills in western Brazil or Mount Roraima in southern Brazil.) It was also a gripping story, putting an idiosyncratic Conan Doyle marker on the long list of prophetic science fiction being written by authors such as H.G. Wells.

Arthur injected part of his own infectiously curious self into his narrator, the young journalist E.J. Malone, who, spurned by a woman in love with an ideal of a hard explorer type, jumps at an opportunity to join an expedition to verify the irascible zoologist Professor Challenger's claims to have discovered a prehistoric world in the jungles of South America. Once there, among exotic plants and animals, Malone's Celtic temperament is said to make him sensitive to the malign presence of an ape-man or "missing link." And, on his return, there was a nice irony in the manner he fails to win the woman he wanted: in marked contrast to the practice in the chivalric Middle Ages, she has opted to marry not an explorer but a solicitor.

At the start of the same month, Arthur's mentor Joseph Bell died in Edinburgh. He already had his memorial in the Sherlock Holmes stories, but Arthur wanted to make public his debt to his alma mater. Not only did he state that Challenger was educated at his old university, but he also emphasized the point by giving his fictional explorer the name of the scientific research ship on which his old Natural History Professor Charles Wyville Thomson had served, and then basing this character on his Physiology Professor William Rutherford. Any doubts about this connection were dispelled when James Ryan went to Edinburgh for Bell's funeral, came across another of their teachers—a

chirpy but very ancient Littlejohn—and reported back to Arthur that he had persuaded Frank Caird, the professor of clinical surgery at the university, to have his statuette of Rutherford photographed from a variety of different angles.

Several of Arthur's recent experiences were recalled in the book. When Challenger came across a three-toed track in the jungle, he described it as very similar to something that he, like Arthur, had seen in the Wealden clay. When he followed it, he found that it came not from a reptile but from a living dinosaur. These fictional iguanodons, the species Arthur had been searching for around his house, turned out to look "like monstrous kangaroos," the animal to which Ruskin Butterfield had dismissively compared Arthur's find in Sussex a few months earlier.

The close link between this story and his own amateur palaeontological research was emphasized in November when Charles Dawson himself visited Windlesham. Arthur was in the middle of his writing but must have come across another mysterious find, for Dawson sneeringly told Smith Woodward of his trip to view "the great fossil" which turned out to be nothing more than "mere concretion of oxide of iron and sand." He noted how he had drawn his host's attention away from this to the drift deposits overhead where there was a flint protruding, and how Arthur had been almost pathetically grateful to have alighted on at least something.

Around this time Arthur was laid low by a bout of rheumatism which he treated by going to the dentist. For some reason he regarded good gums as a universal remedy, which seemed unorthodox for an Edinburgh-educated MD. Nevertheless, by early December he was feeling better and "quite enjoying life." Kingsley had now started at St. Mary's Hospital and was living with Mary and "Aunt Juey" in Paddington, close to where he worked. Innes and Clara were based in new quarters in Chester, and when they paid a pre-Christmas visit to Windlesham Arthur ran up a Danish flag in his sister-in-law's honor. "She will be pleased," he told his mother proudly in advance.

In keeping with his upbeat mood he spent some time thinking about the artwork for *The Lost World*. He asked his brother-in-law Pat Forbes to produce some drawings of its fauna and flora, using doctored photographs from E. Ray Lankester's *Extinct Animals*. He then prevailed on William Ransford, a photographer friend of Pat's, to take a picture of the "members" of the expedition. For this purpose he himself donned a wig and a long dark beard and transformed himself into Professor Challenger. He was so delighted by the effect that he

appeared on a startled Willie Hornung's doorstep in this guise. When he wrote an epigram for the story—

> I have wrought my simple plan
> If I bring one hour of Joy,
> To the boy who's half a man
> Or the man who's half a boy.

—he echoed Rider Haggard's dedication to *King Solomon's Mines* in 1885—"to all the big and little boys who read it." Arthur had been waiting a long time to write this book.

Arthur's mother had been due at Windlesham at the end of April 1912, the date *The Lost World* first appeared in the *Strand*. But he put off her visit after the supposedly unsinkable ocean liner *Titanic* went down in the icy waters of the North Atlantic on the fifteenth. Among those drowned was his old friend W.T. Stead, whom he still respected as a spiritualist, even if he had fallen out with him over politics. (He had written *The War in South Africa* partly as a rejoinder to Stead's pro-Boer sentiments.) In the aftermath of the disaster, a shocked Arthur turned his hand to an uplifting poem, "Ragtime," which was printed in a souvenir brochure for a charity performance at the London Hippodrome, one of many money-raising events for victims' families. Reminiscent of Kipling's "Birken'ead drill," his verses paid tribute to the gallant manner in which the ship's musicians played on:

> Shut off, shut off the ragtime! The lights are falling low!
> The deck is buckling under us! She's sinking by the bow!

Arthur was even more outraged when George Bernard Shaw questioned the crew's integrity, sarcastically describing the disaster as a "triumph of British navigation." After a bitter clash of opinions in the *Daily News*, Arthur showed his common decency in accusing Shaw of lacking "that quality—call it good taste, humanity, or what you will—which prevents a man from needlessly hurting the feelings of others."

In May Arthur found a better cause. Following the Edalji case, his help had often been sought by victims of court decisions. One such figure was Oscar Slater, a German-born Jew with a low-life reputation, who had been the prime suspect after a rich elderly spinster called Marion Gilchrist was hammered to death in Glasgow's West Prince's Street in December 1908. Slater's case was not helped when, after the murder,

he had tried to pawn a brooch (the only item which appeared to have been taken from Gilchrist's first-floor room), and soon afterward assumed another name and sailed across the Atlantic with a girlfriend. After being arrested in New York, he agreed to travel back voluntarily to face questioning in Scotland, where he was put on trial in May 1909. Despite paltry evidence he was found guilty and sentenced to death, later commuted to penal servitude "for the term of his natural life."

Widely regarded as unjust, Slater's conviction came under intense scrutiny. But, despite being approached by Slater's legal team, Arthur declined to become directly involved until the case was highlighted in a special edition of William Roughead's celebrated series of "Notable Scottish Trials" in May 1912. When his mother expressed concern that he was sticking his neck out, he urged her to trust his judgment, declaring that Slater was as innocent as either of them, and they must do their utmost to get him released. He dashed off a sixpenny pamphlet, *The Case of Oscar Slater*, which was published by Hodder & Stoughton in August. This argued that the trial jury should not have been asked to consider evidence about Slater's past life or change of name. Crucially the brooch the imprisoned man had pawned had not been stolen from Miss Gilchrist but was owned by his own girlfriend. Arthur's intervention inevitably put the trial back into the public arena, but it would be many years before there were positive developments.

In July Arthur entertained an ideal *Lost World* reader in twelve-year-old Michael Llewelyn Davies, who stayed at Windlesham with his guardian J.M. Barrie. Michael was one of four brothers who had come under Barrie's care following the deaths of their parents. Together they had helped inspire Barrie's play *Peter Pan*, which had been published as a book the previous year. Barrie had remained close to Arthur, telling him, after his divorce in 1909, how he was planning to look after the boys. (Arthur's fervent support for divorce law reform may well have been influenced by his sympathy for the plight of his friend in his cuckolded marriage.) So now, preparing for his visit, Barrie gingerly informed his host that it would be good, though not essential, if Michael slept in his room, as the boy liked that. A little later Arthur sent Michael a finished copy of *The Lost World*, whose unreal mood may well have owed something to Peter Pan.

That same month Arthur received an unexpected boost when Ronald Knox, an Oxford classics don, published an essay on Sherlock Holmes in a short-lived undergraduate review, the *Blue Book*. This piece was based on a paper, "The Mind and Art of Sherlock Holmes,"

that Knox had given to the university's Bodley Club, subjecting the Holmes oeuvre to the same elaborate textual exegesis that German scholars had afforded the Bible. The Bodley Club members loved it, adding their own commentaries on the Ur-text, including a reading that Watson was a woman. After digesting Knox's published version Arthur wrote to thank the author, taking the opportunity to expand on several points. He stressed, for example, that he had never given Watson anything clever to say as this would have destroyed his bumbling image. Ever sensitive to accusations of plagiarism, Arthur was also careful to point out that Holmes's period of exile in "Thibet" (chronicled in "The Empty House") was not copied, as Knox's learned expert Sauwosch had intimated, from the travels of Dr. Nikola, the Moriarty-type villain featured in the works of the Australian author Guy Boothby in the 1890s. Knox, who was to become a high-profile convert to Catholicism, later thought that Arthur had taken it all too seriously. But mock-Sherlockian "studies" had now joined literary pastiches as an enduring by-product of Arthur's great detective.

Arthur still played the occasional game of cricket, appearing with P.G. Wodehouse for the Authors against the Publishers at Lord's on August 21. A few days earlier Wodehouse had asked if he could visit Windlesham and bring an American woman journalist. "I have traded so much on my friendship with you that my reputation will get a severe jolt if you refuse it," he wrote endearingly, adding that he was "absorbed" in *The Lost World.*

Now that he was in his fifties, Arthur's main sporting activities, apart from cricket, were golf (he had captained the Crowborough Beacon club the previous year) and billiards (he was the holder of the Authors' Club handicap cup). He was also involved in sports administration, which explains his interest in the Olympic Games in Stockholm that summer. Following the Dorando affair in London four years earlier, he had been elected president of the Amateur Field Sports Association, which was eager to improve on a disappointing British haul of medals. But after the national team failed again in Stockholm, Arthur wrote to *The Times* suggesting how it could do better in Berlin in 1916. His ideas struck a chord and soon he was being touted, with Lord Desborough, president of the British Olympic Association, to plan British strategy for the next games, a role he was delighted to take on, telling his mother he would succeed through various ruses, such as bombarding *The Times* with letters.

His initiative led to the launch of an appeal, headed by the Duke of Westminster, to fund the British Olympic team. This injection of cash

into a proudly amateur sport led to protests that the Olympic ideal was being corrupted. Arthur took this criticism unflinchingly: despite his love of "playing the game," he was equally adamant that an improved performance, particularly in Berlin, was vital for national morale.

As a diversion he knocked off "The Fall of Lord Barrymore," a story about the Regency, an era unsullied with moral ambiguity about payments to prize athletes and fighters. In this the eponymous peer, a notorious rake, receives his comeuppance in a comic extra-ring fracas staged by an Oxford undergraduate eager to pry money out of his uncle Sir Charles Tregellis, the buck at the center of *Rodney Stone*.

Jean was pregnant and, to prepare her for what he called her ordeal of childbirth, he took her to France, where they stayed in Le Touquet in September. He returned for the publication of *The Lost World* by Hodder & Stoughton on October 15, 1912, before launching into another Professor Challenger story, *The Poison Belt*, of which he had written 20,000 words, or two-thirds, by November 23.

Arthur's autumnal regime was jolted by the sensational news that Charles Dawson had discovered a prehistoric skull in what was practically his own backyard—a gravel pit at Piltdown, where he regularly played golf, a Sussex village only seven miles from Crowborough. Dawson and Smith Woodward had pieced together an ape-like fossil, which they presented to a packed meeting of the Geological Society as a hitherto undiscovered type of early human, "Eoanthropus dawsoni," Dawson's Dawn Man, later popularly known as Piltdown Man, and described as the vital missing link in human evolution. Arthur sent an immediate letter of congratulation, which had Dawson informing Smith Woodward that Arthur seemed "excited about the skull" and "had kindly offered to drive me in his motor next week anywhere."

Forty years later, well after Arthur's death, this celebrated fossil would be exposed as a fraud, an ingenious but relatively unsophisticated cobbling together of a orangutan's jaw and a modern man's cranium. But already rumors were flying and before long Arthur's name was being put forward as a collaborator in an elaborate hoax. Had he not worked with Dawson? Was he not determined to make his mark as a palaeontologist? His commonplace book would have done little to allay such suspicions, as it shows him mulling over *Ancient Hunters*, written in 1911 by W.J. Sollas, Professor of Geology at Oxford University, and taking notes about the Heidelberg jaw and the cubic capacity of the Neanderthal skull. A bit later, on February 3, 1912, he

recorded how he had just been handling the very oldest skull on earth, which had been found the previous year in East Anglia.

In addition, as a believer in the paranormal, he had suffered so cruelly at the hands of orthodox science that he must have craved an opportunity to discredit its methods. The clues in the novel could not be clearer—lines such as "If you know what you're doing, a bone can be as easily faked as a photograph," and the inscription under the doctored pictures of the author himself as Professor Challenger, "Yours truly (to use the conventional lie), George Edward Challenger."

Although the case for his involvement was surprisingly strong, it does not bear lengthy scrutiny. He would have had to have been the accomplice of a man who had always treated him as a clueless amateur. When a few months earlier Dawson had learned of *The Lost World*, he had described it to Smith Woodward as "a sort of Jules Verne book on some wonderful plateau in S. America with a lake which somehow got isolated from 'Oolitic' times and contained old the [*sic*] fauna and flora of that period, and was visited by the usual 'Professor.' " And he could not help adding dismissively of Arthur, "I hope someone has sorted out his fossils for him!"

The argument that Arthur was trying to discredit orthodox science is undermined by his recourse to the work of E. Ray Lankester, the former head of the Natural History section of the British Museum, who was hardly an obvious ally in such a venture, having taken a robust stance against spiritualism four decades earlier. The admiration these two men held for one another is clear from the trouble taken by Lankester, on the one hand, to convey his congratulations and Arthur, on the other, to retain this letter in his papers. Describing *The Lost World* as "perfectly splendid," Lankester acknowledged his pride in having had "a certain small share in its inception as you indicate by quoting my book on extinct mammals at the start." He believed not only that it was "just sufficiently conceivable to make it 'go' smoothly" but also that Arthur had been correct not to make his dinosaurs intelligent or to give his ape-men the gift of smell. Lankester even made suggestions for a sequel, including a sixty-foot-long snake and a ox-like rabbit.

Just before Christmas, on December 21 , Jean gave birth to a baby girl, who was handed into the care of the capable Nurse Staughton. The new arrival's name went through the usual mutations—first Lena Jean Noel, later changed to Lena Jean Annette, but she was known as either Jean or, more usually, to avoid confusion with her mother, Billy.

Meanwhile Arthur continued with *The Poison Belt*, which he finished on January 28, 1913. In this light science-based fantasy, Professor Challenger claims to have advance knowledge of a threat to the earth from a deadly gas. He summons his *Lost World* expedition colleagues to his house at Rotherfield in Sussex, urging them to bring canisters of oxygen, which will keep them alive as they observe an unfolding catastrophe. But the poison cloud soon passes, with only temporary narcotic effects. In describing Rotherfield, only three miles from Crowborough, Arthur was expressing his personal interest in this story: the view across the Weald from Challenger's window was clearly similar to his own. He strove for wider significance in his efforts to prove that "the possibilities of the universe are incalculable," given "the infinite latent forces" around us. In the process he demonstrated his own scientific knowledge as he dipped into spectroscopy (though, typically, he misspelled the pioneering physicist Joseph von Fraunhofer's name) and, more remarkably, he anticipated modern chaos theory as he danced around the "butterfly effect"—the idea that an event in one place can have startling consequences on the other side of the globe.

Arthur celebrated completing his book by reaching the third round of the Amateur Billiards Championship in February. On the eleventh of the month he braved the winter fog by riding an Autowheel to Brighton for a family lunch at the Metropole Hotel. He almost failed to arrive after his tires got caught in some tramlines and he fell off. While there he heard the devastating news of the death of Captain Robert Scott, whose expedition to the Antarctic he had done much to promote. Happily he had experienced no serious damage from his accident for he was back in Crowborough to open a Boy Scouts Bazaar the following day.

This was appropriate as Arthur had been rethinking his ideas about Britain's military preparedness—something that had occupied him since before the Boer War. His experiences in South Africa had convinced him of the need for a citizen army of trained volunteers. He embellished his views from time to time, arguing strongly in favor of a mounted infantry, using rifles, as opposed to old-fashioned cavalry, with its *arme blanche* or cold steel. As a compromise, he advocated a bicycle cavalry—a topic on which he communicated with Erskine Childers, the Irish Protestant civil servant whose 1903 novel *The Riddle of the Sands* had alerted people to the threat of German invasion. But Arthur remained remarkably relaxed about what others saw as obvious German saber-rattling.

His attitude changed abruptly with the publication in early 1912 of

Germany and the Next War by General Friedrich von Bernhardi, the cavalry commander of the German Seventh Army Corps. In this widely publicized book, the Prussian-born General vented his frustration at his country's vacillation during several recent international incidents including the Agadir crisis, and made clear that he considered war not only necessary but inevitable. Spelling out in chilling Darwinian terms how conflict was beneficial for societies, he claimed for Germany not only a place in the sun but also "a full share in the mastery of the world." To achieve this he advocated destroying the balance of power and talked specifically about the coming naval war against England, which he suggested harbored hostile designs on Germany.

Arthur had first intimated his change of heart the previous November in the unlikely forum of the Franco-British Travel Union, where he had advocated building a Channel tunnel. For the price of three dreadnoughts, this would ensure Britain complete food security, he claimed. He returned to this idea in an article for the *Fortnightly Review* in February 1913. As its title, "Great Britain and the Next War," made clear, this was a direct response to von Bernhardi. Arthur admitted that, as a member of a society for Anglo-German understanding, he had never worried about German aggression. But the General's book had startled him, mainly because it was the work of a serious thinker rather than the ravings of an Anglophobic Germanic nationalist.

Britain clearly needed to look to her defenses. Still unconvinced by compulsory national service, Arthur remained committed to the idea of voluntary associations, such as the Territorial Army. But he was concerned about threats from new forms of warfare, particularly the airship and the submarine. The former was at least manageable, but the latter had the potential not only to halt the nation's food supply but also to prevent British troops from reaching the Continent, where they might be needed to stop France from being dismembered or, indicative of his new thinking, Europe from becoming "a gigantic Germany." He also suggested that Britain's finances be strengthened and her people prepared for the possibility of war since, he concluded, "we should be mad if we did not take very serious notice of the warning."

Hidden within this diatribe was a heartfelt plea to "my Irish fellow countrymen of all political persuasions. If they imagine that they can stand politically or economically while Britain falls they are woefully mistaken. The British fleet is their one shield." This signaled an equally significant change of opinion about Ireland, where Arthur had been concerned about developments since John Redmond and the nation-

alists had gained a parliamentary balance of power at the start of the decade. After discussing the matter with his mother and with Casement, he had taken the radical decision to support limited Home Rule. As he noted when he first went public, he had been swayed by the manner in which recent moves toward self-government had strengthened South Africa's ties with Britain, bringing it into line with other countries in the empire. He told his mother he expected similarly beneficial results in Ireland, promising that he would not go beyond where he intended on this matter.

Over the following year it became clear that the Liberals would not be deflected from introducing a Home Rule Bill, which they duly did in January 1913, and which the Unionists pledged to resist—by force, if necessary. Arthur sent proofs of his *Fortnightly Review* article, with its profession of the similarity of British and Irish interests, to Casement who had been knighted for his work in South America. But the Irishman's loyalties were increasingly torn and he was shortly to retire from the Foreign Office and devote his energies to the nationalist cause. It is not clear if Arthur knew that Casement had recently been to Berlin and, impressed by what he saw, had penned a pseudonymous riposte to von Bernhardi, arguing that Ireland was only being offered Home Rule to secure her as an ally against Germany.

Casement would later claim to have converted Arthur to Home Rule. But that did not stop him from attacking his friend's imperialist apologetics in an article "Ireland, Germany and the Next World War," which argued forcefully that, in the event of conflict, his country needed to seize the initiative and free herself from British control. With tensions escalating, Casement joined the ruling body of the militant Irish Volunteer Force, designed to counter the anti–Home Rule Ulster Volunteer Force.

Arthur did not backtrack on Home Rule, but he also maintained that Ulster had a right to determine its own future, even if this meant opting out of a united Ireland. On this point he felt he needed to reassure Erskine Childers, whom he regarded as an imperialist Home Ruler like himself, that he had not changed his views. "I have always had the feeling that if the majority in any considerable portion of Ireland was in favor of local autonomy they should have it. Anything else is to inflict on others the very grievance against which Irish men have long protested."

Apart from Germany and Ireland, the other main political phenomenon of the day was female suffrage. Here Arthur's opinions were at odds with his generally sympathetic attitude toward the aspirations

of the opposite sex. His often critical daughter Mary was ready to admit: "He didn't concur with the Victorian view that women should marry at all costs—for he thought the un-married woman, with her freedom, was a whole lot happier than a woman married to the wrong man and, he added, 'The worst of it is, the poor things can never tell till they have married the chap!' "

Such enlightened views no doubt informed his support for divorce reform. But that was a personal matter, whereas voting was a constitutional issue, about which he tended to be Conservative. After a recent escalation in rhetoric about women's political rights, his stand was never in doubt, particularly after the violent protests in London following the withdrawal of the women's Franchise Bill in January 1913 and the jailing of the suffragist leader Emmeline Pankhurst for inciting her followers to place explosives outside the house of the Chancellor of the Exchequer, David Lloyd George, three months later.

Arthur clarified his position in a talk to the National League for Opposing Women's Suffrage in Tunbridge Wells on April 28. Suffragists had been accused of burning down the town's cricket pavilion. He claimed this had set back their cause by a generation, suggesting provocatively that all they needed to do now to add to their "mean actions" was to blow up a blind man and his dog. Ironically, he had been in a local magistrate's court only six days earlier defending his collie dog Roy against a court summons for killing sheep. But there was nothing amusing about the noxious black fluid that his gardener saw oozing from the postbox outside the house the following month. It was a deliberate act of sabotage by female activists, indignant at Arthur's speech.

At the time Arthur and Jean were not at home as they had just embarked on an an extended holiday. Departing from Marseilles, they spent four days crossing the Mediterranean, reaching Port Said in Egypt on May 27. Over the course of a week they were able to see Malcolm Leckie and have lunch with the Sirdar, General Wingate. On their way back they spent a week in Greece, a few days in Rome, and another week in Mürren in Switzerland, from where they sent a brief postcard to Lily Loder-Symonds who had been overseeing the care of the children at Windlesham.

Usually such foreign trips were signalled well in advance. But this one came without notice, a possible clue emerging in a letter from Editte Troughton, a former maid with whom Jean did her best to maintain contact. On July 8, Editte wrote to her old mistress saying that she was sorry to hear that Arthur had been "so ill." This suggests his

health had broken down, or he may simply have become exhausted through pressure of work in the early summer.

Appropriately one of his first engagements after returning to Sussex was, on Sunday July 20, to entertain a party of doctors on an afternoon trip from the British Medical Association's annual conference in Brighton. With them he may have discussed the medical implications of his latest Sherlock Holmes story, "The Dying Detective," which he was close to finishing. For the first time in a while, he had called on his professional expertise to write of Holmes pretending to be mortally ill from an infection imported from Sumatra. The detective does this to trap a planter who, after using his knowledge of tropical diseases to murder his nephew, compares himself with Holmes, "He is an amateur of crime, as I am of disease. For him the villain, for me the microbe." This was one of Arthur's most unambiguous statements of the link between medicine and detection which he had explored since *A Study in Scarlet*. Perhaps "The Dying Detective" was a posthumous tribute to Professor Bell, who had once suggested he should write a story about a "bacteriological criminal." Between the lines Arthur was able to explore another interest—theatrical disguise—as Holmes indulges his penchant for dressing up. "With vaseline upon one's forehead, belladonna in one's eyes, rouge over the cheek-bones, and crusts of beeswax round one's lips a very satisfying effect can be produced," the detective tells Watson, as if preparing a decadent manifesto.

In presenting Holmes in this weakened state Arthur was reflecting his own condition, as he passed through what he had recently described as a period of "weary waiting for ideas." It was no coincidence that one effort from this period, "The Horror of the Heights," had originally been contracted to the *Strand* three years earlier. Its eventual American publisher was *Everybody's Magazine,* edited by Trumbull White, who had visited Windlesham with some friends in the spring. For the best part of a decade he had been lobbying Arthur and Willie Hornung to write a new series that pitched Holmes against Raffles. To this end, he had canvassed the support of both William Gillette and Kyrle Bellew, the American actors synonymous with these two characters on stage. On a previous visit to Windlesham he had found Arthur very hospitable, but unenthusiastic about the idea for a series. Returning to England on a quest to secure Captain Scott's journals and photographs for his magazine, he still hoped to bring Holmes and Raffles together, claiming he could guarantee Arthur $100,000 in revenues if this went ahead. Unmoved, Arthur sought to fob off on the American with something from his bottom drawer.

"The Horror of the Heights" had a contemporary enough theme, drawing its inspiration from the recent succession of ever more daring attempts on the world altitude record. In September 1912 the French aviator Roland Garros had reached 16,240 feet, where he found that the rarified atmosphere caused his engine to stop and he had to glide back to ground. Maintaining *The Poison Belt*'s interest in unusual atmospheric effects, this story told of an aviator who, 40,000 feet above Wiltshire, discovers a high-altitude jungle, complete with aerial jellyfish, serpents and other mean-looking monsters. Written in the form of a discovered fragment of his posthumous diary, it raises the intriguing possibility (in the context of the Piltdown saga) that this apparent evidence was "an elaborate practical joke evolved by some unknown person, cursed by a perverted and sinister sense of humour."

"Borrowed Scenes," a short spoof on the style and manners of the writer George Borrow, was little more than a puff piece for his friend Clement Shorter's new book *George Borrow and His Circle*. "How it Happened" looked back to his motoring accident at the entrance to Undershaw in 1904. On that occasion he had emerged from the wreckage unscathed. In this story, after an exciting description of an out-of-control car, the narrator appears to do the same, as he regains his senses and, "like a man in a dream," finds himself in the company of an old university friend called Stanley. Only subsequently does he recall that Stanley had died of enteric in the Boer War. When he points out, "Stanley, you are dead," his friend looks at him wistfully and answers, "So are you." The paranormal tenor of the piece had been signaled at the start, where it was described as written by a medium.

The survival of the spirit had been much on Arthur's mind over the summer after reading Hubert Stansbury's *In Quest of Truth*, an inquiry into the historical, philosophical and scientific bases of religion. In a book reminiscent of Arthur's favorite *The Martyrdom of Man*, Stansbury, a naval captain, took an uncompromising, materialist approach to demolishing the arguments for either an individual soul or a divine presence in the universe, concluding that the "decomposition of the body leads to the decomposition of its soul qualities."

Having wrestled with these (to him) heretical ideas on his Mediterranean holiday, Arthur wrote to remonstrate with the author on July 10, 1913, shortly after his return to Sussex. He had the courtesy to congratulate him for attempting to marry the conflicting worlds of science and religion—something he himself had tried to do almost twenty years earlier in his *Stark Munro Letters*. He even expressed agreement

with five-sixths of what Stansbury had to say, but he balked at the last "vital sixth," saying that he remained a theist, convinced not only of a purposive force in the universe but also of the enduring properties of the spirit or soul. He pointed to Frederic Myers' conclusions in *Human Personality* and to recent work on telepathy as evidence of the growing scientific credibility of his point of view.

Arthur's main grouse was with the naval officer's opinion that everything in nature ran according to mechanistic laws. As Arthur put it in his much annotated copy of *In Quest of Truth*, "It is as if a man endeavoured to eliminate the presence of an engineer by saying 'The reason why the engine works is not really due to any engineer (whose existence is quite hypothetical) but is due to a piston and to an explosion in a gas chamber, according to some law which regulates pistons and may have been evolved by the piston itself.' "

But, in a quick-fire exchange of letters over the next three weeks, Stansbury refused to be convinced by Arthur's arguments for a benign central intelligence. He suggested that this view was hardly consistent with a world of earthquakes or the sinking of the *Titanic*. Arthur was forced to admit the existence of evil, but tried to mitigate its effects by suggesting it could often lead to a better world. Thus, he said, raising an old obsession, a drunkard's death could lead to the pruning of "a branch which had moral weakness . . . from the human tree."

Arthur's communications with Stansbury show him at his best—battling to reach an understanding of a troublesome issue. Despite his crude Darwinism, he remained keen to engage in debate. So in this spirit he allowed these letters to be published in a pamphlet the following year.

He was encouraged by Edward Marshall Hall, a middle-aged barrister who had made his name in a number of sensational murder cases. Marshall Hall had suggested Arthur should visit the Crippen trial in 1910 and later supported him over the Oscar Slater case. His courtroom manner owed something to his own harrowing personal life. His first wife had died in 1890, after an affair with an army officer had ended in a botched abortion. Overwhelmed by a combination of grief and guilt, Marshall Hall had turned to spiritualism.

Having experienced his own matrimonial difficulties, Arthur felt some empathy. Despite Jean's antipathy, he began attending séances again. He found that mediums were no longer content with mere table-rapping but now tried to give physical manifestation to spiritual energy in the form of ectoplasm. And although Arthur remained

wary after his dubious experiences with Craddock a few years earlier, he was as eager to get to the truth here as elsewhere.

With this in mind, he contacted the London publishers C. & E. Layton in December 1912 to complain about not hearing from one of their authors, Douglas Blackburn, who had just co-written *The Detection of Forgery*. Coming so soon after the Piltdown man, Arthur's interest in a book with this title might be seen as further evidence of his complicity in the hoax, if it had indeed been about fossils and skulls, rather than an introduction to handwriting analysis aimed at bankers, solicitors, magistrates' clerks and "all handling suspected documents." In fact, Arthur wanted to make contact because the mysterious Blackburn had been causing havoc at the Society for Psychical Research after admitting that his experiments in thought-reading with George Albert Smith in Brighton thirty years earlier had been fabricated. This had proved embarrassing because the Society, in its early days, had taken a close interest in Blackburn and Smith's very public demonstrations of their paranormal faculties.

More problematic, Smith had been closely associated with the Society, as private secretary to Edmund Gurney and, after Gurney's death, to both Frederic Myers and Frank Podmore. Blackburn had not only cast a shadow over Smith's career as a psychical researcher, but also, by stating that "Myers and Gurney were too anxious to get corroboration of their theories to hold the balance impartially," had questioned the objectivity of two of the Society's leading figures. The Society had been divided in its response: it published a pamphlet refuting Blackburn's allegations, but when Smith, now in the cinema industry, failed to react or issue a writ for libel, several senior members, including the distinguished physicist, Sir Oliver Lodge, who was a past president, began to wonder about his bona fides.

In mid-August 1913 Arthur took his family off for a further holiday at the secluded resort of Frinton-on-Sea in Essex. Even a month relaxing at the seaside could not dim his enthusiasm for paranormal research. On his return home he wrote to congratulate Lodge, who was now a friend, for using his presidential address to the British Association for the Advancement of Science to confront materialism and to argue that personality continued after a body's death. Lodge had told his peers that scientific method could be "applied much more widely, and that the psychic region [could] be studied and brought under law too."

This was music to Arthur's ears. Referring to his communications

with Stansbury, he said he too had been waging a small battle in the same field. He trusted that Lodge's views would not be used to shore up old-fashioned theological dogma but would be "recognized as a trumpet call for all stragglers to bring them back to those spiritual truths which really do not depend on that two-edged business, Faith, but upon direct reason." Now that he was home for the autumn, he had to attend to neglected public commitments. While he had been away, the Olympic committee had without his knowledge increased the target of the 1916 Berlin games to 100,000 pounds. The size of this sum had further enraged critics of the professionalisation of sport. While Arthur did not agree on this point, he did think the amount was too much and 10,000 pounds would have sufficed. This put him in a dilemma: if he showed dissent, he would undermine the appeal. So he did the gentlemanly thing and kept lobbying for this cause. Not that it had much effect: storm clouds were gathering over Europe and the public showed their indifference to the Olympics by contributing only 7,000 pounds.

Arthur was more convinced than ever that sport had a role to play in boosting national morale. He was bitterly disappointed in December when the English challenger "Bombardier" Billy Wells failed to wrest the European heavyweight boxing title from the Frenchman Georges Carpentier. He poured his frustrations into a multitude of causes—supporting a "British-American centenary peace appeal" with the wonderfully disparate aims of honoring George Washington while recalling Britain's 1814 attack on the American capital city which bore his name; signing petitions for Russian and Portuguese political prisoners (the latter, he told his mother, was for his sister Annette's sake); and keeping up his campaign for divorce law reform, even if it meant taking on the priggish High Anglican Lord Hugh Cecil, who had challenged him to define chastity, marriage and fornication. Arthur replied that "a union blessed by the Church, but unaccompanied by love . . . appears to me as fornication," while a union with, say, a divorced person or a deceased wife's sister could be "a true marriage so long as it is blessed by an unselfish love."

Arthur's views on matrimony drew strength from his solid ties to Jean. "Thank you for all you have done for me in the last year, dear one," he told her, as he kissed her goodnight on New Year's Eve. "No man in the world has such a wife. You are perfect. I could not suggest the smallest change in you. God has been very good to me. It has been a very happy year."

At least that is what Jean would like the world to believe Arthur said,

for she added the comment to one of his diaries which she collected after his death. The fact that, having dated it December 31, 1913, she wrote it into a diary for 1912 is odd. Although it raises the possibility that she made it up, this is unlikely. Rather, she had probably included it in a personal memoir of her own that she wanted to destroy. But she was determined that Arthur's words should not be lost to posterity, so she transferred them, along with several other protestations of his love from around this time. Perhaps she was hoping to gloss over the reality that it had been rather a difficult year.

When she showed him an old dress which she intended giving to Lily Loder-Symonds, he became sentimental: "I would like to be buried in all your old dresses then I would take a bit of your savour with me into the next world. I'd take a little of my angel with me." Toward the end of March he recalled his poem "To my Lady" when he told her that if he had ever been asked to make his ideal woman, she would have been just like her, though not quite as nice, since he would never have thought of all her "dear little ways."

She felt much the same: "I can never be grateful enough and do enough for other people . . . to make up for all the wonderful joy and untold blessing I have in my darling Arthur." Her recipe for happiness was "never to think of one's own comfort in the little daily hours" and "to try to brighten and make comfortable all those around one." This philosophy was hardly an advertisement for feminism, but it worked. She was happy to stay in the background, running the house and bringing up the children, while he got on with his work, in all its manifestations.

So, over the extended Christmas holiday, she entertained family and guests, while Arthur started on a new Sherlock Holmes book. When Kingsley took a break from his studies and visited Windlesham on January 17, 1914, he was accompanied by Dorothy Kirkwood, a friend of his sister Mary, whom he was courting. Innes was also there and noted in his diary that on that day Arthur read them all three chapters of his book about the "Scourers" [sic]. This, as emerged in a letter to Greenhough Smith on February 6, was to be called *The Valley of Fear*, another of Arthur's cross-continental revenge mysteries that required him to shift the scene of his action between an English location (a murder at Birlstone Manor, based on Groombridge Place, close to Crowborough) and much earlier goings-on in the coalfields of Pennsylvania. At the center of the plot was a secret society called the Scowrers (its correct spelling) that terrorized their communities under the guise of legitimate labor agitation.

Arthur based them on the Molly Maguires, a clandestine organization that had fought for the rights of Irish miners in the 1870s, before being infiltrated and broken by James McParlan, a detective from the newly formed Pinkerton agency. Allan Pinkerton, the founder, had written about this in his 1877 book *The Mollie Maguires and the Detectives.* Arthur was undoubtedly familiar with this account, though the claim by Pinkerton's son, William, that he had discussed it with Arthur should be treated skeptically. Arthur's source is more likely to have been a rival detective, William J. Burns, who had broken away from Pinkertons to set up his own eponymous agency. Burns had visited Windlesham in April 1913, shortly after his own book *The Masked War: The Story of a Peril that Threatened the United States by the Man who Uncovered the Dynamite Conspirators and Sent Them to Jail* had appeared in the United States under the imprint of Arthur's new publisher, George H. Doran. This dealt broadly with the same subject matter—the danger posed to American business by violent syndicalism. The real-life Molly Maguires owed their origins to an organization of the same name that had agitated for tenants' rights in Ireland since the 1840s. Their American exploits continued to inspire the nationalist movement there, causing Arthur to waver in his new-found enthusiasm for Irish Home Rule.

His embarrassment on this point was clear from the way he tried to downplay the Irish connection. "I change the names so as not to get on to possible Irish politics," he told Greenhough Smith. The Scowrers' true origins should never be admitted, he said on another occasion, because the Irish were very touchy on such matters. "I make it vague and international with nothing to offend anyone. It would be a *most serious error* to be definite in the matter. Any advance matter must be very cautiously done and should pass my censorship." By the time the story was published, war with Germany had broken out and further cosmetic changes were required such as changing the origins of an American family, the Shafters, from German to Swedish.

Arthur had hoped to finish the novel by the end of March, but took longer because he had to attend to other matters. On February 26 he and Jean were in London, staying at the Hotel Metropole, from where he crossed to the City to address a public meeting in support of a Channel tunnel—something for which he had been arguing strongly for the past year or so, usually, as in his *Fortnightly Review* article "Great Britain and the Next War," in the wider context of the threat from submarines to Britain and her food security. As in the years before the Boer War, his unorthodox views interested strategists,

such as General Henry Wilson, the Director of Military Operations at army headquarters. However he faced considerable opposition, particularly from Colonel Charles Repington, the military correspondent of *The Times*. He did his best to rustle up support from serving naval officers, such as Rear-Admiral David Beatty, whom he had met in December 1913 at a weekend house party at Knole, the Kent seat of Lord Sackville. But he found little enthusiasm, particularly as the tunnel lobby seemed to be motivated by commercial rather than military ends. (His own interests in East Kent coal may have been significant here.)

At this latest public meeting he drew his usual quota of laughter and applause, countering the argument that a tunnel would be an ideal conduit for an invading army, for example, with the fine-sounding but meaningless observation that troops inside the tunnel would be as strategically placed as the Pharaoh's army in the Red Sea. *The Times* responded with an *ad hominem* editorial that questioned his ability to quote Repington's views correctly. Arthur was stung to produce another broadside, this time in quasi-fictional form. "Danger! A Story of England's Peril" was a piece of military games-playing that told how, after knocking out the main "enemy" fleet, Britain was reduced to starvation in six weeks by eight small submarines that preyed on her merchant shipping. As so often, Arthur got some factual details right and some wrong (he could not envisage that submarines might engage one another). Ironically, his efforts were read less seriously in London than in Berlin, where, it was later said, they encouraged the German Fleet Commander, Admiral Reinhard Scheer, to think seriously about waging unrestricted submarine warfare.

Toward the end of April *The Valley of Fear* was finished too. In describing it as his swansong, he again signalled an end to Sherlock Holmes. "If I had a good competence I would devote myself to some serious literary or historical work," he told Greenhough Smith, reiterating a familiar mantra, and adding, "I have large commercial interests and if they took a good turn (as they may well do) I should be in that position."

With his novel completed, Arthur no longer had any reason to refuse an invitation to visit Canada. He had been approached a year earlier by Colonel Maynard Rogers, whom he had met in South Africa and who was now superintendent of the new Jasper National Park in the northern Rockies, some 200 miles west of Edmonton.

Rogers and the Canadian government were keen to attract visitors

to this remote, if spectacular, spot. They wanted to exploit the arrival of the railway which, as in the United States, had played a vital part in uniting a far-flung country, which Arthur would describe as having been "clamped together by the steel of the Canadian Pacific." This was the company that in 1885 had completed the first transcontinental railway line across the Rockies to Vancouver—the price British Columbia demanded when it formally joined the Canadian Confederation.

Since then Alberta and Saskatchewan had followed suit but, as the railway system was not a monopoly, the possibility of new business in these fertile prairie provinces had attracted the attentions of two rival companies, one of which, the British-owned Canadian Trunk Railway, was developing a northerly route via Edmonton and Jasper to Prince Rupert on the Pacific coast. So Arthur's involvement was being sought in a multifaceted promotional exercise—partly to attract tourists, partly to boost Canada, and partly to sing the virtues of empire. Jean had not wanted to go the previous year, perhaps because it was too soon after the birth of her daughter. But now she was "reconciled" to the trip, provided the children stayed at home again with Lily Loder-Symonds and she was able to take her maid, Jakeman.

Before leaving Arthur had to deal with a charge of plagiarism from across the Channel, where Paul Souday, a critic on *Le Temps*, claimed that *The Poison Belt* was remarkably similar to *La Force Mystérieuse* by the French science fiction writer J.-H. Rosny. Although Arthur had started work on his book before the other was even serialized in France, he felt obliged to defend himself in both *Le Temps* and *The Times*.

This was not the first time he had been so accused, and it annoyed him. Only recently, in December 1912, the American humorist Alfred Guitterman had written some verses in *Life* magazine taking him to task for drawing so obviously on Poe and Gaboriau, particularly when Sherlock Holmes had been so dismissive of their detectives, Dupin and Lecoq. "Borrow, Sir Knight, but be candid in borrowing!" he had thundered. Arthur had responded in kind with the poem "To an Undiscerning Critic," that argued vehemently that it was wrong to blame him for Holmes's "crude vanity." Claiming legitimately that he had always acknowledged his admiration for Poe, he ended with the delightful lines, "So please grip this fact with your cerebral tentacle, / The doll and its maker are never identical."

But Guitterman had only made the unsophisticated mistake of thinking that Holmes had views similar to Arthur's. Suggestions of copying were more damaging and more significant, because, true or not, they reflected the difficulties Arthur was experiencing in creating

stories for an increasingly competitive market. It was proving more difficult than ever to be original. Arthur's problems on this score had already poisoned his relationship with H.G. Wells. Although they had shared ideas in the late 1890s, Wells had subsequently blossomed as a novelist as he turned his hand to social realism and extended the range of his science fiction. A sense of competitiveness ensued, which even James Ryan could not ignore. When Arthur started *The Poison Belt* in late 1912 Ryan advised his friend to avoid imitating Wells, who probably had "some critical jackal who will try to howl you off your own 'kill.' " Sure enough, Arthur's papers include a petulant letter to an unnamed correspondent, declaring that, "much as I admire Wells, I am not conscious of being at all in his debt. Indeed I am the older man and the older writer, with one or more books of short stories to my name before he appeared."

The Conan Doyles finally sailed with Jakeman from Southampton to New York on May 20. After his contretemps with George Bernard Shaw over the *Titanic*, Arthur made a statement in choosing the sunken liner's sister, the SS *Olympic*. He celebrated his fifty-fifth birthday during a low-key crossing, made tolerable by the company of fellow passengers.

Arthur had not been in North America for almost two decades. Last time, in 1894, he had been merely well known; now, with the success of Sherlock Holmes on stage as well as in print, he was a household name. Even before the ship docked at eight o'clock on the morning of May 27, it had been boarded by a revenue cutter carrying not only his friend the detective William J. Burns but also a film crew eager to incorporate some footage of the famous British author into its topical silent serial "Our Mutual Girl."

Arthur played along and allowed himself to be exploited for blatantly commercial purposes, the results of which he and Jean were at least able to watch at a private viewing the following Monday. They settled into a suite at the Plaza Hotel from where Arthur ventured out to attend a lunch given by the Pilgrims Society, at which Joseph H. Choate, a former American ambassador to London, tickled his vanity by introducing him as "more widely known in the United States than any other Englishman." He subsequently visited the mayor, toured a couple of prisons (the Tombs and Sing Sing), and saw to some business (cinema and stage matters, as well as a deal for Raphael Tuck). Eager to show Jean the city, he took her to the top of the fifty-nine-story Woolworth Building. Together they went to the theatre to see Victorien Sardou's comedy *A Scrap of Paper*, attended a baseball game, and spent

Sunday with the Burns family at a Coney Island amusement park, where they were touched, on entering a restaurant, to find all the diners getting up and clapping, while a band struck up "God Save the King."

Arthur's main problem was the press. In his absence he had forgotten how intrusive the American newspaperman could be. He managed to avoid engaging in too much literary gossip, claiming not to have met modern authors such as Arnold Bennett, though there was an unusual bite to his comment that H.G. Wells had "gotten away from his first excellent novels! . . . Now he seems to concern himself exclusively with—with prognostication, doesn't he?"

After dealing with endless questions about Sherlock Holmes, Arthur talked happily about crime and punishment, heaping praise on the Tombs, even if he was less positive about Sing Sing where he sat in the condemned criminals' electric chair. He liked the way that American detectives such as Burns could be employed to challenge unjust trial verdicts. And he emerged as an early advocate of the "three strikes" approach to justice, arguing, "When a man has thrice been convicted of a penal offense he should for ever be segregated from the community in a permanent seclusion, which need not be an unduly harsh one."

He was less successful when he discussed politics. When he left England the main domestic story had been the passage of the Irish Home Rule Bill. In interviews in New York he underlined the seriousness of this situation, affirming that "the men of Ulster will never give in to the idea of an Irish parliament." But when he tackled another British phenomenon, the suffragists, he could not disguise his personal agenda, stating that, though the Liberal government had not demanded the suppression of these militant feminists, it was on the point of doing so, and "when the English mob is thoroughly aroused it is not a respecter of sex." He was taken aback to find this reported in the *New York World* under the headline: "Sherlock's Here; Expects Lynching of 'Wild Women,' " Needing to dispel the notion that he advocated mob justice, he told a rival paper that such reporting was "perfectly monstrous" and added, "Why, some of my best friends are suffragettes and what will they think of me?" (It is not clear who he was referring to; perhaps his twenty-five-year-old daughter, Mary.)

Jean's views were also sought. Returning from Coney Island at one in the morning, she found a woman journalist who had been waiting in the hotel to talk to her for six hours. Unable to refuse, she shared some bland and weary comments, declaring she liked everything

about New York except its cruelty to animals. The American press warmed to her unsophisticated manner and dubbed her "Lady Sunshine." To her delight, Arthur acknowledged her support and a few days later she noted in her diary, "Arthur said yesterday that I have been such a wonderful comrade to him—that not one clouded or grey moment had he had since we started on the journey from England."

By then the Conan Doyles were in Canada, having left New York on June 2 in a private car which was hitched to the back of the regular Grand Trunk train. Jean was able to relax in a spacious sitting-room, with a sofa, four armchairs, and, unusually, a speedometer, while Arthur showed off his knowledge of the past as they sped north through what he called "Parkman land"—great expanses of upstate New York where, as documented by one of his favorite (now discredited) American historians, Francis Parkman, the English, French and Indians had fought bitter wars for control of North America in the eighteenth century.

After a short stay in Montreal, which Arthur found colorless, he and Jean began their journey across Canada to Jasper. Again they had use of a private Pullman car, the Canada, courtesy of the Grand Trunk Railway. This they abandoned at Sarnia to continue across Lakes Huron and Superior on the SS *Harmonic*. On their arrival in Fort William, they found that their train had made a 900-mile detour round the Lakes and was waiting at the dockside to meet them. From there they pushed on through Winnipeg and then a further gruelling 750 miles northwest across the prairies to Edmonton, where Colonel Rogers met them for the last stage of their journey west to Jasper.

Arthur had been dreaming of the Rockies ever since reading about them as a child in the novels of Captain Mayne Reid. He was not disappointed by the snow-capped mountains, clear blue lakes and blanket of fir trees. He and Jean spent nine restful days, fishing, riding (getting saddle-sore) and camping out overnight to the sound of chipmunks and hummingbirds. On June 18 he went across the British Columbia border to Tete Jaune Cache, which evoked further literary memories—this time of Bret Harte. That was the date he attached to "The Athabasca Trail," a rolling Kiplingesque poem that extolled the natural attractions of the "Land of Lake & stream & mountain." At least he had now paid his way: for many years afterward these verses were used to promote the park and the railway. On another occasion he mapped out a golf course for a hotel that was never built. Arthur even claimed that he had had a mountain (Conan) and Jean a lake (Jean) named after them, but these designations have not found

their way into the gazetteer.

For all his politeness at this hospitality, he was now bored. He did not want to see the country again, he informed his brother from Winnipeg, where he and Jean stayed on their return with the lieutenant governor, Sir Donald Cameron. Moving on to Fort William, he bought a small house as a token of his confidence in the city's future. But this did not prove the investment he hoped, realizing just $15,000 when disposed of by his heirs in 1965, or $1,000 less than he paid.

This time the Conan Doyles attached their car to a Canadian Pacific train that took them north of the Lakes for a few more days' easy outdoor existence in Algonquin Park. They subsequently swung south to the Niagara Falls. Arthur was reminded of the Reichenbach Falls twenty years earlier. According to their young guide, he carved the letters SH on a rock and told his wife that he should have tried to kill his detective there rather than in Switzerland. Perhaps he was indeed contemplating Holmes's final demise as he wrote the words "Die at Niagara" in his notebook.

After Ottawa, where he delivered the latest of several rousing, propagandist speeches, the couple made for Montreal and boarded the White Star Line's SS *Megantic* for their voyage back to Liverpool on July 3. Only a month before, another ship, the *Empress of Ireland,* had sunk after a collision in the fog in the St. Lawrence river. Arthur, whose friend Lawrence Irving, son of the actor, was among over a thousand victims, had to convince a nervous Jean that a recurrence of this unfortunate accident was now less rather than more likely.

Five days earlier a momentous event had taken place in what must have seemed like the other side of the world. On June 28 the Austrian Archduke Franz Ferdinand and his wife had been assassinated by a Bosnian nationalist in the remote Balkan town of Sarajevo. It did not require great foresight to understand that this was likely to tip Europe into war, sooner rather than later.

In the circumstances, Canada quickly slipped from Arthur's mind when he reached home. He had promised to write a story about the country's natural resources, but that did not materialize. What he did write—an account of his travels, *Western Wanderings*—was disappointing. As travelogue it was efficient enough, but as a commentary on Canada's position in the world it opted for a historical romanticism which failed to hide its basic propagandist message. Peering into the future, he believed Canada would spurn the United States and remain dependent on Britain, her mother country, for the capital and immigrants she needed for her growing economy. For these reasons he

foresaw no great change in Canada's constitutional position before the end of the century. He did not know that, within two weeks of Britain declaring war on Germany on August 4, 100,000 Canadians would sign up to fight in Europe, with long-term repercussions for the maturing of their nation. But then he had little idea either that the imminent conflict would lead to radical changes in his own life.

First World War

1914–1918

Within weeks, the deathly boom of the big guns in Flanders could be heard distinctly at Windlesham—their "far-off throbbing like a muffled drum," as Arthur put it in a poem. Aware that East Sussex would be in the front line if the Germans invaded, he wasted no time in calling a meeting in Crowborough on August 4 to discuss setting up a local civil defense force. Surprised at the number of people who responded, he wrote to *The Times* at the end of the week, suggesting that a corps of older men be trained to guard railways and other buildings, and so free the more able-bodied for service in the army or reserves.

Before long he was drilling his first batch of volunteers and encouraging them to dig trenches on the common, south of his house. A reluctant spectator was William Gillette who, in the general hysteria, had been arrested as a suspected spy after being found with a map of the British embassy in Paris, part of his research for a forthcoming production of Sardou's play *Diplomacy* in New York. Because of the war fever, he had been unable to return home as planned. With his money running out, he had to vacate his usual Savoy Hotel suite and take a room in a boarding-house, where he attracted the attention of the police. Asked to intervene, Arthur confirmed the actor's bona fides and invited him to Windlesham.

Over seven years, his property had expanded, both inside and outside, into a substantial domain. The landscaped grounds now boasted a tennis court, a garden hut, where Arthur often worked, and a paddock, overlooked by flowering chestnut and beech trees. Beyond the walls, to the back, between Windlesham and Monkstown, he owned Spring Cottage where visitors could stay. In the other direction,

toward the common, he had agreed to rent (with an option to pur-chase) the adjoining Quarry Hill Farm, which Jean insisted on renam-ing Fey House.

As a result of his *Times* letter Arthur heard from some 1,200 patriotic towns and villages across the country keen to set up similar civilian reserve forces. But the War Office did not want a proliferation of pri-vately run dads' armies and put a halt to further developments. Arthur found a way around the bureaucracy by breathing new life into an existing committee chaired by Lord Desborough. Before the end of the year a new government-sanctioned volunteer force had been set up across the country and was going through much the same procedures as Arthur had envisaged.

By then the War Office had refused his unlikely application for a full army commission. Instead he was happy to enlist as a private in the Crowborough Company of the new national reserve he had helped inspire. Officially he was No. 184343, 4th Battalion, The Sixth Royal Sussex Volunteer Regiment.

Without responsibilities of command, he could devote his ener-gies to something more appropriate. On September 2, 1914, he and more than twenty leading writers, including Barrie, Hardy and Wells, were invited to Wellington House, the headquarters of the new Propa-ganda Bureau in London's Buckingham Gate, where their profes-sional support for Britain's war effort was canvassed. They returned two weeks later for a second meeting, this time attended by publishers and others who would market their work, including A.P. Watt, the Bureau's literary agent. After adding his name to a joint authors' declaration about the justness of the war, Arthur applied himself enthusiastically to the task at hand.

As he was often on the stump, recruiting Sussex men to Kitchener's New Army, it was appropriate that *To Arms!*, his first major work for the Bureau, should be a full-length statement of Britain's case for going to war. Drawing on his earlier anti-von Bernhardi blast "Great Britain and the Next War" and strengthened by a preface by the Conservative lawyer F.E. Smith (later Lord Birkenhead), this was published as a penny pamphlet by Hodder & Stoughton at the end of the month. Helped no doubt by A.P. Watt, a series of Arthur's rabidly anti-German articles in the *Daily Chronicle* were repackaged, one as a pamphlet, *The World War Conspiracy,* and several in a collection, *The German War.* Called upon to deal with proofs of *The Valley of Fear,* which began appearing in the September issue of the *Strand Magazine,* he remarked realistically enough that he did "nothing but write about the war."

He had an added personal incentive since his brother-in-law Malcolm Leckie had disappeared in the retreat from Mons at the end of August, the first major battle as the German army pushed relentlessly through Belgium into France. Like so many families, the Leckies had to endure the ordeal of not knowing what had happened to him. Jean had been doing her bit for the war effort by setting up a home for Belgian refugees at Gorseland's on Hurtis Hill, close to Windlesham. After Malcolm was declared missing and wounded in September, she used her contacts to enlist the help of Winston Churchill's wife Clementine, whose sister worked in a field hospital. But before the end of the year, news of Malcolm's death was confirmed.

As the casualties mounted, Arthur had to revise his earlier prediction to his mother that the war would be over by Christmas. Her views also changed as her initial conviction that it was all a sinister plot engineered by Prime Minister Asquith gave way to a deep quietism expressed in her desire to "pray and truly believe that what our Father sends is for the best."

Though increasingly frail, she managed to travel to Durham in November to see Innes, now a temporary Lieutenant-Colonel in command of the 3rd Northumberland (County Durham) Division of the Royal Field Artillery (Territorial forces). Arthur had played his part in ensuring that Innes's wife Clara and son John got back to England before war engulfed Europe. They had been spending the summer with her relations in Denmark, while Innes settled into his new job. Arthur had reminded his brother that, if they did not return quickly, they might, like the English in France after the breakdown of the Peace of Amiens, find themselves permanently marooned abroad. After Innes wired Clara to come home immediately, she found a passage on the last possible boat, reaching London on August 4.

Like many soldiers, Innes was anxiously awaiting his marching orders (that would come in February). Lottie's husband, Major Leslie Oldham, now commander of the Royal Engineers' 63rd Field Company, preceded him to the front by three months. Others who had signed up, or would soon do so, included Arthur's nephew, Oscar Hornung (the Essex Regiment), his secretary Woodie (the Sussex Regiment) and his son, Kingsley (who abandoned his medical studies for the Hampshire Regiment).

Not content with his other activities, Arthur was determined to write a history of the conflict. As with the Boer War, he had been keeping an account of the action almost from day one. He hoped that, with his track record in South Africa, his contacts at the War Office and

his position in the Propaganda Bureau, this might be adopted as the official record. But he was unaware of the opposition to his breezy anecdotal style of writing within the General Staff, which wanted a sober history that emphasized its own meticulous professionalism and was designed more for internal purposes than for the general public.

Another problem was that others were already jockeying for the job. A strong candidate was the publisher-cum-author John Buchan who, having completed his anti-German espionage novel *The Thirty-Nine Steps*, wanted to commission a history for his own firm, Thomas Nelson, which also worked for the Propaganda Bureau. When Hilaire Belloc turned down an opportunity to write this, Buchan used a period of prolonged convalescence during the winter to embark on his own account, which first came out in February 1915 and continued in 50,000-word installments every couple of months until July 1919.

Still hoping to be adopted as official historian, Arthur went to the top and lobbied the Prime Minister. Having received Herbert Asquith's backing in early 1915, he contacted General Sir John French, the Commander-in-Chief of the British Expeditionary Force, who seemed supportive. But it was never going to be easy. One contact was General Sir Henry Rawlinson, the IV Corps commander, who instructed a member of his staff, Leopold Amery, an experienced journalist who had edited and largely written *The Times History of the War in South Africa*, to send Arthur information about the 7th Division, which had fought heroically at Ypres. Arthur made conciliatory noises about his work not impinging on any larger history Amery might do. But Rawlinson's reply to Arthur had promised details "on condition that they are not published until the war is over." And, although Amery was helpful, such instructions were always likely to lead to problems.

An added difficulty was that several people Arthur approached had ambitions to write their own histories. Thus when the spy writer William Le Queux was asked about the build-up to the war, he was cagey about his sources for a story: it had been a leading German diplomat with an English wife, but he insisted that it would be unpatriotic to reveal his name. But then Le Queux had started a series, *The War of the Nations*, for George Newnes. He would write one volume before the project was taken up by Edgar Wallace.

When Arthur contacted Colonel James Edmonds, a senior member of French's staff, on April 21, asking for input into his account of the battle of Le Cateau, he was strongly rebuffed. He might have expected a more positive response from a Boer War veteran who had been both a historian on the General Staff and first head of MI5. But as

Edmonds was later to write the dry official history, he had a personal agenda. He accused Arthur of a "try on" to obtain details that were government property, and suggested he apply to the War Office for the divisional war diary. When this was refused Arthur lost his temper, telling Edmonds that he had been directed to him by the commander-in-chief, and he would have thought this would have been the absolute authority.

By this time, May 1915, Arthur had been collecting material from other sources and was so well advanced with his writing that he was able to trail his material in a series of well-remunerated lectures on the "Great Battles of the War" that Gerald Christy arranged for him as far afield as Edinburgh and Glasgow. Since Greenhough Smith was keen to publish his early chapters in the *Strand Magazine*, Arthur had to submit them to the military censor. But while awaiting a reply, he was distracted by matters closer to home that put a different complexion on the war.

Like many people, Arthur's thinking about spiritualism had been deeply affected by the events of the first nine months of the war. The horror of the opening battles had led to an explosion of accounts of supernatural happenings. The most famous told how the spirits of English archers (or, alternatively, the Angels of Mons) had protected British troops during the retreat in which Malcolm Leckie had been killed. This became common currency after Arthur Machen's supposedly fictional version, *The Bowmen*, appeared in September and was noted approvingly in *Light*.

Arthur played his part by holding séances at Windlesham in an attempt to get in touch with his brother-in-law. He was joined by Jean, who until then had been skeptical about psychic matters. Unexpectedly, however, her plain and sickly friend, Lily Loder-Symonds, turned out to be a sensitive medium, with a talent for automatic writing. Like Jean, Lily had suffered early personal losses: before the end of 1914 one of her brothers, Jack, a Major in the South Staffordshire Regiment, had been killed at Le Cateau, and two more, Thomas and William, injured.

Lily's suffering intensified in early March, when another of her brothers, Bob, a Captain in the Cheshire Regiment, was killed in what was described as an accident. Even by the standards of the time her family's sacrifice had been unusual, as was noted in an article in *The Times* entitled "Four Brothers Killed and Wounded." Five days after Bob's death, Arthur and Jean tried to get in touch with his spirit in a

séance. As soon as she said "I wonder if Bob will come," the table started moving and, through Jean, he began to write. Arthur sent a sample of Bob's purported text to Lily, inquiring if he had curves in his script when he was alive. Bob had met his brother Jack, Arthur reported, and, though he did not know Malcolm Leckie, he had promised to track him down. The dead man seemed to say that he had been shot by a sniper and, more positively, he forecast that Britain and her allies would win the war in three months' time.

With his signal combination of enthusiasm and credulity, Arthur had entered the dangerous territory of using the paranormal to predict what would happen in the war. When he gave Innes what seems to have been a clean bill of health, his brother responded tactfully, "Your spiritualistic forecast is immensely interesting but I only look at it as one of my prophecies, some of which will come true. I hope I shall come through, but that is everyone's private hope and the reality of war is so near to everyone here that the idea of getting knocked out is quite familiar."

Two months later, on May 9, this was reinforced when Lily suffered the cruel loss of another brother, Thomas, a Lieutenant in the Cameronians (Scottish Rifles), who was gunned down in the second battle of Ypres. She was staying at Windlesham on the thirteenth, when Arthur received the terrible news (through Innes and Clara). This coincided with a tense period in his own life: not only had his son Kingsley nearly died from pneumonia, but also he himself was still anxiously awaiting a reply from the War Office about the fate of his history. Greenhough Smith had been pushing him to pull rank and to ask Sir John French for the relevant permission. But Arthur, with a keen sense of propriety, would have none of that, telling the *Strand* editor that same day that he could not possibly wire the commander-in-chief about such a matter at such a crucial moment in the conflict.

As it happened, Lily was leaving Windlesham that day. Arthur could not face telling her about her brother's loss and opted instead to go for a walk in the rain. Whether his concern about his history had anything to do with this decision is not clear. A couple of days later he wrote to explain his self-restraint (he said he could not bear to think of her returning to Berkshire in distress) and to offer his condolences. The two of them had clearly discussed the afterlife, for he maintained that she knew his thoughts about death. That did not stop him reiterating them, though in a slightly different tone from before, describing it as a much better and happier state than living.

Despite his positive approach, he confirmed the psychic toll such

losses had taken when he pointed to the consequences of Thomas's death on their own occult and religious experiences and admitted they had been seriously upset. Inevitably he, Jean, Lily and possibly others in their circle had been asking spirits about the future of the war. So they were taken aback that Bob had not foreseen this latest tragedy. Arthur tried to reassure Lily that such elementals were not omniscient: perhaps it had been their fault for asking Bob questions he could not answer without causing anguish. He also noted that Lily's brother's powers of prognostication were capricious: though Bob had been right on several matters, he had been wrong about the Dardanelles, and about her brother William escaping from Germany. (He would be vindicated on this latter point three years later.) Given these problems, Arthur bowed to the person with the greater spiritual sensitivity and asked Lily if she would mind once more turning her "hand to the influence and see[ing] if any explanation comes through. We are naturally much darkened and mystified and would welcome some light."

In the middle of this, on May 14, Arthur finally heard from Sir Reginald Brade, the hard-working Permanent Secretary in the War Office, that his accounts of the battles of Mons and Le Cateau could not be published. It is hard to say what upset the censors. Perhaps it was simply that the attentions of an outsider such as Arthur were unwelcome at a crucial moment in the war, when the reverses seemed unending. The diversionary second front opened up by the Gallipoli landings the previous month was going badly; a scandal about the lack of munitions in Flanders had blown up in the pages of *The Times* that very day and would force Asquith to dissolve his Liberal government and set up a Coalition, with Lloyd George as Minister of Munitions. On top of that, a distinct animosity had developed between French and his right-hand men, General Sir Douglas Haig and General Sir Horace Smith-Dorrien, the commanders of the First and Second Army Corps, as well as with Field Marshal Lord Kitchener, the Minister for War.

Arthur was shocked at the War Office decision, which he blamed on French's *amour propre*. Comparing his experience to Kitchener's and Smith-Dorrien's, he said French was becoming "a very difficult man to handle."

He was not going to be deflected from his goal by one querulous general, however. After the final installment of *The Valley of Fear* appeared in the *Strand* in May and the book version was published by Smith, Elder the following month, Greenhough Smith thought he was being helpful when he suggested Arthur might try his hand at some

fiction. But Arthur replied that he was still so tied up with his history that he had no time for stories. With his unquenchable optimism he claimed he was still hoping for a more positive response from the War Office and suggested his editor should have his maps and pictures ready for imminent publication.

He was assisted by his brother-in-law, Pat Forbes, who gathered press cuttings on the war and also by a more positive response from some leading players. General Edward Bulfin, a Stonyhurst contemporary who had made his name as commander of the 2nd Infantry Brigade, provided his diaries, as did Smith-Dorrien and Haig. Promised the papers of the 7th Division by Rawlinson and granted access to regiments such as the Gordon Highlanders and the Royal Munsters, Arthur crowed to Innes that his information was "gorgeous. Outside the W.O. [War Office] no one can poss have such accurate data. It is like a miracle."

He still saw a role for himself as an unlicensed gadfly, peppering newspaper editors with unusual ideas, which were generally motivated by a genuine desire to save lives. He had suggested that ships should be protected by a protruding steel trident to guard against mines and that sailors be equipped with inflatable lifebelts. Now, as the death toll at the front continued to rise (his nephew Oscar Hornung had been killed at Ypres on July 6 and his brother-in-law Leslie Oldham followed three weeks later), he resurrected his ideas about the necessity of body armor. "It has always seemed to me extraordinary that the innumerable cases where a Bible, a cigarette case, a watch, or some other chance article has saved a man's life have not set us scheming so as to do systematically what has so often been the result of a happy chance." If this sounded vaguely medieval, it was not: Arthur regarded proper protection as essential for men who, because of the quaint politics of the British army, had gone to war looking more like old-fashioned gamekeepers than modern soldiers.

At the same time he maintained his more official attachment to the Propaganda Bureau. In October his situation report, published in the *Daily Chronicle* as "An Outlook on the War," appeared in the *New York Times* under the upbeat headline "Conan Doyle Sees Victory for England. One Successful Pounce Will Win." When a week later Robert Donald, editor of the *Daily Chronicle*, informed him that his piece was being translated into several other languages, he passed on the thanks of Charles Masterman, the Bureau's Chief, for "putting the British cause before the world" in "this admirable document."

Ironically Arthur was called on by the Bureau to write an apprecia-

tion of Sir John French, who resigned as commander-in-chief in December 1915 following criticism of his strategy, particularly at Loos three months earlier. This was an odd document since Arthur's personal animus against French had been reinforced by his access to the diaries of the general's enemies, Haig and Smith-Dorrien. But he kept his feelings in check and, as a seasoned propagandist, managed to describe the Loos tragedy as a victory. With some tact, he complimented the general for bringing the nation through a period when "great success was impossible and great disaster was often imminent."

As a diversion, he wrote a generous appreciation of "The Greatest of Cricketers, Dr. W.G. Grace," who died on October 23. Around Christmas he heard from James Ryan, who was in Marseilles en route to Ceylon and no doubt hoped to cheer him up with the news that all French cinemas were showing a film called *Arsène Lupin versus Herlock Sholmes*. This pitched his detective against a gentleman thief created by Maurice Leblanc, whom he had once threatened to sue for using the Holmes name. In light of this background and his recent dispute with the Eclair company over copyright issues, it is doubtful if Arthur's festive spirit was much enhanced.

Arthur's equilibrium was not helped when his main intermediary with the psychic world, Lily Loder-Symonds, who was still reeling from the loss of her three brothers, succumbed to a bout of winter flu and died on January 28, 1916. Arthur forgot his earlier enthusiasm for death and poured out his distress in his diary, describing this as "*dies neganda*," a day to be denied.

At least he was on the home stretch with the first part of his history, as he checked facts and read proofs in advance of its serial publication in the *Strand Magazine* in April. While badgering Greenhough Smith to make sure the work was suitably promoted (he did not want people confusing it with *Times* histories), he showed his appreciation of their twenty-three years' association by sending his editor a bound manuscript copy of his 1904 story "The Adventure of the Golden Pince-Nez," which was unfortunately lost in the post.

He delayed a much-needed holiday because Innes, who had distinguished himself as Deputy Assistant Adjutant-General to the 24th Division, was returning to London to receive a DSO at Buckingham Palace in April. After accompanying his brother on a celebratory visit to Barrie's *A Kiss for Cinderella*, he took Jean for a short break to Bournemouth, where he continued work on the next stages of his history.

Having pined to get to the front, he now took advantage of an

unexpected offer. After criticism of their retreat from Trentino in the Alps in mid-May, Britain's Italian allies felt their contribution to the war effort was undervalued, and they wanted someone to put their case in print. Lord Newton, the influential under-secretary in the Foreign Office, suggested that Arthur might be the man.

Sensing an opportunity, Arthur at first refused Newton's suggestion, arguing that he could not do the job properly since he had never seen British troops in action and thus had no points of comparison. After agreeing this could be arranged, Newton wondered what his new recruit would wear. When the civil servant balked at the idea of a private's uniform, Arthur recalled that his status as Deputy Lieutenant of Surrey gave him the right to wear something more exalted. He was delighted when his tailor was able to run him up a "wondrous khaki garb which was something between that of a Colonel and a Brigadier, with silver roses instead of stars or crowns upon the shoulder-straps."

Another piece of good fortune was that General Sir William Robertson, the new chief of staff who, remarkably, had risen from the rank of private, was going to France at the same time. He suggested that Arthur might like to travel with him, which meant crossing the Channel in a destroyer. The two men had been in touch over Arthur's history and, now that General French no longer wanted his name associated with it, Robertson agreed to be the dedicatee. The general did not say much during the short voyage as his head was deep in papers. France was staggering from the bloody impasse at Verdun and putting pressure on Britain to start a new offensive on the Somme, sooner rather than later. Probably unbeknownst to Arthur, Robertson was on his way to a crucial meeting to discuss this with his French counterpart, General Joffre, and with General Haig.

The next day, after being issued a helmet and gas mask, Arthur was taken to the nearest portion of the front where, without studs on his boots, he slipped and slid through the deep muddy trenches. As guns rattled around him, he peered through a periscope across a grassy field to the German lines 180 yards away and could not help romanticizing the "most wonderful spot in the world—the front firing trench—the outer breakwater which held back the German tide."

In the evening he was delighted to be able to dine with Innes in the 24th Division mess at Bailleul. Afterward his brother drove him many miles north to Mont Noir, from where Arthur was able to watch an awesome *son et lumière* show, in which the participants were the German and Allied troops ranged against each other at night in the Ypres Salient.

On Sunday May 28, after three days at the front, Arthur was asked to lunch at the General Headquarters at Montreuil. (In his memoirs Arthur recalled this as June 1, but Innes's diary tells a different story, confirmed in a dutiful letter telling Jean that her husband was in good health and had just left to meet Haig.) After lunch, the commander moved into a side room, rolled out some maps and gave a briefing at which notes were banned. He may have been dour and an unreconstructed cavalryman to boot, but his extraordinary quality of leadership was clear to Arthur, who idolized him as one of the handsomest men he had ever met. Thoughtful too: learning that Kingsley was nearby, Haig said simply, "You'll see him tomorrow."

Sure enough, after traveling east to Mailly, Arthur found his son "with his usual jolly grin upon his weather-stained features. The long arm of GHQ had stretched out and plucked him out of a trench, and there he was." Kingsley talked of a coming big push—apparently Arthur's first intimation of the Somme offensive that was to take place a month later. Later in the day Arthur met Woodie, now Major Wood of the 5th Sussex Territorial Regiment (reserve unit), who had distinguished himself at Festubert and was now putting his organizational skills to good use as mayor of the town of Beauquesne.

After a forty-eight-hour stopover at the Hôtel Crillon Arthur continued by train to Italy where, on his first night in Padua, an aerial bombardment reminded him that total war was not limited to the Western front. As he discovered when he traveled eastward to the Italian army headquarters at Udine, trench warfare was not unknown in this theatre too, though the chivalrous nature of the exchanges between the Italian and Austrian mountain troops, the Alpini and the Jaeger, led him to conclude that the difference was the absence of the Germans.

Back in Paris on June 6, 1916, he heard for the first time of the death of Lord Kitchener, whose ship had been sunk in the North Sea at the start of a mission to shore up Britain's ally in Russia. Arthur's anger at this loss spilled out at the sight of the "red-epauletted, sword-clanking Russians" at the Crillon because "it was in visiting their rotten, crumbling country that our hero had met his end." He had arranged to meet Robert Donald, editor of the *Daily Chronicle*, his outlet for propagandist pieces, and together they were due to visit the French front in the Argonne, as near as they could get to the still-raging Battle at Verdun.

Donald introduced him to the French politician Georges Clemenceau, whom Arthur unfairly portrayed in his memoirs as a buffoon, railing against the franc's rate of exchange against the pound.

This was not an entirely inappropriate response since, with a view to the end of the war, the Allies were congregating in Paris for a conference on their economic future. But the days when Arthur was interested in tariff reform were past. Before going to the Argonne, he was taken on a day trip to the front at Soissons, which must have been as interesting for the company—Clemenceau's friends, Leo Maxse and André Chevrillon—as for the sight of a devastated French countryside, since the former was editor of the stridently imperialist and anti-German *National Review* (which, surprisingly, Arthur had never written for under him), and the latter an Anglophile man of letters who would soon publish his book, *L'Angleterre et la Guerre*.

When he finally made it to the Argonne, Arthur was taken aback when the French General Georges Humbert asked him abruptly and, presumably, not too seriously, what Sherlock Holmes was doing for the war effort. At the time he could only stammer that his detective had grown too old for active service. But when he returned home, he took time off from his history to pen "His Last Bow" in which Holmes emerges from retirement in August 1914 to nail a German master spy about to flee the country with British secrets. This slight propagandist story is interesting for its insight into Arthur's Celtic identity. He belabors his usual points about Irish perfidy as Holmes passes himself off as a fiery anti-British Irish-American in order to win the spy's confidence. He then negates this effect by giving his detective the *nom de guerre* Altamont, which was his father's middle name. This underlined his confusion about whether the Irish are friends or foes. (And how the detective spent several years developing his cover as a radical firebrand in the United States and Ireland is not clear.) Nevertheless, after being published in the *Strand* in September 1917, "His Last Bow" provided a topical conclusion to another collection of Holmes stories published the following month under the same appropriately terminal name by John Murray, which had taken over Smith, Elder following the suicide of the gangling Reginald Smith in December 1916.

Arthur's approach to "His Last Bow" was colored by his support on his return from France for Roger Casement, whose Irish nationalism had taken him quickly from respected British diplomat to condemned traitor awaiting execution in Pentonville prison. As was clear in 1913, Casement had been prepared to court the Germans in order to rid Ireland of the British. But his attempts to raise an Irish battalion in Germany in the early years of the war had not been successful. His spirits rose when he began to hear encouraging news of an imminent Irish uprising. But after he had prevailed on his German hosts to send

arms to the rebels, his submarine failed to rendezvous with the vessel carrying a shipment to the west coast of Ireland. On April 21 he and two fellow conspirators washed up exhausted on a Kerry shore where, three days before the Easter Uprising in Dublin, he was arrested, brought to London, and charged with high treason.

Determined there should be no sympathetic reaction to Casement's plight, particularly in the United States, the British authorities circulated copies of his diaries detailing his homosexuality. After the Irishman was found guilty on June 29, Arthur joined Yeats, Shaw and others in a campaign to save him from the gallows. This appeared to show Arthur in a favorable light, overcoming his anti-Irish prejudices, linking up with individuals with whom he had not always seen eye to eye, and supporting an old friend. But his motivation was more complex. As he stressed to F.E. Smith, he did not condone Casement's crime or suggest his punishment was unjust. Rather, it was not in the empire's interests that the Irishman should be made a martyr. This was what Casement and the Germans wanted, but it was astute to take the opposite approach. Predictably Casement's appeal in mid-July was rejected, his plight attracted little outside attention, and he was hanged on August 3.

Arthur's concern about Casement was all the more remarkable since he must have been worried about Kingsley, who had been wounded in the neck on July 1, the opening day of the much anticipated battle of the Somme. For the British, this was the bloodiest confrontation of the war so far. Already reeling from the effects of gas, their troops now had to cope with the horror of mechanized tanks at the front. Luckily Kingsley was not severely hurt and, after hospitalization, was able to return to his unit two months later. When people objected to footage of the Somme carnage being shown in cinemas, courtesy of Masterman's Propaganda Bureau, Arthur, who had worked on an earlier recruitment film, leaped to its defense. True to the documentary spirit behind his interest in history and photography, he argued, "How can we learn to understand and sympathize with the glorious achievements and sacrifices of our soldiers so well as when we actually see them in action before our eyes?"

On a more personal level, Kingsley's brush with death encouraged Arthur to come clean about his almost inevitable acceptance of spiritualism. Only a year earlier, in September 1915, he had refused to commit himself, telling the *International Psychic Gazette*, when it asked if he had any advice for people who had lost dear ones, "I fear I can say

nothing worth saying. Time only is the healer." This reply masked profound changes in his thinking on the subject. "In the presence of an agonized world," he later explained, "hearing every day of the deaths of the flower of our race in the first promise of their unfulfilled youth, seeing around one the wives and mothers who had no clear conception whither their loved ones had gone to, I seemed suddenly to see that this subject with which I had so long dallied was not merely a study of a force outside the rules of science, but that it was really something tremendous, a breaking down of the walls between two worlds, a direct undeniable message from beyond, a call of hope and of guidance to the human race at the time of its deepest affliction."

As a result he finally dropped his scientist's detachment and accepted the evidence of his senses that he was witnessing "a new revelation" to the human race in which religion had become a "real thing" and not merely "a matter of faith."

He anticipated his change of mind in a couple of letters to *Light* in March and May 1916 on the topic "Where is the Soul during Unconsciousness?." At last, on November 4, he announced what amounted to his conversion to spiritualism in a piece in the same paper. While stressing the time he had taken to reach this position, he affirmed his conviction that spiritualism provided a true system of religious thought, in some ways similar to the old ones, and in other ways new. The crucial point was that he had abandoned his doubts and now accepted an existence after death. As one commentator put it, Arthur was at last "able to fit spiritualism into the broad humanism which he had perceived played a role in all major religions. Spiritualism confirmed a life after death; it showed the unhappy results of sin; it demonstrated the existence of high spiritual beings and of a 'summerland' or heaven, wherein the individual found his or her restingplace."

Within days his new beliefs were confirmed to his satisfaction after his former sister-in-law Nem died in Devon. Beside her bed was a bottle of chlorodyne, the patent medicinal mixture of opium, cannabis and chloroform to which she was addicted. Eight days later Arthur visited a medium called Vogt Peters who suddenly announced, apropos of nothing, "There is a lady here. She is leaning upon an older woman. She keeps saying 'Morphia.' Three times she has said it. Her mind was clouded. She did not mean it. Morphia!" Convinced Peters was referring to Nem, Arthur reported this and similar sessions to Oliver Lodge, whose experiences after his son Raymond was killed in Flanders in 1915 had influenced Arthur. Confirmed in his own spiritualism, Lodge

had written a book, *Raymond or Life and Death*, published in 1916, about his attempts to communicate with his dead son.

Freed from his doubts, Arthur threw himself into all aspects of psychic phenomena. In the new year of 1917 he started investigating spirit photography—the process by which it was claimed an image of a disembodied being could be captured on camera. He was satisfied by a picture obtained this way of Jean's nephew, Alec Forbes, another recent victim of the war. But he was worried about the number of mediums preying on people in need of spiritual succor: the law should stop impostors, he agreed, but he was also concerned that it was a blunt instrument that could be turned against legitimate practitioners.

By then the first volume of Arthur's history had been published and he was involved in several new projects. Although he had stated he would never again stand (run) for Parliament, in December 1916 he nonetheless toyed with standing as an independent MP for the universities of Edinburgh and St. Andrews. He even issued an election address that claimed he was uniquely qualified, since he knew so much about the war and soldiers' problems from writing his history. As well as calling for a settlement in Ireland, with Ulster's consent, he spoke out strongly for controls on liquor. He believed that alcoholism would be a big problem when the war ended and, although he was against total prohibition, he preferred it to the current light restrictions on drink. However, it was a turbulent period in politics with a new prime minister, Lloyd George who had just taken over from the much criticized Asquith. Arthur's ambition to be an MP proved short-lived and he backed out before the end of the month.

He still had his history to write and, as for politics, he believed he could achieve more from behind the scenes. As a result of his lobbying for the introduction of personal armor, he had forged close links with the Ministry of Munitions (where Lloyd George had first made his mark on the war effort the previous year) and was delighted with the development of the tank, the subject of a warm exchange of letters in October with Winston Churchill, a leading advocate of this new weapon of war. His daughter Mary had been doing her bit for the war effort, working in an arms factory, similar to the one in Gretna that he visited in November and wrote up in hyperbolic terms for the *Daily Chronicle* under the headline "A Miracle Town. Making Food for Hungry Guns."

His propagandist skills had been noted by the Prime Minister, who invited him and Major Albert Stern, chairman of the tank supply committee at the Ministry of Munitions, to lunch in February 1917. Unexpectedly Lloyd George asked Arthur to write his biography. According

to his secretary and mistress, Frances Stevenson, who was also present, there had been a clamor for such a work, particularly in America. But Arthur, whom she described as "a nice old gentleman, very courteous and interesting," declined. Possibly he foresaw the problems that even he, with his silken pen, might have in writing a life of a Welshman who for most of his life had been a radical and pacifist. He excused himself by saying that he had never written a biography and anyway was occupied with his history. Stevenson confirmed that he was absorbed by this task, but he was having difficulty getting material, and even this, she could tell, was only what the powers that be wanted him to know. "Stern and I told him one or two things that opened his eyes. He has a childlike idea of the infallibility of the W.O. officials."

She got it only partly right. There was indeed something ingenuous about Arthur: along with his wide-eyed Victorian curiosity went an inherent belief in the goodness of human nature. He certainly had little time for the War Office's obstructive bureaucracy, but he was still confident that, if approached in the proper manner, individual army officers would supply him with the operational details he wanted.

So he continued peppering generals in the field and subalterns on home leave about their units' movements. Many top commanders were happy to cooperate, hoping to influence a much disputed historical record. (Haig had his wife distribute copies of his personal diaries.) Arthur also kept up lobbying on his usual range of issues. More or less reconciled to conscription, he began worrying about the effects of large numbers of soldiers descending on "harlot-haunted" London. Although against making a visit to a brothel a military offense, he argued that all "notorious prostitutes" should be locked up until six months after the end of the war. When his old friend Malcolm Morris, now a knight and chairman of the Propaganda Committee of the National Council for Combating Venereal Diseases, argued that this was impractical, Arthur countered that this could not be said of a policy that had not been tried. Coming so soon after his concerns about public drinking, his comments about "moral and physical contagion" suggested an affinity with the ultra-Right groups 670 would soon coalesce around the National Party. But despite attempts to rouse him about British decadence, the subject of a notorious libel trial the following year involving the exotic dancer Maud Allan and the director of the old Independent Theatre, J.T. Grein, he held back from any involvement.

His contacts with the Prime Minister had given him a wider perspective. The Zimmerman telegram, which showed Germany threatening

to attack American targets, would soon bring the United States into the war. After visiting Downing Street again for breakfast in March, he bumped into Rider Haggard at the Athenaeum and told him how Lloyd George had been discussing the Menshevik revolution in Russia the previous month. As a result of this inside knowledge, Arthur put a positive spin on the situation there, which was not anti- but pro-war, a rebellion of the army against bureaucrats and corruption. Sure enough in April a letter was published by Masterman's "Mendacity Bureau," signed by a number of authors including Arthur, praising Russia for ridding itself of an autocracy and embracing democracy. But there was more to Arthur's conversations with the prime minister than mere propaganda. Lloyd George recognized his good contacts and used him as a sounding-board. Among Arthur's papers were notes of their discussion about the capabilities of senior officers (Kitchener was deemed to have been particularly obstructive), armor and Russia. His advice was clearly heeded because, not long afterward, he was asked to go on an official mission to Russia, but he declined because he felt it would not be fair to Jean.

This was tied up with a flurry of family activity round Crowborough. In the spring Innes made a brief appearance to settle his wife and son into Windlesham Cottage, which he rented from Arthur for 13 pounds a quarter. He was there when the Conan Doyles entertained 130 officers from the Canadian Engineers, the latest troops to occupy the military camp in the town. Kingsley was now back in France, where he fought with distinction in the battle of Arras in April. Arthur told his mother that, with his spiritualist beliefs, he did not so much worry about his son dying as his suffering and being in pain, so he was relieved that Kingsley's duties as bomb observation officer confined him mainly to headquarters.

He had finally convinced the Mam to leave Yorkshire and move closer to him at Bowshot Cottage, near West Grinstead Park, the Hornungs' estate, thirty miles from Crowborough. He was determined that, despite being in her eightieth year and almost blind, she should enjoy the final part of her life. So he was annoyed when he was unable to find her a summer house, particularly as he had one at Undershaw but did not think his finicky tenant Dr. Selwyn would allow it to be moved. With help from her daughter Connie and her maid Lizzie, Mary Doyle was ensconced in her new house by early July, but when Arthur visited a couple of months later he thought she looked frail (though still happy and bright) and he suspected she might have suffered a stroke.

During the early summer he was laid low by a serious bout of flu that forced him to stop work on his history. Instead, as he told Innes in late May, just as he was departing with Jean to recuperate by Harrogate's spa waters, he had been thinking a lot about spiritualism, which he was convinced was the answer to his and the world's problems.

For the time being, however, Arthur had a parallel calling—his history. After the ninth chapter, taking the narrative to the battle of Loos in 1915, was published in the June issue of the *Strand*, the second collected volume followed. He sent a copy to Malcolm Morris, who expressed his concern that Arthur was overdoing things. "You are obviously tired and worn out, and I would suggest to you to consider whether it is not due to the fact that you are doing both physical and mental work at the same time." He recommended giving up volunteering and consulting the doctor he himself saw when "seedy."

But Arthur was imbued with a sense of mission. "The public don't realise what I set before them," he told Innes, as he took to his desk again and pressed ahead with his next volume about the Somme ("Pray God it is the last"). Throughout the exercise he had traded information with his brother and this time was no different: "The honey which you can hoard for me is some idea of the battle line for the whole campaign."

His state of mind was still confused, however, as was apparent from the dreams he began recording. In one he recalled opening the batting in an important cricket match between Catholics and Protestants. He seems to have been playing for the former and performed well. Eventually he was dismissed by being run out, but in his dream this happened in nightmarish fashion, as he had to run up a hill slowly and with great difficulty. He recalled telling the wicketkeeper that this was wrong. His sense of propriety was further offended by there being no umpire and, even more bizarrely, the wicket was marked on a wooden screen which stood at right angles to the pitch. It was as if his efforts on behalf of his old religion had been undermined by the treacheries and uncertainties of a mad Alice in Wonderland–type game.

Writing a new round of patriotic poems helped revive his spirits, especially when two of them—"The Guards Came Through," about the fortitude of front-line troops, and "The Guns in Sussex," a better piece evoking the horrors of being so close and yet so far from the fighting— were published in *The Times* that summer. As he also delighted in his young family, he tried to capture some of the charming never-to-be-repeated utterances of his growing children. First mentioned in a letter

to Greenhough Smith in early November, and published in a series in the *Strand* from the following April, "Three of Them" is a celebration of his life as "great chief of the leatherskin Tribe," surrounded by his wife, Lady Sunshine (he still rejoiced in the nickname she had been given in New York) and three children, who are neatly characterized— Denis, the restless soul who upbraids his father for hitting his younger brother; Adrian, who is supremely confident and will ask all and sundry if their father can give a war cry; and Lena Jean, or Billy, a five year old whose iron will is belied by her fragile looks. They frolic around Windlesham, acting out fantasies of pirates and Red Indians (often with their uncle Pat Forbes and young cousin John in attendance), spending long hours at cricket and boxing, and asking the sort of probing young person's questions that Arthur thinks worth recording.

Interestingly, for all their father's aversion to traditional religion, they are brought up as Anglicans, albeit with idiosyncrasies. When Billy is taken to task for leaving Adrian out of her evening prayers, she chirrups, "Well, then, God bless horrid Dimples." And when Denis asks if God or the Devil is stronger, he is told patronizingly that God is all powerful. He then inquires reasonably why God does not kill the Devil, whereupon Jean replies in the lame manner of parents through the ages that if people had nothing to struggle against, their personalities would be diminished.

Among Arthur's wider clan, things did not run so smoothly. His conversion to spiritualism had irked several members, particularly his sister Ida, who had returned to teaching and was running a school in Eastbourne. After telling her she was unreasonable, Arthur denied he had been cross. She took up the matter with Kingsley who had inherited a profound Christian faith from his mother and who responded thoughtfully, condemning spiritualism from a viewpoint diametrically opposed to his father's. Elaborating on a dialogue with his sister Mary, Kingsley simply thought it was too materialistic: "I feel that ordinary Christianity and prayer lead possibly to a communion with the unknown very similar to that reached by spiritualism but, though perhaps rare and less defined, is not clogged with the ugliness of material and human shortcomings." When briefly home during the summer, he had been prepared to tackle Arthur about Mary, who was still estranged from her father and suffering financial hardship. But on this matter of belief he admitted in November he "would not pretend to argue with Daddy."

By then Kingsley was again back in Britain because it had been decided he would be more useful to the war effort completing his

training as a doctor. Despite this good news, and the birth of a son, Francis, to Innes and Clara at Crowborough in November, family relations remained strained in the new year of 1918, after Arthur's feud with Willie Hornung again erupted. He had learned from Connie that his brother-in-law was worried about support for pacifism he had encountered while doing voluntary work with troops in France. To the horror of militarists such as Arthur, the Germans had been exploiting this mood with suggestions of an armistice, which some British politicians had taken up. But rather than ask Willie about this, Arthur reported the matter to his superior officer. An aggrieved Hornung told him there was no need for him to "butt in" except for his own "satisfaction." Now it was Arthur's turn to take umbrage, telling Innes that there was something strange about Willie, who did not act like a true friend.

Matters were not helped by the gossip flying around Crowborough that the Conan Doyles had been consuming more than their fair share of food and other produce, particularly tea. Although rationing was not officially introduced until later in 1918, restraint was expected, and Jean was forced to write to a local newspaper in February denying this rumor. (She claimed a gift of tea had unexpectedly arrived eighteen months after being ordered from an estate in India, much of it had been distributed to the needy, and anyway the Conan Doyle household had taken in 2,200 pounds less than its recommended share of vital foodstuffs over the previous year.)

By then the latest (1916) volume of his history had passed the censor, leaving it "mutilated, but not vitally," and ready to begin in the *Strand Magazine* in May. Arthur had started working on 1917, but again asked his brother's help for essential details such as the battle line at Cambrai in November. For security reasons Innes, now a Brigadier-General and Deputy Adjutant-General of 3rd Corps, was not always forthcoming. When in March 1918 he had the misfortune to be part of General Sir Hubert Gough's thinly stretched Fifth Army bearing the brunt of the German spring offensive in France, Arthur was not aware that his brother was taking part in this serious reverse, which temporarily cost Gough his job. Arthur found a new hero in the general, whom he went to interview in Farnham in early May, a couple of days after strongly defending his reputation on the letters page of *The Times*. Gough, who had refused to turn his troops on Ulster in the Curragh incident four years earlier, gave him a good account of Innes on the battlefield and became not only a useful informant but a personal friend.

By May Arthur had finished writing up the events of 1917 and started on 1918. He was still prepared to take a week off to attend camp with his Crowborough volunteers, even if this meant spending his fifty-ninth birthday away from home. He had been devoting considerable time to writing and lecturing about spiritualism, having just published a summary of his views in *The New Revelation*, which was selling well. So perhaps he hoped to win new recruits, like the young officer from the 1st Norfolks who, after hearing the message, converted his three roommates and presented Arthur with a rapt audience of twelve people one Tuesday evening. He told Innes optimistically, "I would go down and take them by hundreds, but the padres might object. Many of them—most of them—would rather the soul withered than be refreshed by any watering pot save themselves." At least he expected to lose some weight at the camp. On one such outing he shed seven pounds, which brought him down to a still portly but manageable 207 pounds, the lowest he had been since he was a schoolboy.

A couple of months later he almost succeeded in converting a Roman Catholic priest, his second cousin Father Dick Barry-Doyle who, after ministering to troops in Egypt and elsewhere, was suffering from shell-shock and under treatment at Thorpe Hospital, the mental asylum-turned-war hospital in Norwich, still run by David Thomson who was now a Lieutenant-Colonel in the Royal Army Medical Corps. The romantic Irish-born Barry-Doyle had appropriated the first part of his name in honor of a celebrated forebear of his mother, Commodore John Barry, the father of the American navy. But when Arthur invited his cousin to convalesce at Windlesham in July, he was more impressed by his warm character than by his ancestors. He told his mother that, for all Barry-Doyle's Catholicism, they both looked on religious matters from a very similar perspective. This was an odd statement, better understood in the context of Barry-Doyle's earnest avowal that, despite his faith, "I should love to go forth and preach what I feel is in me."

By the late summer the tide at the front was finally turning. The German commander General Ludendorff described it as a "black" day when his army was driven back to its defensive position, the Hindenburg Line, in August. Taking the family off to Southsea for a holiday, Arthur looked back on the past year's fighting with satisfaction, though whether this was because of this belated success or, as he mentioned to his mother, the realization that it would provide material for two volumes of his history is not clear.

He had time for one more public campaign (about the criminality

of German treatment of Allied prisoners) and one last trip—a four-day dash in late September to the Australian lines in France. He emerged from the latter with great admiration for Australian soldiers, whose "reckless dare-devilry, combined with a spice of cunning . . . gave them a place of their own in the Imperial ranks." But after a day at the front around Péronne, he could not help reminding 1,200 rain-drenched "Diggers" that England had contributed 72 percent of the manpower and suffered 76 percent of the casualties in the war. This did not go down well but, as a prototype English nationalist, Arthur felt some things needed saying, however politically incorrect: "England is too big to be provincial, and smaller minds sometimes take advantage of it."

Expecting encouraging news of the war's end at any moment, he was "stunned" to learn of Kingsley's totally unexpected death from pneumonia on October 28. The young man was not quite twenty-six and in good physical shape, but his wound had taken more out of him than expected, and he fell victim to the Spanish flu pandemic that in retrospect may have been responsible for Arthur's illness in the summer.

Arthur carried on with a scheduled lecture on spiritualism at Nottingham two days later. Mary, who was particularly close to her brother, arranged his burial at their mother's side in Grayshott on November 1. Although devastated, she still had the wit to write to her father the following day and tell him how his self-control had helped keep her calm at the funeral. But, as she knew, his lack of overt emotion reflected his tricky relationship. Only a year earlier Arthur had commented on Kingsley's secretive nature and said his son remained a closed book to him. It was no surprise when he told Innes that, despite his initial sadness, his cloud lifted after his son's burial and he hoped soon to be in touch with him.

Within days the armistice was declared. Staying in London, Arthur's first indication of something unusual was seeing a conventional-looking woman dance around the lobby of his hotel with a flag in each hand. He was delighted that the war had ended, not least because it brought reassurance: "Britain had not weakened. She was still the Britain of old." But even as he watched the enthusiastic crowds at Buckingham Palace, he was tormented by old demons. When he saw a man take a slug of neat whisky, he wished the crowd had lynched "this beast [who] was a blot upon the landscape." Some deeply etched scars on his psyche did not vanish just because he had adopted spiritualism.

Spiritualist Mission

1919–1924

Almost two decades earlier, Innes had casually suggested that his older brother's true calling might turn out to be politics rather than books. At the time Arthur was campaigning unsuccessfully to become MP for the Border Burghs. He replied unexpectedly and rather portentously, "It will be neither. It will be religious." And they had both had a good laugh about something so unlikely. But now that the war was over, Arthur's prediction appeared to be coming true. As he crisscrossed Britain, extending his experience of mediums and drawing large crowds for his talks, he was obsessed with only one subject, and that was spiritualism. He would soon be able to congratulate himself that his remark to Innes had been another example of man's "unconscious power of prophecy."

Not everyone was convinced, of course. After one address in Hastings on January 12, 1919 Arthur and Jean had supper with Rider Haggard, who lived nearby. "It may be all true," his host noted, "but 'the spirits' seem to be singularly reticent upon many important points. However, he believes in them most earnestly and preaches a most comfortable doctrine, so earnestly indeed that he travels all over England giving these lectures in order to make converts to this creed."

And so the audiences flocked to hear Arthur. The war had exposed the spiritual void that had opened up in the wake of science's assault on Christianity over the previous century, and people were looking for religious succor wherever available. In particular, they wanted closure on the deaths of loved ones who had been wrenched from them, usually in foreign lands and in their prime. By offering the chance of mak-

ing contact in another world and another dimension, Arthur seemed to give hope and often relief.

Sadly, Innes too would soon join the casualties. He was helping restore food and services to battered Belgium when, on February 19, 1919, he succumbed to the deadly Spanish flu epidemic that had already killed Kingsley. Arthur lost the much loved younger (still only forty-five) brother whose career he had nurtured and who had become his closest adviser.

Arthur now became "Vice-Daddy" to Innes' children (the younger of whom, Francis, was one year old). He also had another family member to contact on his excursions into the spirit world. Over the past few months, he had been impressed by a bluff medium called Annie Brittain, who was associated with Longton Spiritualist church in Hanley in the Potteries. He used to send her people who had lost a loved one in the war, and the batch of "thank you" letters from them in his papers suggest this was much appreciated.

Between July 1918 and March 1919 he consulted her four times (three successes and one failure, by his reckoning). On the first occasion he was given the flattering news that he had powers of healing. On the third in November 1918 he was put in contact with Kingsley who, although less than a month in his grave, was already pontificating about the good sense behind his death and referring to his discussions on the other side with Malcolm (Leckie) about medicine. When Kingsley mentioned that he had already been in touch, Arthur noted in his subsequent notes of the sitting that this was indeed true, but implied he was skeptical about the authenticity of this particular piece of information because he had foolishly divulged it to the medium.

By March 1919 his son seemed more comfortable with his new surroundings and begged forgiveness for not having had more faith in Arthur's judgment about spiritualism. This time he said he was with Innes, who had remarked, when he "passed over," "I thought you were dead," to which Kingsley had replied, "Just about as dead as you are."

Although delighted to make this contact, Arthur was soon informing his devout (and on these matters skeptical) mother that not everyone had spiritual powers, even when dead; whereas Innes, Kingsley, Oscar, Malcolm, Alec Forbes and Lily all had the knack, Leslie (Oldham) and Nelson (Foley) had not been in touch, much though he would have liked it. The problem, he told her, was that people could not be summoned at will.

Getting in touch with the deceased involved more than mere con-

versation, however. Spiritualism had a long tradition of communicating in signs. Only recently, in February, Arthur and Jean had witnessed a séance in south Wales where two respected members of the Merthyr Tydfil Spiritualist church, the Thomas brothers, Tom and Will, had allowed themselves to be tied up. Then, working through a spirit guide, a North American Indian called White Eagle, they had managed, without breaking their ropes, to send various objects flying round the room.

Arthur believed such strange happenings were designed to shock people and break up their rigidly materialist thought patterns. "The levitation of a tambourine or the moving of furniture may seem humble and even ludicrous phenomena, but the more thoughtful mind understands that the nature of the object is immaterial, and that the real question has to do with the force that moves it."

This Welsh séance was also attended by Sydney Moseley, a reporter on the *Sunday Express* which, while scoffing editorially at spiritualism, had recognized its popularity and offered 500 pounds to anyone who could materialize a spirit under control conditions. Reluctantly the Thomases agreed to try to repeat their séance in the paper's London offices and, predictably, they failed. Inevitably another medium, known as "Miss Smith," soon tried for the prize. At a séance witnessed by Arthur and others including Lady Glenconner, Herbert Asquith's sister-in-law, she entered the room in dramatic fashion, wearing a veil, and proceeded to identify the history of various items that people had placed in a box—among them, a ring that had belonged to Kingsley. Subsequently the lights were turned down and a ghostly woman appeared to manifest herself behind "Miss Smith." Arthur's uncertainties about this proved well founded because the medium's agent, P.T. Selbit, later revealed how "Miss Smith" had performed a simple conjuring trick. The box had temporarily been substituted and the contents scrutinized, while the ghost had been an accomplice. Selbit himself was a magician called Percy Tibbles, who is credited as the first person to saw a woman in half.

Arthur was finding that spiritualism was under attack from all sides—not just from fundamentalist Christians such as Father Bernard Vaughan, a hardline Jesuit preacher educated at Stonyhurst, whose views on spiritualism he described as showing "all the intolerance and persecuting spirit of the Inquisition," or from mockers like the *Daily Express* (now owned by the Canadian-born former Minister of Information Lord Beaverbrook) which queried why spirits always appeared at séances in the same shapeless robes, but also from committed

materialists, the most dangerous of whom were professional magicians such as Tibbles who thought they could replicate any manifestations by spiritualists and show them up as mere "tricks." Since Arthur was already familiar with this sort of behavior, he had no trouble turning down an invitation by the Magic Circle in July to have his paranormal claims investigated by its Occult Committee, particularly as it was advised by Nevil Maskelyne, son of J.N. Maskelyne, who had made a stage career of copying (and thus seeking to discredit) the illusions of early spiritualists.

Arthur redoubled his platform speaking, giving thirty-six lectures (according to his private diary) in 1919, probably more in reality. Jean was often at his side, enjoying an unaccustomed sense of partnership in an enterprise where, now that she had the power of automatic writing, her input was significant. (Ironically this technique would soon be used subversively by the surrealists, who saw it as a way of tapping into the unconscious.)

His talk on "Death and the Hereafter" in Worthing on July 11 was typical. In introducing him, the mayor, Alderman J. Farquharson Whyte, claimed he "would have preferred to hear Sir Arthur on any subject other than spiritualism." But he recognized the popular demand for information on the topic and would rather it was met from a public platform than "the somewhat doubtful atmosphere of private séances."

On this occasion Arthur took on a new swarm of detractors such as E.F. Benson, who had played a peripheral role in the events leading to Sherlock Holmes's "death" and was the author of a recent article on "Pitfalls of Spiritualism" in the indefatigably hostile *Sunday Express*. Another sometime ally-turned-scourge was the newspaper *Truth*, which had revealed that his favorite medium, Annie Brittain, had two previous convictions for fortune-telling. This last point was easily dealt with: since prophecy was still a criminal offense under Britain's ancient witchcraft and vagrancy laws, little blame was attached, Arthur argued, as he embarked on a new campaign to change the legislation.

The bulk of his speech was devoted to a familiar account of why spiritualism worked for him. He recalled how he had been brought up a materialist, but yearned for something more. Certain crucial influences, such as Lily's automatic writing, had brought about a change of heart. These phenomena (table-turning was another) were "sent as an alarm to the human race, something to call their attention, but nothing more; to shake them out of their mental ruts and make them realize that there was something beyond all this."

Arthur had begun to develop more specific ideas about the spirit world. Taking his cue from Sir Oliver Lodge, he suggested that, like radio waves, communication with the next world was made through the ether. As a result of his séances he was now much more familiar with the surroundings there and could offer comforting travel notes: children who died young were "committed to the care of the most sympathetic of their relatives on the other side," he promised. He was more confident in asserting that Jesus and his disciples were spiritualists. And he was adamant that his sympathies were "strongly with the spiritualist as against the psychical researcher, because the moment you approach these things in what you would call an inquisitorial attitude, by that very sort of attitude you spoil it. It takes a most powerful medium to get results when the surrounding atmosphere is tainted by doubt and skepticism and criticism." In other words, he had little time now for the scientific experiments of his old friends at the Society for Psychical Research. As a believer, he was happy to rely on the evidence of direct experience.

Arthur repackaged these concepts in his book *The Vital Message*, published in November 1919, as a follow-up to *The New Revelation*. He also wrote more newspaper and magazine articles (inevitably on spiritualism) than ever before. *Strand* readers, for example, were treated to a series that sought to provide a paranormal explanation to various crimes in the past. However, his attempt to show that the material manifestations of spiritualism, such as table-rapping and levitations, were becoming more sophisticated through such means as spirit photography and "inspirational addresses, writings, and paintings" backfired when he referred to a portrait of Jesus Christ in a New Bond Street exhibition as the product of a novice artist inspired by spiritualism. He was taken to task by the painter's husband, the Hon. Major Victor Spencer, a distant cousin of Winston Churchill, who complained to *The Times* that, though his wife was something of a naïf painter, she had no time for spiritualism and this was not only "repugnantly distasteful to her, but grossly misleading to the public."

Such publicity did no harm to Arthur's mission, however. He even had to ask his agent Gerald Christy to cut back on his engagements. (Jean noted that although 6,000 people had heard her husband in Glasgow, a further 6,000 seats could have been sold.) Arthur was all the more in demand because he seldom took money for his appearances, asking only that a fee be paid to the spiritual development fund account at his branch of Lloyds Bank in Oxford Street, which would be used to help needy supporters of the movement.

Despite his spiritualist commitments, he still found time for other public campaigns, whether calling for Germans to be tried for war crimes or railing against profiteering by greengrocers. He also concluded the final three volumes of his history of the war which appeared in March 1919, September 1919 and January 1920. But the *Times Literary Supplement* was unimpressed with the last two, which covered the year 1918, describing them as "no more satisfactory than their predecessors," and complaining not only about their lack of knowledge but also their literary failings and poor maps. The paper feared that Arthur's work would "suffer the fate of Entick's History of the Seven Years' War; and if the reader has never heard of Entick we shall say no more. . . . [Sir Arthur] has been much at the front, he has worked hard, he has felt much; but it is not his metier to write military history."

This would have been crushing to an author who only a few months earlier had had the temerity to compare his work with Napier's *Peninsular War*. Ironically, the reviewer was John Fortescue, the historian of the British Army who had once been a rival candidate to write the official history now being undertaken by the newly promoted Brigadier-General John Edmonds. Little short of a century later, Fortescue's forecast has proved remarkably true. Keith Grieves, a recent commentator on *The British Campaign in France and Flanders 1916–1920*, dismissed it as a propagandist work, which "mythologized the British soldier but failed to signify the nature of his achievements in a tortuously complex narrative," ignored vast areas such as "staff work, supplies, morale, artillery and aerial warfare" and tended to take the side of his best witnesses, notably Haig and Gough.

There was no doubting Arthur's commitment to his task. But he was showing signs of getting carried away with his sense of his own worth. He boasted to his mother that his wartime propaganda work could well gain him a baronetcy if he desired it and he was only half-joking when he told her, "Someone has called me 'the Saint Paul of the New Dispensation.' What are we getting to!!" In traditional Christian terms, behind his bluff exterior, he was guilty of the sin of overweening pride.

From a more secular perspective he was in danger of becoming a bore. When asked by the insistent *Sunday Express* about his wishes for 1920, he replied piously that he hoped that people would "cast aside foolish incredulity and shameful levity and . . . seriously examine . . . the enormous new revelation." (A few months later he took the paper's sister, the *Daily Express*, to task for giving the headline

"Wines and Spirits" to a report of one of his meetings where alcohol was served. He later apologized to the editor, his old friend Ralph Blumenfeld, saying, "I am half Irish, you know, and my British half had the devil of a job to hold the hot-headed rascal in.")

The ever-present spirits were too much for Mary, who found her father's antics "acutely embarrassing and painful," and when she told him of her unease he accused her of being prejudiced. So she took herself off to the West Coast of America where she found peace, apparently doing some journalism on the edges of the film world.

The children of his first marriage still seemed superfluous. It was significant that, despite proud claims of his son's heroic qualities, Arthur somehow failed, in the middle of his spiritualist activity, to write a promised monograph about Kingsley. But he did attend to more mundane family matters over Christmas and New Year's. He advised his mother, who was under pressure from her landlord to leave her new house. He rewrote his will, tidying up various loose ends following the deaths of his son and his brother. And, with his capacity for shouldering responsibility, he accepted that there was a new generation of relations to help. Despite thinking that his sister Dodo's son Bramwell was unsuited for university, he was happy to discuss the boy's future and to assist him in starting a career in business. He was better able to do this because the not inconsiderable Windlesham purse had been boosted following the death of Jean's mother Selina in 1919. She had left 60,000 pounds to her three surviving children, providing Jean with an additional income of 800 pounds a year.

There was related drama since Jean's sister Milly had left her husband Pat Forbes and gone to live in Hampstead with William Ransford, the photographer who had collaborated on *The Lost World*. She was a tricky woman, never much loved by either Jean or the Conan Doyle family. But Arthur replied courteously to Milly's letter of explanation, praising her good points, while noting that she could be both fiery and irritating. He accepted the fact that Forbes had probably caused the rift, but put a sympathetic personal spin on his former brother-in-law's plight: "An artist has an artist's failings—do I not remember my own poor father—and it is part of his very self like his skin, but he has usually his own special points as well."

After traipsing around the provinces for much of the previous year, he had agreed to participate in a big debate on spiritualism at London's Queen's Hall in March 1920. His opponent was Joseph MacCabe, a former Franciscan priest who had become a vocal critic of

religious belief. Describing it in advance to his mother as possibly the most important night of his life, he was touched by the prospect of Welsh villages holding special meetings to win him spiritual support. As it turned out, MacCabe demolished one of Arthur's favorite stories— that in April 1917 he had awakened in the night with the word "Piave" ringing so insistently in his head that he wrote it down and later sent it to the Society for Psychical Research. Subsequently the Italians were driven back to the river Piave, and Arthur complimented himself on his prescience. But, according to MacCabe, who had done his home- work, the place had been mentioned in *The Times* the day before Arthur's supposed feat of prophecy. At the end honors were about even, though Arthur was helped in that the meeting was chaired by his old spiritualist friend Edward Marshall Hall.

In March a new challenge unexpectedly arose when the famous American illusionist Harry Houdini sent Arthur a copy of *The Unmask- ing of Robert-Houdin*, his book about the French conjurer from whom he had taken his name. This had started as a history of magic and ended as a disillusioned exposé of Robert-Houdin's trickery. Included in it were some observations on the Davenport Brothers, a couple of Americans whose successful stage show had reproduced the table- tappings and other spiritualist phenomena of the mid-nineteenth century. In his polite letter of thanks, Arthur queried whether the brothers were really the tricksters Houdini implied; he was convinced that they had supernatural powers, but had been traduced by oppo- nents who liked to claim they had been "exposed." Some spiritualists believed Houdini himself had psychic talents, Arthur added, before remembering his own recent experience and opting to dismiss his correspondent's abilities as the product of skill and application.

So began the strange relationship between two canny men deter- mined to win one another to their point of view. As a consummate self- publicist, Houdini had originally written to Arthur because he was about to tour Britain and thought some contact with the celebrated creator of Sherlock Holmes would boost his profile. Emboldened by Arthur's reply, he continued the exchange, and when a little later he was performing on the English south coast and he accepted an invita- tion to visit Windlesham on April 14, their epistolary friendship quickly blossomed into a real one. Houdini found the author "as nice and sweet as any mortal I have ever been near" while Arthur described the wiry American as "far and away the most curious and intriguing char- acter I have ever encountered. I have met better men, and I have cer-

tainly met very many worse ones, but I have never met a man who had such strange contrasts in his nature, and whose actions and motives it was more difficult to foresee or to reconcile."

Despite his skepticism Houdini showed a polite interest in Arthur's tales of his communications with his son and in Jean's dabblings in the occult, which he described as "beyond belief." As a result Arthur changed his original opinion and began to think that his guest's stage escapades really did demonstrate some supernatural power. Houdini, who was naturally curious, decided to play along with this and therefore readily took up his host's recommendation to visit the medium Mrs. Brittain. Arthur saw this as further evidence of Houdini's commitment to spiritualism, whereas it was little more than a showman's recognition of a widespread interest in the paranormal and his cynical decision to explore if it might give a new edge to his well worn act.

Accompanied often by Eric J. Dingwall, an investigator from the SPR, Houdini attended eight more séances in June with Marthe Béraud, an attractive young blonde known as Eva C, whose feats of materializing ectoplasm had gained particular credence as they had been verified by Professor Charles Richet, the French physiologist and Nobel Prize winner. But although he gave Arthur full reports, describing one such evening as "highly interesting," he was in private "not in any way convinced by the demonstrations," attributing the medium's feats to regurgitation and describing the ectoplasm that issued from her body as nothing more than inflated rubber.

By the time Houdini returned to America in early July, Arthur had other things on his mind. He was determined to take his message further afield and was contemplating accepting an invitation to visit Australia. He made clear, however, he would expect to bring six other people (his wife, three children, secretary Wood and wife's maid Jakeman), so he needed 1,600 pounds in travel expenses before he even left the country. At first a local spiritualist promised to provide the funds, but when he failed, Arthur took Christy's advice and hired a professional, Carlyle Smythe, who had once been Mark Twain's tour agent, to organize the trip and make sure it made money.

In the meantime Arthur had been collecting material for an article on fairies for the *Strand Magazine*. Originally this was little more than a nostalgic piece about an eternally fascinating but peripheral paranormal phenomenon. It became much more engrossing in May when David Gow, editor of *Light*, told him that a noted medium, Felicia Scatcherd, had heard about some unprecedented photographs of fairies. This was particularly exciting to Arthur as he was convinced, as

part of his spiritualist creed, that spirit forms could be captured on film. In the past year he had sprung to the defense of the controversial Crewe Circle which, under William Hope, had made much of its experiments in this field. He had discussed the phenomenon with Houdini, and now it seemed his optimism had been justified and it was possible to photograph not only spirits but also their most elusive and playful manifestations in fairy form.

Scatcherd put Arthur in touch with Edward Gardner, a dapper building contractor from Harlesden in north London, who sent him copies of the photographs he had come across through a Theosophical Society connection (he was president of its Blavatsky Lodge). These pictured sixteen-year-old Elsie Wright and her younger cousin Frances Griffiths apparently frolicking with fairies in front of a waterfall at Cottingley, near Bingley in West Yorkshire. He declined to send them to Houdini, perhaps fearing a negative response. But in a state of some excitement he did show them to Sir Oliver Lodge in the Athenaeum Club. The eminent scientist counseled caution: in one of the snaps the girl showed no interest in the fairies, he observed, but had "the usual vague expression of the sitter in ordinary psychic photographs: as if there was nothing to see." He suggested how the photograph might have been faked, using reduced images of dancers from magazines. However he granted that if the photographs were genuine, they were "more remarkable than anything I have yet seen."

Coming from a family so immersed in fairy lore, Arthur had a strong motive to corroborate this story. If he could prove its truth, he would go a long way to rehabilitating the memory of his father and showing that, far from being mad, Charles Doyle had the evolved sensibility to communicate with higher spiritual beings. So he encouraged Gardner to have the negatives authenticated by professional photographers, while he himself took a set to the Kodak company in London's Kingsway. Although he received a non-committal response, he interpreted this as a statement of support. Since he was now also poring over P&O brochures in advance of his Australia trip, he left it to Gardner to visit the Wright family and investigate further. In the meantime, having rejigged his article to take account of this startling new evidence, he did some necessary public relations, sending Elsie one of his books (he also talked of putting aside 100 pounds for her future wedding) and contacting her father to agree on terms for first use of the photographs in *Strand*. The amount proposed (5 pounds or a five-year subscription to the magazine) was not ungenerous, but, set against the 500 poounds he intended charging Greenhough Smith for his article,

with more to come from American rights, it was minimal. (He also offered Gardner 50 pounds for his assistance.)

After a rousing send-off in London, when 290 fellow travelers filled a Holborn restaurant to the rafters, he and his entourage set sail for Australia on the SS *Naldera* on August 13, 1920. The highlight of a long and tedious voyage was his achievement of a boyhood ambition of captaining England versus Australia—at deck cricket. With Wood on hand to take care of the children's education, Arthur was able to bury his head in novels such as *The Mirror and the Lamp* by his favorite W.B. Maxwell. Occasionally he would emerge and, despite the baking sun and prickly heat, lecture the passengers about his beliefs.

His record of his progress, *The Wanderings of a Spiritualist*, showed he still had the capacity to surprise with his opinions. Passing through Gibraltar, for example, he recorded that, though his commitment to empire was second to none, he did not believe "that strange crag" should be under British control. Although his suggestion that Spain should pay for the naval base to be moved lock, stock and barrel to Ceuta in North Africa was half-baked, his underlying idea that wars should be followed by lasting and just peaces was as valid in relation to the Treaty of Utrecht as to the Treaty of Versailles.

On reaching Fremantle in Western Australia on September 17, he was pleased to find a letter telling him that Gardner's trip to Cottingley had been successful. Having left a camera with Elsie Wright, his collaborator had been rewarded with three additional fairy images and was now proposing a joint book, which appeared two years later under Arthur's name as *The Coming of the Fairies*.

With its rugged outback and rippling shores, Australia seemed an ideal environment for an adventurer such as Arthur. But while he was grateful for the hospitality of his fellow spiritualists, and he enjoyed many fine moments such as being made an honorary member of the Melbourne cricket club and witnessing a 3,000-strong audience in Sydney waving their handkerchiefs and singing "God be with you till we meet again," he found the proselytizing side of his trip hard work. The country had an entrenched Christian lobby and, even before he reached it, Presbyterians had been praying to their Lord to prevent his arrival. Melbourne, his home for six weeks, first at the Menzies Hotel and then at a flat in the Grand, proved particularly irksome, which was odd as its quaint ways reminded him of Edinburgh. He made the mistake of lampooning the place, describing it as "spiritually dead" in an article in the *International Psychic Gazette* that appeared while he was still on tour. When his comments were widely reported and interpreted, correctly, as

criticism of Australia as a whole, he was forced to backtrack and apologize unconvincingly that he had only been referring to Melbourne.

He was happier in Sydney, particularly as he was able to spend ten days with his family on the coast in nearby Manly, which provided "a golden patch in our restless lives." With his liking for new sports he took to surfing, recalling the sun gods of the American writer Jack London whose passing during the war he bewailed, "What right had such a man to die, he who had more vim and passion, and knowledge of varied life than the very best of us?"

Leaving his wife and children at the Pacific Hotel in Manly, he and his agent Smythe crossed to New Zealand for a successful series of lectures that took up most of December. But even he could not hide his sense of the ridiculous in Christchurch, where a supposed clairvoyant dog failed to perform its party trick of counting the coins in his pocket by the number of its barks. He could only state that the animal clearly "had these powers, though age and excitement have now impaired them."

Despite a shipping strike, he returned to Melbourne only to discover that, on December 30, his adored mother had died, age eighty-three, at her home in Sussex. Although he was sad not to have been at her bedside, her death was not unexpected, so he decided to leave the funeral arrangements to his sisters and to complete his tour. In fact Willie Hornung took the initiative (it was he who registered her death from cerebral hemorrhage and coma). As a result Mary Doyle was buried not with her husband and three daughters in Dumfries but at St. Luke's church in Grayshott, Surrey, beside her grandson Kingsley and daughter-in-law Louise. This was surprising since Arthur's first wife, for all her qualities, had been brushed from the family history. But Willie had never liked Jean (particularly since he had seen Arthur flaunting her at Lord's over two decades earlier) and he had had more recent spats with his brother-in-law. He is likely to have been supported in choosing Grayshott by the strong-minded Mary Conan Doyle, who was back from California and had arranged her brother's burial in the Surrey churchyard only two years earlier.

The shipping strike spared Arthur having to visit Tasmania for further lectures. Within a short time his tour had ended (and at a profit), and on February 11, 1921, he and his party were able to sail for Europe on the same ship that had carried them out. They disembarked at Marseilles, intending to spend a week in France. Passing through Lyon, Arthur stopped to see Edmond Locard, the head of the national police laboratory, who was a great Sherlock Holmes enthusiast.

His visit confirms he was still keen to write detective stories. (Per-

haps his extended sojourn without earning much had concentrated his mind.) He had been directed to the Frenchman by Harry Ashton-Wolfe, one of his more colorful friends in the criminological world. The son of a Scottish doctor who had emigrated to the United States, Ashton-Wolfe had spent his youth in Colorado and Arizona, before moving to Europe and finding a berth in the Paris police as an assistant to Alphonse Bertillon, the great advocate of criminal anthropometrics. He subsequently decamped to London, where he worked as an interpreter in British courts and from the mid-1920s developed a career as a writer.

In Paris Arthur intended to concentrate on his current passion, the paranormal, visiting the Institut Métapsychique International, headed by France's most renowned psychical researcher, Dr. Gustave Geley, in the Avenue de Wagram. He gave a talk attended by other local luminaries in the field, including Professor Charles Richet, whose protégée, the medium Eva C, was on cue to ooze ectoplasm in a closed séance. No sooner had he arrived in the French capital, however, than he learned that Willie Hornung was seriously ill near Biarritz. Leaving Jean and the family at the Hôtel du Louvre, he rushed to see him. But he arrived too late: his brother-in-law had died two days earlier, on March 22, and Arthur was only able to go to his funeral. He was back in Paris in time to watch an international rugby match between England and France on Easter Monday, March 28. He also took his wife and son Denis off on a two-day tour of the Aisne battlefields, arranged by Thomas Cook.

Domestic matters occupied Arthur on his return—not just finalizing his mother's estate, but also making another effort to sell Undershaw. This time the wording of the advertisement—"to ensure an immediate sale a very low price acceptable"—showed some desperation. It proved successful, though the 4,000-pound bid by a would-be hotelier was significantly less than half Arthur's optimistic valuation a quarter of a century earlier.

After that, Arthur was determined to capitalize on a renewed interest in bringing Sherlock Holmes to the cinema screen. Over the previous decade over fifty silent films about the detective's exploits had been made in various countries, but the copyright situation remained unclear and the financial returns were negligible. During the war Gillette appeared in a film of his Holmes play, but the consensus was that, in his sixties, he was now too old to play the lead. The English Samuelson company also made silent versions of two novels, *The Valley of Fear* and *A Study in Scarlet* (which required the great Mormon trek

across the Rocky Mountains to the plains of Utah to be replicated in the Cheddar Gorge and on the beach at Southport in Lancashire).

After the war the Stoll Film Company, which had recently been set up by the ambitious theatre and music hall impresario Sir Oswald Stoll, approached him about making a series of twenty minute features based on the Holmes short stories. Sensing an opportunity, Arthur had Watt check the validity of his copyrights in the United States and if necessary renewing them. When these were sorted out, Stoll (or his production director Jeffrey Bernerd) surprisingly picked Eille Norwood, an elderly stage actor of modest achievement, to play the detective. It proved an inspired choice: even before Arthur had returned from Australia the first three films (*The Yellow Face, The Dying Detective* and *The Devil's Foot*) had been made and shown to the press. They eschewed original period features, going for a contemporary 1920s ambience, but Norwood's performance (particularly his grasp of Holmes's disguises) was universally fêted, a verdict with which Arthur concurred, describing it as a "masterly personation" of the detective.

He was unlikely to say anything different as he had become heavily involved in the promotional process, something at which he, as a propagandist, was extremely adept. Showing his skill at cross-media publicity, he dusted off the script of *The Crown Diamond*, a play that had been lying in a drawer for many years. It was a slight concoction (recalling "The Empty House") about the attempts of Professor Moriarty's henchman Colonel Sebastian Moran to kill Sherlock Holmes in a contretemps over a missing diamond. Presented in a variety program at the (Stoll-owned) London Coliseum in May, this was an unsuccessful vehicle for Dennis Neilson-Terry, a novice actor but scion of a notable theatrical dynasty that included his aunt Ellen Terry and his parents Fred Terry and Julia Neilson, both turn-of-the-century stars.

Arthur then knocked out a short story, "The Adventure of the Mazarin Stone," based on this play. For only the second time (the other was "His Last Bow") this was told in the third person, thus giving Sherlockian conspiracy theorists ample scope for arguing that this undoubtedly inferior work should not be considered part of the "canon." It was published in the *Strand Magazine* in October, the first of a new series of the detective's tales, which appeared sporadically before being collected in *The Casebook of Sherlock Holmes* in 1927.

Amid much hoopla Arthur attended the grand Stoll Film Convention at the Trocadero restaurant in Shaftesbury Avenue on September 28, 1921. He sat through various toasts and even a message from Prime

Minister Lloyd George, who claimed he had read the latest Holmes story and considered it one of the very best (usually the verdict is the opposite). Arthur then made some good-humored if anodyne comments on the Holmes phenomenon, taking care, rightly, to emphasize the importance of people in supporting roles, such as Greenhough Smith, Sidney Paget, Gillette and now Norwood.

His diplomacy and self-effacement, not to mention the inferior quality of his recent literary output, were the results of his having slipped effortlessly back into his British spiritualist activities following his return from Australia. He lectured less frequently than before, but made his views felt as widely and forcefully as ever. The fairy photographs had not excited as much serious interest as he had hoped, despite the publication of his original article on the subject in the *Strand* in March, complete with the additional new snaps from Yorkshire. Generally, critics were astounded at his credulity, though it would take many years for the truth of the Cottingley fairies to be established: that the images had been cut out of *Princess Mary's Gift Book*, a wartime charitable initiative to which Arthur himself had contributed a story ("Bimbashi Joyce").

That did not stop Arthur from persevering with his research into spirit photography, which gave him an opportunity to relive something of his happy hours in darkrooms forty years earlier. During the autumn he became interested in capturing auras on film and, with his dentist Guy Ash's assistance, embarked on a hunt for dicyanin, a blue dye derived from coal tar that had been identified as an essential coating for the glass screens used in this particular process.

He maintained his friendship with Edward Gardner, inviting him and Leslie Curnow, an Australian who worked at *Light* magazine, for a spiritualist Christmas at a bunker-like Windlesham, where the real world was kept firmly at bay, as suggested in some excruciating verses he composed for a seasonal card:

> "Now for Peace and now for plenty!"
> So we said in 1920.
> Alas there followed fire and flood,
> 1920 proved a dud.
>
> But we were not to be done,
> "Stand by now for '21!"
> Economic strife and bother!
> It was dudder than the other.

Well we raise our peckers still,
'22 may fill the bill,
When old Ireland troubles not,
And the Trotskys cease to trot.

We hope so—and we wear meanwhile
Our patent shock-absorbing smile,
But whatever fate may do,
We send our greeting out to you.

In keeping with this sentiment, a stoical Arthur amused his children
and guests with a version of his party piece of reciting Christmas mes-
sages from absent friends including the King of the Fairies, who sent
festive good wishes to Gardner as the man who had discovered him.

The most controversial work in the psychic field was being done by a
group around a spirit photographer called William Hope in the railway
town of Crewe in Cheshire. Arthur had first visited Hope in 1919,
when he was rewarded with a picture of Kingsley that he convinced him-
self was generated by paranormal means, despite his suspicions that it
originated as a newspaper image. Always prepared to stand up and be
counted, Arthur described this sitting and defended the "Crewe Circle"
in an article in the newspaper *Truth*. As a result he heard from Fred Bar-
low, honorary secretary of the Society for the Study of Supernormal Pic-
tures in Birmingham, who reassured him that such photographs often
exhibited "screen effects." Eager for further "scientific" investigation of
this phenomenon, Arthur again showed his solidarity by agreeing to
become a vice-president of the Society.

It was not until February 24, 1922, that Hope allowed himself to be
tested by Harry Price, a young man who, by carefully sitting on the
fence like Houdini, had developed a reputation as a sympathetic psy-
chic researcher. The venue was the British College of Psychic Science,
a new body set up in Holland Park by James Hewat McKenzie, a noted
spiritualist whose wife was a childhood friend of the Labour politician
Ramsay MacDonald. Price brought his own photographic plates but, to
ensure they were not tampered with, he marked them not only with
pinpricks but also with invisible X-rays. When Hope duly produced a
spirit photograph, but not on one of the marked plates, Price con-
cluded that his batch had been switched and Hope was therefore a
fraud. His report appeared in the Journal of the Society for Psychical
Research in May.

* * *

By then Arthur was in the United States on a long-planned tour arranged by Lee Kendrick, a short-haired, smooth-talking agent whom Arthur regarded as the epitome of the modern American, very different from the bewhiskered Major Pond of the 1890s. After crossing the Atlantic with his family on the White Star liner the *Baltic*, he arrived in New York on April 9, 1922, to much the same reception as in 1914— being greeted by the detective William J. Burns, running the gauntlet of inquisitive newspapermen, before stealing away and settling into the Ambassador Hotel.

He noticed two significant changes since his previous trip—the country-wide ban on alcohol (which had been introduced in 1920) and the greater incidence of crime, which, with his complex attitude to drink, he somehow regarded as interrelated. However, his irrational conclusion was that the authorities should tighten restrictions on liquor, which he felt was still too readily available, particularly—and here his prejudices showed—for unassimilated immigrants, heady with their new-found freedoms.

After an obligatory tour of Manhattan for the benefit of his children, Arthur settled down to the serious business of his "mission," as he liked to call it, which meant visiting mediums and giving public talks. Although his first lecture at the Carnegie Hall drew an audience of 3,500 people, he found the going tough, particularly as members of the press were less respectful than eight years earlier when they had been excited at having the author of Sherlock Holmes on their shores. Now journalists tended to ask frivolous questions about marital relations in the spirit world. As Arthur struggled to curb his impatience, he lurched into ever more convoluted explanations of the spiritualist position, leading clergymen and others to take him to task. His case was not helped when a New Jersey woman killed herself and her baby son, claiming that she had been guided by spirits after hearing Arthur talk on the wireless.

He was relieved to get out on the road for a few days. Instead of Major Wood, who had stayed at home, he had Captain Widdecombe, an "aide-de-camp" supplied by Kendrick, to carry his bags and "smooth all the angles" when he traveled to Boston, where he again made a point of visiting Oliver Wendell Holmes's grave, and then down to Washington, before returning to New York via Philadelphia.

Back in the Ambassador Hotel Arthur was still determined to win Houdini to his cause but the diminutive escapologist, who was now starring in his own films, remained as elusive as ever, and their relationship became even more of a game of jockeying for influence over one

another. When on May 10 Houdini invited Arthur to his plush brown-stone on the Upper West Side, he first amazed him with the extent of his library on spiritualism, and then won him over further by giving him a pamphlet written by one of the Davenport Brothers. But having just written his own book exposing the tricks of stage entertainers, Houdini wanted his guest to understand that he considered most spiritualists to be equally bogus. As a simple demonstration of what could be achieved, in the taxi earlier he had appeared to slice off the end of his thumb and then reattach it. This was all too realistic for Jean, who promptly fainted.

Up on West 113th Street he gave Arthur a slate, with wire attached, which he asked him to hang anywhere in the room. He also handed him four solid cork balls and invited him, first, to check one by cutting it open, then to dip another in a bowl of ink, and finally to go out for a short walk during which he should write a short phrase on a piece of paper and put it in his pocket. After strolling three blocks, Arthur stopped and did as he had been told. He wrote down the Biblical words "Mene, mene, tekel, upharsin" and made his way back to the house. There he was given a spoon by Houdini and asked to take the ink-satured ball and hold it to the hanging slate. He found to his sur-prise that the ball not only stuck to the slate but began to move across the surface, spelling out first an "m," then an "e" and an "n," until the phrase in his pocket was clearly written. He immediately saw this as fur-ther evidence of Houdini's incredible supernatural powers. But his friend told him it was simply a magic trick he had been developing.

Arthur still had to give more lectures which would take him, with his family this time in tow, to New Haven, Rochester, Buffalo and Toronto and then on to Detroit and Chicago. Also on his itinerary was Toledo, Ohio, not so much for its cultural attractions as for being the home of Ada Bessinet, the most spectacular "materialising medium" in America. He and Jean had been to several of her séances when she was in England the previous year, and he was determined to witness her powers on her own soil. Bessinet was known for her dramatic abil-ity to command spirits who played musical instruments and sang in different voices. But on this occasion she (and her Indian control) astounded her visitors by summoning the face of Jean's mother Selina and the voice of Kingsley—the latter through a mysterious trumpet that the sitters were instructed to hold to their ears if it touched them as it passed through the air, apparently of its own accord.

Arthur returned to New York to take up Houdini's invitation to the annual banquet of his Society of American Magicians at the Hotel

McAlpin on June 2. Initially, when Houdini mentioned that some of his professional friends would be recreating the effects of séances, Arthur had huffily refused to go, saying he regarded the subject as sacred and that he abhorred bogus spiritual phenomena. Houdini relented, thus allowing Arthur to attend a somewhat solipsistic gala evening at which every guest was given a gold-trimmed Houdini mascot doll. Not to be outdone as a showman, Arthur asked if he could give an after-dinner speech. This went predictably enough as he thanked the assembled magicians for their help in exposing false mediums before taking them to task for attacking spiritualism, which he said was a phenomenon they did not understand. But at the end he announced he would run a short film that showed lifelike dinosaurs gamboling in a primeval swamp. He added little else, leaving his audience bewildered and uncertain whether they had witnessed some kind of spiritualist apparition from prehistory. They did not know they had been watching some rushes from a film of *The Lost World* which was in production, and the dinosaurs were early examples of the "stop-motion" or frame-by-frame animation technique which Willis O'Brien would perfect a decade later in *King Kong*.

The following day Arthur explained what he had done, emphasizing that "it was not occult, and only psychic in so far as all things human come from a man's spirit. It was preternatural in the sense that it was outside nature as we know it." In the process he had skillfully turned the tables on the magicians and shown he was capable of his own *coups de théâtre* when required. Unexpectedly, however, he was threatened with a lawsuit by an inventor who claimed his patents had been infringed in the animation sequences.

Before leaving for England later in the month, Arthur invited Houdini and his wife Bess to spend a weekend with him and his family at the Ambassador, the largest, most modern hotel in the fashionable New Jersey seaside resort of Atlantic City. He wanted not only to write up his trip (for *Our American Adventure*) while incidents were still fresh in his mind but also to relax with his children, whose resilience had been widely praised. His gawky, bespectacled daughter Lena Jean or Billy certainly showed her mettle when she slipped on the Boardwalk and had some splinters extracted on the spot. Complimented on her bravery by a passerby, she replied disarmingly, "Oh, I am English."

On Sunday afternoon, June 18, they were all having a good time, swimming and playing games, when Arthur casually asked Houdini if he would join Jean in a séance as she felt she might have a special message for him. In the coolness of the Conan Doyles' suite, the atmo-

sphere turned unworldly as Arthur thanked the Almighty for the new revelation, before ceding control of proceedings to his wife who said she had been seized by the most energetic forces she had ever known.

Pencil in hand, she inquired of them, "Do you believe in God?" and banged the table three times in what appeared to be an affirmative answer. After making the sign of the cross, she began to scribble furiously on a pad. When Arthur asked who was standing beside her—was it Houdini's mother?—she again thumped three times. As she filled each page of her pad, she tore it off and passed it to Arthur who read a long message from Houdini's mother saying how much she loved her son, how great Arthur was, and how much she was enjoying her afterlife.

At the end Arthur was so pleased with Jean's automatic writing that he advised his guest to practice it himself. When, in response, Houdini grabbed the pad and wrote a single word, "Powell," Arthur was even happier, as he interpreted this as a reference to a spiritualist friend Ellis Powell, who had recently died. This only confirmed for him the magician's inherent psychic powers. Houdini later told him he had been thinking of someone very different, Frederick Powell, a goateed illusionist who was helping promote his new film, *The Man from Beyond*.

The two men's uncertain friendship remained intact, however, for on his brief return to New York Arthur attended a screening of this movie. He was delighted at the final scene, which showed the hero and heroine reunited, reading a passage from his book *The Vital Message*. As a result he gave the film an encomium that was widely used in its advertising: "The very best sensational picture I have ever seen. . . . It leaves one breathless." On June 22 Houdini invited the Conan Doyles to a show to mark his twenty-eighth wedding anniversary and the next day he accompanied them to their ship, the *Adriatic*. Arthur set sail more convinced than ever of the magician's paranormal abilities, while Houdini remained on shore, still impishly and defiantly skeptical, but with the bankable endorsement of his film he wanted. In his cabin Arthur found a telegram, "Bon voyage. May the Decree of Fate send you back here soon for another pleasant visit. Regards. Houdini."

By the time Arthur resumed his mission to the United States nine months later, his relationship with Houdini had soured as they had both become entrenched in their views. The illusionist's opening salvo came in October 1922 when he announced that, after twenty-five years of research, he had "never seen or heard anything that could convince me that there is a possibility of communications with the loved ones who have gone beyond."

Striving to keep his sangfroid, Arthur wrote to tell Houdini that, in the light of the séance with Jean in Atlantic City, he was upset about this observation. In fact he was deeply hurt—not just because the integrity of his dear wife had been impugned, but also because the two men had seemed to be getting on so well. At one stage Houdini had sent him details of a collection he had acquired of over a hundred letters from Charles Doyle to his boyhood friend Frederick Ellis. He quoted from one of them where Arthur's father had offered Ellis a design for a historical painting in which the souls of the dead rose up and fought.

But Houdini was now toying with the credulous Arthur. On his side of the Atlantic the stakes in the culture wars between mediums and skeptics had been raised when the New York General Assembly of Spiritualists offered a prize of $5,000 to anyone who, by "trickery, fraud or deception," could produce eight separate manifestations of spirit power. (Houdini's denial of communication with the dead had come in response to that.) Then in December the pot doubled when the prestigious journal *Scientific American* offered a further $2,500 for the first spirit photograph and the same sum again for evidence of "an objective psychic manifestation of physical character"—both to be produced under test conditions.

Arthur was horrified by this worldly incursion into his sacred territory. He immediately wrote to the magazine accusing it of "a very dangerous thing" as "a large reward will stir up every rascal in the country, while the best type of medium is unworldly and would not be attracted by such a consideration." He recommended that, if it were to send a representative—"a good level-headed man of affairs with plenty of tact and patience"—to Europe, he himself would introduce him to the right people and allow him to conduct his research in a proper spirit of harmony rather than confrontation.

Arthur's reaction was all the more robust because he had had a breakthrough in his dealings with the "other side." For several years he had been holding private séances at which he talked with dead family members, while Jean practiced her automatic writing. Recently he had even been in touch with his mother, who had in the afterlife abandoned her wariness toward spiritualism, on one occasion even telling him that his Uncle Henry was there and that he and all his other Catholic relations were supportive of Arthur's new work.

On December 10, 1922, however, he had gathered his wife and children around him at Windlesham (they were all now part of the "circle") when he suddenly found himself communicating (through

Jean) with a different type of being, a spirit guide called Pheneas, who described himself as an Arabian from Ur in Mesopotamia before the time of Abraham (an anachronism, as he would not in that case have been an Arabian). Pheneas appeared to be the fountain of all wisdom, and could be peppered with questions. On his very first appearance, Arthur asked if he should go back to America and his guide had answered, in terms strangely similar to Houdini, that it was God's will, adding for good measure that Pheneas should take the children for they all had a role to play in the unfolding of events. In that context he predicted an imminent upheaval that, like Sodom and Gomorrah, would rouse mankind from its stupour and banish all pretences.

This put a new complexion on Arthur's mission. But only nine days later, he received another bombshell from America. Houdini had been asked by Eric Dingwall, the SPR researcher, to confirm that he had received a spirit message from his mother through Lady Conan Doyle. (By then Arthur's account of his trip had been serialized in *Lloyd's Sunday News.*) Because of the new impetus, epitomized by *Scientific American*'s involvement, to reach some intellectual consensus about spiritualism, the American illusionist again decided to make his position clear. He issued a statement, which he had had notarized, declaring that he had never witnessed a mystery or attended a séance he could not explain, and, as for his sitting in Atlantic City, there was no question of his having felt his mother's presence, since she could not speak, let alone write English (Hungarian being her tongue), and he had noted down the word "Powell" entirely of his own volition.

At stake now were the relative powers of magicians and spiritualists, and neither side was going to back down. When in the new year Houdini gave an interview claiming that, as a conjuror, he could replicate anything a medium could do, Arthur, perhaps with an eye to his forthcoming visit to the United States, took the trouble to refute this and at the same time challenged Houdini to demonstrate if he also was able to materialize his mother and talk to her. Houdini shot back that he did not claim to produce such effects, but he did not think anyone else could either.

In the meantime Arthur had had better news from across the Atlantic. Surprisingly *Scientific American* had taken up his suggestion of an arbiter and was sending its young associate editor, Malcolm Bird, who would arrive in England from New York on February 10, 1923. Excited at an opportunity to influence the magazine's thinking on the paranormal and put an end to Houdini's wild assertions, Arthur met Bird, a former math teacher at Columbia University, and readily

accompanied him, as "an American friend and correspondent," on a tour of various British-based mediums. The journalist even had a session with William Hope, in whose support Arthur had written some chapters in the book *The Case for Spirit Photography,* which had appeared in December. Bird brought his own photographic plates but, unlike Harry Price, did not mark them. So his meeting proved inconclusive, leaving him suspicious of Hope's technique, which involved great folds of cloth and offered ample opportunity for concealment. In general, he had been interested by what he saw, but was unable to verify anything scientifically.

Arthur had an opportunity to influence the American a bit more because, by chance or design, they shared the same ship, the *Olympic,* which carried the Conan Doyles to America at the end of March. The crossing took a day longer than scheduled because of stormy weather that caused Arthur to fall on deck, twist his knee and spend two days laid up. After an inevitable delay in shepherding twenty items of baggage through the unruly custom house, the family settled into the Biltmore Hotel, which had the advantage of being managed by a committed spiritualist, and from where Arthur peeled off for his usual rounds of interviews, séances and lectures.

Sherlock Holmes now seemed to belong to another era. The combination of money (the *Scientific American* prize) and a brooding feud (with Houdini) ensured that the newspapers were interested in only one subject—Arthur's attitude to spiritualism. "Conan Doyle Back to Prove Spiritism," headlined the *New York Times,* "More Important than International Politics, Bolshevism or the Ruhr, He Says," while the *New York Mail and Express* took the more personal line, "Sir Arthur Coming to Continue Dispute with Houdini."

If Arthur thought his task would be easy, he was quickly disabused of this idea by the reaction to his comments on the sudden death of Lord Carnarvon, who had financed the recent excavation of Tutankhamun's tomb in Egypt. Arthur chose to interpret this as if it were an episode from one of his earlier ghost stories. With his uncanny blend of sincerity and showmanship, he attributed it to some malign occult influence, thus lending credence to the popular myth of the "curse of Tutankhamun." Even before his first lecture, the *New York Times* took exception to this irrational observation and ran an editorial, headlined "He's Beginning to Strain Our Patience." Houdini, who was touring, gave an interview agreeing that the logical explanation for Carnarvon's death was as reported—an infection, following a mosquito bite. But Arthur would have none of this, firing back a letter to his old rival that

ended, "Pray remember us all to your wife. Mine is, I am afraid, rather angry with you."

At his first major rally at Carnegie Hall on April 6, two nights after his arrival, Arthur showed he had lost none of the attention-grabbing tricks he had first learned from Joseph Bell and other teachers in Edinburgh. Refusing to be cowed, he startled his audience by projecting a photograph that supposedly showed spirits floating above London's Cenotaph on the previous Armistice Day. To his surprise, this induced a mood of near-hysteria: women started sobbing and one cried out uncontrollably, "Don't you see them, don't you see them?" For a moment he was halted in his tracks and stood, pointer in hand, unsure how to continue. Then, recovering his composure, he declared, "It is no wonder that this picture moves people's emotions. I think it is the greatest spirit photograph ever taken."

Tailoring his message cleverly to his audience, he forecast that the new world spiritualist church would be called the Church of America (on the analogy of the Church of Rome) because this was where it had started. Placing his hand to his head and closing his eyes for dramatic effect, he claimed he had had a vision and could see "a great church forming which will take in all sects from the Roman Catholic to the Salvation Army. . . . We will offer them an aid to their religion, which will bring religion and science together, which will . . . place them on a sound foundation. This puts a real vitality into religion. It is not new, for it harks back to the early Christians who, I believe, were all spiritualists. We are trying to get something practical because the old Christianity is dead—dead. How else could ten million young men have marched out to slaughter? Did any moral force stop that war? No, Christianity is dead." Not surprisingly, the reaction was mixed.

The following weekend he traveled 250 miles upstate to talk in Rochester, from where he paid a side visit, really a pilgrimage, to Hydesville, the home of the Fox sisters, who were regarded as the founders of spiritualism in 1848. He had hoped to bring a donation from England for a proposed memorial to these pioneers but, to his chagrin, the response was so poor that he was forced to hand back any money that had been given.

Away from his mission, he had, while in New York, to deal with an unwelcome legal challenge, relating to the tangled issue of film copyrights. The row over the *Lost World* clips the previous year had died down. But a more serious case had arisen in September when the powerful Goldwyn Corporation, flanked by the actor William Gillette and producer Daniel Frohman (brother of Charles, who had gone

down with the *Lusitania* in 1915), had started an action accusing the Oswald Stoll Company of violating their rights in the Sherlock Holmes name in its recent series of short films starring Eille Norwood. Their case was that Arthur had sold them these rights when he had entered into his original agreement with Gillette over the Sherlock Holmes play in the late 1890s. These rights had been passed in 1916 to the Essanay Film Manufacturing Company and in turn in 1921 to the Goldwyn Corporation, which had invested in a major new Sherlock Holmes film starring John Barrymore. This put Gillette and Frohman in direct confrontation with Arthur, who only in March 1920 had granted Stoll a license to use his stories, for a 10 percent share of the overall receipts.

When the claim had come before the New York State Supreme Court in November 1922, it was rejected on various grounds, partly because the original contract could not be found and partly because there was no likelihood of confusion between the Stoll canonical movies and the Gillette play and its derivatives. But the Americans appealed, requiring Arthur to give a deposition, the gist of which was that Gillette's play was a composite drawn from just two Sherlock Holmes stories—"A Scandal in Bohemia" and "The Final Problem" (though his mind was elsewhere as he could not remember the exact title, referring to it as both "The Last Adventure" and "The Last Journey"), while the Stoll films were based on and took their names from a number of specific stories. Once again the court found against the plaintiffs, who withdrew their plea and paid court costs. But the case had created bad blood between Arthur and the actor who, by his own admission, had done so much to establish the image of Sherlock Holmes.

On April 16 he was glad to put further challenges from the likes of the Society of American Magicians behind him and leave the confrontational atmosphere of New York, even if this meant some traveling on his own to various intervening cities before meeting up with Jean and the family in Chicago. Even when he was not around he made his presence felt, since New York's Mayor John F. Hylan saw fit to attack him personally and announce that the less people had to do with "so-called séances and spiritualistic manifestations" the better for both their souls and their peace of mind. Arthur was proud that Jean, who was still at the Biltmore, took up the cudgels on his behalf, informing assembled pressmen that, as obscurantists had tried to deny the possibilities of flying and broadcasting, nothing could stop the progress of knowledge, adding for good measure that the streets of New York were filthier than any she had seen, except in Istanbul.

Earlier in the trip she had made her mark with a radio broadcast that had Arthur trilling about his wife's beautiful voice, bringing hope and comfort, like an angel, to hundreds of thousands of radio listeners.

After spending time in Chicago with Bruce Kemp, a young "trumpet medium" who used a speaking-trumpet to amplify the deafening voice of his Red Indian spirit guide, the Conan Doyles again went their separate ways—Arthur to lecture in St. Louis and Kansas City, Jean and the children to soak up the sun in Colorado Springs, where they met up again to travel to Denver. Arriving there on May 7, they found themselves staying in the same hotel, the Brown Palace, as Houdini, who was appearing at the Orpheum Theatre in town. Arthur took the opportunity to discuss Kemp and other promising mediums and spirit photographers with his old sparring partner, who, he recognized, had an influential role as a member of *Scientific American*'s five-man investigating committee. (Bird was the secretary.) But despite exaggerated courtesies, with each man respectfully attending the other's show, old hostilities could not be ignored, particularly when the *Denver Express* reported that Arthur had issued a challenge, betting his rival $5,000 that he could bring his own mother back to life, or at least to physical form. Arthur quickly apologized, saying he had been misquoted, and Houdini chivalrously agreed that this often happened.

There was now little love lost between the two men, as their squabbling during the remainder of Arthur's trip proved. At his next stop in Salt Lake City on May 10, he was surprised to receive a request from Houdini asking for a promised manuscript of *Our American Adventure*. Unaware of such a commitment, Arthur wrote back suggesting there had been a misunderstanding: he may well have offered a copy of the finished book but not the manuscript, which he wanted to keep in his family, since, he added portentously, "if this mission of mine had any appreciable effect in altering the religious opinion of the world, then the time will come when the account of my travels may be very interesting and even valuable to those who follow me."

Arthur was pleased with his reception in Salt Lake City. The elders of the Mormon Church had a history of opposition to spiritualism and he had been afraid also that they might recall his unflattering description of their faith in *A Study in Scarlet*. But from the moment he was met at the station by Dr. D. Moore Lindsay, a local doctor who had studied medicine with him in Edinburgh over forty years earlier, everything went well, with 5,000 people cramming into the Salt Lake Tabernacle that evening to hear his talk on "Recent Psychic Evidence."

At that stage he was still only halfway through a journey that would

take him on to Los Angeles, where he visited Hollywood and passed some agreeable hours with Douglas Fairbanks and Mary Pickford; over to Catalina Island, which was owned by William Wrigley Jr., who had made his fortune from chewing gum, a habit Arthur abominated; down to San Diego (and a ritual crossing of the border into Mexico for a drink); and then up the West Coast through San Francisco (which he thought less spiritual than Los Angeles); Portland, where he was accosted by a familiar grey-haired character, who spouted secrets of Rosicrucianism and turned out to be another figure from the past—Dr. Henry Pullen-Burry, the former Hampshire GP who had tried to initiate him into the Order of the Golden Dawn; and eventually to Seattle and Vancouver, where he was relieved to get back onto what he regarded as British soil. He was happy to park his family with his old friend Colonel Rogers in Jasper National Park, while he continued to spend long hours on the railways, visiting Edmonton and Calgary. Finally they all made their way across Canada to Montreal and down through the Adirondacks to New York, where Arthur had time to learn of the growing menace of narcotics from city police chiefs, before sailing for England on the *Adriatic* on August 4.

Earlier, on the West Coast, he had had another spat with Houdini—almost a reversal of what had happened in Denver. This time the *Oakland Tribune* had printed some comments by the magician dismissing Arthur's views on certain mediums. Since the *Scientific American* committee was now taking evidence, Arthur felt he had to defend himself. "I hate sparring with a friend in public," he wrote to Houdini, only half apologetically, "but what can I do when you say things which are not correct, and which I have to contradict or else they go by default?"

While in Canada, Arthur had been invited to pass through Boston where Mina Crandon, the wife of a wealthy surgeon, was beginning to make a mark. She had attracted the interest of a team of Harvard academics, including Professor of Psychology, William McDougall, with her dramatic range of psychical effects—causing flashes of light, manifesting ectoplasm (often from her vagina), ringing bells, levitating tables, moving objects round a room, and communicating through a control who was her late brother, Walter. Replying to her husband Dr. Le Roi Crandon from a train in Canada, Arthur regretfully declined, but contact had been made and, when the Crandons traveled to Britain in December, Mina gave a number of séances, including one in the new London flat Arthur had acquired at 35 Buckingham Palace Mansions, in Victoria. He was so impressed that he put her name forward for the *Scientific American* prize.

Back in England Arthur found himself increasingly estranged from academic psychical researchers. He had been turned down when, at the start of 1923, the physicist Sir William Barrett, a founder and former President of the Society for Psychical Research, had tried to get him co-opted onto its influential Research Council. When, partly by way of thanks, Arthur helped arrange a dinner for Sir William at the Authors' Club in November, he found himself rebuffed again. For he tried to get a letter of endorsement for the occasion from Arthur Balfour, the former Prime Minister who had also been president of the SPR. Balfour asked his sister Eleanor, the one-time Principal of Newnham College, Cambridge, for advice. She and her late husband, the philosopher Henry Sidgwick, had been part of the Cambridge group that had differed with Barrett in the early days of the Society. Now living with their brother Gerald Balfour, the current president of the SPR, she replied sniffily, "A public confession of faith to these people and on this occasion would certainly, I think, be taken to imply approval and support of Sir Arthur Conan Doyle's spiritualistic beliefs and methods that in our view not only include a good deal of absurdity but positively hinder the progress of scientific evidence of survival." So Arthur Balfour was left to compose a brilliantly evasive letter that claimed his beliefs were of much older vintage than scientific psychical research and did not depend on it.

In the new year of 1924 Malcolm Bird began testing Mina Crandon's psychic powers, which he wrote up glowingly in the *Scientific American*. To preserve her anonymity he referred to her as "Margery," the spirit name by which she became widely known. When newspapers began reporting Bird's findings and suggested she was on the verge of winning the prize, Houdini, who had been preoccupied with touring and writing a book, *A Magician Among the Spirits*, was annoyed that he had not been asked to participate in these albeit preliminary trials. When he and Orson D. Munn, the owner of the *Scientific American*, finally managed to visit Margery in July, he claimed to see through her immediately, but somehow, by not divulging too much, he also convinced Dr. Crandon, like Arthur before him, that he might be wavering toward the spiritualist cause. (The Boston medic kept Arthur informed, usually referring to the magician in crude anti-Semitic terms.) But when at the end of August the full committee met in Boston to decide if Margery should be awarded the prize, Houdini was back in iconoclastic mode. One of Margery's party pieces was to cause a bell to be rung in a box, even though she was held down and theoretically could not move. Believing she had been helped, probably by

Bird, whose objectivity had waned, Houdini devised a wooden "fraud-preventer"—a desk-like contraption that would further constrain her. He did not help his case, however, by introducing a couple of his own props to make sure the judges were not duped—an eraser, to lessen the likelihood of the bell making contact, and a ruler, probably to give the suggestion that she was cheating. This only created more bad blood, leading to curses from Walter and threats from Margery.

All this was relayed back to England, where the Conan Doyles had rented a house in the New Forest for the summer. There, on September 5, Jean's spirit guide Pheneas entered the fray, saying there was a lot happening in America at that very moment, but the forces of goodness were powerful and would prevail over those of darkness. Then a few days later Jean's spirit guide took up this matter again, striking a more ominous note: "Houdini is doomed! A terrible future awaits him. He has done untold harm. . . . He, and all who uphold him, will be, as it were, chained together and cast into the sea. Your friends the Crandons will even in this world reap the reward of their brave work."

But nothing would deter Houdini now. When the *Scientific American* committee produced a non-committal interim report in October, he made his dissent clear and denounced Margery as a fraud. He followed this up with an unprecedented public attack on Arthur, whom he accused of imagining "he is a Messiah who has come to save mankind by instructing them in the mysteries of occultism. But instead of that he is misleading the public and his teachings are a menace to sanity and health."

Although 3,000 miles away from Margery, Arthur still presumed to act as her gatekeeper. When the SPR investigator, Eric Dingwall, had sought his help in gaining an audience with her, Arthur showed how much his judgment had been affected by raising an old dispute and resorting to petty blackmail. Still smarting from Dingwall's role in exposing the spirit photographer William Hope, he told him he could not put him in touch with Margery unless he recanted on this matter. So outrageous was this tactic that Dingwall was able to send Dr. Crandon a copy of Arthur's "extraordinary letter" and Margery was in no position to decline his request. As it turned out, Dingwall proved positive toward Margery, but, eager to maintain his reputation for objectivity, kept quiet about it. This only annoyed Arthur further, causing him to attack him personally in his *History of Spiritualism* for being two-faced and confirming the truth of the mediumship in private correspondence, while denying it in public.

Harry Price, another researcher who prized his independence, was more fortunate. Having earned Arthur's censure for exposing William Hope and the Crewe Circle, he had mended his bridges by attacking the Maskelyne family of conjurers who had made a point of revealing spiritualists' tricks. After being sent a copy of an article by Price on this topic in the summer, Arthur told the author that it showed him to be a reasonable commentator on the paranormal. But unable to let matters lie, he added, "Is it not a question now whether we can find some means by which the Hope controversy can be settled in some honorable fashion?"

On this latter point, Price kept mum. So, at the end of his New Forest holiday, Arthur picked it up again. Showing once more his willingness to trade access to mediums to achieve his ends, he offered the psychic investigator the opportunity to reassess his attitude toward Hope in return for a new séance with the spirit photographer, as well as one with Evan Powell, another of Arthur's favorite psychics, so long as he cleared things up with Hope. Determined to win Price's favor, he continued unabashedly (this was before the *Scientific American*'s interim report), "I hear from New York—but this is private—that Houdini is accused of dropping objects into a medium's cabinet in order to discredit her. The facts are very clear as stated and I understand that his own Committee is against him. He is a very conceited self-opinionated man but I should not have thought he would have descended to that."

But the slippery Price was in touch with Houdini himself and did nothing to clarify his position on Hope, betraying his ulterior motives when, before the end of the year, he asked Arthur to contribute an introduction to his book *Stella C: An Account of Some Original Experiments in Psychical Research*. While approving the work, Arthur declined this invitation, probably sensing he was being used.

By then Arthur was preparing to take his family to Switzerland for Christmas. Although he hoped to relax (he had promised his daughter that she would learn to skate and ski), he had a further reason for making the trip. For some time Pheneas had been issuing dire warnings about an impending apocalypse—a scenario recently confirmed by one of Arthur's favorite mediums, the Reverend George Vale Owen. As a result Arthur had canceled a proposed trip to Scandinavia in the new year of 1925. However, Pheneas approved of the Villa Berna, where the Conan Doyles would stay in Grindelwald. He promised to form a psychic ring around it and was already getting excellent vibrations from it. The chalet was owned by Sir Henry Lunn, the staunch Christian, now also tour operator, whom Arthur had first met at *The*

Young Man's summer camp in Lucerne thirty years earlier. A man with Arthur's breadth of interests, Lunn had just returned from a global tour promoting church unity and international peace. With Pheneas's help, Arthur had hoped for greater cooperation with Lunn. But little happened in this respect as he was focused on more mundane matters, such as writing to *The Times* warning businessmen of Germany's aggressive designs on their markets. As it happened, he cut his stay in Switzerland short, returning to London to take part in an important spiritualist meeting where the celebrated journalist Hannen Swaffer spoke about his conversion to the cause and about his astounding communication with his old boss Lord Northcliffe in the afterlife. Appropriately Arthur, his energy seemingly undiminished, was still better suited to the cut and thrust of public debate than to the self-absorption and discipline of quiet contemplation in the Alps.

Bignell Wood and Death

1925–1930

Toward the end of his 1922 trip to the United States, Arthur began talking of creating a new fictional character. Although he was hazy about the shape this person would take, he was pretty sure he would not be a detective. "I will break new ground," he said confidently.

It was a fair bet, given his current interests, that he had something to do with spiritualism in mind. But now that he was in his mid-sixties he found a major new feat of imagination beyond his reach. This did not mean he had become a slouch: during the early 1920s he produced an account of his Australian tour and followed this up with books on his two American "adventures"; he gathered his own memoirs, *Memories and Adventures* (published in September 1924); and he poured out journalistic pieces about spiritualism, several of which found their way into books such as *The Case for Spirit Photography*.

He also added sporadically to the Holmes canon. Following the disappointment of the stage-derived "The Adventure of the Mazarin Stone," he was back in form with "The Problem of Thor Bridge," published in the *Strand* in February and March 1922. The plot came, somewhat improbably, from Greenhough Smith, who alerted Arthur to a story in Hans Gross's *System der Kriminalistik*, the criminologists' handbook which was a favorite of Baden-Powell's. Originally called "The Little Tin Box," Arthur's version started with an entertaining overview of some of Holmes's unsolved, confidential cases (details of which were held in a battered tin dispatch box at Dr. Watson's bankers, Cox and Company). Since Arthur (or Watson, as Holmes's biographer) claimed he could not say much about further cases from the box because they often involved family secrets, it was curious that he

revealed that the murder on Thor Bridge had resulted from the intense jealousy of a wife "past her prime" for a "very attractive" young woman for whom her husband admitted a platonic passion. So vivid were Arthur's references to "a soul-jealousy that can be as frantic as any body-jealousy" that it is hard not to conclude that he was giving an imaginative twist to his premarital affair with Jean.

After a year's absence (which coincided with Arthur's first trip to America, and his early sparring with Houdini), Holmes returned in science fiction vein in "The Creeping Man" (notable for his telegram command to Watson, "Come at once if convenient—if inconvenient come all the same—SH") and again a year later in vaguely horror story mode in "The Sussex Vampire," which showed Arthur's sense of humor as he refrained from embellishing his Sherlockian output with any hint of spiritualism, which he realized would mean commercial suicide. "This agency stands flat-footed upon the ground and there it must remain," his detective had stated defiantly when presented with a suggestion of vampirism. "The world is big enough for us. No ghosts need apply."

Once more there were nods to his relations in the tea merchant trade (his father-in-law's job) at the start of the story, the location (south of Horsham, where the Hornungs lived) and the ubiquitous dog (Carlo, the name of his own spaniel whose passing in July 1921 he had mourned in a short poem in his collection "The Guards Came Through"). After that, "The Three Garridebs" (first published in *Collier's* in October 1924) was indeed a bit of "a comedy," as suggested in its first paragraph. It was interesting for its reference to Holmes having turned down a knighthood shortly after the Boer War, suggesting that the circumstances of Arthur's own honor continued to niggle.

Despite his heavy involvement in spiritualism and his feud with Houdini, Arthur informed Greenhough Smith at this stage about his ideas for his new character. "I have for years had a big psychic novel in me which shall deal realistically with every phase of the question, pro and con. I waited and knew it would come. Now it has come, with a full head of steam, and I can hardly hold onto my pen it goes so fast— about 12 or 15,000 words in three days."

Because of his Swiss trip, he did not finish *The Land of Mist* until February 24, 1925, and he was very relieved. "It was to me so important that I feared I might pass away before it was finished." He had failed to create any startling new literary figure, but this was certainly the spiritualist novel he had been threatening. Reviving three of the main protagonists of *The Lost World* (Professor Sumerlee had died in Naples),

he took them on a voyage of discovery through the perilous waters of contemporary spiritualism and psychical research, introducing thinly veiled sketches of the people, events and issues he had personally been involved with over the past decade. Although in his early days as a writer he had rejected the love story as a worthy format for a novel and had prissily reaffirmed as much at the start of this book, *The Land of Mist* followed the burgeoning romance between Edward Malone and Professor Challenger's daughter Enid as they conducted their journalistic investigation into the strange world of the paranormal. (The book's early title was "The Psychic Adventures of Edward Malone," but Arthur preferred the more literary allusion to the spirit of the albatross in Coleridge's "The Rime of the Ancient Mariner.") Challenger himself remained a profound skeptic until the end, when a séance conducted by his daughter convinced him that two men whom he had long thought he had inadvertently killed with a plant drug had in fact died of natural causes.

Arthur could not hide the book's didacticism: there was no action to speak of and several of the basic ideas were familiar. If he failed to capture the full Machiavellian nature of spiritualist backbiting, he was incapable of writing boringly and provided a lasting snapshot of the séances and research institutes of the time, including a vivid portrait of the Institut Métaphysique in Paris, with its director Geley (as Dr. Maupuis) conducting research into the Polish medium Franek Kluski (as Panbek), who made a habit of materializing thin paraffin wax molds of the hands of visiting spirits. (Houdini and others would say this trick was easily achieved by the medium plunging his own hand into two bowls—first boiling wax, then cold water—and quickly extracting it from the cast.) Arthur's reference to Geley was a posthumous tribute since the Frenchman had been tragically killed in an airplane accident the previous July while flying back from a session with Kluski in Warsaw.

One chapter dealt with the prosecution of a medium under Britain's 1824 Vagrancy Act, which was now considered a more precise legal instrument than the earlier Witchcraft Act. Having been concerned about this abuse of justice for some time, Arthur had written to his MP, Arthur Henderson, in September 1924 to protest against the religious persecution of spiritualists in Brighton by what he described as a small but energetic Roman Catholic guild. A similar protest the following year about the prosecution of a medium called Madame Estelle was investigated by the Home Office, but led to no change in the law.

Such goings-on had only heightened Arthur's sense of an impend-

ing crisis, with spiritualists ever more under attack from materialists and orthodox believers, and the only possible outcome being the catastrophe forecast by Pheneas. All around him, spiritualists seemed to be gathering their energies for a forthcoming struggle. Having benefited from a memorial fund for the war dead, the London Spiritualist Alliance had bought a new headquarters in Queensberry Place, South Kensington. With Arthur as its president beginning in 1925, it held a three-day bazaar at Caxton Hall in May, raising 1,000 pounds to renovate and furnish the place. It also rented out its top floor to Harry Price, thus giving him a permanent location for his National Laboratory for Psychical Research. A couple of miles away in Holland Park the Hewat McKenzies' British College of Psychic Science continued to thrive (with Arthur also as president). Around the country the network of spiritualist churches was still growing. The main dissenter within the paranormal community as far as Arthur was concerned was the Society for Psychical Research, which continued to hold him at arm's length.

So, having recharged his psychic batteries in the peaceable Pheneassanctioned atmosphere of Switzerland, Arthur had returned to the fray in no mood to let personal feuds drop. On Christmas Day at the Villa Berna he had written an impassioned defense of Margery, together with some barbed comments about Houdini's "strong prejudices and unbalanced judgement." When this appeared in the *Boston Herald* on January 26, 1925 the illusionist threatened to sue, but satisfied himself with remarking that Arthur was a "bit senile" and therefore easily "bamboozled." Just over a fortnight later the *Scientific American* committee finally pronounced on Margery, rejecting her claim to the prize by a majority of four to one. Undaunted, Arthur proposed that the British College of Psychic Science should give the Crandons a loving cup "in recognition of their heroic struggle for the truth."

He himself decided to contribute to spiritualism's growing infrastructure by setting up a Psychic Bookshop on the ground floor and basement of Abbey House, 2 Victoria Street (at the far end of this street from his London flat). Announcing the shop's opening in a forthright letter to *Light* in January, he asked for the entire movement's backing, explaining how he wanted to ensure that all involved had access to the uplifting body of literature associated with their beliefs. Six months later he extended the scope of the premises, adding a psychic museum, where he exhibited documentary material on famous mediums such as Daniel Dunglas Home, spirit photographs (including copies of the Cottingley fairies), and a range of apports and other items associated with séances such as "psychic

gloves." In time Abbey House gained an appropriate telegraphic address: "Ectoplasm Sowest London" and its letters went out with a clumsy slogan, "Every Psychic Student Should Have his own Library, However Small."

With his interest in the movement's past thus stimulated, Arthur wrote a series of influential articles that integrated marginal characters such as the Swede Emanuel Swedenborg into the mainstream. With help from Leslie Curnow, who had worked on the *Sydney Morning Herald,* he then turned these and other pieces into a full *History of Spiritualism,* which was published the following year.

Wearing his various official hats, he was invited to Paris in September for the International Spiritualist Congress, a body of which, with a certain inevitability, he was also president. As evidence of his pulling power, 4,000 people battled with police to get into the Salle Wagram. If this were not problem enough, Arthur's first lecture (of two) was marred by a projectionist persistently showing the wrong slides. When he mentioned Margery, a picture of Kluski would appear. Before long the audience was hooting with laughter, and Arthur walked off in an unpresidential huff.

He was not the sort of person to allow such setbacks to deter him from his spiritualist mission. But his way of life was beginning to change, in keeping with a man in his mid-sixties with a youngish family. Over the previous year he had begun to spend time on his own at his flat in Victoria, where he joked that, despite the attentions of a housekeeper, Mrs. Murray, his domestic habits were a throwback to his early days in Southsea. "You would have laughed to see me coffee making," he told Jean. "I ended by getting all the grounds into the saucepan. However I had the sense to strain it and it turned out really fine."

In the autumn of 1925 he added to his properties by paying 1,800 pounds for a retreat in the New Forest, his favorite part of the country, where he and his family had spent the previous two summers. A year earlier Pheneas had expressed his approval of an area where nature's vibrations were "more unspoiled . . . than anywhere in England," and had promised to send "a search party out for an earth dwelling that would be suitable for you both to reside in." This turned out to be Bignell Wood, near Minstead on the edge of the Forest. Described in the auctioneer's catalog as "an old-fashioned Cottage Residence with modern additions, Stabling, Garage and Gardens," it offered six bedrooms, with three and a quarter acres of wooded land and a trout stream, the River Cadnam, at the far end of the garden. Nominally it

was a belated birthday present for Jean, a country cottage where she could escape the responsibilities of running a family house in Crowborough. In her revisionist family memoir, *Out of the Shadows*, Georgina Doyle suggests that Jean manipulated the Pheneas sittings to obtain the house she wanted. That is a valid supposition, given the dynamics of her relationship with Arthur. After years in her husband's shadow, spiritualism had given Jean a role apart from mere housekeeping. Once she had hoped to sing for a living; now, through Pheneas, she could articulate whatever she desired.

One reason for acquiring the house was that, while Arthur had been tangling with Houdini, his children had been growing up. Mary, the last of Louise's brood, was now in her late thirties and resigned to the unlikelihood of marrying. She had returned somewhat chastened from the United States at the start of the decade. In a reshuffling of his finances in the wake of his own mother's death, Arthur had decided to be more generous to Mary and had given her 8,000 pounds outright. This no doubt helped her forget her earlier concerns about her father's spiritualism and begin adopting the same general beliefs, even if, as she put it, she arrived at them through the back door. So after continuing to dabble in her musical career (the high point being a concert by the Scolia Folk Song Quartette, which Arthur made a point of attending in the Aeolian Hall, New Bond Street, in October 1925), she settled into a life of helping her father not only with his religious engagements but also with managing the Psychic Bookshop and Museum.

Of the younger generation born to Jean, Billy presented no problems. As a spirited child (often described as a tomboy—by Houdini, in particular) she had overcome most of the disadvantages of growing up in a house with a dominant father. For a while she had had difficulty determining her sexual identity and, in possible subconscious deference to Arthur's wishes, used to sign herself "Your loving son." But on her tenth birthday she announced that she had decided to be a girl after all. She had subsequently attended her aunt Ida's school, Granville House in Eastbourne, where she took after her mother in her love of nature.

The two boys were more of a handful. This was not altogether their fault, as they had suffered from the spirit of competition their mother had built up between her family and Louise's. While Jean had turned her back on Mary and Kingsley, she had cosseted her own children, a process reinforced by Arthur's preoccupation with his work and particularly his spiritualism (the quid pro quo being that his

wife could do what she liked at home), and by Kingsley's death, which created a paragon of industry, self-sacrifice and virtue that Arthur's two younger sons had difficulty living up to.

In March 1925 Denis turned sixteen and Adrian was not quite two years younger. Although their early education had been disrupted by trips abroad, they had both passed through the Beacon prep school in Crowborough, where the headmaster tried to expel them for alarming their fellow pupils with their horror stories after lights out. But Arthur refused to accept this judgment, the boys returned to the school the following term, and the matter was forgotten.

Denis, the more intelligent of the two, declined to follow his half-brother Kingsley to Eton, preferring to become a fortnightly boarder at Tonbridge School, which was much closer to home. He lasted only a year in 1923–24 before going on to Berrow, an inferior establishment in Eastbourne, whose only virtue, as far as he was concerned, was that it did not push him too hard. Adrian (or Malcolm as he was still known) followed him in 1925, after spending time with a private tutor who eventually washed his hands of him.

Arthur's letters to his sons provide an intriguing study of an indulgent parent often having to mask his exasperation at his offsprings' unruliness. Surprisingly he seems to have agreed to spare them the rigor of a traditional English public school. At no stage did he try to engage them in intellectual or literary matters. (Pheneas does not count in this context.) He was prepared to allow them considerable liberty, and they usually wanted more.

When Denis reached the age of seventeen and demanded a car as well as the motorcycle he had at Berrow, Arthur agreed, but stipulated certain conditions. His son had to be in bed by twenty minutes past ten each night (Arthur reminded him if he was away at public school this time would be 9:15). "You came back looking very pale and Malcolm's eyes are bloodshot and his nerves so near the surface that he can hardly be polite to his own mother."

Denis paid little heed. In June 1924 his aunt Connie had died, leaving 500 pounds to be divided among him and his two siblings. Arthur opened a bank account with the legacy and permitted the children access to their portion of the funds. This allowed Denis to finance an even more extravagant lifestyle. In June 1926, his father took him to task for bringing back girls to the London flat. Another time Arthur pleaded with him to cut back on the social whirl: "We both feel that your life has taken rather too much of a jazzy turn. More cricket and golf, less dancing, cinemas and late hours in hot rooms.

Please!" But Denis seemed to like to taunt his Victorian father with stories of his latest friend, Lord Feversham's brother, the Hon. David "Fatty" Duncombe, who frequented the Florida, 43 and Blue Lagoon clubs and was well known to the London chorus girls.

But if Denis was an extrovert product of a materialist age, Adrian was temperamentally more difficult. Not only had he lost more schooling at crucial stages, but also he was overweight and his resulting low self-esteem led even his tolerant father to upbraid him for his self-absorbed and boorish behavior. In May 1926 Arthur told Adrian he was no longer even looking forward to spending time with him within the confined quarters of Bignell Wood. Threatening the ultimate sanction, he said that, though he did not have the heart to send his son away to a public school, he might consider sending him to Switzerland, unless there was a complete change in his attitude, starting with his diet. It did not help when Adrian ran into trouble with the law, once for a bicycling offense, and, more seriously, for dangerous driving. Although Arthur loyally defended his son to the local policeman, he implored him to take more care, since the town was full of gossips and busybodies who did not necessarily have the Conan Doyles' interests at heart.

Later in the year he admitted to Adrian that he was in a quandary. "When you upset your mother last visit I said that we must not have you home so often. You will understand that I have to guard her as you some day will have to guard your wife. Now I can't always be going back on what I have said as if I had never said it. You would imagine that I had no settled will or purpose." So he proposed banning his son from the house for a week. He also suggested that when Adrian felt his "black mutinous moods" coming on—and he admitted he had had some himself—he should "get away alone and fight it out in your own soul. Then come back when you have mastered it."

Adrian took the hint, for when, the following March, his father sent him a copy of *Pheneas Speaks*, a heavily edited version of the spirit guide's utterances, Adrian thanked him profusely for it. "I have already read it from cover to cover," he wrote. "It's wonderful stuff. I am longing to go down to the Forest again. It seems such a long time since I last saw it. I've lost about 8 lbs in weight and suits which used to fit quite tight now hang almost loosely on me."

The previous month another of Arthur's sisters, Dodo, had followed Connie to the grave. Suddenly his wider family commitments were slipping away. Connie's passing had drawn a line under his relations with the Hornungs who, as strict Roman Catholics, had disapproved of Arthur's persistent attempts to encourage them to contact

his brother-in-law Willie in a séance. Dodo's death was particularly sad, as the onetime H. Ripley Crowmarsh was not quite fifty but had been worn down by the rigors of life as the wife of an impoverished clergyman in Somerset. That left Ida and Lottie. Arthur was in regular touch with the former as his daughter was at her school (though Billy boarded with her aunt Clara, Innes' widow, who also lived in Eastbourne). But Lottie, the sister to whom Arthur had once been closest, had drifted away for no obvious reason, except that she held no brief for spiritualism and preferred to live out her widowhood in Lewes, accompanied only by her daughter, Claire.

The other unexpected absence from Arthur's life was Dick Barry-Doyle, who had taken up Catholic relief work among the Greeks and other displaced nationalities of the former Ottoman empire in Istanbul in the early 1920s. This had led to Barry-Doyle, now a Papal Monsignor, making lucrative lecture tours of the United States that culminated in the setting up of the Catholic Near East Welfare Association in September 1924. Perhaps Arthur's antipathy to Catholicism had reached the point where he could not stomach such sectarian initiatives, for he did not mention his cousin in this period even though the two men had (at different times) followed the same lecture circuit, including Carnegie Hall.

Barry-Doyle remained president of this Association for two years, but, innocent of religious politics in America, fell afoul of an Irish lobby, which objected to his British ways and particularly his habit of dressing up as a British officer, one of many uniforms he liked to wear. After being edged out of his position, he suffered a nervous breakdown in London in late 1928, when it is hard to imagine that Arthur did not help. But even here religious politics may have played a part. According to an unlikely story later given credence by Adrian, Barry-Doyle played a mediatory role in an offer to Arthur of a peerage. But this came with a quid pro quo that he give up his spiritualist activities—a condition which, even if it had been suggested (there is no corroborative evidence), makes it most unlikely to have succeeded.

Arthur no longer needed secular titles because he was being showered with honorifics that meant much more to him. An article in the *Christian Spiritualist* described him as a "modern saint." In early 1926 John Lamond, who was to be his first biographer, told him that "in less than two centuries people will be praying to you as the God-man I believe you to be."

With Arthur's life now revolving around an axis between Bignell

Wood, the center of his family life, and Victoria, the base for his spiritualist campaigns, the Psychic Bookshop and Museum had become a sort of shrine, competing with the Roman Catholic Pro-Cathedral at the far end of Victoria Street. When a visiting journalist noticed a queue of people outside, Arthur commented drily, "Yes, this is not a shop only. It is a soul surgery [clinic]. They bring their psychic experiences, their hopes and their worries. Sometimes we can help them; sometimes we can't. But we do our best."

Among those seeking his help, albeit in a different context, were the Crandons. Although he had stopped communicating with Houdini, he had kept up his championship of Margery who he still believed would be the beacon of American yearnings when the catastrophe predicted by Pheneas finally hit. In mid-1924 she and her husband were trying to adopt an English boy, but someone intent on preventing this had spread the scurrilous rumor that they were illegally trafficking children for adoption. By the following summer the American Secret Service had been alerted to this story and a British MP was questioning the White Star Line about its possible unwitting role in the operation.

The MP was the enigmatic Harry Day, who had long been Houdini's British agent. The way he had reinvented himself put even the magician in the shade. Born Edward Lewis Levy in the United States, he first surfaced in Britain as a professional actor in 1900 when his wife, a music hall performer, won a divorce on the grounds that he had beaten her up and committed adultery. After legally changing his name he became a successful if litigious impresario, agent and theatre owner. His First World War record is sketchy, but somehow he attained the rank of lieutenant-colonel as head of the Scottish Cadet Corps. The mystery behind his bluff exterior was not dispelled when in July 1922 his flat in Victoria (around the corner from Arthur's) was raided and 5,000 pounds worth of valuables stolen. Subsequently he expanded into insurance and in 1924 was elected the Labour Member of Parliament for Southwark Central.

His unforeseen intervention in the adoption case suggested the hand of Houdini, who had stepped up his campaign against fraudulent mediums, for which he was on the point of seeking Congress' support. But when Dr. Crandon told Arthur about the matter in August 1925, he was unclear about this background and simply offered the case as "a little problem for Sherlock Holmes." Still in an anti-Papal mood, Arthur replied that he saw the Roman Catholic Church, rather than an individual, behind it, but added the caveat that this was perhaps Watson speaking and not Holmes. Before the end of the month Harry

Day's involvement had been confirmed, but when Crandon wrote to the MP asking him who had put him up to it, he received much the same answer Arthur had—that it would be "a breach of confidence were I to disclose the names of those who called my attention to the original circumstances."

Arthur was now in a difficult position. Although he was busy fighting his own battles for spiritualism at home, the Crandons, his friends and great hopes for the future, appeared to be suffering from persecution, which Houdini was helping to perpetrate. He was increasingly convinced that Houdini was being used by the Roman Catholic Church, the religion of his wife Bess. This obsession had almost certainly fouled his relations with Dick Barry-Doyle. And in the background the sinister refrain of Pheneas could be heard. "Houdini is doomed, doomed, doomed," the spirit guide had unambiguously intoned the previous year. "He will not be allowed to stand in the way of God's progress."

Even so, Arthur was taken aback when this prediction of Pheneas appeared to come true in bizarre circumstances. That very evening Houdini was performing in Montreal, where he took the opportunity to unleash not only a general attack on mediums but also a personal salvo against Arthur, whom he threatened to "tear to ribbons" as a "big school boy" rather than a scientist. Then, after his show the following night, October 22, he was approached by a student who asked if it was true he could withstand the severest blows to his abdomen. Since this was the sort of thing Houdini used to brag about, he could hardly deny the student an opportunity to try. Initially he seemed fine, but the next day he collapsed after a show in Detroit and was taken to hospital with a ruptured appendix. After this was removed, he developed peritonitis, an infection from which he never recovered. He died nine days after the original assault.

Although circles around the Crandons received this news with glee, Arthur was more circumspect, at least in public. "His death is a great shock and mystery to me," he announced. "I greatly admired him, and cannot understand how the end came for one so youthful. We were great friends." This was not altogether untrue: the two men had been close, even though their camaraderie had been greatly strained. And Arthur certainly admired Houdini, but had become frustrated by his denial of his own occult potential. This was his greatest sin in Arthur's eyes, and the one which he believed cost him his life. As he told the American writer Fulton Oursler, "the spirit world might well be incensed against him if he was himself using psychic powers at the very time when he was attacking them."

Arthur's readiness to consider that the "spirit world" was taking its revenge on Houdini indicates the apocalyptic terms in which he now viewed what was happening around him. Aside from his comments on Houdini, Pheneas's general predictions of global disaster had been getting more specific as he had referred to the coming world-surrender to God, starting at harvest time in 1925 with a great storm moving from west to east, followed by a vast upheaval in Central Europe and the submerging of a continent. Most nations would suffer, the sinful Vatican would be destroyed, and only England would survive as a beacon of light. But none of this had happened. So perhaps Houdini's death had a place in this cosmic unfolding, even if only as an early skirmish in some future conflict between the forces of good and evil. Or perhaps, as has been suggested, it was a more cynical murder conducted as part of a dirty religious war by some foot soldiers in the army of spiritualism, who had heard of Pheneas's imprecations against Houdini, thought these were Arthur's orders, and acted accordingly. The ransacking of Harry Day's London apartment once again the following June only added to a sense of a vendetta. This time four paintings were slashed, including one by the seventeenth-century Flemish artist David Teniers that had been given him by Houdini in 1909.

Under the circumstances Arthur decided on a more subtle approach. Houdini had held out against any paranormal explanation of events. But what if he should appear to recant from beyond the grave? This would surely be an important victory for spiritualism. And it was in no way alien to Arthur's point of view. Because he was convinced of Houdini's psychic powers (a line he reiterated in "Houdini the Enigma," published in the *Strand Magazine* in July 1927), he thought it highly likely that the magician might try to communicate with someone from the other side.

The obvious candidate was his widow Bess. So Arthur put aside his anti-Catholic prejudices and began a regular correspondence with her in which he encouraged a grieving woman to explore such possibilities. She responded positively to the attentions of the famous writer and generously sent him his father's youthful letters, which she said her husband would have wanted him to have. At the same time, Arthur used his influence to ensure that Arthur Ford, an ambitious young medium with his own First Spiritualist church in New York, preyed on her vulnerability and pandered to her psychic needs. Bess proved a willing student. By February 1928, fifteen months after Houdini's death, she was admitting that the single word "forgive," which the magician's mother had apparently blurted out in one of Ford's

séances, had some special significance for her husband. With her defenses crumbling, she claimed to recognize ten more crucial words delivered in code through Ford's spirit control in January 1929. She said that, duly completed and interpreted by her, these comprized a message that she and Houdini had agreed on if he were ever to contact her from beyond the grave.

No matter that this coded message seemed a put-up job or that a now ailing Bess later repudiated any suggestion of spiritualist intervention. Arthur finally had a triumph in his drawn-out battle of wills with Houdini. He needed it since, for all the pomp of his various spiritualist offices, his ground campaign had been faltering. Despite all the psychic activity around Buckingham Palace Mansions and Victoria Street, Pheneas's general predictions had resolutely failed to happen. In March 1927 Arthur's Psychic Press and Bookshop published *Pheneas Speaks*. But a comparison of this expurgated printed version with the original typescript in the Henry Ransom Research Center shows that he had not been above embellishing the text. In particular he had added apparent prophecies about earthquakes and storms in Russia, Jamaica and Australia, together with footnotes confirming their triumphant occurrence in 1926 and 1927. According to the charitable interpretation of the scholar Jeffrey L. Meikle, "One might suspect Doyle of fabricating all the messages, but it is likely that he hoped to ensure the book's acceptance with a few dramatically fulfilled predictions." One person unimpressed with the results was Arthur's old sparring partner H.G. Wells, who dismissed Pheneas as "a platitudinous bore."

Arthur received more positive feedback from a debate at the Cambridge Union in April when he spoke against the motion "That spiritualism is repugnant to common sense" that was proposed by the avowedly skeptical chemist and geneticist J.B.S. Haldane. This was an important event for Arthur since he prided himself on his continuing ability to discuss matters of science at the highest level. He had often engaged Sir Oliver Lodge on topics ranging from the astronomical theories of his old Portsmouth friend General Drayson to the properties of the wireless radio, about which he also communicated with the celebrated Italian Guglielmo Marconi. Now in Cambridge he was delighted to feel he had tripped up an opponent who let slip he had only been to one séance. What, Arthur asked the Union members, would Haldane have replied if he had been talking about chemistry and had said he had only once been in a laboratory? As he reported back to Jean without a hint of self-consciousness, "there would not have been ten votes in our favor had the vote been taken when I rose, and

I turned all the tide of a losing battle." (The winning margin was 126 votes.) To make his triumph even more satisfying the audience included his son Denis, who was hoping before long to go up to the university to study medicine.

But in general the spiritualist cause remained a struggle. A man of fierce loyalties, Arthur again clashed with the panjandrums at the Cambridge-dominated SPR in April, when he took up a complaint from Dr. Crandon that the Society's Journal had refused to print his reply to an allegedly biased account of one of Margery's more recent séances. The matter went to the Society's Council where, after intervention from Sir Oliver Lodge, a compromise was reached whereby the Journal agreed to print a signed statement from Mrs. Crandon that certain improprieties ascribed to her had not taken place.

In the meantime Arthur had become involved in another intractable spiritualist row, this time involving F. Bligh Bond, an archaeologist who had lost his official job in Somerset after becoming obsessed with the occult significance of Glastonbury Tor. He had subsequently found a niche as the unpaid editor of *Psychic Science*, the journal of the British College of Psychic Science, in which capacity he had helped transcribe the automatic writings of Cleophas, a first-century Christian, as received by an Irish medium called Geraldine Cummins. These had created a sensation as they appeared to supplement the accounts of the early Church in the Acts of the Apostles and the Epistles of St. Paul. But when Cummins tried to publish them in book form, Bligh Bond, who was being pressed for money by his ex-wife, claimed a share of the copyright. Keen to keep the dispute out of the courts, Arthur introduced the Society of Authors as a neutral arbiter. But his correspondence with the Society showed his exasperation with a "man impossible to deal with" or, simply, "that idiot Bond." Eventually Bligh Bond lost his case and had to pay damages. The Society was appointed the official receiver of his royalties in order to pay off his liabilities. But by then Bligh Bond had decamped to the United States where he found a job as editor of the Journal of the American Society for Psychical Research.

To fulfill his busy schedule, Arthur was seated at his desk at six o'clock most mornings. If he was writing in his study or even in the garden hut at Windlesham, the maid Kath Cornish knew not to disturb him and left his breakfast on a small table outside the door. He would emerge shortly before lunch and sometimes read his family passages from any story he was working on. He would ask for criticisms, but only Jean

was ever forward enough to comment, and then rarely. But if she did, her suggestions were usually acted on by the evening.

He no longer read at the table, but his lack of interest in the ritual of feeding was abundantly clear. As soon as his desert plate was empty he would be off, often for an hour's sleep. The children were allowed to get down once they had finished, the only rule being that the last one at the table had to stay and keep Jean company, since she was the only person who ate at a normal rate.

His postprandial rest allowed him to work into the night if required, sometimes as late as eleven o'clock. If he felt he had done enough, he would repair to the large music-cum-billiard-room where the family congregated. Occasionally he liked to sing; with Jean at the piano, in his deep bass voice he would belt out a sea shanty, taking him back to his days on the whaler the *Hope*. But, as with his approach to art and the theatre, he made no pretence of any sophistication: this was simply the kind of music he preferred. "I don't think he appreciated Bach or music like that," said his daughter Billy.

After dinner, Arthur would retire to bed clutching an assortment of reading matter that, as far as Adrian recalled, might include the Bible, a treatise on archaeology in Egypt and a bundle of press cuttings about the heavyweight boxing championships. This dry selection reflected a drawing-in of literary horizons. Whereas thirty odd years earlier Arthur had condemned calls to ban George Moore's novel *Esther Waters*, in 1928 he was quick to support the Home Secretary Sir William Joynson-Hicks's demands for greater censorship in the wake of the prosecution of *The Well of Loneliness* by the lesbian writer Radclyffe Hall, who ironically was on the Council of the Society for Psychical Research. "We do not want to see this country in the same condition as France which had a great quantity of pornographic literature in circulation," he said. "I hate all these sex novels. That sort of stuff is very cheap and very easy."

Having long turned his back on modernist culture, he had time only for Thomas Hardy, "the greatest author that England possesses at present . . . very philosophical, thoughtful and really beautiful," Winston Churchill, "the finest prose style" of his day, and Kipling, whom he admired as "England articulate." Whether Kipling reciprocated is not clear. Despite living only ten miles from Crowborough, he made no effort to see Arthur after the war, probably because of his implacable opposition to spiritualism which he blamed for turning the mind of his schizophrenic sister Trix, who was much fêted in psychic circles as Mrs. Holland, a medium specializing in automatic writing.

Arthur also had a soft spot for American writers. During the war he had taken issue with Upton Sinclair's pacifist sentiments. But he subsequently warmed to his efforts to incorporate a spiritual, even spiritualist, dimension into his books, describing him as "one of the greatest novelists in the world, the Zola of America." And occasionally he would surprise with his quirky taste. In November 1926 he wrote, apparently spontaneously, to *The Spectator* recommending two American novels, Fulton Oursler's *Stepchild of the Moon* and T.S. Stribling's *Teeftallow*, both virtually unread. He claimed to have no personal interest in the matter, apart from a desire to bring two excellent books to the attention of the paper's readers. But he was being economical with the truth, as Oursler was the editor of *Liberty*, the American outlet for his latest Sherlock Holmes stories.

When it came to sports, now that he was in his late sixties he no longer played cricket but he was often out on the golf course and still competed fiercely in billiards tournaments. Occasionally he would ask Bill Latter, a local taxi driver who acted as his part-time chauffeur, to take the big air-cooled Rover out of the garage and drive him over to a cycle track in Surrey. "This must have been a good way to think," recalled Latter, "because he often came out and said 'I cannot write in the car, you take it back to Crowborough and meet me at Jarvis Brook station.' This I would do, and during the train journey he would often have written out the basis, as he said, of a story, which he would put to rights in a few hours once he was home."

In this way Arthur kept up a steady output of Sherlock Holmes stories which, even if now written from a sense of duty rather than passion, at least provided an assured income that allowed him to pursue his other interests. His detective was no longer the quirky, closet Bohemian redolent of foggy late-Victorian England, but a sadder figure who, though still nominally operating around the turn of the century, was ill at ease with the mores of a harder, modern age, epitomized by Baron Gruner's "lust diary" of female conquests in "The Illustrious Client."

Arthur's own problems with this change were reflected in an apparent uncertainty about his main characters' identities. Two of these late stories ("The Blanched Soldier" and "The Lion's Mane") were told not by the dependable Dr. Watson but by Holmes. In the past he had refracted aspects of his own life through his detective, but in "The Retired Colorman" he gave his old school number (31) to the "rather stupid" Watson. In the same story, when Holmes advised young inspector MacKinnon that he would get results "by always putting yourself in

the other fellow's place, and thinking what you would do yourself," he was parroting a recent literary upstart, G.K. Chesterton's Father Brown.

After "The Illustrious Client" appeared in the *Strand* in February and March 1925, Arthur waited more than eighteen months before returning to Sherlock Holmes. But when he did so, it was with a clear determination to finish the series quickly as he churned out the Adventures of "the Three Gables," "the Blanched Soldier," "the Lion's Mane," "the Retired Colourman," "the Veiled Lodger" and "Shoscombe Old Place," all published in rapid succession between October 1926 and April 1927.

Perhaps, as he told Beverley Nichols in November 1926, it was "really too easy," since he boasted that he had recently managed to write one story (probably "The Veiled Lodger," his penultimate and shortest) and play two rounds of golf, all in the same day. Then after completing "Shoscombe Old Place" the following month he informed Greenhough Smith, "It's not of the first flight, and Sherlock, like his author, grows a little stiff in the joints, but it is the best I can do. Now farewell to him for ever!" Originally titled "The Adventure of the Black Spaniel," this looked back to "Silver Blaze" in its portrayal of a dog's natural instincts exposing untoward goings-on in the world of racing. Without ever convincing, it brought a touch of Arthur's old Gothicism to the trappings of an impoverished aristocrat. (Dogs were the most sympathetic creatures in these late stories. "The Lion's Mane" offers another canine incident, though not in the night-time, when McPherson's Airedale terrier, the same breed as Arthur's Paddy, dies out of grief for its dead master, and Arthur waxes lyrical about the reassuring fidelity of dogs.)

In March 1927, the month before "Shoscombe Old Place" ran, Arthur wrote a valedictory piece in the *Strand* that confirmed the whimsical nature of the project he had started forty years earlier in *A Study in Scarlet*, as he likened its aim to the distraction and stimulation that comes from the heady world of romance. To celebrate its completion he invited his readers to enter a competition where they had to match their choice of the twelve best Holmes stories against his selection, which was headed by "The Speckled Band," followed by "The Red-Headed League" and "The Dancing Men." Once "Shoscombe Old Place" had appeared, all his recent stories could be collected in *The Case-Book of Sherlock Holmes*, published by John Murray on June 16 in an edition of 15,150 copies, the largest since *The Hound of the Baskervilles*.

As the author of Sherlock Holmes, Arthur was still regarded as an

amateur detective whose expertise could be called on by all and sundry. A few years earlier Ralph Blumenfeld, the managing editor of *The Daily Express*, had asked his advice on solving the brutal murder of a wealthy south London woman whose chauffeur was the prime suspect. With a nod to his story "Black Peter," where a newspaper advertisement weeded out a homicidal harpoonist, Arthur imagined that a murderer in this latest incident might want to flee the country and suggested laying a similar trap with a notice seeking a chauffeur for a tour of Spain.

In May 1925 Arthur became involved in a killing closer to home. Norman Thorne had recently moved to Crowborough, where he had started a chicken farm and courted a local girl. However he had left a highly strung fiancée in London and, when she disappeared, the police visited his farm and found her body. When charged with murder his defense was that, after telling her of his decision not to marry her, he had gone out, leaving her on her own, and she, in a fit of desperation, had hanged herself. Later, finding her body, he had panicked and buried her nearby. His subsequent conviction and sentencing to death was based strongly on the testimony of Sir Bernard Spilsbury, a member of the Crimes Club, who was now Britain's leading forensic expert. But Arthur retained his sympathy for potential victims of injustice. He told the *Morning Post* that he thought there was only one chance in a hundred that Thorne had not committed the murder, but so long as that chance remained, he was happy to add his name to a campaign (albeit unsuccessful) for a reprieve. "I am against capital punishment except in very extreme cases, and to justify it I think the evidence should be stronger than it was in this case."

Toward the end of the following year the police asked his advice when the thriller writer Agatha Christie mysteriously disappeared from her house, Styles, near Sunningdale in Berkshire. She was depressed after her husband had admitted an affair and asked for a divorce. This time Arthur adopted the psychic approach he tried to steer clear of in his Holmes stories. Having obtained one of Christie's gloves, he gave it, without further detail, to Horace Leaf, a noted medium and psychometrist, who reported back that it belonged to someone called Agatha who was not dead but who would be heard from the following Wednesday. Sure enough, on that day the missing author was found in the lobby of a hotel in Harrogate where she had checked in as Teresa Neele, the surname of her husband's girlfriend. As a result Arthur began advocating that every police force should employ an in-house psychic.

In the meantime Arthur had returned to the case of Oscar Slater, the petty felon whose conviction for murder he had fought before the war. He had been in touch sporadically with a Glasgow journalist, William Park, who had followed the details closely. As a result Arthur had added his name to a renewed call for Slater's release in 1919. Nothing much happened until early 1925 when Slater managed to smuggle a plea for help out of Parkhead prison under the dentures of a fellow inmate, William Gordon. But when Arthur wrote asking the secretary of state for Scotland for a reprieve, he was rebuffed. That did not stop Park from continuing to gather new evidence, which he assembled in a book highlighting the injustices of the case. Impressed by this "combination of the bulldog and the sleuthhound," Arthur agreed to write an introduction and approached various publishers on Park's behalf. Unsuccessful, he decided to put the book out under the imprint of his own Psychic Press in August 1927. (The actual printing was done by his old friend the paranormal photographer Fred Barlow in Birmingham, while the sales force at Raphael Tuck, where he was still on the board, took copies on the road to sell along with their regular greetings cards.)

Arthur's confident prediction to Park that they would at least get the matter aired in the newspapers proved more than justified when questions were again raised in the House of Commons and two papers, *The Daily News* and the *Empire News*, competed fiercely to find new angles. When the latter discovered Helen Lambie, the murder victim's former maid, in New York and reported that she had gone back on her original story and was now unsure if Slater was the man she had once claimed to see in her mistress Miss Gilchrist's flat, Arthur was delighted and contributed an article to accompany the news. Typically, he felt the paper did not recognize the significance of its own story, which, as he explained to Park, it sent him with some inconclusive headline such as "Was Slater Innocent? Statement by Helen Lambie." He crossed this out and returned it with the more dramatic "Confession of Helen Lambie. End of the Slater case."

However, it was another piece of evidence accumulated by Park—a page from the original detective John Trench's notebook—that turned the case. This showed that the police suspected several people at the time of Slater's arrest and believed the case against him was "very much less strong" than against the others. However those four crucial words had been been weakened to read "no stronger," adding to the impression of an official cover-up. This time Arthur sent a copy of this damning page to Ramsay MacDonald, the former prime minister

(now in Opposition as leader of the Labour Party). An incensed Mac-Donald wrote to the Scottish Secretary, Sir John Gilmour, demanding a "handsome and generous" conclusion to the case as the police had clearly striven for Slater's conviction "by influencing witnesses and with-holding evidence."

Three weeks later, on November 14, Slater was released, though, to Arthur's disgust, there was nothing magnanimous about the decision, as Gilmour washed his hands of all culpability. Arthur immediately wrote to congratulate the freed man and was rewarded with a reply, "Sir Arthur Conan Doyle, you breaker of my shackles, you lover of truth of justice sake. I thank you from the bottom of my heart."

In the middle of his usual spiritualist entanglements, Arthur felt obliged to help Slater launch an appeal, which he agreed to under-write with 1,000 pounds of his own funds. Through the good offices of Leopold Greenberg, editor of the *Jewish Chronicle*, British Jews covered 670 pounds of this. But Slater proved a slippery customer and almost pulled out of his appeal. When the petition was finally heard in the Edinburgh High Court on June 8, 1928, Arthur traveled to the city of his birth to report the proceedings for the *Sunday Pictorial*. Even now the Lord Justice-General, Lord Clyde, gave little away, granting the appeal (and so quashing the original conviction) on a legal technical-ity rather than declaring the appellant's innocence. Nevertheless it was a victory and it opened the door for a claim for compensation. Though Arthur suggested that Slater should ask for 10,000 pounds, the govern-ment offered a more modest 6,000, which was accepted. Arthur then thought that Slater would repay him for his own expenditures. But the chemistry between the two men had deteriorated, as Arthur had never hidden his distaste for Slater's earlier low life. Although Slater had ear-lier promised to reimburse his benefactor, he now held back, greatly to the annoyance of Arthur who knew he at last had ample funds. When Slater sought to appease him with the gift of a silver cigar-cutter, Arthur immediately returned it and said he wanted his 300 pounds instead. Eventually, despite Leopold Greenberg's offer to ask his read-ers to raise this sum, Arthur moved to take Slater to court, while Slater threatened to countersue for slander. It was not until October 1929 that Slater backed down and agreed to pay, but it was a most unsatisfac-tory ending to what had been a noble initiative by Arthur.

The first intimation that Arthur's health was failing came in January 1928 when he admitted to William Park that he was experiencing dizzy spells as a result of overwork and had been put on the sick list.

The fact that he had to give two lectures that week did not help matters, he added. His heroic act of juggling the roles of spiritualist saint, legal crusader, bestselling author and controlling father was beginning to tax him physically.

The Slater case was not resolved, and he had other more bureaucratic problems to deal with. The top floor of the London Spiritualist Alliance's building in Queensberry Place was still occupied by Harry Price, whom Arthur regarded as someone, like Houdini, whose conversion to spiritualism would be a coup. So, despite frequent differences of opinion, he had taken trouble to cultivate an acquaintance with this professed independent psychic investigator. As a result he was all the more annoyed when, in February, he learned that Price was telling people how he (Arthur) had been fooled into believing that a discredited American couple, the Thompsons, had materialized his mother, Mary. He took the unusual step of asking the LSA's lawyer if its tenant's lease could be terminated, but was told this was not possible. But after Price repeated the story later in the year, Arthur lost his temper and wrote to the secretary, Mercy Phillimore, demanding, as president, that Price should be evicted at any cost.

This titular role required him to take a more obvious stand in June when the police raided Queensberry Place and took away Miss Phillimore in handcuffs, later charging her and Claire Cantlon, a medium who had been working there, under the Vagrancy Act. When it transpired that the police had sent three women there to have their fortunes told, Arthur, who appeared in court as a defense witness, was incensed at this use of agents provocateurs. However, when he consulted the home secretary, he was told there was no chance of changing the law. So he began dreaming of a spiritualists' political party. "We are a solid body numbering some hundreds of thousands of voters," he informed *The Times*, whose letters page conducted an interesting debate about whether people in a trance were legally liable: were they under someone else's control or, more controversially, were they subject to the irrational dictates of their unconscious or subconscious?

There were no such niceties when Charles Harris, the butler he had only just hired for Windlesham in February, stole money and had to be sacked. At least, once Oscar Slater's sentence was quashed in July, he could relax with his family at Bignell Wood. The interior had undergone an expensive transformation, as various buildings had been connected and an electric heating system added. Outside, the overgrown gardens had given way to tidy grass verges and flower beds, as well as a miniature golf course, a croquet lawn and a hard-surfaced tennis

court. Dotted around was a unique feature—some full-sized fairies made of Dutch pottery. Sometimes Arthur could be seen in the nearby woods playing a music box and waiting patiently with a camera to photograph the sprites he was sure inhabited the place. Then the peace would be shattered by the noise of Denis and Adrian's cherished Frontenac Special racing car, a modified Model T Ford capable of reaching 100 mph. Both boys had now left Berrow and had little else to occupy them.

While at Bignell Wood Arthur kept his hand in at writing by condensing the five volumes of his history of the war into one. He also worked on an illustrated talk for the latest International Spiritualist Congress in London in September. He went to considerable lengths preparing for this, sending out 200 free tickets to members of the SPR. In all he estimated that it cost him 100 pounds from his own pocket, but, as he told Lodge, he believed some initiative was required.

It was not that he lacked for money. In anticipation of another great tour, this time bringing the spiritualist message to South and East Africa, he calculated that he and Jean together were worth 110,000 pounds (around 4.5 million pounds, or 9 million dollars, in 2007). In October the children were again uprooted—Denis and Adrian from their racing cars, and Billy, not quite sixteen, from school. She was loath to go, as she was beginning to enjoy her time there. (Exams did not come into the question, as she had been excused from them because of her poor eyesight.) Arthur subjected her to appalling emotional blackmail. He had "always brought us up to make our own decisions, from a very early age," she explained, "and he wanted me to decide whether I should go or not. I chose not to go, after much thought, but my father then said that this would hurt my mother so very much, because she was so devoted to us all. So he asked couldn't I think again? Did I really want to hurt my mother to that extent? I, of course, didn't, and so I went." As it happened she did not regret her decision. On the voyage out on the *Windsor Castle*, she even cheered her father by making the women's deck cricket team, taking two wickets in two balls and, particularly commendably, being the only woman to bowl overarm.

In Cape Town he was joined by Charles Ashton Jonson, a spiritualist friend, stockbroker and music critic who was acting as his right-hand man in South Africa. The Conan Doyles were put up in the comfortable Mount Nelson Hotel, where Arthur had stayed at the start of the Boer War. But when he tried to join his sons in climbing Table Mountain behind the hotel, he found the exertion too much in the blazing sun.

As in Australia and New Zealand, there were pockets of strong spiritualist support, so he had no trouble drawing audiences of 1,750 in Cape Town and 2,000 in Johannesburg. But he came under attack from the established religions, particularly the powerful Dutch Reformed Church. And he caused a near-riot in Bloemfontein, scene of his Langman Hospital exertions, where he visited the monument to the thousands of women and children who had died in concentration camps during the Boer War. He took umbrage at an inscription in Afrikaans that he understood to blame the British. After he was reported as saying this was a lie, his hotel was picketed by an angry crowd, though he later played down the incident, claiming it had all resulted from a misunderstanding. Arthur's diplomatic touch was no longer as sure as it once was. He did acknowledge elements of the native African spiritualist tradition when he sent Denis and Ashton Jonson to receive greetings from a female Zulu witch doctor. But his own audiences were entirely white and his attitudes to black economic advancement reactionary. And as a long-term investor in South African gold and diamond mines, which he made a point of visiting, he was unhappy about miners' bargaining power, arguing that every rise in wages made another mass of minerals unprofitable.

After seeing in the new year of 1929 at Johannesburg's plush Country Club, where Adrian picked a fight with someone who poked fun at his father's spiritualism, the Conan Doyles moved north, through Bechuanaland, to Rhodesia. Outside Bulawayo, which seemed to be paradise compared with Johannesburg, Arthur adopted the prevalent but muddle-headed view that it was wrong to say that the ruins of the ancient city of Khami had been built by "Bantu Kaffirs."

After a séance beside Cecil Rhodes's grave in the nearby Matopo hills, Jean took down some bland automatic writing from the "African colossus." Arthur said at the time that Rhodes's observations on his own work were too gushing to warrant widespread publicity, but that did not stop him from transcribing them in *Our African Winter*, his account of his trip. Later in the month Arthur lectured happily in the capital, Salisbury, where he claimed the psychic awareness was greater than in the average British town. But he could not avoid a constant refrain about his health: "I have not my full strength—no golf yet," he told Ashton Jonson, and he was "nearly well but not yet fit to smoke." Sometimes he seemed to accept the inevitable as he observed, "I think my psychic task is nearly done," even if he retained a mordant sense of humor, "It is very nice here, but I want to get on. That, I think, will be my last mortal utterance."

Moving on physically for the time being, Arthur and his family reached Kenya in early February. Wielding his "cinema camera" to good effect, he traveled widely in what he described appreciatively as a sporting colony, while his sons enjoyed the high life on the fringes of the Happy Valley set. He even caused controversy in one of his lectures when a local dentist claimed to be depicted in a psychic photograph used as a prop and therefore it must be bogus.

Back in England in early April, well before his seventieth birthday on May 22, Arthur penned a thirteen-page "open letter to all elderly folk," which confirmed that he did not think he had long to live. He said an actuary might give him five more years, but it could be ten or only one. "Who knows? But you and I are suffering from a wasting and incurable disease called old age, and there is but the one end to it."

With this in mind, he allowed himself to give two interviews—one recorded by the Gramophone Company, which dealt with his spiritualism and the background to Sherlock Holmes, and the other by Movietone News, which covered much of the same ground. In the latter, the only known instance of him on moving film, he seemed in good physical shape as he sat in the garden at Windlesham. Demonstrating his understated communication skills, he told his audience in his clipped Scots-English burr that when he referred to his psychic experiences, "I am not talking about what I believe. I'm not talking about what I think, I'm talking about what I know. There's an enormous difference, believe me, between believing a thing and knowing a thing."

His epistemological ideas had not changed much from his Edinburgh student days, but his attitude toward science had, as became clear with the publication of *The Maracot Deep and Other Stories* in July. The main story was a science fantasy (originally called "The Fabricius Deep" when conceived two years earlier) about a team of deep-sea explorers who, when their expedition to the bottom of the Atlantic Ocean goes wrong, are rescued by Greek-speaking denizens of the fabled city Atlantis. This amiable excursion (an oceanic version of "The Horror of the Heights," with a touch of Professor Challenger) was originally published in the *Strand Magazine* between October 1927 and February 1928. Although barely into her teens, Billy had proudly helped with its writing. While she was in bed with the mumps, her father had given her an encyclopedia and asked her to make notes about a list of fish he provided. He subsequently added an 8,000-word coda, "The Lord of the Dark Face," which gave the published novella an occult flavor as Dr. Maracot, normally a hardened material-

ist, remembered snatches of white magic that enabled him to triumph over the evil Atlantean deity Baal.

The book was bulked up with two authentic Challenger stories that showed that Arthur still liked to balance his belief in spiritualism with an understanding of contemporary science. With an opening self-portrait of a pugnacious professor. "The Disintegration Machine" tells of a mechanical contraption that causes people and objects to appear and disappear at will. Although its workings appear to be based on advances in atomic physics, its Latvian inventor explains them by analogy to Oriental magic and Western occultism where such feats take place as a result of the weakening and movement of atomic particles. But when he reveals he has sold the patent to a foreign power, Challenger decides this is too dangerous a toy to let loose on the world and ensures that the lone scientist is destroyed by his own invention, along with its secrets.

If this seems an indictment of modern science, the same conclusion is reached in "When the World Screamed," where Challenger himself burrows eight miles beneath the earth's crust to reveal the modern ecological truth that the world is a living system. Arthur's opinion about the resulting natural disasters is clear from his less than complimentary description of Challenger's motives. Yet he remains enough of a storyteller to record the Professor being widely fêted for his advances in science. Arthur's own love affair with the fruits of scientific method was, however, clearly at an end.

In a different vein was the last tale in the collection, "The Story of Spedegue's Dropper," an amusing but self-indulgent cricketing piece about a bowler who gets batsmen out with his unusually high lobs. True to the heroic sporting tradition, Tom Spedegue plays a winning role when drafted into the England team for a deciding Ashes Test Match. Arthur based the story on his own career, when he was bowled in similar fashion by the Surrey and England player A.P. Lucas.

What should have been a relaxing summer holiday at Bignell Wood was rudely interrupted on August 15 by a fire in the cottage's thatched roof. Arthur was out on his morning walk when the blaze was spotted by Ezra the gardener. The fire brigade took a crucial half hour to travel from Southampton. In the meantime, Jean, the children and the servants worked to contain the outbreak and save what they could. As news of what was happening spread, local people gathered to help. Arthur later thanked them for their assistance in moving furniture from his house, but could not resist having a go at the one or two who "showed a disposition to remove the goods even further." Arthur esti-

mated the total damage at 2,000 pounds, but took heart from the fact that his most valuable possessions, such as his library, had not been harmed as they were at Windlesham. Jean subsequently learned from a spirit source that the psychic aura at Bignell Wood was not as benign as Pheneas had indicated and that the building would need to be exorcised if it continued to be used for spiritualist pursuits.

Having written most of *Our African Winter* on the hoof, Arthur had this account of his recent trip ready for publication by John Murray in September. His New York publishers Doubleday, however, fought hard against having to follow suit. Their reader described it as "a very dull book . . . The material is treated rather prosily and calculated to interest" English rather than American readers. Eventually, "yielding to extraordinary pressure from Watt" they agreed to take a minimal 250 sheets "of this incidental book of Doyle's."

But Arthur had other priorities. Even at this stage, he was fighting a charge in the magazine *John Bull*, owned by the disgraced former MP Horatio Bottomley, that *The Land of Mist* had been plagiarized from a novel by an unknown author, J.W. Symons. (The publishers backed down when issued with a libel writ in October.) Ever combative, Arthur also wanted to reply to attacks on him and Pheneas in the book *Modern Spiritualism* by the Stonyhurst-trained Jesuit Herbert Thurston, published earlier in the year. So one task over the summer was writing *The Roman Catholic Church—A Rejoinder*, which rehearsed his objections to traditional religion and his arguments for spiritualism. If anything, the gap between his and other people's sense of reality was getting wider. So it seemed natural for Ashton Jonson to tell him that Kingsley had appeared in a séance and had forecast a forthcoming boom in iron and steel shares. Ashton Jonson went so far as to inquire further of his stockbroker, but it is not clear if Arthur took any action.

Arthur was preparing to continue his overseas mission, with the help of his occasional "secretary." Determined to lecture in all the non-Catholic countries in Europe before he died, he had been negotiating to visit the Netherlands and Scandinavia. Dutch spiritualists were keen to hear him but reluctant at first to charge five shillings for the best seats. Eventually, on October 10, with Denis ensconced at Gonville and Caius College, Cambridge, reading medicine, the Conan Doyles set out across the North Sea, accompanied once again by Ashton Jonson and his wife Ethel. Although, as a young man, Arthur had played cricket in Holland, their first destination, he was unimpressed by the monotony of the landscape with "the copper green fields, the wide expanses, the neat little homes, the lines of poplar trees."

That was as good as it got. Traveling by train from Rotterdam to Hamburg on the nineteenth, he complained of feeling unusually tired. After two nights' recuperation in the German city, his party continued to Copenhagen where on the evening of the twenty-first they were welcomed at the station by a group composed partly of spiritualists and partly of family (Clara's Danish relations). That night in the Hotel Angleterre Jean was terrified that her husband was having a heart attack when he woke in the night, feeling faint and having difficulty breathing. He plowed on with plans that included two major lectures and a séance with Einer Neilsen, a local medium with a dubious history. He also went to see a new German film version of *The Hound of the Baskervilles*. Although his dispute with Slater was still not settled, he was happy to call a halt to another unnecessary feud. At the age of seventy-six William Gillette was about to return to the stage as Sherlock Holmes and Arthur decided to forget their differences over film rights and congratulate the actor, adding with slight hyperbole "my only complaint being that you make the poor hero of the anaemic printed page a very limp object as compared with the glamour of your own personality which you infuse into his stage presentiment."

After an overnight journey to Stockholm on the twenty-sixth Arthur plunged into another lecture, only taking time off to attend a performance of R.C. Sheriff's powerful First World War play *Journey's End* in Swedish. As he had already seen this in London, he was probably being a good guest since he felt its antiwar message was too hysterical.

Six days later they reached Oslo, from where Jean informed Adrian of her worries about Arthur being unable to climb the stairs or take off his overcoat without first lying down. They still had to make their way back to Hamburg, where Arthur spent the day in bed. On November 7 he crossed back to Dover and was carried ashore by two sailors. After traveling up to Victoria Station by train, he was taken around the corner to Buckingham Palace Mansions in a wheelchair.

Although his doctor diagnosed angina pectoris, a tightening of the chest usually caused by the blocking of the arteries to the heart, he was determined to attend the annual Armistice Day spiritualist meeting at the Albert Hall. According to Denis, he had another attack in the taxi on the way to the Hall and almost died. Not content with this, he also went to the Queen's Hall in the evening to address the Marylebone Spiritualist Association about his recent trip to Scandinavia. He contrasted the widespread interest in spiritualism in the countries he had visited with the apathy in Britain, which he described as being in the grip of a crypto-Catholic conspiracy. As an example, he noted that he

had tried to advertise *The Roman Catholic Church—A Rejoinder* in the *Church Times,* but had been turned down. "This morning," he declared, "8,000 people stood up in the Albert Hall to say they had been in personal contact with the dead. I am not sure that this was not the most important thing that happened in the world today, but you will find no allusion to it tomorrow in *The Times.*" Subsequently he really did need to take things easy and was unable to take the chair as advertised when Sir Oliver Lodge addressed the London Spiritualist Alliance on November 21.

Restricted as to what he could do, Arthur took the opportunity to "tidy things up," as he told his agent Watt. He updated *Memories and Adventures* to include his recent travels. He put together a collected edition of his works. And he wrote a preface to some general pieces about the paranormal which were published by John Murray the following June as *The Edge of the Unknown.* But the tiny printing of less than one thousand reflected how times had changed and not even the Conan Doyle name could counter popular apathy. The Doubleday reader found the book "awfully sad," the writing "quite mediocre" and the subject matter "childish in the extreme."

On Christmas Eve Ashton Jonson wrote of his concern to "hear of your fainting and consequent fall and strained leg." But he felt heartened by "Pheneas's certainty of recovery by the Spring," to which end he recommended "a prescription of water boiled from soil under one of your Sussex Oaks."

By the new year of 1930 Arthur was able to move from one room to another, which he described as "an advance." But a few weeks later he was telling Denis in Cambridge that he needed to spend a month in bed as he was not making the expected headway, even though he was sure that would come. He still felt he had to beg his son to curb his high spirits and not get too friendly with one particular girlfriend. "She is quite nice but no more fit to be your life's mate than Mrs. Ezra [the gardener's wife] would be. I speak thus plainly lest it should be too late to speak. . . . As a playmate she is all right."

He was more accommodating toward Adrian, whose obsession with racing cars he found more healthy. When his younger son had been fined for speeding in Crowborough the previous summer he had written an indignant letter to the local paper protesting that, despite Adrian's lack of "moral guilt of any kind," his fine of 5 pounds with additional costs was greater than the 2 pounds imposed in the same courtroom on a man who had mistreated his horse. Now he lent Adrian 500 pounds to buy a Frazer-Nash, known as "the Slug" that

both sons raced in the Cambridge Speed Trials in March, coming third. Even level-headed Billy, now seventeen, joined in the family obsession with cars, though when she managed to overturn her Austin 7 in a fit of temper her father did not berate her as she feared, but proved "kind and reassuring."

As spring beckoned, Arthur was still sending out a printed card that read, "Sir Arthur Conan Doyle regrets that owing to ill-health he is unable at present to give attention to the matter which you discuss." On the back of one of these cards (to William Roughead, the crime writer) he added, "I am on a sick bed (angina) but very cheery all the same. To a spiritualist death can have no terror."

In March Denis left his course at Cambridge after just two terms. Since his college has no record of why this happened, it seems likely that, as with his short period at Tonbridge, he riled against the restrictions of institutional life. Just possibly, he felt he needed to help his mother, who was having to deal with the illness not only of her husband but also of her brother Stewart, who was seriously ill in a Folkestone nursing home. In addition, Ashton Jonson had just died and was not able to lend his support.

Arthur showed his usual resilience as, late in the day, he reverted to the family trade and took up painting and drawing. A wry sketch shows him as "the old horse" dragging an overweight cart filled with symbols of his life's work on a path from Edinburgh in 1859 to Norway in 1929.

But the load did not lighten. Despite his illness he had become involved in yet another internecine squabble among psychical researchers. He was impressed by the paranormal experiments conducted by an Italian aristocrat, the Marchese Scotto, at his Millesimo Castle near Genoa. But when a review of a book about these events appeared in the January 1930 issue of the Journal of the Society for Psychical Research, it dismissed the Marchese's work as fraudulent. Arthur immediately fired off a letter to the Society stating his shame at being a member and tendering his resignation. Having accused it of producing no constructive work for a generation, he dismissed it as an "anti-spiritualist organisation" whose influence was "entirely for evil," and called on others to follow his lead in resigning.

Arthur's estrangement from the SPR was well known. But what came next was unexpected and perhaps foolhardy. In his resignation statement, printed in the Society's Journal in March, he had called for refuseniks to patronize the London Spiritualist Alliance as well as a couple of other groups. Still taking seriously his duties as the Alliance's

president, he had been lobbying the prime minister, Ramsay Mac-Donald, and the Home Secretary, J.R. Clynes, for a change in the witchcraft and vagrancy laws relating to mediums. He was rewarded with a meeting with Clynes on July 1. He was due to attend this at the head of a delegation of spiritualists. But the day before, the London Spiritualist Alliance, in which he had placed such faith, pulled out, later claiming differences of opinion with the rival Spiritualist National Union.

At the Home Office meeting, Arthur's voice was "pitifully feeble" as he stood to introduce his colleagues. The Home Secretary felt sorry for him and insisted he sit down. After the spiritualists' case was put by the medium Hannen Swaffer of the SNU, the forum ended inconclusively with Clynes objecting to a description of police behavior as "callous" and suggesting the way forward was a Private Member's Bill.

For Arthur the LSA's treachery seems to have been the final straw. Six days later, at 9:15 on the morning of Monday, July 7, he died in his bed at Windlesham. His last words to his wife at his side were "You are wonderful." He left instructions to Denis to keep the bookshop going, and look after Woodie, who had recently retired, and Mrs. Murray, his London housekeeper. "I think all is clear in my affairs," he said. "I should hate to leave complications." More generally he advised Denis never to sell his capital, to heed the words of his sister Billy, who had the best financial brain among his children, "and for my sake continue to avoid alcohol, all of you. That way safety lies."

As the formal tributes flowed in, others had more personal memories. Recalling his many invitations to attend séances, the novelist Hugh Walpole confided in his diary on July 8, "Conan Doyle dead. A brave simple, childish man. How hard he tried to make me a spiritualist! Very conscious of him to-night."

Meticulous to the last, Arthur had made arrangements to be cremated and had drawn up the outline of his funeral service, which was conducted with hymns, psalms and, in accordance with spiritualist beliefs, exaggeratedly little mourning on the lawn at Windlesham on Friday, July 11, by the spiritualist Reverend C. Drayton Thomas. (Jean explained that her husband, ever the innovator, had wanted "a happier burial service—something that might start a new epoch in the history of funerals.") A large oak coffin rested on trestles, while around it lay a mountain of wreaths including one from the London Spiritualist Alliance which, ever cavalier with finer details, chose to remember "Our beloved President." Another floral tribute, from Jean herself, read, "Sweetheart, from your own beloved: There is no death." After

the ceremony the coffin was carried across the tennis court to a plot that had been dug beside the garden hut where he often worked. After a few more words from Drayton Thomas, Arthur was buried there. Jean threw a rose into the grave, and the ceremony was over.

Even on the day of Arthur's death, Adrian had announced that he did not expect it would be long before his father communicated with his family from the other side. By the time a memorial service was held in the Albert Hall on Jul 13, expectation was at a fever pitch. An estimated 6,000 people filed into the Hall to pay their respects, among them George Edalji, who had returned to his solicitor's practice. On the platform they could see an empty chair beside Jean. Suddenly they heard Estelle Roberts, a clairvoyant, pause and announce dramatically, "He is there." She went across to Jean and had a long whispered conversation. She later explained, "He gave me a message—a personal one, which I gave to Lady Doyle, but am unable to repeat publicly. I saw him distinctly. He was wearing evening dress."

Afterword

It was a game of golf that did it. A decade ago, while researching a biography of Kipling, I visited Brattleboro, Vermont, where the bard of empire had somewhat incongruously built himself a house called Naulakha. Just over a century earlier, in 1894, Arthur Conan Doyle had made the same trip when Kipling was living there. After comparing notes about literature and the state of the world, the two men went outside and played golf. Somewhere I read that Conan Doyle had introduced this sport to the United States which was stretching the truth (along with the claim that he brought skiing to Switzerland).

But the image of these two great authors teeing off on the rolling fields outside Naulakha had captured my imagination. I resolved that, after finishing Kipling, I would look into writing a life of Conan Doyle. A few months later, in November 1997, I read of the death of his daughter Dame Jean Conan Doyle and, with it, speculation that a vast family archive that had long been kept under lock and key, the subject of a protracted legal dispute, would finally be made available to the public.

Not long after my Rudyard Kipling was published in late 1999 I began doing what biographers do and inquired about the new heirs. I learned that an American called Jon Lellenberg might be a useful intermediary. In telling him of my interest, I mentioned I had written a biography of Ian Fleming. This proved a good move since (something I did not know at the time) Lellenberg was a leading light in the Baker Street Irregulars, a U.S.-based group of Sherlock Holmes enthusiasts, one of whose overseas members had been a close associate of Fleming.

He put me in touch with Charles Foley, Arthur's great nephew and the new representative of the Conan Doyle estate, who agreed to see me when he next visited London from his base in Sussex. We met in

the Royal Automobile Club where Conan Doyle had been a member. From him and later from others I learned some of the background of the estate.

Although Mary, a daughter from Conan Doyle's first marriage, survived into the mid-1970s, she was not an heir to his literary heritage. This position was reserved for the children of his beloved second wife, also Jean, on whose death in 1940, her three children, Denis, Adrian and Jean had shared the proceeds of the estate.

Denis and Adrian (and the latter in particular) were both spendthrift playboys. Denis married Nina Mdivani, who claimed to be a Georgian princess. (Her brothers made a habit of marrying and discarding a succession of Hollywood actresses and American heiresses.) Adrian took a more sober Danish woman, Anna Andersen, as his wife, but lived in a chateau in Switzerland, surrounded by Ferraris and mistresses.

These two sons used the Conan Doyle estate as a milch-cow. (Here I call upon other people's witness rather than Foley's.) Because neither man ever did anything useful in his life, they both took pleasure in making things difficult for anyone who tried to write about their father. They even bridled at the Baker Street Irregulars' conceit of playing the game, since this meant taking their father's name slightly in vain. (Inevitably if one regards Dr. Watson as Sherlock Holmes' biographer, the role of Arthur Conan Doyle is rather devalued.)

But even the two sons came to realize that a good biography can be useful for a dead author's reputation. In this respect the relationship between an estate and a biographer is intriguing, as the former struggles to balance a natural retinence about its subject's (often its close relation's) private life with a need to keep his or her name in the public eye as part of a modern media-savvy process of brand creation.

The race to write a life of Sir Arthur began as soon as he died. Even before late 1930, his widow Jean had rejected the advances of a jobbing author W.H. Hosking, choosing instead the Reverend John Lamond, a committed spiritualist, who she knew would give due emphasis to Sir Arthur's passionate interest in the paranormal.

But this was not what the world wanted to read. Even her sons realized the resulting book was not satisfactory. So, soon after Jean's death in June 1940, they grudgingly allowed Hesketh Pearson, a prolific man of letters, to have another shot. Pearson had idolized Conan Doyle from an early age, even if when he met him at his relation Francis Galton's before the First World War, he was disappointed to find a thick-set broad-faced man with "no more mystery about him than a

pumpkin" fulminating against Sherlock Holmes for preventing him from writing the historical novels he wanted.

But the two brothers were not happy with Pearson's sprightly effort, which they thought demeaned their father by suggesting that the secret of his success was that he was the "common man." Adrian threatened criminal proceedings against Pearson's "fakeography" when it appeared in paperback, he published his own riposte *The True Conan Doyle,* and he sought out Emil Ludwig, author of a life of Beethoven (such was the comparison to which he aspired), to write the definitive biography.

After Ludwig declined, Adrian allowed access to his father's unpublished letters and papers to John Dickson Carr, an American writer of detective stories, who had worked on a radio adaptation of *The Lost World* and was hoping to compile an anthology of Conan Doyle's works. Dickson Carr's biography, published in 1949, was a lively read—perhaps too lively, with its made-up dialogue, its lack of precision and its novelist's fanciful touches.

Usefully for future biographers, Dickson Carr included an appendix in which he listed eleven boxes, over thirty envelopes, more than fifty notebooks and commonplace books and sixty scrapbooks he had used in his work and which he described as family papers. Around this time, Adrian, Denis and their sister Jean carried out what they called the Family Division, in which they shared various papers and mementos. For example, each heir chose seven of Sidney Paget's original Sherlock Holmes drawings for the *Strand* magazine. In addition, Jean wanted a Sherlock Holmes bust, Denis his father's writing desk and Adrian a table, which earlier generations of the family had used to entertain such distinguished visitors as Dickens and Thackeray over the years.

In March 1955 Denis died at the age of forty-five. Before the end of the year Windlesham was put up for sale and the bodies of Sir Arthur and his wife were transferred from its garden to a new resting place at All Saints Church, Minstead, in Hampshire, near the family's former house at Bignell Wood. (Even this caused controversy. Not only did the reinterment require Home Office approval, but the Church of England was wary about a spiritualist who had never hidden his hostility to established churches. So the Conan Doyles were buried at the outer extremity of the graveyard, though the rumor that they were laid to rest standing up is mere superstition.)

Now the official manager of the estate, Adrian moved to Switzerland, where he was soon confronted by a formidable widow in Nina who,

while protesting her love for her late husband, wasted little time (in the tradition of the "marrying Mdivanis") in replacing him with Anthony Harwood, a former hairdresser who had been Denis's secretary.

Before long Adrian and his sister-in-law were feuding like wild cats.

In September 1957 he alleged that Denis's estate owed him and his sister Jean $189,000. Nina retaliated with the claim that Adrian, as manager of the Conan Doyle royalties, had been holding back the third share she was owed as Denis's heir. Ken McCormick, editor in chief at Sir Arthur's American publisher, Doubleday, noted succinctly, "I shiver at the thought of getting involved in this because everybody in that family is so unbelievably unpleasant."

Adrian was determined to make something of the literary property at his disposal. In 1959 he oversaw a memorial volume put out by his friend, the London publisher John Murray, to celebrate the centenary of his father's birth. When he tried to interest Doubleday in this volume, he drew a blank, and was reduced to fulminating against their ingratitude to the man who he wrongly claimed had rescued the company from bankruptcy in 1894. (When the BBC commissioned an anniversary talk from Hesketh Pearson, Adrian announced that if it went ahead it would never broadcast another Sherlock Holmes story. The Corporation cravenly caved in.)

Adrian coedited this book with Pierre Nordon, a student preparing a Ph.D. thesis on Conan Doyle at the Sorbonne. Impressed by Nordon's scholarly approach, he allowed the young Frenchman to develop his work into another biography, which appeared in France in 1964 before being translated into English by Frances Partridge, one of the last of the Bloomsbury group, and published by John Murray two years later.

Adrian now decided to put the family archive on show at the Chateau de Lucens, north of Lausanne. In June 1965 he made a deal with the Canton of Vaud. In return for financial help in buying the chateau, and for additional tax breaks, he agreed to set up the Sir Arthur Conan Doyle Foundation whose aim was defined as the deposit, conservation and public exhibition of "archives, manuscripts and books" left by the late creator of Sherlock Holmes.

An article in the Foundation's statutes gave Adrian and four other members of its council free rein financially, but declared the collections and the chateau itself to be inalienable. The problem was that the collections were not defined. No inventory of the manuscripts and letters was attached, though a booklet subsequently put out by the Foun-

dation referred to its ownership of the "originals of literally thousands of documents forming the Conan Doyle biographical archives."

Extraordinarily, this did not stop Adrian negotiating with the University of Texas through a New York book dealer to purchase the Chateau, complete with its contents. The University's Harry Ransom Center had already accumulated a significant amount of Conan Doyle material, much of it through the same dealer, Lew Feldman, who, trading as the House of El Dieff (a pun on his initials) had over the years been acting for both Adrian and Denis.

In May 1966 Adrian was asking $2 million for the chateau and its contents. He was not put off when the university offered only half this price. But when Texas' representative Dr. Joe Neal visited Lucens a couple of years later to inspect the manuscripts supposedly included in the deal, he found little of interest and dropped out of the bidding. Adrian, however, persisted in trying to sell manuscript material on the American market. He claimed this amounted to 6,000 letters, including 1,500 from his father to his grandmother, Mary Doyle.

At this stage Adrian's sister Jean began voicing her concerns. The nature-loving former tomboy "Billy" had forged a career in the Women's Royal Air Force, becoming its director (with the title of "Dame") in 1963. Two years later, at the age of fifty-two, she had married Air Vice Marshal Sir Geoffrey Bromet, a First World War flying ace, who was more than twenty years her senior.

In a letter from Geneva dated April 23, 1969, Adrian angrily brushed off her inquiries, stating high-handedly that her inquisitiveness had only started with her marriage to Bromet. He went over the details of the Family Division in the late 1940s, asserting that she and Denis had chosen manuscripts, while he had gone for family letters and papers. He added that, when their father was alive, Sir Arthur had given him an additional pile of letters that were stuck together after a glue pot had spilled over them. Adrian had spent long hours prising these letters apart with steam and razor blade, which explained, he said, why many in his collection still retained a patina of glue.

Feeling the need to defend himself against suggestions that he had been hoarding jointly owned material, he told Jean that he had been charged by their mother to burn two boxes of her love letters from their father. On the day of her death he had gone to Windlesham and, though aware of the sacrilege, had carried out her instructions.

He claimed that, ever since buying his first Conan Doyle letter in 1932, he had been the true guardian of their father's name. At one stage, he had run a regular advertisement in *The Times* offering,

through a box number, to purchase any of Sir Arthur's correspon-
dence. However to preserve this heritage—and, with it, the Founda-
tion—he now needed to sell some of this accumulated material, 90
percent of which had been bought by him over the previous thirty-five
years, the remaining 10 percent being his from the Family Division.
Under his stewardship, he claimed the estate's gross income had
grown from 3,000 to 30,000 pounds since 1956. But if his sister
wanted, he offered to sell her the Foundation for 1.2 million Swiss
francs. This would allow him to recoup over 100,000 pounds that he
had personally lent the Foundation, but he warned she would also take
over a 250,000-pound mortgage on the chateau, plus its overhead.

Any fruitful conclusion to these negotiations was cut short by
Adrian's own death in June 1970. But this only initiated an even more
acrimonious battle between the widows of the two brothers and Dame
Jean over the estate. As expected, the Canton of Vaud took over the
Chateau and the small amount of artifacts kept there. (Any letters and
photographs were transferred to the University of Lausanne.)

This time Nina Harwood chose to do battle not about the papers
accumulated by Adrian but about the stewardship of the copyrights in
Sir Arthur's published material, particularly the Sherlock Holmes
stories. On the premise that the estate was not generating enough
income, she hired Jonathan Clowes, a London literary agent, to look
into improving matters. He suggested selling the property to Booker
Brothers, a multinational company that had developed a tax efficent
sideline in owning the copyrights of major authors, including Ian
Fleming and Agatha Christie.

Unimpressed with this idea, she negotiated to buy the Sherlock
Holmes literary rights herself through an Isle of Man company
Baskerville Investments. By then the other two women, Dame Jean
Bromet and Anna Conan Doyle, Adrian's widow, were relieved to be
free of this responsibility, though all three retained their interest in
the estate's unpublished material, which was brought back from
Geneva to London in 1976 to languish in a solicitor's vault.

Matters again became complicated when Nina was unable to keep
up the payments on the bank loan she had taken for this purchase. As
a result in 1977 she was forced to sell to Sheldon Reynolds, an Amer-
ican film producer who had made a Sherlock Holmes television series
in the 1950s starring Ronald Howard, son of the actor Leslie Howard.

The real owner (and the person who financed the deal) was
Reynolds' Hungarian-born wife, Andrea, whose mother had come into
a fortune as the widow of Sir Oliver Duncan, an heir to Pfizer chemicals.

Andrea Reynolds subsequently became well-known when, after leaving her husband, she fell for the Danish aristocrat Claus von Bulow. She stood beside him when, in a much publicized 1980s court case (later the subject of the feature film *Reversal of Fortune*), he was charged with and later acquitted of the attempted murder of his wealthy wife Sunny. Subsequently remarried to Shaun Plunket, a former page to the Queen, she has continued to market her Sherlock Holmes rights, but found the Conan Doyle estate frequently opposing her in court.

Meanwhile Adrian's collection of letters and other material still gathered dust at the estate's London solicitor. Nina's death in March 1987 did not help matters as she bequeathed her interest in this to a U.S.-based Mdivani relative, who died intestate shortly afterward.

The surviving heirs, Dame Jean and Anna, invoked provisions in U.S. law that facilitate the retention of copyright interests by close family members. But then in December 1990 Anna died, leaving her share of the estate to three people—Charles Foley, grandson of Sir Arthur's sister Ida, who ran a sound equipment business in Brighton, and Richard Doyle and Catherine Beggs, grandchildren of Sir Arthur's brother Innes.

According to Foley, when he traveled to Anna's funeral in Switzerland, he was as surprised as anyone to learn that he had been designated one of Anna's heirs. At least he had some experience of the estate as he had spent time at the Chateau de Lucens in the 1960s when his father, also called Innes, worked as Adrian's assistant.

Toward the end of 1990 Dame Jean gave a rare interview to Christopher Roden, founder of the Arthur Conan Doyle Society, expressing the hope that all disputes over the family archive would soon be resolved and that it would become available to "people studying my father's life." She added her wish that it should remain in Britain.

She was, however, talking only about her own share of the family archive, which had to wait until shortly before her death in November 1997 to be formally divided. The now elderly Jean chose to keep her father's letters to his own mother, together with a few other items, while Anna Conan Doyle's heirs retained the rest. A deed of consignment was duly drawn up. The executors of Dame Jean's will were Charles Foley and Michael Pooley, her step-grandson.

When I met Charles Foley three years later I had no idea of this background. I did not know that the family papers were split between Jean's and Anna's heirs, and that Foley straddled both camps. When I broached the matter of the archive I had read about after Dame Jean's death, he said he was still sorting through it at the solicitor's.

However, although non-committal, he seemed happy to countenance the idea of a new biography. He said he would talk to other family members and, if there was any consensus, get back when there was movement and the papers could be consulted.

Over the next three years I called him a couple of times to ask how matters were proceeding. He replied that he was still looking through the documents and I understood him to say he would let me know when he was finished. But I heard nothing and got on with another project—a life of Dylan Thomas.

I was astonished therefore to read a lavishly illustrated article in *The Sunday Times* magazine of March 14, 2004, about the forthcoming auction of the Conan Doyle archive at Christie's. Little more than a puff for the sale, this emphasized the range of correspondence (from writers such as Winston Churchill, Oscar Wilde and Rudyard Kipling), artifacts and other treasures in the archive.

I was not the only person taken by surprise. The collector Richard Lancelyn Green, widely regarded as the most knowledgeable Conan Doyle scholar, was more than that: he was incensed. He was adamant that Dame Jean had wanted the collection to go to the British Library. But here were Anna Conan Doyle's heirs putting their share up for sale, which would mean it being dispersed across the globe.

Lancelyn Green took his concerns to *The Times*, which reported his attempts to halt the auction. But despite support from scholars and MPs, nothing could be done. Sadly Lancelyn Green had not understood the stark materialistic fact of life that the Conan Doyle archive had been owned (at its end) by one elderly woman and the executors of another and that the interests of the two did not necessarily coincide. Later Lancelyn Green took his own life. (It is true that the coroner recorded an open verdict but, having attended the inquest, I have little doubt that this is what happened.)

At this stage I re-entered the scene. Having completed my book on Dylan Thomas, I was thinking again of Conan Doyle and, with the sale looming, I secured a commission from *The Independent* to write about this curious background. Using my previous contact, I prevailed on Charles Foley to give his side of the story for the first time.

Over tea at the Grosvenor Hotel he filled me in on the background to the sale. Shortly before her death, Dame Jean had indeed made her choice of items in the archive. These had been hers to dispose of as she wished (mostly to the British Library), while the rest were for Anna Conan Doyle's executors to do with as they pleased.

The sale duly went ahead and, though it failed to reach anything

like the estimated 2 million pounds and a quarter of items remained unsold, it did realize 948,545 pounds, which, after buyers' premium, was divided among Anna Conan Doyle's three heirs.

Luckily some of the most important biographical material—letters between Conan Doyle and his brother and sisters—was bought by the British Library. When this was added to the letters and manuscripts Dame Jean had bequeathed to the Library under her will, it made a significant corpus of work for a biographer to feast on.

I quickly moved to insure that I would be the first biographer to work on these papers. I approached the British Library which promised to make its material available, even though it was uncataloged. I also made contact with the Lancelyn Green family. Under the terms of Richard's will he had bequeathed his substantial Sherlock Holmes and Conan Doyle collection (said to be worth 2 million pounds, rather more than the estate had realized at Christie's) to Portsmouth, the city where, over a century earlier, the young Conan Doyle had doubled as a doctor and writer before choosing the latter profession after the success of his first Sherlock Holmes novel *A Study in Scarlet*.

I traveled to Poulton Hall in Cheshire, where the Lancelyn Green family has lived for over a thousand years. Richard's mother June and his brother and executor, Scirard, graciously offered to help me as much as they could with access to his collection which was now technically owned by Portsmouth City Council, while his sister Cilla in Oxfordshire allowed me to take away print-outs from Richard's computer.

Encouraged that I could now call on material from not only the estate but also Richard Lancelyn Green, I secured contracts from my publishers in London and New York to write a new biography of Conan Doyle.

Imagine my astonishment when on one of my early visits to the British Library's manuscripts room I found Charles Foley at a nearby table. I learned that he was going through all the letters Dame Jean had left to the Library with the intention of withdrawing significant numbers. He was apparently allowed to do this under article 6 of Dame Jean's will which gave the British Library all her "right title and interest" in the physical property of the unpublished material she had bequeathed, but not in any published version nor in "any document or documents which my Trustees in their absolute discretion may decide are documents merely of family interest and my Trustees' decision in this respect shall be final and binding on all parties."

When I asked Foley about his criteria for selection, he declined to answer, saying this was a matter for him and his co-executor. However

I acquired a list of seventy-five items Foley intended to remove from the library. Ninety percent were letters from Conan Doyle to his mother.

After the cooperation I had gained from the British Library, and the speed with which it had made its material available, I now had a frustrating time gaining access to the Lancelyn Green collection in Portsmouth. Despite his family's support, I was repeatedly told that the items had not been properly sorted or cataloged and that, from a curatorial point of view, it was unlikely I would be able to view the material before the end of 2007.

Eventually in early 2007, with my book close to delivery, I enlisted the help of Stephen Fry, the collection's patron. With typical good humor he argued my corner. In April I was at last able to spend some productive hours with the collection and so make useful additions to my text. I am convinced that Richard Lancelyn Green chose well in making his bequest to Portsmouth. The team there is enthusiastic and deserves success in making its city a major port of call in Conan Doyle studies.

In the meantime I kept up sporadic dealings with the estate. I worked hard to keep these friendly because I knew at some stage I would need its permission to quote from material that was still protected by copyright in the United Kingdom. In this respect a biographer's job can be extraordinarily obsequious (and therefore stressful). I tried to promote the idea that our books were complementary, but it clearly looked on mine as competition.

For prior projects, I have had to request permission from three main literary estates. I have usually been asked for a list of the quotations I want to make. In one case I simply had to say how many words I wanted to use and that was sufficient. But the Conan Doyle estate was not satisfied with the actual words (which I had supplied together with sources). Foley asked me for the contexts in which I wanted to use them.

Of course an estate is at liberty to make whatever demands it wants before granting its permission to quote. But as I was not aware of the Conan Doyle estate having made this request before, I took this to be an unfriendly act. Even if it was not the intention to hold me up at a crucial stage, this was certainly the effect, which was exacerbated when I was subsequently refused permission to quote 150—roughly 40 percent—of the copyrighted items I had requested. (These were almost all from letters and other unpublished material written by Conan Doyle and his family, items for which the United Kingdom's

laws still recognize copyright. Most of Conan Doyle's published writings are out of copyright in United Kingdom and elsewhere.) Foley said that he was taking this line to protect the interests of the estate, which had a substantial financial interest in the success of the edition of Conan Doyle's letters it was preparing.

As a result I had to spend further time deleting or paraphrasing quotations I had painstakingly assembled in my text. This was exhausting and annoying, though I was also grateful that the estate had been fair enough to agree to the remainder of my copyright requests. Readers will have noted no lack of Conan Doyle's authentic voice in this biography.

I am left contemplating the relationship between a biographer and a literary estate. Some authors, particularly in America, are endeavoring to be more assertive of their rights to access and use copyright material for the purposes of scholarship (and, indeed, the United States laws permit certain such scholarly uses). I can only speak of an interesting learning experience. I am constitutionally averse to regulation, particularly where not required. But when Kipling and Conan Doyle played their golf, there was a set of rules. At least, as a result of my research in the Conan Doyle archives, I have now seen the weathered card of their round of foursomes to prove it.

Acknowledgments

I am grateful to the Society of Authors for awarding me the Elizabeth Longford bursary for historical biography and to Peter and Flora Soros for funding it. This provided a most welcome financial input at a time when I was embarking on a lengthy visit to libraries and collectors with vital Conan Doyle material in North America.

Each of my biographies has profited from my good fortune in meeting one person (usually a member of my subject's family) who has been happy to answer basic questions without making me feel a total idiot. In this case that role was taken with great dignity and kindness by Georgina Doyle, widow of Arthur Conan Doyle's nephew, Brigadier John Doyle. She proved a sparkling repository of family information and I was extremely lucky that she published her book *Out of the Shadows: The Untold Story of Arthur Conan Doyle's First Family* in 2004. I am grateful to her for permission to quote from copyrighted material of Mary and Innes Doyle. She was also good enough to supply me (with Doug Wrigglesworth's help) with some fine photographs.

I have been lucky enough to enjoy the support of the following eminent Conan Doyle scholars who have allowed me access to their private collections: Dr. Fred Kittle and his wife, Ann; Glen Miranker; Costa Rossakis; Steven Rothman.

The encouragement of the Lancelyn Green family—Scirard, June and Cilla—was very important to me. Stephen Fry, patron of the Richard Lancelyn Green collection in Portsmouth, provided exactly the help I sought at exactly the time I needed it.

A vital part of any book's life takes place between its first draft and its publication. That's when outside readers get to work on the manuscript and point out mistakes and infelicities of style. I owe a huge debt in this respect to Lisa Chaney, Katrin Williams, Charlotte Rogers, Nick Utechin and Susan Greenhill.

I am particularly grateful to the librarians and custodians of a number of institutions holding significant Conan Doyle material. These include: Toronto Public Library (Peggy Perdue); University of Minnesota at Minneapolis (Tim Johnson); Berg Collection at New York Public Library (Steve Crook); Richard Lancelyn Green Collection at Portsmouth Arts, Libraries, Museums and Records (Sarah Speller, Neil McCaw, Claire Looney, Michael Gunton and Alan King); Sherlock Holmes Collection at Marylebone Information Service (Catherine Cooke); British Library (Christopher Wright, Michelle Paul, Jamie Andrews, Rachel Foss); University of North Carolina at Chapel Hill (Matthew Turi); Harry Ransom Center at the University of Texas in Austin (Molly Schwartzburg); Huntington Library (Sue Hodson); National Library of Scotland (Robin Smith); Newberry Library, Chicago (Jenny Schwartzberg, Jill Gage). I would also like to acknowledge the regular help given by Dawn McQuillan of the Edinburgh Room, Central Library, Edinburgh.

A number of people provided additional manuscript material and other useful advice. In this respect I would like to thank Cliff Goldfarb, Doug Wrigglesworth, Julie McKuras, Dick Sveum, George A. Vanderburgh, Dan Posnansky, Mark Samuels Lasner, Phil Bergem, Randall Stock, Roger Johnson, Jean Upton, and Sir Christopher Frayling.

I am grateful to Charles Foley on behalf of the Conan Doyle Estate for allowing me permission to quote from copyrighted material it owns in letters and other writings by Sir Arthur Conan Doyle and members of his family.

A number of other libraries and archives have assisted me enormously with a variety of manuscript material and background detail. These include: Stonyhurst College (David Knight, Jan Graffius and Thomas Muir); Cambridge University Library (Peter Meadows); Bodleian Library (Judith Priestland and Colin Edwards); Trinity College, Dublin (Jane Maxwell); County Waterford Archive services (Joanne Rothwell and Catherine Nugent); Royal Institution (Lenore Symons); News International (Nick Mays); Royal Society of Medicine (Robert Greenwood); Public Record Office of Northern Ireland (David Huddleston); St Mary's Hospital (Kevin Brown); Royal College of Surgeons of Edinburgh (Marianne Smith); Royal Astronomical Society (Peter Hingley); University of Lausanne (Danielle Mincio); House of Lords Record Office (Mary Tahayanati); University of Dundee (Sarah Bland); Portsmouth Grammar School (Catherine Smith); Mercer Library Royal College of Surgeons in Ireland (Mary

O'Doherty); Haslemere Museum and Library (Greta Turner); Priors Field School (Margaret Elliott); Heriot Watt University (Ann Jones and Rosemary Burke); John Murray Archive (Virginia Murray); Royal Archives (Pamela Clarke); as well as National Archive of Scotland, St Thomas's Hospital, Edinburgh University, the London School of Hygiene & Tropical Medicine, V&A Theatre Museum, University of Virginia, Mitchell Library Glasgow, Scott Polar Institute, Morgan Library, Churchill College, Cambridge, Leeds University, Durham University, London School of Economics, University College London, Natural History Museum, Kings College Liddell Hart Archives and Trinity College, Cambridge.

Others have helped me in different ways. My thanks to: Richard Milner, Lindsay Fulcher, Colin and Mary Ellen Davies, Susan Dahlinger, the late Nelson Foley, Robert Foley, Andrew Holmes, Andrew Roberts, Vincent Delay, Leslie Price, Rhodri Hayward, Linda Shaughnessy, Brian Pugh, the late Tom Pocock, Vincent Delay, Alan Williams, Stella Kane, Jon Lellenberg, Rupert Morris, Peter Morton, Gary Sheffield, John Bourne, Lord Newton, John Whittingdale, Cliff Humphries, Peter Cowper-Coles and Andrew Malec.

It gives me great pleasure to thank all those at Weidenfeld & Nicolson who have backed my efforts. As usual the experience and good sense of my editor and publisher Ion Trewin have been invaluable. Linden Lawson was (and indeed is) a brilliant copy editor. Bea Hemming has been a charming and very effective coordinator. Douglas Matthews did an extraordinary job on the index to a very tight schedule.

In the United States Wylie O'Sullivan, my editor at Free Press, has been an inspiration. I have valued not only her general support but also her detailed comments on my early drafts.

In addition I have benefited hugely from the flair and advice of my agent, Natasha Fairweather.

Notes

I have used several abbreviations in the compilation of these notes:

When referring to members of Conan Doyle's family I have used a mixture of abbreviations: ACD (Arthur Conan Doyle), MD (Mary Doyle), JCD (Jean Conan Doyle), CAD (Charles Doyle), KCD (Kingsley Conan Doyle), ID (Innes Doyle), and first names: Mary (Mary Conan Doyle), Ida (Ida Foley), Lottie (Lottie Oldham), Denis (Denis Conan Doyle).

The initials of certain other individuals are also used: RLG (Richard Lancelyn Green), GS (Herbert Greenhough Smith), and of course SH (Sherlock Holmes).

Similarly libraries and other institutions are designated sometimes in abbreviated form: BL (British Library), HRC (Harry Ransom Research Center), UNC (University of North Carolina, NLS (National Library of Scotland), NAS (National Archives of Scotland), Minn (University of Minnesota), NHM (Natural History Museum), RCSEd (Royal College of Surgeons Edinburgh), or sometimes by one word—thus: Berg (Berg Collection at New York Public Library), Lausanne (University of Lausanne), Portsmouth (the Richard Lancelyn Green Collection at Portsmouth).

Where I have used material from various collectors, their names are sometimes shortened. Thus: Miranker (Glen Miranker), Rossakis (Costa Rossakis), Sveum (Dr. Richard Sveum), Kittle (Dr. Fred Kittle, whose collection is now largely housed in the Newberry Library, Chicago).

The names of certain books are abbreviated. Thus: M&A (*Memories and Adventures*), SML (*The Stark Munro Letters*), TNJS (*The Narrative of John Smith*), OAA (*Our American Adventure*), PS (*Pheneas Speaks*), OAW (*Our African Winter*).

Also: nd (no date), ny (no year).

ONE
Two Irish Families

5 In 1820 he married Marianna Conan: Another version of the surname is Coonan, which was how Marianna was described on the certificate of her marriage to John Doyle.

6 a Jesuit school in the Marylebone Road: Park House, Marylebone Road, ran from 1824–36.

8 Dicky particularly liked: to John Doyle, 23? Jul 1842, Lausanne.

9 the Star and Garter Hotel in Richmond: Dickens celebrated his wedding anniversary at the Star and Garter Hotel every year, and hired it for the launch of his book *David Copperfield* in 1849.

12 she was forced to put her Kilkenny property: The school probably closed a little earlier. The advertisements in the local papers ceased in July 1846. See Edward J. Law, "The School that Mrs. Pack Built," *Old Kilkenny Review*, 1995, vol. 47, pp. 140–145. It is not clear what happened to her son Thomas, who would have been eleven (RLG).

13 "Very pleasant people": CAD to Frederick Ellis, 2 Feb 1850, Lausanne?. Charles had already lived at 23 Union Place and 8 Scotland Street (RLG).

16 "very like carrying a certain combustible material": James Doyle to CAD, 10 Jul ny, NLS.

TWO
Early Years in Edinburgh 1859–1868

21 "When you are old, Mammie": M&A.

21 "his father's wit, courtesy and 'delicacy of mind'": M&A.

21 "quaintest mixture of the housewife and the woman of letters": SML, p. 53.

22 an important cultural phenomenon of the age: see "The Truth about the Middle Ages—La Revue des Deux Mondes and late nineteenth-century French medievalism," in *Medievalism and the Quest for the "Real" Middle Ages*, ed. Clare A. Simmons. Frank Cass. For his reading of *La Revue*, see letter from him to his mother from Stonyhurst, nd.

23 "a unique example of the Victorian woman on the warpath": see "Notable Victorians," some recollections of Edinburgh's foremost women by S. A. Tooley, *The Weekly Scotsman*, 20 February 1932—quoted in "Rescued from Oblivion: The case of Mary Burton and Liberton Bank House," by Ann Jones, *Scottish Archives* 2000, Volume 6.

24 Hill Burton: ACD commemorated Hill Burton in the name Holmes used on a visiting card in "The Illustrious Client"—Dr. Hill Barton, 369 Half Moon Street.

24 "art of sinking her voice: interview *New York World*, 28 Jul 1907.

24 his first story: A page from this first story was sold at auction at Christie's in 2004. ACD recalled writing it in his contribution to *My First Book*, Chatto & Windus, 1894.

27 the family would pay: They had inherited little money from their father, who left under 450 pounds, but they were now all fairly wealthy in their own rights.

28 "an accomplished artist": Michael Conan to MD, nd, quoted Norden.

THREE
Stonyhurst and Feldkirch 1868–1876

29 Arthur cried a lot: see M&A.

30 "as a sponge absorbs water": ACD to Father Cassidy, nd, Stonyhurst.

31 "Oh mama, I cannot express the joy": ACD to MD, 10 May 1869, BL. Many of the details of ACD's life at school—and afterwords—are taken from his voluminous correspondence with his mother, now kept at the British Library.

31 "Your very heart and soul": *My First Book*, 1894.

32 "I had a nature which responded eagerly": M&A.

32 its author Gerard Manley Hopkins: Manley Hopkins was a gentleman philosopher at St. Mary's Hall between 1870 and 1872, and later taught there, though there is no evidence that he met Arthur.

33 his love for the old man: ACD to MD, nd, BL.

34 "slovenly—caricature": reports Stonyhurst.

35 The student he lay on his narrow bed: ACD to MD, 31 Oct 1870, BL.
35 beginning to enjoy Stonyhurst: ACD to MD, 10 Dec 70, BL.
36 Annette had followed their mother: see letters between them, BL.
37 his Confirmation: information from Stonyhurst.
37 Arthur was duly confirmed: it seems odd that this should follow his first communion (p. 29) but I am assured this can happen.
37 admitted into the sodality: ACD to MD, Nov 1872, BL.
38 "When you write next": Michael Conan to MD, 30 May 1871, quoted Nordon.
39 "When I had got as far": *My First Book.*
39 another short-lived magazine: His co-editor, Arthur Roskell, a relation of the bishop who confirmed him, wrote a poem titled "The Student's Dream" whose title must have brought a sense of deja vu.
40 The Rector was delighted: ACD to MD, Apr 73, BL.
42 "The Passage of the Red Sea": dated 14 Nov 1873
43 "I believe I am 5 foot 9 high": ACD to Aunt Annette, nd, BL.
47 Arthur had a copy of Poe's *Tales of Mystery and Imagination* at Feldkirch see RLG, *Uncollected SH.*
47 "conscious that real life": M&A.

FOUR
Edinburgh University 1876–1881

48 "jog(ged) along very comfortably": ACD to MD, 1876, BL.
49 "in the inner life of a young man": SML.
50 "one weary grind": M&A.
51 "compress the classes": M&A.
51 "one of the ruck": M&A.
52 Dignity Bob: see B. Bramwell, "The Edinburgh Medical School and its Professors in my Student Days (1865–1869)," *Edinburgh Medical Journal* 30, 133–156, 1923.
54 "Gentlemen, I am deeply grieved": See "Who is Sherlock Holmes?," *Edinburgh Magazine.* Bell's skills were less obvious to his grandson, Alexander Dunlop Bell, who reported that "his own family saw few examples of his power. My only personal memory of anything like detective ability in him was that he once observed an absence of mud on my shoes, from which he gathered—correctly as it happened—that I had bicycled up a steep hill near Mauricewood (his house near Penicuik) instead of walking. See "Monarchs of the Glen," edited from a typescript by Alexander Dunlop Bell, courtesy Nicholas Best. Sherlock Holmes has traits of both Bell and Littlejohn who, along with his forensic skills, also trusted in intuition. In one case he remarked in court, "Some women's intuition is greater than certain men's knowledge."
55 "remarkable men," M&A.
55 "great uninteresting book": Bryan Waller to ACD, 30 Mar [1877], BL.
55 As Georgina Doyle has noted: *Out of the Shadows*, p. 40.
57 Standing outside an Edinburgh theatre: M&A.
57 "I read much": M&A.
57 "the most fascinating bookshop": TTMD.
57 "The short, vivid sentences": TTMD.
57 he represented his university: see Bram Stoker in *New York World*, 28 July 1907, quoted Orel, p. 155.
58 "wild, full-blooded": M&A.
59 He and his contemporaries could only laugh: M&A.
59 "the wonderful poise of the universe": M&A.
60 "that continual leaven of science": TTMD.
61 "one of the most remarkable ever penned": *The Sign of Four.*

62 if he survived at sea: ACD to MD, 18 Jun 1874, BL.
62 "returning to Edinburgh": see ACD to MD, Jul 1878, BL.
63 "a stern and grave physician": to Lottie, 22 Aug 1878, BL. Following in the foot-steps of her mother and older sister, Lottie had recently returned from a spell with the nuns in France.
64 "the bump of self-esteem": ACD to MD, 23 Oct 1878, BL.
64 "Home all quiet": Lottie's Birthday Book, courtesy Georgina Doyle.
65 She had saved the money from toils: Annette to ACD, 29 May 1879, BL.
65 "takes some doing": M&A.
65 a post-prandial cigar: ACD to MD, nd, 1879, BL.
66 sent "The Mystery of Sasassa Valley": In *The Quest*, Owen Dudley Edwards says this was sent at the urging of Dr. Hoare's nephew Rupert.
67 official university lecturer in pathology: on 14 Jul 1879.
67 "Absolve you to yourself": Waller to ACD, nd, BL.
68 Edinburgh had its own *Medical Journal*: Only recently Waller had clashed with Bell over the significance of a new surgical knife. See *Edinburgh Medical Journal*, April 1879.
69 "stained his yellow hair black": M&A.
69 loved challenging conventional opinion: One of Budd's recent articles was on the subject of household ventilators. *BMJ*, 2 Aug 1879. See also *BMJ*, 3 May, 10 May, 31 May 1879; 13 Mar 1880; also *Lancet*, 28 Feb 1880, 25 Sept, 16 Oct, 20 Oct, 18 Dec 1880.
69–70 the Budds' sparsely furnished Edinburgh flat: SML describes this flat as being over a grocer's shop, though an Edinburgh University directory lists Budd as living at 24 Argyle Place, which appears to have been a boarding house.
70 frying the liver: SML, p. 12–14.
70 a letter to the *Lancet*: *Lancet*, 28 Feb 1880.
70 the preserved organ: see ACD to MD, 27 Feb 1881, BL.
70 Three prisoners: notebook RCSEd.
71 the death of his great-uncle Conan: 3 Dec 1879.
71 "first real outstanding adventure": M&A.
71 "a really splendid man": M&A.
71 "It's lucky I was sober, Doctor": ACD to MD, nd, BL.
72 "zoology, murders, executions and Ironclads": Diary, Christie's catalogue, May 2004.
72 "I've got a strong Bohemian element": ACD to MD from SS Hope Lerwick, nd, BL.
73 "coarse" but "very clever": Diary, Christie's catalogue.
73 two whales and 3,614 seals: Diary, Christie's catalogue.
73 "more money than I had ever possessed before": M&A.
73 his final wage packet: "Conan Doyle: Ship's Surgeon," Richard Lancelyn Green in *Helping out Helpless Hopkins*, Sherlock Holmes Society of London, pp. 31–3.
74 "snug little practise": ACD to MD, nd (Jan 1881?), BL.
74 The American's Tale: This was originally copied into his 1879–80 student note-book.
75 his only recent amusement: ACD to MD, 30 Jan 1881 (though it says 1880), BL.
76 "I have crammed my pet sister": ACD to Lottie, 9 Apr 1881, BL.
76 "if I'm not shot as a process server": ACD to Dr. Hoare, nd, Berg.

FIVE
On the road 1881–1882

77 "imploring the citizens of the county": "To the Waterford Coast and Along It," *Essays on Photography*, p. 56.

78 like a "paradise": ACD to Amy Hoare, nd, Berg.
78 "riding a tiger": Foster, *Modern Ireland*, p. 405.
80 "By Jove! Such a beauty!": ACD to MD, Jul 1881, BL.
82 "a bit of a tub": ACD to MD, nd, BL.
82 a Mrs. Rowbotham flirted: ACD to Amy Hoare, 1881, Berg.
82 "Never was there such a hole": ACD to Charlotte Drummond, nd, Minn.
82 "astonish the natives": "On the Slave Coast with a Camera," *Essays on Photography*,
 p. 16.
83 forswear alcohol: In his manuscript log of the voyage he gives a specific date—
 3 December 1881—to his forswearing alcohol until Christmas.
83 she had 1300 pounds worth of capital: scrap ACD to Charlotte Thwaites Drum-
 mond, 23 Nov 1881, Minn.
84 "a mad thing": M&A.
84 "you abhor (our black brothers)": "On the Slave Coast with a Camera," *Essays on
 Photography*, p. 19.
84 "firm belief . . . that an unarmed, unescorted Englishman": "Up an African
 River with a Camera," *Essays on Photography*, p. 27.
85 "Better a week in the Welsh mountains": "On the Slave Coast with a Camera,"
 Essays on Photography, p. 22.
86 scared Waller: see ACD to Lottie, Apr 1882, BL.
86 "Elmo had grown tired of waiting"; ACD to Lottie, April 1882, BL.
86 "very polite and flattering": ACD to MD, nd, BL.
86 "chief editorial fault": ACD to MD, nd, BL.
86 a timely tale: *Bones. The April Fool of Harvey's Sluice.*
86 another topical contribution: *Our Derby Sweepstakes.*
86 "buzzing around England": ACD to Lottie, Apr 1882, BL.
87 "my game is clear": ACD to MD. Scrap on back of unused invoice form for Regi-
 nald Ratcliff Hoare, Clifton House, Aston Road, Birmingham, nd, ?Mar 1882, BL.
88 "half genius, half quack": M&A.
88 "a heroic and indiscriminate way": ACD to Dr. Hoare, nd, Berg.
88 "I see more and more clearly": SML, p. 217.
89 "I have no doubt": M&A.
89 "A man of strange suspicions": M&A.
90 be earning 1000 pounds: see ACD to MD, nd, BL.

SIX
Bush Villas 1882–1883

92 "The place was a Golgotha!": SML.
93 a recent tenant had indeed been a dentist: Stavert, p. 19.
97 expecting to be paid 7 pounds: ACD to MD, nd ?Aug 1882, BL.
97 his story "That Veteran": *All the Year Round*, 2 Sep 1882.
98 "tropical plant": ACD to MD, nd, BL.
99 "Her soul is prettier than her body": ACD to Amy Hoare, 11 Oct ny, Berg.
99 a friendly dentist: William Kirton.
99 a "jolly place": ACD to Mrs. Drummond, nd, Minneapolis.
100 "as drunk as an owl": ACD to Lottie, nd ?Apr 1883, BL.
100 he had recently been in a low state: see ACD to MD, nd ?Apr 1883, BL.
101 "The Captain of the *Polestar*" was only a ghost story: ACD to Mrs. Drummond, nd
 ?Dec 82/Jan 83, Minn.
101 railing against "so-called Christianity": *Evening News*, 24 Mar 1884.
101 a piece on advances in bacteriology: "Life and Death in the Blood," *Good Words*,
 March 1883. Fittingly it was originally titled "The Fishes of the Blood."
101 an article on the Contagious Diseases Act: *Daily Telegraph*, 6 Jun 1883.

103 a "political squib": ACD to "my darling girls," 1884, BL.

103 "will navigate the air": TNJS.



SEVEN
Marriage 1884–1886



106 He could now admit to "the Mam"; see ACD to MD, 2 Mar 1884, BL.

110 so many irons in the fire: see ACD to Lottie, 1885, BL.

110 Arthur moped to Jessie's mother: ACD to Mrs. Drummond, nd ?summer 1884, Minneapolis. See also Lottie's 1884 diary, HRC, which records that a visit to Uncle Henry required them to go to High Mass at Farm Street.

110 Portsmouth Football Association Club: Sometimes this is described as the original of the club which now plays in the Premiership. But this is stretching the truth. Arthur's PFAC folded in 1894, and the professional Portsmouth Football Club started in 1898. But Arthur and his amateur colleagues, such as Norman Pares, a master at Portsmouth Grammar School, did play an important part in the development of the game in Portsmouth.

111 "going off also to fulfil": TNJS.

112 John was a farmer honest and brown: see mss in Berg Library dated May 1885.

113 When in 1894 Arthur tried: see Norwood notebooks, Miranker.

113 his "mother's approval had reached": SML. These are also interesting for hinting that Arthur had met the Hawkins family on a train before they came to Portsmouth. But again there is nothing else to support this.

114 the execrable poem: *Stonyhurst Magazine* Vol. 2, Nov 1889.

115 Arthur sent this story to *Blackwood's*: ACD to *Blackwood's*, received 10 August 1885, NLS, MS 4469.

115 An entry in one of his notebooks: see Southsea Notebooks, Rossakis.

115 *Dreamland and Ghostland*: published by George Redway, October 1887. Redway, later a partner in Kegan Paul, had a line in mystical and occult books. One of his editors was the fantasy author, Arthur Machen.

116 "my brain seems to have quickened": M&A.

116 name "on the back of a volume": M&A.

118 According to his old professor, Joseph Bell: "Adventures of Sherlock Holmes," *The Bookman*, Dec 1892.

119 Poe had anticipated such a development: I am indebted to Professor Ronald Thomas for this point. See his excellent *Detective Fiction and the Rise of Forensic Science*, p. 21.

119 his book *Criminal Man*: first published in 1876 and later much revised.

120 His biographer talks: see Brookes, p. 211.

121 "The terrified woman rushing up to the cabman": Southsea Notebook, Rossakis.

122 "One rebelled against the elementary art": M&A.

122 For the surname "Watson": There are other candidates. Another local GP, Dr. Robert Weston, was a good friend of Arthur, while, from an earlier part of his life, Dr. Patrick Heron Watson, one of the surgeons he had encountered at the Royal Infirmary in Edinburgh, had earlier served in the Crimea.

123 "the most perfect reasoning and observing machine": *A Scandal in Bohemia*.

125 "worked it all out from a post-office map": ACD to Stoddart, 6 Mar 1890. Quoted in the introduction to Oxford edition of *The Sign of Four*.

125 dubbed the Frenchman's approach "the method of Zadig": "On the Method of Zadig," a lecture given in 1880 at the Working Men's College, Great Ormond Street (London), *Collected Essays*, T. H. Huxley, volume IV.

126 as Umberto Eco has pointed out: see *The Sign of Three: Dupin, Holmes, Peirce*, edited by Umberto Eco and Thomas A. Sebeok, Indiana University Press, 1983.

126 "little novel": ACD and Louise to Lottie, nd, BL.

127 "hurt" at the "circular tour": M&A.

128 "Carlyle has started a fermentation in my soul": ACD to MD, nd, BL.

128 "not like a warrior going to the battlefield": TNJS.

129 The *Hampshire Post* ran a disapproving editorial: *Hampshire Post and Sussex Observer*, 19 Jan 1886.

129 "Ireland is a huge suppuration": Southsea Notebooks, Rossakis.

130 "It was one of the tight corners": M&A.

130 *Gas and Water Review*. 19 Nov 1886, Vol. 17, p. 496.

130 "There comes a day when": speech to Authors' Club, 1896.

130 Willie moved to Japan in 1887: he was the dedicatee of *The Firm of Girdlestone*.

132 At one stage he considered him as a prospective match: see ACD to MD, nd, 1888?, BL.

Discovery of spiritualism 1887–1888

133 "And I looked, and, behold, a whirlwind": Ezekiel, chapter 1, vv. 4 and 5.

133 his claimed ancestor Hereward the Wake: This was published by Elliot Stock in 1896 under the stirring title *Hereward, the Saxon Patriot*.

134 Miss Harward became icy: Southsea Notebooks, Rossakis.

134 around twenty such sessions: figure from Jones, *Conan Doyle and the Spirits*.

134 "sat round a dining-room table": M&A.

137 He was cruelly disillusioned: M&A. Details of Hodgson's report started emerging in May 1885, though it was not officially published until December.

137 "about 1885": see Stavert, p. 97. According to him, the history of the Ford family was written by R.A. Parker, but I have not found a copy.

137 He later described it as "the Reminiscences" of Judge Edmonds: This was in *New Revelation*. In his *History of Spiritualism* Arthur mentions two items by Edmonds—"Spiritualism" (with George T. Dexter, M.D., New York, 1853), and "To the Public" (*New York Courier*, 1 Aug 1853).

138 "his whole character would change: *New Revelation*.

140 "This message marks": Southsea Notebooks, Rossakis.

140 dashed off a letter to the magazine *Light*: *Light*, 2 Jul 1887.

141 "Your profession has doubtless accustomed you to weighing evidence": Myers to ACD, 3 Jul 1887, BL.

141 "Feeling large thoughts rise within me": M&A.

142 "I had always felt great sympathy for the Puritans": M&A.

143 *Micah Clarke*—Arthur drew much of his inspiration and background information from his hero Thomas Macaulay's *History of England* (particularly chapter five). But another of his texts was clearly *Fall of the Stuarts* and *Western Europe from 1678 to 1697*, by the prolific American author Edward Everett Hale, since this book provided the map he used to illustrate the Battle of Sedgemoor. It was a natural choice because Hale was a unitarian minister who was a friend of both Emerson and Wendell Holmes. He was married to a niece of Harriet Beecher Stowe whose brother, the preacher and anti-slavery campaigner the Reverend Henry Ward Beecher, had visited Portsmouth in 1886. It has never been established if Arthur heard his lecture. But Ward Beecher certainly made a mark because he became a hero of Sherlock Holmes's amanuensis Dr. Watson, who kept his portrait above his desk at 221B Baker Street. Although this is not mentioned in *A Study in Scarlet*, it is just possible to suggest that, since Ward Beecher died on 8 March 1887, this (or shortly afterwards) was the date on which Arthur started his first Sherlock Holmes story and therefore kept it and the name, firmly in his mind.

143 trumpeted its "skilful presentation": advertisement *The Times*, 25 Nov 1887.

143 two of Arthur's insubstantial contributions: "The Stone of Boxman's Gift," about diamond mines, and "Corporal Dick's Promotion," a propaganda poem based on the recent Egyptian campaign. *Hampshire Telegraph*, 3 Dec 1887.

143 winning praise from *The Times*: *The Times* of 22 Dec 1887 described it as "very interesting."

143 *Philip Molesworth and other Poems*: Published by Sampson Low in 1886.

144 "now bringing it out in a more permanent form": ACD to Blackwoods, received 14 Feb 1888, NLS.

144 "As an Edinburgh man I should be very glad": ACD to Blackwood, 8 Mar 1888, NLS.

144 equally unsympathetic: see Payn to ACD, 22 Jun ny (1888), Rossakis.

145 Arthur fobbed them off: see ACD to MD, 1 Mar 1888, BL.

145 "not that he fears it, on the contrary": medical notes 6 Oct 1887.

145 he himself had been solely responsible: see ACD to MD, 1 Mar 1888, BL.

146 "This is accomplished by our power of resolving": *The Mystery of Cloomber*.

146 A. P. Sinnett's *The Occult World*: published in 1883.

147 "What appears to us": see treatise "The development of hypnotism," Berg.

147 "Parinaud the oculist at the Salpêtrière": ibid.

148 "a great field . . . for good work": Myers to ACD, 3 August 1888, BL.

149 it has been suggested that he wrote this drama: see in particular Owen Dudley Edwards "Angels of Darkness" and "the Genesis of A Study in Scarlet," *ACD—The Journal of The Arthur Conan Doyle Society*, vol 5.

149 "Play 'Angels of Darkness' finished": diary entry 13 Oct 1890, RLG, Portsmouth.

149 "The Bravoes of Market Drayton": *Chambers's Journal*, 24 Aug 1889.

149 "The Geographical Distribution of British Intellect": *Nineteenth Century*, Aug 1888.

150 Despite his reputation as a high-minded folk-lorist: see Luckhurst, also *Realism and Romance Contemporary Review*, 1886, pp. 688/9.

151 article on Stevenson's methods: "Mr. Stevenson's Methods in Fiction," *National Review*, Jan 1890.

152 "It had an unfamiliar intonation": Blumenfeld, *RDB's Procession*, Ivor Nicholson and Watson, 1935.

152 thought Stevenson had been strongly influenced by Meredith: see "Address on literature," c. 1895?, BL.

152 "To read Meredith is not a mere amusement": TTMD.



NINE

Birth of a daughter 1889–1890



154 deliver his first child: Dr. Claude Claremont, his colleague from down the road, also attended once a day to check the progress of mother and baby.

155 his "flying machine story": ACD to Lottie, nd ?Jan 1889, BL.

155 At the end of February: 25 Feb.

156 generally favourable: An exception was the Athenaeum which took him to task for the wordiness of his title page. He was not amused, claiming it was in correct seventeenth-century style. For the number of editions, see ACD to Chatto, 30 Oct 1889, Morgan.

156 Informing Lottie of this development: see ACD to Lottie, 18 Mar 1889, BL.

156 a lecture on fourteenth century trade and commerce: "Some Notes on Medieval Commerce by the Dean of Winchester," the Very Rev. Dr. G.W. Kitchin.

157 "yearn for the glades of the New Forest": see "The Adventure of the Cardboard Box" and "The Adventure of the Resident Patient."

158 "well up" in Froissart: ACD to Macmillan, 22 Jul 1889, BL.

158 "You may possibly have heard my name": ditto.

158 a letter to the *Evening News*: 9 May 1889.

158 150 essential books: A letter to his mother makes note of Commine's *Memoirs Chronicles*, *La Chronicle Scandaleuse* of Jean de Troyes—and Lecroix's *Middle Ages* (ACD to MD, n.d. ?May 1889, BL).

158 began writing *The White Company*: diary RLG, Portsmouth.

159 "His conversation left an indelible impression": M&A.

160 "You said you wanted a spicy title": ACD to Stoddart, 3 Sep 1889, quoted the Oxford Sherlock Holmes edition of *The Sign of (the) Four*, Christopher Roden (ed.) 1993.

162 "It has the advantage over": ACD to Stoddart, 1 Oct 1889, ibid.

162 "The Secret of Goresthorpe Grange": a renamed version of *Selecting a Ghost*.

163 *The Captain of the Polestar and Other Stories*: published 6 Mar 1890 with dedication, "To my friend Major-General A.W. Drayson'.

163 "Keep steadily in view": Charles Doyle *Diary*, see Baker (ed.) *The Doyle Diary*.

164 "Where pussy": ditto.

164 "When I was drawing the Royal Institution": ditto.

164 "I am certain if my many Vols.": ditto.

164 "branded as Mad": ditto.

165 "Modern Science, far from having destroyed": *Hampshire Telegraph*, 5 Apr 1890.

165 "The first half is very good": ACD to Lottie, 5 Jul 1890, BL.

166 his first known letter to his new agent: ACD to Watt, 23 Sep 1890, also 25 and 30 Sep 1890, Berg.

167 an unspecified click in its action: see ACD to Mrs. Sala, 13 Aug 1890, Huntington.

167 a letter to the *Daily Telegraph*: published 20 Nov 1890.

168 "If you have a lupus case": ACD to Dr. Ratcliffe Hoare, 20 Nov 1890, Berg.

TEN
Vienna and London 1891–1892

171 a cheaper pension run by a Madame Bonfort: Universitat Strasse 6.

172 Newnes had made his intentions clear: see Macdonald ff.

172 Arthur disingenously claimed: M&A.

173 "Now! none of your larks": ACD to Lottie, 16 Feb 1890, BL.

174 "I was a revolutionist": *Tit-bits*, 15 Dec 1900.

174 He received encouraging feedback from Watt: see letters between Watt and ACD, Berg.

176 "I should at last be my own master": ditto.

176 *The Picture of Dorian Gray*: published *Lipincott's Magazine*, Jun 1890; Ward, Lock April 1891.

176 "The Adventures of the Five Orange Pips": despatched 18 May 1891.

177 A visitor would remark: "Celebrities at Home," *The World*, 3 Aug 1892.

178 he had imagined his creation: *Tit-bits*, 15 December 1900. The story that Sidney Paget used his brother Walter as the model for Sherlock Holmes is given credence by RLG—*The Uncollected SH*—though discounted in the artist's entry in the new *Oxford Dictionary of National Biography*. That did not stop the waistcoat supposedly worn by Walter Paget when posing for his brother as Holmes in his disguise as "a drunken-looking groom" in *A Scandal in Bohemia* being sold at Sotheby's in July 1981 for 360 pounds.

179 "better things": ACD to MD, 11 Nov 1891, Lucens?.

180 "they treat it too much": ACD to MD, 11 Nov 91, BL.

180 even Arthur had to admit was over the top: ACD to MD, 29 Oct 91, BL. Payn said something very similar in his column in the *Illustrated London News*, 14 November 1891.

180 "a good deal more than a glorification of archery": *The Times*, 27 Nov 1891.

180 180 Another early recipient of the book: see ACD to MD, 29 Oct 1891, BL.

180 the visit he recorded as paying: see Norwood notebooks, Miranker.

181 "a small ugly but very interesting and nice little man": Connie, nd, but from internal evidence October 1891.

181 "A mere man of business": ACD to Stoddart, 29 Dec 1891, Mark Samuels Lasner Collection on loan to University of Delaware.

181 they pedaled their tricycle: ACD to MD, 29 Oct 1891, BL .

181 Strattan and Clara Boulnois: I am grateful to Dr. David Allen for significant information about the Boulnois family. Also Professor Graham Boulnois for putting me in touch.

181 Although an interviewer noted: Harry How, *The Strand*, August 1892.

182 "So now a long farewell to Sherlock": ACD to MD, 6 Jan 1892, Lucens.

182 "conscientious, respectable and dull": ACD to MD, 7 Dec 91, BL.

183 the unfortunate Guy de Maupassant: ACD to MD, 6 Jan 1892, Lucens.

183 *The Fate of Fenella*: published by Hutchinson, Apr 1892.

183 "Between Two Fires": *Gentlewoman*, 15 Dec 1891.

183 "upon household and maternal": ACD to Mrs. Bettany, 2 Apr 92, Kittle, Chicago.

183 Dark eyes, dark eyes: Norwood notebooks, Miranker.

185 "Drama is the poetry of conduct": "A Gossip on Romance," Feb 1882.

185 "we must operate with characters": *Le Roman experimental* (1880).

186 "Such moments to a dramatist": M&A.

186 They had got to know each other on the cricket field: see *Hide-and-Seek*; Chaney, pp. 91, 97 ff.

186 Barrie had written a gentle pastiche of Sherlock Holmes: "An Evening with Sherlock Holmes," published *Speaker*, 28 Nov 1891. It was mentioned ACD to MD, 6 Jan 92, BL. It differs from Barrie's pastiche published in RLG, *Uncollected SH*.

186 his recent short parody, *Ibsen's Ghost*: performed by Toole, 29 May 1891.

187 his membership in the Reform Club was confirmed: 16 Jun 1892.

187 In late 1891 Jerome joined forces with Robert Barr: Barr's memories of his exploits as an honorary member of the Iroquois tribe may have contributed to Arthur's detail in *The Refugees*. Under his pseudonym "Luke Sharp," Barr too had parodied Arthur's work—"The Bowmen's Song" from *The White Company*. In Arthur's version it was about the sterling qualities of the bowmen and their implements, but in Barr's it became a paean to modern weaponry: "What of the gun? The gun was made in Belgium, of wrought steel, of taut steel."

187 denied having been "unfaithful" to "The Strand": M&A.

187 Arthur invited him to stay for a weekend: ACD to MD, 1 Feb 92, BL.

188 Meredith introduced them to Leslie Stephen: see ACD to MD, 7 Mar 92, BL, also Southsea notebooks.

189 he did not want the news getting out of Scotland: see ACD to MD, 18 Nov 1891, BL.

189 his name would encourage it to raise its prices: ACD to MD, 1 Feb 1892, BL.

189 a spot of fishing with Barrie at Kirriemuir: ACD was invited from the 16th to 19th. (Easter was on the 17th). See Barrie to ACD, 10 April 92, BL.

189 great distinction at Heriot Watt College: Ida studied chemistry at the College in 1888–89 and 1889–90. At the end of the first year she was awarded the Marshall Prize, which was 3.pounds 3 shillings., and the Class Medal for the Theoretical and Practical Elementary Course in Inorganic Chemistry. She was the only successful female, compared with twenty-three men. (My thanks to Rosemary Burke of HWC for this.) At some stage—the dates are not clear—she also attended Edinburgh Ladies" College.

189 Charles's transfer: Charles was admitted on 31 May 1892.

190 an interview in *The Bookman*: May 1892.

190 he was wary of introducing the laboratory too obviously: ACD to Bell, 4 May 92, RCSEd quoted RLG, *Uncollected SH*, p. 19.

190 He quoted examples from his own mailbag: ACD to Bell, 7 July 1892, RCSEd quoted RLG, *Uncollected SH*, p. 24.

191 Off the field Willie Hornung: see Richard Lancelyn Green, Introduction to *Raffles: The Amateur Cracksman* (Penguin, 2003), p. xxi. Hornung had published his first collection of stories, *Under Two Skies*, in April.

192 One small notebook: part of Norwood notebooks, Miranker.
192 "The Home-coming of the *Eurydice*": published *The Speaker*, 24 Mar 1894.

ELEVEN
Tennison Road, South Norwood 1892

195 He did not say much about his visit: see *Portsmouth Evening News*, 4 July 1894 quoted RLG, *Uncollected SH*.
196 "I would like now to give Holmes": ACD to Cargill, 6 Jan 1893, noted Oxford edition of *The Memoirs of Sherlock Holmes*, Christopher Roden (ed.), p. 303.
196 "All is very well down here": ACD to MD, 6 Apr 1893, Lucens.
197 Landport branch in Portsmouth: These records are part of the Kittle collection in the Newberry Library, Chicago.
198 "the only literary gift which Barrie had not got": M&A.
199 "not fitted for dramatic representation": ACD to Mrs. Charrington, nd, Rossakis.
199 ready to undertake some lectures: ACD to Christy, 17 May 1893, BL.
199 He had planned to spend part: see ACD to Lottie, 4 Feb 1892, BL.
200 Arthur now suggested: ACD to Stevenson, 30 May 1893; note in *The Letters of Robert Louis Stevenson*, volume 9, p. 132.
201 "Your plan would spoil": ACD to Stead, 22 Jan 1893, noted in article in *Nineteenth Century Fiction*, March 1958.
201 he had written in one of his notebooks: see Norwood notebooks, Miranker.
201 "tact in one's work": ACD to Stead, 22 Jan 1893.
202 With typical exuberance: *Young Man*, Jan 1893.
202 And we talked of many things: *Young Man*, Jan 1894.
203 Dawson admitted in his own magazine: *Young Man*, Apr 1894.
203 "If you are determined on making an end of Holmes": Hocking, *My Book of Memory*.
204 "Everything that I imagined was there": TTMD.
204 "learn and convey to the mind": ditto.
204 "the one about Holmes's death": ACD to Newnes, 28 Aug 1893, HRC.
205 She opted for a traditional wedding: After a honeymoon in Paris, the newly weds lived in Flood Street, Chelsea. For a few months before his marriage Hornung lived at 17 Abingdon Mansions, off Kensington High Street, and it is intriguing to note that an otherwise unidentified Miss Doyle was listed at number 29 in the same block. See *Raffles and his Creator*, by Peter Rowland, Nekta Publications, 1999.
205 "in a very feeble condition": CAD case notes, Crichton Royal Constitution, Dumfries and Galloway Health Board Archives, courtesy Morag Williams.
206 Frederic Myers' talk: report in *Norwood News and Crystal Palace Observer*, 14 Oct 1892.
207 "the great misfortune which darkened": M&A.
207 he wrote to A.P. Watt from the Reform Club: letter received 24 Oct 1893, Berg.
207 who appeared in his bank statements: 23 Oct 1893, Chicago, Kittle.
207 Arthur had to write off his money: letter to Watt from *Reform*, received 24 Oct 1893, Berg.
209 Arthur reluctantly declared: see ACD to Watt, 2 Dec 1893, Berg.
209 The butterfly has wings of gold: ACD to Lottie, 27 Nov ny, BL.
209 "Killed Holmes": Norwood notebook, Miranker.

TWELVE
Swiss interlude 1893–1894

210 she had put on fourteen pounds in little more than a month: ACD to Payn, 12 Dec 1893, HRC.
210 "a most glorious place": ACD to Robinson, 20 Dec 1893, RP 2097, BL.
210 he told Christy: ACD to Christy, 17 Dec 1893, BL.

211 "a queer little book": ACD to Payn, 12 Dec 1893, HRC.

212 "make a religious sensation": ACD to MD, 23 Jan 1894, BL.

214 "What an infernal microbe": ACD to Boulnois, 24 Feb 1894, BL.

215 the *Davoser Blätter* reported: *Davos Blätter,* March 1894.

216 In a letter to her mother: Lottie to MD, Wed (1 May 1895), BL Emily Hawkins lived at St. Ives Cottage, Chart Road, Reigate.

216 Arthur's most recent jottings: *Idler,* Oct 1894, *McClure's Magazine,* November 1894.

218 a contemporaneous account: ACD to Payn, 17 Jun 1894, Rossakis.

218 The odd thing: see M&A.

219 He attempted to involve: see ACD to MD, 14 Sept 1894, BL.

219 a poignant poem: *Speaker,* 6 Feb 1892.

219 Ellen Terry told: Terry to ACD, 22 Sept 94, BL.

THIRTEEN
America, Egypt and Undershaw 1894–1897

222 "He is tall, straight, athletic: NYT, 3 Oct 1894.

222 marveled at the "romance of America": quoted Pond, *Eccentricities of a Genius,* Chatto & Windus, 1900.

223 "Then your friendships and enmities": Bram Stoker, interview with ACD, *New York World,* 28 Jul 1907

225 "By Jove," he thundered: ACD to Sir John Robinson, 3 Nov 1894, quoted *Fifty Years of Fleet Street, Being the Life and Recollections of Sir John R. Robinson,* ed. Frederick Moy Thomas, London, Macmillan, 1904.

225 To friends and family: ACD to Mrs. Drummond, 14 Dec 1894, Minn.

226 "The Recollections of Captain Wilkie": *Chambers's Journal,* Jan 1895.

226 written two of these: *How the Brigadier held the King* and *How the King held the Brigadier.*

227 He thought he was blazing: ACD to MD, 14 Sept 95, BL.

228 the weekly English-language: *Davos Courier,* 12 Jan 1895.

228 The two of them then returned briefly: see ACD to MD, 27 Mar 1895, BL.

228 He asked Henry Irving: ACD to Irving, 29 Apr 1895, V&A Theatre Museum.

228 a notice in the *Saturday Review:* "Mr. Irving Takes Paregoric," 11 May 1895.

229 described Wilde as mad: Ellman, *Oscar Wilde,* p. 361

229 Grant Allen had penned an article: "The New Hedonism," *Fortnightly Review,* Mar 1894. Ives's article in *Humanitarian,* Oct 1894. See Ellman, *Oscar Wilde,* p. 364. "New Hedonism" is a quote from Dorian Gray.

230 his novel *The Woman Who Did:* published Feb 1895. Allen called it his first "230 novel" after his Hindhead home.

230 Arthur was incensed at the censorship: *Daily Chronicle,* 1 May 1894.

231 he could at least realize some capital appreciation: ACD to MD, 2 Jul 95, BL.

232 His immediate neighbor, Louise Tyndall: there is some interesting correspondence between ACD and her in the archives of the Royal Institution.

233 "an exceptionally fine fellow in every way": ACD to Mrs? Drummond, 14 Dec 94, Minn.

234 "He was like a good, open-air Scotsman": William Stone, *The Squire of Piccadilly,* Jarrolds, 1951.

234 "There are Garstin and Wilcocks": quoted M&A.

235 he was finding modern Egypt: ACD to MD, 27 Nov 1895, BL.

235 he expressed reservations: see ACD to Amy Hoare, 30 Dec 1895, Berg.

235 the Southern sky "all slashed with red streaks": Christie's catalog.

236 "If I were a Dervish general": ACD's *Nile Journal,* with thanks to its owner, Professor Sir Christopher Frayling. ACD reached Wadi Halfa afternoon, 16 Jan 1896. His Journal covers 31 Dec to 19 Jan.

237 "a war-like little place": *Westminster Gazette*, 11 May 1896. His work for the paper covered the period 1 Apr to 11 May 1896.

238 "The Three Correspondents": *Windsor Magazine*, October 1896.

238 since Nelson Foley had lost his first wife: see ACD to MD, 3 Mar 1896, BL.

238 "To interest is the ultimate object": see report, *The Queen*, 4 Jul 1896.

239 "splendid lot of servants": ACD to MD, 9 Jul 1896, BL.

239 "I am labouring heavily": ditto.

240 the kindly thought: see ACD to MD, 18 Aug 1896, BL.

240 Trask then proceeded to recall: see notes BL, also *The New Revelation*.

242 "I imagine Conan Doyle": Whyte, *A Bachelor's London*.

243 an affectionate letter: ACD to Kingsley Milbourne, 25 Jun 1897. My thanks to Steven Rothman for this.



FOURTEEN
Jean Leckie 1897



245 Jean, who later claimed: see Dame Jean Conan Doyle to Jon Lellenberg, 28 Sept 1977, Minn. Dame Jean suggested that ACD knew one of her brothers. This was perfectly possible, as he had connections with the South East London sporting world through the Budd family. George Budd's brother Arthur played rugby for Blackheath and became President of the Rugby Football Union. In November 1897 Budd published a book on rugby with C.B. Fry, T.A. Cook and Bertram Fletcher Robinson, a nephew of Sir John Robinson, who was to collaborate with Arthur on *The Hound of the Baskervilles* and became a close friend.

245 as Geoffrey Stavert discovered: see Stavert, p. 185.

246 "I had everything": M&A.

248 once close to the Reverend John Brown: When asked by a magazine at the start of the year to name the best Victorian invention, Arthur had no hesitation in answering "chloroform," recalling the younger Brown's description of the drug in *Rab and His Friends* as "one of God's best gifts to His suffering children."

248 Jean's father, James Blyth Leckie: see Leckie family files in University of Lausanne.

249 According to Georgina Doyle: *Out of the Shadows*.

249 Arthur read from the play version of Sherlock Holmes: ID diary, courtesy Georgina Doyle.

249 "to steady myself down": ACD to MD, 14 May 1897, BL.

249 asked his mother if she knew a young member: ACD to MD, 5 Jul 1897, BL.

249 "The Confession": *The Star*, 17 Jan 1898.

249 First laid out in a notebook: see Norwood notebooks, Miranker.

250 "very comfortable": ID diary, 22 Oct 1897, Georgina Doyle.

250 the house party ate: see servants wage-book, Rossakis.

250 "dressing gown and garden days": ID diary quoted Doyle, *Out of the Shadows*, p. 113.

250 eager to make her mark: see Sidney Paget to Jean Leckie, 27 Dec 1897, BL.

251 forced him to ask Greenhough Smith: ACD to GS, nd, BL.

251 he began disbursing sums of a different order: see diaries HRC total recorded in "Over There: Arthur Conan Doyle and Superstition," Jeffrey L. Meikle, *The Library Chronicle of the University of Texas at Austin*, New series, no. 8, Fall 1974.

251 "I want to give": ACD to GS, nd, BL.

253 "Playing with Fire": *Strand*, March 1900.

254 "The Lost Special": So close is this story to the Holmes norm, that many Sherlockians regard it as part of the canon—truly *The Lost Special*.

254 Arthur poured his grief: ACD to Clement Shorter, nd, Berg.

255 *The War of the Worlds:* The novel was issued in Feb 1898, after serialization in *Pearson's Magazine* from Apr 1897.

255 Nelson Foley: he had worked at Palmers Engine Works, Jarrow.

256 "the whole-hearted boyish warmth": see ACD to *The Times*, 3 April 1913.

256 fearing it relied too much for its effect: publisher's catalog 1899, quoted Green, *Bibliography*, p. 113.

258 to his true love Jean. I am grateful to Dr. Richard Sveum for confirmation of this.

258 "keep clear of the danger of comparisons": Wells to ACD, nd, Sveum.

258 "send you my young couple book": Wells to ACD, nd 1899?, Sveum.



FIFTEEN

Boer War and aftermath 1899–1901



260 "Take us out of the little tick tack": MD to ACD, 26 Jun 1899?, BL.

261 in the words of the *Strand Magazine*: *Strand*, Dec 1901, quoted RLG *Uncollected SH*.

262 "She is as dear to me as ever": ACD to ID, 17 Jun 1899, BL.

262 "Must cultivate the faster leg ball": 1899, diary, BL.

262 this ritual was observed by a reporter from America: *Omaha Sunday Bee*, 24 December 1899.

263 Arthur was against this: see ACD to ID, 24 Apr 1899, BL.

263 another gathering attended by the colonial administrator: 1899, diary, BL.

264 Arthur still held back: see ACD to ID, 29 Jul 1899, BL.

264 His own response remained ambivalent: see ACD to MD, 11 Oct 1899, BL.

265 "Poor chap": ACD to GS, nd (late 1899), Virginia.

265 a questionnaire: HRC.

266 "This war!" he remarked to Greenhough Smith: to GS, nd ?Xmas 1899, Virginia.

267 "Nothing could fit into my life better": ACD to MD, nd Dec 1899?, BL.

267 "Perhaps however they all fit": TNJS.

268 "the curt treatment": *The Times*, 22 Feb 1900.

268 he declared that he did not intend: *The Times*, 3 Mar 1900.

269 "if I have ever seemed petulant": ACD to MD, 20 Mar 1900, BL.

269 "you would have smiled": ACD to Louse, 3 Apr 1900, quoted Nordon.

271 10,000 troops "rolling slowly": Christie's catalog, May 2004.

272 "My mind kept turning on other things": quoted Dickson Carr.

274 "an immense figure of a man": Max Pemberton, *Sixty Years Ago and After*, Hutchinson, 1936. Arthur's links with Fletcher Robinson are discussed here and in the note to page 231. For more see www.bfronline.biz.

274–75 "We had not beds or utensils": *The Times*, 1 Aug 1900.

275 "a huge rock": Mary's notes, courtesy Georgina Doyle.

276 He graciously agreed: Rosebery to MD, 1 May 1900, BL.

277 "It is sweet to me to think of J.": ACD to MD, 27 Sep 1900, quoted Booth.

278 "I do and must feel hurt": ACD to MD, nd, BL.

279 He boasted that in a couple of years: *Glasgow Evening News*, 19 Dec 1900.

279 Hamilton was devoted to Arthur: Arthur was godfather to Hamilton's son, Bruce, who younger brother, Patrick, would excite 1930s literary London with his trilogy of novels *Twenty Thousand Streets Under the Sky*.

280 he became a Unionist parliamentary candidate: see ACD to *Daily Chronicle*, 28 Sep 1900.

280 he wrote in ebullient mood: ACD to Bernard Hamilton, nd, Toronto.



SIXTEEN

Hound of the Baskervilles to Louise's death 1901–1906



282 Arthur's bank account book: HRC.

282 he had not closed the door on his revival: *Tit-bits*, 15 Dec 1901.

283 halfway through his story: ACD to MD, I June 1901, quoted RLG, *Uncollected Sherlock Holmes.*
283 "Robinson and I are exploring the Moor": ditto.
284 a neighbor called Baskerville, see Doyle, *Out of the Shadows.*
288 he always thought its order was too low: ACD to R. Smith, received 22 Jan 1902, auctioned Sotheby's, 16 Dec 2004.
289 this sum came directly from the secret vote: see National Archives, HD3/99.
289 "an able, clearheaded, positive man": ACD to MD, nd, quoted Nordon.
290 described himself as feeling unclean: ACD to Gosse, nd (1899), Leeds University
290 he and the English writer Norman Douglas: see Douglas's diaries, noted McKintry, *Rosebery.*
290–91 Arthur reported with schoolboyish enthusiasm: ACD to MD, 23 Apr 1902, BL.
291 "It is only a morass": ACD to Rosebery received, 22 Mar 1902, NLS.
291 read "a great many novels: *An Account of the Illness of King Edward VII in June 1902* by Sir Frederick Treves (in Royal Archives). I am grateful to Jane Ridley for this reference.
291 "I made my bargain all right: ACD to Irving, 17 Jun 1898, sold Sotheby's.
292 It was Arthur's tribute to a brother: see ACD to MD, nd ?Oct 1902, BL.
292 "Scarcely a day passed": Flora Thompson, *Heatherly.*
292 she later recalled him: Mary's *Recollections of my Father,* courtesy Georgina Doyle. This is the source for Mary's other reminiscences here.
293 described by Frances Partridge: *Memories.*
294 invited the authoress Helen Mathers to supper: Mary's *Recollections.*
295 "I really don't know anyone": ACD to ID, 4 Mar 1903, BL.
295 "What with my diet": see ACD to ID, nd and 4 Mar 1903, BL.
295 several causes to which he contributed money: He used these funds to present six foreign opinion formers who had backed the British against the Boers with a gold cigarette case inscribed "From Friends in England to a Friend of England'. Among them were Yves Guyot, the French journalist and politican, Edouard Tallichet, editor of the Swiss periodical *Bibliotheque Universelle,* and Professor Henri Naville, the eminent French Egyptologist.
295 the British Brothers League: see *The Times,* 14 Aug 1902.
295 the General Jewish Colonizing Organisation: *The Times,* 21 Apr 1911.
296 the British economy was better served: see letters to *Spectator,* 4 & 18 July and 1 Aug 1903.
296 "I have made a lot of converts": ACD to Low, 13 Dec 1903, NLS.
297 hoping to sell to Beerbohm Tree: see ACD to ID, 4 Mar 1903, BL.
297 "Sherlock is another question": ACD to GS, nd ? Toronto.
297 "Very well, A.C.D.": RLG, *Uncollected SH.*
297 get at least 3,000 pounds: ACD to ICD, 4 Mar 1903, BL.
298 a point taken up by Francis Galton: Galton to ACD, 20 Nov 1903, BL.
299 "for subtlety and depth": ACD to GS, 14 May 1903, Toronto.
299 the near-impossibility of "prevent(ing)": ditto.
299 "a strong bloody story": ACD to GS, nd ?May 1903, Toronto.
299 "two bulls and an outer": quoted RLG *Uncollected SH,* p. 100.
300 we thought a wicked party: *Punch,* 27 May 1903.
300 "Conan Doyle was my hero": introduction to paperback edition of *The Sign of Four,* Ballantine Mystery Classic, May 1975.
301 leased a hotel in Montauk: *Evening News,* 8 Jun 1903.
301 it is not unlikely that the series: *Bookman,* Sept 1903.
301 "If I give them an answer by Christmas": A.S. to A.P. Watt, 22 Sept 1903, quoted introduction to Oxford edition *The Return of Sherlock Holmes,* RLG (ed.), p. xxiv.
301–2 the effusive letter: MD to Jean Leckie, 24 Dec 1903, BL.

302 "solid dozen": ACD to GS nd, University of Virginia (quoted in introduction to Oxford edition *The Return of Sherlock Holmes*, p. xxv).

302 A.P. Watt wrote to tell McClure: quoted introduction to Oxford edition, *The Return of SH*, original in Lilly Library, Indiana.

304 Anderson had voiced his disquiet: "Sherlock Holmes Detective As Seen by Scotland Yard," *TP's Weekly*, 2 October 1903.

305 "Conan Doyle seemed very much interested": L. C. Collins, *The Life and Memoirs*.

306 the Automatic Sculpture Company: See comprehensive file in RLG Collection Portsmouth. Also *Illustrated London News*, 22 Aug 1903; *Tit-Bits*, 5 Sept 1903; *Strand*, Nov 1903

307 "the Leckies arrived": 31 Mar 1904 ID diary.

307 usually no further than her mother's cottage: Doyle, *Out of the Shadows*.

307 he ordered a new 20-horsepower car: 1 Oct 1904 ID diary.

307 entering a 9-horsepower Roc machine: *The Times*, 1 May 1905.

307 a blistering letter: Daily Mail, 21 Sep 1905; reprinted *Folkestone Herald*, 23 September 1905.

308 "the best thing I have done yet": ACD to MD, 28 Jul 1905, BL.

308 "Dei gratia finished": ACD to MD, 27 Nov 1905, BL.

309 "I'll supply (or have supplied) the politics,": ACD to A. L.Brown, Sotheby's sale, 16 Dec 2004.

310 slept for forty-eight hours: ACD to ID, 20 Jan 1906, BL.

310 "brave, gay, little smile": Mary's *Recollections* courtesy Georgina Doyle.

311 his poignant obituary: *The Times*, 1 Jun 1906.

311 "tears coursing down his rugged face," Mary's account courtesy Georgina Doyle.

312 "to give her every attention" quoted Carr, *The Life*.

SEVENTEEN
Edalji, second marriage and Windlesham 1907–1908

316 Kingsley had finished his last term: Doyle, *Out of the Shadows*, p. 143.

316 he felt robust enough: *Daily Express*, 7 Aug 1906; see also 11 and 31 Aug 1906

316 "long solitude": M&A.

317 Craddock was convicted of fraudulent mediumship: see *Daily Express*, 16, 17 May, 21 June 1906. ACD's reference to Husk and Craddock in M&A appears to suggest his visits to them took place after Louise's death. But the balance of probabilities suggests it was earlier. As noted by Admiral Usborne Moore in *Glimpses of the Next State*, Gambier Bolton's experiments with Husk and Craddock took place in 1904 and 1905. At the HRC there is an undated letter from Arthur to a Mr. Strachey about these visits, which is tentatively dated 1906, but could be one or two years earlier

318 "If I could feel that I had diverted Mr. Balfour's thoughts": ACD to Alice Balfour, 24 Sept 1906, NAS.

320 he proposed making a test case: ACD to Frohman, nd, Kittle Chicago.

320 He wrote to John Henniker Heaton: ACD to Henniker Heaton, nd, *News International* archives.

321 "Much talk of Edalji": 12 Jan 1907, ID Diary, GD.

322 the case of Adolph Beck: This case had been profiled in the opening (February 1905) issue of a new Newnes publication, the *Grand* magazine, which Arthur would have remembered, as he had been asked to inaugurate its series "My best piece and why I think so" and had somewhat improbably chose "A Straggler of '15."

322 "the appearance of a colored clergyman": M&A.

322 "an incredibly stupid injustice": ACD to Home Office, 21 Dec 1906, HO file, National Archives.

323 "I shall not mention the name": Meredith to ACD, 14 Jan 1907, quoted Nordon.

324 "chronic mental indigestion": Mary to ACD, 11 Feb ny (1907), BL.

324 "I would so gladly do anything": ibid.

325 "the dear Leckies": ibid.

325 "Arthur's Ptomaine": ID diary, 27 Feb 1907.

326 "very flourishing and happy": Mary diary, 18 Oct 1907, quoted Doyle, *Out of the Shadows*, p. 152.

326 "There is no reason why I shouldn't": quoted Doyle, *Out of the Shadows*, p. 153.

327 "I can't think why my father is so hard,": Mary to Kingsley, 24 Nov 1907, quoted Doyle, *Out of the Shadows*, p. 154.

327 "words" with her step-mother: Mary to Kingsley, 13 Jan 1908, quoted Doyle, *Out of the Shadows*.

328 a grand piano: this was actually a wedding gift from Sian's parents. See *The Lady* 26 Sep 1907.

329 He offered to do one such piece: ACD to GS, 4 Mar 1908, Virginia.

329 He told his mother this return: see ACD to MD, 11 Apr 08, BL.

330 The public was incensed: see *Daily Mail*, 25 July 1908.

330 "No Roman of prime": ibid.

330 presuming to speak for "all the English nation": *Daily Mail*, 1 Aug 1908.

330 he reeled off a long list: ACD to MD, 30 June 08, BL.

331 "The idea is to stick very closely": ACD to Dr. Nicoll, 23 Feb ny (1908?), BL.

332 Watt replied cautiously: see letters between Watt and Colliers, 27 Oct and 25 Nov 1908. Formal notice of cancellation of the agreement followed on 14 September 1910, UNC.

332 not above lobbying General Sir Reginald Wingate: ACD to Wingate, 10 Feb 1909, Durham Sudan Archive.

333 *The Times* saw fit to report: *The Times*, 12 Jan 1909.

333 "Faithful Patience to us both,": Mary to Kingsley, nd and 21 Jan 1909, quoted Doyle, *Out of the Shadows*.

333 He congratulated himself: see ACD to MD, 1 Feb 1909, BL.

334 "softer, more genial, less nervous": quoted Doyle, *Out of the Shadows*, p. 175.

335 Morel's archive: at the London School of Econonics.

335 "Then, when he had probed the whole thing": *Bookman*, Nov 1912.

336 "the greatest crime which has ever been committed" *The Times*, 18 August 1909.

336 "As to keeping Belgium for a friend": ACD to Gwynne, 6 Oct 1909, House of Lords.

337 "it is perhaps just as well": Morel to Rene Claparede, 17 Sept 1909. LSE, Morel Archive.

337 "His motto was that of Theodore Roosevelt": De Vere Stacpoole, *Mice and Men*.

338 "He was captain that day.": V.C., 2 Jul 1903.

338 "cynicism and obtuseness": ACD to ID, 21 Jul 1909, BL,

338 "clergymen rather ponderous": quoted Doyle, *Out of the Shadows*, p. 174.

339 "it throws down the whole period": *The Times*. 28 Dec 1909.

339 "We think we will soar up after this week,": ACD to ID, 24 Jan 1910, BL.

340 "Hope to make it up by hard work": ACD to (Frank) Bullen, nd (?end 1900), Chicago Kittle.

340 "the greatest British novelist": *The Wanderings of a Spiritualist*.

341 "infinitely better than my own play": *The Times*, 3 November 1913.

341 "some of these new schemes": Mrs. Humphry Ward to ACD, 24 Sept 1913, BL.

341 "for our rights are an asset": ACD to Mrs. Humphry Ward, 27 Sept 1913, HRC.

EIGHTEEN
Pre-war 1909–1914

342 "unfortunate scene": Mary's diary, quoted Doyle, *Out of the Shadows*.

343 Arthur had his son's career mapped out: ACD to ICD, 22 Jan 09, BL

343 "The romance of medicine": In this he would lecture the current intake on the qualities of healthy scepticism, optimism and kindliness required by a good doctor. He would also warn against the "undue materialism" which he felt had marred his own medical education.

343 he told Arthur he was looking forward: Ryan to ACD, 3 Jan 1910, BL.

344 "traces of some vanished race": *The Adventure of the Devil's Foot.*

344 his diary: BL.

345 "The Marriage of the Brigadier": *The Strand*, Sept 1910.

345 "The Blighting of Sharkey": *Pearson's Magazine*, Apr 1911. The latter was rejected by Greenhough Smith, despite Arthur's entreaties (see ACD to GS, 14 May 1910, Virginia).

345 "The Terror of Blue John Gap": *The Strand*, Aug 1910.

345 "The Last Galley": *London Magazine*, Nov 1910.

345 "The Last of the Legions": *London Magazine*, Dec 1910.

345 Robert Knox's seventeenth-century account: *A Historical Relation of Ceylon together with somewhat concerning Severall Remarkeable passages of my life that hath happened since my Deliverance out of my Captivity*, by Robert Knox James Maclehose, Glasgow, 1911.

345 a Christian slave who smashed: Ryan to ACD, 15 Aug 1910, BL.

345 African pygmies, gorillas and okapis: Ryan to ACD, 11 Nov 1910, BL.

345 "Through the Veil": published in *The Last Galley*, 1911.

346 a similar luncheon for Ernest Shackleton: 15 Jun 1909.

346 a fund-raising meeting for the British Antarctic Expedition: 12 Oct 1909.

346 *The Fair Land of Central America*: written 24 Oct 1909, published Oct 1911.

347 "a wild boy's book . . . The idea roughly": ACD to Casement from Beach Hotel, Littlehampton. 5 August 1910. National Library of Ireland, quoted *The Amazon Journal of Roger Casement*, ed. Angus Mitchell, Anaconda Editions, 1997.

347 "a boy's book in embryo": Ryan to ACD, 15 Aug 1910, BL.

347 "good stuff—rocketing pterodactyls: Ryan to ACD, 20 Nov 1910.

348 Arthur Smith Woodward, keeper of geology: ACD to British Museum, received 17 May 1909 and 19? May 1909, NHM.

348 he would like to meet Arthur: Dawson to Smith Woodward, 26 May 1909, NHM.

348 "We are keeping it carefully": ACD to Smith Woodward, marked 17 Feb 1911, NMH.

348 he was shown a rock: Dawson to Woodward, 13 May 1911, NHM.

349 "One of the singular characteristics": Commonplace book, July 1912?, BL.

349 "It is the difference": ibid.

350 he went up in a biplane: M&A. *The Times*, 25 May 1911. His interest stemmed partly from his membership of the council of the Aerial League of the British Empire, a natural offshoot from organizations such as the Empire Boys League and the League of Frontiersmen, devoted to British supremacy in the air.

350 since he controlled two-thirds of the company: ACD to MD, 30 November 1909, BL.

350 forced to send out: M&A.

350 Here in my room I keep a lump for show: see Lacon Watson.

352 he wrote to *The Times*: *The Times*, 11 July 1911 (He had called North Sea the German Ocean in 1903 see *To Arms* edited by Philip Weller, p. 33).

352 this was not the impression he gave: *The Annotated Lost World*, Pilot and Alvin Rodin (eds), Wessex Press, Indianapolis 1996, claims ACD's letter quoted in Ryan to ACD, 30 Aug 1914.

353 Mount Roraima in southern Brazil: Mount Roraima was associated with botanist Everard Im Thurn. *The Annotated Lost World* claims ACD attended a lecture by Im Thurn.

353 James Ryan went to Edinburgh: Ryan to ACD, 17 Oct 1911, BL.

354 Dawson sneeringly told Smith Woodward: Dawson to Smith Woodward, 30 Nov 1911, NHM.
354 "quite enjoying life": ACD to MD, 3 Dec 1911, BL.
354 "She will be pleased": ibid.
355 a bitter clash of opinions: *Daily News*, 20 and 25 May 1912.
355 accusing Shaw: *Daily News*, 20 May 1912.
356 planning to look after the boys: Barrie to ACD, 29 Sept 1910, BL.
356 Barrie gingerly informed his host: Barrie to ACD, 4 July 1912, BL.
356 Arthur sent Michael a finished copy: see Barrie to ACD, 18 Oct 1912, BL.
357 "I have traded so much on my friendship: Wodehouse to ACD, 9 Aug 1912, Sveum.
357 telling his mother he would succeed: One of his correspondents was indeed Lord Desborough, a genial former MP, turned indefatigible public servant. Having represented Britain at several games and swum the Niagara Falls, Desborough was also the immediate past president of the Marylebone Cricket Club. Arthur flattered him by saying he was not sure if Lord John Roxton, one of the explorers in *The Lost World*, had not been a composite of Desborough and Sir Taubie Goldman, by whom he meant the African administrator, Sir George Taubman Goldie.
358 of which he had written 20,000 words: ACD to MD, 23 Nov 1912, BL.
358 "excited about the skull": Dawson to Smith Woodward, 28? Nov 1912, NHM.
359 "a sort of Jules Verne book": Dawson to Smith Woodward, 14 Feb 1912, Piltdown Papers.
359 "perfectly splendid": E Ray Lankester to ACD, 26 Aug 1912, BL.
360 he advocated a bicycle cavalry: see *Pall Mall Gazette*, 6 Apr 1910.
362 he expected similarly beneficial results in Ireland: ACD to MD, 2 Nov 1911, BL.
362 a pseudonymous riposte to von Bernhardi: "Ireland and the German Menace by Bartha MacCrainn," *Irish Review*, Sept 1912.
362 "I have always had the feeling that if the majority": ACD to Childers, 28 Oct 1913, Trinity College Dublin, MS 3847-51/325.
363 defending his collie dog Roy: see *Crowborough Weekly*, 26 Apr 1913.
363 Editte wrote to her old mistress: Editte Troughton to JCD, 8 Jul 1913, BL.
364 "The Dying Detective": mss dated 27 Jul 1913 published *Strand*, Dec 1913.
364 "weary waiting for ideas": *Bookman*, Nov 1912.
364 "The Horror of the Heights": *The Strand*, Nov 1913.
365 "Borrowed Scenes": *Pall Mall Magazine*, Sept 1913.
365 "How it Happened": *The Strand*, Sept 1913.
367 he contacted the London publishers: 11 Dec 1912, BL.
367 his experiments in thought-reading: see John Bull, 5 Dec 1908 to 9 January 1909, also in *Daily News*, 1 Sept 1911.
367 published a pamphlet refuting Blackburn's allegations: Alice Johnson, *Mr. Blackburn's Confession*, privately printed, 1909.
367 began to wonder about his bona fides: see *The Strange Case of Edmund Gurney*, by Trevor H. Hall, Duckworth, 1980.
368 waging a small battle: see ACD to Lodge, 12 Sept 1913, Society for Psychical Research archive, Cambridge University Library.
368 "Thank you for all you have done": BL.
369 "I would like to be buried in all your old dresses": dated 31 Jan 1914, BL.
370 "I change the names": ACD to GS, 6 Feb 1914, HRC.
370 "I make it vague": ACD to GS, nd, HRC.
370 his *Fortnightly Review* article: Feb 1913.
371 a weekend house party at Knole: 6/7 Dec 1913. It was Lord Sackville's army officer brother Charles who had introduced Arthur to General Wilson.
371 "If I had a good competence": ACD to GS, 6 Feb 1914, HRC.
372 "clamped together by the": *Western Wanderings*.

372 "reconciled" to the trip: ACD to MD, nd ?early 1914, BL.

372 both *Le Temps* and *The Times*: 1 and 2 May 1914.

372 "So please grip this fact": *London Opinion*, 28 December 1912.

373 Ryan advised his friend: Ryan to ACD, 3 Sept 1912, BL.

373 "much as I admire Wells": ACD to unnamed recipient 6 Aug ny, BL.

374 H.G. Wells had "gotten away": quoted Barbara and Christopher Roden (eds.), *Western Wanderings*, Arthur Conan Doyle Society, 1994.

374 "the men of Ulster": NYT, 28 May 1914.

375 "Arthur said yesterday": JCD diary, Toronto,

376 According to their young guide: Borden Clark, see Christopher Redmonds, Welcome to Canada Mr. Sherlock Holmes: Arthur Conan Doyle in Canada, Occasional Paper No 2 of the friends of the Arthur Conan Doyle Collection of the Toronto Public Library.

376 *Western Wanderings*: Cornhill January to April 1915, published in book form in the United States by George H Doran, 1915.

NINETEEN
First World War 1914–1918

379 a joint authors" declaration: *The Times*, 18 September 1914.

379 "nothing but write about the war": ACD to GS, nd Sept 1914?, Virginia.

380 Malcolm's death was confirmed: he died on 28 August 1914.

380 "pray and truly believe": MD to JCD, 9 November (1914). Lausanne.

381 Herbert Asquith's backing: according to Brian Bond (op. cit.) this backing came while ACD was guarding prisoners at Lewes jail as part of his reserve duties. I could find no source for this claim.

381 cagey about his sources: Le Queux to ACD, 15 Feb 1915, BL.

382 he had been directed to him by the commander-in-chief: ACD to Edmonds, 4 May 1915, Liddell Hart Archives. The ACD–Edwards correspondence is in these archives. Edwards" assertion of Arthur's "try on" comes in a memo to Col. Hon W. Lambton, 25 Apr 1915.

382 "Four Brothers Killed and Wounded": *The Times*, 8 Mar 1915.

383 he forecast that Britain: ACD to Lily Loder-Symonds, 8 Mar 1915, BL.

383 "Your spiritualistic forecast": ID to ACD, 29 April 1915, Christie's auction, May 2004.

383 Lily was leaving Windlesham: correspondence, BL.

384 turning her "hand to the influence": ACD to Lily Loder-Symonds, 15 May 1915, BL.

384 "a very difficult man to handle": ACD to GS, nd, BL.

385 he was still so tied up: ACD to GS, 27 Jul ny (1915).

385 his information was "gorgeous": ACD to ID, nd, BL.

385 a protruding steel trident: *The Times*, 8 Sept 1914.

385 inflatable life belts: *The Times*, 29 Sept 1914.

385 "It has always seemed to me extraordinary": *The Times*, 27 Jul 1915.

385 old-fashioned gamekeepers than modern soldiers. The concept is John Bourne's in J.M. Bourne, "Haig and the Historians," in B. Bond & N. Cave (eds.), *Haig: A Reappraisal 70 Years On* (Barnsley: Leo Cooper, 1999).

385 "putting the British cause before the world": Duncan to ACD, 3 Nov 1915, BL.

386 "great success was impossible": *Daily Chronicle*, 20 Dec 1915.

386 appreciation of "The Greatest of Cricketers": *The Times*, 27 Oct 1915.

386 he heard from James Ryan: Ryan to ACD, 20 Dec 1915, BL.

386 *"dies neganda"*: ACD diary, 28 Jan 1916, BL.

387 "wondrous khaki garb": M&A.

387 "most wonderful spot in the world: M&A (source for many of the following descriptions of the front).

390 "How can we learn to understand": *The Times*, 4 Sept 1916.

391 "In the presence of an agonized world,": *New Revelation*.

391 As one commentator put it: Jones, *Conan Doyle and the Spirits*, p. 112–3.

392 He was satisfied by a picture: to Oliver Lodge, 3 Apr 1917, SPR archives, Cambridge.

392 "A Miracle Town": *Daily Chronicle*, 28 Nov 1916.

393 "Stern and I told him one or two things: 7 Feb 1917, *Lloyd George: A Diary*, by Frances Stevenson, edited by A.J.P. Taylor, Hutchinson, 1971.

393 descending on "harlot-haunted" London: *The Times*, 6 Feb 1917, see also 10,15 and 17 February 1917.

394 he bumped into Rider Haggard: 15 Mar 1917, *The Private Diaries of Rider Haggard*, ed D.S.Higgins, Cassell, 1980.

394 it would not be fair to Jean: ACD to ID. 2 Jun 1917.

395 "You are obviously tired": Malcolm Morris to ACD, 11 Jul 1917, BL.

395 "The public don't realise": ACD to ID, 2 Jun 1917, BL.

395 "The honey which you can hoard": ACD to ID, 12 Jun (1917), BL.

395 opening the batting:12 Aug 1917, *Dream book*, BL.

395 First mentioned in a letter: ACD to GS, 2 November (1917), Virginia.

396 Arthur denied he had been cross: ACD to Ida two letters, Aug 1917, BL.

396 "I feel that ordinary Christianity": KCD to Ida, 7 Nov 1917, BL.

397 no need for him to "butt in": Hornung to ACD 23 Jan 1918, BL.

397 forced to write to a local newspaper: 2 Feb 1918, *Sussex Daily News*.

397 "mutilated, but not vitally": ACD to ID, 14 Feb (1918), BL.

397 strongly defending his reputation: *The Times*, 4 May 1918.

398 "I would go down and take them by hundreds: ACD to ID, 5 May (1918), BL.

398 Father Dick Barry-Doyle: Barry-Doyle's grandfather was the brother of Arthur's grandfather John Doyle.

398 Barry-Doyle's earnest avowal: Barry-Doyle to ACD, nd, BL.

399 "stunned" to learn of Kingsley's: ACD to ID, 28 or 30 Oct 1918, quoted Doyle, *Out of the Shadows*.

399 Only a year earlier Arthur had commented: ACD to ID, 4 Sept (1917), BL.

399 "Britain had not weakened": M&A.



TWENTY
Spiritualist Mission 1919–1924



400 "It may be all true,": D.S. Higgins ed. *The Private Diaries of Sir H. Rider Haggard*, he consulted her four times: notes on sittings HRC.

402 "The levitation of a tambourine": *Introduction to Sydney Mosley, An Amazing Seance and an Exposure*, Sampson Low, 1919

402 "all the intolerance": *Light*, 23 Jun 1917.

402 queried why spirits: *Daily Express*, 30 Oct and Nov 1917.

403 His talk on "Death and the Hereafter": published by Rupert Books in 1992 as *A Full Report of a Lecture in Spiritualism*.

404 a paranormal explanation to various crimes: *The Strand*, between Dec 1919 and May 1921. Later reprinted in *The Edge of the Unknown*, 1930.

404 Jesus Christ in a New Bond Street exhibition: *Daily Mail*, 16 Dec 1919.

404 He was taken to task: *The Times*, 29 Dec 1919.

405 compare his work with Napier's *Peninsular War*. ACD to MD, 13 Nov (1918?), BL.

405 Ironically, the reviewer was John Fortescue: *TLS*, 11 Mar 1920.

405 dismissed it is a propagandist work: Keith Grieves, *Early Historical Responses to the Great War: Fortescue, Conan Doyle and Buchan*, in Bond.

405 "cast aside foolish incredulity: *Sunday Express*, 28 Dec 1919.

406 "I am half Irish, you know": *RDB's Procession*, by Ralph Blumenfeld, Ivor Nicholson & Watson, 1935.

406 "acutely embarrassing and painful": quoted Doyle, *Out of the Shadows*.
406 "An artist has an artist's failings" ACD to Milly Forbes, Feb 3 (1920), BL.
407 Some spiritualists believed: see Kalush and Sloman, *The Secret Life*.
407 "as nice and sweet as any mortal": quoted Polidoro, p. 37.
409 "the usual vague expression": Lodge to ACD, 2 Jul 1920, HRC.
410 an article in the *International Psychic Gazette*: January 1921.
411 "What right had such a man to die": *The Wanderings of a Spiritualist*.
413 the grand Stoll Film Convention: see Stoll Editorial New vol V, pp. 11–14, also *John O'London's Weekly*, 22 Oct 1921.
414 a hunt for dicyanin: see correspondence between ACD and Guy Ash, Kittle, Chicago.
414 "Now for Peace and now for plenty!": later added to Christmas Trouble, one of his collected poems published in Sep 1922.
415 an article in the newspaper *Truth*: 13 Aug 1919.
415 often exhibited "screen effects": Fred Barlow to ACD 3 Sept 1919 HRC.
418 "it was not occult": reported NYT 4 Jun 1922.
418 threatened with a law suit: see NYT 6 and 7 Jun 1922.
419 "never seen or heard anything": *New York Sun* quoted Polidoro, p. 100.
420 He immediately wrote to the magazine: *Scientific American*, Jan 1923.
421 he predicted an imminent upheaval: transcript of Pheneas's first appearance HRC quoted Kalush and Sloman.
421 He issued a statement: dated 19 Dec 1922.
421 challenged Houdini to demonstrate: NYT, 3 Mar 1923, written 9 February 1923.
421 Houdini shot back: NYT, 22 Mar 1923.
422 "He's Beginning to Strain Our Patience": NYT, 6 Apr 1923.
423 "Pray remember us all to your wife": ACD to Houdini, 30 Apr 1923 quoted Kalush and Sloman, p. 399.
423 hoped to bring a donation from England: *Light*, 3 Feb and 10 March 1923.
424 When the claim had come before the New York Supreme Court: see *The First Sherlock Holmes Cinematic Lawsuit*, by Albert M. Rosenblatt, *Baker Street Miscellanea*.
424 "so-called seances": NYT, 19 Apr 1923.
424 the streets of New York were filthier: NYT, 21 Apr 1923.
425 "if this mission of mine": ACD to Houdini, quoted Polidoro, p. 117.
426 "I hate sparring with a friend in public": quoted Polidoro, p 121.
427 a letter of endorsement for the occasion: ACD to Balfour, 12 Nov 1923, NAS.
427 "A public confession of faith": Eleanor Sidgwick to Balfour, 15 Nov 1923, NAS.
427 he wrote up glowingly: *Scientific American*, Jul 1924.
428 "Houdini is doomed!": ACD to Crandon, 10 and 15 Sept 1924, quoted Kalush and Sloman, pp. 435–6.
428 "he is a Messiah": quoted Kalush and Sloman, p. 439.
429 "Is it not a question": ACD to Price, 19 July 1924, University of London.
429 "I hear from New York": ACD to Price, 22 Sep 1924, University of London.
429 he had promised his daughter: ACD to Billy, nd, Berg.
429 He promised to form a psychic ring around it: *Pheneas Speaks*, Nov 1924.
430 warning businessmen: *The Times*, 5 Jan 1925.

TWENTY ONE
Bignell Wood and death 1925–1930

431 "I will break new ground": NYT, 7 Jun 1922.
432 "a big psychic novel": ACD to GS, 23 October 1924, quoted Green, *Bibliography*, p. 197.
432 "It was to me so important": ACD to GS, 24 Feb 1925, quoted Green, *Bibliography*, p. 197.

433 Arthur had written to his MP: 20 Sept 1924, HO45/11968.
434 Arthur proposed that the British College of Psychic Science: *Light*, 19 Dec 1925.
434 "It has long seemed to me": *Light*, 24 Jan 1925. For a description of the museum see *Strand Magazine*, May 1927.
435 "You would have laughed to see me coffee making": ACD to JCD, 1 Mar 1924, BL.
435 "more unspoiled . . . than anywhere in England": *Pheneas Speaks*, Jul 1924.
436 had given her 8,000 pounds outright: 9 May 1921; see National Archives.
437 Arthur refused to accept this judgement: *Recollections of Sir Arthur Conan Doyle by Residents of Crowborough*, collected by Malcolm Payne, The Conan Doyle (Crowborough) Establishment, 1993.
437 "You came back looking very pale": ACD to Denis, 17 Feb 1926, Berg.
438 Denis seemed to like to taunt: Denis to ACD, 30 May 1927, RLG, Portsmouth.
438 Lord Feversham's brother: David Duncombe was killed in a motor crash age seventeen.
438 he might consider sending him to Switzerland: ACD to Adrian?, 26 May 1926, Berg.
438 "When you upset your mother": ACD to Adrian, 13 Oct 1926.
438 Adrian thanked him profusely: Adrian to ACD, 24 Mar (1927), Berg.
439 Dick Barry-Doyle: for an interesting article on Barry-Doyle see *One*, magazine of the Catholic Near East Welfare Association, Oct 1991.
439 a "modern saint": *Christian Spiritualist*, 16 September 1925.
439 "in less than two centuries: Lamond to ACD 29 Mar 1926 BL.
440 "Yes, this is not a shop only": *Sussex County Magazine*, Dec 1926.
440 The MP was the enigmatic Harry Day: see National Archives.
440 "a little problem for Sherlock Holmes": Crandon to ACD, 4 Aug 1925, quoted Kalush and Sloman, p. 471.
440 saw the hand of the Roman Catholic Church: ACD to Crandon, 12 Aug 1925, quoted Kalush and Sloman, p. 473.
441 "a breach of confidence": Day to Crandon, 14 Oct 1925, quoted Kalush and Sloman, p. 473.
441 "Houdini is doomed, doomed, doomed": PS, 12 Apr 1925.
441 threatend to "tear to ribbons": Kalush and Sloman, p. 507.
441 "His death is a great shock": NYT, 2 Nov 1926.
441 "the spirit world might well be incensed": ACD to Fulton Oursler, nd, marked 20 February (1927), Georgetown University.
442 Pheneas's general predictions: see "Over There": *Arthur Conan Doyle and Spiritualism*, by Jeffrey L. Meikle, The Library Chronicle of the University of Texas at Austin, New series no. 8, Fall 1974.
442 The ransacking of Harry Day's London apartment: see NYT, 23 June 1927.
443 Bess later repudiated: see Bernard Ernst to ACD, 10 Mar 1930, HRC.
443 According to the charitable interpretation: Meikle, "Over There."
443 "a platitudinous bore": *Sunday Express*, 1 Jan 1928.
443 "there would not have been ten votes": ACD to JCD, nd, BL.
445 "I don't think he appreciated Bach: interview Christopher Roden, ACD, the *Journal of the Arthur Conan Doyle Society*, Volume 1, Number 2 (Mar 1990). See also *My Father as My Father*, by Jean Conan Doyle, SH Journal, summer 1980.
445 so far as Adrian recalled: Conan Doyle, *The True Conan Doyle*.
445 "in the same condition as France": NYT, 4 Nov 1928.
445 "the greatest author: *Sussex County Magazine*, Dec 1926.
445 "the finest prose style": *The Times*, 15 Feb 1927.
445 "England articulate": 68th annual dinner Savage Club, *The Times*, 7 December 1925.
446 "one of the greatest novelists in the world": *Our African Winter*.

446 "This must have been a good way to think": see *Recollections*, collected by Malcolm Payne.

447 it was "really too easy": *Sketch*, 10 Nov 1926, quoted RLG, *Uncollected SH.*

447 "It's not of the first flight": ACD to GS, Dec 1926 (according to Booth).

447 the twelve best Holmes stories: ACD's initial list, published in *The Strand*, June 1927, was *The Speckled Band, The Red-Headed League, The Dancing Men, The Final Problem, A Scandal in Bohemia, The Empty House, The Five Orange Pips, The Second Stain, The Devil's Foot, The Priory School, The Musgrave Ritual, The Reigate Squires.* These were reprinted in *Grand* magazine between Jun 1927 and Jun 1928. The winner of the competition chose ten of these twelve.

449 Arthur had added his name: *Sunday Mail* and *Record*, 3 Apr 1919.

449 "combination of the bulldog and the sleuthhound": ACD to Park, 19 Jan (1927?), HRC.

449 Arthur's confident prediction: ACD to Park, 2 May ny (1927), HRC.

450 Arthur was delighted and contributed an article: *Empire News*, 23 Oct 1927.

450 Macdonald wrote to the Scottish secretary: 24 Oct 1927, see Toughill.

450 "you breaker of my shackles": Slater to ACD, 17 Nov 1927, Mitchell Library.

450 experiencing dizzy spells: ACD to Park, 23 Jan (1928?), HRC.

451 wrote to the secretary, Mercy Phillimore: 5 Sept 1928, College of Psychic Studies quoted Morris, *Harry Price*, p. 107.

451 "We are a solid body": *The Times*, 26 Jul 1928.

451 had to be sacked: There had been another problem a couple of years earlier when Jean's faithful maid Jakeman left abruptly after John Matthews the parlourman had pushed her into the river.

452 "always brought us up to make our own decisions": Roden interview (op cit 418).

453 greater than in the average British town: OAW.

453 "I have not my full strength": ACD to Ashton Jonson, Christie's catalogue May 2004.

454 a thirteen page "open letter to all elderly folk": unpublished ms BL. This was published by ACD's Psychic Press as *An Open Letter to Those of My Generation* (1929).

455 "The Disintegration Machine": *Strand*, Jan 1929.

455 "When the World Screamed": *Strand*, April/May 1928.

455 "The Story of Spedegue's Dropper": *Strand*, Oct 1928.

455 "a disposition to remove the goods even further": *Southern Daily Echo*, 19 Aug 1929.

456 "a very dull book": 11 Nov 1929, Doubleday Archive, Library of Congress.

456 "this incidental book of Doyle's": Dec 1929, Doubleday Archive, Library of Congress.

456 enquire further of his stock broker: Ashton Jonson to ACD, 14 Jun 1929, RLG, Portsmouth.

456 "the copper green fields": ACD diary (from which much of the other detail is derived) property of Steven Rothman.

458 "8,000 people stood up in the Albert Hall": *Light*, 23 Nov 1929.

458 "tidy things up": ACD to Watt, 12 Nov (1929), Miranker.

458 "awfully sad": Doubleday Archive, Library of Congress.

458 Ashton Jonson wrote of his concern: see Christie's catalogue, May 2004.

458 move from one room to another: ACD to Watt, 28 Dec 1929, Miranker.

458 "She is quite nice": ACD to Denis, Feb 1930, Berg.

458 written an indignant letter: *Surrey County Herald*, 20 Jul 1929.

459 "kind and reassuring": Roden interview (op cit. 418).

459 "I am on a sick bed (angina)" ACD to William Roughead, 8 Mar 1930, NLS, Acc 5273.

460 Lobbying the Prime Minister: on another tack ACD told the *Sunday Times* in a 71st birthday interview (22 May 1931) that he regarded a new European war as

inevitable within 25 to 30 years unless the Treaty of Versailles was modified. (Pheneas seemed to have predicted a much more imminent conflagration.) ACD seems a strange appeaser. But his daughter Mary said he did not think much of Mussolini, distrusted dictators in general and thought democracy the lesser of two evils in comparison with totalitarianism.

460 never to sell his capital: ACD to Denis, 30 Jan 1930, Berg.
460 "A brave simple, childish man." Horace Walpole's diary, HRC.
461 "He gave me a message—a personal one": NYT, 14 Jul 1930.

Note on the value of money:

May I direct readers to an excellent website:

www.measuringworth.com/ppoweruk/

Using the most reliable measure, the retail price index, this tells what the value of 100 pounds (£100) is in the following years:

1855	£6253	1885	£7423	1915	£5506
1865	£6704	1895	£7937	1925	£3920
1875	£6478	1905	£7832	1935	£4772

Thus money kept its value well in the latter half of the nineteenth century where, in the period covered by this book, a rough measure is to multiply any figure by 75. It dipped with the First World War and its aftermath.

Select Bibliography

SHERLOCK HOLMES

A Study in Scarlet (1888)
The Sign of Four (1890)
The Adventures of Sherlock Holmes (1892)
The Memoirs of Sherlock Holmes (1893)
The Hound of the Baskervilles (1902)
The Return of Sherlock Holmes (1905)
The Valley of Fear (1915)
His Last Bow (1917)
The Casebook of Sherlock Holmes (1927)

NOVELS, STORIES, PLAYS, AND POETRY

The Mystery of Cloomber (1888)
Micah Clarke (1889)
Mysteries and Adventures (1889)
The Captain of the Polestar and Other Tales (1890)
The Firm of Girdlestone (1890)
The White Company (1891)
The Doings of Raffles Haw (1892)
The Great Shadow (1892)
The Refugees (1893)
Round the Red Lamp (1894)
The Parasite (1894)
The Stark Munro Letters (1895)
The Exploits of Brigadier Gerard (1896)
Rodney Stone (1896)
Uncle Bernac (1897)
The Tragedy of the Korosko (1898)
Songs of Action (1898)
A Duet with an Occasional Chorus (1899)
The Green Flag and Other Stories of War and Sport (1900)
The Adventures of Gerard (1903)
Sir Nigel (1906)
The Croxley Master (1907)
Waterloo (1907)
Round the Fire Stories (1908)
Songs of the Road (1911)

505

The Last Galley (1911)
The Speckled Band (1912)
The Lost World (1912)
The Poison Belt (1913)
Danger! And Other Stories (1918)
The Guards Came Through and Other Poems (1919)
The Poems of Arthur Conan Doyle-Collected Edition (1922)
The Land of Mist (1926)
The Maracot Deep and Other Stories (1929)

NON-FICTION

My First Book (with others) (1894)
The Great Boer War (1900)
The War in South Africa—Its Cause and Conduct (1902)
The Story of Mr. George Edalji (1907)
Through the Magic Door (1907)
The Crime of the Congo (1909)
The Case of Oscar Slater (1912)
Great Britain and the Next War (1914)
In Quest of Truth: Being a Correspondence between Sir Arthur Conan Doyle and Captain (Hubert) Stansbury (1914)
Western Wanderings (1915)
A Visit to Three Fronts (1916)
The British Campaign in France and Flanders
The New Revelation (1918)
The Vital Message (1919)
The Wanderings of a Spiritualist (1921)
The Coming of the Fairies (1922)
The Case for Spirit Photography (1922)
The Three of Them (1923)
Our American Adventure (1923)
Our Second American Adventures (1924)
Memories and Adventures (1924)
The History of Spiritualism (1926)
Pheneas Speaks (1927)
Our African Winter (1929)
The Edge of the Unknown (1930)

OTHER AUTHORS

Baker, Michael (ed.), *The Doyle Diary* (Paddington Press, 1978)
Barsham, Diana, *Conan Doyle and the Meaning of Masculinity* (Ashgate, Aldershot, 2000)
Barrie J.M., *The Greenwood Hat* (Peter Davies, 1937)
Beckson, Karl, *London in the 1890s: A Cultural History* (W.W. Norton, New York, 1992)
Belford, Barbara, *Bram Stoker* (Weidenfeld & Nicolson, 1996)
Bergem, Phillip G., *The Family and Residence of Arthur Conan Doyle* (Picardy Place Press, St. Paul, 2003)
Blum, Deborah, *Ghost Hunters* (Century, 2007)
Blumenfeld, R.D., *R.D.B's Diary* (William Heinemann, 1930)
Bond, Brian (ed.), *The First World War and British Military History* (OUP, 1991)
Booth, Bradford A. and Mehew, Ernest, *The Letters of Robert Louis Stevenson* (Yale University Press, 1994, 1995)

Booth, Martin, *The Doctor, the Detective & Arthur Conan Doyle* (Hodder & Stoughton, 1997)

Brogan, Hugh, *The Penguin History of the United States of America* (Penguin, 1985)

Brookes, Martin, *Extreme Measures* (Bloomsbury, 2004)

Burgin, George, *Memoirs of a Clubman* (Hutchinson, 1921)

Burton, John Hill *Narratives from Criminal Trials in Scotland* (Chapman & Hall, 1852)

Caesar, Gene, *Incredible Detective* (Prentice Hall, New York, 1968)

Campbell, John L. and Hall, Trevor H., *Strange Things* (Birlinn, Edinburgh, 2006)

Carr, John Dickson, *The Life of Sir Arthur Conan Doyle* (John Murray, 1949)

Cather, Willa, *The Autobiography of S.S. McClure* (University of Nebraska Press, 1994)

Chaney, Lisa, *Hide-and-Seek with Angels: A Life of J.M. Barrie* (Hutchinson, 2005)

Cheroux, Clement et al., *The Perfect Medium: Photography and the Occult* (Yale University Press, 2004)

Christie's, London, *The Conan Doyle Collection Sale Catalogue* (19 May 2004)

Collin, B.M., *J.P. Hornung: A family portrait* (The Orpington Press, 1970)

Collins, L.C., *Life and Memoirs of John Churton Collins* (John Lane, the Bodley Head, 1912)

Conan Doyle, Adrian, *The True Conan Doyle* (John Murray, 1945)

Conan Doyle, Adrian (ed.) *Sir Arthur Conan Doyle Centenary 1859–1959* (John Murray, 1959)

Conan Doyle, Mary, *A Visit to Heven* (A. Conan Doyle, privately 1899)

Connell, John, *W.E. Henley* (Constable, 1949)

Costello, Peter, *Conan Doyle, Detective* (Constable & Robinson, 2006)

De Vere, Stacpoole H., *Mice and Men, 1863–1942* (Hutchinson, n.d.)

Doyle, Georgina, *Out of the Shadows: The Untold Story of Arthur Conan Doyle's First Family* (Calabash Press, Ashcroft, B.C., 2004)

Engen, Rodney, *Richard Doyle* (Catalpa Press, Stroud, 1993)

Edwards, Owen Dudley, *The Quest for Sherlock Holmes* (Mainstream, Edinburgh, 1983)

Ellman, Richard, *Oscar Wilde* (Hamish Hamilton, 1987)

Egremont, Max, *Balfour* (William Collins, 1980)

Evans, Colin, *The Father of Forensics* (Berkeley Publishing, New York, 2006)

Finkelstein, David, *The House of Blackwood* (Pennsylvania University Press, University Park, 2002)

Foley, Nelson, *A Pocket Book of Coal And Speed Tables for Engineers and Steam Users* (Crosby Lockwood and Co., 1884)

Foster, R.F., *Modern Ireland 1600–1972* (Allen Lane, 1988)

Freeling, Nicolas, *Criminal Convictions* (Peter Owen, 1994)

Gibson, John Michael and Lancelyn Green, Richard (eds.), *33 by Arthur Conan Doyle* (Avenel Books, New York, 1982)

Gibson, John Michael and Lancelyn Green, Richard (eds.), *The Unknown Conan Doyle: Letters to the Press* (Martin Secker & Warburg, 1986)

Gibson, John Michael and Lancelyn Green, Richard (eds.), *The Unknown Conan Doyle Essays on Photography* (Martin Secker & Warburg, 1982)

Goldfarb, Clifford S., *The Great Shadow: Arthur Conan Doyle, Brigadier Gerard and Napoleon* (Calabash, Ashcroft B.C. 1997)

Green, Douglas G., *John Dickson Carr: The Man who Explained Miracles* (Otto Penzler, New York, 1995)

Gross, John, *The Rise and Fall of the Man of Letters* (Penguin, 1991)

Gunther, R.T. *Pausilypon, The Imperial Villa near Naples* (Oxford for the author, 1913)

Hamilton, Bernard, *A Kiss for a Kingdom, or A Venture in Vanity* (Hurst & Blackett, 1899)

Hamilton, Bernard, *One World At a Time* (Hurst & Blackett, 1928)

Harman, Clare, *Robert Louis Stevenson* (HarperCollins, 2005)

Higham, Charles, *The Adventures of Conan Doyle* (Hamish Hamilton, 1976)

Hoare, Philip, *England's Lost Eden: Adventures in a Victorian Utopia* (Fourth Estate, 2005)

Hochschild, Adam, *King Leopold's Ghost* (Macmillan, 1999)

Hocking, Silas K., *My Book of Memory* (Cassell, 1923)

Huntford, Roland, *Shackleton* (Abacus, 1996)

Inglis, Brian, *Natural and Supernatural* (Hodder & Stoughton, 1977)

Inglis, Brian, *Roger Casement* (Penguin, 2002)

Jackson, Holbrook, *The Eighteen Nineties* (Jonathan Cape, 1931)

Jackson, Kate, *George Newnes and the New Journalism in Britain 1880–1910 Culture and Profit* (Ashgate, Aldershot, 2001)

Jeal, Tim, *Baden-Powell* (Pimlico, 1991)

Jolly, W.P., *Sir Oliver Lodge* (Constable, 1974)

Jones, Kelvin I., *Conan Doyle and the Spirits Aquarian* (Wellingborough, 1989)

Jones, Nigel, *Through a Glass Darkly The Life of Patrick Hamilton* (Scribners, 1991)

Kalush, William and Sloman, Larry, *The Secret Life of Houdini* (Atria Books, New York, 2006)

Lacon, Watson E.H., *I Look Back Seventy Years* (Eyre & Spottiswoode, 1938)

Lambton, Arthur, *The Salad Bowl* (Hurst & Blackett, 1928)

Lamond, John, *Arthur Conan Doyle: A Memoir* (John Murray, 1931)

Lancelyn Green, Richard, *The Uncollected Sherlock Holmes* (Penguin, 1983)

Lancelyn Green, Richard and Gibson, John Michael, *A Bibliography of A. Conan Doyle* (Hudson House, 2000, revised edition)

Lellenberg, Jon (ed.), *The Quest for Sir Arthur Conan Doyle* (South Illinois University Press, Carbondale, 1987)

Le Queux, William, *The Crimes Club* (E. Nash and Grayson, 1927)

Liebow, Ely, *Dr. Joe Bell* (Bowling Green University Popular Press, Bowling Green, 1982)

Luckhurst, Roger, *The Invention of Telepathy 1870–1901* (OUP, 2002)

Lyon, Peter, *Success Story: The Life and Times of SS McClure* (Scribners, New York, 1963)

Macdonald, Peter D., *British Literary Culture and Publishing Practice 1880–1914* (CUP, 1997)

MacDonald, Robert H., *Sons of the Empire: The Frontier and the Boy Scout Movement, 1890–1981* (University of Toronto Press, Toronto, 1993)

McKinstry, Leo, *Rosebery* (John Murray, 2005)

Messinger, Gary S., *British Propaganda and the State in the First World War* (Manchester University Press, Manchester, 1992)

Moore, Decima and Guggisberg, Major F.G., *We Two in West Africa* (William Heinemann, 1909)

Morris, Harold, *Back View* (Peter Owen, 1960)

Morris, Richard, *Harry Price: The Psychic Detective* (Sutton Publishing, 2006)

Morton, Peter, *Grant Allen, The Busiest Man in England: Grant Allen and the Writing Trade 1875–1900* (Palgrave Macmillan, 2005)

Nordon, Pierre, *Conan Doyle* (John Murray, 1966)

Oppenheim, Janet, *The Other World* (CUP, 1985)

Orel, Harold (ed.), *Sir Arthur Conan Doyle Interviews and Recollections* (Macmillan, 1991)

Partridge, Frances, *Memories* (Gollancz, 1981)

Payne, Malcolm, *Crowborough Growth of a Wealden Town* (Brewin Books, Studley, 1985)

Pearson, Hesketh, *Conan Doyle: His Life and Art* (Methuen, 1943)

Polidoro, Massimo, *Final Séance The Strange Friendship between Houdini and Conan Doyle* (Prometheus Books, New York, 2001)

Pound, Reginald, *The Strand Magazine 1891–1950* (Heinemann, 1966)

Redmond, Christopher, *Welcome to America, Mr. Sherlock Holmes* (Simon and Pierre, Toronto, 1987)

Rodin, Alvin E. and Key, J.D., *Medical Casebook of Dr. Arthur Conan Doyle* (Robert E. Krieger, Malabar, 1984)

Rzepka, Charles J., *Detective Fiction* (Polity Press, 2005)

Spencer, Frank (ed.), *The Piltdown Papers 1908–55* (OUP, 1990)

Stashower, Daniel, *Teller of Tales: The Life of Arthur Conan Doyle* (Holt, New York, 1999)

Stavert, Geoffrey, *A Study in Southsea* (Milestone Publications, Portsmouth, 1987)

Symons, Julian, *Criminal Practices* (Macmillan, 1994)

Thomas, Ronald, *Detective Fiction and the Rise of Forensic Science* (CUP, 1999)

Toughill, Thomas, *Oscar Slater* (Sutton Publishing, 2006)

Trail, H.D., *From Cairo to the Soudan* (John Lane, 1896)

Wagner, E.J., *The Science of Sherlock Holmes* (John Wiley, Hoboken 2006)

Walker, Dale L, *Jack London,* Sherlock Holmes and Sir Arthur Conan Doyle (privately printed, New York, 1974)

Waller, Bryan Charles, *The Twilight Land and Other Poems* (George Bell and Sons, 1875)

Weller, Philip (ed.), *Recollections of Sir Arthur Conan Doyle by Residents of Crowborough collected by Malcolm Payne* (The Conan Doyle (Crowborough) Establishment, 1993)

Whyte, Frederic, *A Bachelor's London Memories of the Day before Yesterday* (Grant Richards, 1931)

Worthington, Heather, *The Rise of the Detective in early nineteenth century popular fiction* (Palgrave, 2005)

Wynne, Catherine, *The Colonial Conan Doyle* (Greenwood Press, 2002)

Index

NOTE: Works by Arthur Conan Doyle (ACD) appear directly under title; works by others under author's name.

Edge of the Unknown, The (collection), 458
Edinburgh:
 described, 3–4, 14
 Charles Doyle works in, 10, 13–14
 Catherine Foley moves to, 13
 ACD's childhood home in, 26
 conditions and reforms, 26, 53
 Sciennes Hill Place, 26
 Argyle Park Terrace, 43, 48, 56
 medical school, 49–50
 George Square, 55–56, 64
 ACD completes medical studies in, 75–76
 Lonsdale Terrace, 75
 concentration of intelligence in, 149
 ACD stands for Central constituency in 1900 election, 277
Edinburgh Ladies' Educational Association, 40, 52
Edinburgh Philosophical Institution, 21, 199
Edinburgh Photographic Society, 81
Edinburgh Review, 23
Edinburgh University:
 and women students, 40
 women excluded from medical studies, 50, 52, 60–61
 ACD makes donation to, 296
 ACD plans to represent in Parliament, 333
 and ACD's *The Lost World,* 353–54
Edmonds, Brigadier-General James, 381–82, 405
Edmonds, John Worth, 137–38
Edward VII, King *(earlier* Prince of Wales):
 ACD meets, 228, 289
 donation to ACD's Boer War fund, 289
 invests ACD with knighthood, 291
 Coronation, 294
 Balfour accuses of ignorance, 317
 ACD attends court, 331
 and ACD's *Fires of Fate,* 338
 death, 339
Edwards, Owen Dudley, 74, 146

Egypt:
 ACD's trip to with Louise, 232–36, 238
 ACD refuses to return to, 263
Einstein, Albert, 350
Eliot, George, 151
Eliot, T.S., 117
Elliot, Dr. Henry, 63
Ellis, Frederick, 13
Ellmann, Richard, 229
Elmore, Colonel, 217
Emerson, Ralph Waldo, 67, 103, 126, 128, 221
Emery Down, Hampshire, 156
Empire News, 449
Empress of Ireland, SS, 376
"Empty House, The" (ACD), 298, 357
Engen, Rodney, 10
Esher, Reginald Balliol Brett, 2nd Viscount, 305, 339
Esmond, Jill, 338
Essanay Film Manufacturing Company, 424
Estelle, Madame, 433
Eton College, Kingsley attends, 316, 342
eugenics, 120
Everybody's Magazine (USA), 364
Exploits of Brigadier Gerard (ACD), 227, 234
 stage version, 297, 309–10, 316

Fairbanks, Douglas, 426
fairies, photographed, 409, 414, 434
Fairley, J. Graham, 56
"Fall of Lord Barrymore, The" (ACD), 358
Farr, Florence, 252, 253
Fate of Fenella, The (joint serial novel), 183
"Fate of the *Evangeline,* The" (ACD), 109–10, 116
Faulds, Henry, 119
Fawcett, Percy, 347, 353
Feldkirch, Austria, 45
Felkin, Dr. R.W., 252

About the Author

A former foreign correspondent specializing in Africa and the Middle East, Andrew Lycett has written a number of successful biographies. Starting with Muammar Gadaffi (from his journalistic days), he has also written lives of Ian Fleming, Rudyard Kipling and Dylan Thomas. He lives in London.